CTA:

Creative Talk in Asia 亞｜洲｜創｜意｜對｜話

Creative Talk in Asia　亞｜洲｜創｜意｜對｜話

是一本介紹亞洲地區不同領域但關於「創意」的刊物，內容包含創意人及作品收錄，

並精選亞洲創意活動與讀者分享。CTA 試圖透過這樣的對話交流平台，

提升亞洲設計活力，並挖掘創意人作品背後動人的故事。

CTA is an issue introducing various domains of creativities in Asia.

We collect creators and their works. Also,

pick out special creative activities for our readers.

CTA tries to promote the design energy in Asia and to discover more touching stories

behind the creators' works through such exchanging platform.

序 Introduction

這幾年亞洲設計屢屢在國際設計競賽中獲得極大的肯定，東方的哲學思維與美學觀也逐漸被西方國家所喜愛，因此我們試圖透過

「CTA 亞洲創意對話」這樣的媒體平台，去記錄亞洲近幾年在設計上的顯著改變，將設計師精彩的想像火花和真摯情感記錄下來，

透過簡要的訪談形式，本期 " 遺珠之憾 " 主題讓讀者能夠深入瞭解設計師對於每個設計專案的用心與努力不懈的自我堅持，並分享如

何在兼顧自我理想與商業現實考量中取得完美的平衡。

21 世紀的亞洲除了延續東方美學與傳統哲學觀的美好價值，相信新世代的設計師們更想藉著創作去演繹出獨有於這個時代的新設計

語彙，在一個變化無比巨大且溝通快速更替的時代，設計師為大家留下來細膩地優雅地的人文哲思相信更加值得我們去好好品味。

CTA 也希望能夠替擁有無比潛力的亞洲市場盡一份綿薄之力，祝福大家 !!

In these days the designs in Asia are recognized by many International design awards, and the design thinking and

aesthetics in Asia is gradually being taken for granted in the whole world, so we launched CTA, and tried to record

the significant changes in Asia designs in recent years, and note the designers' sparks of imagination and passions

of creating through this media platform. With a form of brief interview and the subject "Hidden Gem," we hope that

readers can more understand the designers' intention behind each project. Besides, designers can share how they

strike the perfect balance between the ideal and commercial.

In addition to last the value of East aesthetics and traditional philosophy in 21st century, we believe that designers of

new generation expect their works can interpret an unique and new design language in this era. In an age of change

and the communicative modes replace rapidly, it is the designers that leave delicate and graceful philosophizing,

and we believe it deserve to be tasted by everyone.

CTA group hopes to do our bit for the Asia market with endless potential, best wishes!!

CTA 總編輯 Chief Editor

翻閱說明
direction for read

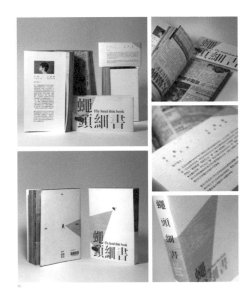

每張作品名稱後面都有標示頁碼，翻至對應的頁數後，可看到此作品的設計師簡介、網站、問答、作品理念，能更進一步了解設計師！

Behind each work's name has marked the page number, you can see more detail about work's designer, designer's introduction, Q & A, work's description after turning to the corresponding page, to further understand designers!

李杰庭 Lee Chieh-Ting
www.behance.net/leechiehting

台灣 Taiwan－

1991 年出生，台北人，主修商業設計，目前就讀於台灣科技大學商業設計所

Born in 1991, Taipei, major in commercial design in National Taiwan university of science and technology.

Q.請問您如何獲得靈感？

Q.How do you draw inspiration?

Q.請和我們分享您喜歡的書籍、音樂、電影或場所。

Q.Share good books, music, movies or places with us.

Q.現在，回頭來看這些作品，您有什麼新的感慨嗎？

Q.Now, look back to these works of regret for not been selected, how do you feel that?

Q.你對生活的細節上有什麼堅持嗎？像是上廁所時一定要看詩集之類的？

Q.What is your insist on your life's details ? like toilet with your favorite poem?

Lee Jae-Goo
www.behance.net/leejaergoo

韓國 Republic of Korea－

Graphic designer. Information Visualization, UX, UI, Branding based on Typography.

Q.請問您在貴國最棒的是什麼 ? 如國家的特色或文化作品?對您的創作是否受到影響?

Q.What do you like best in your country? (such as country feature or culture)Has it made a difference on your creation?

Q.請問您如何獲得靈感？

Q.How do you draw inspiration?

Q.請和我們分享您喜歡的書籍、音樂、電影或場所。

Q.Share good books, music, movies or places with us.

Q.現在，回頭來看這些作品，您有什麼新的感慨嗎？

Q.Now, look back to these works of regret for not been selected, how do you feel that?

Q.你對生活的細節上有什麼堅持嗎？像是上廁所時一定要看詩集之類的？

Q.What is your insist on your life's details ? like toilet with your favorite poem?

 可依照作品名稱後面標示頁碼翻到該頁觀看設計師作品。

 You can follow the page number behind each work's name and turn to the page to see designer's work.

出版印刷設計
PUBLISHING DESIGN

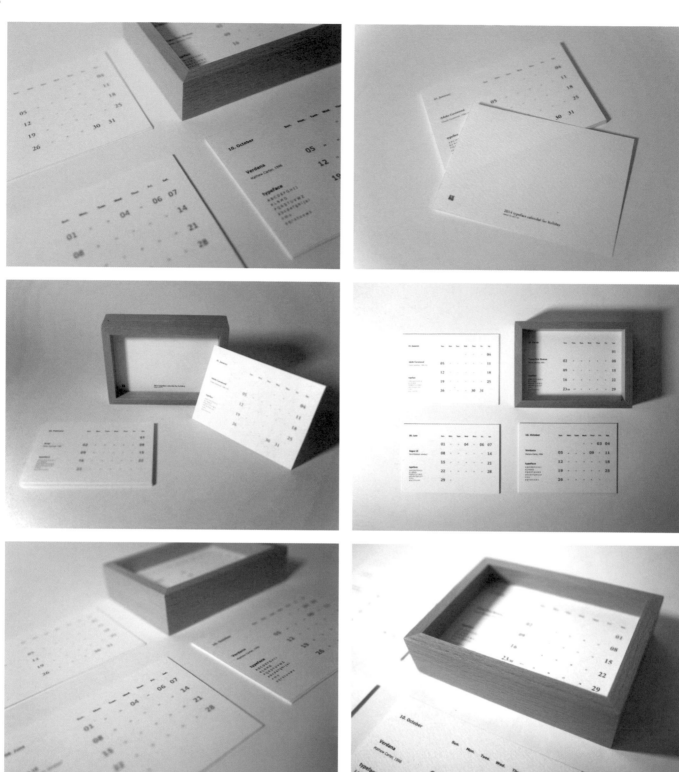

01/ 2014 Typeface Calendar for Holiday *P.349*
02/ 蠅頭細書 – 概念書籍設計 Flies head tiny book-Concept of Book Design *P.393*

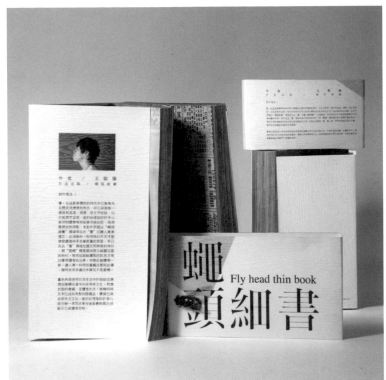
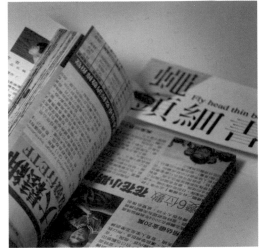

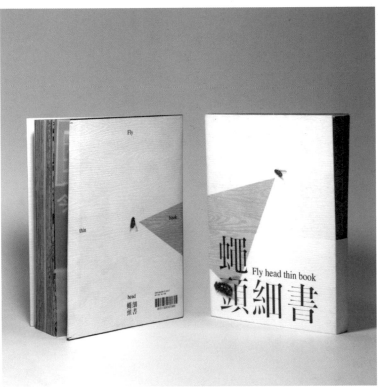

02

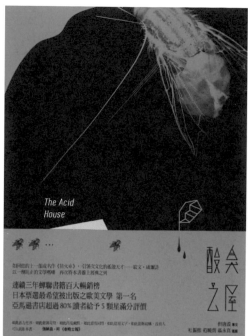
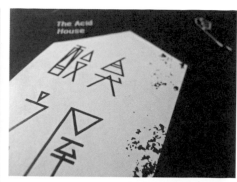

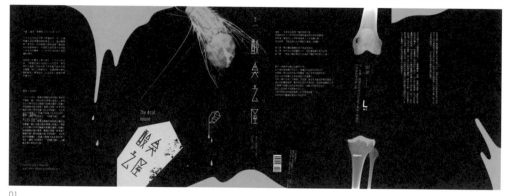

01

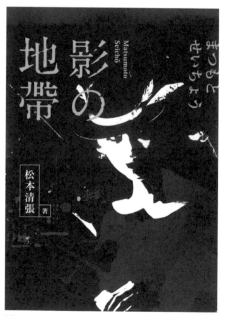
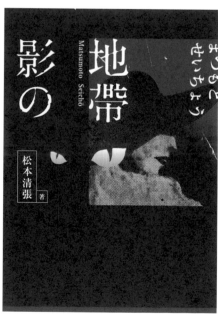

02

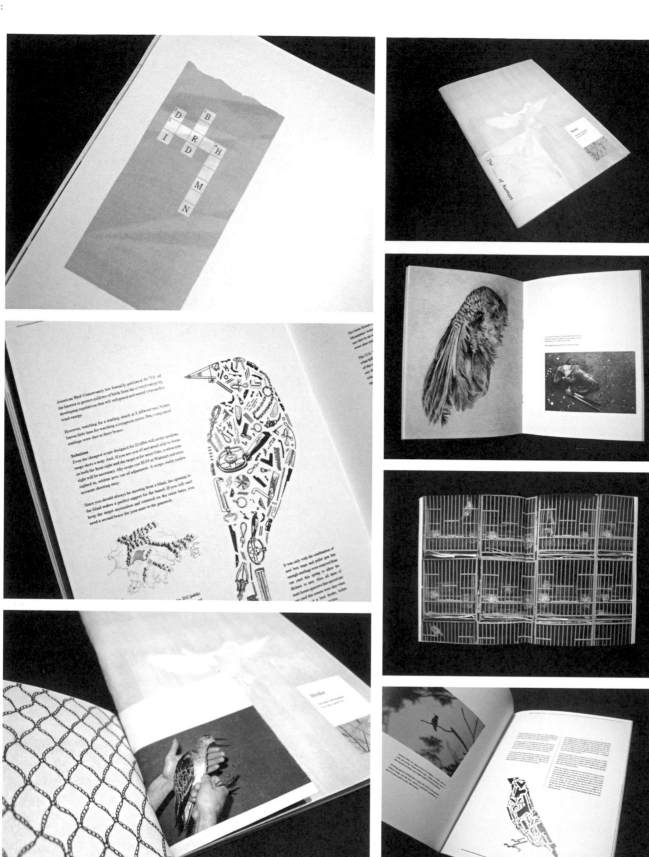

02

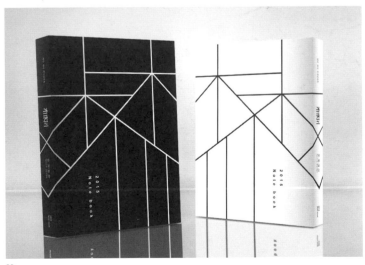

03

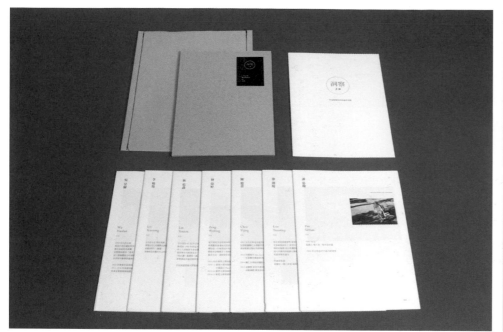

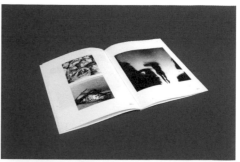

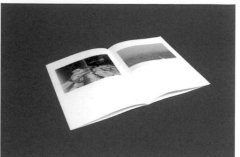

01

02

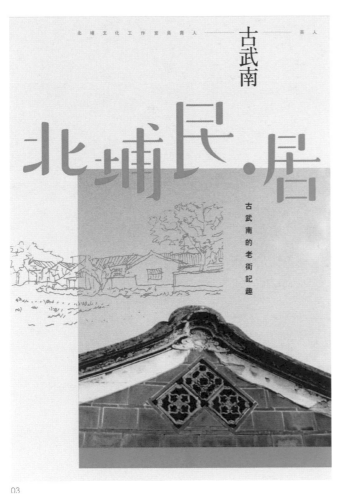

古武南

北埔文化工作室負責人————茶人

北埔民．居

古武南的老街記趣

03

有一種

張
讓

謠傳

04

BUDDHA
STANDARD TIME:

*Awakening to
the Infinite Possibilities
of Now*

佛陀
標準時間

覺·察·當·下·的·無·限·可·能·

123

舒雅達——著
項慧齡 譯

Lama Surya Das

05

舒雅達——

佛陀
標準時間

BUDDHA
STANDARD TIME:
Awakening to
the Infinite Possibilities
of Now

覺察當下的無限可能

項慧齡——譯

Lama Surya Das

01

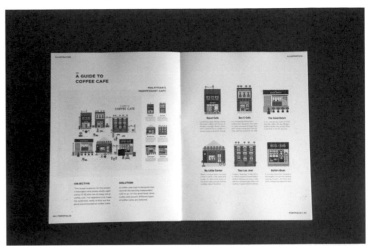

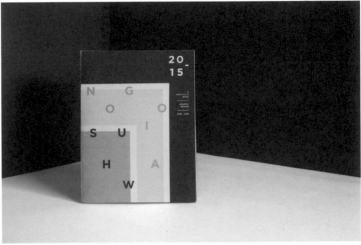

02

03

17

01

02

X

Paper Street.
est une compagnie de publication et de design. L'idée vient de "paper street", une rue qui apparaît sur les cartes mais qui n'existe pas réellement. Ce nom est généralement utilisé lorsque les architectes font une première mise en place

PAPER ST

SANS PAROLE

DURALEX. TW

Duralex est une marque très connue en France, mais son exportation vers Taiwan a seulement commencé en 2014.
Le design de la marque m'a été confié afin de mieux correspondre au marché taiwanais.
On peut également voir quelques photos du lancement de la marque à Taiwan.

BLOOMING FIELD

THE BIG ISSUE

Un magazine fondé en avril 2010, avec le même objectif que The Big Issue UK créé il y a 24 ans, celui-ci étant de permettre aux sans-abris de gagner de l'argent de façon digne en vendant des journaux.

Les journalistes du magazine viennent de partout dans le monde. Le magazine présente les événements sociaux ainsi que l'actualité artistique. Le magazine est aujourd'hui présent dans plus de 20 pays.

MOITIÉ

Autre projet personnel basé sur un simple portrait représentant quelques-uns de mes traits de caractère.

CYAN

Une carte de visite pour mon propre atelier de design.
CYAN est une équipe composée de 2 personne focalisées sur le design graphique.
L'idée vient du bleu tendant vers le vert qui est utilisée dans le panel de couleur RGB.
Cette couleur nous convient particulièrement car elle permet un large choix de possibilités et de compositions.

DAC. Taipei

Cette impression a été designé pour l'événement de noël au Digital Art Center à Taipei. Le client souhaitait une image impressionante sans phrases.

御品堂

C'est une marque de cosmétique qui encourage des produits naturels. Voici une des propositions livrées au client.

03

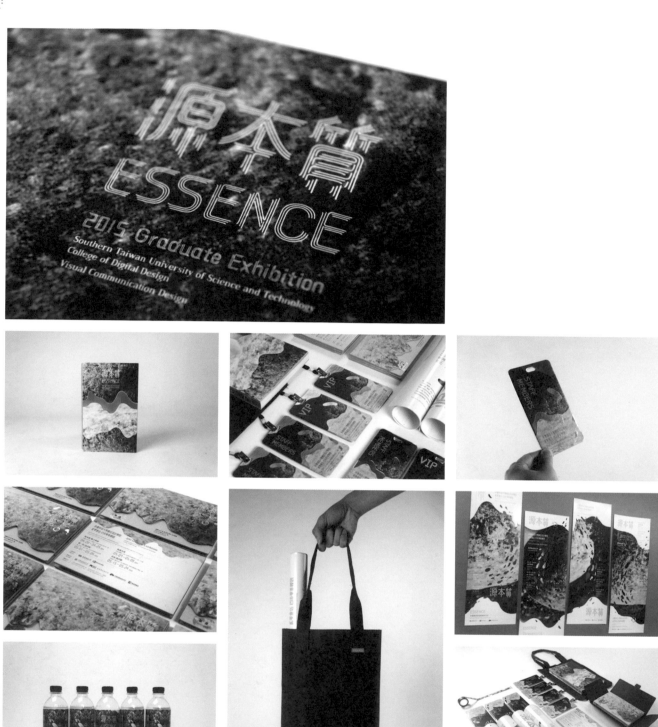

01

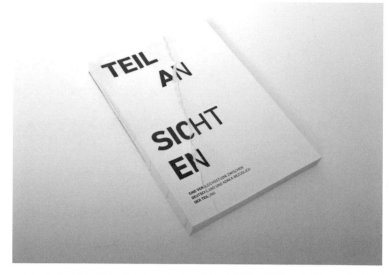

01

02

03

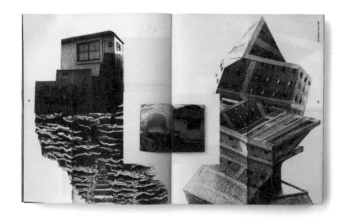

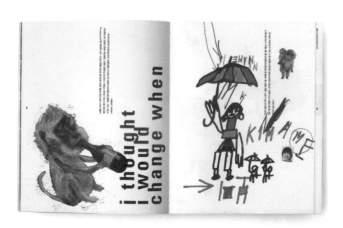

01

02

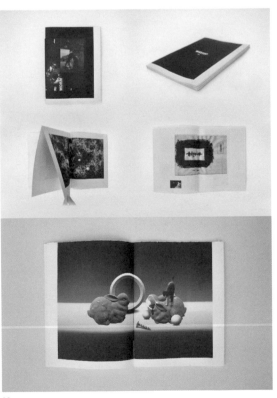

03

01

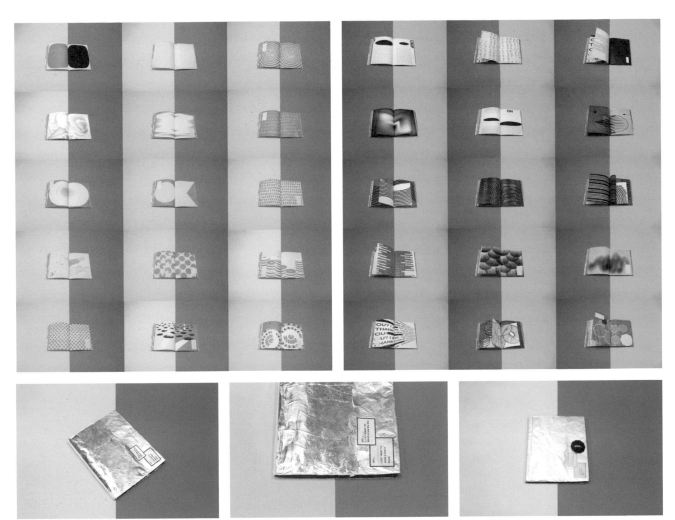

02

03

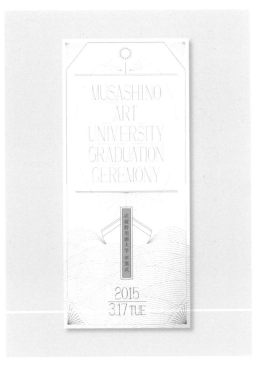

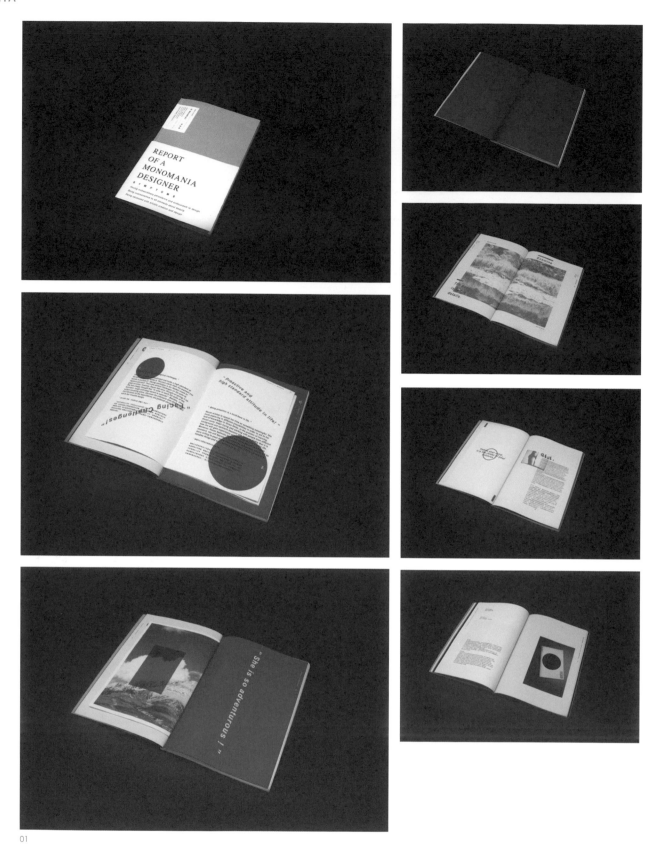

01

02

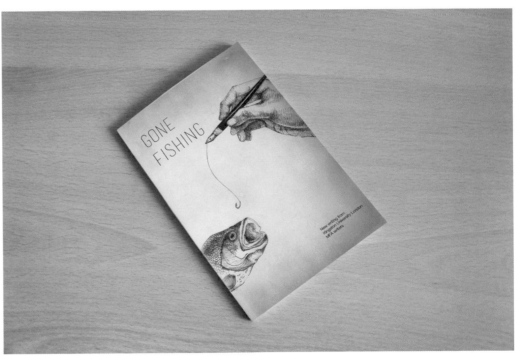

03

01

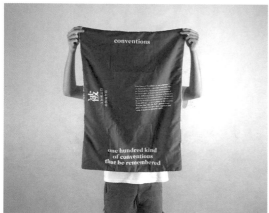 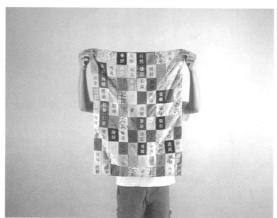

02

03

04

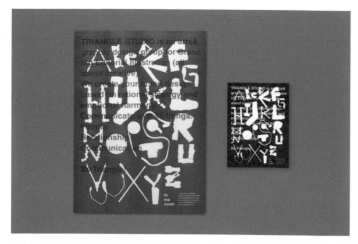

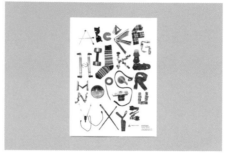

01

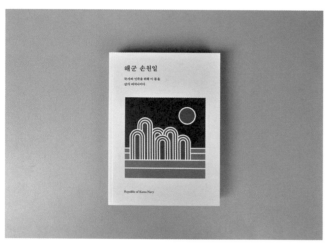

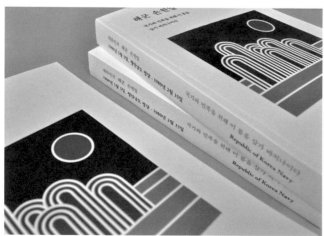

02

01/ In Ma Room *P.337*
02/ Republic of Korea Navy, admiral Son Won-il biography *P.349*
03/ Korea *P.344*
04/ Death Money *P.367*

03

04

01

02

01/ Try Angle Paper #01 P.337
02/ Try Angle Paper #02 P.337
03/ Try Angle Paper #03 P.337
04/ Try Angle Paper #04 P.337

34

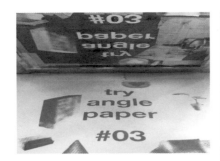
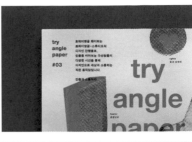

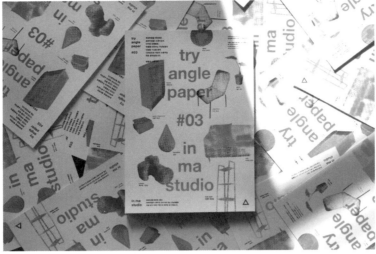

03

04

01

02

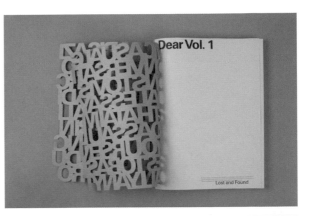

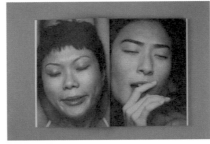

03

04

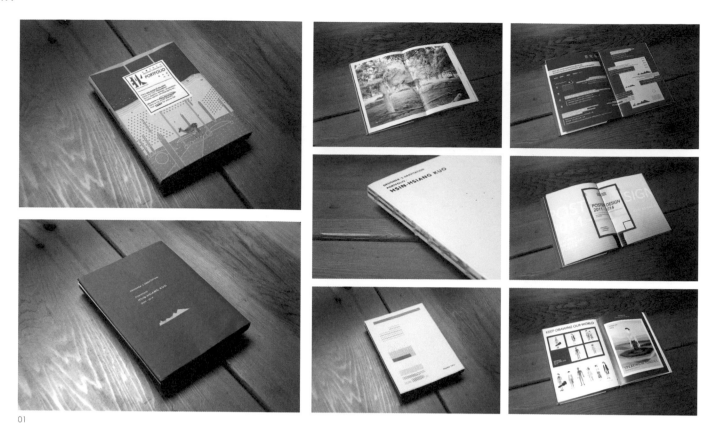

01

02

03

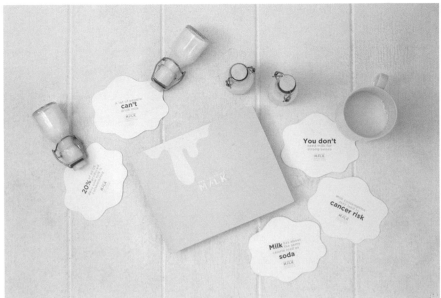

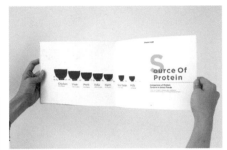

04

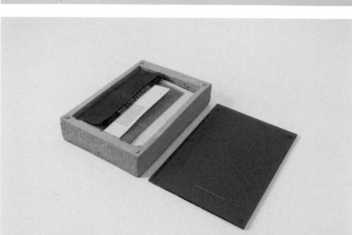

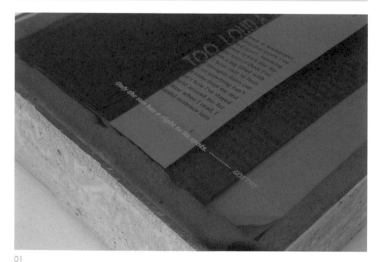

01

02

03

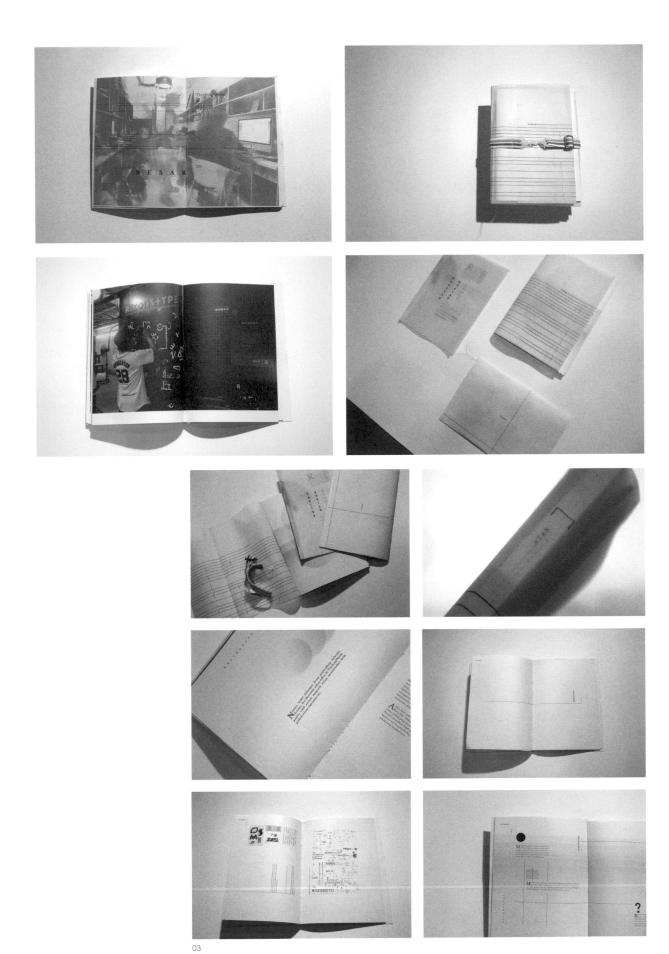

包裝設計
PACKAGING DESIGN

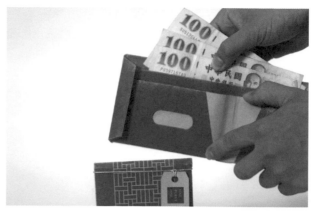

01

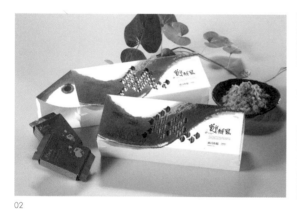
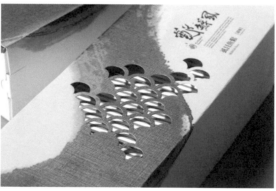

02

03

01/ 留一份情 Leave a Memory *P.370*
02/ 鄭鮮虱 – 虱彼壽魚鬆系列 ZHENG SIM SAY - SHI BI SHOU *P.370*
03/ 鄭鮮虱 – 老虱說生鮮系列 ZHENG SIM SAY - Simon Say *P.370*
04/ Happy GOAT(GOLD) Year *P.317*

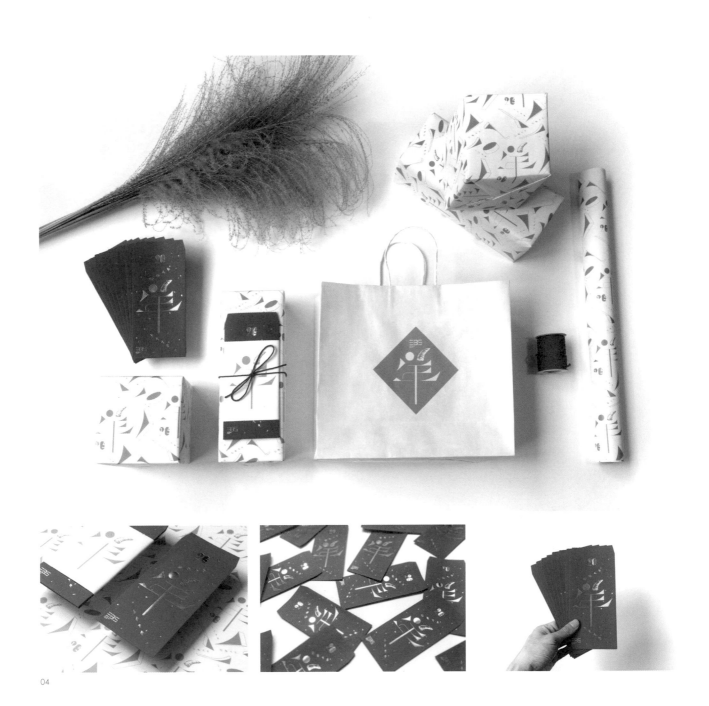

04

01

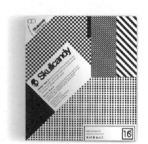
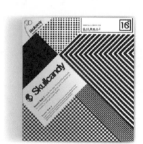
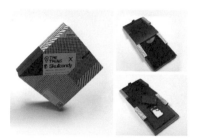
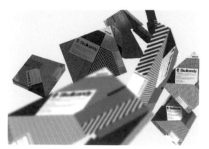

02

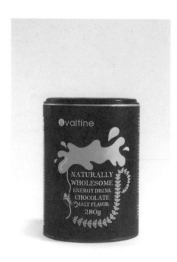

03

04

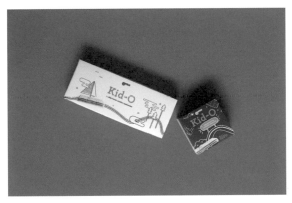
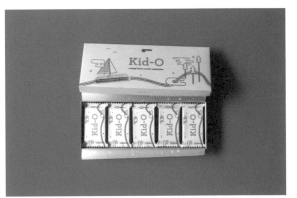

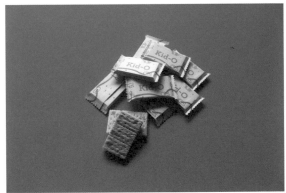

05

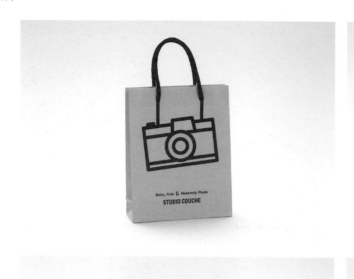
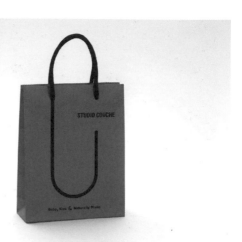
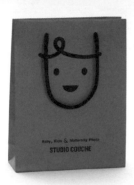
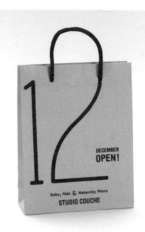
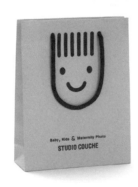
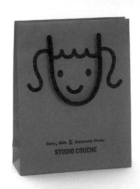

01

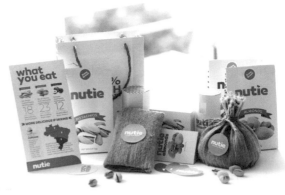

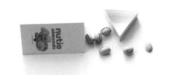
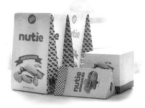

02

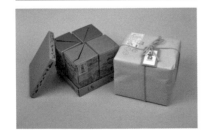
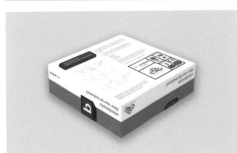

03

04

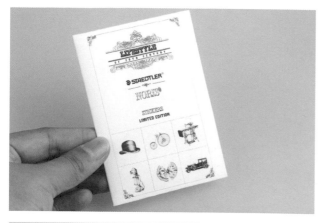

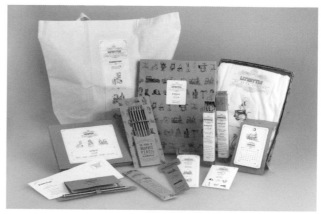

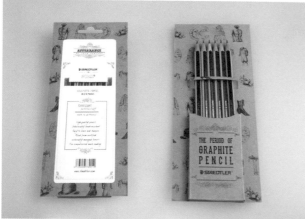

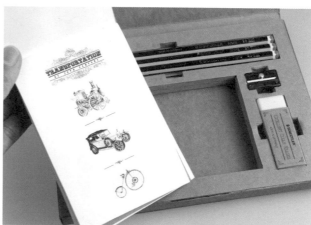

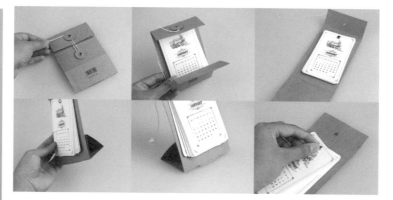

01

01/ STAEDTLER Limited Edition Packaging *P.380*
02/ The Sunshine at Night *P.392*

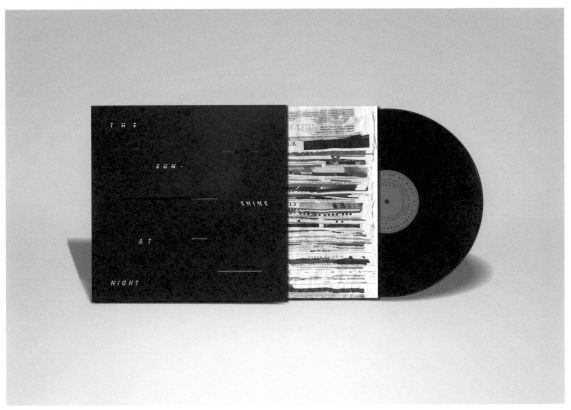

02

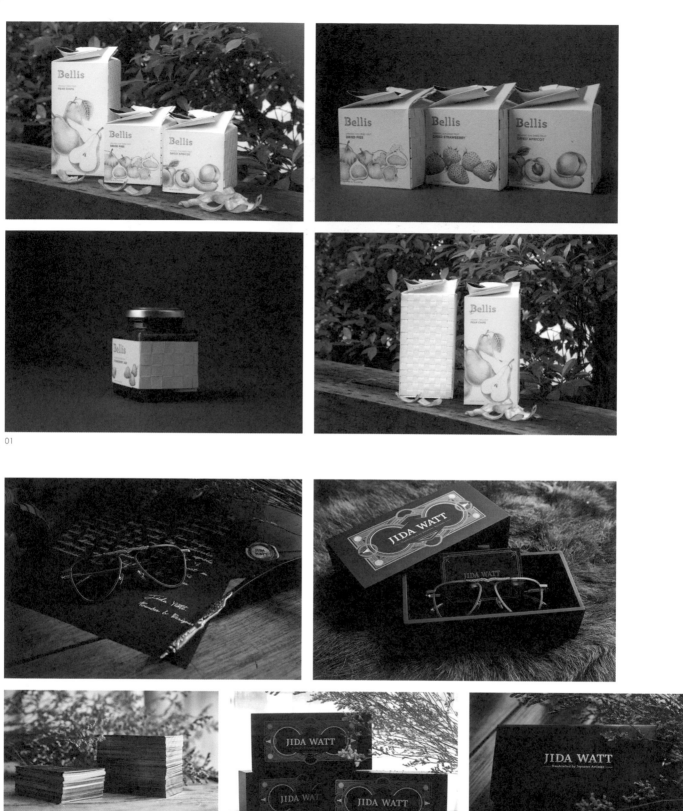

01

02

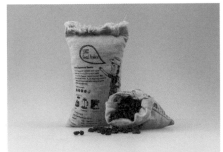

03

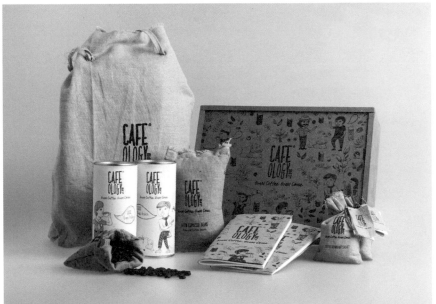

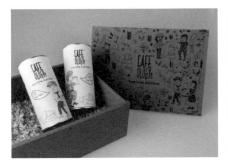

視覺設計 含、毛伸產品
VISUAL DESIGN

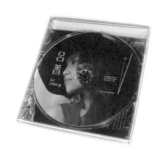

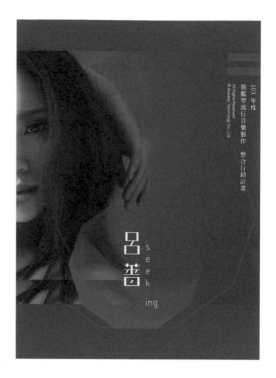

01

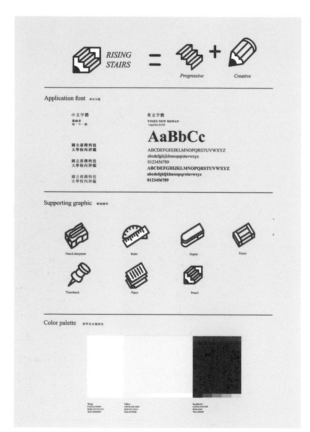

02

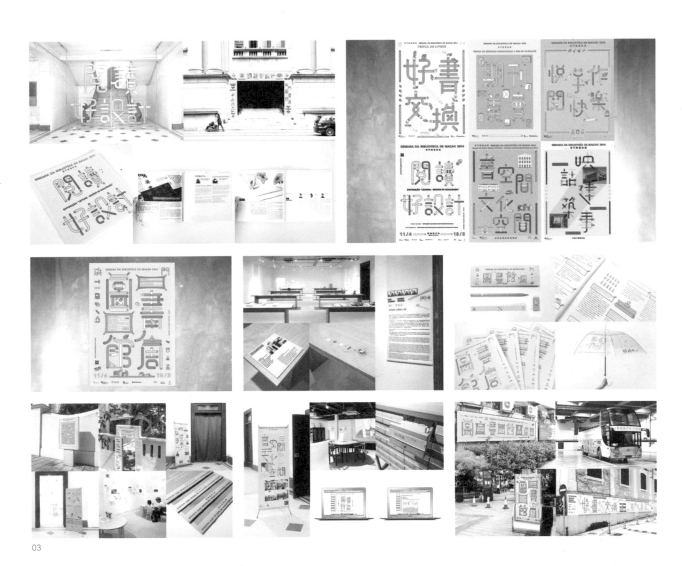

03

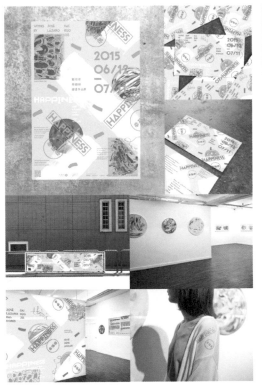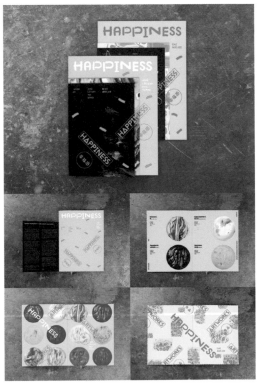

04

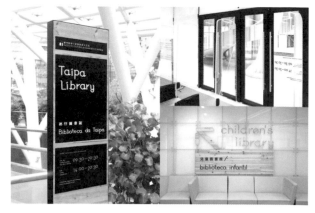

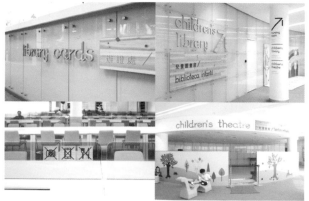

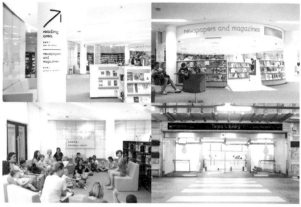

Taipa Library

Biblioteca da Taipa

09:30 – 20:30 opening hours children's library children's theatre lockers newspapers and magazines reading area information library card reader services check in / out photocopy service nursing room restroom

09:30 – 20:30 horário de funcionamento biblioteca infantil informações teatro infantil jornal e revistas área de leitura atendimento dos leitores cartão de leitor empréstimos e devoluções serviço de fotocópias cacifos casa de banho berçário

abcde

abcdefghijklmnopqrstuvwxyz
1234567890()[]!?()/'",;:---

áâãà

aáâãàbccçdeéêfghíijklmnoóôõ
pqrstuúûüùvwxyz

01

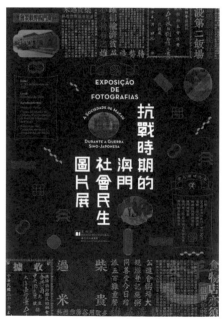

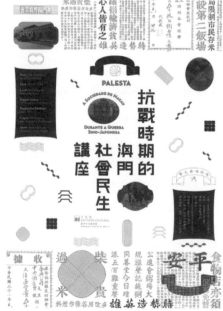

02

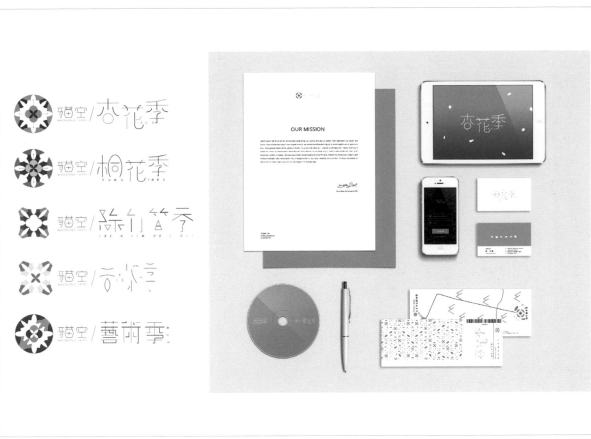

03

04

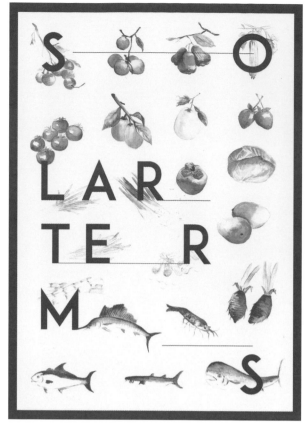

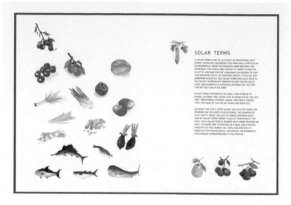

01

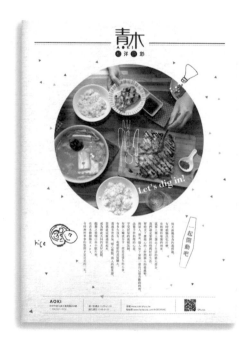

02

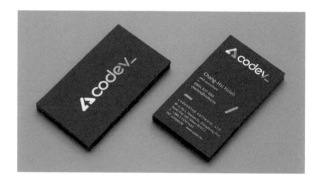

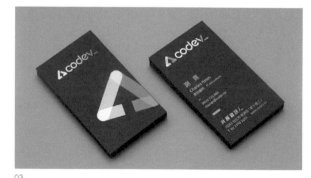

03

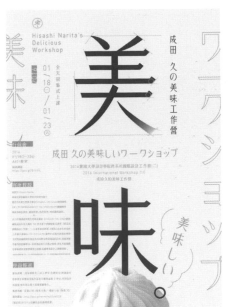

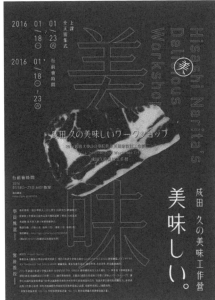

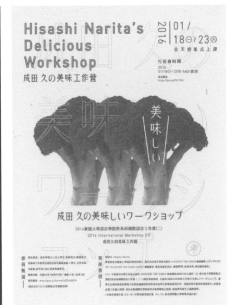

04

05

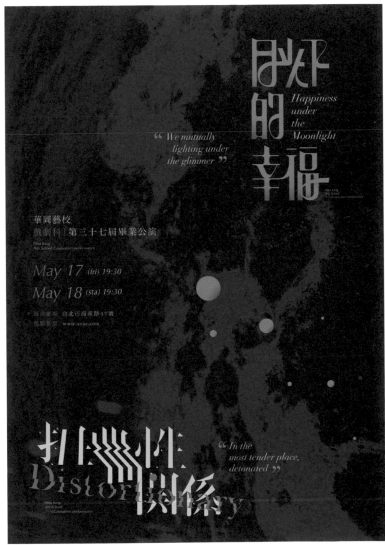

06

01

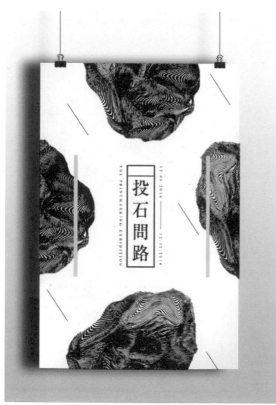
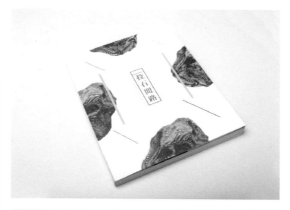

02

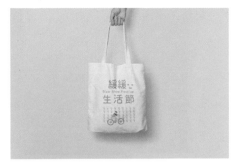

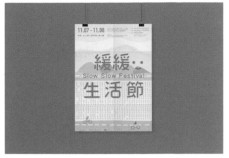

03

04

05

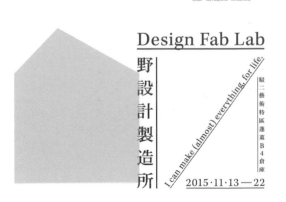

06

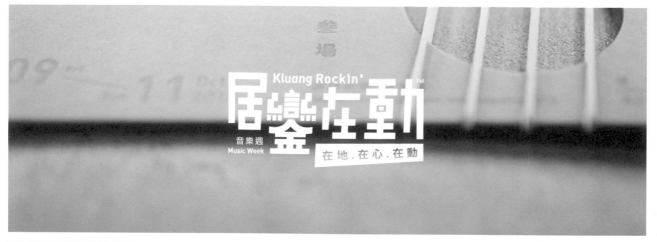

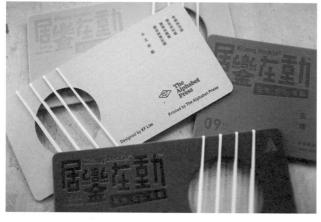

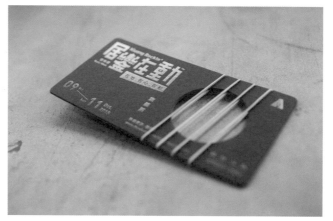

01

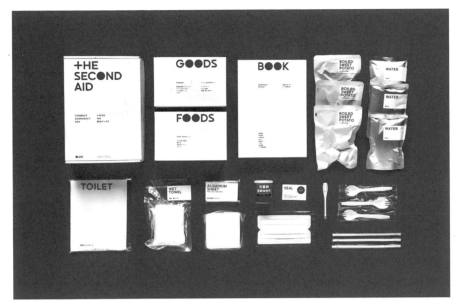

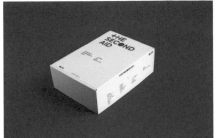

02

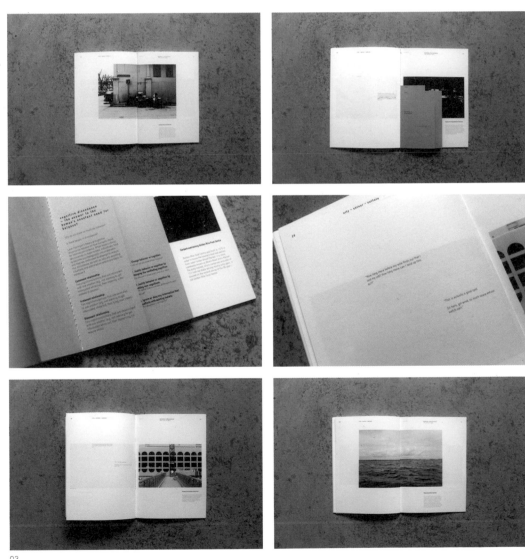

03

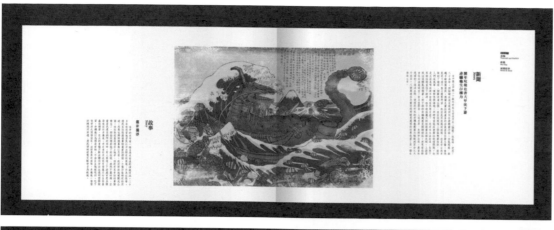

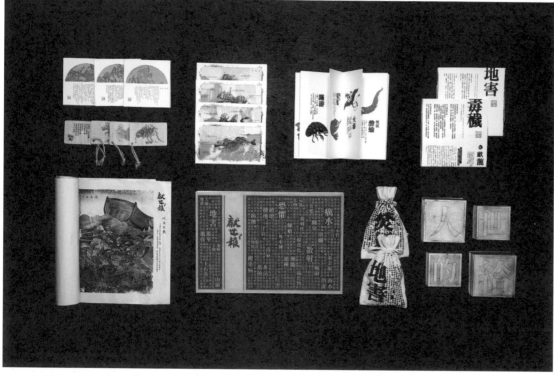

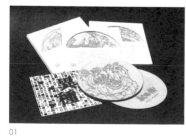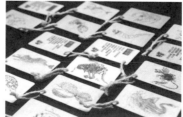

01

02

03

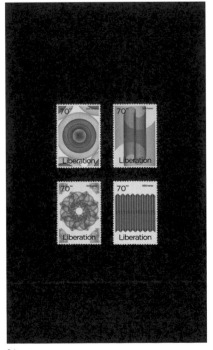

04

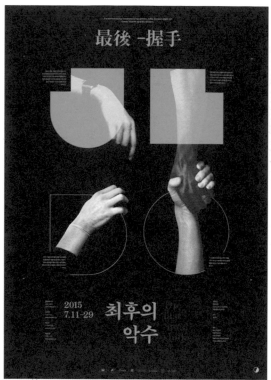

01

02

03

04

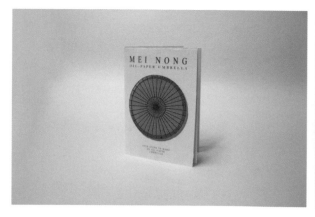
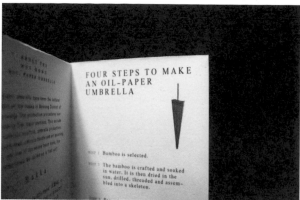

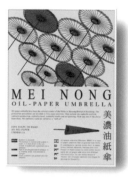
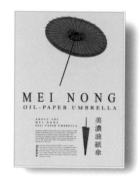
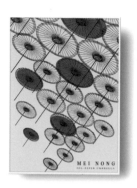

01

02

03

04

01

02

- Punyeta, eto na naman siya.

- isang buwan na yung due ng project mo.
- teka bili lang ako istapegi.

- walang kalimutan ha
- tuloy ang forever.

03

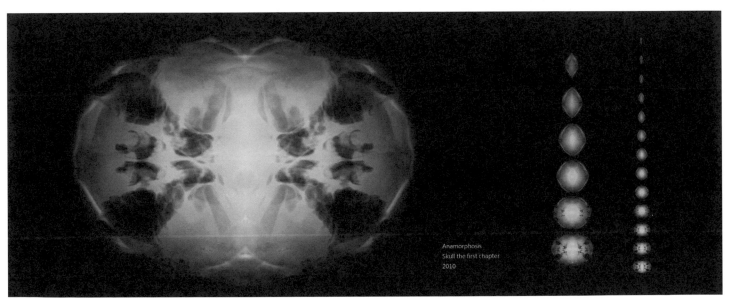

Anamorphosis
Skull the first chapter
2010

04

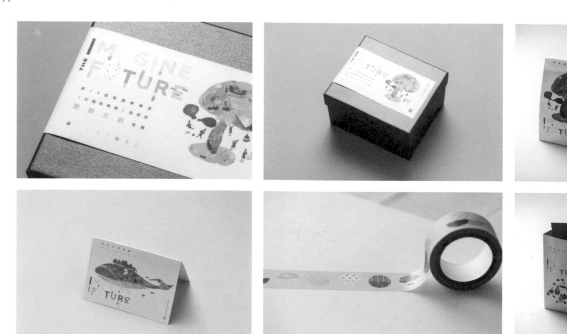

01

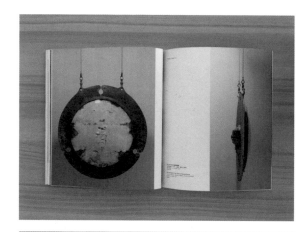

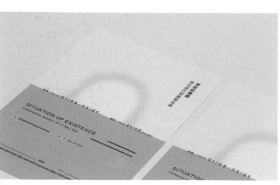

02

03

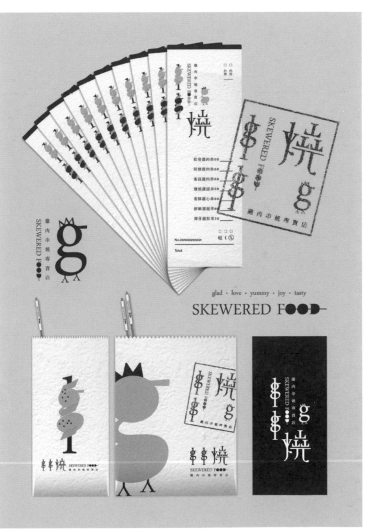

04

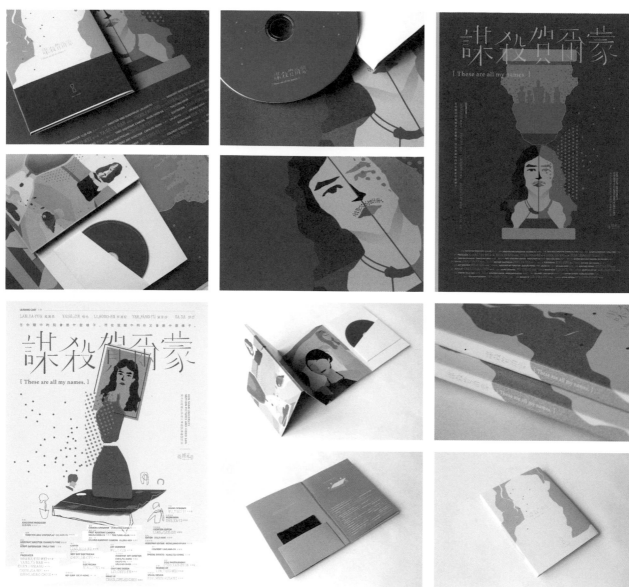

01

瀚字選
Bohan's Logotypes Collection

製慢家名心
新施龍最煮管當
人碼處花展代
祭者壁留之場
巷計館漬花展代
放星雅問沙設客健輕
本選鬼沙設瀚
博的茶顧得桐

02

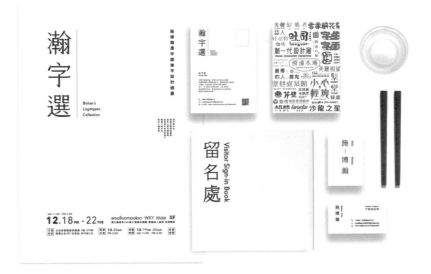

瀚字選
Bohan's Logotypes Collection

留名處　Visitor Sign-in Book

施　博　瀚

12.18 FRI - 22 TUE　woolloomooloo WXY Xhibit 5F

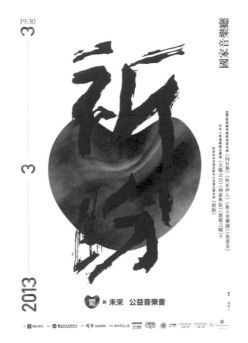

19:30
3
3
2013

國家音樂廳

愛與未來 公益音樂會

03

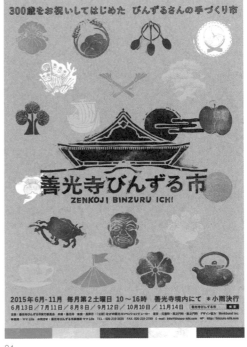

善光寺びんずる市
ZENKOJI BINZURU ICHI

300歳をお祝いしてはじめた びんずるさんの手づくり市

2015年6月-11月 毎月第2土曜日 10～16時 善光寺境内にて ＊小雨決行
6月13日／7月11日／8月8日／9月12日／10月10日／11月14日

04

01

02

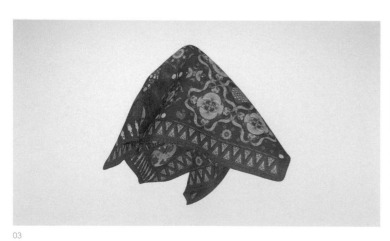

03

04

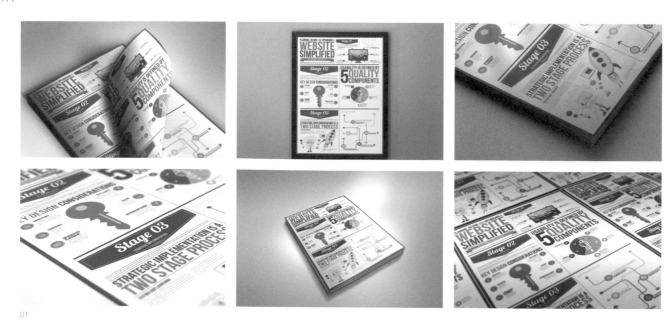

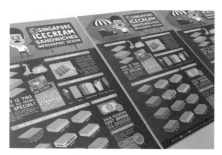

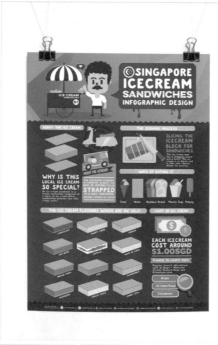

01

02

01/ Website Simplified infographic design *P.353*
02/ Singapore Icecream Sandwiches infographic design *P.353*
03/ The Art of montivation infographic design *P.353*
04/ Saving Water infographic design *P.353*

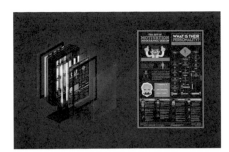

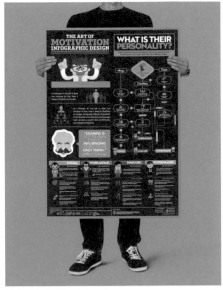

03

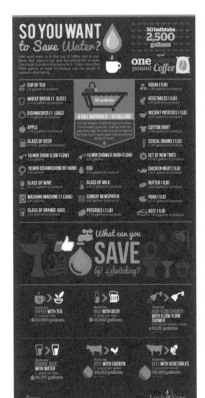

04

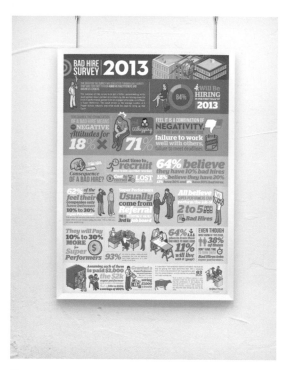

01

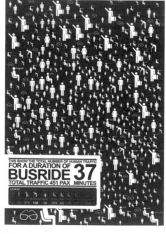

02

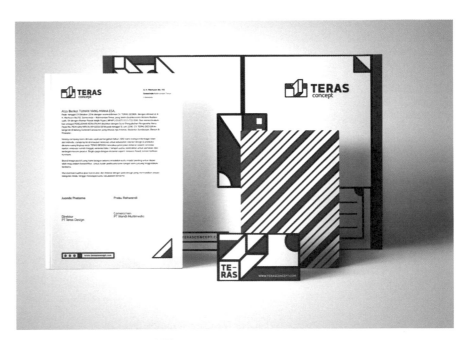

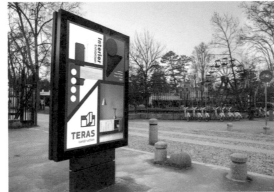

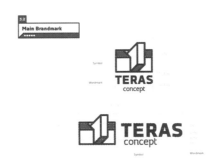

03

海報設計
POSTER DESIGN

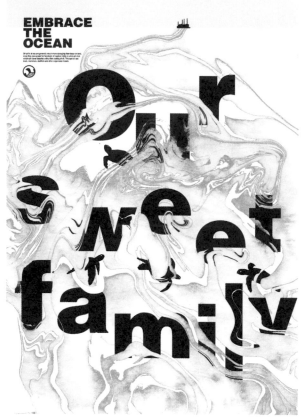

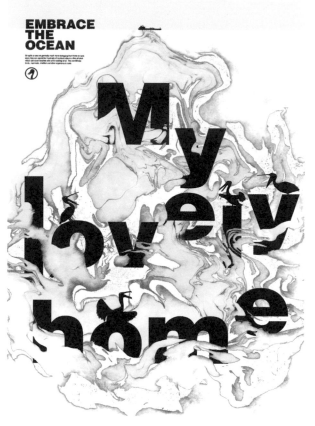

01

02

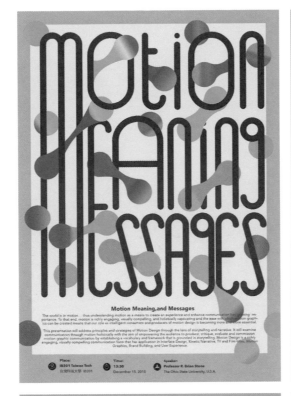
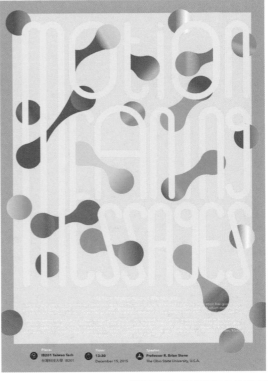
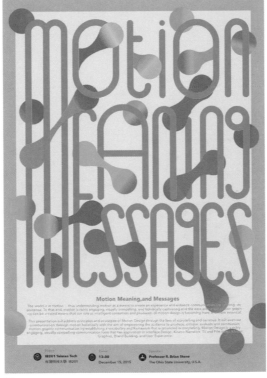
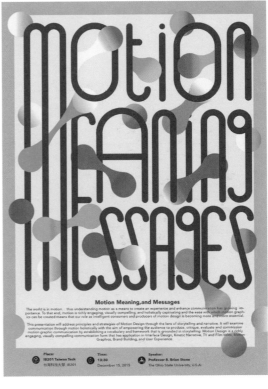

03

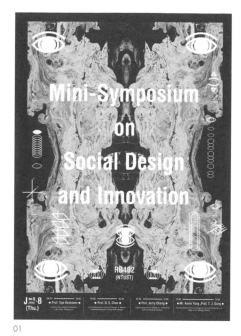

01

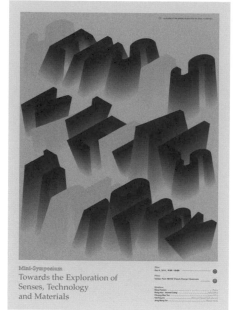

02

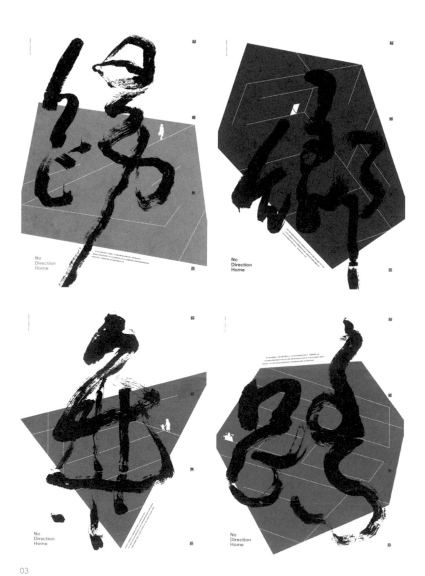

03

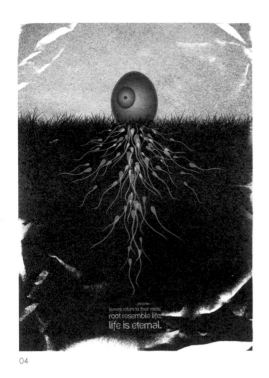

04

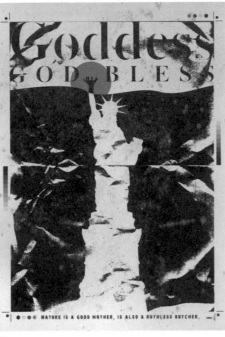

05

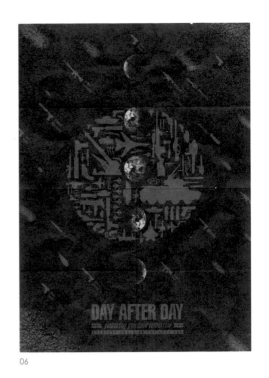

06

07

07/ 獨立急行 インディーエクスプレス INDIE EXPRESS　*P.391*

01

02

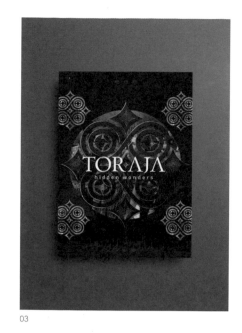

03

2015
SEP
IX X XI XIII

SMOOTH POET
TROUPE
MULLERSALON

TAIPEI
FRINGE FESTIVAL

€xchange
Rate
/
Itching

04

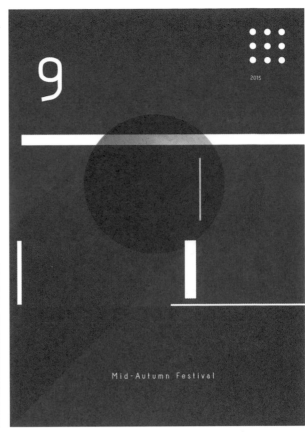

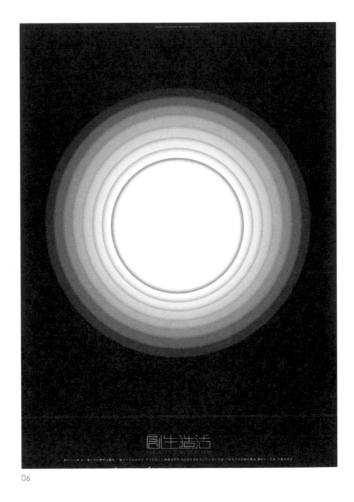

01

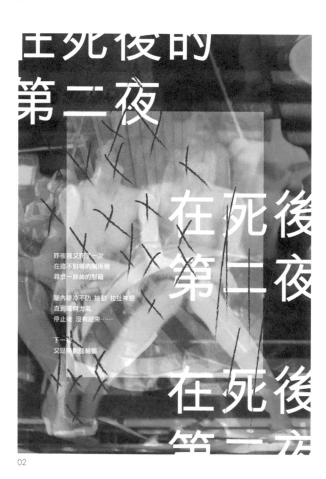

02

03

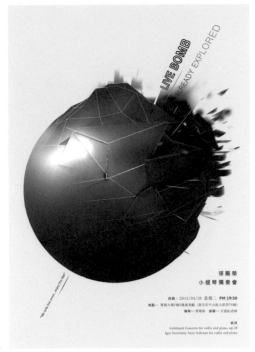

04

05

06

07

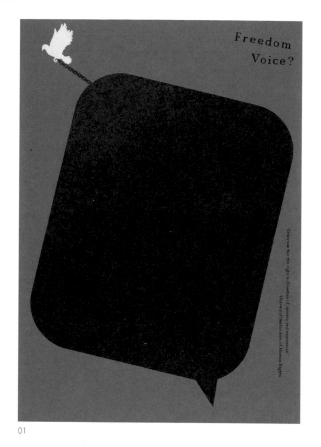

Freedom
Voice?

'Everyone has the right to freedom of opinion and expression'
Universal Declaration of Human Rights.

01

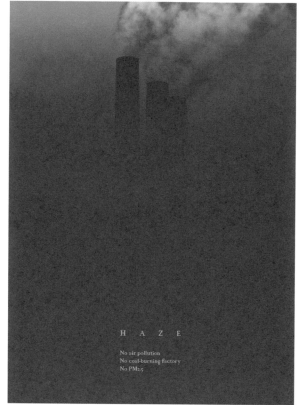

H A Z E

No air pollution
No coal-burning factory
No PM2.5

02

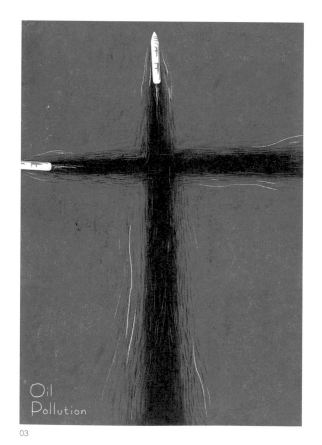

Oil
Pollution

03

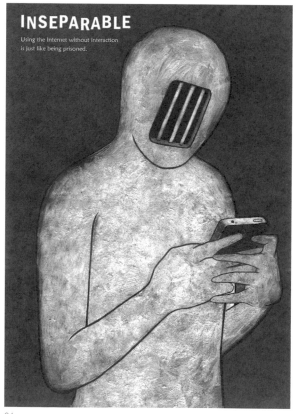

INSEPARABLE

Using the Internet without interaction
is just like being prisoned.

04

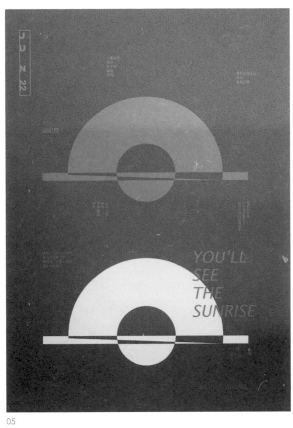

05

06

07

08

07/ 勇敢 brAve *P.332*
08/ 留下來陪你生活 Stay by your side *P.332*

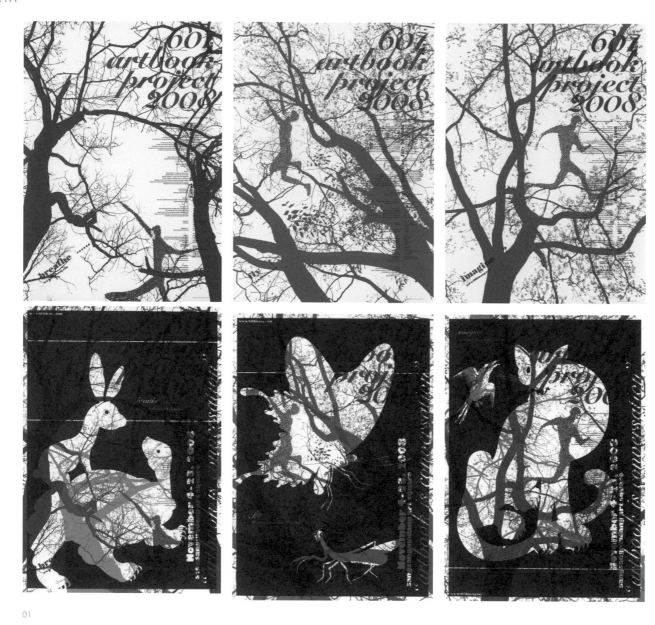

01

4 EMOTIONS' EYE

4 EMOTIONS' EYE

4 EMOTIONS' EYE

4 EMOTIONS' EYE

02

01/ 601 ARTBOOK PROJECT *P.371*
02/ 4EMOTIONS' EYE *P.371*
03/ Digilog 601-Harmony through Design *P.371*
04/ The 3rd? Korea International Poster Biennale! *P.371*

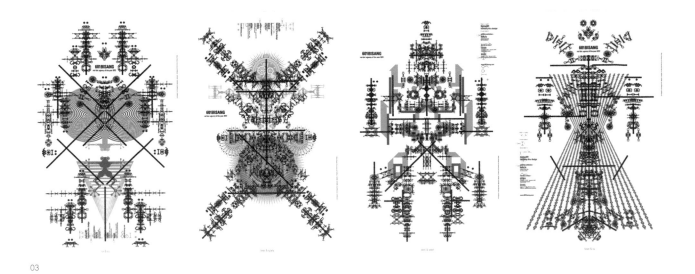

03

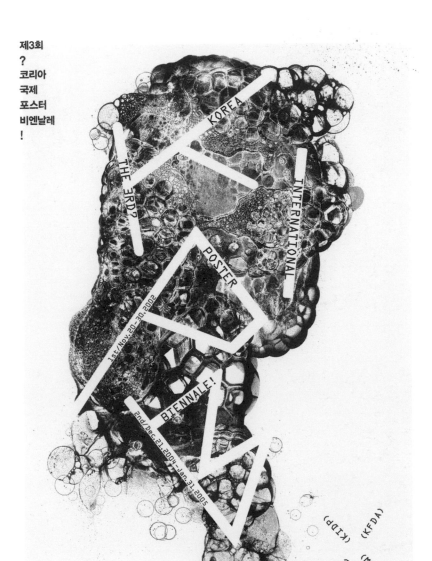

04

01

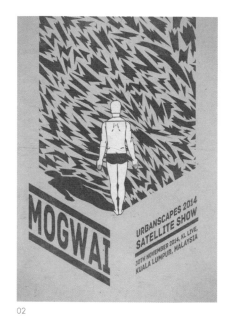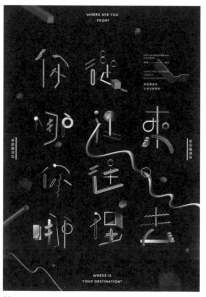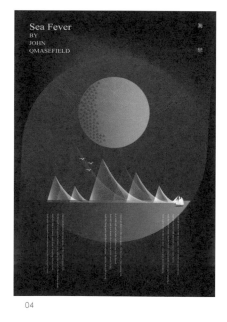

02 03 04

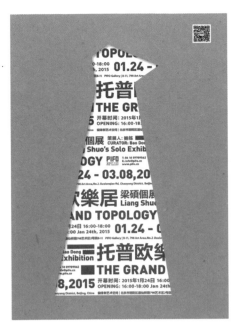

05

06

07

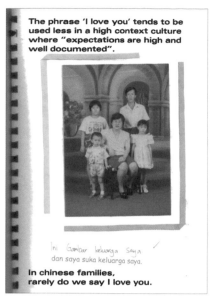

The phrase 'I love you' tends to be used less in a high context culture where "expectations are high and well documented".

In chinese families, rarely do we say I love you.

01

02

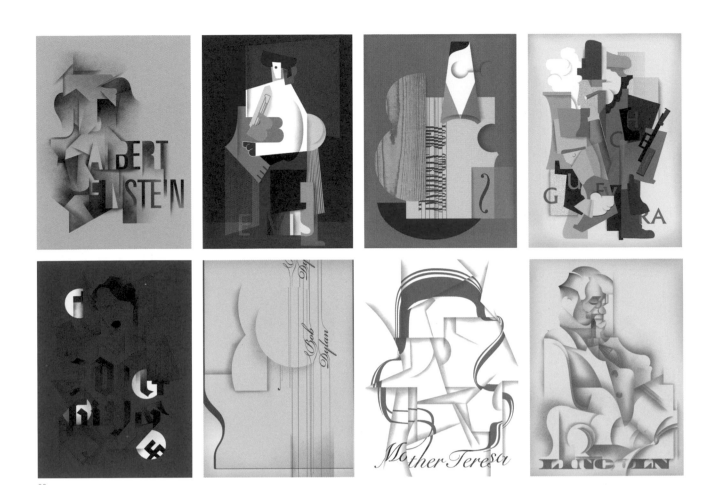

03

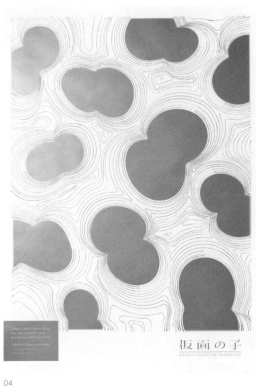

04

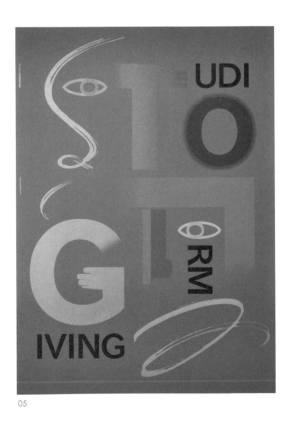

05

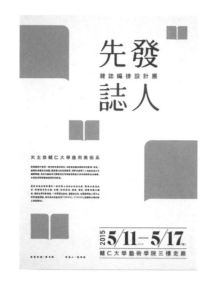
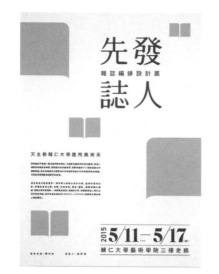
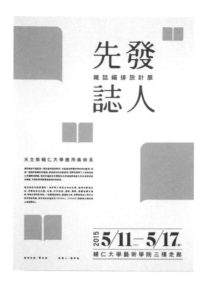

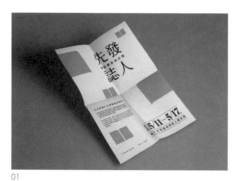
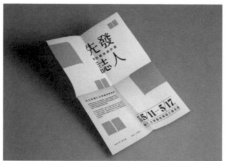

01

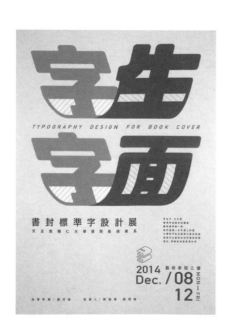
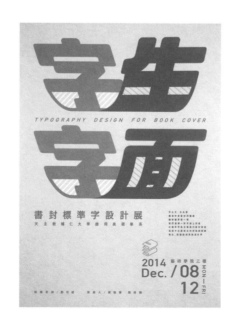

02

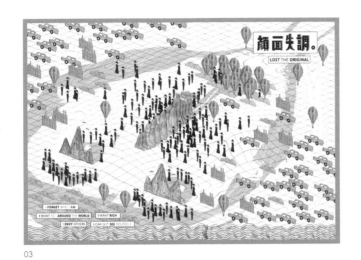

03

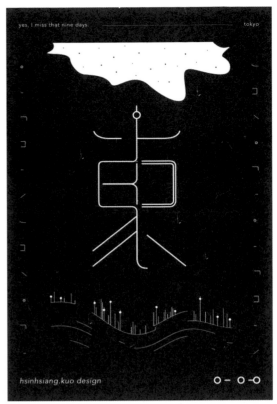

04

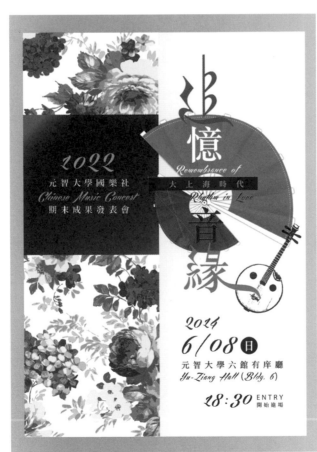

05

01

02

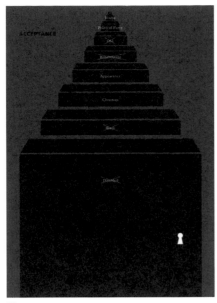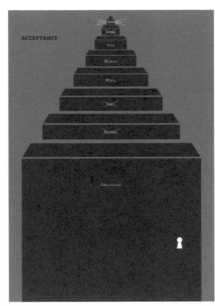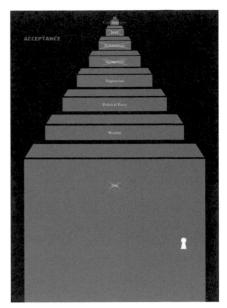

03

04

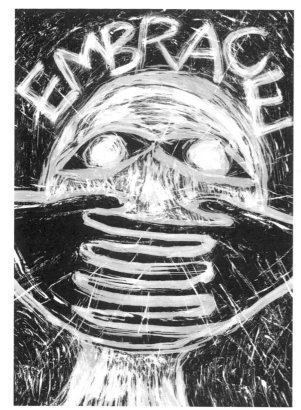
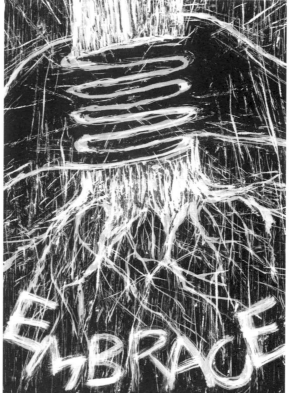

01

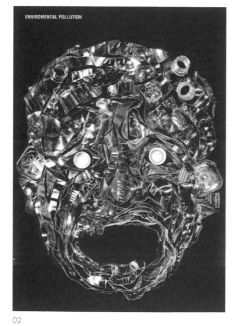
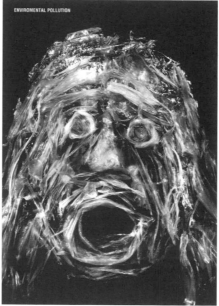
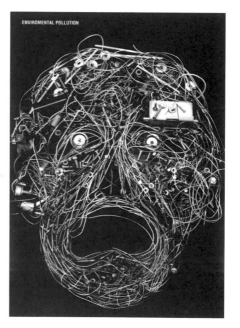

02

03

04

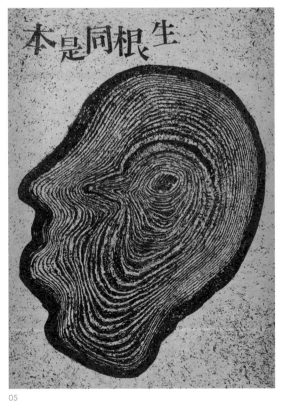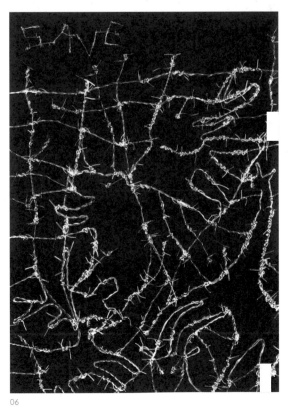

05

06

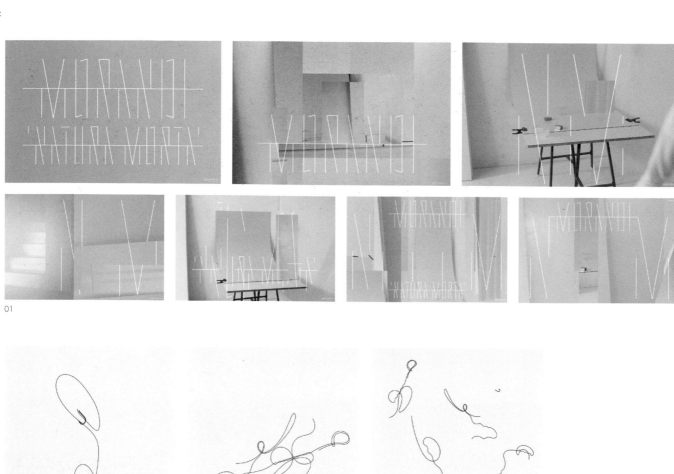

01

02

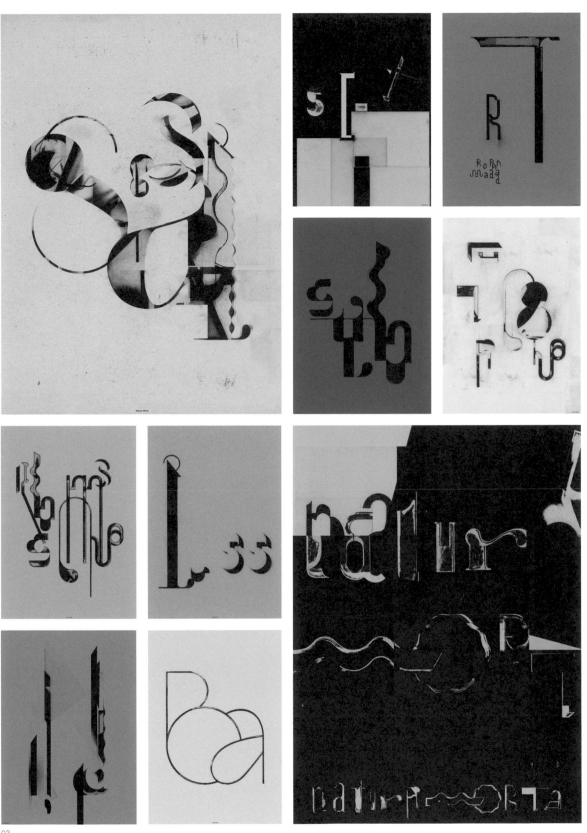

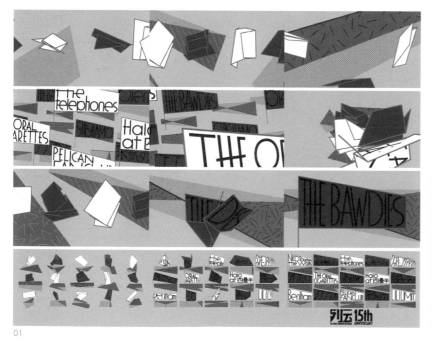

01

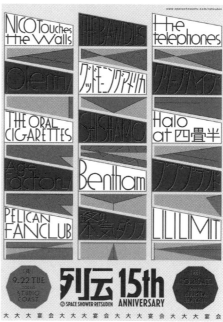

01/ SPACE SHOWER RETSUDEN　*P.388*

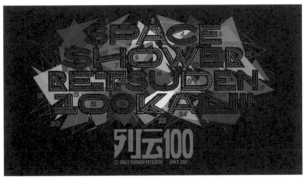

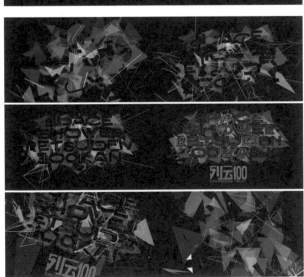

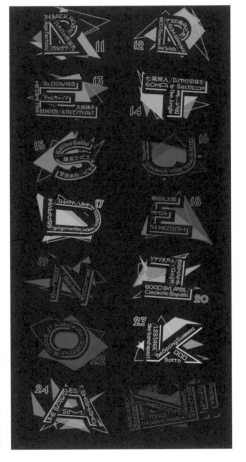

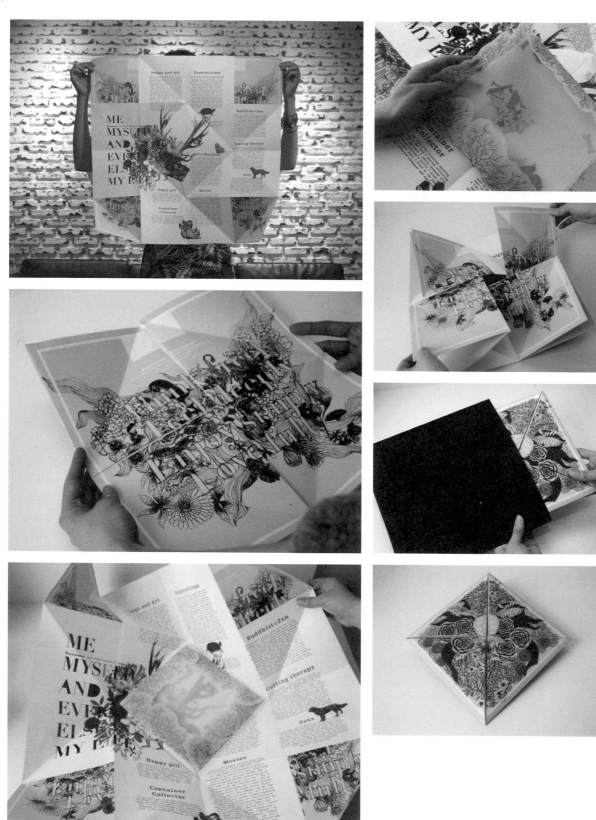

01

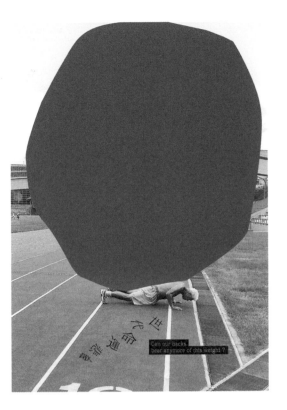

02

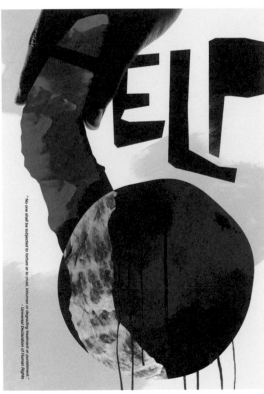
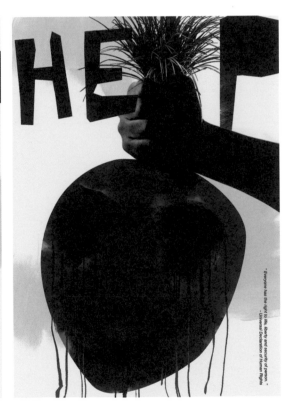

03

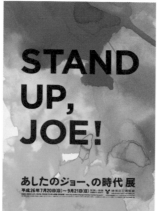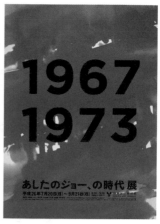

01

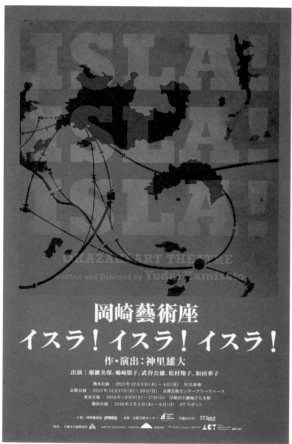

02

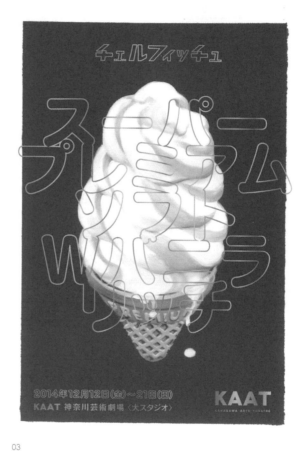

03

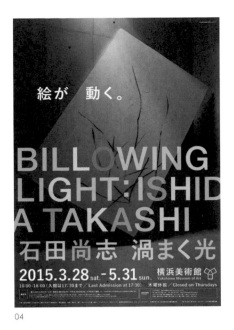

04

05

06

07

07/ In the Winter *P.305*

01

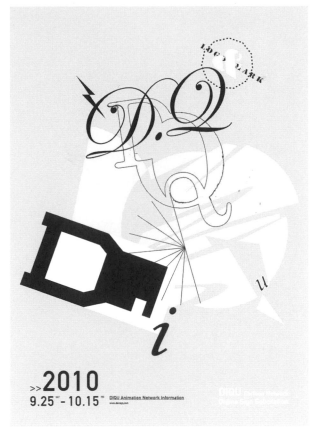

02

03

04

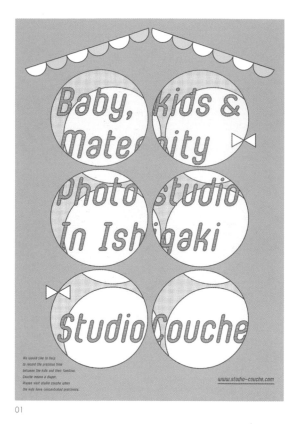

01

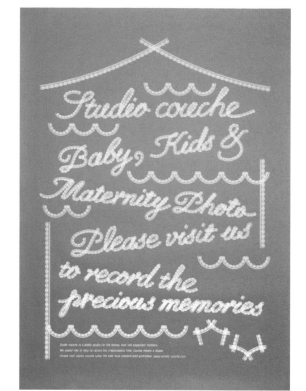

02

03

04

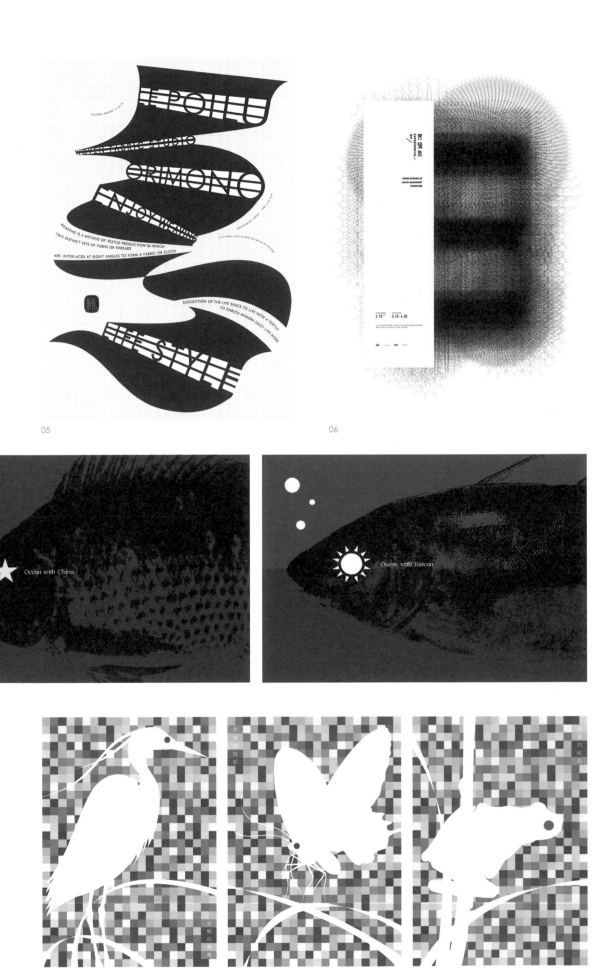

05

06

07

08

07/ 海洋強國夢 Ocean with country *P.361*
08/ 家園系列 Homeland Series *P.361*

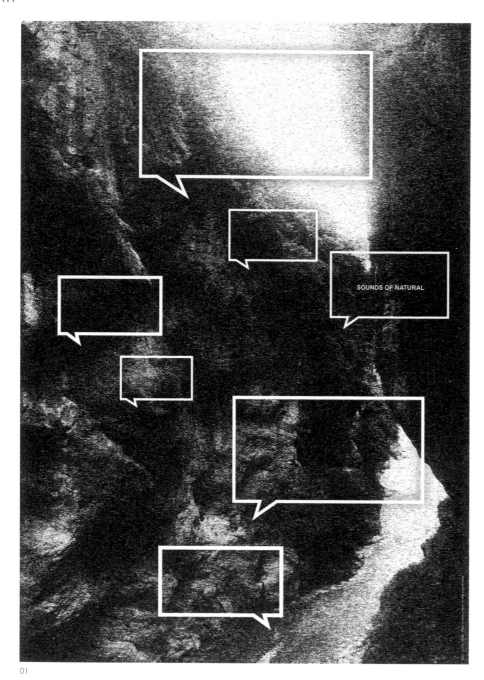

01

02

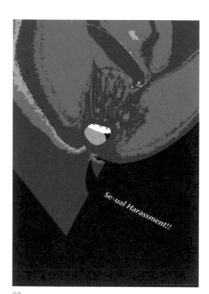

03

04

COUNTEROFFENSIVE

COUNTEROFFENSIVE

05

PROTECTION!

HAPPINESS

06

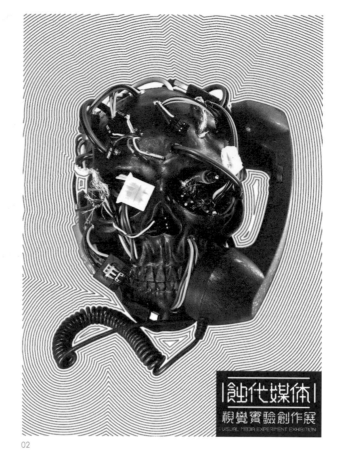

309

01

02

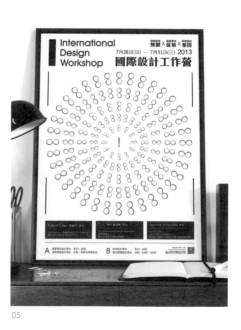

03

04

05

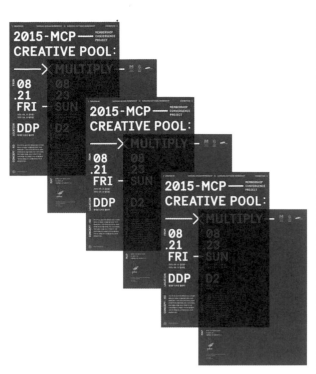

06

07

07/ MOYEORA Poster *P.341*

01

02

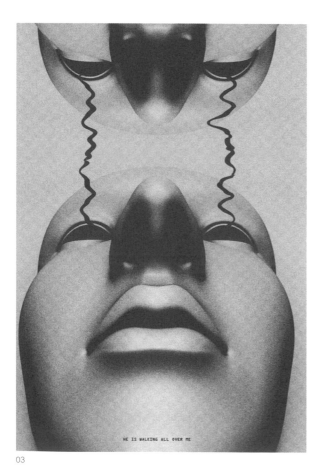

03

04

05

06

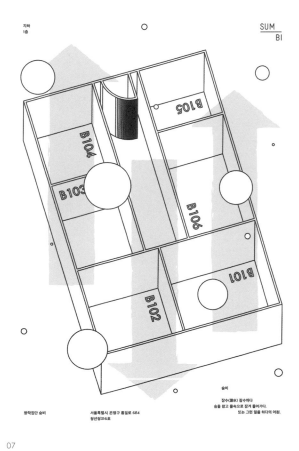

07

08

07/ SUM-BI : opening poster *P.343*
08/ 2015 visual impact : series 2015 - 02 -03 *P.343*

CTA

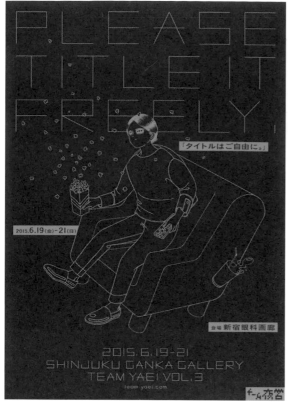
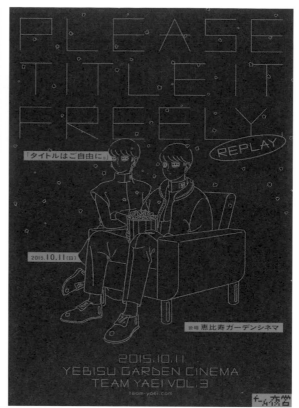

01

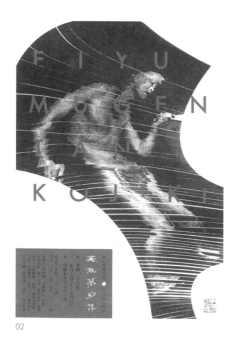

02

03

04

01/ 請自行命名 Please title it freely　*P.377*
02/ 英雄夢幻譚 EIYU MUGENTAN KOJIKI　*P.377*
03/ 觀光 Sightseeing　*P.377*
04/ y 與 x 的事情 The situation of y and x　*P.377*
05/ White Bird in a Blizzard　*P.354*
06/ PANTONE 4675 C　*P.354*

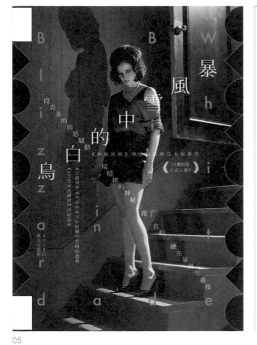

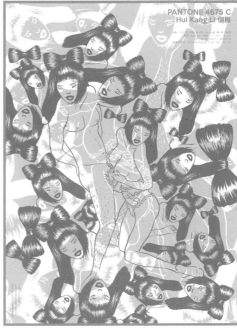

05

06

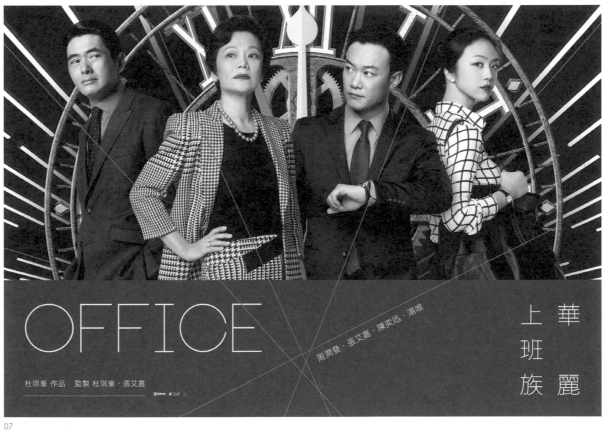

07

01

12th Puchon International
Fantastic Film Festival
부천국제판타스틱영화제
2008.7.18 – 7.27

PiFan2008 PiFan2008

12th Puchon International
Fantastic Film Festival
부천국제판타스틱영화제
2008.7.18 – 7.27

02

01/ Forest to precede civilization, desert to follow *P.387*
02/ Puchon International Fantastic Film Festival Official Poster *P.387*
03/ College *P.300*
04/ HamOn *P.300*
05/ Sasakure festival *P.300*
06/ RISD Visiting Designers poster *P.344*

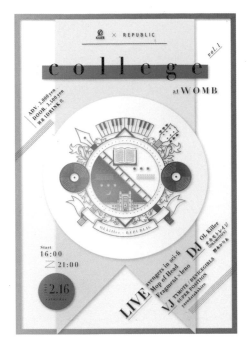

03

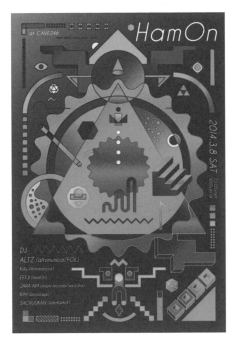

04

05

06

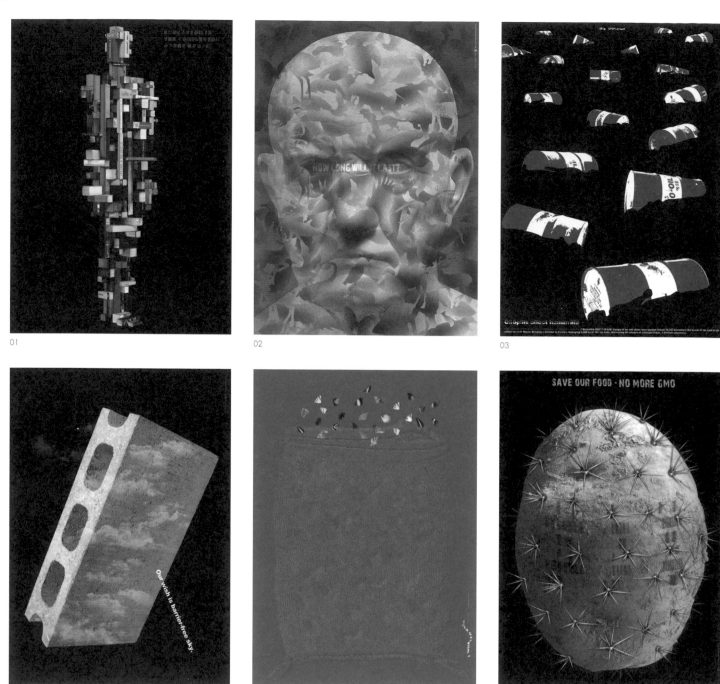

07

08

07/ GaraGara Summer festival *P.300*
08/ 無心 山水 Uncontrived Mountains and rivers *P.401*

品牌設計
BRANDING DESIGN

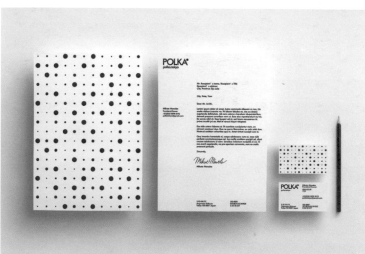

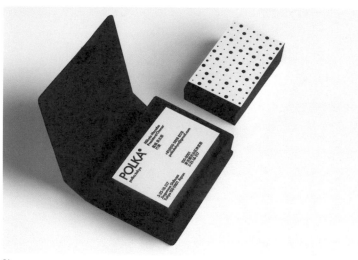

01

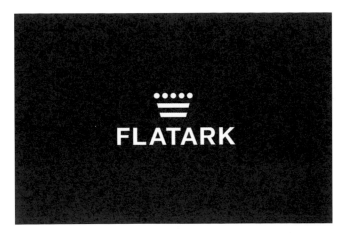
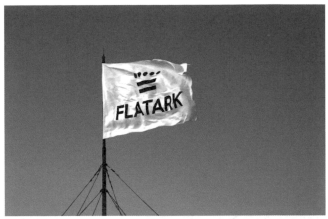

02

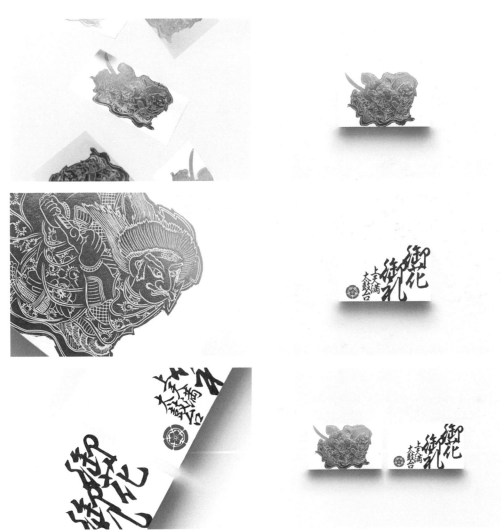

03

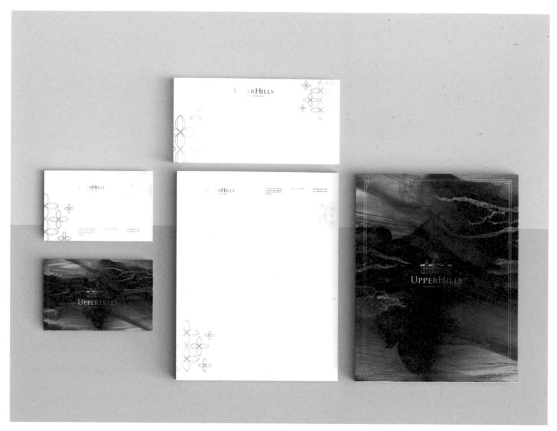

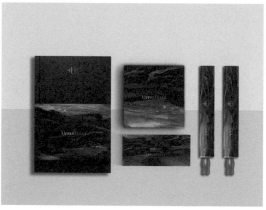

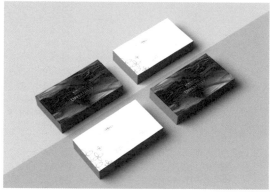

01

01/ UPPERHILLS - Convention Hall *P.399*
02/ 辰楓室內設計 CHENG FENG INTERIOR DESIGN *P.347*
03/ 比特尼克 BEATNIK *P.347*
04/ Mandarin natural Chocolate *P.400*

CHENG FENG

INTERIOR DESIGN

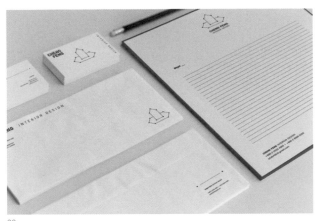

02

CHENG FENG
INTERIOR DESIGN

Commandé par CHENG FENG, une entreprise de design d'intérieur. On peut voir une des solutions que nous avons fourni au client. Celle-ci étant basé sur une simple composition de lignes et de points.

INTERIOR DESIGN

Commissioned by CHENG FENG, which is a interior design company. Here is one of the solutions we provided to the client. Based on a simple composition of lines and points.

YI-CHIN LAI

Client

CHENG FENG

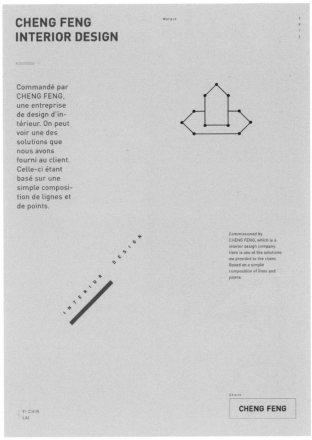

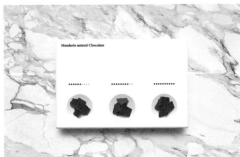

04

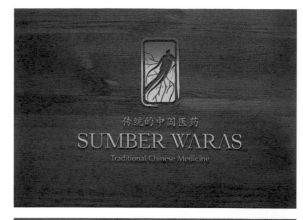

01

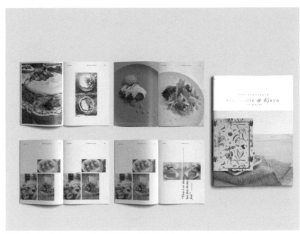

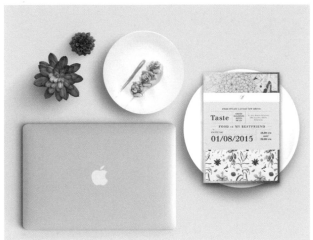

02

warew

03

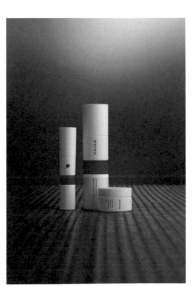

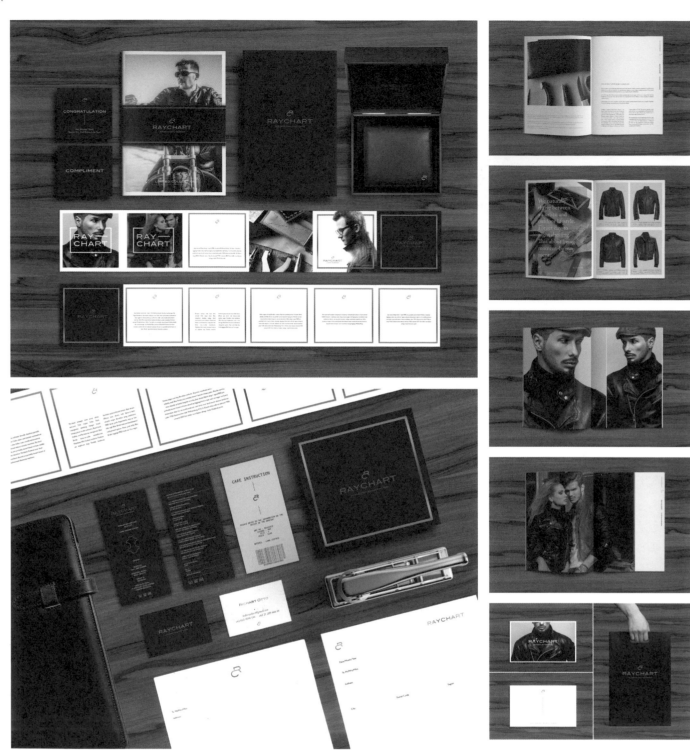

01

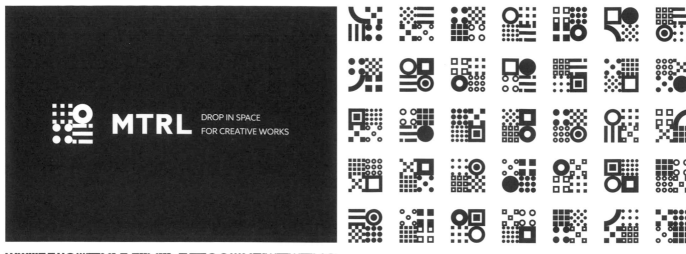

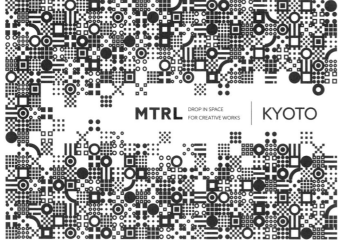

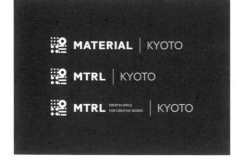

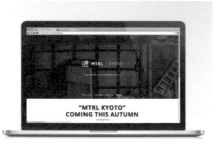

01

01/ MTRL KYOTO New Identity *P.325*
02/ DOTO Rebranding *P.325*
03/ MICAI Identity Renewal *P.325*

DO|TO

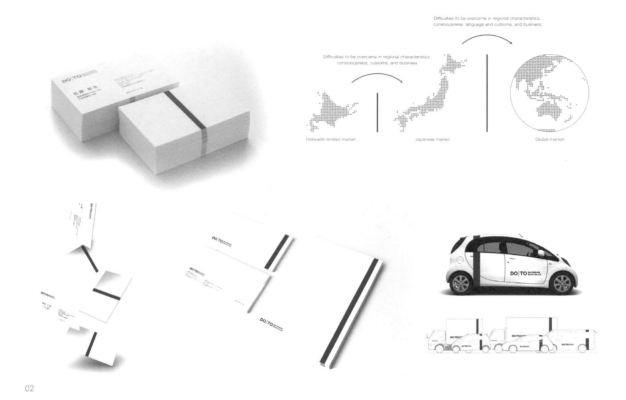

DO|TO DO|TO

Difficulties to be overcome in regional characteristics, consciousness, customs, and business

Always, to act while foreseeing one step ahead for every kinds of purposes (TO)

Difficulties to be overcome in regional characteristics, consciousness, language and customs, and business

Difficulties to be overcome in regional characteristics, consciousness, customs, and business

Hokkaido-limited market

Japanese market

Global market

02

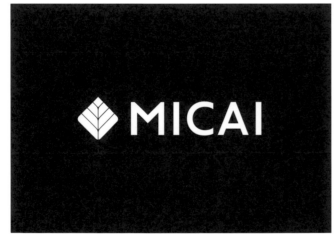

03

ALBAn
ALBAn

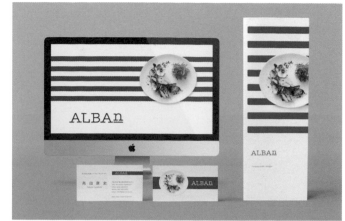

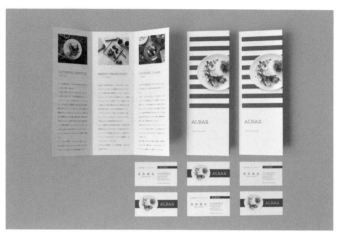
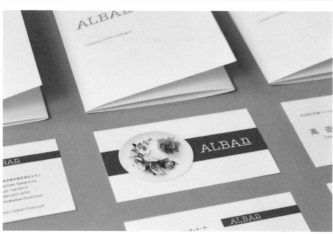

01

02

03

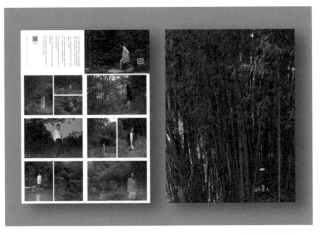

04

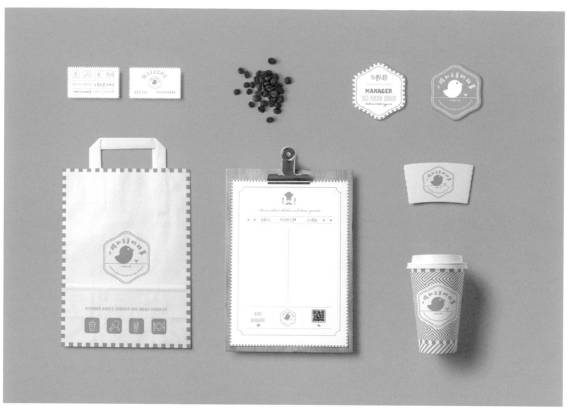

01

01/ 小雞和豆芽的故事　Chicken and bean sprouts　*P.364*
02/ Yaker Coffee　*P.364*
03/ 河北大學工商學院 2015 年畢業設計展覽 College of business, Hebei University graduate design exhibition　*P.364*

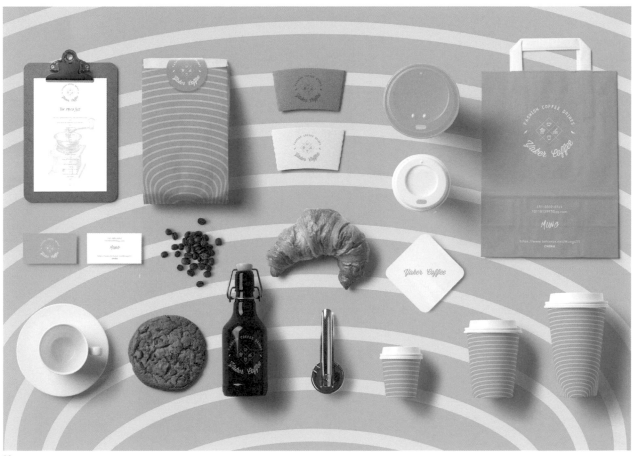

02

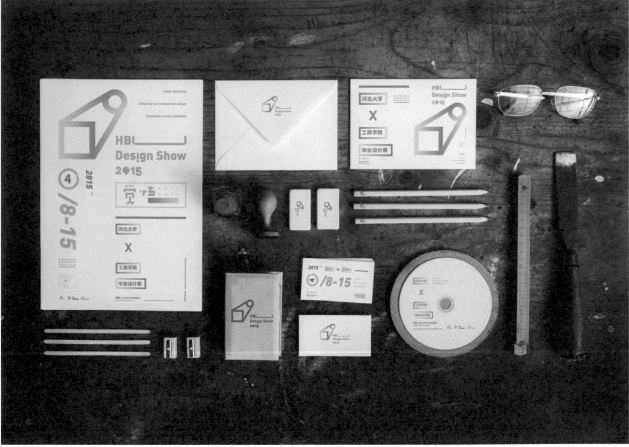

03

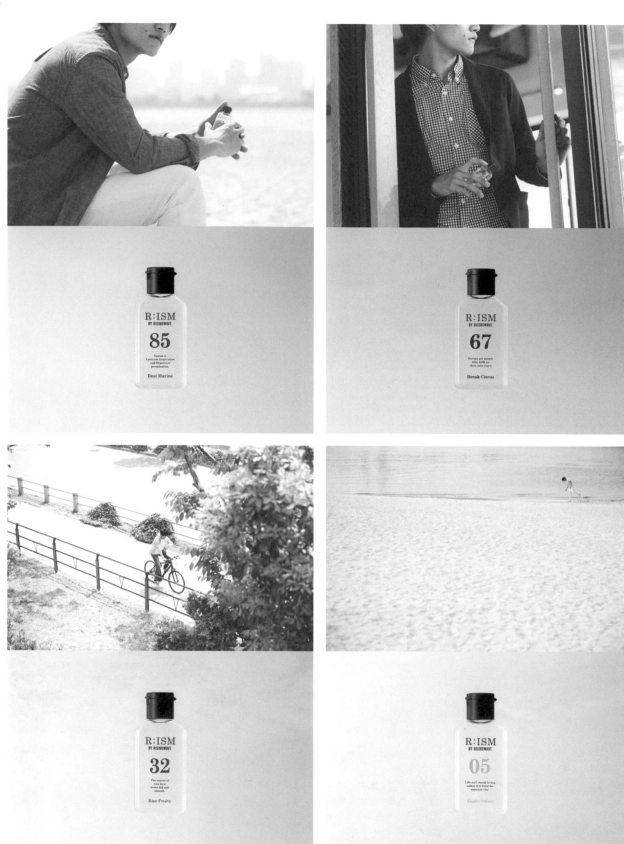

01

02

03

01

02

03

04

05

STAND

06

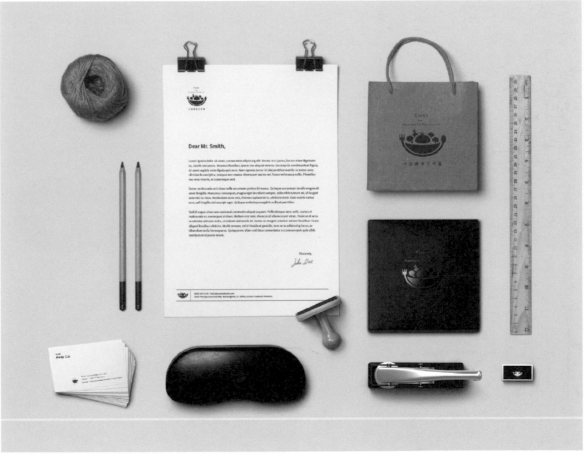

07

07/ 小丑蔬食工作室 Crown has a vegetarian restaurant　*P.355*

01

02

03

04

05

06

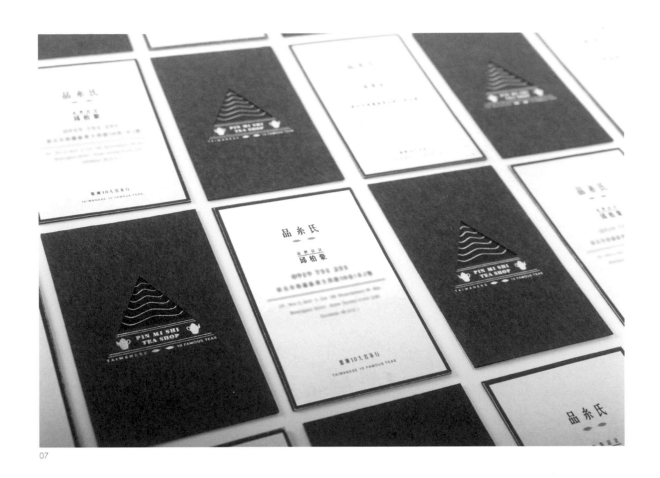

07

08

09

10

LOGO

Happy to cook
Happy to share
Happy to try

大家都是好廚師

COOKBAR表示著群體創作空間大家在這
邊扮演廚房的大廚，並享受創作的喜悅
，人人在這裡都是好廚師，快樂是甜美
的好滋味。

COOKBAR is a community kitchen.
Everyone can enjoy being a chef here
People can enjoy the creating happiness
and share with others.Here everyone is
a good chef.Happiness is the best flavor.

Support
HAP

COOK IS simple

eve
be

BLACK & WHITE

Horizontal

a com

Happy to cook
Happy to share
Happy to try

Vertical

Happy to cook
Happy to share
Happy to try

Happy to cook
Happy to share
Happy to try

Happy to cook
Happy to share
Happy to try

COLOR PLATE

C:13 M:0
Y:100 K:33

C:32 M:0
Y:10 K:79

C:0 M:0
Y:0 K:90

Logotype:
HERO

ABVDEFGHIJKLM
NOPQRSTUVWXYZ
abvdefghijklm
nopqrstuvwxyz

Supporting graphic:
HAPPY CHEF

Logotype_Chinese:
文鼎細圓、中圓、粗圓

大家都是好廚師
大家都是好廚師
大家都是好廚師

01

aphic:
EF

n we form a community
for enjoy cooking

tchen

東

DONGCHANG

東長

02

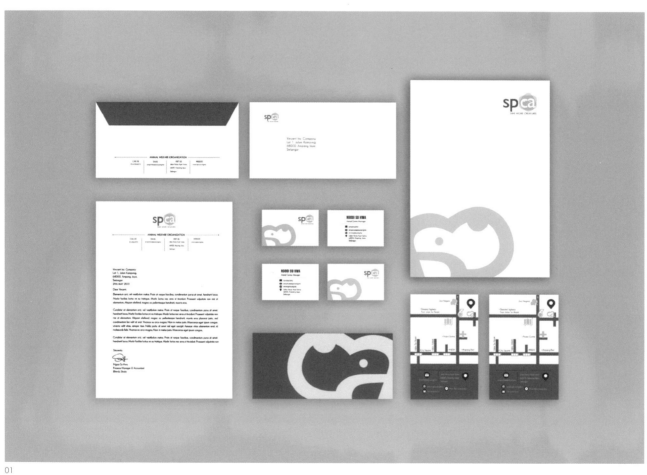

01

02

03

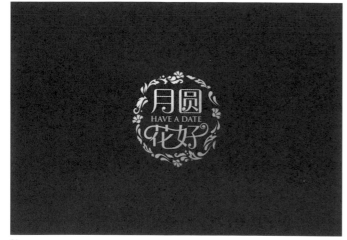

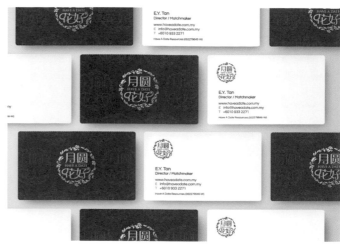

01

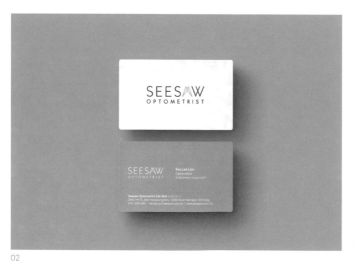

02

03

04

Play / Rubbing / Experimental

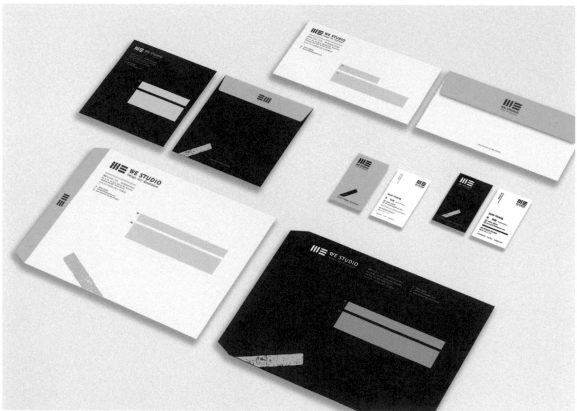

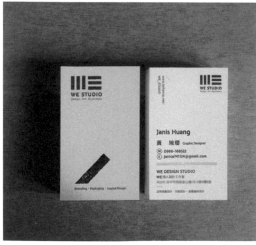

01

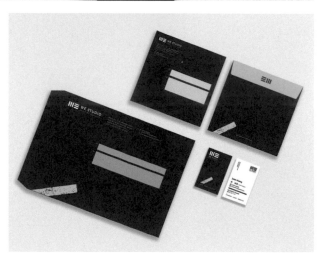

01/ WE STUDIO 品牌形象設計 WE STUDIO VI *P.335*
02/ WE STUDIO 品牌形象設計 WE STUDIO VI *P.335*

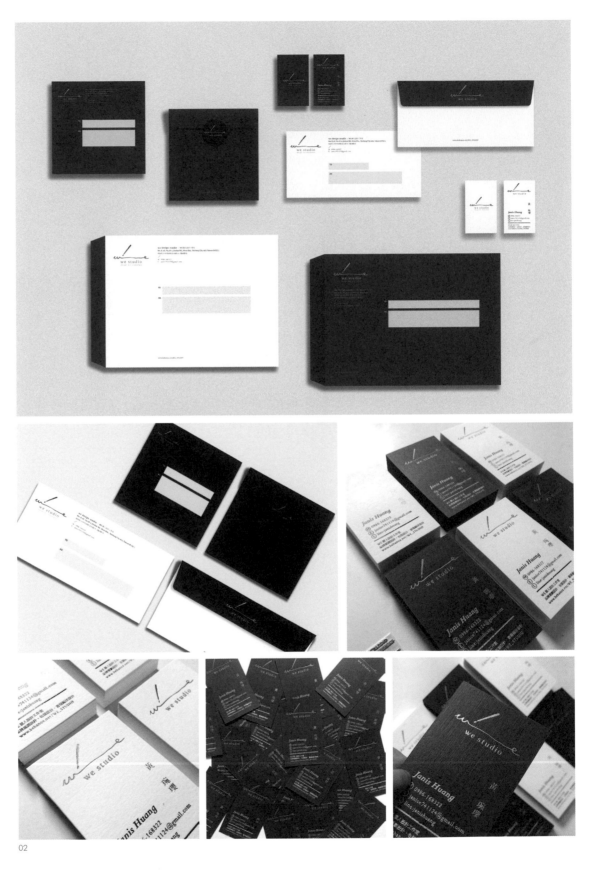

WE GET UP.
WE COFFEE.
WE EAT BREAKFAST.

WE EAT BREAKFAST.
WE COFFEE.
WE WALK.

WE CHAT.
WE COFFEE.
WE MOVE.

WE WALK.
WE COFFEE.
WE WORK.

WE WORK.
WE COFFEE.
WE EAT LUNCH.

WE LOVE.
WE COFFEE.
WE FRIENDLY.

WE EAT LUNCH.
WE COFFEE.
WE WORK.

WE WORK.
WE COFFEE.
WE CHAT.

WE MOVE.
WE COFFEE.
WE LOVE.

WE GOT UP.
WE COFFEE.
WE WORK

```
HAPPYLIFE
WORKCUPNA
DEMAILOBF
OUCHATNRT
WECOFFEEE
WITHFAAAR
DRINKFTKN
MORINGETO
RESTLOVEN
```

WE COFFEE.

WE COFFEE. WE COFFEE. WE COFFEE.

WE COFFEE.

01

嘀嘀打车

CMYK 6	37	84	0	CMYK 100	100	100	100
RGB 79	16	71	RGB 0	153	255		
PANTONE 2995 C							
	CMYK 0	0	0	0			
	RGB 15	60	200				

02

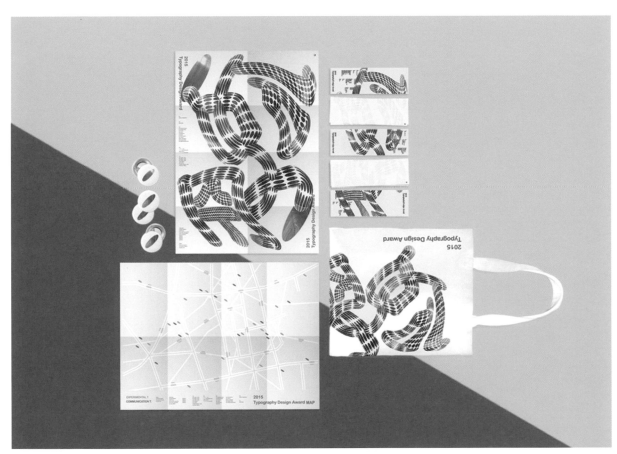

03

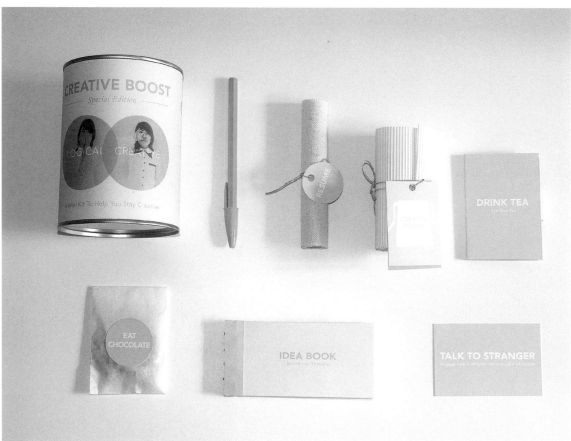

01

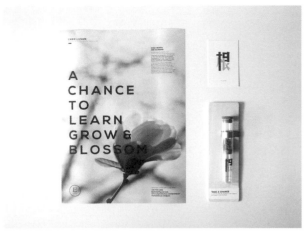

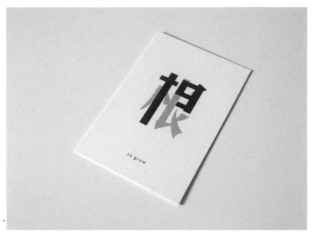

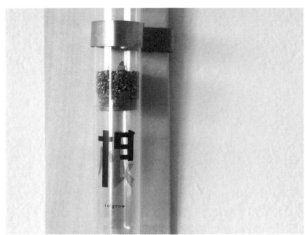

02

03

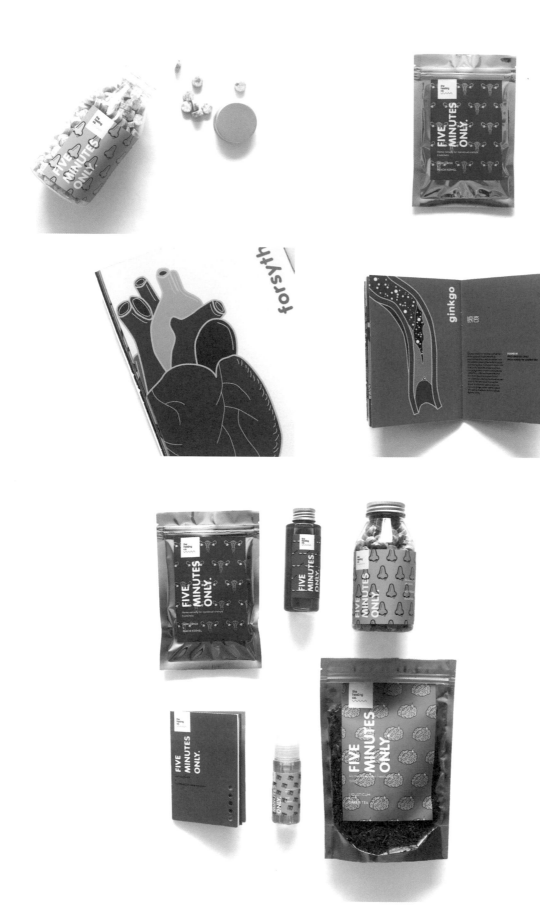

02

03

THE
pod

BOUTIQUE
CAPSULE
HOTEL

WWW.THEPOD.SG

Michelle Lim
MANAGING DIRECTOR

65 9773 3982
michelle@thepod.sg

289 BEACH ROAD LEVEL 3
SINGAPORE 199552

T 65 6298 8505
F 65 6298 8591

You are cordially invited to the exclusive launch of The POD, Singapore's latest boutique capsule hotel catering to discerning travellers who desire fuss-free and convenient living.

DATE & TIME
22 AUGUST, THURSDAY • 7PM. REGISTRATION STARTS AT 6.30PM
Light bites and refreshments will be provided.

VENUE
THE POD
289 BEACH ROAD LEVEL 3 SINGAPORE 199552

Please RSVP to marketing@thepod.sg by 19 August 2013, 4PM.
We look forward to seeing you!

THE
pod

BOUTIQUE
CAPSULE
HOTEL

BOOK DIRECT AT WWW.THEPOD.SG
and Get 5% Off Our Best Available Rates

COUPON CODE BookThePodDirect

COMPLIMENTARY
• Hot buffet breakfast and Nespresso coffee
• High speed Wi-Fi
• 1 item dry cleaning per night's stay
• Use of washing machine and dryer
• Local calls and use of computer PODS

THE
pod

BOUTIQUE
CAPSULE
HOTEL

WWW.THEPOD.SG

289 BEACH ROAD LEVEL 3 SINGAPORE 199552 | 65 6298 8505

WASHROOM

SHOWER

WASH / DRY

STAIRS

THE
pod

NO ENTRY

ROOM 1 2 3

SHOE LOCKER

01 | 02

POD NUMBER

ROOM NUMBER

01

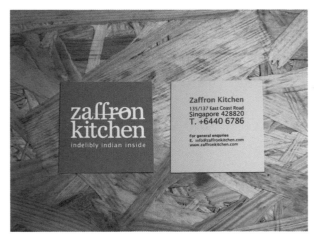

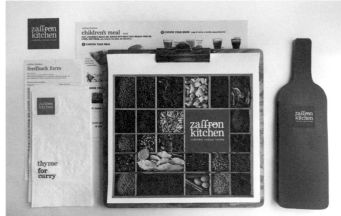

02

03

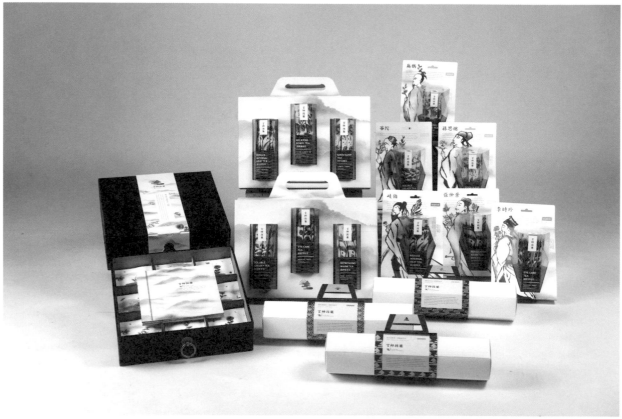

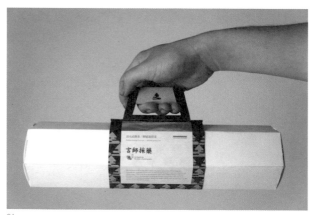

01

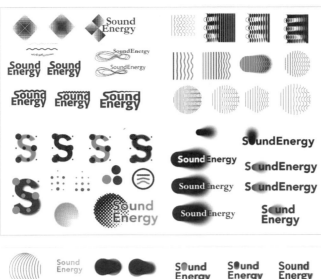

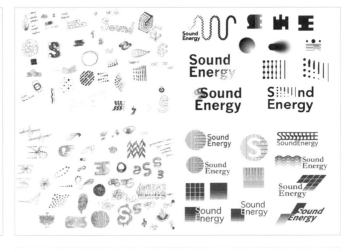

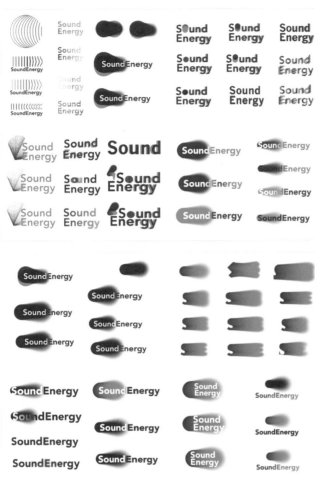

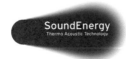

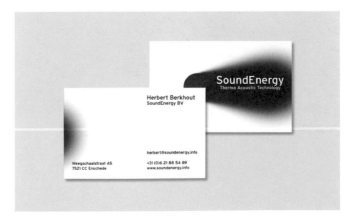

EXISTING

UPDATED

EQUALITY
& FAIRNESS

POSITIVE
COMMERCE

TRADITIONS
& VALUES

COMMUNITY
& NETWORK

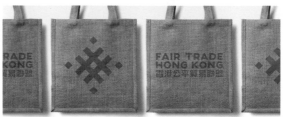

MASTER LOGO
WITH GRADIENT

SECONDARY
FLAT COLOUR

GRAYSCALE
W/GRADIENT

GRAYSCALE
FLAT

01

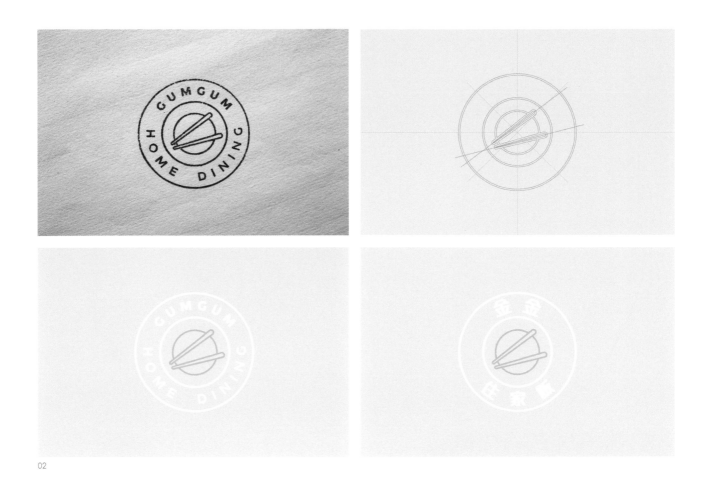

02

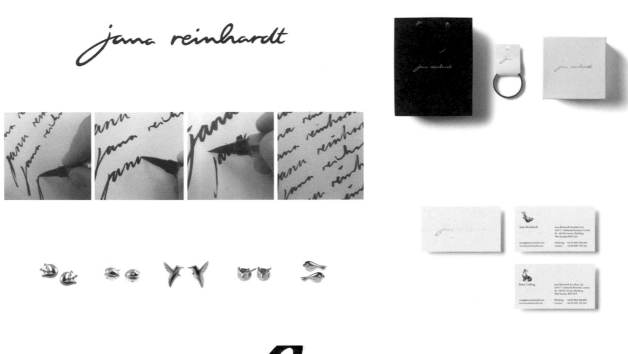

03

RI|PRISM

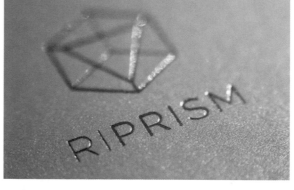

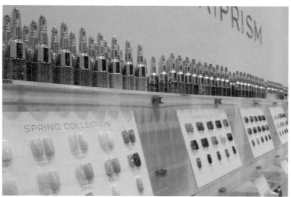

01

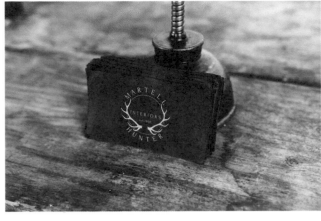
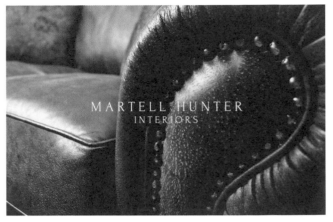
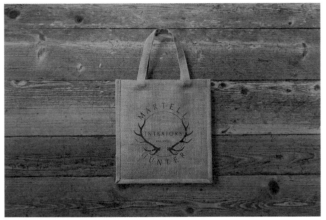
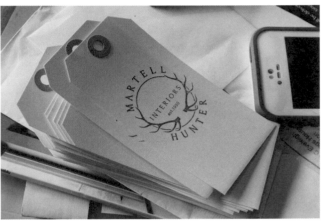

02

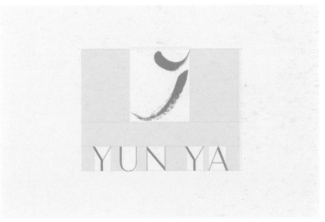

earth fire wood metal water

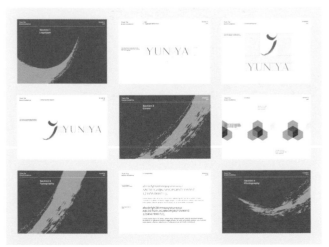

03

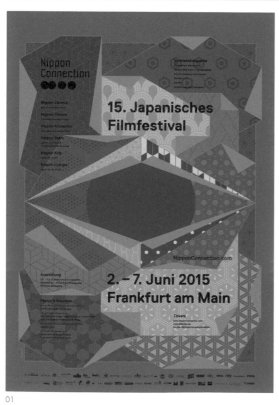

01

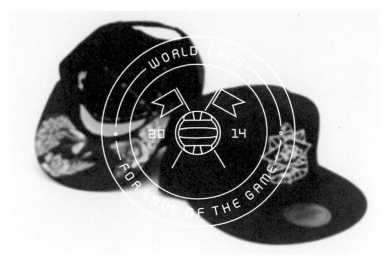

02

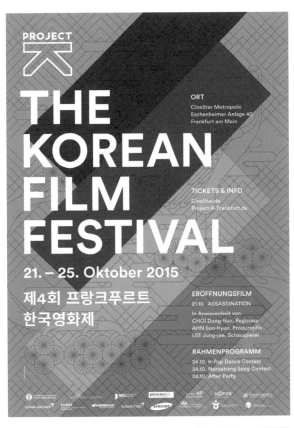

03

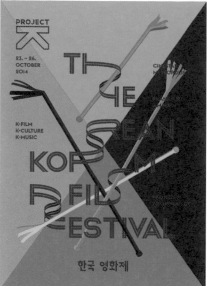
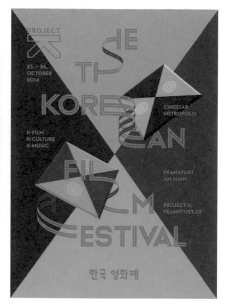
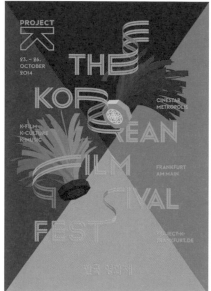
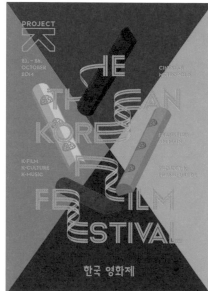

01

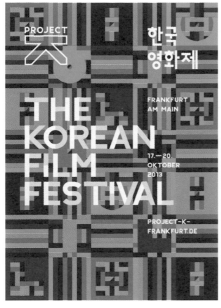

THE
KOREAN
FILM
FESTIVAL

I'M A CYBORG. BUT THAT'S OK

OLD BOY

THE ISLE

MY SASSY GIRL

SPRING. SUMMER.
FALL. WINTER ... AND SPRING

02

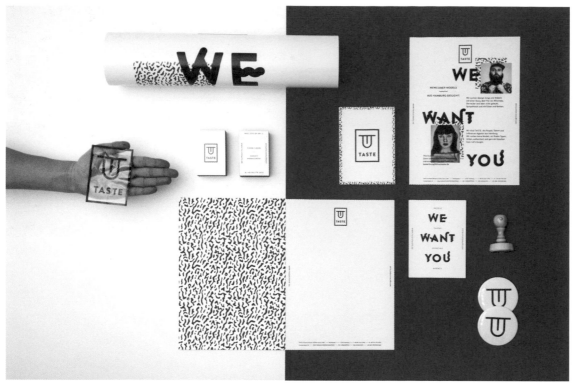

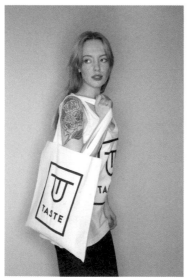

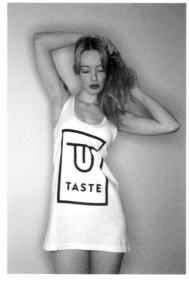

01

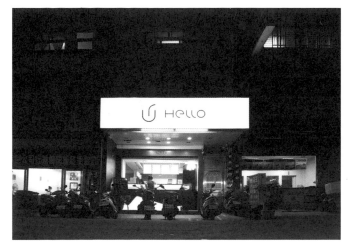
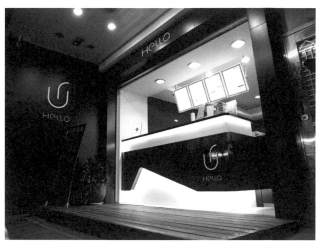

02

OLIA

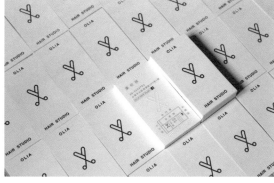

HAIR STUDIO

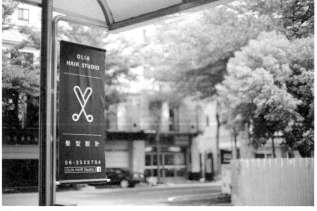
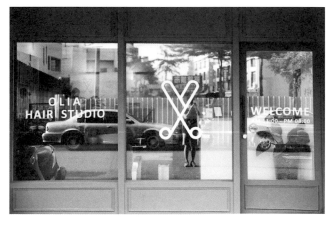

03

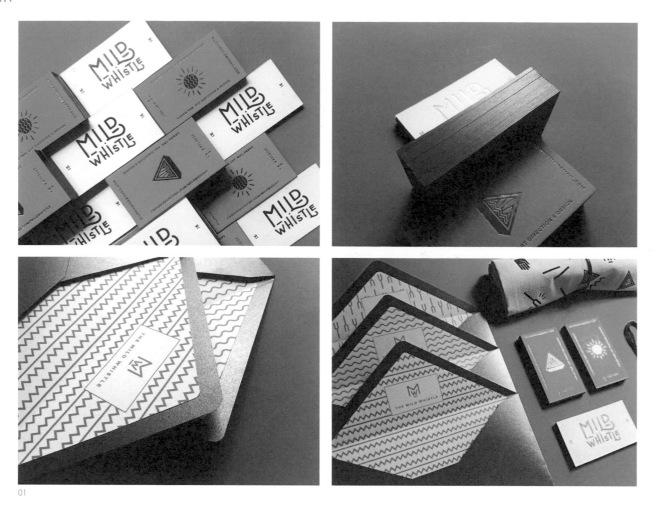

01

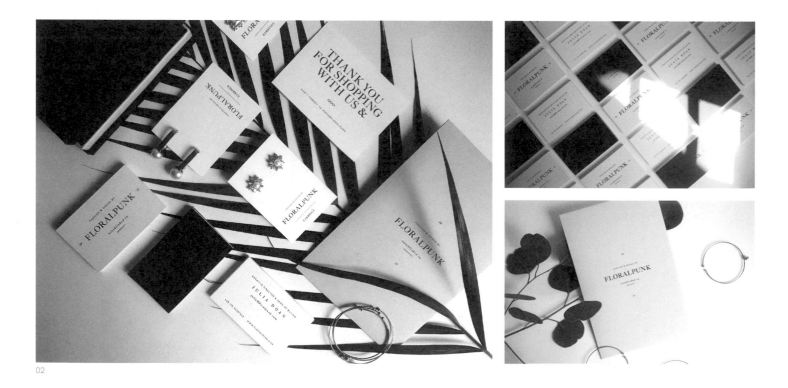

02

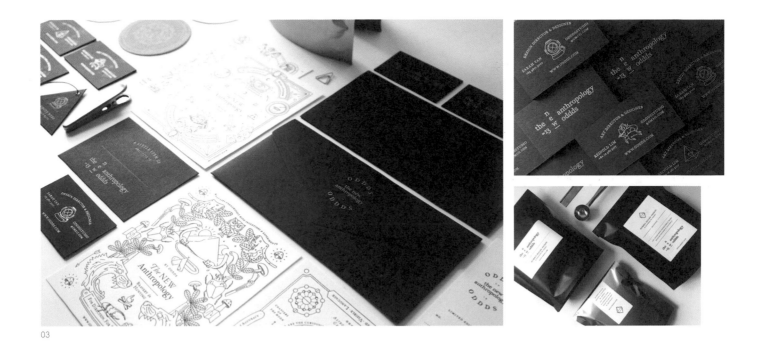

03

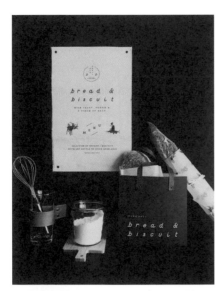

04

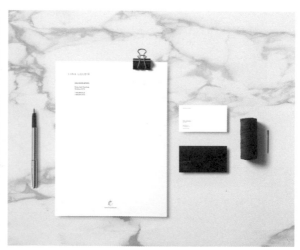

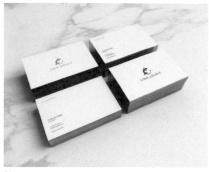

01

PF BeauSans Pro

TELECOM SB

02

Font: Noto Sans

AMENTO NEVA

AMENTO NEVA

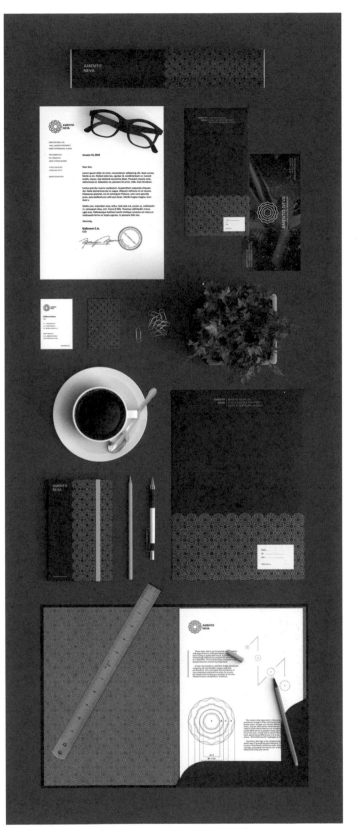

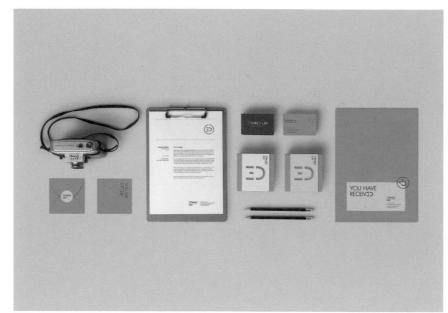

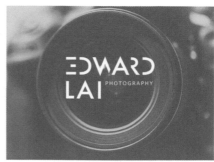

01

02

SHENG TENG

菓 香 小 舖

03

05

Girafe
Meadows

06

07

08

千 笹 日 本 料 理
CHI SASA JAPANESE RESTAURANT

09

10

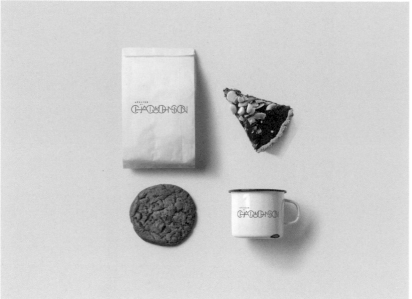

01

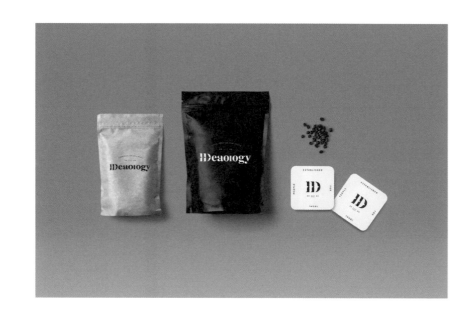

02

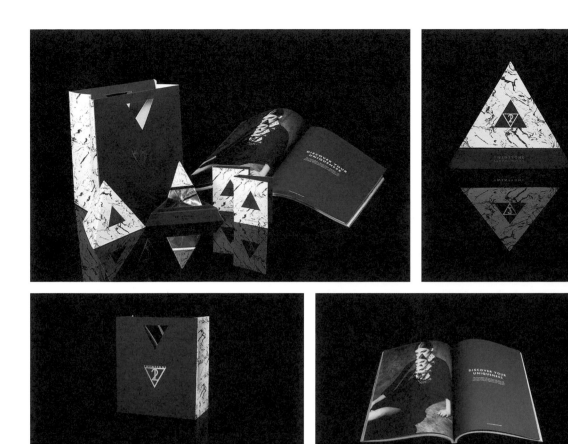

03

04

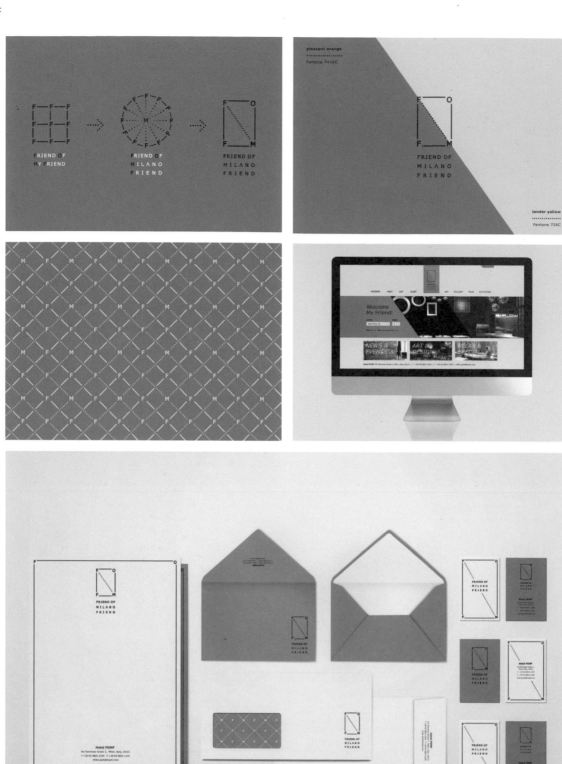

01

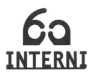

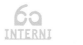 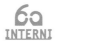

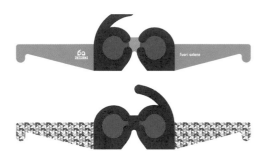

02

03

SYMPOSIUM ON
ROOTBIOLOGY

**Symposium On
Rootbiology**

慢空間

慢空間
dimension

CReative
collectiON

OZ DESIGN

atelier de
CHAIO &
JOHNSON

IDEA
O
LOGY

LE VENT ET
LE SOLEIL

LE VENT ET
LE SOLEIL

LeVentEt
LeSoleil

01

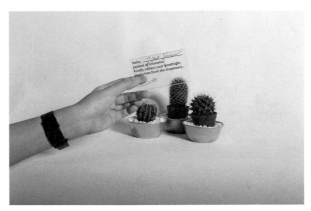

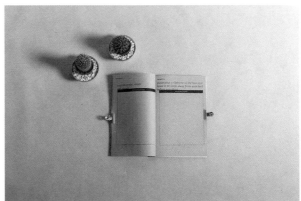

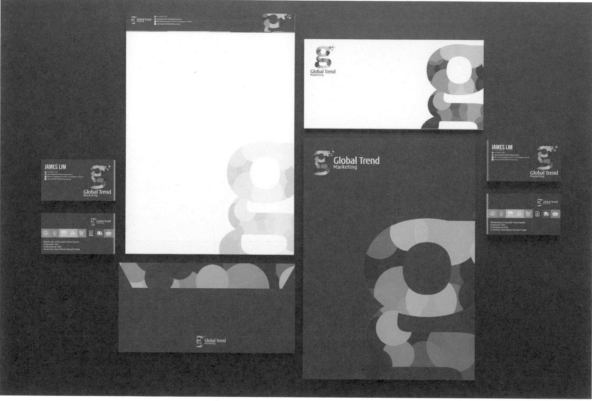

01

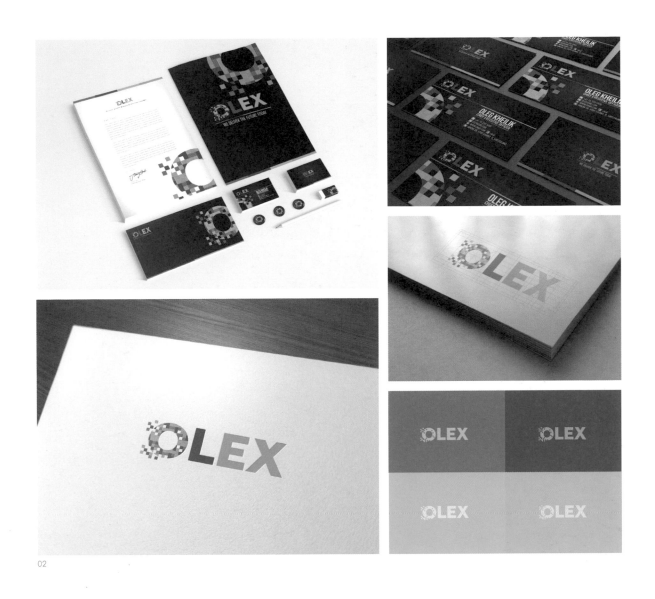

02

Piano Piano

03

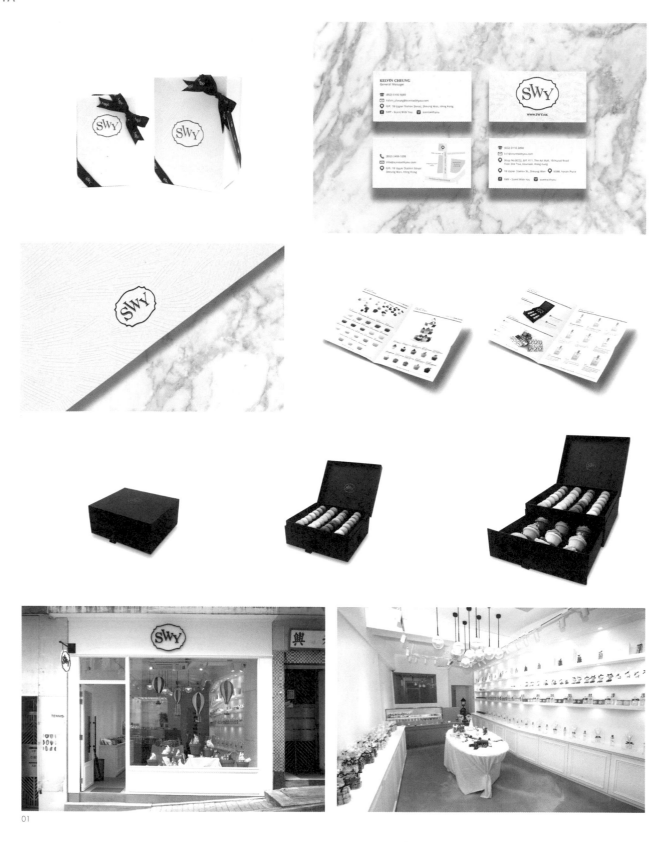

01

01/ Scent With You | A Luxurious Sensory Experience *P.319*
02/ Kamara Spa Indulgence *P.372*

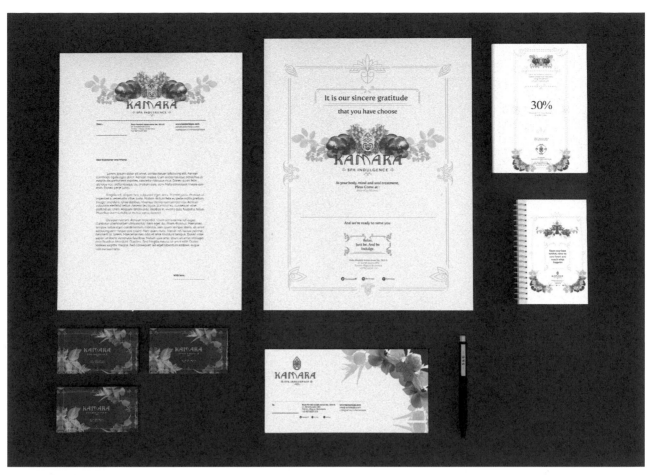

02

01

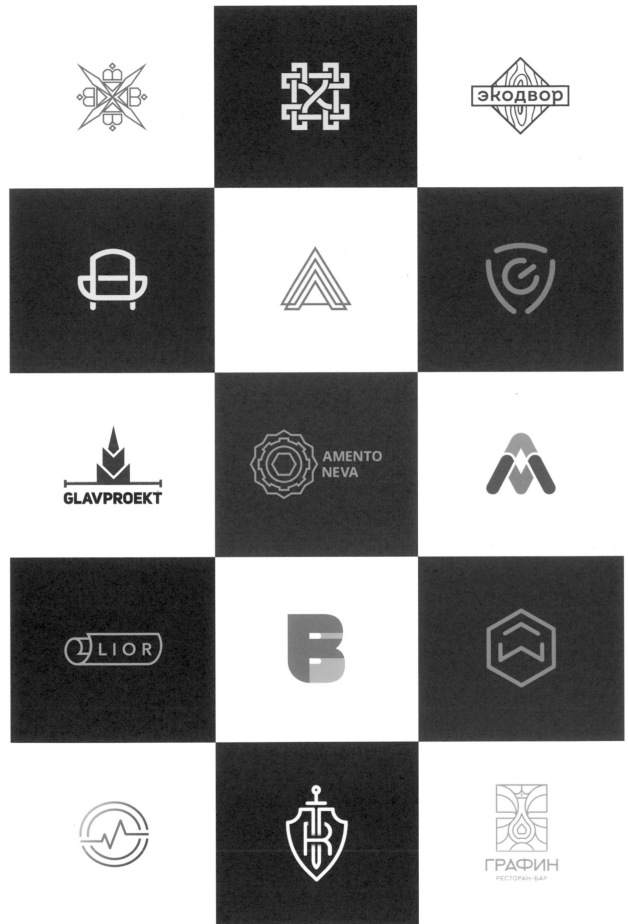

01

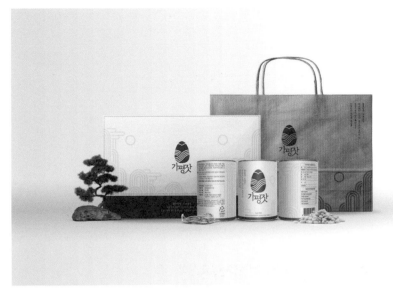

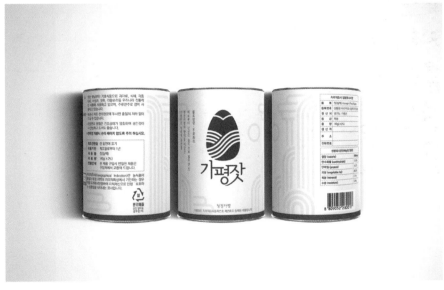

Breeze

Mountain

Vallev

MARY J

MARY J
MARY J COMPANY

MARY J

MARY J COMPANY

010101 # 59595b # a6a8ab

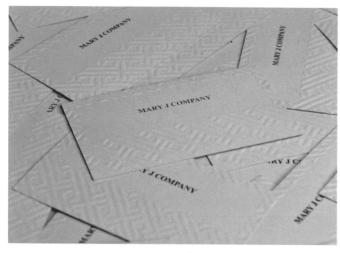

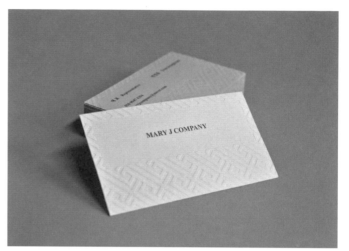

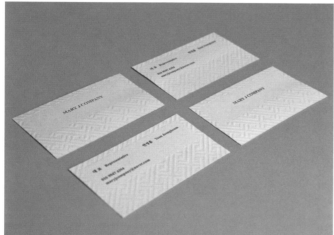

01

02

205

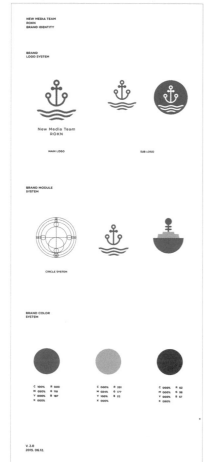

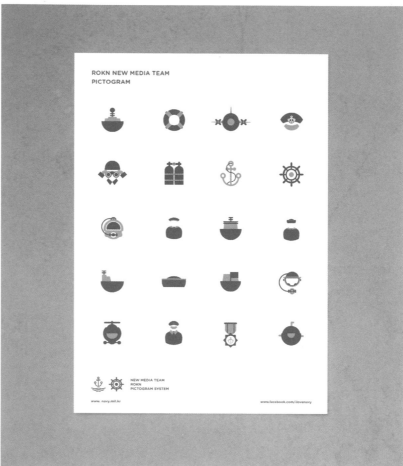

01

01/ Republic of Korea NAVY New Media Team Branding *P.349*
02/ Korea Traditional Ensemble BEDAN *P.349*

BE
DAN

tranditional
performing art
ensemble

02

字體設計
TYPOGRAPHY DESIGN

01

02

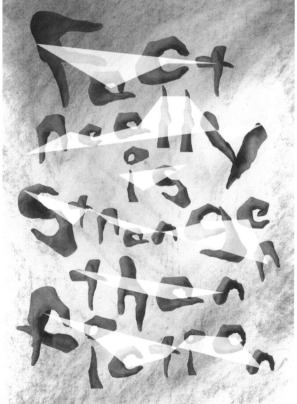

03

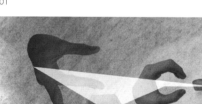

04

蜜 般

多 若

波

罗

SUTRA TEXT FONT DESIGN

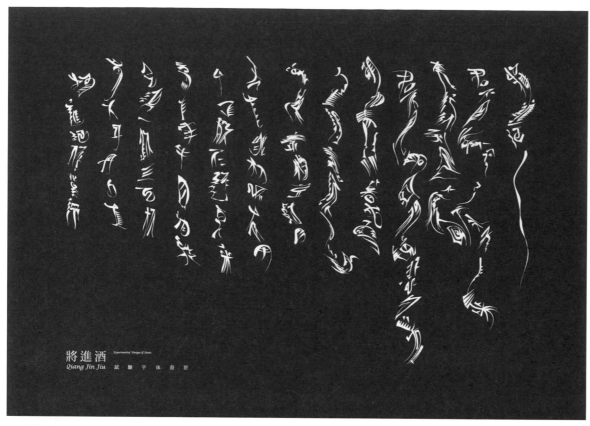

將進酒 *Experimental Design Of Fonts*
Qiang Jin Jiu 試 驗 字 体 設 計

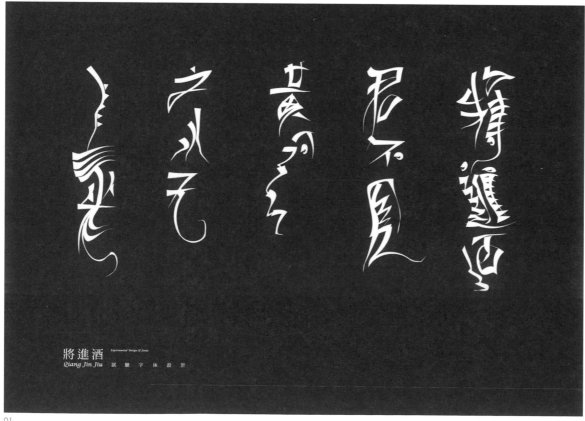

將進酒 *Experimental Design Of Fonts*
Qiang Jin Jiu 試 驗 字 体 設 計

01

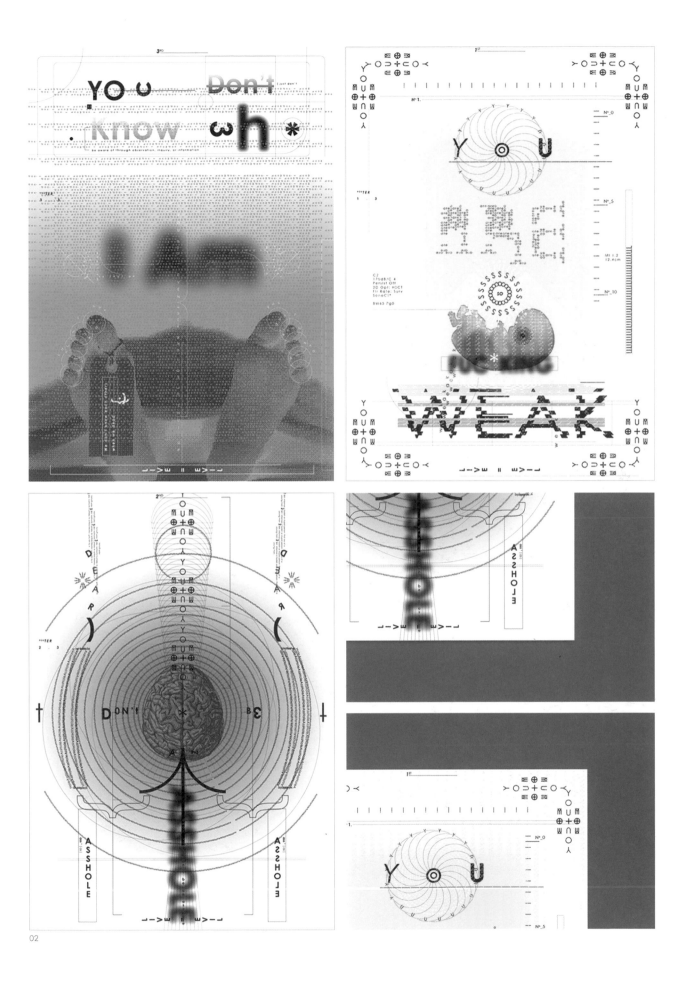

01 文黑體 WH

人文黑体

文则数言乃成其意书则一字可见其心可谓得简易之道欲知其妙初观莫测久视弥珍虽书已缄藏而心追目极情犹眷眷者是为妙矣文则数言乃成其意书则一字可见其心可谓得简易之道欲知，。

，。

8 pt　文则数言乃成其意，书则一字可见其心，可谓得简易之道。欲知其妙，初观莫测，久视弥珍，虽书已缄藏，而心追目极，情犹眷眷者，是为妙矣。

10 pt　文则数言乃成其意，书则一字可见其心，可谓得简易之道。欲知其妙，初观莫测，久视弥珍，虽书已缄藏，而心追目极，情犹眷眷者，是为妙矣。

12 pt　文则数言乃成其意，书则一字可见其心，可谓得简易之道。欲知其妙，初观莫测，久视弥珍，虽书已缄藏，而心追目极，情犹眷眷者，是为妙矣。

14 pt　文则数言乃成其意，书则一字可见其心，可谓得简易之道。欲知其妙，初观莫测，久视弥珍，虽书已缄藏，而心追目极，情犹眷眷者，是为妙矣。

18 pt　文则数言乃成其意，书则一字可见其心，可谓得简易之道。欲知其妙。初观莫测，久视弥珍，虽书已缄藏，而心追目极，情犹眷眷者，是为妙矣。

21 pt　文则数言乃成其意，书则一字可见其心，可谓得简易之道。欲知其妙。初观莫测，久视弥珍，虽书已缄藏，而心追目极，情犹眷眷者，是为妙矣。

（右側直排文字，略）

02 瑞意宋體 RuiYiSong

放 绽 心 用
美 之 字 文

瑞 意

字体设计的精髓
不仅在于点画的
设置搭配技巧更
注重情感的表达

汉 字

（左側及下方字符表，略）

03 絳雲明朝 JiangYun Mincho

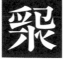

絳雲明朝
字研意匠文字
典藏汉字之美

一万之叶书云人体典
化匠十文方地万坠字
山岌峰工意戈房捺撇
明朝枯横汉法点石研
程空竖端绛美艺藏藤
里锦间阵集雪雲高

04 文本明朝 WenBen Mincho

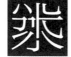

文本明朝

天地寒露懂爱一国爱慕文本明朝
天地寒露懂爱一国爱慕文本明朝
天地寒露懂爱一国爱慕文本明朝
天地寒露懂爱一国爱慕文本明朝

天地玄黄宇宙洪荒日月盈昃辰宿列张
寒来暑往秋收冬藏闰馀成岁律吕调阳
云腾致雨露结为霜金生丽水玉出昆冈
剑号巨阙珠称夜光果珍李柰菜重芥姜
海咸河淡鳞潜羽翔龙师火帝鸟官人皇

05 鐵線黑體 TieXian H

铁线黑体

天地寒露霜懂爱一国铁线黑体
天地寒露霜懂爱一国铁线黑体
天地寒露霜懂爱一国铁线黑体
天地寒露霜懂爱一国铁线黑体

一个京以体力助勺和国天地孩寒小平
广律思慕懂才承推日明晴日月朝杂永
汉河流灵爱珍知立线结腾说道铁锦闪
雀雪露静黑山，，。：；！？《（·
）》"''……'"／

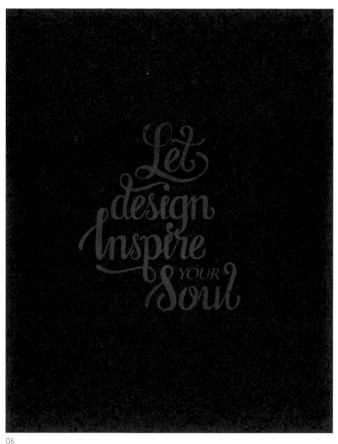

06

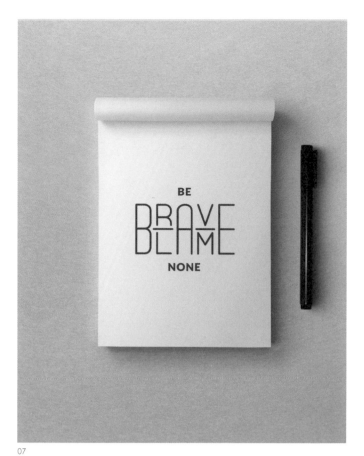

07

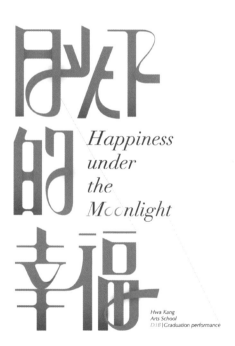

Happiness
under
the
Moonlight

Hwa Kang
Arts School
DJB|Graduation performance

08

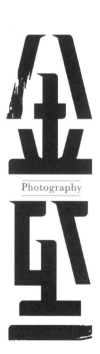

Photography

09

01

02

03

04

05

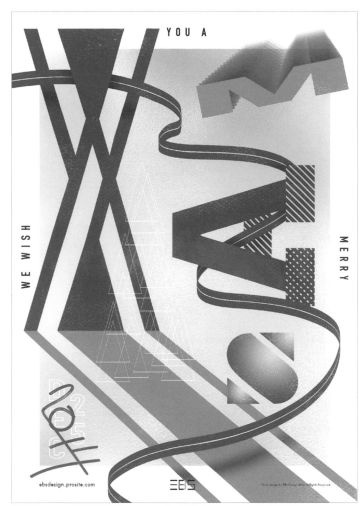

06

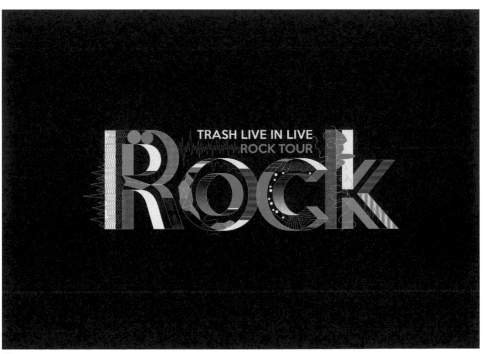

07

01

汉字字体试验·《枫桥夜泊》唐 张继诗一首

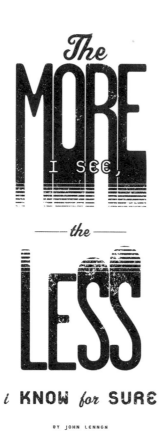

01

02

03

04

倍潔雅

倍潔雅

倍潔雅

来方日长 Long Day

花草与潮

誣尽其以位谓。敢私患居量之，不容遭贤过显此矣，而令矜见禄尊若士，身法力死受能行正，察奉心避上无自方

書法

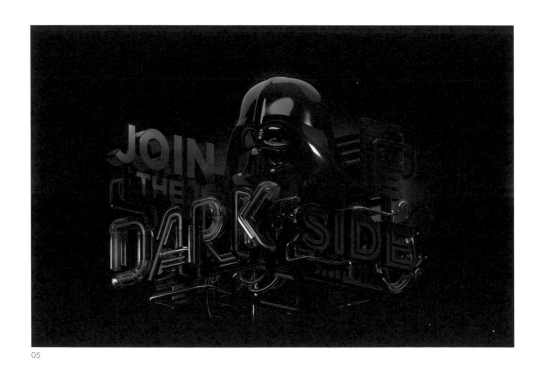

01

02

03

04

05

01/ 味研堂 Flavor study *P.332*
02/ 哭泣 Crying *P.332*
03/ 現場介入 Sound of Field *P.332*
04/ 我不是生來當母親的 I'm not born to be a mother *P.332*
05/ Join the Dark Side *P.323*

222

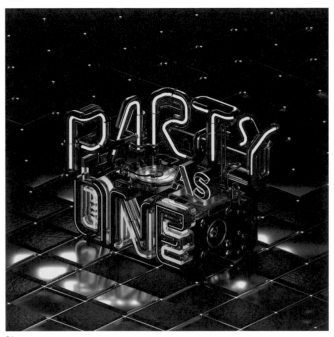
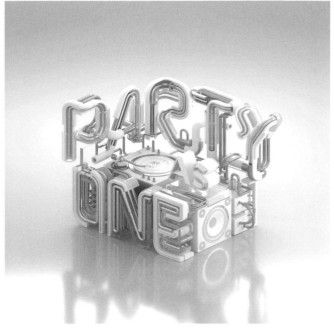

06

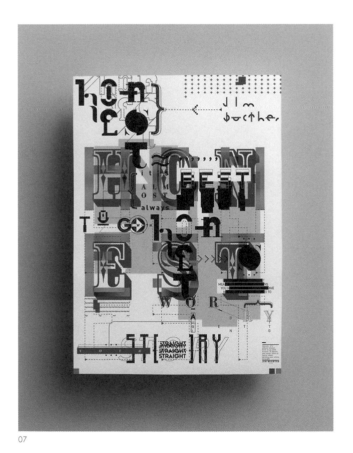

07

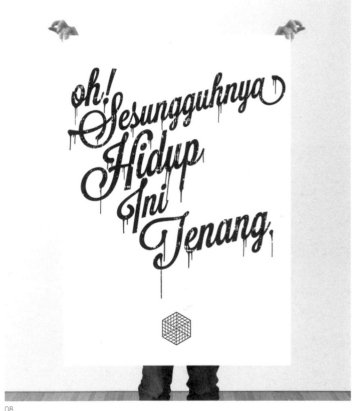

08

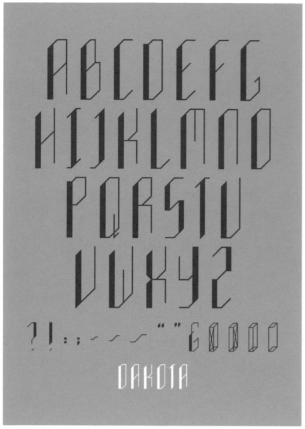

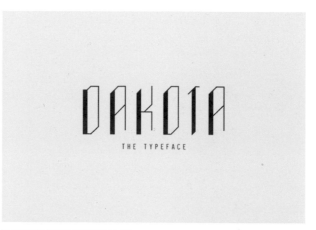

01

02

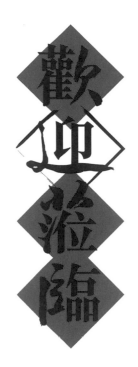

03

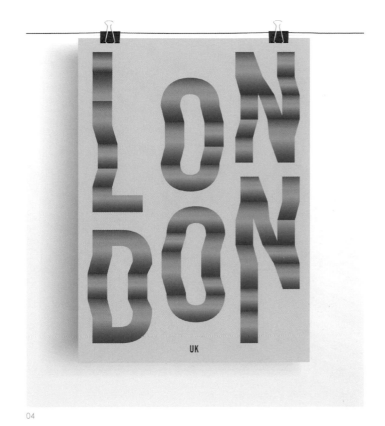

04

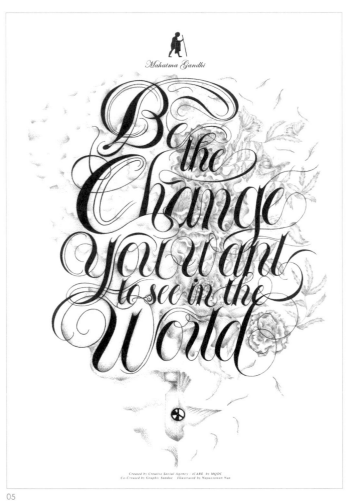

05

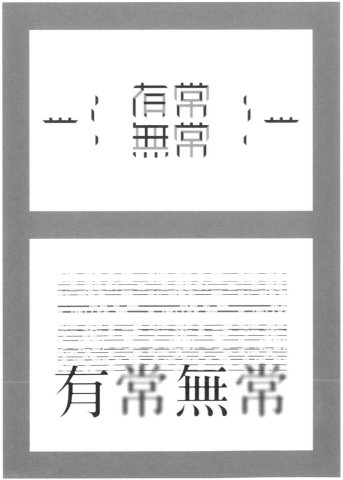

06

Grain Rain

the Beginning of Summer

Grain Full

Grain in Ear

the Summer Solstice

Slight Heat

the Autumnal Equinox

01

02

03

04

01

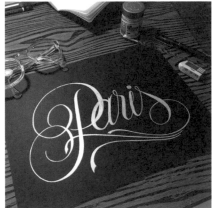
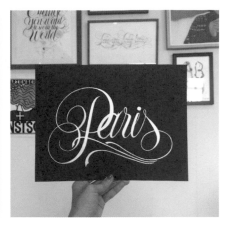

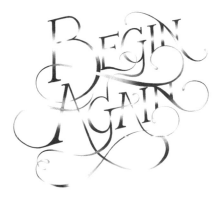
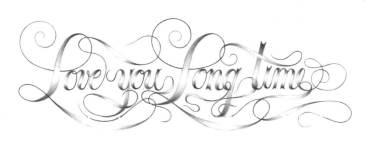

02

03

圖形設計
GRAPHIC DESIGN

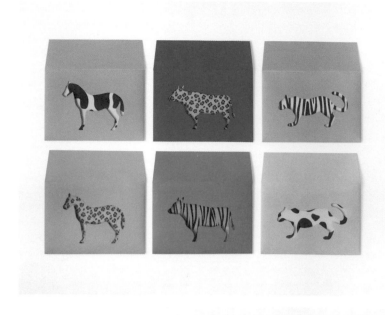

01

01/ 動物卡片 Animal card *P.324*
02/ YouTube Space Tokyo Art Night *P.325*

01

02

03

04

05

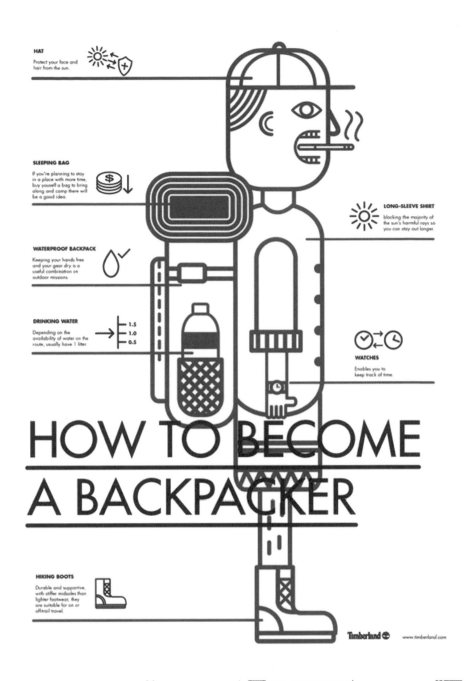

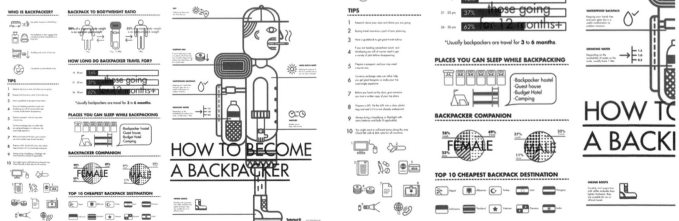

01

02

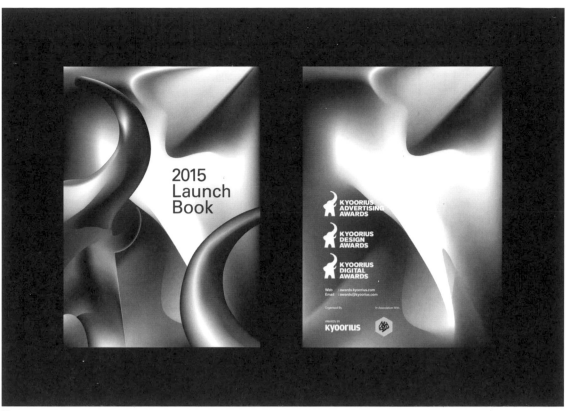

03

04

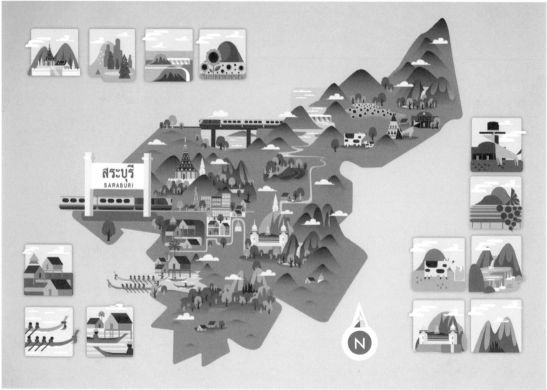

01

01/ Guide to Saraburi *P.312*
02/ GP HISTORY BOOK *P.312*

02

01

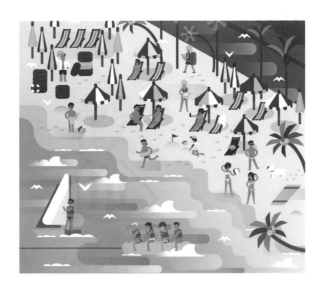

02

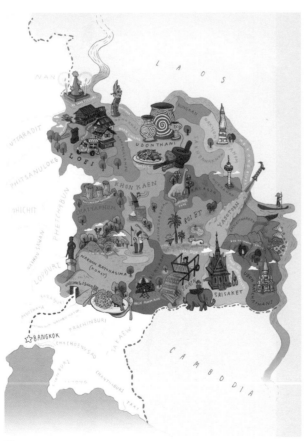

03

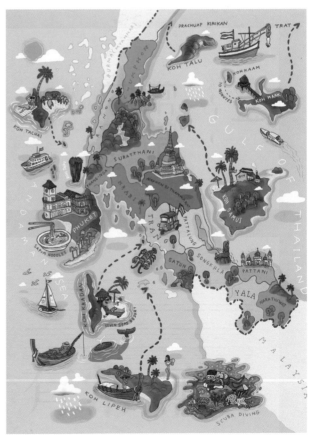

01

01/ The Economist - Digital Solutions *P.319*
02/ Alchemy Christmas Card *P.319*

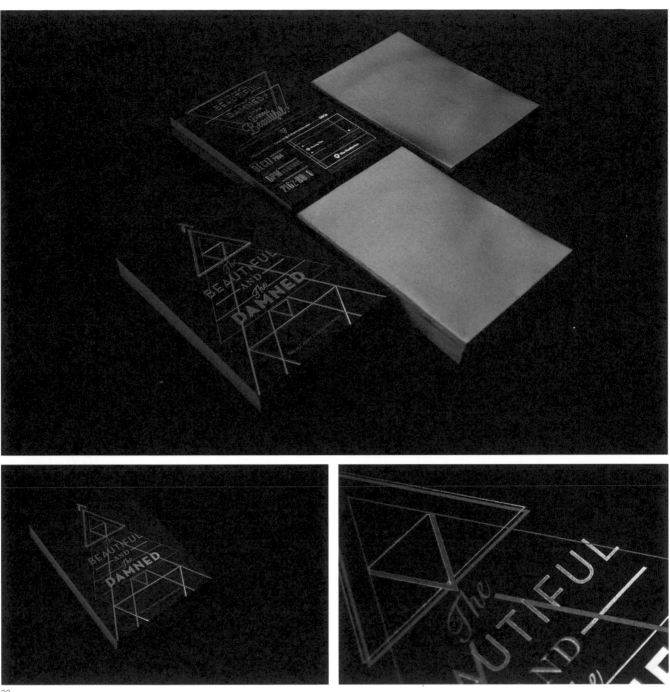

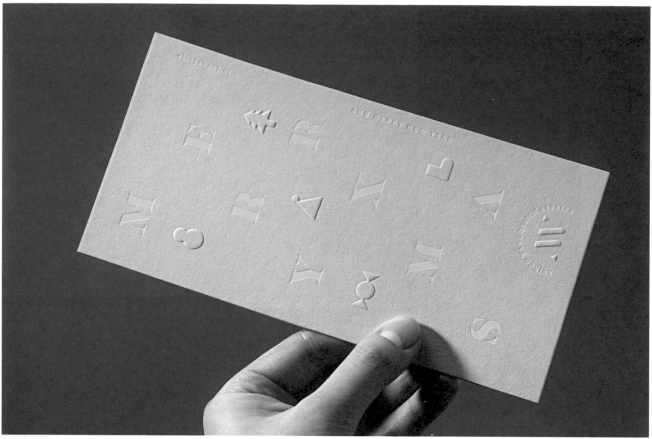

01

01/ 聖誕卡設計 Personal Xmas Card *P.394*
02/ 王氏鄭氏夫婦婚宴邀請卡設計 Wang & Cheng's Wedding Invitation *P.394*

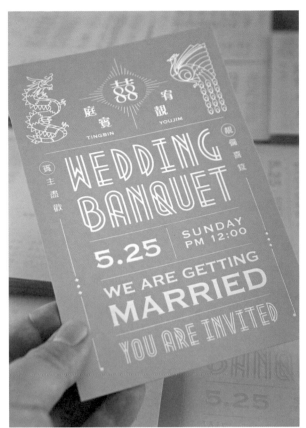

02

01

01/ Korean Thanksgiving Day Illustration *P.351*
02/ Move like this *P.351*

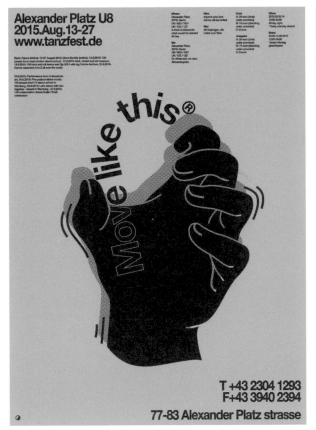

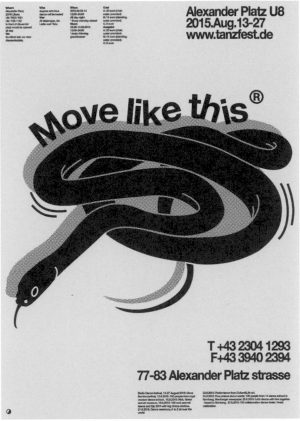

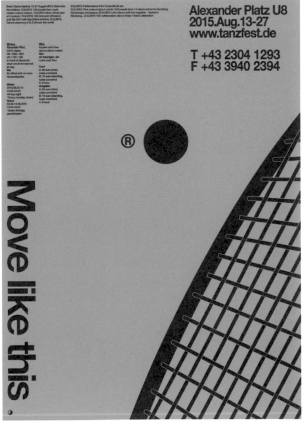

02

01

01/ EMPRESS (BLACK, WHITE AND SKATEBOARD DECK) *P.322*
02/ Line Fixation *P.322*

02

01

02

03

04

01

02

03

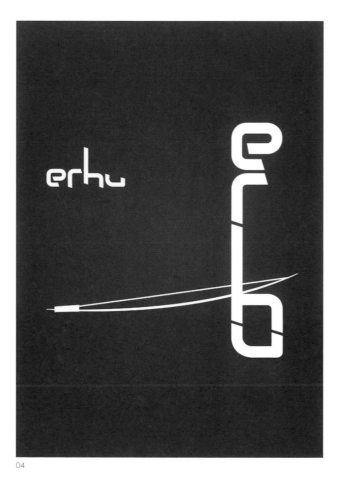

04

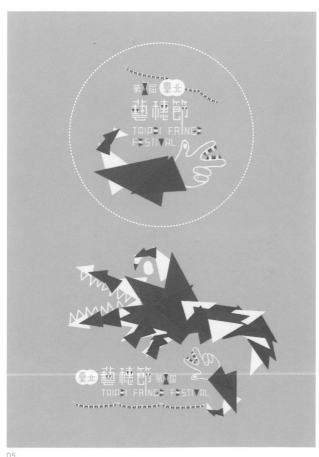

05

01

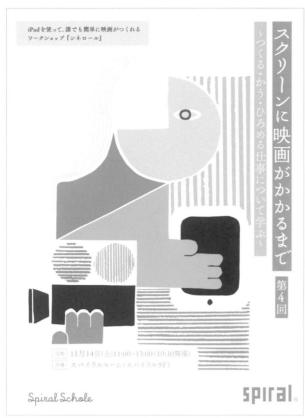

iPadを使って、誰でも簡単に映画がつくれる
ワークショップ『シネロール』

スクリーンに映画がかかるまで
～つくる・かう・ひろめる仕事について学ぶ～
第4回

日時 11月14日(土)11:00～13:00 (10:30開場)
会場 スパイラルルーム(スパイラル9F)

Spiral Schole

spiral®

ニッポンファッション最前線

Vol.2 2015年12月6日(日)13:30～15:00
Vol.3 2016年2月27日(土)14:00～15:30
会場 スパイラルルーム(スパイラル9F)

Spiral Schole

spiral®

02

03

Live with GODS

The gods near by us /
Chinese indigenous religion and Taoism

In chinese religion the gods will bless you if you
worship to him. But we dont familiar with gods stories
and realize what they are in charge of, for example: which
god takes charge of your hair cut ?
and which god takes responsibility to your food tasting?
let's find out the interesting knowledge of chinese gods!

 45 symbols

Related to my work ●
Related to my life ○
Related to my hobby ◑

Caishen - the God of money ○
Fu xing - the God of lottery ○
Kitchen God- the God of Snacks ◑
Wenchang Wang- the God of Final exam ◑
Ding mu - the God of Power supply

Lu Dongbin - the God of hair Style ◑
Yue Lao - the God of Lover ○
Hu Yeh - the God of Dessert ◑
Shenshu - the God of Safty ◑
Dragon King- the God of water activities
the God of Good weather ○
Yu Bo -
Lei Gong - the God of Swearing ○
Feng sheng - the God of Flying a kite ◑

Yulü - the God of Safty ○
Chen Tuan - the God of Sleeping well ○
Guan Sheng Di Jun - the God of Homework ●
Lu Ban - the God of Nice tool ●
Nüwa - the God of repairing ○
Cai Lun - the God of Graphic ●
Lu Yu - the God of Interior design ●
Lu Yu - the God of Good tea ◑

Chuangmu - the God of sex ○
hua xian - the God of flower viewing ◑
Zhi Nü - the God of Clothes ◑
Wu Daozi - the God of painting ●
Sun Bin - the God of Nice shoes ●
Zhuge Liang - the God of Tasty bread ○
Jiutian Xuannü - the God of Drinking ◑
Jiutian Xuannü - the God of Lamp ●

Chenghuang Ye - the God of Trafic ○
wen pan guan - the God of Scores ○
wu pan guan - the God of Fighting ○
Guanyin - the God of Social networks ●
Yuen Tin Sheung Tai - the God of Tasty pork ●
Lord Xiqin - the God of Good movie ◑
Baosheng Dadi - the God of Getting well ○
Nezha - the God of Driving car ●

Wind-following Ear - the God of Gossiping ○
Thousand-li Eye - the God of Peeping ○
Skanda - the God of Time ●
TienTu YuanShuai - the God of Music ◑
Taishang Laojun - the God of Fitness ○
Zhang Shuai - the God of pimple ○
Faju zhenjun - the God of Traveling ◑
Houji - the God of Rice ○

01

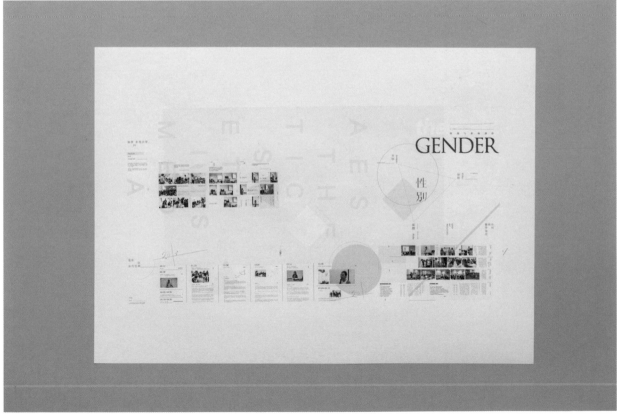

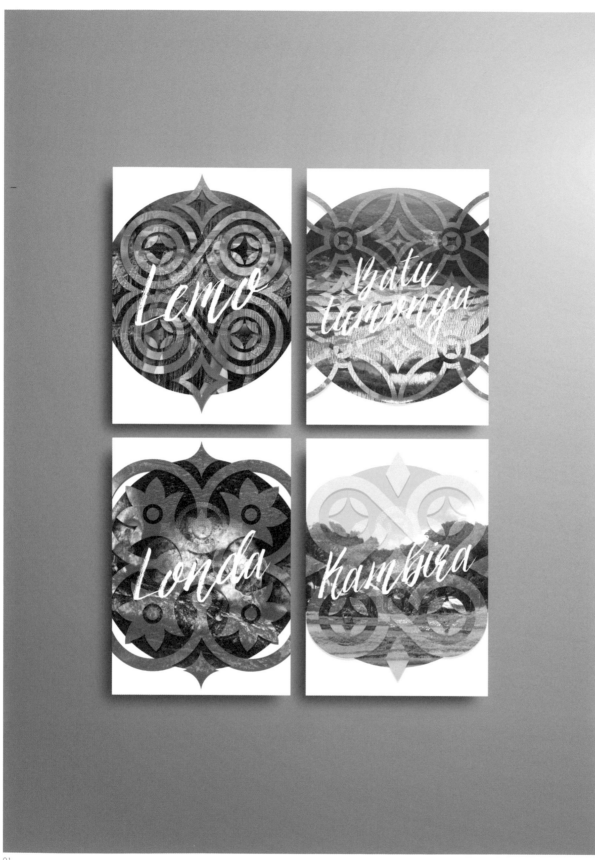

01

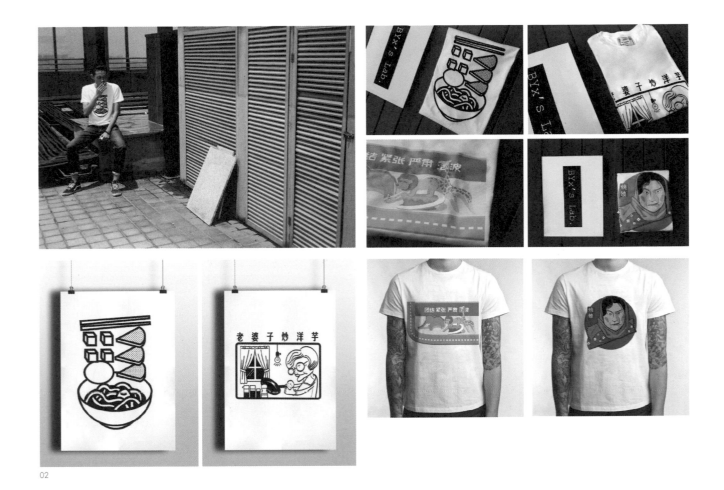

02

03

01/ SeMA Biennale Mediacity Seoul *P.327*
02/ Typojanchi *P.327*

슈퍼텍스트
슈퍼중의성
슈퍼공공재산
슈퍼샌디 마니아
슈퍼유혼
슈퍼시제
슈퍼명상
슈퍼기준선
슈퍼불신의 유예
슈퍼실화
슈퍼쌍무지개
슈퍼자동암시
슈퍼서명

Supertext
Superperformative
Supermontage
Superplay
Supertrue story
Superinflection
SuperDJing
Superover-responsiveness
Supersuspension of disbelief
Superdisappearance
Superrestraint
Superpalindrome
Superprocessed language
Supermimesis
Superpage
Superdecoding

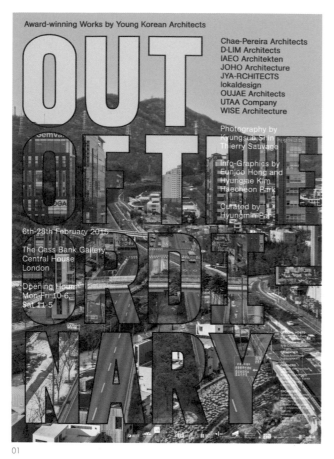

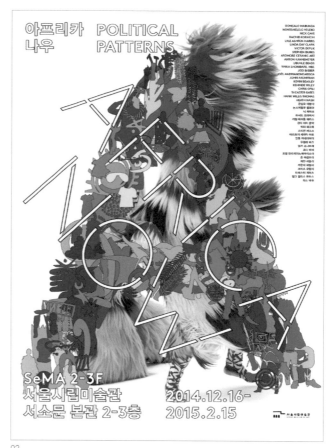

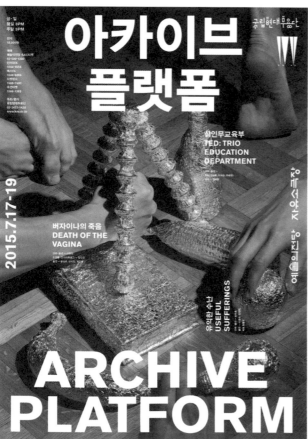

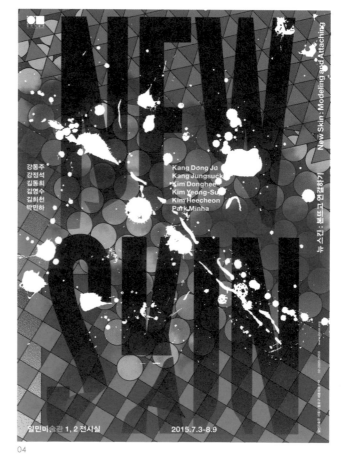

01

02

03

04

訝　奸　犯

莫　鎖

05

263

插圖
ILLUSTRATION

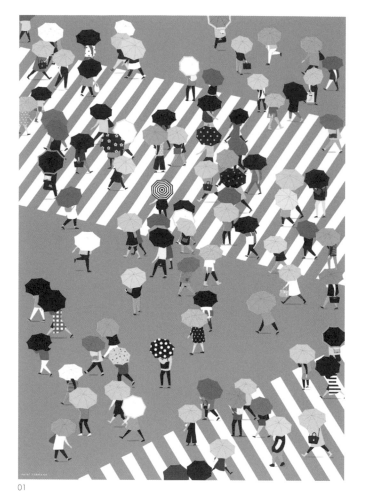

01

02

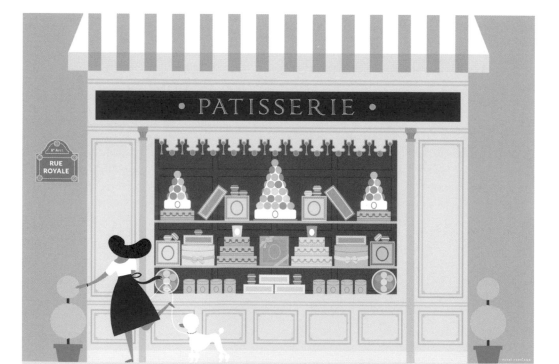

03

04

05

06

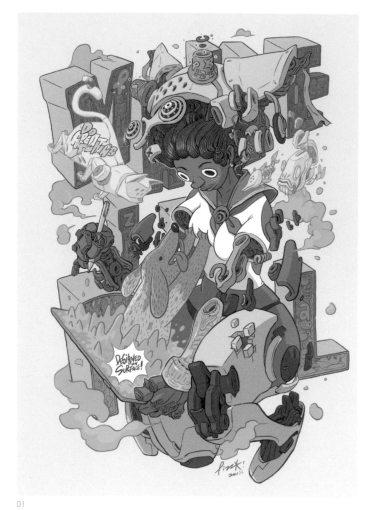

01

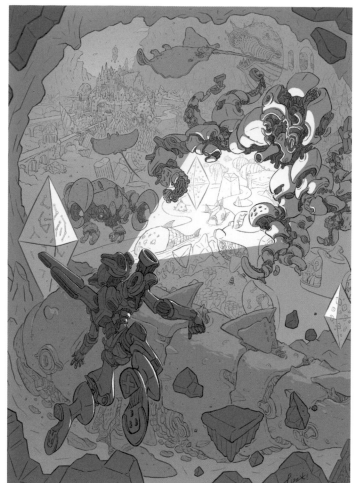

02

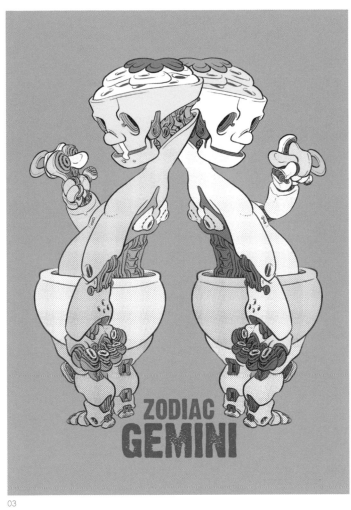

03

04

05

06

A GUIDE TO
COFFEE CAFE

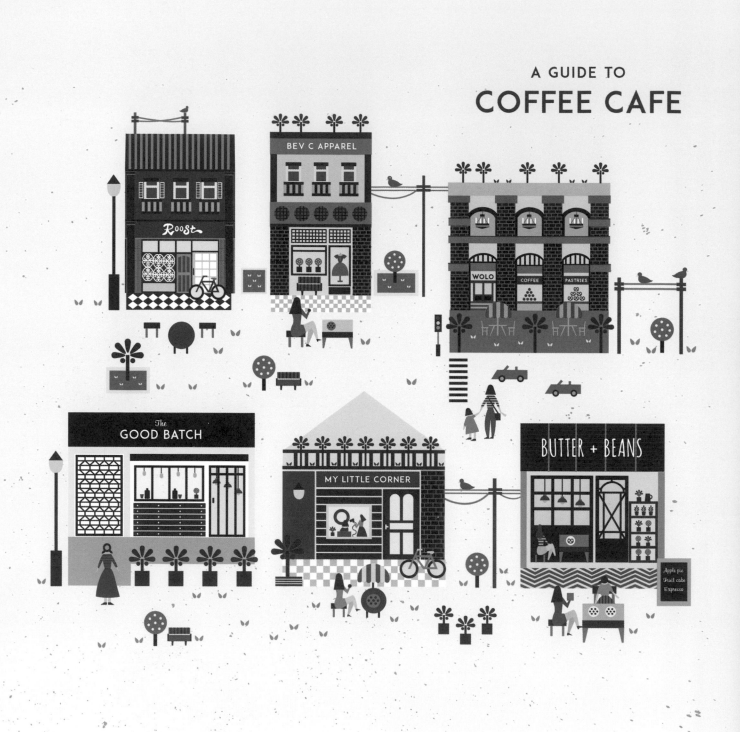

01

Roost Cafe

...ocated at Jalan Dhoby where ...e street is filled with the air of ...odern vintage. Roost cafe's ...tro inspired decor made it a ...omey hangout place for friends.

Bev C Cafe

It is founded by Malaysian's independent designers who want to inspire everyone to shape their own fashion sense and lifestyle. They sell their brand in the cafe.

My Little Corner

...y Little Corner is both a hair ...lon and a cafe. They serve Thai ...shes and Thai drinks. An old ...orld charm of this place has ...little sky deck to chill out on!

Tour Les Jour

It means "Everyday" in French. It is a french inspired Korean bakery at Bukit Bintang serving a wide selection of beverages, cakes and pastries. A great place to sit back.

The Good Batch

...is a cafe focuses more on food ...an the coffee. All-day Western ...ekkie dishes are served. What ...the best is the all-day bar.

Butter+Bean

It is a little place that located at the neighbourhood with a limited seating. Modern chic New York style is where the inspiration from.

02

03

04

01

02

03

01/ 臉 Face *P.368*
02/ Body (La peste magazine) *P.298*
03/ Flavours magazine editorial *P.298*
04/ British council ads *P.298*

04

The moonlight is seeping through the trees, as the boy made of fire noticed that there was a shadow of something he never saw. His heart suddenly beats faster followed by a sigh racing in silence. There was a pair of eyes that shone like stars, staring at him. Such a strange creature standing before him.

Her gaze pierced him.

An intense chemistry grew on the elements. Reacting, synthesizing in synchronized chaos such as the universe itself. Blood like embers rushing through his veins. As strange as it was, he never thought that he had the nerves to move a muscle, but he did. He move towards the girl. In the darkness of night, their eyes met.

"I am the girl made of water" she whispered.
"I've seen you walking here before, this is the same path that I took. Come..."

Then he followed her steps into the deepest part of the forest. She was taking him to her secret garden where dreams grew and bloomed. They said nothing but just sat in silence as the night turned to pitch-black.

Could it be fate
Or just a coincidence?
At the right place
At the right time
Two roads intertwine. "

01

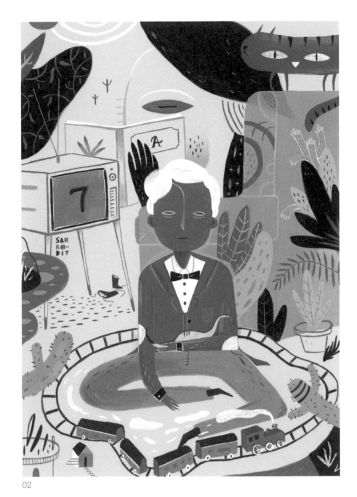

02

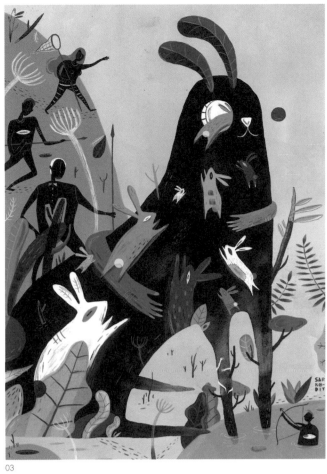

03

04

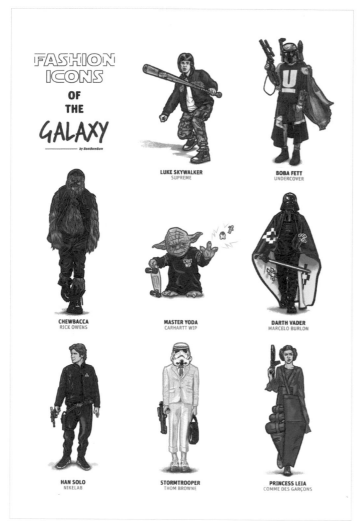

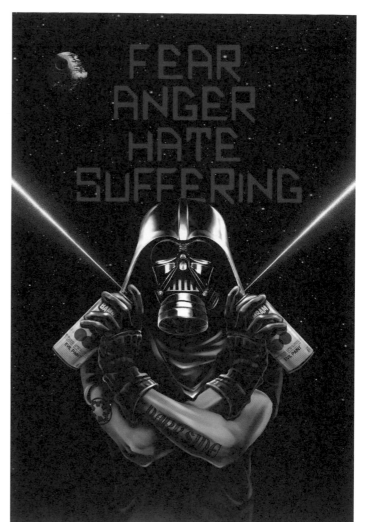

01

02

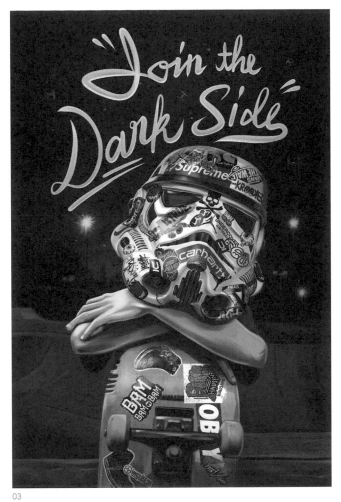

03

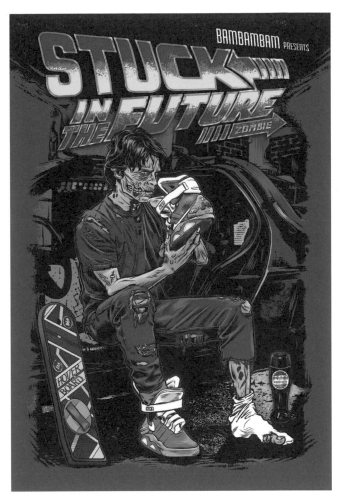

04

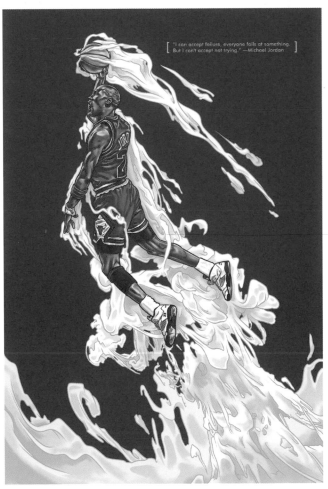

05

06

01

02

04

05

03

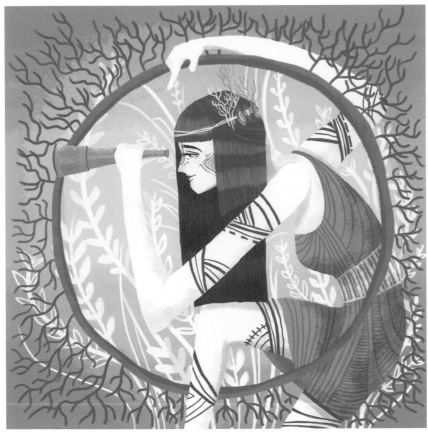

06

01

02

03

04

01

02

03

01

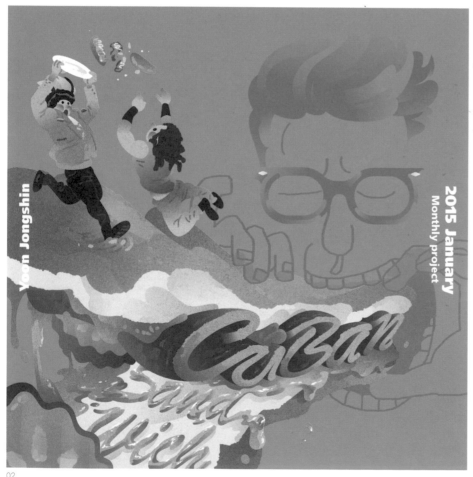

02

01/ 500th-day anniversary *P.320*
02/ Cuban sandwich *P.320*
03/ 3 words *P.320*
04/ People with coffee *P.320*
05/ Winter wind *P.320*

03

04

05

01

01/ Collaborations with nine years old of me *P.320*
02/ Camry in fall *P.320*
03/ 2016 New year's card *P.320*

02

03

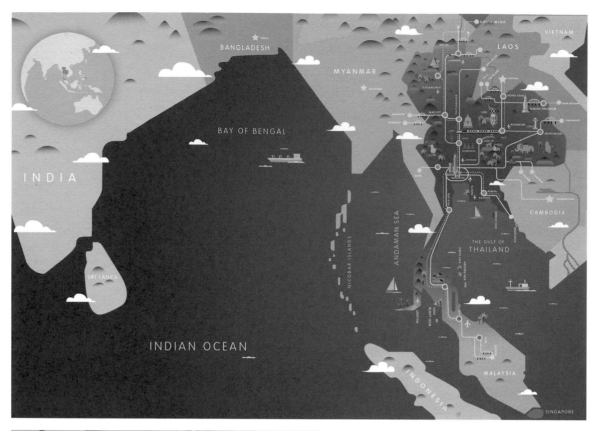

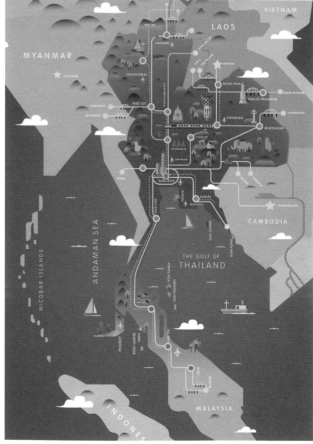

CHAPTER 01

OIA, Santorini, Greece

—— CHIN YEUK ——

SHIRAKAWA GO, Gifu, Japan

—— CHIN YEUK ——

PRAGUE, Czech Republic

—— CHIN YEUK ——

ALEXANDRIA, Egypt

—— CHIN YEUK ——

TAKAYAMA, Gifu, Japan

—— CHIN YEUK ——

CHAPTER 12

SAN FRANCISCO, California, USA.

—— CHIN YEUK ——

DUBLIN, Ireland

—— CHIN YEUK ——

SHANGHAI, China

—— CHIN YEUK ——

AGORA / CYCLADES / OIA, Greece

—— CHIN YEUK ——

CHIANG-MAI, Thailand

—— CHIN YEUK ——

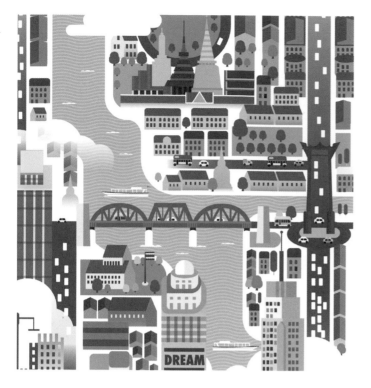

01

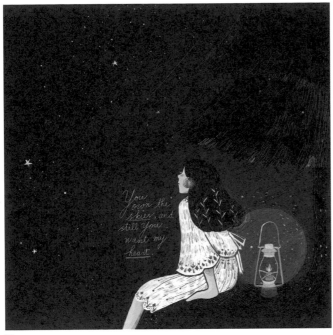

02

03

04

05

01

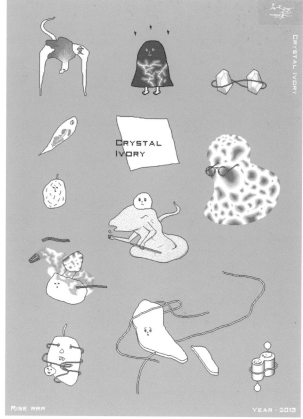

02

03

04

05

06

01

02

03

04

05

設計師簡介
BIOGRAPHY

印度尼西亞 Indonesia

Aditya Pratama

bersama-sarkodit.tumblr.com

Aditya Pratama 是印尼的插畫家，曾在印尼萬隆理工學院學修讀視覺傳達設計，他喜歡使用傳統與數位媒體作畫，他的一些作品發表在雜誌、報紙、網站、廣告與書籍上，最近一次獲獎是 2015 年 Genkosha 插畫集獎（日本），他也收藏許多小說與童書，而他最喜歡的書是克里夫‧巴克的 Abarat。

Aditya Pratama is an Indonesian illustrator who studied Communication Visual Design at National Intitute of Technology, Bandung. He enjoys drawing in both traditional and digital media. Some of his works published on magazines, newspapers, website, ads, and books. The most recent award received by him is Genkosha Illustration File Award 2015 (Japan). He also collects a lot of fiction and children book. And his favourite book is Abarat by Clive Barker.

Q. 請問您認為該國最棒的是什麼？(如國家的特色或文化等) 您的創作是否受其影響？

A. 我喜歡印尼的環境，我住在爪哇島某處的小鎮，這個地方仍然保有自然的環境，而現在發展成為一個小鎮。或許這影響到我的創作，我的創作通常由自然的環境主導還有發展。

Q. 請問您如何獲得靈感？

A. 我的靈感大部分來自我的感受，還有每天經歷過的事物。當我沈浸在情緒裡，我可以從我身邊所看到的東西中，描繪出任何細節或對話，我喜歡基於平凡的日常，而創造出特別的插畫，擁有真實的觸感以及多彩的個性。

Q. 請和我們分享您喜歡的書籍、音樂、電影或場所。

A. 喜歡的書是克里夫‧巴克的《阿巴拉特》，因為這本書是根據他花了六年創作的一系列畫作而完成的，對我來說，《阿巴拉特》不只是一本書，它是夢想與體驗。音樂的話我喜歡澀谷系的音樂，關於這種音樂最好的描述是，融合了爵士、流行，還有電子搖滾，澀谷系很像是慢搖、新爵士或是前衛浩室，我推薦 perfume、cornelius、capsule、towatei 還有 round table。而我最喜歡的電影是史蒂芬‧史匹柏導的《辛德勒的名單》。

Q. 除了當設計師 / 插畫家，你是否已經開始規劃下一階段的目標？例如策展、學習煮菜、登山

A. 寫作！直到現在我還是夢想能出版自己的書。

Q. 你對生活的細節上有什麼堅持嗎？(像是上廁所時一定要看詩集之類的)

A. 我想要自己的臥室有一個很大的水族箱 :)

Q. What do you like best in your country? (such as country feature or culture)Has it made a difference on your creation?

A. I like environment in Indonesia. I live in a small village somewhere in Java Island. This place still has a natural environment and now growing into a small town. Maybe that influence my work, which is often dominated by natural atmospheres and the development within them.

Q. How do you draw inspiration?

A. Mostly my inspiration come from what I feel and what I go through everyday. When I'm in the mood for swimming, I can draw any little details or conversation from what I see around me. I like to create extraordinary illustrations based on ordinary everyday life with surreal touch and colorful personalities.

Q. Share good books, music, movies or places with us.

A. For the book I like "abarat" by clive barker. Because the book is based upon a series of paintings that Barker spent 6 years creating. For me, abarat it`s not just a book, its dreams and experience. For music, I like shibuya-kei genre. It is best described as a mix between jazz, pop, and electropop, and is similar to downtempo, nu-jazz or progressive house. I recommend perfume, cornelius, capsule, towatei and round table. And my favourite movie is Schlinder List directing by Stephen Spielberg.

Q. Have you started to set up new goals for next period except being a designer or illustrator ? like curating, learning cooking , climbing......

A. Writing! until now I still have a dream to publish my own book.

Q. What is your insist on your life's details ? like toilet with your favorite poem?

A. I want a big fish aquarium in my bedroom :)

La Guarimba International Film Festival 2015 *2014 P.101*

這個案子是作為南義大利電影節宣傳的一部分，30 位來自不同國家的插畫家們替這次活動製作自己版本的海報，我則被選為印尼國家的代表。我的海報靈感來自許多擁有海洋設定的指標電影，像是鐵達尼號與少年 Pi 的奇幻漂流。

This project made as a part of La Guarimba film festival promotion in Italy. 30 illustrators from different countries made a poster with their own version for this event and I have chosen to represent Indonesia country. The idea of my poster version came from many iconic movies with ocean setting like Titanic and Life of Pi.

Body (La peste magazine) *2015 P.272*

替法國哲學家米歇‧翁福雷在 La Peste magazine 上發表的系列俳句插畫，這次的議題是以身體為主題。

Illustration for a series of haikus written by french philosopher Michel Onfray on La Peste magazine. This issue have the theme of Body.

Flavours magazine editorial *2015 P.272*

Flavours magazine 是馬來西亞的飲食與生活雜誌，這頁的故事是在描寫發酵飲料，像是酶、酸乳飲料，還有紅茶菌。

Flavours magazine is a Malaysia food and lifestyle magazine. This pages story write up about the fermentation drinks. Such as enzyme, Kefir drinks, and Kombucha.

British council ads *2015 P.273*

英國文化協會透過新加坡廣告公司作的系列廣告，英國文化協會可以幫助你更快速找到詞彙，讓英語更加流暢。

British Council ads series for Singapore advertising agency. British Council helps you find that word faster by becoming more fluent in English.

One short story *2014 P.274*

這是我個人與作家的案子，故事是關於一個由火和水組成的生物。因為有叢林的設定，我想將這個故事描繪地像是一首詩。

This is my personal project with a writer. The story is about a creature that made from fire and water. With a jungle setting, I try to portray the story like a poem.

ELLE Indonesia 7th anniversary *2015 P.275*

為了慶祝七週年，印尼雜誌 ELLE 在 2015 年 4 月發行由 7 位視覺藝術家作品，收藏用的空白筆記本共 7 款，包含 EkoBintang、Agra Satria、AndhikaMuksin、YkhaAmelz、Kims、LalaBohang 還有我自己。我的插畫是描述自己的童年回憶。

Celebrating 7th anniversary, ELLE Indonesia Magazine April 2015 issue come up with 7 collectible blank note designs from 7 visual artist : EkoBintang, Agra Satria, AndhikaMuksin, YkhaAmelz, Kims, LalaBohang and myself. And my illustration tell about my childhood memories.

Rabbit hunter *2014 P.275*

這件作品是插畫機構的藝術書其中一部份，這間機構與設計師共同合作，由機構內的每位插畫家繪製個人版本與想像的兔子插圖，這件作品表現兔子奔跑著，想要逃離獵人的模樣。

This artwork is a part of an artbook for the illustration agency`s that designer work with. Every illustrator in this agency make a rabbit illustration in their own version and imagination. This artwork shows rabbits running and try to escape from the hunters.

Success because the act of giving *2014 P.275*

一幅替報紙畫的插畫，這份報紙刊載企業故事的文章，故事告訴讀者們，如果公司不要吝嗇，並且能管理有效率地「給予」行動給其他公司，那麼公司就能一直成長。

An illustration for a newspaper that contain an article about business story. The story told the readers that business can always grow if the company not stingy and can manage an effective act of "giving" to another companies.

日本 Japan

中國國際海報雙年展 / 金獎
NY Graphis / 銀獎
芬蘭拉赫第國際海報三年展 / 入選
NY TDC 紐約字體設計競賽 / 印刷卓越獎
其他

China International Poster Biennial / Gold Award
N.Y.Graphis / Silver Award
Lahti Poster Triennial / Finalist
NewYork TDC / Typographic Excellence
And many others

宮前 陽　Akira Miyamae

www.kasugamaru-d.com

Q.請問您認為該國最棒的是什麼？(如國家的特色或文化等) 您的創作是否受其影響？
A. 我喜歡看以前的書籍。
從迴溯過去的行為裡，我可以得到許多靈感。

Q.請問您如何獲得靈感？
A. 我必須一直思考。

Q.請和我們分享您喜歡的書籍、音樂、電影或場所。
A. 日本傳統的景觀和當代景觀的融合,例如:淺草寺和天空樹。

Q.現在,回頭來看這些帶著遺珠之憾的作品,您有什麼新的感觸？
A.因為每個人都有不同的看法,作品的評價也會隨著看的人不同而有所改變,如果作品有具體的部分需要改善,那麼我就會試著去改善它。

Q.除了當設計師 / 插畫家,你是否已經開始規劃下一階段的目標?例如策展、學習煮菜、登山......
A. 我開始一個人旅行。

Q.你對生活的細節上有什麼堅持嗎?(像是上廁所時一定要看詩集之類的)
A.「打一場美好的仗(為自己持守的信念而戰)」,我喜歡這個句子。

Q.What do you like best in your country? (such as country feature or culture)Has it made a difference on your creation?
A. I like to read past books.
I get a variety of sensation by dating back the past.

Q.How do you draw inspiration?
A. I have to always thinking.

Q.Share good books, music, movies or places with us.
A. Traditional landscape and the fusion of contemporary landscape of Japan. For example, Sensoji Temple and Sky tree.

Q.Now, look back to these works of regret for not been selected, how do you feel that?
A.There is various estimation method, so I think evaluation may change again when it's shown to a lot of people. When there is improvement points in detail, I'm trying to be improving a work.

Q.Have you started to set up new goals for next period except being a designer or illustrator ? like curating, learning cooking , climbing......
A. I started to be a traveling alone.

Q.What is your insist on your life's details ? like toilet with your favorite poem?
A. Fight a good fight! I like the sentence.

鐵砂 Iron sand　2014　P.210
以鐵砂為創作主題的作品,透過字體排版表現出鐵沙被磁力吸引的狀態。
It is the work with the motif of iron sand.
We have to express how the iron sand stick to a magnet by typography.

信號字母 Semaphore alphabet　2011　P.210
以旗語作為表現的作品,陰影變成英文字母。
It is a work which is represented by the semaphore.
Shadow has become the alphabet.

現實比虛構更加強烈 Fact really is stronger than fiction　2013　P.210
我用手的形狀創作字體。
I created the alphabet in the hands of the form.

2011.3.11　2011　P.210
它是以「連結」為主題,對於日本的東北大地震災後重建所創作的作品。
It is a work on the theme of "connection" towards the reconstruction of the Great East Japan Earthquake.

日本 Japan

渡辺明日香是設計師、插畫家。目前以平面設計師的身分在東京接案，包含標識設計、編輯設計、介面設計與插畫。

Asuka Watanabe is a multidisciplinary designer and illustrator. She is currently freelancing in Tokyo as a graphic designer including logo design, editorial design, identity design, UI design, and illustration.

渡辺明日香　Asuka Watanabe

www.asukawatanabe.com

Q. 請問您如何獲得靈感？

A. 隨時觀察身邊的事物，從中得到靈感。

Q. 請和我們分享您喜歡的書籍、音樂、電影或場所。

A. 陰間大法師 (電影)。

Q. 除了當設計師 / 插畫家，你是否已經開始規劃下一階段的目標？例如策展、學習煮菜、登山

A. 我也喜歡料理，喜歡學習如何製作餅乾和其他食物。

Q. 你對生活的細節上有什麼堅持嗎？(像是上廁所時一定要看詩集之類的)

A. 在鎮上走路的時候觀察鳥類、貓咪和昆蟲。

Q. *How do you draw inspiration?*

A. When I observe things minutely or closely, I draw inspiration from the things.

Q. *Share good books, music, movies or places with us.*

A. Beetlejuice(movie).

Q. *Have you started to set up new goals for next period except being a designer or illustrator ? like curating, learning cooking , climbing......*

A. Also, I love cooking as well, I'd like to study making cookies more.

Q. *What is your insist on your life's details ? like toilet with your favorite poem?*

A. Watching birds, cats, insect and so on when I'm walking around the town.

College　2013　*P.131*
音樂活動「College」的海報設計。
This is a poster design for a music event, which is called "College."

HamOn　2014　*P.131*
音樂活動「HamOn」的海報設計。
This is a poster design for a music event, which is called "HamOn".

Sasakure festival　2012　*P.131*
音樂活動「Sasakure Festival」的海報設計。
This is a poster design for a music event, which is called "Sasakure Festival"

GaraGara Summer festival　2015　*P.133*
GARAGARA 在日本是代表「喀啦喀啦」的聲音，這個作品是替在池袋 PARCO 舉行的抽獎活動所作的平面設計。
Gara Gara meanings " 喀啦喀啦 " in Japan, so this work is designing for lucky draw of Parco in Ikebukuro.

NEAT1　2015　*P.292*
在科學雜誌的平面設計和插畫。
Graphic and illustration for science magazine.

台灣 Taiwan

Bam Bam Bam

bambambam99.tumblr.com

Bam 是一名生長於台灣 / 台中，目前定居於台北的插畫家 / 設計師。也是體育賽事狂熱者、潮流與生活愛好者。主要作品主題包涵：運動員、球鞋、潮流、電影甚至政治時事，並且時常把他們殭屍化 (Zombify)。名稱 Bam 取自於中文名字中的「竹」字英文 - Bamboo，另外 BAM 在英文中也是一種用來表達興奮與開心的狀聲詞（大多用在完成了某件事情 / 成就之後），藉此期望每完成一件作品，對自己跟觀看者來說都是一聲大大的 BAM!

Born and raised in Taichung, Bam is a Taipei based illustrator/designer. As a sports maniac and an enthusiast on street style fashion trends and lifestyle, the majority of his work includes athletes, sneakers, street style fashion trends, movies, and even political events, with a tendency to zombify some of the figures in his work. The name Bam originated from the Chinese character " 竹 ",("bamboo" in English,) which is part of his Chinese name. The word BAM is also an exclamation used to express extreme excitement or happiness, resulting from some sort of accomplishments. Hopefully, each of his work can bring out a big BAM!

Q. 請問您如何獲得靈感？

A. 電影、影集、音樂、逛街。接收大量的視覺、聽覺資訊存在腦中。之後靈感自己會來找你。

Q. 請和我們分享您喜歡的書籍、音樂、電影或場所。

A. 書籍方面我喜歡日本小說家伊坂幸太郎的系列作品，他擅長將許多看似不相干的人事物，用非線性的寫作方式編排，最後再將所有角色的關聯集合在一起。看他的小說就像看一部精彩的電影，而精彩的程度也跟自己的想像力成正比。

Q. 除了當設計師 / 插畫家，你是否已經開始規劃下一階段的目標？例如策展、學習煮菜、登山

A. 未來想開一間在電影裡常看到的英式風格酒吧。經典的木造裝潢，室內放著真正的搖滾樂，一邊招呼著下班來放鬆喝一杯的客人。

Q. 你對生活的細節上有什麼堅持嗎？(像是上廁所時一定要看詩集之類的)

A. 不管幾點起床，起床後的第一餐一定要吃早餐類的食物。早上一定要喝咖啡。

Q.How do you draw inspiration?

A. Movies, tv series, music, shopping. Received a lot of visual and auditory information then stored in my brain. After the inspiration will come for you.

Q.Share good books, music, movies or places with us.

A. I love Japanese novelist series works of Isaka Kotaro, he is good at writing at many seemingly un related people and things with a nonlinear way, and put every connect together in the end. Just like watching a great movie when I reading his novel, and amazing is proportional to my imagination.

Q.Have you started to set up new goals for next period except being a designer or illustrator ? like curating, learning cooking , climbing......

A. I would like to have a British style pub which kinds like seeing in the movies. Classic wooden decor, play the real rock music, and greeting guests who have a drink after work.

Q.What is your insist on your life's details ? like toilet with your favorite poem?

A. I must drink a cup of coffee and have a breakfast whenever I wake up.

Fashion Icons of the Galaxy *2015 P.276*

A long time ago in a galaxy far, far away.... 是星際大戰 (Star Wars) 系列電影，經典捲動式片頭的開場台詞。從文化與流行時尚的角度來看，系列首部於 1977 上映的 Star Wars，將近 40 年前，至今似乎沒有離我們太遠。導演 George Lucas 深受日本導演黑澤明的影響，第一部星戰電影即從黑澤明的《戰國英豪》(The Hidden Fortress) 中借用了許多元素。例如絕地武士 (Jedi) 其實就是日本封建時期武士的概念。裝扮上也借用了類似日本和服、充滿垂墜感的長袍設計當作 Jedi 的制服。大約於同一時期，日本的山本耀司、三宅一生、川久保玲，等設計師也開始活躍於全球時裝界。於是時裝界跟 Star Wars 系列電影之間的交互影響一直持續到今日，絲毫沒有減弱的趨勢。每一個 Star Wars 的主角代表的穿著風格，也吸引了不同族群的喜好。有人偏好賞金獵人般的武器、盔甲裝扮，有人喜歡 Jedi、Sith 那種寬鬆垂墜的服裝，也有人只求讓自己看起來跟 Han Solo 一樣屌。在看過香港插畫家 John Woo，跟義大利插畫家 Marcello Pisano 的星戰結合時裝系列作品之後，讓我也想嘗試這樣子的創作。我挑選了其中八個主要的角色，搭配上自己喜歡的八個時裝、街裝品牌：Undercover, Rick Owens, Marcelo Burlon County of Milan, NikeLab, Supreme, Comme des Garçons, Thom Browne, Carhartt Work In Progress。創作了我自己的星際大戰×時裝系列作品："Fashion Icons of the Galaxy."

Star Wars Episode IV: A New Hope - the header of the Star Wars series was released almost 40 years ago. However, to see it in a cultural and fashion perspective; many die-hard fans felt like it was days ago. George Lucas, the director of Star Wars himself proclaimed that he was heavily influenced and inspired by Japanese director Akira Kurosawa. A new hope borrowed several elements from Akira's The Hidden Fortress. For instance the Jedi represents the concept of Samurais in Feudal Japan. Jedi uniforms were inspired by the drape feel Japanese Kimonos. Meanwhile, Japanese designers such as Yohji Yamamoto, Issey Miyake, Rei Kawakubo roam the stages of international fashion industry. The chemistry effect between Star Wars series and fashion industry sustained until nowadays, showing no signs of weakening. Every wearing style each main character represents attracted the likes of different groups of fans. Some prefer the bounty hunter style armors, some prefer the drape feel robes that Jedi and Sith wears, some just wants to look as badass as Han Solo. After seeing several fashion illustration that merges fashion and Star Wars by Hong Kong illustrator John Woo and Italian illustrator Marcello Pisano, I was deeply inspired and wanted to create my own. I chose 8 main characters and matched them with 8 other fashion, street-wear brand outfits: Undercover, Rick Owens, Marcelo Burlon County of Milan, NikeLab, Supreme, Comme des Garcons, Thom Browne, Carhart, Work In Progress. Hence the birth of my Star Wars x fashion project: "Fashion Icons of the Galaxy"

Star Wars: The Path to the Dark Side *2015 P.276*

星際大戰的黑武士改裝了他的頭盔，變成了塗鴉藝術家使用的防毒面具。雙手拿著裝著「邪惡」的噴漆灌，噴出了走向黑暗面的四大元素「懼怕、憤怒、憎恨、受苦」。

Darth Vader from the classic sci-fi movie "Star Wars", remodeled his helmet into gas mask. With both hands holding spray cans which contain with "EVIL". He sprayed the evil paint out, painted "The Path to the Dark Side" into a graffiti art.

Star Wars: Skater Boy Trooper *2015 P.277*

如果我是星際大戰的風暴兵，在不用服務帝國的時候我會做什麼？我想我一定是一個滑板小子，我會把頭盔改裝成溜滑板的安全帽，上面貼滿我喜歡的品牌貼紙。並且護目鏡有 3D 功能，這樣看電影也不用拿下頭盔，多神秘阿。

What will I do in my time off serving the Empire if I'm a Stormtrooper? I definitely will be a Skater Boy. Remodel my Stormtrooper helmet into a skateboarding safe helmet, with all my favorite brands stickers on it. With the built-in 3D goggles, you don't even need to take off the helmet while you're watching Star Wars: The Force Awakens movies in 3D. Fascinating!

STUCK IN THE FUTURE *2015 P.277*

「我擔心總有一天技術將超越我們的人際互動；那麼，這個世界將出現一個充滿傻瓜的世代。」
"I fear the day that technology will surpass our human interaction. The world will have a generation of idiots."

Hang Time V *2015 P.277*

「我能接受失敗，不可能有人樣樣都成功。但是我不能接受的是不去嘗試。」麥可‧喬丹。此作向永遠的籃球之神 - 麥可‧喬丹，致敬。
"I can accept failure, everyone fails at something. But i can't accept not trying." - Michael Jordan. This is a tribute to the GOAT: Michael Jordan.

Lebron Zombie James *2015 P.277*

殭屍化 NBA 球星。
Lebron James. Lebron James zombified.

馬來西亞 Malaysia

Bel Koo，平面設計師和攝影師，來自馬來西亞怡保，畢業於 PIA 藝術學院設計系。在 2007 成為了自由工作者，活躍於網頁、平面設計。目前專注於品牌設計，婚禮及人像攝影，最愛婚禮請柬設計，因每場婚禮和新人都有著各別的故事與感動。

I'm Bel Koo, a Malaysia based Graphic Designer with more than nine years of experience. I graduated from PIA Institute of Art. I specialize in Brand Identity / Logo Design, Wedding Stationery, Web Design & Photography. I love wedding stationery design the most because it is meaningful.

Bel Koo

www.dream-design.net

Q. 請問您認為該國最棒的是什麼 ?(如國家的特色或文化等) 您的創作是否受其影響？

A. 馬來西亞是一個多民族、多元文化的國家。其多元種族、文化的特徵，正顯示出馬來西亞的魅力所在，設計與創作上也擦出更多的火花與靈感。

Q. 請問您如何獲得靈感？

A. 瀏覽世界各地設計師的作品與網站。缺乏靈感時來杯咖啡，休息下，或許會有意想不到的設計概念和靈感。

Q. 請和我們分享您喜歡的書籍、音樂、電影或場所。

A. 攝影書籍，它是可以訴說故事的書。

Q. 現在，回頭來看這些帶著遺珠之憾的作品，您有什麼新的感觸？

A. 對於未被選用的作品，我沒有遺憾反而會把這錯誤改正，反省和做更好的設計。

Q.除了當設計師 / 插畫家，你是否已經開始規劃下一階段的目標？例如策展、學習煮菜、登山

A. 攝影師，成為更好的攝影者，保存當下:)

Q.What do you like best in your country? (such as country feature or culture)Has it made a difference on your creation?

A. I like Malaysia because it is a multicultural country where we live in harmony. The colorful culture here inspired me to do variety of design.

Q.How do you draw inspiration?

A. Inspirations from other respected designers around the world always keeps me fueled to have more out of the box design for my work.

And research, stay creative. Don't take all day to brainstorm, get off that computer! Sometimes it's best to just have a break and have a cup of coffee to get new idea and inspiration.

Q.Share good books, music, movies or places with us.

A. Photography or documentary book, it's a storytelling book.

Q.Now, look back to these works of regret for not been selected, how do you feel that?

A. I have no regret instead I keep on working on a better design.

Q.Have you started to set up new goals for next period except being a designer or illustrator ? like curating, learning cooking , climbing......

A. Photography. Being a better photographer to preserve the moment. :)

月圓花好 Have A Date　2013　*P.160*
Logo 就表現了其本身，用花的元素圍繞其名。
月圓花好 , the logo name represent itself. The logo plays around with floral elements and circling the name 月圓花好 .

SeeSaw Optometrist　2014　*P.160*
SeeSaw Optometrist 是有著專業資格提供全面眼睛保健。
SeeSaw Optometrist Logo 設計概念是來之於 " 眼睛 "。眼睛是如何 " 看見 " 物體？SeeSaw 融合了字母 A, 用眼睛與光線接觸的線條來表現 SeeSaw。
Logo design for SeeSaw Optometrist. SeeSaw Optometrists who are professional and qualified to provide comprehensive eye care. The main identity of the brand and hidden meaning is a eye diagram - 'How the human eyes sees / how light travels into eye' and letter A to complete a logo and represents the brand SEE and SAW.

Sofia Lee Fine Jewellery　2015　*P.161*
為珠寶設計師的品牌設計。Sofia Lee 從事珠寶首飾設計和高級訂製服務。
Logo 概念來自於鑽石。鑽石是珠寶首飾的一個重要角色之一。Logo 設計使用了鑽石切割線條和字母 S 組合成並代表 SOFIA LEE 的品牌。選用了金色, 代表豪華、時尚、女人味。
Branding design for a jewellery designer. Sofia Lee Fine Jewellery is specializes in fine jewellery design and custom making services. Sofia Lee brand identity is inspired by diamond shapes in diagram. Connecting diamond shapes and letter S represents the brand - luxury, modern and feminine. The gold texture and color is used to symbolise the premium feel.

ZOX　2014　*P.161*
ZOX 股份有限公司，主要從事木材、木材貿易發展。ZOX 要求標誌設計上可以融合老虎的圖標。標誌上也加入了木與線條的元素組合成一個新的標誌來代表 ZOX。
Zox - it's a holding company mainly doing timber, wood trading, and development. Zox would like to include a Tiger symbol into the logo. The logo plays around with tiger symbol, and the combination of wood texture to bring out a contemporary and timeless logo.

雙喜請柬　2014　*P.236*
婚禮主題是復古及傳統華人婚禮，請柬設計當然少不了這兩個元素，也加入了一對愛情鳥代表著新娘與新郎的愛和浪漫。
Save the Date card for a lovely couple in Malaysia. The theme is about love, vintage and chinese traditional wedding. Love birds meaning of two people are very much in love with each other.

中國 China

中國設計師，1991 年出生於甘肅蘭州，現居香港。出於興趣自己學習設計並且以此為業 3 年，熱衷於品牌設計及印刷設計。2015 年遷至香港生活。

Bian, Hong Kong based graphic designer who was born in Lanzhou in 1991. Self-taught and has been working as graphic designer for 3 years. Keen on branding and printing design. Graduated from Nanchang Institute of Technology with a bachelors degree in advertising in 2015. Moved to Hong Kong at the same year via ASMTP.

邊雲翔 Bian Yun-Xiang

www.behance.net/yumsh

Q. 請問您如何獲得靈感？
A. 多數時候我會瀏覽 Behance，看看別人都在做什麼樣的創作。日常也會發現很多很棒的生活細節，會啟發我很多。

Q. 請和我們分享您喜歡的書籍、音樂、電影或場所。
A. 書籍：《金閣寺》- 三島由紀夫。
音樂：Balmorhea (Post rock) Buena vista social club (World music) Nova heart(Electro)。
場所：家鄉甘肅的荒原。

Q. 除了當設計師／插畫家，你是否已經開始規劃下一階段的目標？例如策展、學習煮菜、登山 ……
A. 希望可以去更多不同的城市生活，充實自己的人生。有機會的話希望可以做一些極簡的電子音樂。

Q. 你對生活的細節上有什麼堅持嗎？(像是上廁所時一定要看詩集之類的)
A. 永遠都只穿白 T-shirt，就不用再考慮穿什麼。

Q.*How do you draw inspiration?*
A. Normally I'd like to explore Behance to see what others are doing. And I would see daily life also inspires me a lot,there are loads of amazing details.

Q.*Share good books, music, movies or places with us.*
A. Book:<The Temple of the Golden Pavilion>Yukio Mishima.
Music:Balmorhea (Post rock) Buena vista social club (World music) Nova heart(Electro).
Place:Wasteland in my hometown Gansu.

Q.*Have you started to set up new goals for next period except being a designer or Illustrator ? like curating, learning cooking , climbing......*
A. I really wish to experience different life in more different cities.And probably start creating some minimal music.

Q.*What is your insist on your life's details ? like toilet with your favorite poem?*
A. Always in white T-shirt, so that not need to bother about what to wear.

《山頭村，人家》唱片設計　2015　P.48
這是 2015 年和朋友合作的民謠音樂項目，作為獨立發行的唱片，成本控制非常低，每張只有 2 元。我參考了童年時摺紙遊戲的結構，使用螢光色單頁雙面印刷有效的控制了成本並且盡可能的保證包裝美觀。
This is a CD jacket for folk music. As an indie project, the budget is only 2 CNY for each. Then I recalled a childish game with folded paper. I regarded the conformation as reference to do the package and print with pastel color.

Package of Skullcandy and Thething　2014　P.48
這是我在 2014 年接到的一個品牌合作項目，為兩家品牌的聯名產品設計包裝，其中有一副耳機和一件 T-shirt。通過與產品呼應的黑白幾何圖案以及可以雙面開啟的特殊結構盒子結合完成了這次設計。但最終因為製作工藝過於繁瑣僅僅保留了平面部分放棄了特殊結構。
It's a cobranding project between Thething and Skullcandy in 2014. I was supposed to crate a special package for T-shirt and earphone. In order to match the black and white color with goods, I crate this geometrical pattern. For the construction, I craft a double side box for each product.

Key visual of Throw a stone to clean the road　2014　P.64
匆忙中為朋友的策劃的版畫展覽的視覺設計，展覽的主題叫做投石問路。使用軟件將石頭的照片處理成抽象的無機形狀，用線條和矩形與之形成結構與顏色的對比。再加上傳統的老報宋排版。在一下午為這場以傳統藝術形式進行前衛化的實驗性展覽完成了視覺設計。
Throw a stone to clear the road is a Chinese idiom, I did this key visual for a groping exhibition of etchings. Since I got the brief very late, everything was finished in an afternoon. I found picture of stone online and did the abstract effect in photoshop to make the contrast between geometric figure and inorganic shapes. The chosen font once was used for newspaper in 1960s' China. We can also find it on old signs. In order to built the relation between old Chinese etching art with modern art, I referenced the traditional typeface to contrast the abstract graphic.

家鄉 T-shirt　2013　P.259
一直以來獨自生活在大城市，慢慢就有了鄉愁。所以我做了這一系列的 T-Shirt 設計。當中有家鄉的特色牛肉麵，童年念的方言童謠，具有特色的中年婦女打扮以及兒童中心的滑滑梯。我希望以這套設計為我和我兒時的伙伴記錄下來，我們這一代人在那個小城市所經歷的童年。
I did this series in 2013. Since I have been living out of my hometown for several years. I was homesick at that moment. All the illustrates come from the memory of what our generation has went through in my city. This small town is famous of stretched noodles as daily breakfast. It is also a city out of vogue, people with outdated clothes walking on street. In the downtown, we have a children's palace where kids play slide. Dialect is also part of the city, we start learning it with nursery rhymes from grandma.

香港 Hong Kong

Brand Craft HK

www.brandcraft.hk

Brand Craftg 是香港具有創意的設計實業，專業是替各種行業的公司打造獨一無二的品牌識別，擁有流程領導的設計實踐，重視研究和理解，成為敘事構成與進化的方法。

Brand Craftg 由來自英國的 Adam Charlton 帶領，他在 2012 年畢業於倫敦金匠學院批判實踐設計研究所，Adam 是紐約藝術指導協會和 D&AD 的成員，2014 年他入圍 Design Week 的新星獎，2015 年被任命為摩根大通的品牌顧問。

Brand Craft is a creative design practice working globally from Hong Kong. We specialise in crafting unique brand identities for companies in all sectors. We have a process-led design practice, valuing research and understanding as a way of narrative ideation and evolution.

Brand Craft is directed by Adam Charlton. Originally from the UK, Adam graduated with a Masters Degree in Design and Critical Practice from Goldsmiths University of London in 2012. Adam is a member of the New York Art Directors Club and D&AD. In 2014 Adam was shortlisted for Design Week's Rising Star Award and in 2015 was appointed as a Global Brand Consultant for JP Morgan.

Q. 請問您認為該國最棒的是什麼？(如國家的特色或文化等) 您的創作是否受其影響？

A. 我是一個來自英國的設計師，在香港著陸的時候，完全地被香港的文化遺產征服。我們嘗試在作品裡去捕捉香港當代的背景，我們希望保持謙虛，並且透過創作增加品牌的景觀。

Q. 請問您如何獲得靈感？

A. 我們試圖在自己的生活中尋找靈感，我們不會在自己擅長的領域去仔細窺探，而是盡量從自己的興趣還有走在香港的小巷，去尋找靈感。我們喜歡旅行，體驗新的文化，和耀眼的人們相遇，擴展自己的視野。

Q. 請和我們分享您喜歡的書籍、音樂、電影或場所。

A. 作家保羅·奧斯特、建築師弗蘭克·蓋裡、伍迪·艾倫和韋斯·安德森的電影，人物 / 神話，比爾·莫瑞。

Q. 現在，回頭來看這些帶著遺珠之憾的作品，您有什麼新的感觸？

A. 來得容易，去也快。你不能贏得所有事情，保持謙虛是很重要的。

Q. 除了當設計師 / 插畫家，你是否已經開始規劃下一階段的目標？例如策展、學習煮菜、登山......

A. 我想在攝影方面變得更好，然後盡量減少懶散。

Q. 你對生活的細節上有什麼堅持嗎？(像是上廁所時一定要看詩集之類的)

A. 獎項對我來說是沒有意義的，我不欣賞那些汲汲營營於得獎的人。

Q.What do you like best in your country? (such as country feature or culture)Has it made a difference on your creation?

A. I am a designer from the UK, when landing in Hong Kong the cultural heritage is totally overwhelming. We try to capture the context of contemporary Hong Kong in our work, we hope to be humble and produce work that adds to the brand landscape.

Q.How do you draw inspiration?

A. We try to find inspiration in our day-to-day lives. We do not look too closely at peers in our fields, we try to be open to inspiration from our hobbies, and walking Hong Kong's alleyways. We like to travel, and to open our eyes through experiencing new cultures and meeting brilliant people.

Q.Share good books, music, movies or places with us.

A. The author Paul Auster, the architect Frank Gehry, the movies of Woody Allen and Wes Anderson, the man/ myth Bill Murray.

Q.Now, look back to these works of regret for not been selected, how do you feel that?

A. Easy come, easy go, you can't win everything. It is important to stay humble.

Q.Have you started to set up new goals for next period except being a designer or illustrator ? like curating, learning cooking , climbing......

A. I would like to get better at photography, and to be generally less lazy!

Q.What is your insist on your life's details ? like toilet with your favorite poem?

A. Awards are meaningless to me, and I have nothing but disdain for anyone who actively campaigns to get one.

香港公平貿易聯盟 Fair Trade Hong Kong　2015　P.174

公平貿易聯盟想要更新他們的外貌，將一切大或換新，並且變得更貼近香港最近的社會趨勢。在動態品牌參與的時代，公平貿易聯盟需要和環境與社會領域維持連繫。首先，我們解構組織，找到真正的核心價值，然後使用視覺的隱喻去表達香港公平貿易聯盟的核心價值。接下來以竹籃的編織與傳統的中式重複圖形為標誌基礎，讓標誌達到視覺上的平衡。創造與香港有文化關聯，而非只是與公平貿易聯盟有關的標誌，這是很重要的一點。

Fair Trade wanted to update their appearance, to generally freshen-up and become more relevant to Hong Kong's current social climate. In the age of dynamic brand engagement, Fair Trade needs to stay relevant within both environmental and social spheres. We first worked with Fair Trade Hong Kong to deconstruct the organisation into its true core values. We then used visual metaphors to express the core values of Fair Trade Hong Kong. These forms were progressed into a visually balanced logo based on the weave for a bamboo basket and a traditional Chinese repeating pattern. It was important to craft an identity that is culturally contextual to Hong Kong, and not simply just relevant for the Fair Trade family organisation.

Gum Gum　2015　P.175

Gum Gum 是一間在地的家鄉菜餐廳，他們希望我們製作的識別，可以隨著公司成長可以輕鬆地執行在所有設計中進行。我們做了一個圓形的標誌，可以蓋在名片或預約卡之類的紙上面，加蓋標誌的質感給人家鄉菜餐飲親切和在地化的印象，隨著 Gum Gum 成長，他們也可以把識別推廣到餐飲器皿、圍裙和社交媒體上。

Gum Gum is a boutique and local home-dining experience. We were asked to create an identity that could easily be executed across all manner of design collateral as the company grows. We created a circular logo which can be stamped across paper including contact and reservation cards. The textured feel of the stamped logo illustrates the intimate and local-position of the home-dining event. As Gum Gum grows they will push the identity across dining ware, aprons and into social media.

Jana Reinhardt　2015　P.175

Jana Reinhardt Jewellery 是一對夫妻經營的團隊，位於英國的薩塞克斯。他們創造了當代珠寶系列以及訂製的單品。我們更新了它們的識別，用個性化簽名的 Logo 做為小型的視覺辨識。

Jana Reinhardt Jewellery is a wife & husband team, based in Sussex in the UK who create contemporary jewellery collections and bespoke pieces. We updated their identity with a personal, signature styled logotype as a minimal visual identifier.

RiPrism　2014　P.176

RiPrism 是韓日的美甲藝術配件品牌，專業是在個別企業的主題裡，製作各種色調和質感的亮粉。品牌標誌使用稜鏡解構後的形狀，這個形狀同時是正形與負形的方塊與金字塔，框架的空間創造出一個允許透過色彩

與形狀不斷產生改變的品牌識別。在珠光紙上燙金的創意參考了亮粉產品系列，包裝則體現了高檔的品牌定位，使用簡潔線條的稜形來展示產品。

RiPrism is a luxury Korean and Japanese nail art and accessory brand specialising in producing glitter in a vast range of tints, hues and textures within individually curated themes. The brand identity uses the shape of a prism sculpture deconstructed into outlines. The shape plays with both the positive and negative shapes of a cube and pyramid. This creates a framed space which allows the identity of the brand to infinitely change through colours and shapes of the glitters held within. The hot stamp gold foil on pearl paper used throughout the branding acts as contemporary reference to the glitter product range. The packaging reflects the high-end brand positioning and uses angular shapes with clean lines to showcase the products.

Martell Hunter Interiors　2014　P.177

Martell Hunter Interiors 是位於蘇塞克斯小鎮中心一間由家族經營的精品家具店，販賣來自南非的高檔真品沙發，MHI 提供傳統的服務，是當地引以為傲的店家。這個在西薩塞克斯經營事業的家族，希望透過雄鹿和老式英文字母的形式，反映自己的識別。客戶希望能表現出它們的傳統服務與產品能夠轉化成現代的語彙與家庭。我們在豐富的印刷品上，利用反覆的金箔圖樣以及浮凸的商標，將這種傳統與現代的轉化巧妙地彰顯出來。

Martell Hunter Interiors is a family run furniture boutique located in the heart of small Sussex town. Specialising in supplying high-end leather sofas from South Africa, MHI offer a traditional service and pride themselves on their local reputation.The West Sussex based family run business is reflected in the identity through the stag and established old English letter forms. The client wished to show how their traditional service and products can translate into modern contexts and households. This translation is subtly highlighted in the use of the repeated gold foil pattern and embossed logo throughout the rich printed collateral.

Yun Ya　2015　P.177

Yun Ya 是英國的中式男女通用的沐浴產品。客戶想要一個以品牌為中心的 Logo，因此，我們設計了這個識別，以捕捉其跨文化的歷史與景象。以中國書法與日本藝術家篠田桃紅的水墨畫作為識別的靈感來源，Logo 用兩個抽象的筆劃構成代表 Yun Ya 的 Y，為了製作 Logo，我們花了很多時間研究中國書法還有練習筆劃。

Yun Ya is a Chinese-inspired unisex body-wash positioned in the UK. The client wanted an authentic logo at the heart of the brand thus we set about designing an identity that would capture it's cross-cultural history and framing. The identity was inspired by Chinese calligraphy and the Japanese artist Toko Shinoda's sumi ink paintings. The logo is formed of two abstract strokes to represent the 'y' of Yun Ya. To execute the logo we spent a great deal of time both researching Chinese calligraphy and practicing with brushstrokes.

中國 China

蔡鵬，藝術指導／平面設計師。畢業於北京工業大學藝術設計學院，視覺傳達設計系。2013年，創建 lab.Choi-system 工作室任創意總監。主要在圖形和字體領域設計研究。美國平面設計師協會（AIGA）會員，深圳平面設計協會（SGDA）會員。

CaiPeng is a Beijing based Designer, Typographer, and Creative Director. In 2006 he graduated from Beijing University of Technology Institute of Art and Design, major in visual communication design. His work has been recognized by The Tokyo TDC, The BJDW, AIGA, Hiii Typography, UK Guardian, Victionary, Hightone, Gallery Magazine, and idNTM Magazine. In 2013 he established his own lab. Choi-system Studio. He is currently focused on the design and research of graphics and fonts.

蔡鵬 Cai Peng

choi-system.com

Q. 請問您如何獲得靈感？
A. 日常，音樂，藝術。

Q. 請和我們分享您喜歡的書籍、音樂、電影或場所。
A. 雜誌：《IDEA》《＋81》《Novum》。
音樂人：青木孝允（AOKI takamasa），辻子法子（Tujiko Noriko）。

Q. 現在，回頭來看這些帶著遺珠之憾的作品，您有什麼新的感觸？
A. 引薦我贊同的觀點，"並非只能在有委託時才設計，我們也可以主動去做一些研究來呈現我們的想法，這些研究可能是對目前某個事件的思考，也可能是對未來的思考"。—— 伊麗莎白·科福（Elisabeth Kopf）

Q. 除了當設計師／插畫家，你是否已經開始規劃下一階段的目標？例如策展、學習煮菜、登山
A. 旅行。

Q. 你對生活的細節上有什麼堅持嗎？(像是上廁所時一定要看詩集之類的)
A. 茶，早餐，紙製品。

Q.How do you draw inspiration?
A. My daily life, music and art.

Q.Share good books, music, movies or places with us.
A. Magazines: "idea アイデア","+81","novum".
Musicians: AOKI takamasa, Tujiko Noriko.

Q.Now, look back to these works of regret for not been selected, how do you feel that?
A. I would quote the point of view I agree by Elisabeth Kopf: "Do not design only when we having a commissioned, we can also take the initiative to do some research to present our ideas, these studies could be a thinking of current things, and could be the thinking about the future."

Q.Have you started to set up new goals for next period except being a designer or illustrator ? like curating, learning cooking , climbing......
A. Traveling.

Q.What is your insist on your life's details ? like toilet with your favorite poem?
A. Tea, breakfast, paper products.

信號 Signal 2015 P.117
對於日常生活中視頻信號中斷或故障顯示的設計。希望更多這樣的設計應用可以緩解處於等待過程中不安和感覺乏味的人群。
For video signal interruption or failure in everyday life. Want more of these design applications can ease in a nervous and feel boring in the process of waiting for the crowd.

RE-DESIGN 2013 P.117
我嘗試將不同時期蒐集的印章在紙上多次拓印，重新排列疊加後獲得新的字體（TYPOGRAPHY），使本身俱有意義的圖形物件轉化成新的視覺語言，同時強調字體、版式、印刷的可能及手工製作的重要性。
I try to different period to collect the signet on the paper several times, rearrange the stack after new font (TYPOGRAPHY), to make itself has the meaning of graphic objects into a new visual language, may also stressed the font, layout, printing and the importance of handmade.

In the Winter 2010 P.117
尚都SOHO商城，即將開業海報。以動物元素之企鵝排隊組成商城開業主題字體，寓意冬日歡樂氛圍。
Poster is SOHO mall, is getting ready for the opening. With animal element composition of penguins queuing mall opened theme fonts, means the winter joy atmosphere.

迪趣動漫線上標誌徵集海報 DIQU Animation - logo collection online 2010 P.119
這是關於迪趣動漫公司線上標誌徵集活動的海報。我以迪趣二字的首寫字母為創作元素，進行不同的字體和平面構成嘗試，預示參與徵集活動和徵集結果的多樣性以及創意價值。
It's about DIQU cartoon company online search campaign posters. I did boring with letter of the word as creative elements, try to different fonts and plane composition, predict to participate in the activities of collecting and collect the results of the value of diversity and creativity.

常態 Natural State of Mind 2013 P.119
海報的設計是取自中國古代佛學中的一句經典詩句："無窮般若心自在，語默動靜體自然"。意思是：大的智慧是在自然的態度中所產生的。所以我想通過自由類似律動的圖形，製造出不易識別的字體設計方式，以嘗試並挑戰圖形與字體之間的視覺關係。讓人們通過一種自然的心態來看待身邊的一切事物。
Poster design is taken from a classical poem in Chinese ancient Buddhism: "infinite prajnaparamita heart at ease, language's action body nature". Means: big wisdom is produced in the natural attitude. So I think similar to free rhythm of graphics, making way is not easy to identify the font design, in order to try and challenge the visual relationship between graphics and fonts. Through a natural state of mind to look at everything around you.

四色 For Color 2011 P.119
我通過以"四色印刷"的原理，使每一個字母的不同朝向面全部由C、M、Y、K四種色彩構成，以表達印刷過程中色彩的調配、疊加。然後又在字體基礎上進行解構，拆分形成每個獨立的單元，體現著字體與版式設計的相互依存關聯性。巧合的是Four-Color 與 For Color 的英文發音相同，並且C、M、Y、K四種色彩是印刷技術中色彩的本源，即 For Color。
I made the surfaces of each letter constitute by C, M, Y and K four colors in the principle of Four-color Printing to express the mix and blending of colors during the process of printing. Then unique cells are split on the basis of letterform to express the relationship between the design of letterform and format. Coincidentally the English pronunciation of Four-Color is similar with For Color, and the Four-Color C, M, Y and K are the foundation of all colors in the printing technique. That is why it is called For Color.

奇幻之旅 Wonder Trip 2011 P.120
我希望用隱匿的字體與明亮的色彩製造反差，通過對英文字體的解構拆分而得到中文"奇幻之旅"四個漢字。當受眾被色彩吸引後，便開始形成對字體圖形探索的慾望，從而控制視覺流程。這樣的過程就是視覺與思維的"奇幻之旅"。
The connotative letterform is in shape contrast to the bright color. After deconstruction and split to the English letterform, the Chinese characters which mean WONDER TRIP will appear. In this way, people get interested in the exploration to the letterform after attracted by the color. Meanwhile, they enter into the vision flow of my design. That course is a WONDER TRIP of both vision and emotion.

CYMP Identity 2013 P.254
CYMP 形象系統設計，正面通過以平面構築的方式建立視覺形象，背面解構信息作為整體的依存，並製造出視覺邏輯遊戲，使其探索過程在整體形象構築中產生趣味性。
CYMP Identity system design, the front through visual image plane construction way, dependent, on the back of the deconstruction of information as a whole and produce visual logic game, the exploration process to generate interest in the whole image building.

新加坡 Singapore

曾偉中是一名新加坡的創意人。喜歡嘗試用不同的藝術和設計創作，如：街頭裝置藝術、字體、產品和平面設計......等。

Chan Hwee Chong is a Singaporean creative who loves experimenting with different fields of art and design to create street installations, typography, product and graphic design.

曾偉中　Chan Hwee-Chong

www.cargocollective.com/HappilyWrong

Q. 請問您認為該國最棒的是什麼？(如國家的特色或文化等) 您的創作是否受其影響？

A. 新加坡被稱為是一個 "fine" 城市。大量的限制和嚴格的法律，在一定程度上，它限制了創造力。然而，它迫使創意創新。就像我的一個街頭藝術，The Doors Project，當我不能用塗鴉或貼紙，我用了一個 OHP 投影機把不同門的影像投影在不同的牆上。

Q. 請問您如何獲得靈感？

A. 我喜歡散步，看著人們。很多的想法是我邊走邊看陌生人的時候來的。

Q. 除了當設計師 / 插畫家，你是否已經開始規劃下一階段的目標？例如策展、學習煮菜、登山......

A. 我剛開始兼職教學，也許未來我可以全職教學。

Q. 你對生活的細節上有什麼堅持嗎？(像是上廁所時一定要看詩集之類的)

A. 我不認為有一個。在中國我每天都嚼口香糖，當回到新加坡我停止了，因為是違法的。

Q.**What do you like best in your country? (such as country feature or culture)Has it made a difference on your creation?**

A. Singapore is known for being a "fine" city. With lots of restrictions and tough law, it does limit creativity to a certain extend. However, it forces creatives to innovate. Like for one of my street art, The Door Project, instead of painting or using stickers, I used a OHP to project doors on walls around the city.

Q.*How do you draw inspiration?*

A. I love walking and looking at people. A lot of the ideas came while I was walking and watching strangers.

Q.**Have you started to set up new goals for next period except being a designer or illustrator ? like curating, learning cooking , climbing......**

A. I have started teaching and maybe I can teach more in the future.

Q.**What is your insist on your life's details ? like toilet with your favorite poem?**

A. I don't think there's one. I was chewing gum everyday in China but not anymore when I got back to Singapore as it's ban.

THE LIGHTSTIX GRAFFITI *2015* *P.71*
一個利用螢光棒的新塗鴉方式。
A new form of graffiti, using glow sticks.

ONE LINE ART *2012* *P.94*
平面海報展示 Faber Castell 筆的絕密精度和控制。
We could go on and on about the Faber Castell Artist Pen's precision and control,but we thought we'd just show you.

BUCHABET *2012* *P.159*
德國漢堡書店 cohen+dobernick 的品牌設計。"Buchabet" 是一個使用書形成的字母。
Corporate identity for cohen+dobernick bookstore in Hamburg. "Buchabet"- an alphabet made of books, each letter was created with real books.

PIXEL PORN *2014* *P.240*
馬賽克是日本色情電影不可分離的一部分。但它也能幫助我們在這情色氾濫的社會裡留住一份純真。
Pixels are a synonymous part of Japanese pornography. That fine line which helps preserve a little innocence and order in the world of debauchery.

中國 China

小文，首飾設計師，畢業於巴黎 Ecole BJOP 珠寶學院，與畢業於廣州美術學院平面設計師張碩共同創立設計師品牌東長。

Wen , after graduated from Ecole BJOP in Paris . She started Dongchang Jewelry Atelier with shuo Chang,who is a graphic designer , studied visual communication in Guangzhou Academy of Fine Arts.

張碩、小文　Chang Shuo & Wen

www.dongchang.co

Q. 請問您認為該國最棒的是什麼 ?(如國家的特色或文化等) 您的創作是否受其影響？

A. 該國家擁有深遠的歷史和斷層的近代, 所以當代的創作人在創作形式上沒有任何歷史負擔和形式束縛。

Q. 請和我們分享您喜歡的書籍、音樂、電影或場所。

A. 低俗小說、刺客聶隱娘, 西洋美術史等。

Q. 現在, 回頭來看這些帶著遺珠之憾的作品, 您有什麼新的感觸？

A. 多元文化的接收需要滿足不同的人群, 信息同質化使得我們身邊沒有精彩。

Q. 除了當設計師 / 插畫家, 你是否已經開始規劃下一階段的目標？例如策展、學習煮菜、登山……

A. 我們的工作室已經開始進行對專業學術的研究階段, 或者說我們的研究沒有停下過, 我們馬上要推出我們的一個新作品, 是記錄人類 25000 年歷史的諸多首飾信息圖, 這項研究可以讓我們清晰看到人類的珠寶歷史發展的軌跡。

Q. 你對生活的細節上有什麼堅持嗎 ?(像是上廁所時一定要看詩集之類的)

A. 我們希望家裡的每件東西都是自己設計並製作的。

Q.What do you like best in your country? (such as country feature or culture)Has it made a difference on your creation?

A. This country have a profound history and modern faults, so contemporary ceators do not have any historical burden and the shackles with creating form.

Q.Share good books, music, movies or places with us.

A. Pulp Fiction, The Assassin, Western art history.

Q.Now, look back to these works of regret for not been selected, how do you feel that?

A. The multicultural culture receiving needs to satisfy different people, so that homogenization of information around us would not exciting us.

Q.Have you started to set up new goals for next period except being a designer or illustrator ? like curating, learning cooking , climbing......

A. Our studios have begun to start a research stage of academic, our studies never stop yet, now we are going to release our new works, it is about the infographic of ornaments which recording 25000 years of human history, this study can make we clearly see the trajectory of human development in the history of jewelry.

Q.What is your insist on your life's details ? like toilet with your favorite poem?

A. We hope that everything in the house are designed and produced by us.

東長畫冊　2011-2015　P.13

記錄東長 2011 年到 2015 年的創作過程和生活狀態的記錄, 全書大部分是右邊是小文相關的圖片, 另一邊是張碩相關的圖片。

Record Dongchang about how we creative and living style form 2011 to 2015. All images about Wen on right side, another side are Shuo.

東長包裝　2011-2015　P.49

形式美感 - 東方的包裹 The Oriental Package／Parcel

設計靈感來源於東方包裹文化。不僅在折合動作上沿襲了包裹折疊的行為, 在本質上也延續了東方收納的思考。包裹文化的核心正是用材料本身的特性去完成收納的目的, 在盡可能不使用其他構件的前提下, 一塊布、一片紙等材料, 靠其結構本身完成收納。

結構創新 - 卡榫的結構 The Structure of joint

為了實現單一材料靠其結構實現收納, 我們在結構上也進行了大膽的創新。單純的紙質材料, 以卡榫形式連接組合。在概念上與東方的包裹文化有異曲同工之妙。

The inspiration comes from the culture of oriental parcel. We have inherited the act of package folding, and continued the thinking of oriental parcel culture. The essence of oriental parcel culture is to obtain the purpose of packaging by utilising the features of the material.
We have made a bold creation on the structure to obtain the purpose of packaging by utilising the structure of material itself. It is jointed with mortise and tenon by only using the paper material, thus any jewelries can be settled by one single structure.

東長 LOGO　2011-2015　P.157

東長得名來源於兩位品牌發起人的姓氏 " 張 " 與 " 陳 " 漢字的一半, 而標誌設計沿襲了這個概念, 用繁體漢字 " 東 " 字與 " 長 " 字組合而成。

"Dongchang"the name comes from the right part of the first name of the two founder " 陳 "and" 張 "," 東 "and" 長 ".

台灣 Taiwan

陳憶菁　Chen Le

www.behance.net/chenle

1991 年生於新北市瑞芳，目前就讀輔仁大學應用美術研究所，同時也是自由接案設計師，工作範疇包含編排、印刷等平面設計事務，2015 作品入選第十一屆亞太設計年鑑、2015 田園城市參展者、2012 金蝶獎新世代書封競賽創意獎、2014-2015 年天主教輔仁大學附設醫院 CI 小組成員。2015 年分別在賴佳韋設計實習與海流設計擔任助理。

Born in Rui Fang, New Taipei City, Taiwan in 1991. Now studying in the Department of Applied Arts at Fu Jen Catholic University. I also work on piecework basis, the scope of work includes layout, printing and other graphic design services.2015 the Asia- Pacific Design No.11 Honorable Mention, 2012 the Golden Butterfly Award—New Generation Book Cover Design Competition Creative Award. 2014-2015 Member of the Corporate Identity (CI) of Fu Jen Catholic University Hospital.2015 the Exhibitor of Zine Zine Fair 2015. 2015 Intern of David Lai Design and Assistant of Flowing Design.

Q. 請問您如何獲得靈感？

A. 靈感來源主要是缺乏靈感才會誕生，這個時候我會開始做去自己喜歡的事，例如：睡覺、看電影或書、聽音樂或者選擇走出戶外感受生活，放鬆心情多看多閱讀，這樣可以讓我重新歸零省思後，以愉悅的情緒面對並且提升思考的動力。

Q. 請和我們分享您喜歡的書籍、音樂、電影或場所。

A. 近期特別喜歡閱讀散文與圖像類的書籍(不在＿＿＿博物館)，因為文字的用法多樣化，我很喜歡細細去咀嚼體悟文字，加上圖像更可以說出背後所傳達的涵意。

我在做任何事情都會需要有音樂的作伴，喜歡的音樂範圍很廣泛，最近很喜歡落日飛車、輕晨電，他們有療癒放鬆的感覺，跟隨著音樂的節奏做起事來特別舒服自在。

電影則會推薦王家衛導演的重慶森林，講述都市中陌生人之間的愛情關係與觀念，沒有太多的劇情比較屬於個人的獨白，尤其是在後段的部分感情是非常強烈，這是一部需要花時間細細品嚐的電影，有太多太多的細節值得探討，不過前半段十分枯燥，因此建議有一定耐力與思考能力的人觀賞。

Q. 除了當設計師／插畫家，你是否已經開始規劃下一階段的目標？例如策展、學習煮菜、登山……

A. 在研究所裡重新檢視設計師的價值，發覺我是一個很跟隨自己感覺的設計師，一旦認定它應該執行成怎樣的面貌，就不是很能夠換位思考，比起設計師似乎更適合成為一位藝術家。另外也受到某些電影導演的影響，電影具有獨特的魅力可以將觀者帶入另一個空間，即使電影結束仍然帶有很強烈的後勁，使人深陷其中不斷的反覆思考，以前的我不喜歡思考只會做就對了，現在反而喜歡先思考後執行，引發我想從事有關電影的藝術工作。

Q. 你對生活的細節上有什麼堅持嗎？(像是上廁所時一定要看詩集之類的)

A. 從小就很不喜歡吃蔥、香菜、芹菜等香料菜，只要是食物裡有添加這些菜，必定會挑出後再吃，另外我當然也試著嘗試過接受它們，只不過一旦確立不能接受實在無法強迫自己，這也算是某種特別的堅持。

Q.How do you draw inspiration?

A. At this time I will start to do the things I like, for example: sleeping, watching movies or books, listen to music or choose to go outside to experience life. The more relax and read make me restart from the beginning, reflect on myself and face it in a pleasant mood, last, enhance the thinking.

Q.Share good books, music, movies or places with us.

A. Recently I particularly like to read prose and picture books " Absente: Musée de ＿＿＿." Because of the variety use of text, I like to carefully understanding the text. Plus, the images can convey the meaning behind the text more clearly.

I need to do everything with the company of music so the range of music I like is very wide. Recently I enjoy listen to Sunset Rollercoaster and Morning call, their music is relaxing, it is especially comfortable to do everything following the music.

As for the movie, I recommended Chungking Express directed by Wong Kar-Wai. This is a story about the love relationships between the strangers in the big city, there is not much personal monologue in the plot, especially the emotion in the final part is very strong. This is a movie you need to spend time to think about, there are too many details worth exploring. But the first part is very boring so I highly recommend a person who has patient and thinking ability to watch.

Q.Have you started to set up new goals for next period except being a designer or illustrator ? like curating, learning cooking , climbing......

A. Re-examine the value of being a designer in the Institute. I found myself is a kind of designers who follow their own feeling. Once I determine how its' appearance should be performed, I would not change my mind, this kind of designers seem more suited to be an artists. On the other hand, I was affected by some film directors, the film has their unique enchantment that could bring the viewers to another space. Even though the film end, it still has a very strong power. that drags people into the film's world and makes them constantly ponder of it. I used to do the design without thinking, but now I prefer to think before executing, this let me want to start the arts-related jobs.

Q.What is your insist on your life's details ? like toilet with your favorite poem?

A. I really hate to eat spices like green onion, parsley and celery, as long as there is food to add these spices, I will definitely pick them over before eating. Certainly, I had tried to accept them but once I established that I am unable to eat them, I realize that I can't force myself anymore. This is kind of special insistence.

洞察 2.0 GAZE 2.0　2015　P.14

一份記錄觀察與情感的刊物，觀察融入攝影聚焦生活，並任由潛意識推動、反射，直到按下快門的瞬間，激發產生意念、情感填補我生活中缺失的部分。「日常」往往被人們所忽略，收錄七位攝影師對日常的見解與詮釋，用不同的角度將常人不會發現的生活細節，以個人的觀點記錄而呈現。

A zine that documents observations and sensibilities.Observation via photography focused on living. To reflect and evolved by subconscious freely, leading to the moment of shutter released, senses sparks. Vacancies in life is then fulfilled. "Mundane" is easily dismissed by us. The print includes interpretations and sentimentalisations from seven photographers on the subject. Gazing on the subtlety of the mundane from different prospective. The documentation is delivered with Individual perceptions.

游離四度森林—多重獨白 Fourth Dimension Dreamin　2015　P.63

喧囂的都市造就了寂寞的人與浮動不安的情緒，某一段關係的結束便是新的開始，而寂寞的人即便在多變的都市裡仍保有對愛情的希望，都市人既孤寂自閉卻又渴望交流的內心獨白。王家衛導演的「重慶森林」引述出人與人之間的愛情關係，就是交會了然後結束亦或延續，其間藉由暗示而不做任何解釋，由觀者自由聯想，這是一種流動的、非水平與垂直間的多層重組模式，讓觀者進入本真的狀態。

A noisy city. Created people of loneliness and uneasiness. The end of a relationship is a new beginning. Even in this ever-changing city, lonely people. Remain hopeful about love. Metropolitans are alone and secluded. Yet they desire communication of heartfelt soliloquies. The film "Chungking Express" directed by Wong Kar-Wai. Describes romantic relationship between people. Two paths cross, it happens, and it either ends or continues. With hints but without any explanations. Letting viewers connect the dots freely. It is a flowing, multi-layered, recombinant model between vertical and horizontal lines. Allowing viewers to be in their true state.

在死後的第二夜 Post-mortem, the Second Night　2015　P.94

昨夜我又死了一次，在這不對等的關係裡，尋求一絲絲的慰藉。腦內啡冷不防、抽動、拉扯神經，直到毫無力氣，停止後沒有結束……。下一夜，又是無數個輪迴。

Last night I have died once more. Within this imbalanced relationship. Seeking for the slightest consolidation. Endorphins. Sudden. Spasm. Pulling the nerves. Until exhausted. There is no end after termination......Another night. Countless reincarnation.

最慢的人當鬼 TAG　2015　P.94

我們不斷追逐，勇往直前是向昨日告別，開啟明日的視野，全力以赴。這是一場聚合當下、未來再見的時間遊戲，你的語言、我的話術，秒數倒數揭開序幕，這次是誰當鬼。

We always chasing something. Keep going and farewell the yesterday to widen our horizon, than apply ourselves to tomorrow.

This is a game of time, gather the present and the future. your language, my phrase, the game begin with the countdown. This time, Who is the man in the middle?

台灣 Taiwan

陳品丞，平面設計師，臺中人，1991 年生。大學時期專攻平面設計，致力於字體、視覺形象、海報及印刷設計研究。作品曾於俄羅斯、德國、中國、新加坡等國公開展覽，並獲得四十餘項國內外設計競賽獎項肯定。

Ping-Chen Chen, graphic designer, was born in Taichung in 1991. College specializing in graphic design, is committed to the font, visual image, and poster printing design research. Works had Russia, Germany, China, Singapore and other countries publicly display, and access to more than forty domestic and international design competition award recognizes.

陳品丞　Chen Ping-Chen

www.behance.net/nedchen

Q. 請問您認為該國最棒的是什麼？(如國家的特色或文化等) 您的創作是否受其影響？

A. 台灣是個很棒的地方，有熱情、有活力。但我最喜歡的地方，就是台灣「很小」，和鄰近的其他國家相比，因為地域關係生活機能便利，人們彼此間幾乎沒有距離。台灣的文化可能和我的創作沒有明顯的關聯(雖然我很多創作看起來也沒什麼關聯)，但我是生活在台灣的創作者，我的觀念、思考與表現形式都一定會在無形中直接、間接地受到影響。

Q. 請問您如何獲得靈感？

A. 雖然我做設計，但我不是那種生活裡面「只有設計」的人。我也會玩遊戲、看電影、追日劇、找朋友聊些沒營養的話題。我發現有時候在我不碰設計時居然才是腦筋最活絡的時候，很多感受、想法都在那些看似浪費時間的玩樂中被激發出來，也因為「設計時間」與「非設計時間」的拉鋸、衝突，我不斷的在兩個截然不同的狀態內吸收、釋放不一樣的東西，這能讓我隨時保持思考，當我能感覺我的頭腦是清晰的、是隨時預備好進入下一個狀態的，靈感就會主動上門。

Q. 現在，回頭來看這些帶著遺珠之憾的作品，您有什麼新的感觸？

A. 現在回頭來看，最終採用的那些作品的確有他的道理，這些遺珠之憾相對零碎、不完整，但又還保留著基本的價值，我會把它們看作一些可拆解的素材，無論是概念或手法，都有機會在適合的時機重出江湖。

Q. 你對生活的細節上有什麼堅持嗎？(像是上廁所時一定要看詩集之類的)

A. 我吃飯時喜歡喝茶類飲料，不然吃不下去。除非是趕稿地獄期，不然睡前一定會看部日劇或 ASMR 之類的東西。然後我有一點潔癖，喜歡把房間整理乾淨後窩在房間裡當宅男。

Q.What do you like best in your country? (such as country feature or culture)Has it made a difference on your creation?

A. Taiwan is a great place, enthusiastic and energetic. But my favorite place is Taiwan's "small", and compared to other neighboring countries, because of geographical relations to facilitate life, people almost no distance between each other. Taiwan's cultural creations and I may no obvious associated (although I have a lot of creative looks nothing association), but I was living in Taiwan creator, my ideas, thinking and expression forms will be virtually immediate, indirectly affected.

Q.How do you draw inspiration?

A. Although I do the design, but I'm not the kind of life "design only" man. I play games, watching movies, chasing Japanese drama, find a friend to chat about something boring topics. I found that sometimes I do not touch the design is brains actually the most active, a lot of feelings, thoughts were seemingly inspired by wasting time, but also because of "design-time" and "non-design time" in tug of war, conflict, I have been in two distinct states absorb and release the different things, and this will make me to stay in thinking, when I can feel my mind is clear, it is ready at any time to go to the next state and the inspiration will be initiative to come.

Q.Now, look back to these works of regret for not been selected, how do you feel that?

A. Looking back now, those works finally adopted does have its reasons, these hidden gems looks relatively fragmented and incomplete but retained some basic value can be keep. I would like to see them as some of the material can be disassembled, no matter the concept or technique, also have the chance to coming back at a right time.

Q.What is your insist on your life's details ? like toilet with your favorite poem?

A. I like drinks tea when I eat, or can eat more. Unless hell of deadlines, or I will see a Japanese drama or ASMR something like that before going bed. Then I have a little neat freak, like being a homebody after cleaning up my room.

核子，還是孩子？ Nuclear, or Children？　2013　P.124
2013 年 3 月 9 日，超過 150 個民間團體共同發起規模巨大的「309 廢核大遊行」，訴求包含停止追加核四廠預算及裝填燃料、拒絕不合理公投等，但遲遲未獲政府明確回應，而後更發生十餘次規模不等的抗爭行動。
From March 9, 2013, Over 150 civil society groups sponsored a huge parade protesting nuclear waste, called "The 309 Parade." Their demands were to stop spending on nuclear power plant fueling, and reject unreasonable voting. However, the government has not yet provided a clear response. Therefore, more than a dozen anti-nuclear protests have taken place following "The 309 Parade."

超載 Overload　2014　P.124
隨著科技的快速進步與網路世代的來臨，我們不斷的吸收各種不必要的資訊。大量的資訊讓我們變得既懶惰又焦慮，進一步還可能引發沮喪、挫折、判斷力減弱等症狀，我們變得單薄、空洞、行屍走肉。
With the rapid improvement of technology and the coming of internet era, we are constantly consuming different and sometimes unnecessary information. Such a large amount of easily accessible information has made us not only lazier but also more frustrated due to not being able to manage this information effectively. We are faced with destruction, hollowness, and loss of energy because of lack of judgment and appreciation.

Love in Motion　2013　P.124
從歌曲的感受延伸的自主創作，我的腦海裡充滿斷斷續續的畫面，有點反社會，在瘋狂之中有什麼東西正在規律的移動著。
Achieving independent creations from the feeling of the song, my mind is full of choppy pictures. I feel a little antisocial, while in the madness, something is moving the law.

彰顯藝能、幻化首映 - 彰化縣立美術館首展 Artworks Displayed in the Changhua Country Museum of Art　2014　P.124
彰化縣立美術館的首展名稱為「彰顯藝能、幻化首映」。提案時以「化」字為主題，不僅是「彰化」、「幻化」的字面關係，美術館落成是「化」的一種，藝術家創造作品也是「化」的一種，遂將之結合彰化「山城」的意象。
The first exhibition of the Changhua County Museum of Art was called "The Power of Art Gathered in Changhua." My proposal was a design based on the character "hua," (化) which has several interpretations including "change," "illusion," or "dream," and which also happens to be part of the name "Changhua." The opening of the Changhua County Museum of Art can be viewed as "a change," and the artworks can also be seen as "an illusion." The location of Changhua is on a mountain. Therefore, I initially

created two posters showing Changhua as a mountain along with the word "hua" representing change.

無限綻放 -2013 國際設計工作營 Infinite Blooming-2013 International Design Workshop　2013　P.124
工作營邀請到三位國際名師，以阿拉伯數字「3」組合無限符號，符號以紅色、淺藍色的搭配象徵「基因」，並以驚嘆號表示創意，搭配無限符號的旋轉帶出「綻放」意象。
The Work Camp invited three international masters for the event, so I used the number 3 to assemble an infinite sign. And the Symbols are created by combination of red and blue to indicate design "gene". I used an exclamation mark to indicate creativity and worked with a rotated mirror image of the infinity symbol to bring out the image of blooming.

中央研究院生物多樣性研究中心標誌設計 Logo Design for BRCAS　2013　P.169
我以台灣黑熊及寬尾鳳蝶兩種瀕臨絕種的生物為原型製作標誌，並讓台灣黑熊在比例上往左偏移一些，帶出像是伸長脖子在觀望、期望的視覺感受。
I advocated using diversity in the creation of the design, illustrating the endangered Formosan Black Bear and the endangered Flaring Papilio butterfly species in the prototype logo. The image of the Papilio butterfly appears as the chest mark of the Formosan Black Bear. The image of the Formosan Black Bear is shifted to the left, as if the bear is stretching to look at something.

有常無常 - 鐘俊雄 x 陳炳臣多媒材創作聯展 Exhibition of Chuan-Hsiung Chung's and Alex Chen's Creative Works in Multiple Mediums　2014　P.225
展覽以「有常、無常」為主題，傳達兩位風格截然不同的藝術家對於生命的一致的體悟。
An exhibition with the theme "Control, Lack of Control" conveyed the different styles and viewpoints on life of two artists, Chuan-Hsiung Chung and Alex Chen.

樓上樓 Upstairs　2013　P.255
因為一次設計案需要拍攝臺中市各個地區的照片，某次返家後整理照片時發現這棟建築保留了樓梯下方的鋸齒狀構造，有趣地彷彿也能倒著上樓一樣，便創作了此作品。
Due to taking many pictures in various regions of Taichung for a previous work, I found a particular photo of a building stairway which fascinated me. The image appears as if one is climbing upstairs. It can also appear as if one is climbing downstairs.

台灣 Taiwan

陳品如 Chen Pin-Ju

www.pinjuchen.com

台灣藝術大學視傳系畢，赴英就讀金斯頓大學 (Kingston University) 取得傳達設計碩士學位。研究領域為書籍裝禎、紙張和手工印刷，並對科技演進的過程感到特別有興趣，論文題目便是探討智慧型通訊裝置於未來的想像與可能性。

認為設計就像 massage，設計師就像按摩師父一樣，以專業賦予觀眾（顧客）絕佳視覺（觸覺）體驗。創作靈感多從生活經驗或當代議題中汲取，佐以些許幽默感香料提味。曾為金斯頓大學出版的文集設計封面，作品並曾在倫敦 Clerkenwell Gallery 展出。

Pin-Ju Chen is a Taiwanese visual artist based in London. She graduated from Kingston University London majoring Graphic Design MA.

She thinks, "Design is the massage." Simply because it provides people awesome experience just like what massage does. Her works are usually based on daily life experiences and current issues, with some humour flavours added.

Q. 請問您認為該國最棒的是什麼 ?(如國家的特色或文化等) 您的創作是否受其影響？

A. 我可愛的國家台灣永遠有吃不完的美食，我們永遠可以在裡面找到靈感。

Q. 請問您如何獲得靈感？

A. 靈感隨時可能發生：用心生活, 好好吃飯, 常常出走！

Q. 請和我們分享您喜歡的書籍、音樂、電影或場所。

A. 發條橘子永遠帶給我無限的暴力美感和繆思。

Q. 除了當設計師/插畫家,你是否已經開始規劃下一階段的目標？例如策展、學習煮菜、登山

A. 身為設計師，用視覺和客戶、觀眾溝通是每天都會碰到的課題，說到下一階段的目標 我要學習好好和我家的貓 Beer 溝通！她真是隻很難溝通的貓！

Q.What do you like best in your country? (such as country feature or culture)Has it made a difference on your creation?

A. There is always great and cheap food in my lovely country, Taiwan. We could be always inspired by those cuisine.

Q.How do you draw inspiration?

A. Inspirations appear in every life experience. Live hard, eat well, and often travel.

Q.Share good books, music, movies or places with us.

A. "A Clockwork Orange" is always my muse.

Q.Have you started to set up new goals for next period except being a designer or illustrator ? like curating, learning cooking , climbing......

A. As a designer, to communicate with clients with my work is an everyday issue. As for the new goals......I would like to try to communicate with my cat, she is a difficult one.

Gone Fishing 2014 P.29
Gone Fishing 是為英國金斯頓大學文學碩士作品合輯設計的書封。「如果文學是一片海洋, 寫作者就是漁人, 在垂釣著名為繆思的魚。」
The cover is designed for "Gone Fishing" — new writing from Kingston University MFA writers.
"The literature world is like sea.
Muses are fish.
The writers are fishermen. They have gone fishing."

iNostalgia 2014 P.72
在不久的將來，智慧型手機可能被更先進的科技取代。iNostalgia 的概念即是：以傳統的的文具載體呈現, 設計一款能儲存智慧手機時代記憶的一套紀念品。
The concept is shaping a container to store the memory of intelligence phone, that is, to produce a series of souvenir for the people in the future as a reminder of former technological memories.

Font Book 2014 P.73
Font Book 嘗試運用三種書籍裝幀的形式來呈現正體、斜體和粗體；輔以日月恆常、水的流動以及穩如泰山的符號作為象徵。
Font Book is a self-initiative project demonstrating three forms of type "Regular", "Italic" and "Bold". I use three signs to symbolize the forms: sun and moon show up regularly (periodically); the fluidity of italic font is similar to water; the bold fonts are as stable as mountain.

Sausage Clock 2014 P.73
Sausage Clock 這個專案靈感來自於德國柏林的 Mengenlehreuhr（集合論鐘），我嘗試用有趣的方式報時—把香腸切成一塊一塊來拼成 24 小時和 59 分鐘來呈現時間。
"Sausage Clock" is inspired by Mengenlehreuhr (German for "Set Theory Clock") located in Europa-Center in Berlin, which indicates the time by the illuminated and coloured fields. By using different flavours of sausages and salami to imitate the system of Mengenlehreuhr, I try to form a new way of telling the time by arranging the food into a certain pattern.

新加坡 Singapore

我的名字是周麗娟，來自新加坡的平面設計師，也是一個創造性的愛好者。我畢業於新加坡理工學院，創意設計系。

My name is Chew Lijuan, a graphic designer and a creative enthusiast born and based in Singapore. I have earned my diploma in graphic design at Singapore Polytechnic, Creative Media Design.

周麗娟　Chew Li-Juan

www.cargocollective.com/taromijuan

Q. 請問您認為該國最棒的是什麼？(如國家的特色或文化等) 您的創作是否受其影響？

A. 新加坡是一個多元種族的國家，不僅如此，大多數的新加坡人可以掌握一到兩種語言進行交談。作為一個多元化的國家，我們都深受彼此的文化和語言的影響，因此我可以使用這些元素來創造更有本土文化的設計或物品。

Q. 請和我們分享您喜歡的書籍、音樂、電影或場所。

A. 我最喜歡的作家是來自日本的村上春樹。我讀的第一本書是《世界鏡頭與冷酷仙境》。小說共 40 章，單數 20 章《冷酷仙境》，雙數 20 章《世界鏡頭》，這種交叉平行地展開故事情節的手法是村上春樹的特徵。本書想象力奇特，藝術水準高超，情節極其荒誕而主題極其嚴肅，用變形的手法寫出人們對當代資本主義社會的混亂現狀逃避無門的真實心態。

我聽的都是獨立樂團或歌手如：The Staves, Hoizer, Jose Gonzalez, Stu Larsen, Odessa, Hyukoh, Of Monster and Men, The XX, Stars, Isobel Anderson, Wet, Crown Lu, The Drums

電影的話，我最喜歡的是：韋斯·安德森的月升王國，神奇的福克斯先生，宮崎駿 - 神隱少女、幽靈公主、阿麗埃蒂。

喜歡的地方如：

1. Little Drom Store 是位於新加坡的一門藝術和設計驅動的零售商店。裡面有無數的隨機小擺設，鼓舞人心的東西和令人振奮的本地藝術家所設計的物品。

2. Carpenter and Cook 是位於新加坡的一門老式的家居賣場和咖啡館。他們售賣一系列精心策劃的古董家具，家居裝飾，以及新鮮自製烘焙食品和糖果。

3. 下北澤是位於東京的一個古樸的街區。裡面有很多有趣的咖啡館，商店，獨立的時裝零售商，酒吧和劇院。

Q.What do you like best in your country? (such as country feature or culture)Has it made a difference on your creation?

A. Many words can describe Singapore. Among these words, I love this the most- Multilingualism. Most Singaporeans are able to converse comfortably in more than one language, and some even have the ability to use dialects. In addition, Singaporeans are able to enjoy cuisines and even adapt recipes belonging to the different races of Singapore. Singapore's multi-racial society results in a culture which people are influenced by the cultures and languages of different races. These influences could be useful in the generation of unique graphic designs or products.

Q.Share good books, music, movies or places with us.

A. Haruki Murakami is my favorite author and the first book that I have read from this author is "Hard-Boiled Wonderland and the End of the World". It is such as interesting novel with chapters that alternate between two bizarre narratives and is interlink with each other in the end.

Favorite indie band/artists: The Staves, Hoizer, Jose Gonzalez, Stu Larsen, Odessa, Hyukoh, Of Monster and Men, The XX, Stars, Isobel Anderson, Wet, Crown Lu, The drums

Movies:Wes Anderson – Moonrise Kingdom, Fantastic Mr Fox

Hayao Miyazaki – Spirited Away, Princess Mononoke, Arrietty

Places:

1. Little Drom Store is an art & design driven retail store in Singapore that houses countless random knick knacks, collections of all things inspiring and heartening products designed locally by Singaporeans artist.

2. Carpenter & Cook is a vintage home store and artisan bakery café in Singapore. They have a range of carefully curated vintage furniture, home decor, as well as fresh homemade baked goods and confectionery.

3. Shimokitazawa is a quaint neighborhood in Tokyo which has a lot of interesting cafes, shops, independent fashion retailers, bar and theaters.

Rant Expression *2014 P.64*

抱怨是一種舒緩情緒的方式，但研究顯示這反而有反效果。因此，我們需要學會如何控制我們的思想和行為。這一本書只不記錄了我對人事物的抱怨，也讓我領悟人生的道理。

Ranting is a form of expression where we whine endlessly about an absurd situation. We rant because it gives us a temporary sense of relaxation. However, research shows that venting actually creates more anger and aggression. Therefore, the key to solving every problem is to make peace with our differences. We might not be able to control the actions of others, but we do have the power to control our own thoughts and actions. This publication documents my rants and the process of embarking on a new journey of self-improvement and the discovery of life.

Self Promotion: Creative Boost *2012 P.166*

我為了應徵一個初級平面設計師的職位而創作了這個自我推銷工具包。手工製作這個工具包的目標是想要有效地展示出我的獨特點、個性和設計知識。我的靈感來自一幅海報。海報的內容展示了 29 種保持創意的方法。有時候，設計師、創意總監和藝術總監們會在思考的過程中找不到靈感，因此，我的宣傳工具包是一個提高我們創造力的指南。該套包含：茶、巧克力、IDEA 書和筆，陌生人談話卡。總體而言，我希望自己能為公司創造出更多有創意的作品。

I created this Self-promotion kit while searching for a Graphic Designer position. The aim is to stand out from the pool of fresh graduates, while displaying my personality and expertise effectively at the same time. This idea was inspired from a poster that showed 29 ways to stay creative. Designers, creative directors, and art directors could face many creative blocks throughout their careers. When such blocks arise, my promotion kit can be used to boost their creativity. It contains: A tea bag, some chocolates, an idea book, and a talk-to-a-stranger card. Overall, the main idea was to promote myself as a person who can be the creative input for the company.

Self Promotion: To Grow *2014 P.167*

我在一間品牌公司做了兩年的平面設計師，最後決定改換新公司來嘗試新的挑戰。我想從我的推銷工具包傳達的訊息是（以種子和花作為比喻）：一間設計工作室如一個花園，年輕的設計師在創意總監和藝術總監的努力耕耘下，就能開花結果，設計出好作品。因此，我希望能在這樣的環境裡學習，最後能創造出更好的作品。

After a 2-year stint as an in-house graphic designer in a branding company, I have decided to challenge myself and be a humble graphic designer in a new design agency.
The message that I want to bring across from my promotion kit is (using a seed and a flower as an analogy): A design studio is like a garden where a creative director and art director provide solid foundation for the designers to blossom into beautiful flowers who will eventually bear fruits of creatively designed works of good quality. Such an environment will allow me to flourish and show the world my unique and authentic work.

Provence Bakery & Cafe *2011 P.167*

Provence 是一間日式咖啡館。他們的獨特點是使用法式烘焙技術和日本食材去烘烤麵包。因此，我把日本和法國的元素融入在我的整個品牌的設計上。該標誌的設計看起來像一盤羊角麵包和咖啡杯，也創造了屬於他們的文字商標。
注意：這是一個自發的設計作品與品牌沒有直接關係。

Provence is a Japanese-style Bakery & Café that introduces fusion pastry where the breads are made with Japanese ingredients and French baking techniques. Therefore, I have added a tinge of Japanese and French look and feel in my overall branding design. The logo is a combination of a croissant on a plate and a coffee cup that symbolizes the Bakery and Café, while a customized font was created for the word mark.
Note: This is a self-initiated project and the design present below has no direct relationship with the current brand.

泰國 Thailand

別名：Chin Yeuk

生於 1990 年 8 月 9 號，現居於泰國曼谷。畢業於曼谷 Silpakorn 大學藝術學院視覺傳達設計系。在廣告公司中擔任平面設計師及自由插畫家，大多是向量及地圖插畫。

Name：ChinapatYeukprasert，Author Name：Chin Yeuk，Born 8/09/1990，live in Bangkok. Thailand，I Graduated from Department of Visual communication Design，Faculty of Decorative Art，SilpakornUniversity,Bangkok Work as a Graphic Designer in Advertising Agency and a freelance Illustrator, almost vector Illustration and Map Illustration.

Chinapat Yeukprasert

www.behance.net/chinapat

Q. 請問您認為該國最棒的是什麼 ?(如國家的特色或文化等) 您的創作是否受其影響？

A. 在泰國各個地區有不同的文化，但最重要的是顏色, 泰國的顏色是獨一無二的, 既繽紛又快樂。我在許多作品上使用了與泰國事物相關豐富的顏色。

Q. 請問您如何獲得靈感？

A. 我的靈感來自過往的經驗還有在畫素描本上的一些小東西, 還有在旅行時或在城市裡散步時拍的照片。因為我喜歡城市的生活、景觀、建築還有地圖, 因此我最多的工作都是地圖。

Q. 請和我們分享您喜歡的書籍、音樂、電影或場所。

A. 書籍：Monocle、Juxtapose 還有歷史或政治的書, 世界地圖集。
音樂：Alt-J、Novo Amor、Of Monster And Men、Part Time Musician(泰國的樂團)。
電影：2001 太空漫遊 (藝術指導)、小太陽的願望、魏斯‧安德森的所有電影 (顏色還有構圖)。
場所：圖書館、工作室、工作用的咖啡廳、藝術與設計的博物館、放鬆用的公園和商場。

Q. 現在, 回頭來看這些帶著遺珠之憾的作品, 您有什麼新的感觸？

A. 就算作品沒有被採用, 我也不會氣餒。不過我想知道沒被選中的原因 (笑)。而有時卻沒有原因, 但為了客戶的滿意度, 這都會發生在每個人的設計過程中。沒被選中沒關係, 我有盡力做好就好了。

Q. 除了當設計師 / 插畫家, 你是否已經開始規劃下一階段的目標？例如策展、學習煮菜、登山……

A. 每個月辛苦工作之後, 我都想到北方某個寒冷的地方, 充分感受來自大自然寂靜的聲音, 或是來一場旅行, 探索陌生國度與程式的文化, 將我遇到的事情描繪下來。

Q. 你對生活的細節上有什麼堅持嗎?(像是上廁所時一定要看詩集之類的)

A. 外出的時候一定要帶一個包包。喜歡戴帽子。

Q.What do you like best in your country? (such as country feature or culture)Has it made a difference on your creation?

A. In Thailand we have many different culture of the region, but most of all the colour is the best, Thai colours is unique, and colourful and joyful. I used colourful colour palette for many work that are about This Thing.

Q.How do you draw inspiration?

A. My inspiration are from my experience and sketch some little things that I see on my sketch book or taking a picture when I walking in the city or travelling somewhere. Because I like the city life, landscape, architecture and map that why mostly work is a map.

Q.Share good books, music, movies or places with us.

A. Book : Monocle, Juxtapose and history or politic books. World atlas.
Music : Alt-J, Novo Amor, Of Monster And Men, Part Time Musician(Band in Thailand).
Movies: 2001 Space Odyssey(Art direction), Little Miss sunshine, All Wes Anderson movie.(colour and composition).
Place : Library ,Co-Working space and coffee shop for work, Art & Design museum , Park and Mall for relax.

Q.Now, look back to these works of regret for not been selected, how do you feel that?

A.I'll fine if any of my work not been use of select but I just want to know the reason why Lol. Sometime there are no reason. but it can happen to anybody in design progress because we are working on the clients satisfaction. So that it fine you you won't select it but I'm do it best at my job that 's ok.

Q.Have you started to set up new goals for next period except being a designer or illustrator ? like curating, learning cooking , climbing......

A. After I working so hard for month I wanted to go north to somewhere cold and full feel the sound & silent of the nature and retreat myself or the trip to exploring the culture in the strange country or city and sketch the things I met.

Q.What is your insist on your life's details ? like toilet with your favorite poem?

A. Carrying a bag whenever I going outside. Love to wearing a cap.

'BIGFISH' Bangkok River Music Festival Map　2015　*P.101*
地圖插畫。在曼谷 8 luxury riverside hotels 音樂節，擁有八場不同類型舞蹈和音樂的表演。
Illustration Map for the music festival located on the 8 luxury riverside hotels in Bangkok with the 8 shows about difference kind of dance and music.

Guide to Saraburi　2011　*P.238*
Faculty of decorative Arts 的視覺傳達設計課時的學生作品，這個項目是要替我泰國的故鄉北標府，用景觀 icon 製作旅遊導覽。
A Student Project Visual communication Design class, Faculty of decorative Arts. The project it's about the guide for travelling in Saraburi by landmark icon of the attraction in 'Saraburi' my home town in Thailand.

GP HISTORY BOOK　2014　*P.239*
地圖、資訊圖表還有關於 GP 公司在世界各地的歷史插畫。
A Map and infographic ,illustration about the History of a GP Company business around the world.

A TWIST OF THAILAND　2014　*P.241*
替 Oriental-Escapes.com 出版的旅遊口袋書《A TWIST OF THAILAND》繪製地圖插畫。設計泰國東北以及南海的地圖景觀插畫，提供泰國的旅遊指南。
A Map Illustration for the tourist pocket book "A TWIST OF THAILAND" published by Oriental-Escapes.com ,Design the illustration map of the north-eastern and the southern sea of Thailand surrounded by the landmark place of travel lifestyle and guide for travel in Thailand.

Sea Sand Sun　2015　*P.241*
Giraffe Magazine 雙週刊 2015 年 4 月第 12 期：Look and Sea for Core column. Sea sand sun，共 4 頁。內容是關於人類與海洋的聯結。
Editorial Illustration with Giraffe Magazine Bi Weekly Journal Issue 12 April 2015 : Look and Sea for Core column Sea sand sun, 4 pages. The content is about the connecting of human and the sea.

Modern Thailand　2013　*P.288*
地圖插畫，發表在雜誌 Monocle，同時也是泰國政府未來要建立的大型工程基礎設施的一部份。
Map Illustration published in Monocle [issue 66.vol.07,September 2013] the part about mega project of Thai government to build the infrastructure for the future.

WORLD'S NOT MINE　2015　*P.289*
替 นโลกที่ไม่ได้เป็นของเรา (世界不是我的) 這本書繪製插圖，作者是 Tomorn Sookprecha，Salmon Books 出版。我負責繪製封面插圖，是關於作家在這世界上孤獨的心情。
Illustration for the book "WORLD'S NOT MINE"(Nailok tee maidai pen kongrau : world's not mine) Author : TomornSookprecha Published by Salmon Books, I design an Illustration and Book cover it's about the journey of the writer around the world alone in the lonely mood.

Bangkokian　2015　*P.290*
Giraffe Magazine 雙週刊 2015 年 4 月第 12 期：Look and Sea for Core column. Sea sand sun，共 4 頁。
Editorial Illustration with Giraffe Magazine Bi Weekly Journal Issue 12 April 2015 : Look and Sea for Core column Sea sand sun, 4 pages.

台灣 Taiwan

朱俊達　Chu Chun-Ta

www.behance.net/chuchunta

朱俊達，平面設計師，出生於 1990 年。

作品曾獲第 11 屆莫斯科金蜜蜂國際平面設計雙年展、GDC13、GDC15 平面設計在中國、2015 玻利維亞國際海報雙年展、第 7 屆中國國際海報雙年展、第 3 屆上海 • 亞州平面設計雙年展等多項入選獎及第 17 屆全國大師獎優良獎、第二屆兩岸新銳設計競賽華燦最佳新稅設計師獎。並作品有收錄於第 10 屆及第 11 屆《亞太設計年鑑》中。

Chun-Ta Chu, Born in 1990, Graphic Designer.

His works have been featured in publications like Asia-Pacific Design No.10 & No.11, and awarded by 11 Golden Bee Global Biennale Moscow selected, and Biennial of Poster Bolivia 2015 selected and Graphic Design in China GDC13 & GDC15 selected, and the 7th China International Poster Biennial selected , and the 3rd Shanghai Biennial Exhibition of Asia Graphic Design selected, and 17th National Design Master Award Excellence Award, etc.

Q. 請問您如何獲得靈感？

A. 我覺得靈感是生活上的積累。也許只是一頓晚餐或是窗外的景色，更亦或是朋友的一句玩笑話，都有可能成為創作靈感。而我個人更偏好與不同的朋友聊天，討論時事或者是價值觀，透過不同思維的碰撞，去產生各種火花，這有助於換個面向思考，又或是重新審視自己的觀點，發現新的可能。

Q. 請和我們分享您喜歡的書籍、音樂、電影或場所。

A. 我非常喜歡 Viction:ary 他們家出版的設計書，除了收錄的作品精采外，書體本身的設計也非常精彩，具收藏價值。

Q. 現在，回頭來看這些帶著遺珠之憾的作品，您有什麼新的感觸？

A. 這些作品當中，有部分是創作練習，也有是跟客戶提案的稿子。遺珠之憾的原因有的是不適切也有的是練習作品而不夠完整。這不禁讓人思考，如果是在知道問題後現在的我來重新做設計，是否會有不一樣的結果。在這樣的借鑑當中，期勉未來的創作能夠更完善。

Q. 除了當設計師 / 插畫家，你是否已經開始規劃下一階段的目標？例如策展、學習煮菜、登山 ……

A. 目前暫時沒有設計或藝術領域外的計畫。我覺得要做好設計，需要顧及的面向相當多，現階段我還在這方面做努力，在挖掘跟探究的過程當中，不排斥一切可能。

Q. 你對生活的細節上有什麼堅持嗎？(像是上廁所時一定要看詩集之類的)

A. 我在創作或是在工作時，旁邊一定會有一杯微糖飲料，這好像不是一個健康習慣，但是對我的設計很有幫助。

Q.How do you draw inspiration?

A. I believe inspiration comes from the experiences through life. Sometimes it can be from a meal, the view outside the window or maybe just from a joke of a friend. I prefer having conversation with different people, different people have different point of views in everything. The sparks between different minds then appear, it helps one to think from different angle or to rethink one self's personal view and discover new possibilities.

Q.Share good books, music, movies or places with us.

A. I personally like the books published by Viction:ary a lot. Besides the great works selected in their books, the book covers are also splendid in design, very worth collecting value.

Q.Now, look back to these works of regret for not been selected, how do you feel that?

A. In between those works, some were practices and some were proposals to clients. It was pity that some were not competent or the work weren't intact. This made me think now that I know where the problems were, if I redesign these works now, will the outcomes be different? From these experiences, helps me to produce works that are more intact in the future.

Q.Have you started to set up new goals for next period except being a designer or illustrator ? like curating, learning cooking , climbing......

A. At the moment there's no other plans associating with design or art. I believe that to create a a good design, there's a lot of aspects to consider. This instant point I'm still learning and figuring out the different aspects, through this process of exploring I'm not rejecting any possibilities.

Q.What is your insist on your life's details ? like toilet with your favorite poem?

A. While I work, there's always a cup of slightly sweet cool drink. I know it's not healthy but it helps a lot for me and my works.

向山本耀司致敬 Saluted the Yamamoto Yōji　2015　P.106

這是課堂作業衍伸出來的創作練習。藉由探究山本耀司的生平、作品以及處事態度，而得到靈感啟發，以平面設計的形式向這位服裝設計大師致敬。

This work is an extend version from a class assignment. Inspired from Yōji's life experience, work and attitude. As a graphic designer, I salute this Fashion designer in a graphic form.

國泰民安 People live in peace　2013　P.106

燒香拜佛就如同對政治的期望一樣，我們都期望明日能夠燦爛，但對於政黨的訴求，在多方面的拉扯與時間的推移中，漸漸就如同燃至了末端的香，當初燃燒的那一點火苗終會熄滅。希望人民的聲音跟力量是火焰，可以把政黨的詬病燃燒殆盡，願國泰民安。

As there are a lot of difficulties that need overcoming in the daily life, people used to pray to God, just like asking political parties for help, but it useless.

接納 Acceptance　2015　P.107

透過三款系列海報，來表示主流上層、中層大眾及下游少數群體等，現今社會的刻板歧視，人們無法接納不符合自身期待的角色，扭曲成各種歧見，阻隔了人與人之間的距離。

I used three posters to represent different social rankings: upper class, middle class and lower class. People cannot accept others who act against their beliefs.

感官世界 In the Realm of the Senses　2013　P.107

世界十大禁片電影感官世界的觀後有感視覺創作，在暴力與情色的漩渦當中，以視覺的手法嘗試捕捉這份衝擊與迷幻。

A visual work on one of the top ten prohibited movies "In the Realm of the Senses" after viewing it. I used the visual technique to express the clash and the psychedelic feeling between violence and lust.

盛騰體系 Sheng Teng LOGO　2013　P.189

為友邦人壽底下的其中一個子團隊所設計的形象標誌。強調互助、與愛的保險業務團隊。

This is the brand logo designed for the company Shen Teng which is underneath the AIA International Limited Taiwan Branch. This insurance company emphasize on helping each other and love.

菓香小舖 LOGO　2015　P.189

這是幫一間結合茶飲及輕食的全素餐廳所做的品牌標誌。因為講究飲茶以全素食，標誌以菓、香二字為主體，將葉片結合果物作為視覺意象。

This is a brand logo designed for a vegetarian restaurant. The restaurant's core in their product as full vegetarian, therefore I used the Chinese characters of fruit and incense as the focus of the logo combining the leaf and the fruit as the visual effect.

台灣 Taiwan

邱柏豪　Ciou Bo-Hao

www.behance.net/Cox1

邱柏豪，1991 年出生於台北，專注於視覺傳達、品牌形象、文字創作及書封設計。目前在 Idealform 理式意象設計擔任平面設計師。認為設計的價值看似若有似無，但實際的重要性是：無可取代。

My name is Ciou Bo - Hao. I was born in Taipei in 1991.I focus on visual communication, brand Image, word design and book cover design. I am a graphic designer in Idealform. I think the value of design is consciousness seemingly. In fact the value of design is Irreplaceable.

Q. 請問您如何獲得靈感？

A. 先了解設計的需求，接著找切入點，整理出想要表現的形容詞，透過 facebook, behance, pinterest 等網路平台，以大量圖片訊息刺激大腦獲得靈感。

Q. 請和我們分享您喜歡的書籍、音樂、電影或場所。

A. 林宥嘉、HUSH、田馥甄三位歌手歌曲，透過他們迷幻音樂的帶領，讓自己像遨遊外太空一樣，在無邊無際的宇宙太空，和自己沒完沒了的對話。

Q. 現在，回頭來看這些帶著遺珠之憾的作品，您有什麼新的感觸？

A. 雖然沒有被評審選中，但回過頭看還是很喜歡，等待伯樂的知心知會。

Q. 你對生活的細節上有什麼堅持嗎？(像是上廁所時一定要看詩集之類的)

A. 隨時隨地都要欣賞新的作品，活在資訊爆炸的年代一定要適時更新自己的美學新知識。

Q.How do you draw inspiration?

A. First, understand the needs of design, then look for a point and the adjectives want to show up, through Facebook, Behance, Pinterest, stimulates the brain with plenty of pictures to get the ideas.

Q.Share good books, music, movies or places with us.

A. Yoga Lin, HUSH, Hebe. The three singer's song , by their music, just like traveling in the outer space, endless conversation with my own, in the immense universe of space.

Q.Now, look back to these works of regret for not been selected, how do you feel that?

A. Although has not been selected, but still like it, wait for the admirer's meet.

Q.What is your insist on your life's details ? like toilet with your favorite poem?

A. Enjoy the new works anytime and anywhere, live in the era of information explosion, it must be timely to update their knowledge of new aesthetics.

貓空五季活動識別系統　2013　P.61

貓空被視為台北的後花園，鄰近城市的小郊區觀光休閒的好去處，貓空五季活動為貓空地區建立屬於自己的文化特色，以貓空的五種季節活動作為形象識別發想。五季活動分別為：杏花季、桐花季、綠竹筍季、春茶季、藝術季，針對這五種季節元素，進行創新整合的圖形創作，發展出新的圖案設計，再將新的圖形運用呈現貓空五季活動識別系統，使貓空地區獲得美化，觀光品質獲得提升，原有的地景藉由設計煥然一新，進而促使貓空地區蓬勃發展。

Maokong five seasons activities recognition systemMaokong is regarded as back garden of Taipei's. A good place for travelling for nearby cities. Maokong five season activities create their own cultural characteristics. Use Maokong five seasons as the idea .Five season activities: Apricot season, Blossom season, Green shoots season, Spring tea season, Festival of the ArtsDevelop innovative integrated graphics creation to develop new graphic design according to this five season. Then use theses graphics to show Maokong five season activities recognition system.Making Maokong area be more beautiful and tourism quality improveent.Original landscape will be fantastic via design Maokong will be a prosperous area.

品糸氏　2014　P.155

臺灣茶發展至今已有兩百多年，茶飲與台灣的人文風俗有著密不可分的關係，據品茶專業人士的評比，訂下台灣十大名茶，分別是凍頂烏龍茶、文山包種茶、東方美人茶、松柏長青茶、木柵鐵觀音、三峽龍井茶、阿里山珠露、台灣高山茶、桃園龍泉茶和日月潭紅茶。依照十大名茶其各特色繪製插畫表現口感、產區、製法等特色，並創立品牌「品糸氏 - 品味來自臺灣茶細細的純淨」，將傳統與創新結合呈現新的台灣十大名茶典藏禮盒。

It has been more than two hundred years for the development of Taiwanese tea. There's close relationship between tea and Taiwanese culture. According to the assessment of tea expert, the Top ten famous Taiwanese tea were finalized as following, Dongding Oolong Tea, Wenshan Pouchong Oolong Tea, Oriental Beauty Tea, Light Ching oolong tea, Mucha Iron Goddess oolong Tea, Sansia Longjing green tea, Ali Mountain oolong Tea, Taiwan High Mountain Oolong Tea, Longquan oolong Tea, and SunMoonLake Black tea. They illustrated pictures based on the character respectively to indicate the taste, origin and manufacturing process of the Top ten famous Taiwanese tea, then build the brand "PIN MI SHI-taste the purity of Taiwanese tea" which combines the tradition and innovation together to show a whole new Top ten Taiwanese tea classic gift.

1111 未婚聯誼網　2015　P.155

以四個一交錯呈現聯誼網站使單身男女互相連接，亦有男女牽手之意，外圓以顏色區分將圓切半，顯現出上半圓為W (女) 以及下半圓為M (男) 呼應主題 1111 聯誼網。

Use four 1 staggering to express single men and women link each other and it means hand to hand. Outside circle distinguishes by color and the round cut in half. The top semicircle means woman and the underneath semicircle means man. The circle echo the theme which is 1111 friendship network.

爭鮮　2014　P.155

爭鮮的主力商品為壽司，壽司料理需透過師傅捏製握壽司的手讓每個盤子上的握壽司美味的呈現，設計爭鮮文字時以微彎曲線傳達師傅捏握壽司時我們最熟悉的手勢展現每盤壽司全是壽司師傅以及爭鮮的心血結晶。爭鮮二字中 " 鮮 " 字內的田，營照了迴轉壽司的軌道，使得整體更加呼應「爭鮮迴轉壽司」。

Zensen main commodities are sushi. Sushi needs chef's hands to let it delicious. When I design the Zensen's word I used the curve to express gesture of doing the sushi and sushi is the brainchild by the chef. The words of Zensen have a circle in Chinese and it just means revolving belt sushi.

TAF 空總創新基地　2015　P.155

TAF 空總創新基地成為臺灣人的夢想基地，圖像設計上將 A 以紙飛機的意象呈現，象徵夢想高飛。顏色上選用透明清澈湖水綠，代表追求夢想時那份純淨真誠的心。整體的 Logo 像是一個停機坪讓我們將空總創新基地成為夢想的轉捩點，給臺灣實現夢想的力量。

In this documentary / biography film the legendary Iranian children's songwriter Abbas Yammini Sharif is made eternal. The multimedia aspects of his work is presented through various textures and forms. The Bi-Lingual audience for Jordan Center if Persian Studies further considered - hence both Persian as well as in English information design is implemented.

合唱 Chorus　2015　P.220

以基本的幾何形狀：「三角」、「矩型」、「圓型」，形狀及概念上分別隱喻著合唱中的高、中、低音不同聲部，亦運用此三種基本元素，簡化並對應著漢字筆畫；共構組成「合唱」2字，圖形如同迴圈般循環繞線；在自 (字) 身中迴盪著；人聲組合的隨機美妙形塑著空間；每次都是獨一無二的體驗，讓聽眾深刻銘記在心。

Use base geometry that is triangle, rectangle and round. The shape and concept means high, medium and low of the chorus. And use three of the base element to Simplify and correspondence Chinese character strokes. To build up the two word " 合唱 ". Shape like the loop surrounding and reverberating in itself. The combination of the vocal is random and wonderful Shaping the space. Every time is unique experience. Let audience keep in mind deeply.

印度尼西亞 Indonesia

Clara 是印尼的插畫家，也喜歡替自己的畫製做小動畫，最近她加入創意團隊 Leo Burnett Malaysia，她的畫有些是自己對生活的想法，有些是她最近的感受，或單純只是她在生活中看到的事物，她希望自己的畫可以吸引別人的好奇，並讓他們反思自己的生活。

Clara is an Indonesian illustrator who likes to make a little animation for her drawings too. Currently she's working as part of creative team at Leo Burnett Malaysia. Some of her drawings are her thoughts of life, while some is just what currently her feeling is, or simply what she sees during the day. She hopes her drawing can draw people's curiosity, and makes them reflect on their life.

Clara Christine Wijaya

www.behance.net/clarawijaya

Q. 請問您認為該國最棒的是什麼？(如國家的特色或文化等) 您的創作是否受其影響？
A. 目前我居住在馬來西亞，我愛上了他們的食物！馬來西亞在文化上非常豐富，而且人們都很友善。我覺得他們對藝術的開放性影響了我，使我主動、有目的地去創作事物。

Q. 請問您如何獲得靈感？
A. 我的靈感來源是我到目前為止的經歷。我可以從同事的對話裡、當前的狀態，或是單純在早晨慢跑時看到的景色裡得到靈感。

Q. 請和我們分享您喜歡的書籍、音樂、電影或場所。
A. 保羅‧科爾賀的《鍊金術士》是一定要看的書！音樂方面最近我在聽好自在樂團、鳳凰樂團，還有 KOOP。

Q. 現在，回頭來看這些帶著遺珠之憾的作品，您有什麼新的感觸？
A. 沒有太認真想過甚麼階段性目標，但現階段還處於每天都有所獲有所想，鬥志滿滿的狀態。

Q. 除了當設計師 / 插畫家，你是否已經開始規劃下一階段的目標？例如策展、學習煮菜、登山
A. 參加馬拉松，這樣一來我就能更深入探索這個美麗的國家，同時也可以變得更健康。

Q.What do you like best in your country? (such as country feature or culture)Has it made a difference on your creation?
A. Currently I'm residing in Malaysia, and I'm so in love their food! Malaysia also very rich in culture and the people are very friendly too. I think their openness to art is affecting me to keep me motivated to create something with purpose.

Q.How do you draw inspiration?
A. My inspiration comes from what currently I experience. It can be from some conversation with my colleague, current situation, or even simply what I see when I do morning jog.

Q.Share good books, music, movies or places with us.
A. The Alchemist by Paulo Coleho is a must read! For music currently I'm listening to The Kings of Convenience, Phoenix, and KOOP.

Q.Now, look back to these works of regret for not been selected, how do you feel that?
A. Most want to graduate and then to continue my career. I do not thinking about what goals seriously, but still be in harvested and thought and fighting everyday.

Q.Have you started to set up new goals for next period except being a designer or illustrator ? like curating, learning cooking , climbing......
A. Join a marathon, so I got to explore this beautiful country even more, and get to be healthier in the same time.

Hear Me Roar 2015 P.278
這是關於一位安靜而勇敢的女孩，擁抱在她生命中的種種挑戰的故事。我喜歡畫堅強的女孩，我相信美麗不是需要變的有女人味，或是化妝，我認為所謂的美麗的是你面對人生的態度，是這種態度造就了你。
It's about being a serene yet brave and lively girl who embraces challenges in her life. I like to illustrate a strong girl, I believe being beautiful doesn't mean you need to be feminine, wear make-up, etc. I think it's more into your attitude, how you embrace life, that's what define who you are.

Mother Nature 2015 P.278
詮釋出我多麼想要親近大自然到自己想像成為大自然的一部份。被摩天大樓團繞住的生活讓我感到非常有壓力，它給你冷漠的印象，在這裡的所有事物都只是商業與消費。相反的，能讓人們感到快樂的東西，事實上僅是度過大自然給與我們的美好時光。
An expression of how I miss being close with nature until I imagine being part of it. Living surrounded by skyscraper is very stressful for me, and it gives you the impression of coldness where everything is just about business and consumerism. In contrast, what makes people happy is actually just to spend their quality time with what mother nature gives us.

The Big Catch 2015 P.278
你永遠不知道下一次會抓到什麼，可能是你引頸期盼已久的大收穫，就像是得到成功一樣。我相信成功是努力與運氣的結合，而你唯一能控制的是你自己的努力，你永遠不知道運氣什麼時候會降臨，因為它總是像個不速之客說來即來。
You'll never know what will you catch next. It might be the big catch that you've been waiting for so long, just like being success. I believe being success is both combination of hard work and luck. The only thing you can control is your own work, and you'll never know when luck come, because most of the time it comes just like an uninvited guest.

An Ukulele 2015 P.278
表現出我對於玩樂器的想念。玩音樂可以讓我感到冷靜，也幫助我表達自己的感受。表現出我對於玩樂器的想念。玩音樂可以讓我感到冷靜，也幫助我表達自己的感受。
An expression of how I miss playing music instruments. Playing music really calms me down and it helps me to express my feeling.

Hysteria 2015 P.279
在你內心感到恐慌的時刻，當你意識到有些事進行得不是很順利，但是沒有任何人知道你內心發生什麼事，他們以為一切都很好。
A panic moment inside you, when you realize something is not going well, but nobody knows what actually happening inside you. They thought everything is just fine.

Looking For Something 2015 P.279
她在找尋某個東西，但她並不知道自己確切想要的是什麼。在生活中，很多時候我們以為自己知道在追求什麼，但只有少數人知道他們真正想要追求的事物。
She's looking for something, but she doesn't know what exactly is she looking for. In life most of the time we thought we know what are we looking for, but only a few know what it really matter is.

新加坡 Singapore

Do Not Design

www.donotdesign.com

Do Not Design 是位於新加坡，研究調查與內容驅動的創意機構。
運用周到的思考與巧妙的設計，我們讓擁有企業策略的企業和品牌有勇氣去嘗試創新的想法去拓展、參與、告知、驚艷每個人。
在新加坡從事品牌、互動設計和空間設計，擁有發展良好的網絡，從設計師、策略家、營銷人員到作家、攝影師、插畫家。

Do Not Design is a research and content-driven creative agency based in Singapore. With thoughtful thinking and well crafted designs, we transform businesses and brands who embraces design with your business strategy; has the courage to try innovative ideas to push boundaries, and to engage, inform and surprise. Based in Singapore with aa well-developed network of designers, strategists, marketers to writers, photographers and illustrators working in branding, interaction and spatial design.

Q.請問您認為該國最棒的是什麼？(如國家的特色或文化等) 您的創作是否受其影響？

A.新加坡是一個很小，但步調非常快的國家，有許多種族和民族，還有許多移民者和本地人生活、工作在一起，因為這樣，我們並沒有真正獨特的文化，我們從各處得到靈感，並將它列入我們自己的敘述和背景。

Q.請問您如何獲得靈感？

A.幾乎所有事物都能給我啟發，包含在我周圍的人們，我可能不知道他們但他們是 — Studio Toogood、Bompass、Parr、Bonsoir Paris、March Studio、Les Suen、John Clang、Theseus Chan、James Plumb、Snarkitecture 還有 Made Thought。

Q.請和我們分享您喜歡的書籍、音樂、電影或場所。

A.可能是我經營十一年的部落格吧。www.theartistandhismodel.com

Q.現在，回頭來看這些帶著遺珠之憾的作品，您有什麼新的感觸？

A.我總是往前看，從不活在過去已發生的事物，甚至是現在這個瞬間。

Q.除了當設計師/插畫家，你是否已經開始規劃下一階段的目標？例如策展、學習煮菜、登山......

A.我一直想成為畫家、成為烹飪藝術家。我試著朝這個方向前進，還有試著從事更多寫作。

Q.你對生活的細節上有什麼堅持嗎？(像是上廁所時一定要看詩集之類的)

A.在我的手臂有 "i am always hungry" 的刺青，這幫助我腳踏實地，對於脂肪、知識和動力感到飢渴。

Q.What do you like best in your country? (such as country feature or culture)Has it made a difference on your creation?

A. Singapore is a small but very fast pace country and we are a multi racial, multi nation with lots of immigrants and local living and working together. And because of this, we don't really have a distinct culture and we take our inspiration everywhere and put it in our own narratives and context.

Q.How do you draw inspiration?

A. I am inspired by almost anything but the people around me spur me on. I might not know them personally but they are — Studio Toogood, Bompas and Parr, Bonsoir Paris, March Studio, Les Suen, John Clang, Theseus Chan, James Plumb, Sharkarchitecture, Made Thought.

Q.Share good books, music, movies or places with us.

A. Maybe my blog that I had for eleven years or so. www.theartistandhismodel.com

Q.Now, look back to these works of regret for not been selected, how do you feel that?

A. I am always looking ahead and not living for the past for what had happened or even the present.

Q.Have you started to set up new goals for next period except being a designer or illustrator ? like curating, learning cooking , climbing......

A. I always wanted to be a painter, to be a culinary artist. I am trying to work towards that and also, trying to write more as well.

Q.What is your insist on your life's details ? like toilet with your favorite poem?

A. I have a tattoo "i am always hungry" on my arm. It helps to keep me grounded and being hungry for fats, knowledge, drive as possible.

Architecture and the Architect: Image-making in Singapore 2015 P.36

因新加坡人工景觀快速變遷所產生的焦慮，刊物目的是透過建築看待地域、記憶和留戀，試圖了解在集體意識下新加坡的形象，而我們身為建築環境的代理人和接受者，如何聚結在一起，決定我們後代將要繼承的景觀？建築師和使用者，組合了個人的記憶，以自己的方式來創造城市的形象，拼湊身體與感官而成的結果，訴說著關於時代交替的精神。使用歡慶的語調，書中的圖像和趣聞讓我們意識到自己所擁有的事物，鼓勵讀者尋找他們所在之地的意義之前，使用客觀的角度看待這個我們稱為新加坡的地方。我們將這書視為一種祭品，也是對於加強我們國家認同的提醒。還有兩篇分別由資深建築師 William Lim 和 Alfred Wong 發表的文章，以及八篇新的訪談，對象是在新加坡工作的建築師、建築攝影師，最後加入這裡的居民、房客、商家和保全人員，完整呈現眾人的聲音。

This publication arises out of an anxiety towards the fast-changing built landscape of Singapore. Its objective is to look at place, memory and nostalgia through architecture, while attempting to understand the images of Singapore in the collective minds. How do we, as agents and recipients of the built environment, come together to decide the landscape that generations after our own would inherit? We have gone about assembling individual memories of architects and users who are both, in their own ways, image-makers of the city. The result is a collage of both the physical and the sensory coming together to inform something about a spirit of intersecting times. In its most celebrative tone, the images and anecdotes in this book recognize what we have. we encourage readers to take an unprejudiced look at this city we call Singapore, before searching for their own meaning of place. We see this publication as a tribute, as well as a reminder of the choices we make to strengthen our national identity. Theses featured buildings sit alongside two republished essays—by veteran architects, William Lim and Alfred Wong, respectively — and eight new interviews with architects and an architecture photographer based on their works in Singapore. Lastly, anecdotes on the ground from residents, tenants, shopkeepers and security officers have been inserted throughout the pages of the publication to complete this collective gathering of voices.

Being Together by John Clang 2013 P.36

紐約的新加坡攝影師 John Clang 個展，Being Together。這本出版物使用許多不同材質、大小、顏色的紙，彼此互補，體現了一個家庭即使面臨差距，仍可以存在著和諧與親密，鬆散的頁面將不規則的紙和攝影，以及不同的家庭都連結在一本書裡，這本影像是對於連繫這疏離的城市社會的備忘錄。

Documenting New York based Singaporean photographer, John Clang's solo exhibition, Being Together. This book also includes essays by Szan Tan, Patricia Levasseur de la Motte and Gwen Lee. In this globalised, fluid world where migration is prevalent, family units are often broken up and displaced. Being Together is an exhibition that speaks of the triumph of the family unit thanks to the usage of technology. To celebrate the indomitable spirit of human relations, this publication is made up of papers of varying

textures, sizes and colours that manage to complement each other as well – reflecting the harmony and intimacy that can still exist even if a family faces disparity. The loose leafs of varying irregular papers and photographs of different families all bound together in one book serves as a reminder of the ties that bind in this isolating urban society.

Dear Vol 1: Lost & Found 2015 P.37

DEAR 是一本收集有趣特別的事物的雜誌，從所談到瞄準你感官的視覺隨筆，基本上是任何可以激起我們好奇新的事物。我們的創刊號探訪了鄉愁，以失落和尋獲為主題，探索民族大融爐，新加坡，其混合的文化、身分認同的遺忘，讓許多藝術家回顧、探討這些問題。主題 Lost and Found 是封面設計的重點，切割了文字的空間，產生大量嘈雜的文字，刀模和重疊的表現讓它本身看起來像是一大塊的字體。儘管看起來很熟悉，但充滿干擾、不舒適的設計，在看第一眼的時候，文字和意義彷彿都失去了，但是後來仔細檢查，又能再次找回。

DEAR is a zine that collects, archives and immortalises in print, all things fun and unique. From casual conversations to visual essays that aim to assault your senses, to basically anything that piques our curiosity. For our inaugural issue, we visit nostalgia by exploring the theme of Lost and Found in our salad-bowl of a nation, Singapore. Mixed cultures, forgotten identities and the quest for meaning in retrospection are uncovered and probed into by contributing artists. The theme Lost and Found was the main focus of the cover design. A noisy mass of text created through the removal of word spaces, die-cuts and overlaps presents itself as a chunk of letterforms, albeit so familiar to us, in a disorientating, and uncomfortable fashion. Words and meaning are lost at first glance, but later found again upon careful inspection.

Singapore's Visual Artists 2015 P.37

Singapore Visual Artists' 是一個全方位的知識庫，以專業性的文章描述將近 300 位視覺藝術家。雖然包裝成珍藏版，並且作為替新加坡藝術家產生更高視角的推廣工具，它還是被定位成適合給非專業人士入門的刊物，提供了對於本地藝術產業的介紹與認識。

Singapore Visual Artists' is a comprehensive repository that profiles close to 300 visual artists with professional practices. While packaged as a collector's edition, and serving as a promotional tool in generating higher visiblity for Singaporean artists, it is also positioned as an accessible point of entry for lay-persons that provides an introductory understanding of the local art industry.

台灣 Taiwan

張晉嘉，台灣藝術大學視覺傳達設計系畢業，擅長品牌形象與各式平面視覺設計，現為早鳥形象設計有限公司創辦人暨創意總監

Arron Chang, graduated from Department of Visual Communication Design of National Taiwan University of Arts. Specializing in brand and graphic design. Now he is the founder and creative director of EBS Design.

早鳥形象設計　EBS Design

ebsdesign.com.tw

Q. 請問您認為該國最棒的是什麼？(如國家的特色或文化等) 您的創作是否受其影響？

A. 台灣的優點是高度的民主化以及多元文化的融合，雖然國際化的程度還需要加強，但現在網際網路已相當發達，我們可以很輕易地透過網路來獲取非常多的資訊。而在風格和創作上我一直希望能透過「中學為體，西學為用」的方式來結合東西方設計特長並體現在作品之中，我想應該或多或少也是受到環境以及當代的文化所影響。

Q. 請問您如何獲得靈感？

A 其實和其他設計師沒有太大的不同，就是多看、多聽、多感受身邊所發生的任何人事時地物。因為靈感通常不是硬想就可以得到的，有時候如果在發想上卡關我會試著離開辦公室，出去走走逛逛或是翻雜誌和看電視，讓自己暫時脫離原本發想東西的情境，往往這時候靈感就會莫名其妙的出現了。

Q. 現在，回頭來看這些帶著遺珠之憾的作品，您有什麼新的感觸？

A. 以前對於花費了許多心血或是自己很喜歡的作品沒有被業主選上會滿在意的，但是時間久了以後就會發現其實未雀屏中選並不一定是因為作品不夠好，而是許多複雜且離奇的原因所造成的 (笑)。所以現在雖然一樣會覺得可惜，但就是當作花時間做自己喜歡的作品，或許未來某一天還是有運用的機會也不一定囉。

Q. 除了當設計師/插畫家，你是否已經開始規劃下一階段的目標？例如策展、學習煮菜、登山⋯⋯

A. 下一階段除了好好順利的活著以外，希望趕緊學會騎馬、滑雪以及有朝一日能上太空。

Q.What do you like best in your country? (such as country feature or culture)Has it made a difference on your creation?

A. Advantages of Taiwan are highly civilized and multicultural fusion. Although the level of internationalization needs to be improved more, the Internet is very advanced and we can easily access to lots of information from it. As for the style and creation, I always want to combine the designing features of eastern and western, presenting them in my works. I think I'm more or less influenced by the environment and modern culture.

Q.How do you draw inspiration?

A. There is no big difference form other designers. I see, listen to, and feel everything around me. Since inspiration does not pop out on its own, I sometimes try to leave the office when I am out of ideas, going outside, reading magazines or watching TV, separating myself from the original scenario of developing ideas, and inspirations will somehow appear.

Q.Now, look back to these works of regret for not been selected, how do you feel that?

A. In the past, I cared a lot about those works I spent lots of time working or I like a lot weren't being chosen, but with the time passes, I find the not being chosen doesn't mean that the work isn't good enough; sometimes it's because of some complicated and strange reasons(LOL). I still think it is a pity; however, I consider it as taking time to do the works I like, and maybe someday I will have opportunities to put them into use.

Q.Have you started to set up new goals for next period except being a designer or illustrator ? like curating, learning cooking , climbing......

A. Apart from being well alive, the next period will be learning to ride a horse, skiing, and go to the outer space someday.

Happy GOAT(GOLD) Year　2015　P.47
由於 2015 年適逢中國的羊年，我們便決定以此為主題設計賀年的主視覺。在概念上使用了「羊」與「年」的中文字外型做結合，搭配「GOAT」與「GOLD」諧音字的雙重含義，整合成為一特殊的文字化形象；加上分解排列中文筆畫而成的 pattern 圖樣，最後完成了一系列贈與我們客戶的主題產品包裝。
Because year 2015 meets Chinese year of goat, we decide to use this as the subject to design primary vision of New Year greeting. On the concept, we combined the shapes of Chinese characters "goat" and 'year', and match with double meanings of the phonograms "GOAT" and "GOLD", integrate them to a special literary image; together with the pattern which comes from the decomposition and arrangement of Chinese strokes, then complete a series of theme product packages to present to our clients.

祈盼 Just Listen　2013　P.79
祈盼 (Just Listen) 是一場公益性質的音樂會，主題為愛與未來，希望藉由音樂的力量跨越藩籬，撫慰人心。設計的概念上是以極具力量的書法字為主體，對比出圓所轉化而成的心型視覺，以表達主題同時帶來沈重與溫潤的感覺；而左方左轉 90 度的日期文字「3」則是呼應了主要的愛心圖標。
"Just Listen" was a music concert of public welfare with the theme of love and future, hoping to break the boundaries and comforting with the power of music. The concept of design was to contrast the powerful calligraphy with the visual heart shape which was transformed from circle to express the heavy and warm senses came with the theme; the 90-degree-left-rotated number "3" of the date echoed with the main heart image.

EBS Design Visual Series　2012-2014　P.88
此系列作品是以自身工作室「早鳥形象設計」做為發想，於三年之中前後完成的三件系列形象海報，分別以工作室的格

言「DON'T STOP THINKING AND KEEP EXPLODING」、形象「早起的鳥兒有蟲吃」、以及名稱「EARLYBIRDS DESIGN」為主題所設計。將文字變化結合單純的黑白點線面，表現早鳥純粹簡要的設計風格與精神。
The concept of this series was developed from our studio "EARLYBIRDS DESIGN." These three image posters were designed in sequence within three years respectively with the motto of studio, "DON'T STOP THINKING AND KEEP EXPLODING;" the image of "The early bird catches the worm;" the name "EARLYBIRDS DESIGN," presenting the pure and simple designing style and spirit with change of words and pure black and white point-line-surface.

Hangee Brand Identity　2014　P.159
Hangee 為一強調全民共創以及為全民而生的台灣在地新創手機品牌。在識別圖形設計的概念上，將名稱諧音的番薯與台灣造型，結合字首 "h" 打造出簡潔現代的品牌符號，並選擇以接近蕃薯色但較亮的橘色作為識別主色，以表現此新興品牌的活力與以人出發的人情味。
Hangee is a new local brand of cellphone which emphasizes civil co-creation and is born for people in Taiwan. The concept of graphic design is to combine Taiwan, which is the homophonic of sweet potato in Taiwanese, with prefix "h", creating a simple and modern brand mark. The choice of main color is orange, which is close to the color of sweet potato but brighter to present the energy of this new brand and hospitality.

MERRYXMAS　2014　P.217
適逢佳節所創作的聖誕視覺設計，主視覺海報以 XMAS 四個字母所變化的幾何符號所構成，並挑選桃紅與藍綠主色營造出同時具有復古與現代的繽紛節慶感覺。
A Christmas visual design came with the holidays. The main visual poster was formed with geometric symbols which were transformed from four letters XMAS, using peach and cyan to build the retro and modern holiday atmosphere.

日本 Japan

Eisuke Tachikawa (NOSIGNER)

www.nosigner.com

在還是學生的時候便創立了 NOSIGNER，太刀川瑛弼是設計的戰略家，追求跨領域的設計方法，現在，他擔任 NOSIGNER 的執行長，並透過他的活躍努力創新。他提供廣泛範圍的創新設計，包含科技、教育、在地產業還有其他。瑛弼的作品獲得全球性的讚賞，囊括世界多種大獎如 Design for Asia Award、iF、Pentawards 柏金獎、SDA 最優秀獎等。同時他也被日本政府任命為 Cool Japan Movement 促進會議的概念指導。

Founding NOSIGNER while still a student, Eisuke Tachikawa is a design strategist who pursues a multi-disciplinary approach to design. Today, he serves as CEO of NOSIGNER, and strives to produce social innovation through his activities. He has provided a wide range of innovative design encompassing science and technology, education, local industries, and more. Eisuke's works have been acclaimed internationally, winning numerous global awards: Design for Asia Grand Award, iF Design Award, PENTAWARDS PLATINUM, SDA Grand Award, etc. The Cool Japan Movement Promotion Council by the Japanese government in 2014.

Q. 請問您認為該國最棒的是什麼？(如國家的特色或文化等) 您的創作是否受其影響？

A. 日本是長期暴露在劇烈轉換的自然之下，所以我們日本的發展主要崇敬自然、尊重多元性，而不是單方面與其他人競爭。以協調與平衡為中心的文化，從外頭看有時候似乎曖昧不清，但它同時創造了非常漂亮的和諧，我也希望自己能創作出這樣的設計。

Q. 請問您如何獲得靈感？

A. 到處走動。如果我們發自內心去感受各種各樣的事物，就可以自然擴展自己的視野。另外，歷史也教導我們許多思考的標準。

Q. 請和我們分享您喜歡的書籍、音樂、電影或場所。

A. 書：Richard J.Brenneman 的 FULLER'S EARTH A Day with Bucky and the Kids / 賈克. 阿塔利的 A Brief History of the Future / 維克多. 巴巴納克《為真實世界設計：人類生態與社會變遷》。

音樂：Las Jansson Trio 的 I am that / toe 的 Hear You。

場所：大谷採石場礦區 (日本櫪木縣) / 1994 年列為聯合國教科文組織世界遺產名錄的西芳寺 (苔寺) (日本京都)。

Q. 除了當設計師 / 插畫家，你是否已經開始規劃下一階段的目標？例如策展、學習煮菜、登山......

A. 我在 35 歲的時候開始寫書法，我相信因為書法的關係，我在平面設計上的感受性變得更強了，現在我比以前也開始更了解歷史的內涵，我相信書法可以幫助我成長為更專業的設計師。

Q. What do you like best in your country? (such as country feature or culture)Has it made a difference on your creation?

A. Japan is a country that has been constantly exposed to the harsh changes in nature. Rather than contending with others upon a one-sided justice, we Japanese have developed primarily through respect and awe towards nature and acceptance of the diversity.

A culture that centers on harmony and balance may sometimes seem ambiguous from outside, but at the same time, it creates a very beautiful harmony. I also hope to create such a design.

Q. How do you draw inspiration?

A. By moving around. If we continue to feel various things in my bones, we can naturally expand our perspective. Also history always teaches us various standards of thinking.

Q. Share good books, music, movies or places with us.

A. <Book> "FULLER'S EARTH A Day with Bucky and the Kids" by Richard J.Brenneman / "A Brief History of the Future" by Jacques Attali / "Design for the Real World: Human Ecology and Social Change" by Victor Papanek.
<Music> "I am that"(Las Jansson Trio) / "HEAR YOU" (toe).
<Place> The old mining site of "Oya" Stone(Rock quarry)(Tochigi Prefecture, Japan) / Koke-dera (Moss Temple) *UNESCO World Heritage List in 1994 (Kyoto, Japan).

Q. Have you started to set up new goals for next period except being a designer or illustrator ? like curating, learning cooking , climbing......

A. I've started calligraphy at the age of 35. I believe that, because of calligraphy, my sensibility as a graphic designer has been enhanced. I also now understand the context of the history more than ever. I believe calligraphy can help me grow even more as a professional designer.

THE SECOND AID　2014　P.67

NOSIGNER 與日本仙台的 Kohshin 貿易公司合作設計了名為「THE SECOND AID」的急難包，這款急難包是反映 OLIVE 的產品，OLIVE 是 NOSIGNER 在日本大地震後 40 小時推出的維基式網站，網站分享災難情況下實用的技巧與知識。急難包的包裝為白底與紅字，表現出緊急救難包的藝像，能在急難時刻第一時間拯救我們的生命。OLIVE's 的 O 代表日本國旗上的紅色圓圈，LIVE 意思是「活下去」，也是我們的願望：「拯救日本」，在缺乏資源的受災區裡，要如何快速有效地利用物品，我們蒐集了許多想法。透過志工的協力，這個網站被翻譯成英文、中文與韓文，並且持續擴張成為集結多方智慧的資料庫。我們把在 OLIVE 上收集到的情報編輯成平裝書《OLIVE BOOK》，所有在受災情況下實用的資訊都以插圖的方式描述出來，可以讓人方便理解。在 THE SECOND END 裡還有簡化版的 OLIVE BOOK，設計成 A4 大小的手冊，和盒子裡的物品為一組，裡面提供的資訊在緊急情況下非常有幫助。

Upon collaboration with Kohshin Trading Company in Sendai, Japan, NOSIGNER designed the disaster kit called "THE SECOND AID." This disaster kit reflects the output of "OLIVE," a wiki-style web product launched by NOSIGNER just 40 hours after the Great East Japan Earthquake, in order to share tips and knowledge useful in the event of a disaster. The package consists of a white background and red font, with an image of a first-aid kit that would save lives during an emergency. OLIVE's "O" represents a red circle of Japan's national flag while "LIVE" means "live," reflecting our wish, "Survive, Japan". We have collected various ideas on how to efficiently and effectively utilize items in affected areas where there is a lack of resources. Upon voluntary contribution, the website is translated into English, Chinese and Korean while still expanding as a database that utilizes collective wisdom. We now have an "OLIVE BOOK," a paperback book consisting of information collected on the OLIVE website. All the useful information during disaster situations is well described with illustrations, making it easy to understand. An abridged version of the "OLIVE BOOK" is included as an A4 size notebook in "THE SECOND AID," making the set a box of items and information that would be helpful in case of an emergency.
ART DIRECTION: EISUKE TACHIKAWA (NOSIGNER)
GRAPHIC DESIGN: KAORI HASEGAWA,TOSHIYUKI NAKAIE (NOSIGNER)
CLIENT: KOHSHIN SHOJI CORPORATION
PHOTO: TAKESHI KAWANO (NOSIGNER)

Warew　2013　P.141

替護膚品牌 warew 做品牌設計，warew 在日本的意思是「日式風格」，warew 嚴選國內的天然材料，以成為日本美容新的指標品牌為目標。我們選擇赭紅和純白兩種顏色做為品牌指定色，紅與白是白無垢這種白色婚紗和服的顏色組合，是要讓最美麗的新娘穿上的服飾，這兩種顏色也代表日本的美學。商標從日本國旗象徵與日式美學中萃取出精華，它看起來也像是一個手鏡，與女性的美也有強烈的關係。商品是專門為日本女性的行為而設計，warew 的概念主打使用他們的護膚產品來展現自己的內在美，你的行為變得成自然、端莊、美麗，因為你發現了自己的重心，就像是繫上了和服的寬腰帶一樣。這個品牌來自日本「侘寂」美學，認為美就是簡單、是一種無形的精神。

We are providing design to a skin-care brand called "warew" which means "Japanese Style". "warew" is careful in selecting domestic and natural materials and aims to be a new standard for Japanese beauty. We chose a deep vermilion and pure white as brand colors, because of the composite of a shiromuku, a white dress kimono, which is used when the women is known as being the most beautiful, a bride. These colors represent Japanese beauty. The Symbol mark illustrates how to extract the essence of Japanese beauty, symbolized by the national flag symbol. It also looks like a hand mirror which is strongly related to the beauty of women. The products are designed from the behavior of Japanese women. "warew"s concept is made to expresses your inner beauty while you use their skin care products. Your behavior changes naturally, dignified and beautiful because you find your center of gravity, like it does when you put on the "obi". This brand is derived from the Japanese unique aesthetic "wabi-sabi" which is the idea that beauty exists in simplicity or in the invisible spirit.
CREATIVE DIRECTION : EISUKE TACHIKAWA(NOSIGNER)
ART DIRECTION : EISUKE TACHIKAWA (NOSIGNER)
DESIGN : EISUKE TACHIKAWA , TAKESHI KAWANO(NOSIGNER)
CLIENT : COSMEDIA LABORATORIES Co.,Ltd.
PHOTO : HATTA [products, hands, and woman dressed in a kimono] , TAKESHI KAWANO(NOSIGNER)[packages]

香港 Hong Kong

Elaine Yum Ling Fok

www.fokfolio.com

擁有加拿大多倫多約克大學（YSDN）設計榮譽學士學位，曾斬獲 Adobe® 卓越設計大獎及 Applied Arts Magazine Awards 大獎。擅長跨領域設計，如平面、文字、美術、數碼及動畫等。曾服務過多個國際集團品牌，如瑞吉酒店、馬哥孛羅酒店集團、澳洲 QT 酒店、《經濟學人》、嘉里建設，中信銀行國際及維記牛奶等。

Received her design education (BDes Hons) at York University (YSDN) in Toronto. Award-winning designer at the Adobe Design Achievement Awards (ADAA) and Applied Arts Magazine Award. Multi-disciplined designer with wide range of design practices in print, typography, creative thinking, art direction and digital, interactive and motion design.

Worked with brands such as the Marco Polo Hotels Group, The Economist, St. Regis, Citic Bank International, Value Partners, JP Morgan, Danone, Kerry Properties, Kowloon Dairy, QT Hotels (Australia), the AHL group (Australia), Innosparks (Singapore), Hongkong Jet and Vista Jet.

Q. 請問您認為該國最棒的是什麼？（如國家的特色或文化等）您的創作是否受其影響？

A. 香港是一個大熔爐。這裡是一個國際化，但也以自己的方式保留住鄉懷的地方。樂觀、快速、充滿活力，文化的體驗與靈感讓它不斷地煥發著青春。對我來說，設計是編譯人性、文化，還有視覺娛樂的一門藝術，而香港是取得各種靈感元素的完美場所。

Q. 請問您如何獲得靈感？

A. 觀察、體驗事物，在互動中得到靈感。有時候最好的靈感來自一場熱水澡，我也不知道為甚麼。

Q. 請和我們分享您喜歡的書籍、音樂、電影或場所。

A. 我最喜歡的書是原研哉的《白》。我反覆讀它，因為它的設計哲學就是我的信仰。我也喜歡在咖啡店看 Monocle，它給我很好的視覺資訊圖表以及廣告，其收錄的內容廣泛，像是商業、旅遊和設計。我會因為角色設計還有精美的場景細節而觀看英雄電影，這些基本上是構成我宅的部分。

Q. 現在，回頭來看這些帶著遺珠之憾的作品，您有什麼新的感觸？

A. 學習並且繼續前進。有時候我重新審視這些作品，它們的確有不被選上的原因，但我很確定它們一定有些好的地方被埋沒了，一切發生都是有原因的，對吧？

Q. 除了當設計師／插畫家，你是否已經開始規劃下一階段的目標？例如策展、學習煮菜、登山……

A. 我想在冰島偏遠的地方坐卜來，凝視著漂亮又微小的風景。

Q. 你對生活的細節上有什麼堅持嗎？（像是上廁所時一定要看詩集之類的）

A. 我辦公桌上的筆和鉛筆必須完美地對齊，我是非常在意精確的 99% 完美主義者。

Q. What do you like best in your country? (such as country feature or culture) Has it made a difference on your creation?

A. Hong Kong is a melting pot. It's international, yet nostalgic in its own way. It's up-beat, fast and vibrant, which is constantly rejuvenated with cultural experiences and inspirations. To me, design is an art of compiling humanity, culture and visual amusement, which Hong Kong is the perfect place for getting all sorts of inspirations.

Q. How do you draw inspiration?

A. I see things, observe, experience it and get inspired through interactions. Sometimes the best ideas come from having a hot shower, I don't know why.

Q. Share good books, music, movies or places with us.

A. My favorite book is Kenya Hara's "White". I have read it repeatedly, simply because his design philosophy is what I solely believe in. I also love reading Monocle in coffee shops, which gives me nicely designed infographics and advertisements, as well as a wide range of contents related to business, travel and design. Watching hero movies for their character designs and the details in all the carefully crafted scenes. This is basically the nerdy part of me.

Q. Now, look back to these works of regret for not been selected, how do you feel that?

A. I learn and move on, sometimes I revisit them, they are not selected for its own reason, but I'm sure there are good things about them that are hidden. Everything happens for a reason right?

Q. Have you started to set up new goals for next period except being a designer or illustrator? like curating, learning cooking, climbing......

A. I want to sit in the middle of nowhere in Iceland and stare at the beautiful and minimal landscape.

Q. What is your insist on your life's details? like toilet with your favorite poem?

A. My pens and pencils are perfectly aligned on my work desk, I'm very precise and 99% of a perfectionist.

St. Regis Lijiang | Define High Society 'Insidership' in China Positioning, Design, Digital and Launch 2013 *P.23*

要定位麗江，特別是麗江瑞吉，身為投資、商務聚會和家庭旅遊的度假勝地，為了在麗江競爭激烈的豪華別墅市場下脫穎而出，為了創造故事敘述的經驗，我們替以潛在客戶為目標的團隊，打造出特別的行銷包裝，多重感官的行銷經驗，讓身為集團的客戶能夠享受樂趣。

To position Lijiang, and specifically St. Regis Lijiang, as the getaway place for investment, business get-together and quality family vacation. To stand out in the increasing competitive luxury villa market in Lijiang. In order to create a story-telling experience, a special marketing package was created especially for a group of targeted potential customers. It's a multi-sensory marketing experience that customers could enjoy as a collection.

Scent With You | A Luxurious Sensory Experience 2015 *P.198*

SWY 是位於香港的薰香與香水國際品牌，這個品牌的誕生到現在我都參與其中，從品牌的創建到應用、產品理念、包裝和室內設計概念。SWY 提供廣泛數量的香味，慶祝「分享給你愛的人」這個理念。因此，品牌設計為極簡，並以白色為基底，讓繽紛、歡慶的產品，得到最佳的展示舞台。

SWY is a Hong Kong based, internationally branded home fragrance and perfume brand concept. I have been involved from the scratch to present, from creating the branding and application, product ideas, packaging and interior design concept. SWY provides a wide range of scents to celebrate the idea of "sharing with your loved ones". Therefore, the brand design is minimal and white colour-based, in order to create the best showcase for the colourful and cheerful products.

The Economist - Digital Solutions 2013 *P.242*

亞太地區的經濟學家並需要與媒體採購商溝通，而 The Economist 擁有正確的數位廣告解決方案，針對 200 個媒體營運企劃、採購商與其他業內人士，創造三管齊下的解決方案。首先，視覺資訊圖表的小冊子，突顯 The Economist Digital Solutions（經濟數位解決方案）的優勢。第二，互動的問答遊戲挑戰他們對於 The Economist 還有小冊子內容的知識。第三，包裝裡的觸控筆，說明在科技之下手寫文字的進化。

The Economist needed to communicate to media buyers in Asia Pacific that The Economist

has the right digital advertising solutions. A three pronged solution is created and targeted to 200 media planners, buyers and other people in the industry. First, an infographic pamphlet that highlighted all the strengths of The Economist Digital Solutions. Secondly, an interactive quiz game that challenged their knowledge of both The Economist and the content of the pamphlet. Thirdly, a direct mailer packed it all with a stylus pen, to illustrate the point that the written word was evolving with technology.

Alchemy Christmas Card 2014 *P.243*

設定為 1920 年代迷人的聖誕派對邀請函，以 Alchemy 的品牌設計為基礎，使用多個三角形的結構組成聖誕樹的圖形。而字體用許多細節處理，織成幾何的形式。

An invitation to a Glamorous Christmas Party set in 1920s', the Christmas tree graphic was constructed with multiple triangles based on the Alchemy branding. The typographies were crafted with many details to weave into the geometric forms.

南韓 Republic of Korea

來自南韓的溫馨問候！我是一位自由平面設計師及插畫家。同時在一家設計公司工作。插畫的主題通常是日常生活、戀人和朋友。

Warm greetings from South Korea! I am a freelance graphic designer and also a illustrator in South Korea. I am working in a design company at the same time. I usually draw illustrations with subjects like a daily life, sweet hearts and friends in general.

Eomgogi

www.eomgogi.com

Q. 請問您認為該國最棒的是什麼 ?(如國家的特色或文化等) 您的創作是否受其影響？

A. 韓國有個特別的文化稱為『Jeong』,這是個特別的感覺,是對於長時間相處的人的關懷與感情。我想這是韓國最棒的文化,對於擁有這個的我們非常自豪。所以我試著將這個融入到我的作品裡。

Q. 請問您如何獲得靈感？

A. 通常都是從生活中得到靈感,特別是我印象深刻的或之前的經驗,或和愛人度過的時光。

Q. 請和我們分享您喜歡的書籍、音樂、電影或場所。

A. 我喜歡電影,而且我還會感動到掉淚,例如怪獸電力公司、把愛找回來。

Q. 除了當設計師/插畫家,你是否已經開始規劃下一階段的目標?例如策展、學習煮菜、登山……

A. 因為我的英文不好,有時必須面臨介紹作品和交談時的困難,為了這個,我必須把英文練好。

Q.What do you like best in your country? (such as country feature or culture)Has it made a difference on your creation?

A. We have a special culture which is called 'Jeong' in South Korea. It is that particular feeling of affection for and caring about someone after spending a lot of time together. I think it is a best culture in South Korea and I am proud of that we have it. So I am always trying to capture this feeling on my works.

Q.How do you draw inspiration?

A. I usually get inspirations from a daily life, especially, something that I got a impression and experienced before, or a time spent with sweet heart.

Q.Share good books, music, movies or places with us.

A. I love to watch a movie with ending that I can be moved to tears, for example 'Monster Inc.(2001)' and 'August Rush(2007)'.

Q.Have you started to set up new goals for next period except being a designer or illustrator ? like curating, learning cooking , climbing......

A. Because of my poor English skills, sometimes I am faced with an unexpected difficulty to introduce my works and communicate with people all over the world. For this reason, I am planning to learn English in depth.

500th-day anniversary *2013 P.284*
這「五百天紀念日」是特別獻給我的愛人的。數字 120305、130717 是對我們來說有意義的數字。2012 年 3 月 5 號是我們第一天見面, 2013 年 7 月 17 號是第 500 天。用數字的外型, 裡面塞滿我們的回憶。
This '500th-day anniversary' is organized specially for my lover. The numbers 120305, 130717, and 500 on the screen are meaningful dates for us. March 5th, 2012 is the day we first met, and July 17th 2013 is the 500th day. With the shapes of these numbers, I tried to reflect our memories.

Cuban sandwich *2015 P.284*
這是給我最愛的歌手專輯的二次創作。看完『五星級主廚快餐車』後, 我試著表達那歌手在咬下一大口 cuba sandwich 後的感覺。
It is a fan art for celebrating my favorite singer's project album. After watching the movie'Chef 2014', I tried to express the feature of the singer's a big bite of Cuba sandwich on the album jacket.

3 words *2014 P.285*
為了這作品我從我的母語韓文 (Hangeul) 中選了三個字, 通過組合那三個字的外型, 描述字的涵義。對我來說真的很有趣, 因為當我在創作時, 沒有預期到有這樣獨特的作品。
To make this work, I chose 3 words from my mother language called 'Hangeul'. My work describes the meaning of the words in the frame formed by combining the shapes of the three words. It was really interesting to me because of this unique output that I couldn't expect when I drew it.

People with coffee *2014 P.285*
喝一杯熱咖啡安慰我們在艱難的生活中疲憊的心靈。在這插畫中, 我試圖描述在咖啡熱氣中的人們。
The warmth from drinking a cup of coffee comforts our tired souls in tough lives. In this illustation, I have tried to discribe features of those people in the steam of coffee.

Winter wind *2015 P.285*
描述一位母親保護他的小孩遠離冷冽的寒風, 傳達其母愛。那一刻是如此的令人印象深刻, 我站在那看著很久。
This work which describes a mother who protects her child from a bitter wind gives a message of devoted love of mother. That moment was so impressing that I was standing there and staring at them for a long time.

Collaborations with nine years old of me *2015 P.286*
身為一個設計師, 我已經想了很多未來如何舉辦展覽的事情。心中浮現出一個非常有趣的想法, 是以我的童年來當主題。我會想把那稱作是未來的自己和過去自己的結合成一個禮物。首先, 我選了一些以往的作品再加上一些插圖和故事。
As a designer, I have thought a lot about what to show when holding an exhibition in the future. An interesting idea that came up in my mind was to give the opportunity to host an exhibition to myself in the childhood. I would like to call this that is a kind of a collaboration with myself in the future and 'another' myself in the past, and also is a gift to give him. At first, I chose some of the drawings that I made in the past, and then I added the illustration with well-matched stories on the old works.

Camry in fall *2014 P.287*
這是豐田汽車雜誌要求為 Camry 畫的插圖。秋天, 有些貓會待在汽車溫暖的引擎蓋上的想法浮現在我腦中, 我跟著那時的感覺完成這項作品, 用我自己的風格描述那溫暖和秋天的色彩。
It is for Camry AD illustration requested from Toyota magazine. The scene of some cats sitting on a car's warm bonnet in a autumn popped up in my mind, and I followed that moment to make this work with my own style of describing the warmth and colors of autumn.

2016 New Year's card *2016 P.287*
這是我自己公司出的賀年卡, 慶祝南韓 2016 年猴年。公司的名字成了山, 以紅色的猴子爬著山代表節節高昇。
It is a New Year's card for the company I work for to celebrate 2016 which is called 'The Year of Red Monkey' in South Korea. The name of the company is described as a rocky mountain and the graph with red monkeys was drawn as a meaning of growth.

菲律賓 Philippines

2014 年畢業於聖道頓馬士大學的美術系，為生存而設計。最近是自由接案的狀態，同時也管理大學時代和朋友組成的藝術團體 Studio｜501b，喜歡 C2 這款飲料，暗自期待他們會請自己當品牌代言人。

A fine arts graduate from University of Santo Tomas, batch 2014.

He designs for a living, currently doing freelance works and at the same time, managing the art group (Studio｜501b) he made with his friends back in college.

He likes the drink C2, and secretly wishing that they"ll get him as an ambassador of the brand.

Euc Reyes

euccue.tumblr.com

Q. 請問您認為該國最棒的是什麼?(如國家的特色或文化等) 您的創作是否受其影響？

A. 食物！每個人一定都要去嘗試菲律賓的美食！還有藝術團體在我的國家正在慢慢的成長當中，我非常自豪自己是這個國家的一份子。

如果它讓我在創作上有不同的話，那麼我會說是的，因為在這個競爭的環境裡，你需要和潮流不一樣，才能脫穎而出。

Q. 請問您如何獲得靈感？

A. 在延誤的期間創作，在這段期間，所有瘋狂的想法傾巢而出，此外，它給我更多的休閒時間。

我在網路上看很多有趣的發現，在旅行的時候觀察人們和地點，還有不斷地記筆記還有隨機的格言。

Q. 請和我們分享您喜歡的書籍、音樂、電影或場所。

A. C2 是你一定不能錯過的飲料！

另外，我會看百富勤小姐系列，一個擁有炫目視覺的偉大冒險故事！

在從事藝術創作的時候，我都聽很少歌詞或無歌詞的音樂。

像是 Spazzkid (Mark Reddito)、Special Others、Tide/Edit。

Q. 除了當設計師 / 插畫家，你是否已經開始規劃下一階段的目標？例如策展、學習煮菜、登山

A. 我一直想嘗試搭雲霄飛車。

還有快點開設經營自己的設計工作室。

Q.What do you like best in your country? (such as country feature or culture)Has it made a difference on your creation?

A. The food! Filipino cuisine is a must try for everyone! And the art community in my country is slowly growing and I'm pretty proud and stoked that I am a part of this community.

If it made a difference on how I work, I'll say yes because of the competitive environment. You need to be different with the trend here if you want to stand out.

Q.How do you draw inspiration?

A. I create during procrastination hours. The time where all the wild ideas sprout. Plus it gives me more leisure time.

I read a lot of interesting finds on the internet, observing the people and places in my travels, and always jotting down notes and random quotes.

Q.Share good books, music, movies or places with us.

A. C2 is a drink that you shouldn't miss out on!

Also, I read the Miss Peregrine series. A great adventure story with exciting visuals!

When making art, I do listen to music with minimal lyrics to no lyrics at all.

The likes of Spazzkid (Mark Reddito), Special Others, Tide/Edit

Q.Have you started to set up new goals for next period except being a designer or illustrator ? like curating, learning cooking , climbing......

A. I always wanted to try roller coaster rides.

And to start managing a design studio soon.

Film Stills *2014 P.75*
一個惡作劇，把不存在的 / 不相關的說明放入照片裡，但令人驚訝的是，這一切都結合得很好。
A gag. Giving an out-of-place/not related subtitles to the photograph but surprisingly, it all blends well.

Candy Minimal *2015 P.280*
將沉悶的環境改變成充滿活力和俏皮的視覺。
Changing the dull environment to a vibrant and playful visuals.

Stamps *2014 P.281*
無。
None.

Selfies *2014 P.283*
興趣使然。(主要作為我的顯示圖片或在我社交媒體帳戶的 "DP")，還有做給我的朋友 (出自雙關語)，這也是我開始將攝影和插畫結合在一起的起點，照片是我的畫布，我將它視為放入的元素的基礎來使用。
Started out as a hobby (primarily used as my Display Picture or "DP" on my social media accounts) and creating for my friends (out of pun), this is where I started combining photography and illustration into one. The photograph is my canvas, and I use that as the basis of the elements I'll be putting.

馬來西亞 Malaysia

IMMJN 喜歡向量、幾何、對稱、直線和網格，IMMJN (eem•maa•jin) 的意思是我是 Majin。

IMMJN loves vectors, geometry, symmetry, lines and grids. IMMJN (eem•maa•jin) is I am Majin.

Falah Naim

www.behance.net/immjn

Q. 請問您認為該國最棒的是什麼？(如國家的特色或文化等) 您的創作是否受其影響？

A. 我一直在圖案裡尋找靈感，而馬來西亞有許多來自傳統圖形設計的靈感，還有種族的融合，以及本地原住民，讓這個國家變得更加有趣。使用在布料和磁磚上的圖騰也啟發著我，文化的聯姻孕育了有趣的設計思考，從幾何到自由流動的圖案，這些事物都打開了我的視野，讓我想做更多創作。

Q. 請問您如何獲得靈感？

A. 布料市場非常地眷顧我，僅僅是參考圖案設計那龐大的數據庫，對我的設計就起了很大的幫助，我也很幸運地擁有各行各業的朋友們，他們時常提供我想法，有時候那些令我覺得有趣的想法就會套用在自己的創作上。

Q. 請和我們分享您喜歡的書籍、音樂、電影或場所。

A. 尼爾·蓋曼的奇幻小說《美國眾神》，它講述了古老文化與流行文化、上古之神和新的神之間的衝突。另外我也是後搖音樂的死忠樂迷，這類音樂幫助我在創作的時候集中精神，我最喜歡的樂團是魔怪。

Q. 除了當設計師／插畫家，你是否已經開始規劃下一階段的目標？例如策展、學習煮菜、登山

A. 到那時，我想要回頭騎自行車，我已經讓自己的腳踏車形單影隻多年，我想它現在一定很寂寞吧，我必須再次成為它的朋友。

Q. 你對生活的細節上有什麼堅持嗎？(像是上廁所時一定要看詩集之類的)

A. 我建議人們要更加友善、開放，你永遠不會後悔保持善良。

Q.**What do you like best in your country? (such as country feature or culture)Has it made a difference on your creation?**

A. I've always find inspiration in patterns. And Malaysia has a lot of inspiration from traditional pattern designs and the mixture of races and also the indigenous races that populate the country makes it even more interesting. The patterns that are used on fabric and tiles are what that inspires me. The marriage of culture have given birth to interesting designs ideas. From geometry and free flowing patterns, these have open my mind and make me want to produce more work.

Q.**How do you draw inspiration?**

A. The fabric market have been very kind to me. The huge database of pattern design that I can refer has helped me a lot in coming out with my designs. I'm also blessed with having a lot of friends from different walks of life. They often give me ideas and sometimes I find their thoughts interesting, where I'll use them to create my work.

Q.**Share good books, music, movies or places with us.**

A. Fantasy books by Neil Gaiman, American Gods. It tells the story about the clash of old culture and pop culture. Old Gods and New Gods. Also I am a big fan of post rock music. This genre helps me concentrate when I do my work. My favourite band is Mogwai.

Q.**Have you started to set up new goals for next period except being a designer or illustrator ? like curating, learning cooking , climbing......**

A. At the moment, I'm trying to get back to cycling. I've a bicycle that has been left alone for a year, I think it is lonely now. I need to be his friend again.

Q.**What is your insist on your life's details ? like toilet with your favorite poem?**

A. I suggest that people be more friendly and open. You never regret when you are being kind.

Mogwai. Live in Kuala Lumpur (fan art poster) 2014 *P.100*
MOGWAI 音樂會的粉絲藝術海報，是個人的創作。
A fan art poster of the Mogwai live concert. Produced for personal use.

Sesungguhnya Hidup Ini Tenang 2014 *P.223*
這個在設計裡有一個隱藏的意義，我只是想要玩一下，自己做一個手寫字體。
There is a hidden meaning in the design. I wanted to just play around with customising a script font.

EMPRESS (BLACK, WHITE AND SKATEBOARD DECK) 2015 *P.248*
這些作品都是企圖在探索如何以幾何形創造風格化的人像畫，我故意不在臉部留下表情。
These works were my attempts on exploring how geometric shapes can be formed to do a stylised portrait. The faces are intentionally left expressionless.

Line Fixation 2015 *P.249*
這系列作品是為了 Urban Xchange 2015 跨城藝術交流展的 The Artisan Project 而做的。所有印刷品都展示在馬來西亞檳城的風車路興巴士藝廊，將所有設計品編成十種版本，透過網版印刷印在檔案紙上，並提供販賣。
These works were done for Urban Xchange 2015 - The Artisan Project. All prints were on display at Hin Bus Art Depot, Penang, Malaysia. All designs were screen printed in editions of 10 on archival paper and are for sale.

Duality - Balanced Forces (The Great Wave) 2014 *P.251*
現在已經有許多北齋原畫的二次創作，我認為自己必須保存北齋畫作真正的意義，像是海嘯朝海岸襲去，而漁船在海浪之間搖擺，那股純粹的力量。我的設計過程走便許多地方，也嘗試了許多方法，但是最後我決定了想法，著重於大自然該如何在其中扮演重要的角色。這件作品是作為吉隆坡一間咖啡廳的委託完成。
There have been a lot of reimagining of the original artwork by Hokusai, and I feel that I've to keep the true meaning of it, which the sheer force of a tsunami hitting a coast with boats rocking in the between waves. My design process went all over place and went through many treatments, but I finally settled on the idea of how balance plays an integral in nature. This work was done as a commission for a cafe in Kuala Lumpur.

新加坡 Singapore

Fizah Rahim & Rezaliando

www.machineast.com

Machineast 是兩位設計總監 Fizah Rahim 與 Rezaliando 的組合，歷經十年極為豐富的創意產業經驗之後，他們決定在 2014 年合作，向自身的創意與技術挑戰，讓創意不受限制，獲得國際品牌與世界各地的合作者好評。

Machineast is a collective of two design directors - Fizah Rahim and Rezaliando. After having a very extensive experience in the creative industry for ten years, both of them decided to collaborate in 2014 to challenge themselves creatively and technically. Machineast is a platform for both of them to express their creativity without any creative constraints and it has been very well received internationally from brands and worldwide collaborators.

Q. 請問您認為該國最棒的是什麼?(如國家的特色或文化等) 您的創作是否受其影響？

A. 我們都來自小小的城鎮，擁有豐富的文化背景 (Rezaliando 是來自印尼，Fizah 是來自馬來西亞)，我們的生長環境並沒有暴露在許多品牌和科技之下，但我們適應了傳統與文化。我們相信這有助於我們深耕強烈的藝術感受。另一方面，住在新加坡絕對幫助我們進入技術與硬體的創作，在這裡科技、藝術和設計都很受到推崇，這是我們非常幸運的地方，它可能不像紐約這麼大，但新加坡在藝術和設計都正在進步當中，我們對此充滿希望。

Q. 請問您如何獲得靈感？

A. 旅行對我們來說絕對是觸發創意的方式之一，因為它迫使你離開數位世界和你的電腦螢幕，離開你的舒適圈，這會讓你獲得新鮮的想法還有創意的流動，我們也很享受從遊戲找靈感，我們會注意開場的標題、介面設計、電影鏡頭還有構成，基本上我們會分析不同鏡頭和遊戲所有的細節，現在的電玩遊戲就像是在看電影。還有聽喜歡音樂、結識新朋友也可以得到靈感，可以說其實任何事情都可以尋得靈感。

Q. 請和我們分享您喜歡的書籍、音樂、電影或場所。

A. 我們強烈推薦去拜訪日本的京都，去年十一月我們到了京都，讓我們感到非常驚豔，舊的傳統的設計與現代科技能夠聯手融合，這是我們故鄉缺少的某種東西，書的話，我們推薦 Austin Kleon 的書 (Steal Like An Artist 和 Show Your Work)，這是關於讓你的書在那裡，如果沒有網路，它就不存在。

Q. 現在，回頭來看這些帶著遺珠之憾的作品，您有什麼新的感觸？

A. 作品被退回的時候，我們並不會覺得難過，而這並不會讓我們停止嘗試下一次的案子，你的作品不被採用沒什麼大不了，這就和生活一樣，總是有起起落落，你必須先知道失敗，才能知道成功。

Q.What do you like best in your country? (such as country feature or culture)Has it made a difference on your creation?

A. We both came from small towns that have a rich cultural background (Rezaliando from Indonesia and Fizah from Malaysia). Growing up we were not exposed to a lot of brands and technology, but we were more attuned to tradition and culture. We believe that this helped in ingraining strong art sense in us. Living in Singapore, on the other hand, helped us in accessing technologies and hardware to create our craft. We are very fortunate that technology, art, and design are appreciated here. It may not be as big as in New York, but we are very hopeful that Singapore is progressing towards a great art and design movement.

Q.How do you draw inspiration?

A. Travelling is one of the creative triggers for both of us when it comes to drawing inspiration because it forces you to get away from the digital world and your computer screens as well as from your comfort zone. We get fresh new ideas and the creative juices flowing. We also enjoy gaming as a source of inspiration. We would pay attention to the opening titles, the interface design, the cinematic camera & composition, analyzing every single detail on different shots and gameplay. Video games nowadays are equivalent as watching a movie. We also get inspired when we listen to music that we like and meeting new people. I guess you could say you could get inspiration from anything.

Q.Share good books, music, movies or places with us.

A. We highly recommend visiting Kyoto, Japan. We were at Kyoto last November, and we were amazed at how the mixture of old traditional design as well as the modern technology could go hand in hand.

For books, we recommend books by Austin Kleon (Steal Like An Artist & Show Your Work). It's about getting your work out there. If it is not online, it doesn't exist. As for movies, watch The Fall by Tarsem Singh. The cinematography is breathtaking and every time we watch the film, it inspires us to create new artwork.

Q.Now, look back to these works of regret for not been selected, how do you feel that?

A. We do not feel bad about getting our work rejected and this does not stop us from trying in the next project. It is alright to get your work rejected because similar to life, there are always ups and downs. To know success, you have to know failure.

Join the Dark Side 2015 P.222
個人的粉絲創作，出自對於星際大戰的愛。
A personal fanart piece that we created out of our love for Star Wars.

Party As One 2015 P.223
我們的任務是建立主視覺 / 標誌字，捕捉 ZoukOut 的精神以及兄弟般的感覺。PARTY AS ONE 將會是他們的戰鬥口號，這是我們的發展，也是替這項活動做的最終設計。在這個案子裡我們提了三個主視覺，但這兩個都被客戶拒絕，即使它最後沒被採用，但我們還是對這件作品感到驕傲。
Our task is to develop a key visual / logotype to capture the spirit of ZoukOut and the sense of brotherhood. PARTY AS ONE will be their rallying cry, and this is our development and the final design for the campaign. We delivered three key visuals for the project however these two were the ones that the client rejected. Even though the client didn't use these visuals in the final event, we are still proud of these pieces.

Oh My Pastel! Series 2015 P.293
我們想在這次的系列使用可口的全息顏色和粉蠟，探討顏色混合的模擬。這張實驗的抽象設計，某種程度上是從 Rainbow Paper Series 的延續。
We wanted to explore mixing cloth simulations with yummy holography colours and pastels with this series. These experimental abstract design pieces are in a way, a continuation from the 'Rainbow Paper Series' which paid homage to the bygone era of shiny, shimmering, colors that so characterized our childhood. Oh, pastels just want to have fun!

Rainbow Paper Series 2015 P.293
我們在 80 年代長大，已經發展了大量迷人的全息色彩，這系列的實驗抽像設計作品，是我們以自己的方式，向童年的特色，向那些閃亮亮的色彩致敬。
Having grown up in the 80s, we've developed a massive fascination with holographic colours. These experimental abstract design pieces are our way of paying homage to the bygone era of shiny, shimmering, colours that so characterised our childhood.

Translucent Iridescent 2015 P.293
最近我們在秋天到日本進行啟發之旅，回來後神清氣爽，而且想重新創作出那種寒冷帶點溫暖，那種不合常理感覺，因此催生了這個系列 " Translucent Iridescent "。
Recently we had an inspiring trip to Japan in autumn. We came back refreshed and wanted to recreate the feeling of coldness and a little warmth that is unconventional. That's when we came up with this series "Translucent Iridescent".

日本 Japan

1981 年生於日本，在東京生活、工作。

她在 2011 年成立個人設計機構 coton design，得過的獎項包含香港海報國際三年展 2010 銅獎及評審獎、第 18 屆芬蘭拉赫第國際海報三年展榮譽證書。

Born in Japan 1981. Lives and works in Tokyo.

She started her own solo design unit called coton design in 2011. Her Awards include Bronze Award and Judges Award at Hong Kong International Poster Triennial 2010 and a Certificate of Honour in the Lahti XVIII Poster Biennial.

Hiroko Sakai

www.coton-design.com

Q. 請問您認為該國最棒的是什麼?(如國家的特色或文化等) 您的創作是否受其影響?

A. 日本的四季。我喜歡隨著日本的景觀會隨著季節轉換，花朵在各自的時節綻放，造就了每個季節多元的景色，在我配色和繪圖的時候，日本的四季景色就是我的靈感來源。

Q. 請問您如何獲得靈感?

A. 想像與回憶過往的經驗。

Q. 除了當設計師 / 插畫家，你是否已經開始規劃下一階段的目標? 例如策展、學習煮菜、登山......

A. 花道(日本插花)。在插花的過程裡，我可以練習找尋自己的感覺，以及訓練理解空間的能力。

Q. 你對生活的細節上有什麼堅持嗎?(像是上廁所時一定要看詩集之類的)

A. 到我工作室附近的公園散步。

Q. What do you like best in your country? (such as country feature or culture) Has it made a difference on your creation?

A. Japanese four seasons. I like seasonal scenery with the changing colors of nature. Many flowers bloom seasonally so each season has very different landscapes and colors. Japanese seasonal colors are my inspiration when I decide color combination and make illustration.

Q. How do you draw inspiration?

A. Image and recall my memory and experience.

Q. Have you started to set up new goals for next period except being a designer or illustrator ? like curating, learning cooking , climbing......

A. Ikebana (Japanese flower arrangement). When I do the Ikebana, I practice to seek own sense of regarding things. I can train an ability of understanding space.

Q. What is your insist on your life's details ? like toilet with your favorite poem?

A. To take a walk in leafy park near my studio.

Studio couche paper bags *2012 P.50*

替兒童攝影工作室 Studio Couche 設計的原創紙袋，當放下紙袋的時候，把手形成兒童的臉部輪廓，而拉住把手時，會出現字母跟數字。

They are original paper bags for the kids' photo studio "Studio Couche". When you put a paper bag, handle makes the facial contour of a child and the child's face appears. When you hold the bag, an alphabet and a number appear.

Colorful shadow *2010 P.118*

2010 年做的實驗海報，我使用特殊的形狀與字體，加入光影變化。

Experimental posters in 2010. I made unique shapes and typography with light and shadow.

Studio couche poster – hole – *2013 P.120*

這是在 2013 年替兒童攝影工作室 Studio Couche 做的海報。

A poster for the kids' photo studio "Studio Couche " in 2013.

Studio couche poster – lace – *2012 P.120*

這是在 2012 年替兒童攝影工作室 Studio Couche 做的海報。

A poster for the kids' photo studio "Studio Couche " in 2012.

Utsuroi *2010 P.120*

在 2010 年的展覽「ATTENTION」展出的海報，靈感來於日本的一首古詩。

A poster for the exhibition "ATTENTION" in 2010 . The inspiration was from the Japanese old poem.

Le poilu poster *2015 P.121*

替「le poilu」這間織物工作室設計的海報。

A poster for the woven fabric studio "le poilu".

動物卡片 Animal card *2014 P.232*

這是兒童攝影工作室 Studio Couche 的原創卡片，花紋卡片與信封可以讓孩子們賞玩，將印有花紋的卡片放進信封裡，可能就會出現一隻斑馬、一頭牛、一隻老虎或是一隻豹。

They are original cards of the kids' photo studio "Studio Couche".

Children can play with envelopes and patterned cards. When you put the patterned cards in the envelope, a zebra, a cow, a tiger or a leopard appears.

Food cloth *2009 P.267*

為了展覽「たべものと布(食物與布料)」做的食物樣式布料。

A food cloth for the exhibition "tabemono to nuno (Food and Cloth)".

日本 Japan

Hiromi Maeo | enhanced Inc.

www.behance.net/enhanced_hiromimaeo

我的格言是「設計因抓住本質而不朽」，一直以來，我幾乎參與了所有關於 CI 和 VI 的企業品牌、藝術指導，幾年前我的作品被刊登在許多設計相關的網站和出版物裡，在 2015 年 9 月的時候，國際認可的協會 Adobe ico-D(設計的國際理事會) 將我任命為營商友導計劃的第一位日本導師。

My Motto is timeless design with grasp of essence. I have been involved in pretty much everything related to CI and VI for corporate branding, Art Direction, Design Consulting etc. Past few years my works has been featured in various design related web sites and publications around the world. In September 2015, I have been appointed as the first Japanese mentor by internationally recognized association, Adobe ico-D (the International Council of Design) mentorship program.

Q. 請問您認為該國最棒的是什麼 ?(如國家的特色或文化等) 您的創作是否受其影響？

A. 服飾工藝與注重細節的地方。我的設計風格最大的特色就是使用精緻的網格結構，我覺得這是來自於日本對於細節的注重與勤奮的職業道德，此外我的極簡主義設計，大半是受到來自於禪宗和神道精神的影響，這兩者已經成為我生活的一部份了。

Q. 請問您如何獲得靈感？

A. 首先，我會撿拾客戶所描述的關鍵字，根據這些關鍵字使用類似心智圖的工具，系統化地擴展訊息，然後產生「這樣設計之後看起來像是什麼？」的想法。靈感從何而來，我會說從設計經驗與人生經驗得到過去得到的知識也會幫助自己得到靈感。

Q. 現在，回頭來看這些帶著遺珠之憾的作品，您有什麼新的感觸？

A. 有句俗語叫做「啐啄同時」，小雞從蛋殼內破殼稱為「啐」，母雞從外頭幫助小雞破殼稱為「啄」，兩邊需同時進行，小雞才能順利誕生。這句話教導我們時機的重要性，機會是不可求的，它只會在兩者時機成熟的時候起作用，我相信這就是我的作品有段時間無法問世的原因，我還沒準備好。現在以我為名的作品終於開始展現出來，我覺得這個被稱為「啐啄同時」的時機終於來到我的身邊。

Q. 你對生活的細節上有什麼堅持嗎 ?(像是上廁所時一定要看詩集之類的)

A. 每天我開始工作之前會播放一首音樂，音樂可以提升我整天的創意。

Q.What do you like best in your country? (such as country feature or culture)Has it made a difference on your creation?

A. Finery of works and attention to details. Characteristic of my design style is use of refined grid structuring. I think this come from Japanese sensibilities in details and diligent work ethics. My design is also significantly influenced by minimalism rooted by Zen, and the philosophy of Shinto that has been part of our life.

Q.How do you draw inspiration?

A. First and foremost, I pick up key words from clients descriptions and based on those keywords, I systematically expand information using something like a mind map. Then form ideas of what the design should look like. In terms of where those ideas come from, I would say those come from both my design experience and life experience also come from knowledge I have gained in the past.

Q.Now, look back to these works of regret for not been selected, how do you feel that?

A. There is a saying in ZEN called 啐啄同時 (Settaku – Douji). 啐 (Sotsu) means a chick pecking inside of egg in effort of trying to come out of the shell, 啄 (taku) means a parent bird helping a chick from outside. When timing of both efforts are in sync, chick will be born smoothly. So this word teaches importance of chance(critical timing) when achieving something. The chance does not come to you just by going after or just being given. The chance only works when time is ripe for both parties. I believe that this is the reason why my works did not come out for a while, until the time is right. I was not ready. Now works that carry my name finally start coming out in the world. There are more to come. I feel that the time described as 啐啄同時 (Settaku – Douji) is finally here for me.

Q.What is your insist on your life's details ? like toilet with your favorite poem?

A. I play one music every day before I start my work. That music boosts my creative drive up for the day.

MTRL KYOTO New Identity 2015 P.144
MTRL KYOTO 是最近在東京和京都成立的共同工作空間，由我負責視覺設計與藝術指導。我設計的商標結合四種基礎素材的象徵，分別是：1. 實體 (傳統素材、新素材)、2. 人 (創作者和學者)、3. 企業 (提供新的技術和傳統素材的公司) 4. 經理人 (MTRL 的創辦人)。當這四樣素材結合在一起時，它就成為了名為 MTRL 的空間，因此這個符號可以組合出許多不同的變化。
VI design and art direction for recently opened Co-working spaces in Kyoto and Tokyo. I have created logo combining 4 fundamental material symbols. 4 fundamental materials are 1. Physical Materials (Traditional material, New material) 2. Human Materials (Creators and Academics), 3. Corporate Materials (Corporation which provide new technology and traditional materials) 4. General materials (Founder of MTRL). When these fundamental materials comes together, it create the space called MTRL, thus there can be many different variations of the symbol combination.

DOTO Rebranding 2015 P.145
替一間擁有超過 50 年歷史的北海道東部的公司進行品牌重塑。我想讓象徵極簡化而且不朽，成為未來五十年都可以一直使用的視覺標線。商標中間的紅線像是一道每天都必需要跨越的牆，因為必須面臨挑戰，所以他們會茁壯到可以面對更高大的牆。紅色象徵著克服一切的熱情與能量，也是代表著日本魂的顏色。
Rebranding project for the company that has more than 50 years history in Eastern Hokkaido. I wanted the symbol to be minimalistic and timeless, designed to be there visual milestone marking the next 50 years. The red line at the center of the logo is the wall they have to get over daily. Because they challenge to do so, they will grow and be able to face even bigger wall. Color red symbolize the passion to conquer and energy and it is the color of Japanese soul.

MICAI Identity Renewal 2015 P.145
商標識別更新的對象是香港的投資顧問公司，他們的目標是設立簡單方便的私人投資平台，成為適合所有人的個人財務管理者。使用樹做比喻，形容這個平台帶給投資者良好的財務與美好的人生。我設計的商標符合普遍的喜好，所以他們可以擴展亞洲以外的市場。
The logo renewal project for investment solution provider based in Hong Kong. Their objective is to become personal finance manager for all people by making the simple and easy investment

platform for private investors. Metaphor used is a tree representing the financial prosperity and good life brought to users who invest through this platform. I created the logo to have universal appeal so they can expand the market beyond Asia.

YouTube Space Tokyo Art Night 2015 P.233
這項作品是為了 Youtube 設計師和藝術家的見面會所設計。使用許多相同形狀的物體，像是點、圓和條紋，表達出他們的共通點：「創造事物」，而把這些形狀疊加起來產生的波紋效應，代表著設計師與藝術家彼此見面之後產生的轉變，然後再把 Youtube 加入，覆蓋在它們上面，這樣的轉變就變得更加明顯。
The Graphic is designed for the meet up events of Youtube creators and artists. Group of same shape objects such as dots, circles, stripes are used to represent their common trait "create something" which creators and artists share. By layering objects, its moire effect represents the transformation of their minds that can be caused by meeting of two. When you add Youtube over them, such transformations become even more significant.

澳門 MACAU

Tun Ho(何立騰)，香港出生、現居澳門，從事平面設計；設計方面主要是品牌識品、書刊設計、活動視覺等，偶然畫插圖，曾經想當個漫畫家。畢業於台灣中原大學商業設計學系。

Tun Ho, born in Hong Kong, now living in Macau. Works as a graphic designer, specialized in branding, editorial design, dynamic visual, etc. Sometimes illustration, once wanted to be a cartoonist. Graduated from Chung Yuan Christian University Taiwan, bachelor of Commercial Design.

何立騰 Ho Tun

imtunho.com

Q. 請問您如何獲得靈感？

A. 一般人會做的上網、看書、逛展那些都一定要的, 但我覺得最重要的是聊天, 跟客戶也好跟朋友也好, 很多有趣的想法都是邊聊邊開玩笑後就出來了。

Q. 請和我們分享您喜歡的書籍、音樂、電影或場所。

A. 書籍：《世界末日與冷酷異境》，喜歡那種夢與現實的交錯；
音樂：我很鍾情已解散的東京事變，後來就開始聽吉他手浮雲自己的團 Petrolz，他的編曲跟彈法都很讓人意想不到。
場所：茶餐廳是我最自在的地方，但我不太吃豬扒包；要喝過奶茶或鴛鴦才算是一天的開始。

Q. 現在, 回頭來看這些帶著遺珠之憾的作品，您有什麼新的感觸？

A. 回頭看有些都還是讓我覺得「你當初怎麼不選這個提案」的感覺，有些則是讓我自己看到自己當時的不足之處。有些是長期的客戶，所以看到的除了是自己的進步，也會有看到客戶想法上的一些改變，世界就是不停在轉，人的品味也跟著變，所以覺得做設計的確是很有趣。

Q. 除了當設計師 / 插畫家, 你是否已經開始規劃下一階段的目標？例如策展、學習煮菜、登山

A. 那對我來說還太早了點，自己還很年輕我想未來十幾年都還是會做設計吧！但我有想過如果不做設計的話應該會想要開計程車，因為看了手塚治虫的漫畫《午夜計程車》覺得很酷，哪裡有人有緊急需要就去載他再大賺一筆。這幾年來澳門本地人要攔到計程車真的是超困難，讓我又想起了這部漫畫，當然前題是要先研發出那台有思考能力的計程車才行。

Q. How do you draw inspiration?

A. You have to surfing the Internet, reading books, visiting the exhibition, do the things must people will do. But I think the most important things is to chat with your clients or friends, a lot of interesting ideas are come out while chatting or joking.

Q. Share good books, music, movies or places with us.

A. Book: " Hard-Boiled Wanderland and the End of the World ," like the blend of dream and reality;

Music: I'm fond of Tokyo Incidents, after it disband I started to listen Petrolz, the guitar Ukigumo's band, his arrangement and the skill of playing guitar are very unexpected.

Place: The tea restaurant is the most comfortable place for me, but I don't eat Pork Chop Bun; I always have a cup of milk tea or Yuanyang as the beginning of the day.

Q. Now, look back to these works of regret for not been selected, how do you feel that?

A. I would still think like: "Why you did not choose this proposal?" when looking back some of my works. But some make me discover the deficiencies that time. O work with some long-term clients, so I saw not only my advancement but the change of client's mind. The world is keep going round, and people's taste constantly changed, so I think it is fun to do design.

Q. Have you started to set up new goals for next period except being a designer or illustrator ? like curating, learning cooking , climbing......

A. That is too early for me, I'm still young and will keep doing design in the next ten years! But I might want to drive a taxi if I don't design anymore. Because I had read the comic "Midnight Taxi" by Tezuka Osamu and I thought it is so cold to make a fortune by picking people up when they have urgent need. In recent years, it is hard for local to stop the taxi in Macao, so I thought of the comic, of course, the dream will come true.

酒吧 LAUNCH 2012 *P.189*
LAUNCH 是一間休閒酒吧，店裡氣氛不會過於熱鬧，希望能為客人提供一個舒適的環境小酎一番，即使是一個人來也不會感到不自在。Logo 設計走比較隨性的路線，沒有過於工整的線條，像隨風飄逸般，讓人視覺上有放鬆的感覺。
LAUNCH is a lounge bar that doesn't have much activity atmosphere, hoping to provide a comfortable environment for the guests who like to have a drink, even will not feel uncomfortable to come along. A casual route was designed for logo without overly neat lines, just like the wind flowing and make a feeling of relaxation on the visual.

Giraffe Meadows 2013 *P.189*
Giraffe Meadows，女裝服飾店，六角形中的曲線波浪、圖點及空白素色代表衣服不同的圖案合集，而切割後的梯形、平行四邊形及三角形則代表不同的剪裁。以衣服掛標牌的形狀為 Logo 設計主體，是有考慮到以後在名片及標籤等延伸的應用上。
Giraffe Meadows is a clothing store for women, expresses the different pattern collections on clothes through the hexagonal curve waves, dots and solid color. The cutting trapezoid, parallelogram and triangle represent a different cut of clothes. Using the form of hanging tag as logo design for considering the application such as business cards and labels.

Poison Manufacture 2013 *P.189*
用「毒品工場」命名的男裝服飾店，店家搜羅日本不同男裝潮牌，令人買衣服買上癮。以紳士及骷髏兩大潮流 icon 結合作為設計形象，以統一粗細的線條構成，原因是為了建議客戶用霓虹燈管製作招牌。
A men's clothing store given a name " Poison Manufacture," collecting different Japanese tide brand and make people become a shopaholic. Combining two major trends of icon, gentleman and skull, as the design visual. With stander thickness of lines to construct logo, the reason is to advice the clients to make the sign with neon tubes.

澳門中央公積金制度 Macao pension system 2014 *P.189*
澳門社會保障基金提出構建雙層式社會保障制度，除了第一層基本的養老保障及就業期間的工作風險保障，退休後較寬裕的生活保障則由第二層中央公積金制度支持。三個未完成的圓代表僱主及僱員雙方供款以及政府的管理及特別撥款，三方共同構築及儲蓄而成的退休基金。

The Social Security Fond of Macao come up with building a Two-tier Social security system, in addition to the first tier, basic pension system and job security during employment period, the retirement living security system is supported by Central Public Accumulation System form second tier. The three unfinished circles represent the contributory of both employers and employees, and the special contributory from the government, the retirement fund accumulated from these three parts build together.

千笹日本料理 Chi Sasa Japanese Restaurant 2012 *P.189*
以日本家紋為概念，「笹」意思為矮小的竹，本想以竹的形態做出接近傳統的 Logo，但因客戶想以文字為主體，捨棄植物圖案，把筆劃做得比較細及不規則代之。
Using the family cress of Japan as the concept. "Sasa" means short bamboo. At first, I wanted to make traditional logo by using the form of bamboo, but the clients wanted the text as the main visual, so I thrown away the plant pattern and replaced it with relatively thin strokes and irregular shape.

觀妍中醫美學 Guan Yan 2015 *P.189*
以中醫角度及中藥配方調理身體達至美容效果，觀妍帶出的是傳統中醫及年輕美容的結合。以最小量的中式元素放到設計裡，線條主要是 45 度和 90 度，務求做到現代感與古典並存。
Formulate the physical conditioning with the angle of Chinese medicine to achieve cosmetic results, Guan Yan combine the traditional Chinese medicine and young beauty. With a minimum amount of Chinese elements put into the design, and the line main with 45 degrees and 90 degrees, to reach the coexist of modern and classic.

南韓 Republic of Korea

Hong Eun-Joo,Kim Hyung-Jae

hongxkim.com

Eunjoo Hong 和 Hyungjae Kim 都是自由設計工作者, 有廣泛的視覺設計經驗, 從沒有被任何概念或目標限制。從 2007 年在首爾開始彼此合作夥伴關係。兩位的作品都曾在各大媒體網路、出版展示, 並涉及寫作、編輯和策展。Gazzazapzi 則是在 2007 年聯合一起出版, 且為非定期文化雜誌 DOMINO 創始成員及投稿人。

Eunjoo Hong & Hyungjae Kim are a freelance graphic designer duo who work on a wide range of visual experiments without restrictions in concept or aim. They have been working together as a full partnership since 2007 in Seoul. Their design works are showcased in various media including web and publication, and also involve in writing, editing and curating. They have been co-publishing Gazzazapzi since 2007, and are founding members and contributors to the non periodical culture magazine DOMINO.

Q. 請問您認為該國最棒的是什麼？(如國家的特色或文化等) 您的創作是否受其影響？

A. 我們喜歡首爾。首爾非常大又複雜, 復古又新潮, 快速又沉靜。但對我們來說是有趣的且相對舒適。我們也不懂為什麼感到安心。

Q. 請問您如何獲得靈感？

A. 當我們精疲力盡時, 我們會在市中心街頭散步。

Q. 請和我們分享您喜歡的書籍、音樂、電影或場所。

A. Netflix (網飛) 最近在韓國開通了, 我們目前喜歡一些美式和英式節目, 跟喜歡日本和韓國節目一樣。

Q. 你對生活的細節上有什麼堅持嗎？(像是上廁所時一定要看詩集之類的)

A. 為我們的家和工作室用上好的香味, 我們熱愛使用香氛蠟燭和香氛水氧機。

Q.What do you like best in your country? (such as country feature or culture)Has it made a difference on your creation?

A. We like Seoul. Seoul is an enormous and complex city, old and new, fast and stillness. It may look messy, but it interests us for that complexity and it also comforts us in various ways. We don't understand why we feel comfort from it.

Q.How do you draw inspiration?

A. When we are exhausted from working, we usually walk along the street in the center of the old city of Seoul.

Q.Share good books, music, movies or places with us.

A. Netflix launched its service in Korea recently. We enjoyed some American and English TV shows as much as we love Japanese and Korean TV shows.

Q.What is your insist on your life's details ? like toilet with your favorite poem?

A. Good scent for our home and work place. We love to use candles and fabric softeners or flowers or fruits.

SeMA Biennale Mediacity Seoul *2014 P.260*

這是 2014 韓國媒體城市首爾雙年展的網站。網頁開啟時, 一個怪異的物體緩慢地飄游在螢幕上像個鬼魂。關鍵詞是：鬼、間諜和祖母。

It is a website for the SeMA Biennale Mediacity seoul in 2014. The Page opens up with the weird objects flying slowly on the screen like ghost. It represents the keyword, 'Ghosts, Spies, and Grandmothers.'

Typojanchi *2013 P.261*

於 2013 年韓國印刷雙年展的網頁, Typojanchi。每一個網頁, 每個元素在按下的瞬間會重新排列, 強調 Supertext 的不穩定, 符合雙年展的主題。

It is a website for the Typography Biennale in Korea, Typojanchi in 2013. Every web pages, in which the elements are rearranged the moment one touches upon any of them, emphasize the unstable nature of the 'Supertext', which is a theme of the biennale.

Out of the Ordinary *2015 P.262*

「Out of the Ordinary」是展出韓國年輕建築師得獎作品的展覽, 在倫敦卡思畫廊舉辦。照片是在韓國附近郊區拍的。

"Out of the Ordinary" is an exhibition for the award winning works by young Korean architects. It is held in the Cass Gallery, London. The two photographs in the poster were taken in suburb area near Seoul.

Political Patterns *2015 P.262*

這個展覽特點是一些藝術家的做法, 試圖以非洲的政治局勢和傳統圖案的語意及美學作為一個交集點。我們用 A, F, R, I, C, A, N, O, W 與各種形狀的圖標融合在作品中。

This exhibition features artists whose practices serve as a meeting point for Africa's political situation and the semantics and aesthetics of traditional patterns. We made alphabet A, F, R, I, C, A, N, O, W with various shaped icons what is looks like a part of artists' works.

Archive Platform *2015 P.262*

這是為舞蹈公司繪製的海報。封存身體舞動的瞬間是此次演出特別的概念, 我們希望這張圖片能表現這演出的核心概念。

It is a poster for the dance company. 'Archiving' the movement of body was a special concept for this show. We thought that the image of some 'archived objects' could represent the concept of choreography of the show.

New Skin: Modeling and Attaching *2015 P.262*

這是一個宣告年輕藝術家如何在上一個世代的媒體環境能與眾不同的成長的展覽。我們希望能讓 skin 在這麼鮮豔複雜的圖案中凸顯出來。

It was the exhibition for announcing young artists who grew up in a media environment very different from what the previous generation. We want to make showy skin so lay several colorful patterns out intricately.

台灣 Taiwan

自由平面設計師，1989 年出生，現居台北。

憑著對設計的熱情、對美感的直覺，努力自學、隨時觀察、不斷自我要求。

三年平面設計專案經驗後，2015 年起獨身全職接案，致力為客戶量身打造優質設計，專長平面設計、文字設計 ... 等。

Freelance Graphic Designer.Born in 1989.Now live in Taipei.

With the passion on design, confidence on sense of beauty, Constant observation, high demand to myself.

After the experience of three years on Graphic design,I decided to become a freelancer in 2015.Worked for the clients who needs high quality design.

Focus on Graphic design, Typography...etc.

徐慶安　Hsu Ching-An

www.behance.net/ht22660001227

Q. 請問您如何獲得靈感？

A. 我喜歡聽音樂激發靈感，曲子的旋律及節奏都能營造出特有的氛圍，在我腦裡浮現不同情境與畫面。另一方面是因為聽音樂能紓解壓力、保持好心情！心情輕鬆之下，常常會有意想不到的靈感來敲門。

Q. 現在，回頭來看這些帶著遺珠之憾的作品，您有什麼新的感觸？

A. 因為不斷的學習，因此覺得自己一直進步！每個作品完成時，通常都已經是自己覺得這作品最好的狀態了，但時間一久，回頭再看，有時卻能找出當初沒注意到的細節。我喜歡這種一步一腳印的踏實感，比昨天的自己更精進了！

Q. 除了當設計師/插畫家，你是否已經開始規劃下一階段的目標？例如策展、學習煮菜、登山

A. 接下來的目標是練熟自己喜歡的曲子：黃海懷的《賽馬》以及林姆斯基 - 高沙可夫的《大黃蜂的飛行》。我學二胡已經 8 年多了，平時喜歡拉一些簡單的曲子紓解壓力，它是我放鬆時的最佳良伴！希望自己有朝一日能輕鬆駕馭這兩首快節奏的曲子。

Q. 你對生活的細節上有什麼堅持嗎？(像是上廁所時一定要看詩集之類的)

A. 不論冬天多冷，也不管長髮吹乾有多麻煩。早晨洗髮是我的堅持，超過十多多年從沒間斷過的習慣。打理好三千煩惱絲，整個人神清氣爽，能夠保持愉悅的心情應對生活大小事。

Q.How do you draw inspiration?

A. By listening to Chinese music like "Horse Racing", lots of rhythm and tempo bring out a special atmosphere of enthusiasm. It will appear so many different pictures and thoughts on my mind. Another reason is just simply keeping me a good mood and thoughts will come to say hello to me more easily.

Q.Now, look back to these works of regret for not been selected, how do you feel that?

A. I feel I get improved every single time by constantly learning. Every time I finish one case, I feel like it's the best design I have ever created. And when time goes by, look back to those cases, I can still see some parts that need to work on and can be even better.I like the way it feels like. That means I get improved day by day.

Q.Have you started to set up new goals for next period except being a designer or illustrator ? like curating, learning cooking , climbing......

A. The next goal is mastering my two favorite songs: "Horse Racing-Huang Hai-huai" and" Flight of the Bumblebee - Rimsky Korsakov".I've learned erhu (Chinese violin) for about eight years, I play it to relax and enjoy the songs.Hope someday I can easily catch all the hard songs.

Q.What is your insist on your life's details ? like toilet with your favorite poem?

A. No matter how cold the weather is, no matter how much time it takes to dry the hair, washing hair in the morning is what I insist. It's been over ten years.After doing this, it makes me so energetic, so I can start a whole new beautiful day.

低調堅持 Insistence　2015　P.77

幾何圖形層層堆疊，如積木般、如鋼架般，雖不醒目，卻代表心中那股默默卻紮實的堅持。

The design of the mark shows up the Chinese character "insistence". Several layers of geometric figures lay together, Just like building blocks, steel frame. It's not attractive. But it turns out to be the most fundamental element of the all. We call it "Insistence".

串串燒 Skewered Food　2015　P.77

為了打造屬於台灣味的串燒店，把台灣特有的思維與串燒結合：餐廳為快速分辨便當的主菜，時常會在紙餐盒上，把「雞肉」諧音以 "G" 代替。

開心 × 享受 × 美味 = 吃串燒，將 "Glad"、"Joy"、"Yummy"、"Tasty"、"Love" 英文字首組合成串燒二字。

In the thought of creating a unique Skewer shop for Taiwan, mixing Taiwanese culture with skewer. It's often to see that restaurants use the word "G" to simply mean "Chicken" as it just sounds like the same when you say "chicken" in Chinese."Glad", "Joy", "Yummy", "Tasty" and "Lovely."By combining five English words' first letter into Chinese words which represents Skewered Food.

追憶 · 音緣 Remembrance of Rhythm in Love　2014　P.105

為元智大學國樂社打造一以大上海時代為主題的音樂會海報，底圖運用大面積的旗袍花布，象徵女人的愛情如花朵綻放與凋零般的美麗與哀愁；並在主視覺加入升降記號及休止符，用音樂述說一段若即若離、忽遠忽近的淒美愛情故事。

The Chinese music concert topic is Love story.Poster's background is a large cheongsam piece which represents that love is full of joy and sadness such as flowers blossom and falling.

歡迎蒞臨 Welcome　2014　P.225

端莊卻不拘束，安分中又帶點變化。

Dignified and unrestrained.

琴中有琴 Erhu　2013　P.253

我眼中的二胡組成元素，胡琴中又有胡琴。

By combining four English words into Chinese musical instruments erhu.

鱷魚叭叭 Mr. Crocodile - "Ba-ba"　2015　P.253

這是參加第八屆臺北藝穗節主視覺徵選的作品。把台灣人常用手比的 8 手勢想像成一隻鱷魚，象徵著各個才高八斗的非主流藝術者，就如這隻鱷魚先生一「叭叭」，自信的眼神沒有想像中的距離感，不怕被批評大方展現引以為傲的利齒，呈現最真實的自己，用牠扁平卻充滿力量的尾巴帥氣一甩，只要敢秀，處處都可以是盡情揮灑創意的舞台！來吧！張燈結綵一起迎接充滿驚奇的藝穗節吧！！！

Due to the reason of eighth time on Taipei Fringe Festival,I make the Taiwanese gesture eight as a crocodile.Outsider art is like this Mr. Crocodile called "Ba-ba".

Confident eyes full of friendly feeling,Not afraid of being criticized, showing up its great teeth,Be the truth self.Swing its powerful tail around.

It's always your show time as long as you dare to do.

台灣 Taiwan

來自台灣南投縣的平面設計師，喜好玩電玩。
創作的方向以因地制宜、形隨機能為主軸，
認為設計重心不在風格而在合適。
期望一日能在家鄉草屯鎮，效勞自己的所學。

A graphic designers comes from Nantou, Taiwan.
Likes to play video games.
Creates direction as the main varies as practical situation and form follows function, the design center is not in style but in right.
Hope one day can serve what I learned for my home, Caotun.

許瑋筌　Hsu Sion

www.sionhsu.com

Q. 請問您認為該國最棒的是什麼？(如國家的特色或文化等)您的創作是否受其影響？

A. 台灣的缺點可能就是優點，我們的美學教育，相較同樣經濟水平的國家，其實還滿差的，小小一個台灣設計圈裡面，程度落差就非常大，也因此沒有太典型的規範，或許真的有機會走出不同特色。

Q. 請問您如何獲得靈感？

A. 我生活在山麓下的小村落，像這樣的地方，通常會意外的封存舊時光，這些聚落巷弄，通常是自然形成，而非按照都市計畫而成的，許多該從復古劇看到的，在這都還生活著；因此我的靈感來源十分在地化，但表現形式不免還是很全球化的。

Q. 請和我們分享您喜歡的書籍、音樂、電影或場所。

A. 我最深刻的書籍是 Carson McCullers 的 " 心是孤獨的獵手 The Heart Is A Lonely Hunter"，裡面有一段文字，描述從黑夜到清晨的過程，那極度令人眼瞎的藍，十分確著，至今另我難以忘懷。音樂喜好一直很多元，大多時候聆聽 Dragon Quest 以及 Final Fantasy 的配樂。
電影則是 " 勢不兩立 The Edge"，美國的森林逃難片，印象中在南投戲院看的，當初本來不是要看這部，但當時的消費是一票兩片，算是伴隨著的，但是一直記著到現在。
最喜歡的場所就是所有田園野外，我實在嚮往村居。

Q. 現在，回頭來看這些帶著遺珠之憾的作品，您有什麼新的感觸？

A. 甫看到這個主題覺得很有趣，他一定會帶來抱怨的，回頭再看這些作品，我仍認為業者應該同意執行的，因為我並不是會應付了事的人，這些作品沒能問世，其實對彼此都是一種損失。

Q. 除了當設計師/插畫家，你是否已經開始規劃下一階段的目標？例如策展、學習煮菜、登山

A. 想著手振興故鄉草屯的文化，因為現有的傳統藝術家與作家，都太不與時並進了，過去的時代已經被完成了，該試著走過來當代。

Q. 你對生活的細節上有什麼堅持嗎？(像是上廁所時一定要看詩集之類的)

A. 出門一定要帶保溫杯跟一大包衛生紙。

Q. What do you like best in your country? (such as country feature or culture)Has it made a difference on your creation?

A. The art education is the weakness of Taiwan. It is behind other countries with same economy level. It leads to degree of drop in the design industry. However, it can be the opportunity as well because there are not much rules existed so it is more likely to try something different.

Q. How do you draw inspiration?

A. I lived in a small village in the bottom of a mountain. There are some villages still preserve the original ways of living. It is like what we saw in the vintage movies. As a result, my inspiration is more local, but still, I use a "globalized" way to present it.

Q. Share good books, music, movies or places with us.

A. My favorite book is "The heart is a lonely hunter" written by Carson McCullers. There is a part describes the transition from night to morning. It is a kind of blue that makes people blind. I was truly impressed. I listen to all variety of music. But most of the time I listen to the music from Dragon Quest and Final Fantasy. I really llke a movie called "The Edge".
I wasn't planning to see it, but it is free with other movie, and I watched it. It became a part of my memory until now.
Most love place is all landscape, I really want to live in the country.

Q. Now, look back to these works of regret for not been selected, how do you feel that?

A. This is an interesting question. When I looked back, I think it's the loss of them when it was not executed. Because I am not the kind of person who perfunctory.

Q. Have you started to set up new goals for next period except being a designer or illustrator ? like curating, learning cooking , climbing......

A. I want to revive the culture of my hometown. There are so many artists and writers and they don't want to change with time. What has been done is done. It's time to go modern.

Q. What is your insist on your life's details ? like toilet with your favorite poem?

A. I always bring a thermo mug and a big pack of tissue paper.

對未來的想像 Imagine the future　2014　P.76
專案目標是整個冬季檔期，採用一個較大的主題包覆，而不侷限於所謂聖誕檔期；由於必須囊括公司所有插畫師，所以完整的創作一套視覺出來，稱之為 mas graphic，並因應聖誕節衍伸出 Xmas graphic，與一系列周邊，可惜公司突然結束營運，此套視覺無法面世，頗為缺憾。
The project is aiming at winter, covering with a wider theme but not just about Christmas. It is called "mas graphic" is because it have to include all the Illustrator in the company, creating a series of visual design. There is also a special Xmas graphic and products, but it couldn't be executed because the company ran out of business.

存在的情境 Situation of existence　2015　P.76
我對存在的情境，概念是一遍灰白的畫面，繼虛無卻也存在，佐上大半氣質特殊的綠，來代表當他給人的印象，由於這是我從小生長的地方，所以以我來設計是最為適合的了，錯落的編排呈現，是我又一次自我突破，可惜在不專業的引導之下，此份作品最終走上毀滅之途，我只能以 Mockup 來重現他了。
"Existing" is like a "grey and white" image to me. It seems not there, but it is there. I use a lot of special green, to show its impression to people. I think I'm the best one to design it because I grew up there. Layout is a trying bringing me to the next level. However, it was misguided, and leaded to its destruction. So I can only show it again by Mockup.

關於性別 Think about gender　2011　P.257
這三件作品可說是我踏入平面設計的起始，正式嘗試架設版面的結構，是我至今仍然很滿意的作品，其中並

無太多圖像意念，僅以高閣連性的編排手法，來表達性別這個議題的纖細，也奠定了我往後，多以編排特性來處理視覺，而非特色強烈的圖像。
These three piece of works is the starting point of my career of being a designer. I tried to set up the structure of layout. It is one of my most satisfying pieces of works. It doesn't contain much imaging concept, but to arrange them according to the high connection in between, to show the simple of the topic of gender.

質樸的形象 Rustic image　2014　P.294
這系列插圖，是以我曾到過的場所發起的創作，從草屯到我旅行過的日本，共繪製了五幅，目的是想以圖像的手法，重新詮釋鄉土畫作。
This series of illustrations are about all the places I've been to. From Tsaotun to Japan. There are five of them. I try to redefine local by graphic.

台灣 Taiwan

徐毅驊，一個住在台北的自由設計師，今年二十歲，從事平面、字體等設計工作，喜歡吃東西。

Hsu-Yi-Hua, A freelance designer living in Taipei, twenty years old, work as graphic design and font design, like eating.

徐毅驊 Hsu-Yi-Hua

www.behance.net/hsuyihuadesign

Q. 請問您認為該國最棒的是什麼？(如國家的特色或文化等) 您的創作是否受其影響？

A. 俗麗。

多少，這是一種淺移默化的生活經驗。

Q. 請問您如何獲得靈感？

A. 它就會突然出現。

Q. 現在，回頭來看這些帶著遺珠之憾的作品，您有什麼新的感觸？

A. 知道自己又更進步了一點。

Q. 除了當設計師 / 插畫家，你是否已經開始規劃下一階段的目標？例如策展、學習煮菜、登山……

A. 我只想繼續當設計師。

Q. 你對生活的細節上有什麼堅持嗎？(像是上廁所時一定要看詩集之類的)

A. 不喝放隔夜的水。

Q.What do you like best in your country? (such as country feature or culture)Has it made a difference on your creation?

A. Tacky but glamorous.

Little by little I'm Influenced by the living experience in Taiwan.

Q.How do you draw inspiration?

A. It just pop out all in a sudden.

Q.Now, look back to these works of regret for not been selected, how do you feel that?

A. Knowing myself a little more.

Q.Have you started to set up new goals for next period except being a designer or illustrator ? like curating, learning cooking , climbing......

A. I still want to be a designer.

Q.What is your insist on your life's details ? like toilet with your favorite poem?

A. I don't drink over-night water.

成田久の美味工作營 Hisashi Narita's delicious Workshop 2015 P.63

將文字做為主軸，仿寫了資生堂體，探討傳統字學工藝。將美味解釋成，品味自身之美。藝術與設計本身就是一個非常美味的！而在視覺上回歸主題「美味的」，運用各種食物食材，希望呈現出一種好吃的感覺，食材也像是創作的基礎或材料，參與的設計師藝術家就像廚師一樣在工作營中烹飪這些食材。希望大家能有一頓豐盛美味的閱讀經驗。

From the imitation of the typefont by Shiseido, I started the design project to explore the traditional art of typography. By using all different kinds of food, I thrived to present the sense of deliciousness, and food itself is also the base and materials of creativity. Designers and artists will be participating like a chef, cooking the food during the workshop. Hoping everybody to have a tasty experience of reading.

華岡藝校第三十七屆畢業公演 Hwa Kang 37th Graduation Performance 2013 P.63

華岡藝校戲劇科第三十七屆畢業公演，為兩齣戲製作了劇名 Logo 與海報視覺。使用了大量的暗藍色做為主色，呈現出深沉、詭譎的氛圍，而在字體上運用燙霧金表現出有如月光灑落般的效果。

A lot of navy were used as the main color, to perform a deep and clingy atmosphere. As font, using gold stamping to reach the effect of moonlight shimmering on the ground.

匯率 / 癢 Exchange rate / Itching 2015 P.92

運用性徵性的物件：破裂的燈管、口紅、死掉的蚊蟲帶出劇情影射的內容。

Working with sex symbolic objects: broken light tube, lipstick, and dead bugs so as to bring out the content of the plot.

月光下的幸福 Happiness under the moonlight 2013 P.215

呈現出月光如綿延絲綢般的幸福感。

To express the silky soft greatness of the moonlight.

金堅 Photography 2015 P.215

鏗鏘有力，浮光掠影。

With strength and the light and shadows.

台灣 Taiwan

黃俊誠，於 1992 年生，畢業於雲林科技大學。作品分別入圍 2013、2015 台灣國際創意設計大賽、澳門雙年展、金點新秀設計獎等國際大獎。對於平面設計、插畫充滿著熱情，熱愛設計、喜歡藝術。認為設計脫離不了現實，想把對這世界的理解告訴更多人，也滿足對於說與創作的慾望。

Jyun-Cheng Huang, born in 1992. Graduated from the National Yunlin University of Science and Technology. The works has nominated 2013&2015 Taiwan International Design Competition, Macau Design Biennial, Young Pin Design Award etc. Full of passion about graphic design and illustrate, love arts too. Design can not be divorced from reality, trying to tell the world to understand that, also to meet the desire for talk and creation.

黃俊誠　Huang Jyun-Cheng

www.behance.net/evan-huang

Q. 請問您如何獲得靈感？

A. 喜歡看展覽、看電影、看書與聽音樂，覺得靈感似乎就存在於生活之中，越認真地生活著，就不怕沒有靈感，最重要的是，要對自己的生活有想法。

Q. 現在，回頭來看這些帶著遺珠之憾的作品，您有什麼新的感觸？

A. 不會認為沒得什麼大獎的作品就不好，認為每個階段的創作都是過程，我時常重新檢視自己的作品與檢視現在的想法，比較自己與過去的想法、看法是否一致，常常問自己，如果是現在的我再重新創作這樣的題目，我會怎麼做？藉由不斷檢視過去作品，讓自己的思維能夠比以前更新穎，進而創作山更優秀的作品。

Q. 除了當設計師／插畫家，你是否已經開始規劃下一階段的目標？例如策展、學習煮菜、登山......

A. 如果有機會，希望能成為一位舞者。常常幻想覺得自己是舞者，認為這樣更能更貼近的感受生活與身體之間的氣息，努力的生活與鍛鍊，接觸生活中的每個小點滴，將創意與思維用最曼妙的舞姿表演出來，並獲得觀眾的掌聲。其實我認為這跟設計很像，只是表達的方式與抒發的窗口不一樣。聽起來很美妙，但前提是我必須要先學會跳舞。

Q. 你對生活的細節上有什麼堅持嗎？(像是上廁所時一定要看詩集之類的)

A. 生活細節上的堅持，莫過於創作的時候一定會大聲撥放音樂來聽，音樂類型從搖滾橫跨到抒情都有，而且通常都在半夜創作，有幾次還因為撥放音樂太大聲，遭到鄰居上門關切，在他們的耳中我可能就是不折不扣的壞鄰居吧。認為聽音樂能讓我更能投入於創作之中，進而激發出更多的靈感。

Q. *How do you draw inspiration?*

A. Like to going to exhibitions, watching movies, books and listening to music. Feel the inspiration seems to exist in my life, the more live seriously more not afraid of no inspiration. The most important thing is to have ideas of own life.

Q. *Now, look back to these works of regret for not been selected, how do you feel that?*

A. It is nothing at all that work never win big award, in each stage of the creative is process. I often re-examine my own works and ideas at now, compare the past are the same. I ask myself if now re-create this project, how would I do? Make my minds can be more innovative than before and create more excellent works by review past works constantly.

Q. *Have you started to set up new goals for next period except being a designer or illustrator ? like curating, learning cooking , climbing......*

A. If I had a chance, I wish I could be a dancer. I always image I am a dancer, believing it can be more closer to feel the breath between life and body, try to live and train, touch each moment in my life. Use the most graceful dance act out the creation and thinking, just different between how you show it and how you release. I know it sounds wonderful but only if I must learn how to dance.

Q. *What is your insist on your life's details ? like toilet with your favorite poem?*

A. Insist on the details of life more than listen to music very loud when I creative. From rock to lyrical, and usually play it in the middle of the night. Neighbor came to deeply concerned couple times because of music is too loud, maybe I am a bad bad neighbor in their eyes. Listening to music makes me come over into create, and excite more inspiration.

Freedom Voice？ 2015 P.96

不能暢所欲言的言論，讓自由變的沉重。人人有權享有主張和發表意見的自由。

Everyone has the right to freedom of opinion and expression; this right includes freedom to hold opinions without interference and to seek, receive and impart information and ideas through any media and regardless of frontiers.

霾害 Haze 2015 P.96

灰色的陰霾正在籠罩著整個天空，空氣挾帶著有害人體健康的懸浮微粒，嚴重危害國人的健康。這種陰霾來自汽車和工業燃料燃燒和製造業。希望藉由這個海報，呼應大家重視空氣汙染問題，還我們健康的空氣。

The gray haze is hanging over the whole sky, this kind of haze come from vehicles, and industrial fuel burning, and manufacturing operations. Even the effect of airborne particulates on healthy. The serious air pollution and the following problem of public health. We should strive to solve the air pollution, to bring the fresh and clean environment back.

油汙染 Oil pollution 2015 P.96

兩條水波在垂直的關係上創造了對稱的 " 十 " 字圖形，強調船造成海洋油污染的訊息，已經不需要任何文字再去解釋。

The symmetrical "cross" created by placing two water traces in a perpendicular relationship. Graphically emphasizes the posters oil pollution message, without the need of any words or text.

形影不離 Inseparable 2013 P.96

科技日新月異，人們依賴網路的程度漸高，卻造成人與人的互動程度漸低，陷入自我與虛擬網路的互動空間，如同住進監牢。畫面利用使用率最高的「Facebook」與「使用手機」的意像做結合。諷刺手機與臉形影不離。網路雖然便利，卻也疏離人與人之間的關係。

Using the Internet without interaction is just like being prisoned. Design concept: Following the rapidly-changing technology, people rely on the Internet more and more, which leads to the rare face-to-face interaction. Such condition is just like that people are prisoned in the virtual world. I combine the image of Facebook, the highly-used online social networking service, with the image of the cellphone to mock people about their addiction to the virtual world. Though the Net is convenient, it keeps people away from others.

台灣 Taiwan

黃千芮，1990 年出生的台灣平面設計師。畢業
於銘傳大學，主修商業設計。對平面設計與字體
設計有著極大熱情。

Connie huang, born in 1990. A graphic designer based in Taiwan. Graduated from Ming Chuan University with a degree in Communications Design. She is passionate about typography.

黃千芮　Huang Connie

www.behance.net/connie_huang

Q. 請問您認為該國最棒的是什麼？(如國家的特色或文化等) 您的創作是否受其影響？

A. 繁體字, 熱情的人們, 傳統技藝, 繽紛的不夜城, 影響我設計最深的是繁體字之美。

Q. 請問您如何獲得靈感？

A. 閱讀、獨處、書寫。逛設計網站像是 behance 與整理 pinterest, 對我來說, 放鬆時最有靈感, 睡前看書或是半夢半醒的時候。

Q. 請和我們分享您喜歡的書籍、音樂、電影或場所。

A. 最近喜歡的書是李雲顥的詩集《双子星人預感》, 音樂最愛 beach house 的 depression cherry。電影有《盲》《雙面勞倫斯》《維多莉亞》《寂寞心房客》。

Q. 現在, 回頭來看這些帶著遺珠之憾的作品, 您有什麼新的感觸？

A. 覺得他們是我的一部分, 累積的自我。創作的時候最能梳理自己, 努力學習不強求, 也學習適當的逼自己。

Q. 除了當設計師 / 插畫家, 你是否已經開始規劃下一階段的目標? 例如策展、學習煮菜、登山......

A. 想學做一樣甜點。

Q. 你對生活的細節上有什麼堅持嗎? (像是上廁所時一定要看詩集之類的)

A. 看書時會盡量將書攤開 45 度角, 避免凹折到書, 這樣能保持書的完整性。我偏愛空白沒有格子的筆記本, 感覺比較沒有限制。畫草圖時則喜歡畫在空白的 A4 紙上。

Q. What do you like best in your country? (such as country feature or culture)Has it made a difference on your creation?

A. Traditional Chinese Characters, enthusiastic people, traditional artistry, and the city that never sleeps. What affects my design most is the beauty of Traditional Chinese Characters.

Q. How do you draw inspiration?

A. Reading, writing and being alone is the way I get my inspirations. Also check interesting design websites like behance and pinterest. When I feel relaxed, is always the moments I can be creative.

Q. Share good books, music, movies or places with us.

A. My recently favorite book is the poetry 双子星人預感 . The music I've been listening to is Beach House's "Depression Cherry", and the movies that linger in my mind are"Blind", "Laurence Anyways", "Victoria" and "Asphalte".

Q. Now, look back to these works of regret for not been selected, how do you feel that?

A. I feel like my works are part of who I am, part of my personal identity. The more I feel creative, the more I can understand my own being. I also try to learn how to push myself to the limit, without breaking myself.

Q. Have you started to set up new goals for next period except being a designer or illustrator ? like curating, learning cooking , climbing......

A. I want to learn how to make a dessert.

Q. What is your insist on your life's details ? like toilet with your favorite poem?

A. When I read a book, I prefer holding it as 45 degree to avoid folding the page, so I can keep the book in beautiful shape. I also prefer blank notebooks, without any line on it, because it gives me the feeling of creative freedom. And when I draw a draft, I like to draw on a blank A4 paper.

日出 You will see the sunrise　2015　P.97
個人形象海報設計, 以日出時的形象做出符號, 一切重新開始, 期待抱持正向的心出發, 顏色吸取日出時的色彩而成。
Self-promotion poster, making symbols out of the image of sunrise. Looking forward to be positive, and restart. The choice of color is the color of sunrise.

ANIKi Poster　2014　P.97
健身房視覺規劃提案海報部分, 業主希望結合外星人元素顏色選擇上以搶眼的螢光綠為主色, 搭配神祕的圖形與蓮蓬頭健身中的幾何圖象及動態的視覺聯想, 表現健身會館的活力四射。
ANIKi Gym identity design poster. The owner wants to combine an alien element. Color choice with eye-catching fluorescent green, and with a mysterious figure and fitness shower head geometric images, and dynamic visual association, which to show the vitality of fitness gym.

勇敢 brAve　2015　P.97
以不同的灰色球體代表道路中的困境, 更要加勇敢堅毅。
Gray spheres represent the difficulty on the way to the future. You have to be more courageous, determined and persistent.

留下來陪你生活 Stay by your side　2015　P.97
以手寫字體和斑駁的痕跡表達私語和內心的情緒, 走過的道路和傷痕, 還是想留下來陪你生活。
Handwriting and mottled with traces express personal emotions and inner whispers, by traveling through roads and scars, still want to stay with you.

味研堂 Flavor study　2014　P.222
烘焙堅果食品公司的提案, 堅果有較古典的聯想因此使用兩種襯線字體結合, 希望給人可靠與淵遠流長感受。
Proposal for baked nuts food company, nuts have a classical association, so I choose two serif fonts to form the new logotype, which I hope to deliver a reliable and profound feeling.

哭泣 Crying　2015　P.222
水滴, 垂降的方塊和纖細的情感, 因此將字骨架做極細處理, 但又有點堅強在裡面, 所以沒有太支離破碎, 是這個詞給我的感受。
Water droplets, rappelling box and slender emotion is the way I feel the word "crying". But I think this word still has a strong inside, so I design this logotype, which appears not too fragmented.

現場介入 Sound of Field　2015　P.222
展覽字體設計, 展覽內容為聲音和影像的結合, 因此將字體融合與重疊象徵介入, 代表兩種媒介的結合。
Exhibition logotype design. The exhibition is a combination of sounds and images. Integration and overlap the font symbol intervention represents combination of two media.

我不是生來當母親的 I'm not born to be a mother　2014　P.222
書籍標準字設計, 利用狂亂的情感, 表達被困以及痛苦的情緒, 因此字體以破碎顫抖的方式手寫而成。
Logotype for a book named " I'm not born to be a mother ". To express trapped and painful feelings by using this shattered and shivering handwritten font.

台灣 Taiwan

黃宏穎　Huang Hung-Ying

www.facebook.com/zozodesigner1

黃宏穎，1993 年生，台中人。目前就讀於國立雲林科技大學視覺傳達設計所。

作品曾獲德國紅點－最佳設計獎、北京國際設計週－華燦獎－優秀新銳設計師獎、兩岸文創中華青年學子創意大賽－視覺設計類－金獎與銀獎、時報廣告金犢獎－金獎等百餘項設計獎。

以及於義大利、烏克蘭、塞爾維亞共和國、北京設計週、杭州創意設計節等地展出。

Hung-ying Huang, born in 1993, Taichung. Now studying at Department of Visual Communication Design of the National Yunlin University of Science and Technology. As a manager of ZOZO DESIGN and Partner with Mr.Tod.

His works won the Red Dot: Best of the Best, Beijing International Design Week - Huacan Award: Emerging Designer Award, 兩岸文創中華青年學子創意大賽 - visual design category: Golden Award and Silver Award, Times Young Creative Awards, etc.

Exhibited in Italy, Ukraine, the Republic of Serbia, Beijing Design Week, Creative Design Festival in Hangzhou and other places.

Q. 請問您如何獲得靈感？

A. 體驗生活。生活中存在許多不同屬性的事件進行著不同的狀態，觀察它，並使用自身的經驗從中轉譯出一絲又一絲，也許適切、創新的想法。

Q. 現在，回頭來看這些帶著遺珠之憾的作品，您有什麼新的感觸？

A. 多涉獵不同領域，不停地學習。審視過去的作品就像找尋裂痕，發現新的裂痕有時候會選擇放著，因為那是過去的我最期待找到的寶石。

Q. 除了當設計師／插畫家，你是否已經開始規劃下一階段的目標？例如策展、學習煮菜、登山 ……

A. 成為設計師一直都不是我唯一的志向，單純認為快速找到自己的定位並不適合我的性格。未來對我而言就像一只很不確定、浮動的形象，這個不安感促使我做更多地嘗試；「設計」很像一座開端與橋樑，它使每一件進行式通向未來時有著更多的可塑性。

Q. 你對生活的細節上有什麼堅持嗎？(像是上廁所時一定要看詩集之類的)

A. 哈哈，認識我的人第一印象一定是我身上隨時都會攜帶許多撲克牌，因為我已是接觸十多年的花式切牌藝術的玩家。興趣之一是蒐集許多牌盒上印刷與後加工技術精美的紙牌，千奇百怪的牌背設計也是我在創作的靈感之一，不同國家的民族、文化、美學等，皆可以從紙牌呈現的的形式、風格去感受與探究，是件很有意思的事情。

Q. How do you draw inspiration?

A. Experiencing the life. There are so many different events carry on under different state. Observe these and translate these with your own experience into some appropriate and innovative ideas.

Q. Now, look back to these works of regret for not been selected, how do you feel that?

A. Be involved in different fields as more as possible and learn constantly. Looking back at past works is like looking the cracks. Sometime I would choose to keep it when found new crack because that is the gems I looking forward to find most in the pass.

Q. Have you started to set up new goals for next period except being a designer or illustrator ? like curating, learning cooking , climbing......

A. Being a designer has not been the only ambition for me, it is not suitable for my personality to simply find my own position quickly. For me, the future is an uncertain and floating image, this sense of uncertain push me to do more and more to try on, "design" is like a start or a bridge that leading future to have more possibilities.

Q. What is your insist on your life's details ? like toilet with your favorite poem?

A. Haha, people who know me at the first impression is that I always carry a lot of playing poker cards, because I am a player who contacted with art of card flourishing for 10 years. One of my favorite hobbits is to collect a lot of card box and fancy post-processing cards, the design of card backs is one of my inspiration for creating, the ethnic, cultural, aesthetic form different countries could be presented by the cards. It is interesting to explore the form and style of cards.

EMBRACE　2015　P.108
擁抱是暴力，擁抱是環境破壞。
Embrace is violence, embrace is environmental damage.

Environmental pollution　2014　P.108
透過各種廢棄物拼湊而成的表情，傳達環境汙染帶給後代的恐慌。
Through the expressions that put together by the variety of waste, it shows the panic, which was caused by the pollution of the environment.

EVOLUTION OF LIFE　2014　P.109
各種生命的演化是漫長的時間與過程，透過一圈圈輪廓表達時間的流動與生命的進化；猴子進化成人類，魚類進化成爬蟲類，爬蟲類進化成鳥類。藉此傳達生命隨著時間持續演化，永不停止之概念。
The evolution of every living being's is a long time and process. Through the circles that shows the movement of time and the evolution of life, the monkeys become human and fish turns into reptiles. While reptiles evolve into birds, it shows that every living life will evolve through time, no matter long or short, and the process of evolution will never stop.

SYMBOL OF LIFE　2013　P.109
「＋」象徵生命的增長也代表死亡、「－」象徵刪減也代表生命的逝去、「×」象徵事物的倍增也代表事件的擴散，膠帶則意喻束縛大自然的產物。海報以手繪插畫各種主題結合膠帶構成的各種符號，講述生命的各種現象。
"+" symbolizes the increasing of life and death, while "-" represents minus, and the fading of life, "x" symbolizes the extending and the multiplying of something. The tape hampers our mother nature. The poster is totally hand-drawn with every themes combining lots of symbols made up by tapes, shows every appearances and aspects of life.

本是同根生　2013　P.109
使用拓印的技法將象徵大自然的葉子、象徵動物的鳥以及人類，三個重要的生態。透過樹木因時間而成長變化的年輪，彷彿一圈圈呈現出他們共同生活的輪廓與模樣。我們是共同生活的大環境，一個和諧的群體，於每個世代一起生活與一同成長，彼此吸收養分；在同樣的空間裡相互扶持茁壯。三種由裡而外結合的元素期望使畫面透過年輪的視角傳達缺一不可，萬物共生共存，和諧生活的概念。
Using the technique of plant rubbing to symbol three important ecology: leaf from nature, birds

and human from animal. The tree rings changes due to the time, just like the outline of their jointly lives. We are living in the same large environment and a harmonious community. Each generation grow together with each other to absorb nutrients, and support each other in the same space. With the perspective form trees rings, I tried to convey the concept of living in harmony with all the creatures through these three combined elements.

SAVE　2013　P.109
將鐵絲一根根摺製而成的鐵網裡困住各種保育類動物，有大象、長頸鹿、犀牛、鹿、羚羊 …… 等。藉此傳達人類因自己的貪婪、慾望、慘忍剝奪這些動物的生命，迫使動物們身陷黑暗般的地獄。
The iron nets made of iron wire trap all kinds of endangered species such as elephants, giraffes, rhinos, deer, antelope and so on. To convey the greed and lust from humanity is cruelly expropriate the animals form their lives, and push them into the dark hell.

台灣 Taiwan

國立臺北藝術大學美術系畢業，畢業後到芬蘭當一年的國際志工做文化交流，回來後發行平面設計產品，曾開發過移動平台上的兒童教育軟體 App 和遊戲類 App，現在專職為介面設計師。

Graduated from Taipei National University of the Arts,participated an international cultural youth exchange program as a volunteer in Finland. Used to publish print design works, mobile applications for games and kid education. Now is working as a UI designer.

黃姿榕　Huang Kate

www.behance.net/gracekate

Q. 請問您如何獲得靈感？

A. 雖然聽起來有點老派，但是我常常從詩集或日本俳句當中獲取靈感！

Q. 請和我們分享您喜歡的書籍、音樂、電影或場所。

A. 我喜歡 Muse 和 Sigur Rós 的音樂！Muse 是一個英國的搖滾樂團，Sigur Rós 則是一個冰島的後搖滾樂團，我喜歡 Muse 歌詞的旋律和歌詞帶來的意思。而 Sigur Rós 雖然大部分的歌詞都是冰島語，但是他們的作品總是能夠給我帶來驚喜。

Q. 現在，回頭來看這些帶著遺珠之憾的作品，您有什麼新的感觸？

A. 不管這些作品最後能不能得到他們發揮的地方，但創作的過程和經驗將讓我有機會看見更多的事物，這將啟發我下一份創作的靈感，或在未來的創作之路中嘗試使用不同面向的作法，更棒的是可以幫自己帶來進步。

Q.除了當設計師 / 插畫家，你是否已經開始規劃下一階段的目標？例如策展、學習煮菜、登山⋯⋯

A.當然是學開飛機啊！我說的是 GTA(Grand Theft Auto V) 裡面的飛機，裡面有直升機，客機和不同的機型可以選擇，但是在這之前我的目標是先拿到每個課程的金牌成就才行，這樣才能成為一個優秀的飛行員，出搶劫任務的時候可以比較順利的進行。

Q.How do you draw inspiration?

A. Although it sounds a bit old fashioned, but I often get inspiration from poems or the Japanese haiku!

Q.Share good books, music, movies or places with us.

A. Muse and Sigur Rós! Muse is an English rock band Sigur Rós is a post-rock band from Iceland, I love Muse's lyric and melody. I didn't understand the lyric of Sigur Rós' songs, their songs are usually made in Icelandic, but their works always bring me pleasantly surprised.

Q.Now, look back to these works of regret for not been selected, how do you feel that?

A. Whether these works can get its own stage or not, but the process of create and experience will give me the opportunity to see more things, which will inspire my next inspiration , I can try to use a different aspects on new works , or even better,it helps me make progress.

Q.Have you started to set up new goals for next period except being a designer or illustrator ? like curating, learning cooking , climbing......

A. Learning fling a plane, of course! I mean fling a plane in GTA(Grand Theft Auto V), there are helicopters, aircraft and other different vehicle to choose from. Before that my goal is to get gold medals in all flying courses, so that I can become a good pilot, and make the robbery task much easier.

The Bridge　2014　P.234

有一天我朋友在跟我談論一部愛情電影，這時我突然腦海中有個畫面，畫面中有一座紅色大橋，在綿綿細雨的天氣裡，一個情人在岸邊凝視著河上的一艘船，不過，我腦海中的畫面跟朋友談論的那部電影一點關係也沒有。
One day my friend was talking about a romantic movie, the first image came in my mind is a red bridge, and on a rainy day the lover was gazing at the boat on the river, even though the image is nothing about the movie.

The Ice Mountain　2014　P.234

在那個世界裡也有季節，有一種樹種因為一些不明的原因可以再那樣極度寒冷的天候下生存，我想知道是否那個樹種也可以對抗炎熱，或是抵禦像是蟲害之類的災難。
The world there also has seasons, a breed of tree there somehow can strongly against extreme cold, I wonder if the trees can also defeat hot weather or other pest like insect.

The Light House　2014　P.234

這是一個座落在無人小島的燈塔，燈塔的擁有人日以繼夜的在海面上搜尋著什麼，不過沒有任何人見過那個燈塔的擁有人，也沒人知道他究竟在找什麼。
This is a lighthouse which located on a small, unknown island, the owner of the lighthouse are searching something through day and night, nobody sees the owner, nobody knows what the owner is looking for.

The Mountain　2014　P.234

有時候我腦海中會有一些幻想的畫面，在那個畫面的世界裡，寂靜，優雅而且充滿了未知。
Sometimes I have fantasy images in my mind, in the world there are silent, elegant and yet fill with the unknown.

The Temple　2014　P.234

煙霧繚繞的景象總是讓我覺得有什麼神秘的事件要發生了，如果在那邊可以看到一座廟，說不定或許正有一個強大的力量居住在其中？
The misty view always makes me think there is something mysterious event going on. If there is a temple, will it be a strong spirit who lives inside?

台灣 Taiwan

黃琬瓔　Huang Wan-Eng

www.behance.net/WE_STUDIO

朝陽科技大學視覺傳達設計系畢。與組員合作之畢業專題獲得第9屆新一代設計獎平面類 銀獎。曾任職大可意念、奇想創造、種籽設計視覺設計師。團隊作品曾獲美國 IDEA 包裝設計類 金獎。2014 年開始自由設計師的接案生活，現為 We Studio 設計工作室負責人。

Graduated from Department of Visual Communication Design, Chaoyang University of Technology. Silver award winner of the 9th Young Designers' Exhibition (graphic design), the award to the graduate project by teamwork. Worked in Duck image, GIXIA GROUP, and Seedesign as a graphic designer. Gold award winner of the USA IDEA (package design), the award to the team work. Worked as a freelancer since 2014. Now in charge of We Studio.

Q. 請問您如何獲得靈感？

A. 我很喜歡蒐集設計印刷品，且無論身在何處，我會不斷觀察周遭環境與設計元素，並隨手以相機記錄下來。所以無論是招牌、包裝、印刷品、特殊材質或是展示設計等等，都是我靈感的資料庫。至於創作精神的深化和開發，則往往是透過寫日記及深入的自我探索來獲得創作靈感。

Q. 請和我們分享您喜歡的書籍、音樂、電影或場所。

A. 我很喜歡閱讀哲學、心理學方面的書籍。最近看的是研究阿德勒（Adler）心理學的一本書——《被討厭的勇氣》，透過閱讀這類書籍，可以讓我盡情探索人性、了解自我，期望未來可以更豁達的去生活，達到心靈更高度的自由。

Q. 現在，回頭來看這些帶著遺珠之憾的作品，您有什麼新的感觸？

A. WE STUDIO 品牌形象設計　WE STUDIO VI

這個作品是幫自己工作室設計的第一版形象設計。由於考慮到之後期待接觸的客戶類型與這版 V.I 設計風格類型不同，於是推翻這版設計，但我一些朋友反而喜歡這一版本。我覺得，設計作品往往沒有絕對的好與壞，端看你的目標是什麼，能達到目標就是好設計。

青木和洋食彩菜單　AOKI dining menu

其實當時設計的幾款菜單客戶都還蠻喜歡的，只是最後的定稿是多數人都喜歡的版本。所以從另一角度來看，這款設計最後有沒有被選到，有時候是需要一點緣份，這和接案或找工作的道理很像。所以若某個設計沒有被選到，有時我會把它解讀成緣份不夠，而非設計不夠好。

Q. 你對生活的細節上有什麼堅持嗎？（像是上廁所時一定要看詩集之類的）

A. 所有瓶罐上的標籤或衛生紙盒一定要正面朝外；進浴室一定要穿拖鞋；開始工作時一定要放音樂；每天一定要記錄當天發生的事。

Q.How do you draw inspiration?

A. I love collecting printed matters of design. No matter where I am, I constantly observe the surroundings and design elements, keeping records by camera. So my database of inspiration originates from signboards, packages, printed matters, special materials, or exhibition designs, etc. To deepen and exploit creative spirits, I always acquire creative inspiration through diary-keeping and in-depth self-searching.

Q.Share good books, music, movies or places with us.

A. I love reading books regarding philosophy and psychology. Recently, I have read the book " 嫌われる勇気 " (Chinese version) that researches on Alfred Adler's psychology. By reading these books, I can heartily search humanity, understand myself, and hope to live open-mindedly in the future, therefore to achieve the highest freedom of soul.

Q.Now, look back to these works of regret for not been selected, how do you feel that?

A. WE STUDIO VI

This work is the first edition of image design for my own studio. Due to considering category of oncoming clients will be different from design style of this edition V.I, I overthrow this edition, some of my friends contrarily love this, however. In my opinions, design works are not absolutely good or bad, but it depends on your goals. Which can achieve goals is good designs.

AOKI dining menu

Actually clients were fond of several types of designed menus, but final edition was what most people liked. So on the other hand, whether this design is finally chosen or not sometimes requires destiny, similar to freelancing or looking for jobs. If one design fails to be chosen, sometimes I would interpret it as unlucky, rather than as a bad design.

Q.What is your insist on your life's details ? like toilet with your favorite poem?

A. Labels of all bottles/cans or tissue box must be placed right-side out. Wear slippers when entering bathroom. Play music while starting to work. Daily take down what happened that day.

好吉祥家具型錄　Good luck furniture catalog　2015　P.16

本次家具型錄希望能提升以往的設計格調，故封面照片特別選用極簡風格的木頭家具為主圖，搭配簡潔的設計，希望能以大器、簡約、素雅的風格提昇整體的品牌價值。

This furniture catalogue is hopefully to enhance the design style of previous catalogues.Wooden furniture, the minimalistic style, is especially chosen as the cover picture, combined with simple designs so as to promote whole values of this brand with style of greatness, simplicity, and elegancy.

青木和洋食彩菜單　AOKI dining menu　2015　P.62

本菜單希望突破一般菜單形式，以「雜誌風」的形式呈現，使點菜成為輕鬆、知性的享受。雜誌形式意在喚起休閒的記憶連結，使顧客告別工作壓力，進入悠閒的用餐時光。本次主題是「開動的美好想像」，故採用「圓桌」意象，希望能營造出「回家」一般的溫馨、放鬆與歡樂。

This menu is to break through common menu forms, so it is shown in "magazine style" that makes ordering dishes as enjoyment of relaxation and intellectuality. Magazine style is to awaken memory linkage of leisure, which makes customers farewell their pressure of jobs, entering carefree meal time. This theme is "beautiful imagination when eating," so image of "round table" is adopted to create the same feelings of harmony, relaxation and happiness just like at home.

共展資訊 Codev　2015　P.62

共展資訊，是一間軟體開發公司。Logo 結尾處 "_" 的符號，傳達「游標閃爍等待輸入」的意象，象徵以開放心態等待夥伴一起共同開發，創造更多可能，並將 "_" 符號做為品牌形象的應用圖騰。整體標準色以接近靛藍的色系為底色，希望呈現出沉穩、專業的品牌形象。

Codev is a software development company. Symbol "_" at end of its logo conveys the image of "cursor blinking for inputs" to signify waiting open-mindedly for partners to work together, creating more possibility, and also used as an applied totem of its brand image. Background color is close to indigo, chosen as whole standard color, in order to show steadiness and professionalism of its brand image.

WE STUDIO 品牌形象設計 WE STUDIO VI　2015　P.162

" WE " 為我的個人工作室名稱，它擷取自我的英文名 Wan Eng 的字首。Logo 將 " WE " 簡化成色塊圖形，除了強化商標記憶外，三直線與三橫線的「三」還蘊含了老子「三生萬物」的精神，象徵設計師以創意開發各種作品。而在色塊表現上，以剛健穩重的線條輪廓，融入象徵藝術的 " 拓印 " 效果，使整體呈現剛柔並濟、融合科技與藝術的品牌精神。

"WE" is name of my personal studio, which is adapted from acronym of my English name Wan Eng. Logo of "WE" is simplified as color graphics to strengthen the impression of this brand. Especially "three," from three straight lines and three horizontal lines of this logo, implies the spirit of "three for all living things," the philosophy of Lao-tzu, so as to embody designers' works by originality. For color performance, rigid-and-staid contour of lines is assimilated into artistic "rubbing" effect to entirely express the brand spirits of hardness with softness as well as technology with art.

WE STUDIO 品牌形象設計 WE STUDIO VI　2015　P.163

"We" 為個人工作室名稱，它擷取自我的英文名 Wan Eng 的字首。Logo 字體以手寫簽字的方式呈現 "We" 的品牌精神：人性化、藝術感與靈活度。" W " 與 " e " 看似分處兩端，事實上卻是一線相連，象徵客戶端與設計端雖是不同角色，但透過充分溝通與設計師的創意畫筆，「我們」將一起圓滿每一項任務。

"WE" is name of my personal studio, which is adapted from acronym of my English name Wan Eng. Font of this logo is shown by handwriting to express spirits of brand: humanity, art, and flexibility. "W" and "E" look seemingly at two ends of different positions, but actually is linked together with one line, which symbolizes that clients and designers are distinct roles, but "WE" cooperate to complete every mission via thorough communication and designers' creative painting brushes as well.

中國 China

深圳華思設計 HUATHINK

www.huathink.net

劉永清，深圳平面設計師協會主席、方正字庫特邀字體設計師、深圳年度十大創意人物、年度十大風雲設計師、中國品牌年鑑編委、意大利全球最佳品牌設計大獎賽評委、深圳公益廣告大賽評委、大運會海報設計大賽評委、國際CCII企業形象研究會會員、深圳華思品牌設計管理機構創始人，深圳市華禮文化產業董事長。

President of Shenzhen Graphic Designer Association, he specially invited by Founder font as a designer. His experience and glory: Top 10 of the designers and Creative Character Shenzhen Founder Annual, editor of Chinese Brand Global Best Brand Design Yearbook, judge of 10th Worldwide Logo Design Annual, judges the Public Service Advertising Competition in shenzhen, judge of Poster Design Contest for International University Sports Federation, member of CCII International Corporate Image Research Association, founder of Huathink, a brand design and management agency, CEO of HuaLi, a cultural industry company in Shenzhen city.

Q. 請問您認為該國最棒的是什麼？(如國家的特色或文化等) 您的創作是否受其影響？

A. 中國文字是最棒的之一。

Q. 現在, 回頭來看這些帶著遺珠之憾的作品, 您有什麼新的感觸？

A. 現在看有些遺珠之憾的作品還是很興奮。

Q. 除了當設計師／插畫家, 你是否已經開始規劃下一階段的目標？例如策展、學習煮菜、登山......

A. 下一個長遠的目標, 把自己十幾年的設計經驗和思想體系整理出版一本書籍。

Q. 你對生活的細節上有什麼堅持嗎？(像是上廁所時一定要看詩集之類的)

A. 堅持每天閱讀書籍。

Q.What do you like best in your country? (such as country feature or culture)Has it made a difference on your creation?

A. Chinese characters is the best.

Q.Now, look back to these works of regret for not been selected, how do you feel that?

A. Still feel excited when looking back these works.

Q.Have you started to set up new goals for next period except being a designer or illustrator ? like curating, learning cooking , climbing......

A. The next goal is to sort out my 10-years experience of design and thinking system and publish it into a book.

Q.What is your insist on your life's details ? like toilet with your favorite poem?

A. Insisting on reading book every day.

漢字字體試驗 CHINESE CHARACTERS FONT TEST *2013 P.218*

漢字的起源和發展歷經了倉頡造字的古老傳說及甲骨文、金文、篆文、隸書、草書、楷書、行書等階段，到宋代印刷術的出現及二十世紀初宋體、仿宋、楷體和黑體的確立。發展至今，我們嘗試著用設計的基本元素"點、線、面"，從"草書行雲流水般的奔放"中吸取精華，用"漢字象形、形聲、會意"等造字方法進行現代漢字的認識再造，結合中國的《道德經》、《易經》、《菩提偈》三大古老哲學中的精粹典著，探索漢字字體設計的可能性，釋放漢字的美學魅力。透過對大家耳熟能詳的唐詩「楓橋夜泊」字體的再造、藝術化設計探索嘗試，將景與字融為一體，傳達了中國字的象形、形聲、會意，展示中華漢字的豐富性。

The origin and development of Chinese characters through the ancient legend Changjei creation and Oracle, Jin, Zhuanwen, official script, cursive script, regular script, running script phases, to the emergence of the Song Dynasty and the early twentieth century typography Times New Roman, italics, italics and bold established. Today, we try to use the basic elements of the design of "point, line, surface," to learn the essence from the "cursive Hangyunliushui unrestrained" in use "Chinese pictograms, phonetic, knowing" and other coinage methods of modern Chinese character recognition recycling, combined with China's "moral", "Book of Changes", "Bodhi verse" the essence of the three ancient philosophy with the Code, to explore the possibility of Chinese font design, the release of the aesthetic charm of Chinese characters. Through Tang Poetry Night Mooring by Maple Bridge, well-known to the everyone, try to explore font reforger, the art of design ,the scene with the word integration and convey the Chinese pictographic characters, phonetic, semasiography, showing the munificence of Chinese characters.

南韓 Republic of Korea

為 TRIANGLE-STUDIO 的藝術總監及創立人。TRIANGLE-STUDIO 是一個藝術及平面設計團隊，主要是品牌推廣設計（所有創意）。我們創造的品牌設計基於合理的策略及融洽的感情。

Kisung Jang is a founder and an art director of TRIANGLE-STUDIO. TRIANGLE-STUDIO is an arts and graphic design group for Branding Editorial Illustration (all about creative). We create your brand design based on rational strategy and emotional harmony.

張基星　Jang Ki-Sung

www.triangle-studio.co.kr/

Q. 請問您認為該國最棒的是什麼?(如國家的特色或文化等) 您的創作是否受其影響?

A. 韓國很有熱情,有很多商店和公司行號 24 小時不關門。這個活力刺激了我。

Q. 請問您如何獲得靈感?

A. 就是一直思考案子,什麼是原創?有什麼區別?什麼是美麗?我的經驗是?然後我用很多菸跟咖啡想了一個故事。

Q. 請和我們分享您喜歡的書籍、音樂、電影或場所。

A. 三國演義（羅貫中著）、Demian of Hermann Hesse、David Fincher 和 Quentin Tarantino 的所有電影, Sting 的所有音樂。

Q. 除了當設計師 / 插畫家,你是否已經開始規劃下一階段的目標?例如策展、學習煮菜、登山

A. 我有很多個職業,導演、平面設計師、插畫家、作家等等,但我還不是間書店老闆,總有一天會的。

Q. 你對生活的細節上有什麼堅持嗎?(像是上廁所時一定要看詩集之類的)

A. 菸和即將成為妻子的女朋友。

Q.What do you like best in your country? (such as country feature or culture)Has it made a difference on your creation?

A. Korea is very passionate. Korea has many shops and companies that do not turn off the lights for 24 hours. The energy is stimulating to me.

Q.How do you draw inspiration?

A. I'm just keep thinking about the project.

What is originality, What is difference, What is beautiful thing, What is my experience?

And then I make a story and make images with so much tobacco and coffee.

Q.Share good books, music, movies or places with us.

A. Romance of the Three Kingdoms by Luo Guanzhong

Demian of Hermann Hesse

All movies of David Fincher, Quentin Tarantino.

All musics of Sting

Q.Have you started to set up new goals for next period except being a designer or illustrator ? like curating, learning cooking , climbing......

A. I already have several occupations.

Director, graphic designer, illustrator, writer,,,

But I'm not Bookstore owner yet. I will become a bookstore owner someday.

Q.What is your insist on your life's details ? like toilet with your favorite poem?

A. Tobacco, and Girlfriend who be my wife.

In Ma Room 2015 P.32

講述的是我在自己房間做排版編輯工作,是在我房間的物體,用字母 a 到 z 構成。

"In Ma Room" is a typography editorial work about variable object in my room. Objects were found in my room, They were reconstructed with the letter(alphabet a to z).

Try Angle Paper #01 2014 P.34

「Try Angle Paper」是 TRIANGLE-STUDIO 的設計出版。透過我們成員看各種事物的眼睛來跟世界溝通的小活動。「try angle paper #01」是我們實驗排版作品。

"Try Angle Paper" is a design publication of TRIANGLE-STUDIO. It is a small movement to communicate with the world by design through the eyes of our members looking at the variety of things. "Try Angle Paper #01" is our experimental typography work.

Try Angle Paper #02 2014 P.34

「Try Angle Paper」是 TRIANGLE-STUDIO 的設計出版。透過我們成員看各種事物的眼睛來跟世界溝通的小活動。「try angle paper #02」由每月計劃人和大理石花紋藝術明信片組成。

"Try Angle Paper" is a design publication of TRIANGLE-STUDIO. It is a small movement to communicate with the world by design through the eyes of our members looking at the variety of things. "Try Angle Paper #02" is composed of a monthly planner and postcards with marbling artwork.

Try Angle Paper #03 2015 P.35

「Try Angle Paper」是 TRIANGLE-STUDIO 的設計出版。透過我們成員看各種事物的眼睛來跟世界溝通的小活動。「Try Angle Paper #03」是手工絹印海報組成。限量印刷 100 份並免費發放。

"Try Angle Paper" is a design publication of TRIANGLE-STUDIO. It is a small movement to communicate with the world by design through the eyes of our members looking at the variety of things. "Try Angle Paper #03" is a handmade silkscreen poster that configured as objects in my studio. It is a limited edition of 100 parts. It was distributed free of charge.

Try Angle Paper #04 2015 P.35

「Try Angle Paper」是 TRIANGLE-STUDIO 的設計出版。透過我們成員看各種事物的眼睛來跟世界溝通的小活動。「Try Angle Paper #04」由圖畫和大理石花紋組成。我用指彩做成的。

"Try Angle Paper" is a design publication of TRIANGLE-STUDIO. It is a small movement to communicate with the world by design through the eyes of our members looking at the variety of things. "Try Angle Paper #04" is composed of a drawing note and pin buttons with marbling artwork. We've used a manicure to make this marbling artwork.

台灣 Taiwan

鄭曜德，1997 年生於台北。
專注於平面視覺、海報設計之實驗與研究創作，
作品獲多項設計獎項與展出。

YAO-DE JHENG, born in Taipei City in 1997.
Focus on experiment creations of graphic visual and poster design, his works won many design award and have been invited by many exhibitions.

鄭曜德　Jheng Yao-De

www.behance.net/jhengyaode

Q. 請問您認為該國最棒的是什麼？(如國家的特色或文化等) 您的創作是否受其影響？

A. 台灣是一個華人設計能量十分集中的地方，來自世界各種不同的設計風格，得以在被接納與融合起來。但事實是台灣同時也是一個沒有文化的地方，當我在創作作品時時常會受到西方與日本設計風格大量資訊的影響。身為十分年輕的設計師，我認為現在開始創作的方向，學著更要反映出屬於在地社會、文化的議題。

Q. 請問您如何獲得靈感？

A. 我認為現今獲得大量資訊是一件十分容易的事情。像在松山文創園區，看些展覽，或是在誠品書店裡快速翻閱設計年鑑、書籍。更多時我會在各種設計社群平台(如：Behance)查閱各設計師的作品。但如何停下來思考與解析設計思路是件困難的事，每次創作作品的靈感多來自於最根本生活問題，有時只是想反映或表達最深處的核心思想，所以對我來說靈感就是去學著品析、解決人與生命本質，想法自然或湧現。

Q. 請和我們分享您喜歡的書籍、音樂、電影或場所。

A. 最令我印象深刻也帶我進入平面設計領域的是東京 TDC 的設計年鑑，當時看到裡面的作品其高度藝術性的風格確實十分驚訝，到現在我每年還是會定期購入年鑑來收藏，同時也樹立我進行實驗設計的思想與風格。到現在東京 TDC 對我來說仍是的最高殿堂的設計競賽。

Q. 現在，回頭來看這些帶著遺珠之憾的作品，您有什麼新的感觸？

A. 對於身為一個學生身份的設計師來說，面對的客戶與經驗實在不多，這次投稿的都是一些私人的設計創作。當然有些作品在設計競賽上有拿到一些不錯的名次與獎項，但對我來說這些獎項不僅是經驗與學習，同時更重要的一個自我肯定的過程，隨著時間的推進，創作的作品數也漸漸多，回頭來看這些作品不僅在表現技法上有突破，更重要的是對於作品整體的設計想法與思維有著更深更多的想像。

Q.**What do you like best in your country? (such as country feature or culture)Has it made a difference on your creation?**

A. Taiwan is a place concentrate the energy of Chinese design, different design styles all over the world are admitted and being mixed together. But Taiwan is also a place where doesn't have its own culture. I often influenced by Western and Japanese design style when creating works. As a very young designer, I think this is the time I have to learn more about reflecting on my native society, and cultural issues in my works.

Q.**How do you draw inspiration?**

A. Nowadays, it is easy to get much information, for example: go to exhibition at Songshan Cultural and Creative Park, or look into the design yearbook at the Eslite bookstore, more often I browse the designers' works on the design community platforms (e.g. Behance). But the different thing is how to stop to think and analyze the idea of design. The inspiration usually comes from the problems based on the life, sometimes I just want to reflect or express the deepest core idea. So, the seeking inspiration is to learn how to analyze and solve the essence of human and life, then the idea will naturally emerge.

Q.**Share good books, music, movies or places with us.**

A. The Tokyo TDC yearbook impressed me the most and it also took me into the field of graphic design. I was surprised by its highly artistic works style, until now I keep purchasing the yearbook as my collections every year. This yearbook establish my ideas and style of experimental design at the same time, for me, the Tokyo TDC is still the highest palace of design competitions.

Q.**Now, look back to these works of regret for not been selected, how do you feel that?**

A. For a student designer who has little experience of facing clients, the works I submit for CTA are my private creations. Of course, some, of them won great awards on the design competition, but for me, these award are not only the good experience but a process of self-affirmation. As the time goes by, the works gradually have accumulated. Looking back to these works, they are not only have a breakthrough in expression techniques, more importantly, their overall design ideas and thinking have a deeper imagination.

奧秘送行文創設計 ChinPaoSan Farewell Creative Design　2014　P.38

設計這個主視覺中，我更希望他是能夠延續的，引人聯想的，可愛的，甚至低調到你能忽略的。因為重要的絕對不是那套視覺，而是你深愛的人。也就是場奧秘，我無權為你詮釋任何你生命的意義，但我能確保你怎麼詮釋他都是正確的。

In the design of key vision, I want it to be continued, reminiscent and adorable, even can be so invisible that you can hardly find it. Because the important thing definitely is not the visual but the one you love the most. He is the mystery, I have no right to interpret the meaning of life for you, but I can make sure whether you interpret him is correct.

世代政治公民海報 Generations & Political Poster　2015　P.115

兩張海報皆利用海報侷限的性質，透過巨型幾何形壓滿海報的空間，來凸顯社會、政治問題所帶來的壓力，與龐大的問題。其海報分為「世代命運悲歌」、「政治施壓」兩個主題。壓黑的圓快塞滿了整張海報，表達那些被掩蓋且不當對政治施壓的行為。

In these two posters, I use the character of posters that have been limited, with the giant geometric shape squashed the space of poster, to outstand the huge pressures and problems the society and polity brought about. These posters are divided into two themes: "The elegy of generations" and "The pressure from polity." The squeezed black circle almost fill the entire poster, express the concealed behavior of political pressure.

HELP　2015　P.115

世界上仍有許多人，正在遭受不公平的凌虐與虐待，基本人權是天賦的，沒有人可以隨意剝奪與侵犯。設計師透過海報這個媒介，讓觀者提出問題給作品，讓觀者與海報產生一些理解與關聯。使得設計師、作品與觀者之間形成一種奇妙的空間與關係，它或許是帶一點曖昧，但也許是直接的。但重要的是那個意念與關係得以被傳達與思考。畫面設計上，我想表達殘忍，那種殘忍已經超出對人與人之間的理解。

There are still many people in the world who are suffering from unfair torture. We are born to have basic human right and no one can deprive it arbitrary. Designers raise a question to viewers through the poster, so that some understanding and relationship appear between the viewers and the posters. A strange space and connection formed among the designers, works and viewers, maybe the connection is ambiguous or maybe direct, but the important thing is that thought and connection could be communicated. In the design of screen, I want to express the cruelty, the kind of cruelty beyond the peoples' understanding.

致 柏拉圖 故事字體實驗設計 To.Plato. experimental typography design　2015　P.228

對我來說重要的就是告訴自己生命的美與理性，柏拉圖，這是我第一個想到的。

There is an important thing for me to tell myself about the beauty and sensibility of my life. Plato is the person I first think of.

病態形圖形實驗創作 Morbid Form　2015　P.263

想嘗試實驗用一些負面的字彙，將文字進行簡化，看是否還可以保留原本文字的情感，甚至引導觀者投射自己的情緒。研究六書理論並對應現在使用的文字，會發現漢字的設計十分有趣，透過研究這個理論與歷史，會發現過去華人祖先對於將具象的形體抽象畫，並組織化的思考是經相當熟練，甚至到現在的書法，都可以看到那講究抽象形流動空間之美。我想透過這個實驗設計，學習將漢字進行抽象化，看是否最後的圖形還能保留其字體的感知解讀。

I want to try a experiment with some negative vocabulary to simplified the text, see if this can still retain the original character of its emotion, and even guide the viewer projecting their emotions on it. If you do the research on The six methods of forming Chinese characters, and apply to the characters today, you would get interested in Chinese character design. Though this theory and history you will find that the ancient Chinese were skilled in abstracting the specific forms and organized thinking. Look at the calligraphy today, you can see the beauty of abstract and flowing space. I tried to learn how to abstract the Chinese characters thought this experimental design, and see if the final image could retain the meaning and interpretation of words.

台灣 Taiwan

「每一件事物都有著不同的含意和獨特的一面，正因如此，愛上了詮釋它們的過程。」
1991 年生，台灣科技大學商業設計系畢，於 2012 成立 Hong Da Workshop 個人設計工作室，致力於平面視覺設計、書籍及封面設計、影音及唱片專輯包裝設計、廣告設計等。

"Be ture to work, and work will be ture to you."
Born in 1991. Graduated from National Taiwan University of Science and Technology Department of Industrial and Commercial Design. Founded Hong Da Workshop Personal Design Studio in 2012, dedicated to graphic visual design, book and cover design, video and record album packaging design, advertising design.

江宏達　Jiang Hong-Da

vicaketmoregtcsnvcboy@gmail.com

Q. 請問您認為該國最棒的是什麼？(如國家的特色或文化等) 您的創作是否受其影響？
A. 台灣最棒的是擁有強烈濃厚的傳統台式風格，五彩繽紛，具衝擊性的視覺，也因地理位置的關係，受鄰近亞洲國家的影響，東、西方風格在設計執行能夠相輔相成，較能激發更多可能，並製作出多元豐富的作品。

Q. 請問您如何獲得靈感？
A. 雜誌科技網路的發達，以及交通生活的便利，通常我會使用網路觀看各個國家的設計作品，有時會到書店翻閱設計書籍及年鑑，若設計案件有充足的時間，我會透過旅行以及看展覽尋找靈感。

Q. 請和我們分享您喜歡的書籍、音樂、電影或場所。
A. "Typographica" 是我非常喜愛的雜誌，它介紹 60 年代英國專業的印刷技術，除了能看見印刷的工法外，也收錄許多優秀的視覺藝術作品，編排、裝訂等手法都相當出色，第一次在二手書店看見時，感到相當讚嘆！但可惜的是現今很難搜尋到它。

Q. 現在，回頭來看這些帶著遺珠之憾的作品，您有什麼新的感觸？
A. 我只能說：「我還是愛著那些作品。」，即便設計案件最終沒有選擇它們，但一段時間後，我再次看見它們時，仍然有當初將它們納入提案的悸動，這有點像一段感情，很難就這樣放下它們，總是會想想這些作品是否有不一樣的再創性、可能性。

Q. 你對生活的細節上有什麼堅持嗎？(像是上廁所時一定要看詩集之類的)
A. 對於一些數字，在設計時會滿執著的，我喜歡設計作品和數字有關係時，尾數是「0」、「5」，例如長與寬或其他的尺寸等，都習慣將尾數改成「0」、「5」，這真的不為什麼，單純是這樣的設定，會讓心情變得很好。

Q. What do you like best in your country? (such as country feature or culture)Has it made a difference on your creation?
A. Taiwan has its own unique traditional culture which contains a lot of colors and visual impact in my opinion. Not only the location of Taiwan but the influence from western countries. I manage to combine the essence of east and west in order to create more designs and possibilities.

Q. How do you draw inspiration?
A. With the Technology these days, I normally just browse people's portfolios from all over the world through the internet. Sometimes I go to a bookstore to see some design books and printouts. If I have enough time I prefer to go on a trip or visit exhibition instead.

Q. Share good books, music, movies or places with us.
A. "Typographica" is one of my favorite magazine. It talks about the UK printing industry and some great visual communication in the 60s. The layout and binding of the actual magazine is quite impressive when I first saw it in the second-hand shop. Sadly, It is hard to get my hands on it today.

Q. Now, look back to these works of regret for not been selected, how do you feel that?
A. All I can say is " I'm still in love with those works". Even though they were not selected but I still get motivated and touched every time I see them. It is like a relationship between me and the works, very hard to let go because I always think of the adjustments, improvements and possibilities of the works.

Q. What is your insist on your life's details ? like toilet with your favorite poem?
A. I am into some certain amounts. Especially when it comes to numbers such as width and length or some other measurements. The last number must be 0 or 5 when designing. I always do it, It is just my thing. It makes me feel better.

酸臭之屋 書籍封面 The Acid House Book Cover 2014 P.10
選用蒼蠅和骨頭 X 光片作為書籍視覺，來表現小說中的「腐爛」、「赤裸的身軀」，搭配的圖像是「液體」，使用特色螢光綠印刷，營造潮濕又黏稠的空間。《酸臭之屋》標準字以符號、密碼碎型的概念進行設計。
The main idea is from fly and X-ray to give a decayed, dirty and corrupted feel. A lot of liquid graphics were applied and printed with fluorescent green color to create a sticky layout in order to match the name of the book "The Acid House".

影之地帶 書籍封面 Shadow Place Book Cover 2015 P.10
系列 A：小說男主角第一次遇見神祕女子的媚笑，赤色鮮豔的斑駁血跡，凝視的貓眼增加神祕感，好奇心能夠殺死一隻貓，營造懸疑小說書籍封面的詭譎氣氛。系列 B：吸引小說男主角的神祕女子，渲染鮮血懸疑案件的鮮血，在城市中揮之不去的女子身影做為書籍封面的主要視覺。
Series A: Never know a smile from a secret woman can lead the man to a bloody scene. The stare of a cat is quite mysterious which make the atmosphere of suspense fiction extra treacherous. Series B: The lady that catches leading man's eyes with her unforgettable figure. The main feature of the book cover conveys the idea of haziness.

瀞空界 Peace World 2014 P.11
以導覽手冊呈現，介紹「生死相關」議題，有趣的圖文資訊結合傳統文化習俗，除參考既有的文獻外，也創造名為「瀞空界」的新世界觀，讓死亡相關的知識能夠更加有趣。
Use a brochure to introduce "Life and Death". Combining infographic and traditional culture. I try to make the knowledge of death interesting by creating a whole new peace world.

Birdie 2012 P.12
敘述人類破壞鳥類生態的書籍，包裝設計為證物袋 (意謂此書籍是人類的罪證)，用各類負面器物排列出鳥類的形狀，象徵人類的迫害、殘殺和貪婪，內文也實際列出鳥類減少的數據，藉此提倡、宣導鳥類的保育。
This book tells how human have affected the environment of birds. Packaging is designed as a criminal evidence bag meaning the actual book is the proof. The content shows the extinct of birds by research, also symbolize different species of birds with weapons that harm them to inform and encourage people the important of care.

呂薔音樂專輯 Lu Chiang Music Album 2014 P.58
音樂專輯設計概念從「登高」的方向為重點，登峰造極、越過山嶺登上巔峰！歌手 20 歲紀念音樂專輯，以俐落的線條代表躍上山峰。附圖為音樂專輯企劃封面設計及音樂專輯標準字設計。
The concept of this music album is from mountain climbing to begin with. In order to convey the idea of reaching the peak of perfection and the highest level at singer's 20th. I used lots of sharp lines to represent the peaking.

楊袁喜帖卡 Yang Yuan Wedding Card 2015 P.61
運用新穎流行、豐富可愛的視覺元素，使喜帖邀請卡擁有新樣貌，並用孔版印刷金、螢光紅等特別色，跳脫傳統台灣囍帖邀請卡，均以深紅厚卡、燙金製作。
I take current trends and use chic visual elements to give the wedding card a new look by using Risograph Printing, fluorescence red and special colors. Instead of the traditional Taiwanese wedding cards which only design with red thick cards and golden prints.

南韓 Republic of Korea
(Korean German 韓裔德籍)

Jung Il-Ho

www.il-ho.com

Il-Ho Jung 是住在德國的跨領域設計師兼藝術指導，對設計擁有熱情，從不同的學科領域發展出廣泛的知識，在每次接案時總是渴望能學習更多新知，他逐一思考每一件作品，並從精準的設計中創造出強烈的概念，他相信設計要有實驗精神，但不會失去設計的焦點，將設計的樂趣丟失。

Il-Ho Jung is a multidisciplinary Designer and Art Director based in Berlin. With passion for design, he has developed a broad knowledge of many different disciplines and is always eager to learn more with each new project. He considers every work individually and creates strong concepts from the right design. He is convinced that design should be experimental without losing its focus and that the joy for design shouldn't be missed out.

Q. 請問您認為該國最棒的是什麼？(如國家的特色或文化等) 您的創作是否受其影響？

A. 我的家人是韓國人，但我在德國出生長大，生長在兩個截然不同的文化圈對我產生極大的影響，我的想法、思考、言行舉止和我的創作。我的家和其它德國家庭沒什麼不同，除了你可以發現韓國傳統工藝的片段，在家具、廚具、花瓶、繪畫等，這些吸引了我的注意，我總是對於韓國技藝的藝術性和複雜性抱有感情。

另外我的教育受到包浩斯教育很大的影響，它影響了我對於環境的感知，徹底性、極簡主義、結構和抽象讓我很愉快。德國還有我很多喜歡的東西，但我最欣賞的是他們對於歷史的意識，擁有承擔過錯的責任感，並願意從中學習，我最喜歡韓國的地方是他們的競爭力，還有「沒有不可能的事」的心態。

Q. 請問您如何獲得靈感？

A. 這關乎你的態度，如果你對你的環境敞開心胸，你可以從任何事情或任何地方得到靈感，最簡單的方式就是和人見面、旅行、多元的經歷還有享受人生。

Q. 你對生活的細節上有什麼堅持嗎？(像是上廁所時一定要看詩集之類的)

A. 我會避免擁有習慣，我想要自由 — 選擇的自由、行動的自由、心靈的自由。

Q. 除了當設計師 / 插畫家，你是否已經開始規劃下一階段的目標？例如策展、學習煮菜、登山……

A. 我沒有打算發展其他非設計相關的專業，我不得不提供豐富和多樣的設計。而且我想保持當一位設計師的樂趣，所以我的新目標是，未來跟朋友一起做更多設計並享受其中。

Q. What do you like best in your country? (such as country feature or culture) Has it made a difference on your creation?

A. My parents are Korean, but I was born and raised in Germany. Growing up with two different cultures definitely has been a huge impact on my thoughts, ideas, demeanor and ultimately on my creation. Our home didn't differ from other German homes, accept you could discover fragments of Korean traditional craft on furniture, kitchenware, vase, paintings, etc., which attracted my attention. I always had an affection for the artistry and complexity of Korean craft.

On the other hand my education was highly influenced by the teaching of Bauhaus, which has effected my perception of my environment. Thoroughness, minimalism, structure and abstraction appear pleasant to me. There are a lot of things I like about Germany, but what I admire the most is their awareness of their history, carrying the burden with responsibility and willing to learn from it. What I like about Koreans is their competitiveness and their "nothing is impossible" mentality.

Q. How do you draw inspiration?

A. That's a matter of your attitude. If you are open and free to soak up your environment, you can draw inspiration from everything and everywhere. The easiest way to get into that state of mind is when you meet people, travel around, experience diversity and enjoy life.

Q. What is your insist on your life's details? like toilet with your favorite poem?

A. I'm trying to avoid having habits. I want to be free – free in my choice, in my movements, in my mind.

Q. Have you started to set up new goals for next period except being a designer or illustrator? like curating, learning cooking, climbing......

A. At the moment I don't have any desire to explore another profession than the profession of the designer. I'm still compelled with the richness and diversity the world of design has to offer. Further more I want to keep up the fun of being a designer. So my new goals for the near future are working more with friends and enjoy design regardless the output.

Teilansichten 2011 *P.22*
雖然德國以前是分裂國家，但很少德國人知道韓國也被分裂成兩個國家，在第二次世界大戰後，兩國幾乎是在同一個時間點建立然後分裂，而且兩個國家都是透過武力去變動邊界線。
Although Germany was a formerly divided country, little is known in Germany about Korea being a divided country as well. Both countries were founded and divided almost at the same time after World War 2. In both countries a border ran through which divided the land by force. "Teilansichten" deals with the similarities and differences of the two countries during their division history.

Nippon Connection Festival Design 2015 *P.178*
替 Nippon Connection Festival 15 週年的設計，由 15 種傳統日本紙的花色組合而成，中心的圓盤，是由日本國旗和 Nippon Connection 的 Logo 衍生而來，這些紙被摺疊並圍繞著圓盤，形成擁有摺紙式外表的眼睛。
For the 15. anniversary of Nippon Connection a collection of 15 sheets with traditional Japanese pattern were created. In the center of the composition is a disc, which is derived from the Japanese flag and the Nippon Connection Logo. The sheets are folded around the disc and shaping an eye in a origami-esque appeal.

World Caps 2014 *P.179*
World Caps 是在巴西一個由個人興趣而發起的獨立計畫，發起人是兩位設計師，Il-Ho Jung 和 Lukas Weber。這項計畫因為 Jan Wilker / karlssonwilker 和 Lance Wyman 兩位絕讚的客串而充滿特色。
World Caps is an independent and self fun-initiated project on the World Cup in Brasil by the two designers Il-Ho Jung & Lukas Weber. The project is featured by the two amazing guest-appearances of Jan Wilker / karlssonwilker (for USA) & Lance Wyman (for MEX).

Project K – The Korean Film Festival 2015 *P.179*
四條使用 Project K 顏色的粗線十分醒目，與直線產生對比的是細膩的金線花紋背景，其中還融合了丹頂鶴和松樹的圖案，此圖形是以傳統韓國木製品和陶瓷藝術為創作靈感。
The Korean Film Festival attracts attention with four bold stripes in the colors of Project K. In contrast to the striking stripes the background insist of a fine filigree pattern in which a red-crowned crane and pine-trees are integrated. The pattern is inspired by traditional Korean woodwork and ceramic art.

Project K – The Korean Film Festival 2014 *P.180*
第三屆韓國電影節 Project K 的標語是《Play》，因此韓國的傳統遊戲被新增到這此的計畫裡，所有玩具都要被拋擲、踢或翻轉到空中，我們捕捉這樣飛行 / 運動中的狀態，形成主視覺。
The motto of the third Project K – The Korean Film Festival was »Play«. Therefore Korean traditional games were a new addition to the program. All playthings are flying in the air by throwing, kicking or flipping. The state of flying/motion has been captured as key visuals.

Project K – The Korean Film Festival 2013 *P.181*
主題是《在首爾的四天》，會場被裝飾成韓國首都的許多街區：梨泰院、南大門、弘大區、明洞、仁寺洞，受到 Dancheong (寺廟屋頂的花色) 啟發，我們替這次的設計創造了新的圖案，結合了 Saekdong (韓國的線條) 和 Hangul (韓國的文字)。
Themed »4 Days in Seoul« the event location was decorated according to the Korean capital in various districts: Itaewon, Namdaemun, Hongdae, Myeong-dong and Insa-dong. Inspired by Dancheong (temple roof pattern), a new pattern was created for the design, consisting of Saekdong (Korean stripes) and Hangul (Korean Type).

Taste 2015 *P.182*
Taste 品牌的中心是頭一個字母《T》，是一個伸出舌頭的形狀，表達出大膽嘗鮮的態度，舌頭被一個框框圍起來，強調鮮明的性格，並創造出一個時尚標籤的生活形貌。
The center of the Taste branding is the initial letter »T«, which is shaped as a outstretched tongue. It expresses a bold and fresh attitude. The tongue is surrounded by a frame, which emphasizes the striking character and creates a lifestyle appeal of a fashion label.

Kangnam Day & Night 2012 *P.224*
《Kangnam Day & Night》出發點是 logo 的模型以字母 I 和 O 為基礎，和數字 1 與 0 一樣，兩種字體是因為受到首爾江南街區的啟發而開發的。
»Kangnam Day & Night« emerged for my own website. The starting point was the form of the logo which was the model for the letter »I« and »O« and at the same for the numbers one and zero. Inspired by the Kangnam district in Seoul two typefaces were developed, imitating the local change from day to night.

南韓 Republic of Korea

Su Young Kang 從 2013 年起在首爾從事平面設計和介面設計，設計作品橫跨許多文化與軟體的領域，相信設計的精髓不只在於風格、外觀，還要具有意義。

Su Young Kang is Graphic & UI Designer based in Seoul, Korea since 2013. I create a various design work at cross-field of culture and IT. I believe in design that is not only style and look, but meaningful.

康秀榮　Kang Su-Young

www.behance.net/sykang

Q. 請問您認為該國最棒的是什麼 ?(如國家的特色或文化等) 您的創作是否受其影響？

A. 我居住在韓國的首爾 24 年, 首爾對我來說是非常迷人的城市。事實上, 在首爾最感官的事就是「顏色」, 根據不同的時間和季節產生的光譜相當廣, 所以自然而然的, 我在首爾受到許多顏色光譜的影響。

Q. 請問您如何獲得靈感？

A. 通常我會在沒有預期的時間點下接收到設計的靈感, 所以我會在我的 iphone 和 ipad 使用 Evernote, Evernote 有非常強大的功能, 像是即時同步、和夥伴分享想法, 還有記事本之類的功能。

Q. 請和我們分享您喜歡的書籍、音樂、電影或場所。

A. 我通常會在工作的時候聽傻瓜龐克的音樂, 我最喜歡的專輯是《Alive 2007》, 這張專輯因為聽了太多次, 已經不能在我的 CD 播放器播放了。傻瓜龐克的音樂讓我能專心在設計, 它也帶給我設計的靈感。

Q. 除了當設計師 / 插畫家, 你是否已經開始規劃下一階段的目標？例如策展、學習煮菜、登山

A. 最近我開始騎單車了, 這是我最大的嗜好, 因為我熱愛訂製和裝扮我的新配備, 去年我很專注在組裝 fixie 的配件, 現在, 我立下新的目標, 我要在今年騎 300 公里, 和我的 fixie 一起。騎單車幫助我提神。

Q.What do you like best in your country? (such as country feature or culture)Has it made a difference on your creation?

A. I live in Seoul, South Korea for 24 years. Seoul is very attractive city for me. Actually, most sensual thing in Seoul is 'Color'. It has wide spectrum depending on difference of time and seasons. It is naturally that I was influenced by various color spectrum in Seoul.

Q.How do you draw inspiration?

A. Usually, I inspired about my design in unexpected time. So I used 'Evernote' in my iphone and ipad. Evernote has powerful function such as realtime synchronization, workchat and notebook..etc.

Q.Share good books, music, movies or places with us.

A. I usually listen Daft Punk's music during work. My most favorite album is 'Alive 2007'. That album doesn't suit my CD player anymore, because I played that album too much. So I had to buy one more. Daft Punk's music makes me concentrate and inspired at my design.

Q.Have you started to set up new goals for next period except being a designer or illustrator ? like curating, learning cooking , climbing......

A. I started riding these days. I bought Fixie last year. It is best hobby to me because I love customizing and dressed up my new equipments. I focused on customizing fixie parts last year. And now, I set a new goal. I'll ride 300 km this year, with my fixie. Riding helps me refreshing.

FITBOX 2014 P.74

現今, 人們因為越來越忙碌而沒有時間健身。FITBOX 提供你差異化的服務。當你在地上攤開軟墊, FITBOX 會自動幫你調整音效、空調和燈光, 有了 FITBOX 配備, 你可以利用電網和智慧型電視上的語音教練服務做出各種健身運動。在你的日常生活裡, 你的行動版 FITBOX 應用軟體會檢查並告知你適合的運動量, 在一天的健身結束後, 你可以得到回饋和獎勵, 讓你能持續個人的健身護理。

Today, people are getting more busy so they have no time to spend for exercising. FITBOX will provide you a differentiated service. When you spread the mattress on the floor, the audio, air conditioning and lighting will be automatically adjusted. With the FITBOX equipment, you can do variety of exercises with grid and voice coaching service of smart TV. During your daily life, your FITBOX mobile app will check you and inform the appropriate amount of workout. In the end of your daily workout, you can get feedback and rewards so you can sustainably get the personal gym care.

Dailymoment 2014 P.74

DAILYMOMENT 是一款安卓的螢幕鎖定應用程式, 支援新型態的日程安排方法, 一旦預訂了今天的日程表, 圖標就會依照指令時間的順序顯示在鎖定的螢幕上, 每個圖標依據類別而有所不同, 並且會隨著時間改變。

DAILYMOMENT is an android lock screen application that suggests a new method of displaying today's schedule. Once today's scheduled is registered, the schedule icons are presented on the lock screen in a chronological order. Each icon differs from a category to another and changes along with time.

MCP - MULTIPLY Exhibition 2015 P.125

「Multiply」透過三星設計夥伴計畫和三星軟體人才計畫所重疊的時間, 傳達心價值的表現。multiply 在字典上的解釋是「在數量上增長」或是「放大」, 但這個詞對開發員來說意味著電腦運作, 對設計師來說則意味著圖層混合。2015 年 MCP 想要公平的讓兩個在語言和系統上截然不同的群體, 各自擴展這兩個分開的領域的界線, 然後組合兩者的能力。

"Multiply" conveys the manifestation of a new value through overlapped time between Samsung Design Membership and Samsung Software Membership. The dictionary definition of 'multiply' is 'to grow in number' or 'to enlarge', but the term connotes computer operation to developers and image layer blending to designers. 2015 MCP aims at holding a fair where the two groups of distinct languages and systems cross the boundaries of the two separate fields and assemble their capacities.

MOYEORA Poster 2015 P.125

2015 年第 24 屆三星設計夥伴計畫的海報。「MOYEORA」在韓國的意思是「聚集某些人」, 我想要透過重複的線條排版表現出聚集的形象, 夥伴募集計劃的過程是很難完成的, 由於要一夕之間與其他申請人組成工作室, 感覺像是漫長的競賽, 所以我讓海報的視覺看起來像是車道。

2015 Samsung Design Membership 24th Recruitment Posters. 'MOYEORA' means 'Gather someone' in Korean. I want to represent gathered image through line duplication typography. Recruitment process is hard to complete because of overnight workshop with other applicants. It feels long race, so I visualize it looks like lanes.

印度尼西亞 Indonesia

Kathrin Honesta 是印尼的插畫家及平面設計師，目前在馬來西亞的吉隆坡工作，畢業於 The One Academy 傳達設計，主修廣告及平面設計。曾在廣告業中工作，五年後，決定更專心於設計和插畫。出生於 1933 年的聖誕節，擁有兩個弟弟，曾在檳城及東京展示他的作品。

Kathrin Honesta is an Indonesian illustrator & graphic designer based in Kuala Lumpur, Malaysia. Graduated from The One Academy of Communication Design; Diploma in Advertising & Graphic Design major. She worked in advertising industry for 1,5 years after then decided to focused more on design & illustration. She was born on a Christmas day in 1933 and is the eldest sister of two younger brothers. She is an exhibiting illustrator and her works have been exhibited at Penang and Tokyo.

Kathrin Honesta

www.behance.net/kathrinhonesta

Q. 請問您認為該國最棒的是什麼？(如國家的特色或文化等) 您的創作是否受其影響？

A. 我在印尼土生土長，但我想吉隆坡會是我最熟悉的地方，就談談吉隆坡吧。我愛吉隆坡，特別是這裡的人和食物、文化的多樣，但我想這只是大致上。人們的多樣性開啟了我的心門，也改變了我的想法。吉隆坡像是我的第二個家，有時候，我感到我自己屬於這裡遠超過雅加達，因為我更熟悉這。遠離家鄉也影響我的創作，我偏向反映我現在獨立的生活，幫助我通過藝術來表達我自己。

Q. 請問您如何獲得靈感？

A. 靈感來自許多方面，有時是一個引用、一本書、音樂或就是一個簡單的想法，我沒有什麼公式，一切油然而生。

Q. 請和我們分享您喜歡的書籍、音樂、電影或場所。

A. 好書：牧羊少年奇幻之旅(Paulo Coelho 著) / 返璞歸真(C.S Lewis 著) / 習慣的力量(Charles Duhigg 著) / 小王子(Antoine de saint Exupéry 著)。

音樂喜歡的太多了，但以下是我的終極最愛：

Jason Mraz- A Beautiful Mess / Ella Fitzgerald- I'm Making Believe / Singing in the Rain (Jamie Cullum version) / The Whitest Boy Alive- Burning。

Q. 除了當設計師/插畫家，你是否已經開始規劃下一階段的目標？例如策展、學習煮菜、登山 ……

A. 我真的真的很愛刺繡，希望有天可以學會並擁有個自己的品牌，印上我的圖案或插畫在文具衣物上，這些都是我未來很想要做的。

Q.What do you like best in your country? (such as country feature or culture)Has it made a difference on your creation?

A. I am originally from Indonesia, but I guess since I became more familiar to KL, I will talk about KL instead.
I love KL. The people and the food especially. Also the culture and the diversity, but I think that is just Malaysia in general. The diverseness of the people opens my mind. It sort of changes the way I think too. KL is like my second home already. Sometimes, I feel I belong here more than Jakarta because I am more familiar to this city. Being away with home affects my creation as well. I tend to reflect more since I live independently by my own now, and it helps me to express my thoughts through arts.

Q.How do you draw inspiration?

A. Inspirations come in many ways. Sometimes I was inspired by a quote, or a book, music or just simply an expression of my thoughts. I have no formula, it all happens rather spontaneously.

Q.Share good books, music, movies or places with us.

A. Good books: The Alchemist by Paulo Coelho / Mere Christianity by C.S Lewis / Power of Habit by Charles Duhigg / Le Petite Prince by Antoine de saint Exupéry.
Music: (too many! but here are my ultimate favorites)
A Beautiful Mess by Jason Mraz / I'm Making Believe by Ella Fitzgerald / Singing in the Rain (Jamie Cullum version) / Burning by The Whitest Boy Alive.

Q.Have you started to set up new goals for next period except being a designer or illustrator ? like curating, learning cooking , climbing......

A. I really, really love embroidery and wish to learned it one day later, also I have a thought of having my own brand/ line of stationery or clothing line where I can apply patterns or my illustrations on it. Those things are something that I would love to do in the future.

The Undaunted Dandelion 2014 P.18
無畏的蒲公英是我在學最後一年的自我推銷的計畫。是一個有關於我自己旅程的故事。我想要這本書是很個人化的，讓人們一眼就能看見我的獨特以及作品背後的含義和力量。所以我把它變成插畫故事書，以關於無畏的蒲公英的故事開始並解釋我所有大學作品。
The Undaunted Dandelion is a self-branding project for my final year of college. It is a story about my journey. I wanted this book to be personal, so that people can have a glimpse of my characteristic, strength and also the thoughts behind all the works. So I made it into an illustrative story book. It begins with a story about The Undaunted Dandelion and slowly then, it brings you to all the compilation of my college works.

A Relationship 1&2 2015 P.291
呈現我和神之間的關係。
A personal expression about a relationship between me and God.

The Girl and The Moon 2015 P.291
關於一個女孩為了去月球的旅程的一系列插畫。月亮代表看起來不可能又遙遠的夢想和希望，為了追求她的夢想，她將會迷失、墜落、一路學習，最後將會發現。
A series of illustration about a girl's journey to find her way to the moon. Moon is symbolizing dreams and hope that seems impossible and too high. In the journey of pursuing her dreams, she will get lost, she will fall, she will learn along the way and she will find it.

Outgrowing 2015 P.291
這是基於我當時的情況下表達我個人的插畫。是到了讓我脫離我自己的舒適圈的時候，我已不適合以往的方式和舒適圈，從某種定義上來說我並不是自願但我無從選擇，我想這是一個成長的過程。
This illustration is a personal expression based on my circumstances at that time. It was about time to outgrow my own comfort zone. I couldn't fit into my old ways and my old comfortable space anymore. In a sense, I wasn't willing to, but I had no choice. I guess it was just a perk of growing up.

People of Malaysia 2015 P.295
作品是為了日本東京 Asia Creative Data Map (ACDM) 展覽所做的插畫作品。ACDM 是個揭開亞洲城市如何

變強的計畫，它的目標是成為一個工具，通過多種方式為各個城市提供其他城市的可視化數據。在這次展覽，我代表馬來西亞，用插畫表現城市裡的人們。我使用的元素是來自於我個人的觀察以及馬來西亞式的標誌。
This is an illustration that I did for "Asia Creative Data Map (ACDM)" exhibition at Tokyo, Japan. ACDM is a project deciphering how Asian cities continue to change strongly. Its goal is to be a tool for cities to know each other by visualising data in variety ways. In this exhibition, I am representing Malaysia and we have to do an illustration about the people of the country. The element that I take for this illustration are mostly of my observation of the people, and also things that are really iconic for Malaysians.

Drowning in Thoughts 2015 P.295
在我的個人插畫作品中代表寧靜，用我當下的感受表達我自己。
This is a peace of my personal illustration projects. This is a literal self-expression about how I feel at that moment.

Sweeter Streets 2015 P.295
呈現過去食物供應商用肩膀扛著他們的商品，包含傳統的清淡午餐和娘惹糕點。然而現今社會已很少見了，因此洗都的人們只能將這當作甜蜜的兒時回憶保留在心中。
It is about food vendors of the past who used to carry their wares by shoulders. These carriers traditionally contained light lunches and Nyonya traditional cakes. However, they are hardly be seen nowadays, therefore the people of Sentul can only keep it as sweet memories during their childhood days.

The Turning Point 2014 P.295
「你的人生目標是什麼？」在這個速度飛快的世界並沒有給我們多餘的空間思考，世界設定的標準給了很多壓力，無庸置疑，任何人都會被追趕上，甚至都沒有嘗試過就被這個體制併吞，不要隨波逐流！當個追求真相的人，質疑事情的始末並查出真相。
"What is the purpose of your life?" In the world that is moving really fast, it gives no room for us to think about it. There is a lot of peer pressure to conform to the standards set by the world, and without a doubt it is possible for anyone to be caught up and absorbed into the system without even trying. Don't follow the crowd. Be the truth-seekers; question the merits of how things appear, and they seek out how things really are.

南韓 Republic of Korea

用嚴謹的態度探索創意，和各式各樣的藝術家合作。目前經營一家設計工作室 Printlab。

He engages in rigorous creative exploration and collaborates with various artists. Currently, he runs a design studio and hyphen.

金普輝　Kim Bo-Huy

www.kimbohuy.com

Q. 請問您認為該國最棒的是什麼？(如國家的特色或文化等) 您的創作是否受其影響？

A. 我超愛我從小到大住的一條鎮上的狹窄小巷。在這條巷子發生的許多事給了我動力。

Q. 請問您如何獲得靈感？

A. 我會試著去享受我在工作的時刻。有些人偏向理性和邏輯性，但我比較偏向情緒化和即興。所以我不會在工作時想別的事，我只沉浸在其中。

Q. 除了當設計師 / 插畫家，你是否已經開始規劃下一階段的目標？例如策展、學習煮菜、登山

A. 我最近的目標是拿到駕照，最近我真的需要它。

Q. 你對生活的細節上有什麼堅持嗎？(像是上廁所時一定要看詩集之類的)

A. 我的態度決定我的未來。努力和耐心，我的父親總是這麼說。

Q. *What do you like best in your country? (such as country feature or culture)Has it made a difference on your creation?*

A. I love a narrow alley in the town that I have grown up.
Many things that happens in the alley usually give me motivations.

Q. *How do you draw inspiration?*

A. When I work I try to enjoy it. There are some people who are rational and logical but I am rather emotional and extempore. So I do not really think about anything while working. I just try to enjoy it.

Q. *Have you started to set up new goals for next period except being a designer or illustrator ? like curating, learning cooking , climbing......*

A. My recent goal is to get a driver license. I have needed it for real lately.

Q. *What is your insist on your life's details ? like toilet with your favorite poem?*

A. My attitude decides my future. Effort and patience, these are what my father always talks about.

A spring night in Seoul 2015 *P.126*
做錯的事情。關於錯誤。
Doing wrong things. About errors.

SUM-BI : The boundary of water 2015 *P.126*
Soompi 是女潛水員在她們長時間閉氣後出水面的聲音。我研究並描繪此主題的形成和作用 - 水的邊界。試圖傳達死亡和生命之間的訊息。
Soombi which means the sound that female divers make above the water when they exhale after a long breath hold. I delved into the formative function of type when portraying the theme - a boundary of water. Tried to convey the message of the boundary between death and life.

He is walking all over me 2015 *P.126*
他正走過我，就是字面上的意思。
He is walking all over me. Literally.

The present is bleak, the future is bleaker 2015 *P.126*
" 現在是令人沮喪的，未來也將會是鬱悶的 " 的視覺化，包括將不舒服的感覺表現出來。
It's visualization of "Present is depressing and the future will be depressed as well." including the uncomfortable feeling out of it.

MAM 2015 *P.127*
做錯的事情。關於錯誤。
Doing wrong things. About errors.

Just another face 2014 *P.127*
一個人的自畫像。一張臉裡面也有很多其他張不一樣的臉。
A self-portrait or a portrait about a human being. One face but there are a lot of faces inside of it.

SUM-BI : opening poster 2015 *P.127*
地下一層。我們正在等待一個你需要忍受某件事、遮遮掩掩、樓下，而某天我們可以上樓，有個暫停。
First basement. We're waiting for the action you need to endure something, secretive behaviour, downstairs, and the days when we can go upstairs. Having a pause.

2015 visual impact : series 2015 - 02 -03 2015 *P.127*
一個關於視覺衝擊力的個人成果。主題：錯位。
Deliverable of a personal project which is called visual impact.
Subject: Misalignment.

南韓 Republic of Korea

金玹辰　Kim Jenny

jinyus.com

Jenny 是現居於紐約的平面設計師，品牌設計有廣泛大量的宣傳和印刷出版、數位化、螢幕設計、大規模的環境與展覽平面。Jenny 是國際性大獎的得獎者，包括 2011 紅點設計、2012 Adobe 設計成就。個人作品曾在多個展覽展出，包括 2012 CA Design Thinkers Conference、2013 光州設計雙年展、2015 Samwon Paper Gallery。擁有羅德島設計學院的平面設計碩士和梨花女子大學的視覺設計學士。

Jenny is a New York based graphic designer working in a broad range of graphic design from branding and printed publications, digital, screen-based designs, to large scale environmental and exhibition graphics. Jenny was a recipient of international design awards, including a Red Dot Design Award (2011) and Adobe Design Achievement (2012). Her personal work has been shown at a number of exhibitions, including at the Design Thinkers Conference (CA, 2012), Gwangju Design Biennale (KR, 2013) and Samwon Paper Gallery (KR, 2015). She holds an MFA in Graphic Design from Rhode Island School of Design and BFA in Visual Design from Ewha Womans University.

Q. 請問您認為該國最棒的是什麼 ?(如國家的特色或文化等) 您的創作是否受其影響 ?

A. 韓國在文化上是保守的，但人們很樂於接受新事物。我覺得這是一個很多韓國人如何在藝術、設計和娛樂等行業上的成功因素。韓國人喜歡有趣的事，我也是 ! 我認為這使我的作品與眾不同。在一天結束後，這是最有趣的事。

Q. 請問您如何獲得靈感 ?

A. 我喜歡看電影、吃一頓好吃的和旅行，我不斷地驚訝有那麼多有才華的人知道自己在做什麼並熱愛、渴望，透過自己的方式與世界溝通。平常在生活中有很多有興趣的事，我的工作是用我的方式和作品告訴世界我經歷過什麼。

Q. 請和我們分享您喜歡的書籍、音樂、電影或場所。

A. 我喜歡現代樂。Bajofondo、Otros Aires、The Shanghai Restoration Project、Örsten、Break of Reality。

最近看了一部動畫「恐龍當家」，我記得我在某一個情節笑到流淚。「數造天才」我沒想過是這麼好看的電影，是我現在的最愛。

Q. 現在，回頭來看這些帶著遺珠之憾的作品，您有什麼新的感觸 ?

A. 你可以到我的個人網站 (jinyus.com) 看看 :)

Q. **What do you like best in your country? (such as country feature or culture) Has it made a difference on your creation?**

A. Korea is culturally conservative but people are very accepting and open to new things. I think that's how a lot of Koreans became successful in art, design and entertainment industries. Koreans like to have fun and I do too (all the time!) and I think that's what makes my work different and unusual. At the end of the day, it's all about having fun.

Q. **How do you draw inspiration?**

A. I like watching movies, eating good meal and traveling, and I am constantly amazed by the fact that there are so many talented people out there who are so passionate about what they are doing and eager to communicate with outside of the world through their own ways. I am interested in a lot of things in life in general, and my work in the end is all about what I have experienced and what I have to say to the world in my own way.

Q. **Share good books, music, movies or places with us.**

A. Love contemporary instrumental music and this is the list:

Bajofondo, Otros Aires, The Shanghai Restoration Project, Örsten, Break of Reality.
Recently saw an animated movie The Good Dinosaur and I remember I was laughing to tears at some point.
A Brilliant Young Mind is something I didn't expect to be good but it is my favorite movies now.

Q. **Now, look back to these works of regret for not been selected, how do you feel that?**

A. You can always go to my personal website (jinyus.com) and see them :)

Korea　2014　*P.33*

這本書表現了自 1950 年代以來南北韓持續的鬥爭。300 頁的書，印刷設計當書翻轉到相反的方向時會有兩個各個國家的國旗圖片，而在書的前線有個統一的標誌。

This book embodies a division of South and North Korea who have been engaged in a continual struggle since the 1950s. As a 300 pages book, this printed object creates an image of each country's national flag when it's flipped to opposing directions while displaying a unified flag on the fore-edge of the book.

Russell Reynolds Associates Event Design　2014　*P.69*

為美國羅盛諮詢公司柏林分部設計的塗鴉壁畫及節日宣傳品。這次德國活動靈感來自街頭藝術、塗鴉風格的壁畫，是專為德國 Adlon 飯店設計的公司年度股東大會。在圖畫的設計上，將公司名字設計成不同的字體和顏色，並應用在整個活動中的藝術牆、菜單、桌卡。

Graffiti mural and event collateral designed for a executive search consultancy Russell Reynolds Associates in Berlin. The event was inspired by street art in Germany and graffiti-inspired mural was designed for the company's annual shareholder meeting which was held at Adlon hotel in Berlin. In the mural graphics, the company's name was designed in different typefaces and colors, and the art was used throughout the entire event as a graffiti mural, hanging wall art and menu/table cards.

RISD Visiting Designers poster　2014　*P.131*

海報是宣布設計師們到 Rhode 設計學院一系列演講。訊息有關設計師、演講和在 2014 年春季在 Rhode 的「Graphic Design:Now in Production」展覽。

Poster announcing visiting designers lecture series at Rhode Island School of Design. This poster informs about the guest designers, lectures and the upcoming exhibition "Graphic Design: Now in Production" scheduled at RISD in 2014 spring.

London　2014　*P.225*

海報主題是表達倫敦這個城市。被選定為 ShowUsYourType 線上 / 非線上季刊展覽。

Poster designed with the mission of expressing the city of London. This poster was selected for on/offline exhibition for a quarterly online magazine ShowUsYourType.

台灣 Taiwan

郭欣翔　Kuo Hsin-Hsiang

www.behance.net/hsinhsiang1990

目前於出生地台南繼續從事設計方面的發展，接觸多以視覺平面設計為主，大學畢業後鑽研文字設計以及 2D 動態設計，喜好面向廣泛，除了平面方面，也製作過動畫 MV、演唱會視覺之美術，以拍攝約四部線上歌手 MV，擔任攝影職位，也曾經以底片攝影師身份拍攝 NOT TODAY 家訪單元。
近期期望可以持續發展書籍方面的領域，以及接觸音樂娛樂界更廣泛的設計。

Currently in Tainan continue to engage in development Birthplace design, the contact more visual graphic design, text design study after graduating from college and 2D dynamic design, like wide-oriented, in addition to the plane, it also produced the animation MV, Concerts vision of art to take about four lines Singer MV, as a photographer jobs, but also had to film a photographer shooting NOT TODAY visits unit.
Recent books expect to continue the development of the field aspects of the entertainment industry as well as exposure to music the wider design.

Q. 請問您認為該國最棒的是什麼？(如國家的特色或文化等) 您的創作是否受其影響？

A. 台灣人與人的溝通是很特別的，關於之間的衝突、和諧，總是能帶給我以人性為出發點的設計。

Q. 請問您如何獲得靈感？

A. 從生活、電影、一個人獨處的時候。

Q. 請和我們分享您喜歡的書籍、音樂、電影或場所。

A. 書籍：向達倫大冒險。

電影：全面啟動。

場所：沒有人的樹林。

Q. 現在，回頭來看這些帶著遺珠之憾的作品，您有什麼新的感觸？

A. 這些作品不需要迎合所有人的口味，他也不會是我所代表的樣子，而是一個階段性的記憶以及審視。

他們存在這我個人還沒被抹去的獨特性。

Q. What do you like best in your country? (such as country feature or culture) Has it made a difference on your creation?

A. Taiwan interpersonal communication is very special, the conflict between respect, harmony, always bring me to humanity as a starting point for the design.

Q. How do you draw inspiration?

A. Life, movie, from one man alone.

Q. Share good books, music, movies or places with us.

A. book: The Saga of Darren Shan.

movie: Inception.

place: Nobody woods.

Q. Now, look back to these works of regret for not been selected, how do you feel that?

A. These works do not need to cater to everyone's taste, he would not be the way I represent, but the memory of a stage and scrutiny. They exist which have not erased my personal uniqueness.

狄賽耳的引力 - 郭欣翔個人作品集　DESIGNER'S GRAVITATION - KUO,HSIN-HSIANG PORFOILO
2013　P.38
整理大學時期的個人作品，再出社會的時期作為一個回顧的里程碑。以概念的跳躍式編排著重在設計上，跳脫以往制式的編排，希望達到文字與圖像相輔相成的風格。
Personal works finishing college, and then a period of society as a review milestone. The concept of leaping choreography focuses on the design, escape the conventional standard layout, text and images hopes to achieve complementary style.

謀殺賀爾蒙 These are all my names　*2014　P.78*
學生電影形象設計，以人格分裂為題材的電影。海報視覺以男性化成女性的容顏為概念去設計，DVD 包裝以故事性的翻閱為設計，帶入一個身體，五個靈魂的意象。
Student film image design, with split personality for the theme of the film. Posters Vision male into female face concept to design, DVD packaging is designed to read the narrative, into a body, the soul of the image of five.

顏面失調 Lost the original　*2013　P.105*
「那些物質離我好近，有時候我連自己是誰都不曉得」
我的原始為一座「島」，一個不被汙染、不被扭曲、不被侵蝕的象徵。一旦我們想要更多，只有徒增，卻沒有消化，那這些慾望便便使我們逐漸迷失自我，失去最乾淨的本質、最原始的樣貌。
畫面以象徵慾望的紳士淑女、熱氣球、房子、汽車等為元素，反覆地排列著淹沒已被扭曲的我的臉孔。島為完整的我，想要的更多，而不去實踐，則顏面予之失調。「島」即消失。
「我看不見自己了，好像在你們眼中的扭曲的我。」
"Those substances from me so close, sometimes I do not even know who he is."
My original is an "island", a non-contaminated, not distorted, a symbol of not being eroded. Once we want more, only inviting, but not digested, then these desires will make us increasingly disoriented and lose the essence of the cleanest, most original appearance.
Screen to symbolize the desire for ladies and gentlemen, hot air balloon, house, car, etc. for the elements, arranged to repeated flooding has been distorted my face. My island is complete, more want, and not to practice, then face to the disorder. "Island" disappeared.
"I can not see myself, as if I twisted your eyes."

東京概念動態海報 TOKYO MOTION POSTER　*2014　P.105*
以自己腦海的東京印象，關於天空、關於城市、關於隅田川，並且結合地鐵圖的概念，以「東」「京」兩字合而為一的形式做視覺動態設計。
Tokyo impression in their own mind about the sky, about the city, on the Sumida River, and incorporates the concept of subway map, in order to "東" "京" to make visual word form into one dynamic design.

Olia Hair Studio　*2014　P.183*
髮廊的品牌設計，除去以往尖銳的印象，以圓滑的剪刀型態帶給觀者專業卻用溫暖可愛的風格，更容易有記憶點，並且帶出設計師的親和力。
Salon brand design, removing the previous sharp impression, with rounded scissors patterns give the viewer a professional but with a warm and lovely style, more likely to have memory point, and bring out the designer's affinity.

馬來西亞 Malaysia

90 後，來自馬來西亞，於 2015 年畢業於達爾尚藝術學院（dasein academy of art）。
喜歡觀察身邊的人事物，多元文化往往是設計的靈感來源。

The 90's generation, come from Malaysia, graduated from the Dasein Academy of Art in 2015.
I like to observe people and things around me, multiculturalism is often the source of idea for the design.

魏光莨　Kwee Jino

jinokwee.jk@gmail.com

Q. 請問您認為該國最棒的是什麼？(如國家的特色或文化等) 您的創作是否受其影響？

A. 最特別的馬來西亞是擁有不同的種族 , 多元的文化 , 再加上馬來西亞以前被不同國家佔領 , 所以設計方面也會被影響。

Q. 請問您如何獲得靈感？

A. 從觀察身邊的人事物獲得靈感。

Q. 請和我們分享您喜歡的書籍、音樂、電影或場所。

A.「樓下的房客」。

喜歡林宥嘉和五月天的音樂。

Q. 現在, 回頭來看這些帶著遺珠之憾的作品, 您有什麼新的感觸？

A. 對我來說獎項並不是特別的重要, 重要的是有沒有影響人或者說與人產生共鳴。

Q. 除了當設計師 / 插畫家, 你是否已經開始規劃下一階段的目標? 例如策展、學習煮菜、登山

A. 用小創作把馬來西亞的價值帶出來。

Q.What do you like best in your country? (such as country feature or culture)Has it made a difference on your creation?

A. The best is the culture of Malaysia have different races, diverse culture, and also Malaysia has been occupied by different country, so the design will also be affected.

Q.How do you draw inspiration?

A. Get idea from my daily lifestyle.

Q.Share good books, music, movies or places with us.

A. "The Tenants Downstairs".

Love the music of Mayday and Yoga Lin.

Q.Now, look back to these works of regret for not been selected, how do you feel that?

A. For me Awards are not really important, the important is my works can affect people.

Q.Have you started to set up new goals for next period except being a designer or illustrator ? like curating, learning cooking , climbing......

A. Brings out the value of Malaysia.

百家被 Hundred family convention　2014　P.30
這作品是說馬來西亞的文化, 用不同的角度看馬來西亞傳統文化。由於馬來西亞的文化大部分並不是完全屬於馬來西亞, 有些留下來的傳統文化可能來自於別的國家。馬來西亞的傳統文化是來自於每個家庭的特殊習慣 / 傳統, 所以訪問了一百個家庭, 一百個特殊習慣 / 文化, 這一百個特殊習慣 / 文化造就了屬於馬來西亞獨一無二的文化。馬來西亞是一個多元種族的國家, 它是由很多不同的文化和人所組成的。這就像 " 百家被 ", 集聚的每一塊布縫在一起, 使之成為一個完整的被子。
This project is talking about Malaysia Culture. Discover Malaysia culture with different perspective, The Malaysia's culture is not originate from Malaysia but it's from other countries. The real part of the Malaysia's culture is own from the special habits and conventions of every different family who lives in Malaysia. Malaysia is a multiracial country, it sustain by a lot of different cultures and conventions from different races of people in the country. It's just like "Bai Jia Bei" , gather every piece of cloth and sew them together and make it become a complete quilt.

自我提升 Self Promotion　2015　P.31
這作品是要表達我是怎樣的人, 我形容自己像個小偷, 喜歡在我身邊的人事物「偷」靈感。
This project was done to present myself. I am a person that love to steal idea in my daily life.

MWM medical without medicines　2015　P.195
這作品是要表達每個人都有病 (文明病), 理念是要人們意識到文明病都是因為不健康的生活習慣所造成的, 要讓人們不要依賴藥物, 依賴藥物可能會帶來副作用, 改正生活習慣, 飲食習慣才是治本的方法。
MWM is a project about civilized disease. Concept is to let people be aware of diseases of civilization are come from their wrong life.

如何成為一個背包客 How to become a back packer　2014　P.235
這是一個教人們在當背包客之前需要注意或準備的事情 / 資料。
This is the infographic that educate people how to become a backpacker and what should the take care and need to know.

台灣 Taiwan

賴依靖，自由接案者，來自台灣。畢業於國立台灣藝術大學戲劇與劇場應用學系，曾任職於 The Big Issue Taiwan 大誌雜誌美術設計，和負責 Paper St. 紙街咖啡視覺設計。

My name is Yi-Chin, Lai. I'm a graphic designer based in Taipei, Taiwan. I graduated from National Taiwan University of Arts, with a major in drama and theater. I have worked for 4 years as a graphic designer at The Big Issue Taiwan Magazine, a street paper which features international briefings, cultural and artistic topics. And 1 year as a visual director at Paper St. Coffee Company.

賴依靖　Lai Yi-Chin

www.behance.net/laiechin

Q. 請問您認為該國最棒的是什麼？(如國家的特色或文化等) 您的創作是否受其影響？

A. 在台灣最棒的是自由，創作思考和整體環境都越來越開放，投入、推廣文化創意產業的人也越來越多，這些都給予年輕設計師與藝術家們更多的機會發展。而且我們同時擁有來自各國的資源，能夠輕易地與不同文化接觸、交流。很多時候，在創作中容易陷入瓶頸，或侷限在既有框架，但我會嘗試用新的角度去思考，將不同觀點融合原有的想法，轉化為希望藉由作品傳達的訊息。

Q. 請問您如何獲得靈感？

A. 保持對事物的好奇心，多看、多吸收，並不侷限在設計相關，反而稍微離開一點舒適圈，去學習觀察細節和培養敏銳度。

Q. 現在，回頭來看這些帶著遺珠之憾的作品，您有什麼新的感觸？

A. 就算當下覺得滿意的作品，現在看來還是不完整。相信著事情總是無法達到一個完美的狀態，這樣的想法除了把自己逼死外，應該也是個激勵自己進步的方式。

Q. 除了當設計師 / 插畫家，你是否已經開始規劃下一階段的目標？例如策展、學習煮菜、登山 ……

A. 想做的事一直都太多，也是個很不會做目標規劃的人。目前應該是想跟更多不同領域、經驗豐富的人接觸、交流，如果能夠參與到一些團隊的計劃，應該會很有趣。再來就是想要把手和頭腦練得厲害一點。還有希望戒掉焦慮地工作時一定要蹲在椅子上直到腳麻為止的習慣。

Q.What do you like best in your country? (such as country feature or culture)Has it made a difference on your creation?

A. The best part in Taiwan, it's that we have the freedom. The creative thinking, and the whole environment are getting more and more opened and developed. Besides, there are more people who consciously and generously place themselves in The Cultural and Creative Industries. For these reasons, young designers, artists have much more opportunities to expand their careers. Furthermore, we have a great deal of resources from everywhere in the world, which allow us easily approach diverse cultures. During creative process, I find myself occasionally stuck or not able to think outside the box, then I need to use a new point of view to think. Trying to integrate several different perspectives into my original idea, then turn them into the message that I expect to transmit by my work.

Q.How do you draw inspiration?

A. Keep the curiosity of everything, the more we look, the more we absorb. Meanwhile, try to step out of our comfort zone for being more observant.

Q.Now, look back to these works of regret for not been selected, how do you feel that?

A. Even though I was satisfied with my work by the time I finished, it still remains some incomplete parts. My belief is that things are always imperfect, for sure this is a thought that drives us crazy, but also it's a way to encourage ourselves to reach the perfection.

Q.Have you started to set up new goals for next period except being a designer or illustrator ? like curating, learning cooking , climbing......

A. I always have lots of things on my to do list, but I'm really bad at making a plan. For the moment, I hope to know more people that I appreciate in every domain in order to exchange our ideas. Besides, if there's a chance of participating in projects with different groups, it might be interesting. Secondly, I'm eager to better my freehand skill and innovative thinking. Lastly, I really want to stop staying on the chair until my legs become numb while I'm anxiously working.

LAI 2015　2015　P.19
這是我近期的作品集。主要的視覺編排和裝幀設計有很大的關聯，因為最初的概念是希望做一本書可以輕易地分享頁面。為了避免在摺頁時破壞每個元素，在編排設計時，我將每面視為一個完整的畫面，但仍要保持展開後畫面的平衡，這成為我在做設計時一個新的觀點和方式。
This is my lastest portfolio. The initial concept was to design a book which can be viewed and shared easily. Every page is formed as a complete layout to ensure no content falls on the binding line. A new design perspective was brought out in order to keep the balance of each layout.

Solar Terms　2015　P.62
延續為 The Big Issue Taiwan 繪製的節氣插畫，想將這個特別的傳統介紹給不同文化的朋友。運用黃、藍色調代表日月，再以文字間的線條呈現延續感。
The concept is extended from the illustrations that I designed for The Big Issue Taiwan. Those illustrations signifies our traditions and natural phenomenon. I used yellow and blue to represent the sun and the moon, and I also played with the typography. Presented by the poster for showing our tradition to other different cultures.

Mid-Autumn　2015　P.93
延續一個為 Digital Art Center,Taipei 設計的中秋視覺。概念為反轉傳統的印象，創造一個數位時代的節慶形象。選擇紅色的月作為主要元素，以其強烈的視覺，強調節慶文化的重要性和影響，搭配背景雜訊和幾何形狀帶出無形的數碼訊息。
The concept is extended from a design for Digital Art Center, Taipei. To reverse the traditional impression into a new image from digital generation, I used the moon in red as a main element to show the importance of our festivals and culture. The noise and geometrics in the background brought up the intangible digital informations.

辰楓室內設計 CHENG FENG INTERIOR DESIGN　2012　P.139
一間室內設計公司的視覺識別提案。設計發想自「藍圖」，將「內」的概念使用點和線構成。

Designed for a interior design. Here is one of the propositions we provided to the client. Based on a composition of lines and points, which represents the blueprint.

比特尼克 BEATNIK　2015　P.139
以 50 年代保守社會的「Beatnik」精神為設計概念。為了呈現「Beat Generation」（垮掉的世代）中的自由、無懼，並努力實現目標。使用黑白搭配為基礎，保留其鮮明的形象。六角形的方正感和線條的簡單利落，象徵一種堅定、單純的意念。
Inspired by the Beatnik , a media stereotype prevalent throughout the 1950s. The "Beat Generation" are free, undaunted, and always striving to achieve their goals, so I kept their vivid image by using white and black, and I applied a hexagon and stripes to represent a strong, simple idea.

A corner　2015　P.282
構圖來自於一個不起眼的角落，意外發現它自然形成了一個完美平衡的畫面。試圖保留結構，運用顏色和材質的搭配，創造元素間單純、直接的連結，使畫面呈現不同的質感。
Inspired by an obscure corner. I found that it naturally forms a perfect balance of an image. Then I retained the structure, and applied colors, materials to create a straightforward link between elements. And I tried to show different perceptions through the image.

Falling　2015　P.282
延伸自一個喜帖設計，以「跌入愛河」為概念。選擇藍綠、粉紅代表男女，兩色間的漸層色調，呈現融合為一的意念。
The concept of "falling in love" is extended from a wedding invitation that I designed. Aquamarine and pink were chosen to represent male and female, and the gradient colors symbolize the unification of the two.

台灣 Taiwan

1991 年出生，台北人，主修商業設計，目前就讀於台灣科技大學商業設計所。
近年參加台灣國際學生創意設計大賽、台灣國際平面設計獎、朝倉直已教授紀念獎、上海 - 亞洲平面設計雙年展、澳門設計雙年展、國際字體設計大賽 - 融，喜歡以實驗媒材與創意思考從事創作，近期研究中英字體的不同創作手段。

Born in 1991, Taipei, major in commercial design in National Taiwan university of science and technology. Recently was awarded in 2015 Taiwan International Student Design Competition, Taiwan International Graphic Design Award, ASAKURA NAOMI Award, Shanghai Biennial Exhibition of Asia Graphic Design 2015, Macau Design Biennial award 2015, Blend-2015 International Typography Design Awards. Experimenting different materials and thought plays a important role in my work. Recently I am working on my research about the design of Chinese and English typography.

李杰庭　Lee Chieh-Ting

www.behance.net/leechiehting

Q. 請問您如何獲得靈感？

A. 對我來說看一些設計雜誌、網站或是展覽是比較輕鬆的方式來獲得靈感，但是參加競賽並觀看得獎者的作品也扮演重要的角色，有時在實驗一個媒材時可以觸類旁通，引導出新的嘗試方式。

Q. 請和我們分享您喜歡的書籍、音樂、電影或場所。

A. 我喜歡看很多電影尤其是一些特定導演的，像是楊德昌、李安、蔡明亮、侯孝賢，他們的電影你永遠猜不到結局，這也是我喜歡看獨立電影的原因之一，藝術價值我是看滿重的。順帶一提，我滿推薦 " 雙面薇若妮卡 "，這是尤其是勞斯基導演的一部片。

Q. 現在，回頭來看這些帶著遺珠之憾的作品，您有什麼新的感觸？

A. 會當作是一個學習，視覺傳達的重點就是溝通，溝通不只是作品也包含人的溝通。當主任告訴我不能使用這張視覺的時候雖然是相當難過，但是溝通的過程中會建立彼此對於案子本身的理解跟認知，我相信這會是設計業者的養分之一，當建立起足夠的信任時，實驗的手法就可以被接受而不需等待前人的參照樣本。在學校真的可以玩很多方法是業界不能玩的，很珍惜主任給的機會，希望將來可以用得獎當作認可。

Q. 你對生活的細節上有什麼堅持嗎？(像是上廁所時一定要看詩集之類的)

A. 不可否認的，我對甜點有些要求，如果甜點不符合期待的話心情會滿沮喪的，一天的開始勢必是一杯好的咖啡，所以我一定很認真地挑選咖啡店。

Q.How do you draw inspiration?

A. For me,the easy way is to read some design magazines, design websites or go to the exhibition.However entering a competition will also play an important role to get a good inspiration. Besides, sometimes I can get inspiration from my prior experiment and it can led you to a right direction.

Q.Share good books, music, movies or places with us.

A. I like to see movies and I like specific directors such as Edward Yang,Ang Lee,Tsai Ming-liang and Hou Hsiao-Hsien. Their movies contains the surprising things in daily life, and you can never guess what is the end of the movie.that's the reason why I love to see the independent film.The artistic is the element that I take as the first place. By the way, my favorite movie is "The Double Life of Véronique"which was directed by Krzysztof Kieslowski .

Q.Now, look back to these works of regret for not been selected, how do you feel that?

A. In my point of view, I will prefer to take this opportunity as a experience of learning communication. Communication is an activity that goes from both sides which are not only for designer but also for customer. It's really frustrated when your advisor refutes your original idea but the process of communication will build stronger connection between the designer and the advisor. I take this as one of the nutrient for design workers. When we build enough trust we can easily persuade the employer to accept our idea. I think I am lucky that my advisor gives me chance to show my talent because our design industry don't allow our designer to show these crazy ideas so I really appreciate him. Hope I can get another award as my personal compensatory.

Q.What is your insist on your life's details ? like toilet with your favorite poem?

A. It's no doubt that I have a higher standard of my snacks, If the flavor and the taste can't fit my requirement I will feel down that day. A good quality of a cup of coffee is the basic beginning of my day so I always choose a nice coffee shop seriously.

Taiwan good fruits　2014　P.51
藉由四季的水果脆片包裝讓外國人和本地人了解到耕作的辛勤與好吃的由來，歡迎喜歡品嘗零食的民眾在享用美食的過程中也能窺見當地農民栽種的故事幫助發展他們的農業。
A box of fruit crisp is a good way to preserve the flavor of the fruit and extend the limit of the food preserving time. Welcome to enjoy the snacks and read the stories behind the package that will help the local farmer developing the local agriculture.

RISING STAIRS　2014　P.58
學校的校內評鑑視覺，設計系希望具有進步與能表達該校設計系特色：研究與創作並進的生態識別，因此選用創作與思考的象徵物 (鉛筆作為視覺標誌，並規劃一系列視覺。設計系所在近年以豐沛的得獎數量聞名，藉由愉悅歡樂的視覺及文具傳達系所的展望與進步空間。
This project is for the evaluation committee of school. The design apartment of school focus on delivering the idea with progress and creativity.Recently the school's design department has won several international awards such as IF, Red dot,IDA....,and they achieve the high goal in the research area too. In order to present the progress in both the research area and good design works of the student, the idea comes out in pencil and stairs for the identity system.

擁抱海洋 Embrace the ocean　2015　P.88
海報呈現以浮水顏料 (油性顏料) 來製作圖樣，企圖象徵水上的油汗，顏料忠實也反映了水的紋理與油漬的交會，在這之中消失的是生物對環境破壞的血訴與掙扎，文字被油汗漸漸吞噬，家庭與環境也消失殆盡。
I use the marbling pigment (an oil paint material) to present the visual and it shows the oil subtracting the words with the homeless seabirds to present the idea of huge damage from the oil spill.

Motion Meaning, and Messages　2015　P.89
系上的演講海報，主題是動態意涵和多種訊息，我嘗試將 " 動態 " 以顏色和粒子的移動表達，畫面上有許多點穿梭於文字之中，藉此表達，訊息與動態意涵的結合。
The poster series was about a speech which is hold in Taiwan tech. The speech topic is about "motion meaning, and Messages". I experiment the particles on the poster by assigning them the organic shape and color gradient which refers to the old-new process. I make them disperse in the space and interposition with words so that they can look like more appropriate in the poster.

Mini-Symposium-FLOW OF MIND　2015　P.90
設計所的研討會視覺，視覺的重心放在 " 傳達 " 與設計實踐上。在傳統認知心理學中只要將符號化的人臉元素：眼睛、鼻子、嘴巴放置在空間中人們就會去觀察並且賦予想像合理化。
This project is focused on the visual of symposium in Taiwan tech,this topic is about the communicating and the information delivery by design research.
I use the acrylic color to present the flow of visual and contact with the speaker led to change.

The face on the plane is composed of three elements eyes,mouth and nose.These elements resemble clues on the poster that makes the subject trend to find out the face on it. Researching is always the first step for design analysis because designer wants to find out what elements can be use to fit their task and than they take action.By combining the research and action the poster deliver the idea by visualizing the interaction.

感知技術與材料的摸索 Towards the exploration of sciences,Technology and Materials　2015　P.90
這是幫同做的活動提案，我希望以主題的三個字 :sciences,technology,materials 作為研討會的主題，我將 s'e'a'r'c'h 這六個字母隱藏起來，希望與觀者產生互動，讓觀者在遠處就會產生好奇，近看時就會發現我賦予的意義，為了呼應主題的 " 探索 "。
This proposal is about the symposium in Taiwan tech. I hide the letters which are "s,e,a,r,c,h" in the words (sciences, technology, materials).The missing letters in the poster will spurs the curiosity of the viewers, and make them try to find the meaning on the poster so it will be match to the topic" exploration of sciences,Technology and Materials".

Cook bar　2014　P.156
與同學合作的案子。群創廚房的 Logo 設計提案，在設計上希望以 cook bar 作為設計基底，我使用了字母本身拼組出廚師的實驗，呼應群創廚房的精神：人人都是好廚師。
Cook bar is a visual identity proposal which is designed for community kitchen,I use the words "cook bar"as my design base and rebuild it as a chef's smile face to match the core idea of community kitchen"everyone is a good chef"

Live with gods -45symbols　2015　P.256
這是在暑期工作營中與紐約帕森斯的老師一起執行的專案，我選擇了道教中與我們生活最密切的神明作為主題將每個神明圖像化並結合現代生活，像是酒神、畫仙和戲劇神這些與我有關的神明。
This project was made in summer camp which I worked with a teacher from Parsons School. I chose the gods from my daily life, each god manages the closest thing to me, such as the god of drinking, the god of painting and the god of movie.

南韓 Republic of Korea

平面設計師，專長是資訊視覺化、使用者體驗、使用者介面設計，以字體設計為基礎的品牌設計。

Graphic designer, Information Visualization, UX, UI, Branding based on Typography.

Lee Jae-Goo

www.behance.net/leejaegoo

Q.請問您認為該國最棒的是什麼？(如國家的特色或文化等) 您的創作是否受其影響？

A.在我的國家, 我喜歡韓國的傳統文化, 特別是韓國傳統的宮廷。

Q.請問您如何獲得靈感？

A.出門散步、冥想。

Q.請和我們分享您喜歡的書籍、音樂、電影或場所。

A.這是我最推薦的電影：2013 年的大亨小傳、2015 年的神鬼獵人。事實上, 我是李奧納多‧狄卡皮歐的超級粉絲。

Q.現在, 回頭來看這些帶著遺珠之憾的作品, 您有什麼新的感觸？

A.我對自己的作品感到遺憾, 除此之外也不能為它做什麼。

Q.除了當設計師/插畫家, 你是否已經開始規劃下一階段的目標？例如策展、學習煮菜、登山......

A.沒什麼特別的計畫, 我常常外出散步。

Q.你對生活的細節上有什麼堅持嗎？(像是上廁所時一定要看詩集之類的)

A.答案是一樣的, 韓國傳統宮廷。如果要再加一個, 那就是沖澡。

Q.What do you like best in your country? (such as country feature or culture)Has it made a difference on your creation?

A. In my country, like Korea Traditional culture. Specially Korea traditional palace.

Q.How do you draw inspiration?

A. Constantly, Go out for a walk and meditation.

Q.Share good books, music, movies or places with us.

A. Here's a list of my top movie recommendations. The Great Gatsby, 2013 / The Revenant, 2015. Honestly, I am a huge fan of the Leonardo Dicaprio.

Q.Now, look back to these works of regret for not been selected, how do you feel that?

A. I'm so sorry my work. but It can't be helped.

Q.Have you started to set up new goals for next period except being a designer or illustrator ? like curating, learning cooking , climbing......

A. There are no specific plans. I always go out for a walk.

Q.What is your insist on your life's details ? like toilet with your favorite poem?

A. The answer is the same. Korea Traditional palace. When you add one more It is time to shower .

2014 Typeface Calendar for Holiday 2014 P.8

2014 Typeface Calendar for Holiday, 將重點放在替 win 7 和 Adobe CS 的字體排版練習, 這個日曆結合了對假日的期待與對於日常生活簡節乾淨的審美理想, 我使用兩種顏色 (橘和黑), 因為想把焦點集中在系統字體上, 包裝方面也以相同的意象構成。

2014 typeface calendar for holiday project places emphasis on typography practical work for fonts from window 7 and Adobe creative suite. This calendar combined the concept of the holiday anticipation with a neat and clean aesthetic ideal for everyday life. I used two color, (Orange and black) because to place emphasis on system font. The package organized a same intention.

Magazine apostrophe #1 Pen 2013 P.29

Apostrophe Magazine 是韓國的產品故事雜誌, 內容包含資訊、故事、採訪與攝影。從 2013 年開始這份雜誌的設計就以人的產品為主題, 因此這本書設計成模擬情感, 然而這本書的概念同時要求乾淨。我選擇紅色作為封面與內一的主色, 它展現出積極活躍的精神, 也會讓人覺得精力充沛, 在書架上也變得出眾、顯眼。

Apostrophe Magazine is a product and story magazine from Korea including information, story, interview and photography. Since 2013 the magazine has been designed for product themes with person. Therefore, the book of Analog sensibility is designed. However, concept is not analog but clean. The red is chosen as the main color, both the cover and the inner pages. It shows the spirit of enthusiasm and activity. It will make people feel energetic. On the bookshelf, it will be also outstanding and conspicuous.

Republic of Korea Navy, admiral Son Won-il biography 2015 P.32

孫元一是大韓民國海軍中將, 以擔任韓國首任海軍參謀長而出名, 為了迎接 70 週年而開始了孫元一將領的傳紀計畫。傳記結合了文章、影像與動畫。

Son Won-il was a Republic of Korea Navy vice admiral best-known for being the first Chief of Naval Operations (CNO) of the Republic of Korea Navy. This admiral Son Won-il biography project was start, welcome to 70 anniversary. It was composed by writing, photo and animation.

MARY J COMPANY Branding 2015 P.204

MARY J COMPANY 是以電影為基礎的新品牌公司, 範圍十分廣泛, 像是運動、時尚、品牌推廣。因此我設計比較靈活的符號系統, 這個符號系統用直覺的圖像將 MARY J COMPANY 介紹給大眾。

MARY J COMPANY is new branding company based on movie. Range of MARY J COMPANY are very variety. For example sports, fashion, branding so on. Therefore I designed flexible symbol system. This symbol system will give intuitive images of MARY J COMPANY to many people.

Shin Drum x Kim Guitar 2015 P.205

Shin Drum & Kim Guitar 挑戰了新的音樂模式, 他們是熱愛音樂的音樂家。品牌的風格以音樂人的感情為設計基礎。兩個圓圈代表鼓和吉他, 黑色與白色取決於音樂。

Shin Drum & Kim Guitar Challenging new music and is musicians who love music. Branding style is designed with great feeling of musicians. Two circle means the drum and the Guitar. Black and white color is depending on the music.

Republic of Korea NAVY New Media Team Branding 2014 P.206

這是一個概念性的項目, 將一些圖像使用在韓國海軍媒體團隊中, 項目的主題是睿智與親切, logo 和圖標設計都可以應用在各種類的媒體。

It is a conceptual project and some of images will be used in ROK navy media team. The theme of this project is smartness and intimacy. The logo and pictograms are suitable for all kinds of media.

Korea Traditional Ensemble BEDAN 2015 P.207

BEDAN 是位於韓國首爾的韓國傳統表演藝術合奏樂隊, BEDAN 以韓國傳統音樂為基礎, 展現出多元的表演形式, 舉例來說, 四物 (韓國傳統打擊四重奏)、板索里 (韓國傳統清唱藝術)、融合音樂等。我用非常簡單的符號來隱喻韓國的音樂, 像是 sangmo(韓國民俗舞蹈)。其他應用設計以單調和加工處理的方式保持團隊沉著的形象。

BEDAN is a Korea traditional performing art ensemble team, located in Seoul, South Korea. BEDAN based in a Korea traditional Music. In order to show various performance. For example Samulnori, Pansori and Fusion music etc. I used very simple symbol within Korea Music metaphors such as sangmo. I designed application with monotone and post process to keep cool image of the team.

印度尼西亞 Indonesia

出生於望加錫，位於印尼東部的海洋城市。夢想家。以優秀畢業生的身份畢業於比娜大學，學習設計經過四年後，發現自己的真愛是品牌和編輯設計，喜歡特定的字體，深信 Ampersand (&) 是人類創造出最美的符號。

Born and raised in Makassar, the city of oceans in the eastern part of Indonesia. A full-time dreamer. Graduated as the best graduate from Binus School of Design. After almost 4 years of design study, found out that his true love was branding and editorial designs. Have a tendency to love certain types of typeface. Believes Ampersand (&) is the most beautiful character ever made by humankind.

李恩平　Lee Jonathan Edward

jonathanedward.co

Q.請問您認為該國最棒的是什麼？(如國家的特色或文化等) 您的創作是否受其影響？

A. 人民。印尼擁有得天獨厚的多元文化和遺產，每個地區的角落都有它們自己獨特的文化要述說，在這裡你可以真正找到文化之間形成的鮮明對比，創造出與眾不同，有趣的組合。身為印尼設計師，這種奇妙的多樣性某方面也創造了自我的認同感，我出身在一個擁有許多文化的地方。

Q. 請問您如何獲得靈感？

A. 一杯拿鐵和書。

Q. 請和我們分享您喜歡的書籍、音樂、電影或場所。

A. 最近在聽 Banda Neira 和 Tulu，非常愉快的曲調，我在工作的時候會聽。

Q.除了當設計師／插畫家，你是否已經開始規劃下一階段的目標？例如策展、學習煮菜、登山......

A. 我未來的規畫是在家鄉海邊開咖啡店，在那邊不但能聞到咖啡的香味，還能感受海洋的氣息，因為我也在創意產業工作，所以或許我會在咖啡店的閣樓開一間小型設計工作室，不過，未來會發生什麼，我們都不知道呢。

Q.What do you like best in your country? (such as country feature or culture)Has it made a difference on your creation?

A. The people. Indonesia is blessed with diverse culture and heritage, every corner of every region has their own unique local story to tell, where you can really find a stark contrast between cultures, creating really different yet intriguing mix, at some point this marvellous diversity have created a sense of identity for myself as an Indonesian Designer, where I was born not only by one culture, but by many cultures.

Q.How do you draw inspiration?

A. A cup of cafe latte and books.

Q.Share good books, music, movies or places with us.

A. Currently listening to Banda Neira&Tulus, a really pleasant tunes to here while I was working on my projects.

Q.Have you started to set up new goals for next period except being a designer or illustrator ? like curating, learning cooking , climbing......

A. My future plan is to build a coffee shop by the sea in my hometown where you can smell the coffee but also feel the ocean breeze, but while also working in the creative industries, maybe I will open a small design studio in the attic of my coffee shop, well we all don't know what the future holds.

Toraja Hidden Wonders –Kandora　2015　P.92

當地的拖拉查人認為自己的祖先來自天堂，他們相信這個地方是神聖的，並且刻印著他們血脈的歷史，我在這張海報選擇的符號是當地的設計 BomboBuai，代表機智與當地傳統，這張海報也是觀光活動的一部份，也展示了設計如何替當地的文化創造新的可能性。

Kandora is known by the local Torajan people as the land where their ancestor descent from the heavens. They believe this place is sacred and mark the history of their bloodline. The symbol that I choose for this poster is called BomboBuai, a native Torajan design that represents resourcefulness and local heritage. This poster is also as a part of the tourism campaign by showing how design can create new possibilities to local culture.

Toraja Hidden Wonders –Ketekesu　2015　P.92

Ketekesu 是塔納托拉查縣最奇妙的地區之一，住在當地的人們天生擁有高超的工藝技巧，製作的木雕注入了當地的哲學，我在海報中使用的象徵符號是 BarreAllo，這是當地的托拉查人設計的圖騰，代表智慧與創造力，這張海報表現 Ketekesu 當地人們的智慧與創造力，也是振興當地經濟的觀光活動的一個部份。

Ketekesu is one of the most intriguing region in TanaToraja, where people here are blessed with craftsmanship skills, creating wooden crafts embedded with local philosophy. The symbol that i choose for this poster is called BarreAllo, a native design by the local Torajan people to represent their wisdom & ingenuity. This poster is to represent the local wisdom and ingenuity of Ketekesu Region of Toraja as a part of the tourism campaign to elevate the local economy.

Toraja Hidden Wonders –Lemo　2015　P.92

Lemo 是托拉查文化的中心，托拉查人會將死亡的親屬埋葬在石製的墓穴裡，當他們要進行埋葬的時候，他們會舉行盛大的祭典護送遺體到墳墓，我在海報中選擇的符號是當地的圖騰 TangkoPattung，代表著拖拉查家庭永恆與無止盡的連結，這張海報想說明血緣與家庭對托拉查文化而言是非常重要的，他們創造出引人入勝的文化，即使是死亡也不能將家人分開。

Lemo is one of the center of Torajan Culture, where Torajan people bury their dead relatives in the stone carved hills. Everytime they want to bury someone, they will create a huge festival to escort the body to the grave. The symbol that I choose for this poster is called TangkoPattung, a native design by the local Torajan people to represent eternal & endless ties between Torajanfamily. This poster is to represent how bloodline and family are really important in Torajan culture, creating an intriguing culture where even death cannot separate families apart.

Toraja Hidden Wonders –Postcard Designs　2015　P.258

在托拉查祕景的活動裡，我做了一些明信片，總共有 15 件作品，每件作品都代表著當地特色，海報的符號都有每個地區都獨特的設計做為象徵，最重要的原因是要傳達設計如何混和當地文化並創造出新的設計，打造新的可能性。

These are some of the postcard designs I have created as the part of Toraja Hidden Wonders campaign, there are 15 designs total, each represents their own regions, where each regions have their own designs with a symbol from native Torajan design as a part of the design. One of the main reason is to show how design can blend local culture and creative new designs to create a mixture of new possibilities.

南韓 Republic of Korea

李秀辰是大韓民國首爾活動的平面設計師。她在建國大學學習視覺傳達設計。 4 年級，休學中。她原來在韓國的品牌設計公司 PlusX 實習當動態圖像設計師。現在在 getty 當攝影師。2015 年，她住在柏林做自己的創作及與其他公司合作。

Soojin Lee is a graphic designer based in seoul, South Korea. She is studying a visual communication design at Konkuk University in Seoul and take a couple of year off now. She had worked for internship as a motion graphic designer at PlusX where works branding, and has been a videographer at gettyimage. She has been living in Berlin with working personal works and collaboration.

李秀辰　Lee Soo-Jin

www.cargocollective.com/soojinlee0213

Q. 請問您認為該國最棒的是什麼？(如國家的特色或文化等) 您的創作是否受其影響？

A. 我喜歡在我們文化、任何領域追求應有的水平。我們有個著名的四字成語「過猶不及」。人們的態度和往常一樣，談話、行為、設計，凡事都融合了屬性階級在韓國人的思想裡。我喜歡這樣的控制能力。我現在住在柏林，有些人往往喜歡文化本身，但我發現我的控制能力使我在這之中有所不同，我喜歡。

Q. 請問您如何獲得靈感？

A. 我通常經歷了任何事。一年前，我是個不會想要獨自旅行的女生，甚至離開首爾。些許經驗讓人有著狹隘的觀點，對設計師來說，這是最糟糕的。經驗和探索幫助我想得更廣，會影響我工作的結果。而我終於瞭解經驗不是花很多錢和時間的旅行，也可以藉由做很多不尋常的事或反思後中練習。

Q. 請和我們分享您喜歡的書籍、音樂、電影或場所。

A. 我現在住在柏林，所以讓你知道一個我在柏林最喜歡的地方。"Books and Bagel" 是間咖啡書店，可以看書也可以買很多書，喝杯美味的咖啡，做我的工作。住在這邊的期間，我真的很喜歡這家店中，人們談天的聲音，一杯卡布奇諾，可以鼓舞我。我喜歡 Sebajun 的音樂，沒有歌詞，就一直重複。我也享受音樂裡的憂鬱，裡面的低氣壓效果很好。

Q. 除了當設計師 / 插畫家，你是否已經開始規劃下一階段的目標？例如策展、學習煮菜、登山

A. 當我獨自在柏林居住時，了解到兩件有關於我的創造力的事。一是無價的家人，為了工作已經來到柏林一年了，我發現我的家人鼓勵了我的人生，使我工作更努力，也更快樂。另外是用設計裝飾我的工作室，最愛的海報等等。這是因為我知道室內設計可以大大地影響設計師的靈感。

Q.What do you like best in your country? (such as country feature or culture)Has it made a difference on your creation?

A. I like pursuing of proper level at any fields in our culture. We have a famous four-character-idiom ;Too much is as bad as too little. The attitude of people as usual, talking, behavior, design, everything there is melted a property level Korean think about. I like this ability of control. In Berlin where I am living now, there are some culture people tend to like the raw things themselves. And I noticed that my controlling ability make me different amongst them. I like it.

Q.How do you draw inspiration?

A. I usually experience anything. one year ago, I was a girl who had not ever taken a trip alone, even out of Seoul. Few experience make anyone take a narrow viewpoint. To designer, it is the worst of worst. Experience and exploration help me think wider, it affects my work as a result. And I finally realized experience does not mean only travel spending lots of money and time, but also can be practiced by doing unusual things or thinking backward in daily routine.

Q.Share good books, music, movies or places with us.

A. I am living in Berlin now, so let you know my one of favorite places in Berlin. "Books and Bagel" is a kind of book cafe, you can take a look and purchase lots of books, drink nice a cup of coffee, even do my work till I want. I really love this place during living here because of the sound people's talking when I do my work with a cup of Cappuccino. It really inspires me. I like a kind of Sebajun's music. No lyrics, just repeat. Also I enjoy the mood of melancholy in music. A depression from mood music works well.

Q.Have you started to set up new goals for next period except being a designer or illustrator ? like curating, learning cooking , climbing......

A. I realized two things related with creativity during staying Berlin alone. The one is priceless my family. I have been living in Berlin about one year for my work, I noticed that family is really good inspiration for my life. It help me work hard, happily as well. The other is a decorating my working room with design stuff, favorite poster, etc. It's because now I know interior design could affect designer's inspiration so much.

70th National Liberation Stamp　2015　P.69
2015 年的光復節紀念光復 70 週年。所以，為了體驗光復節的熱情做了一些郵票。設計的靈感來源於韓國的國旗：韓國的曲線、代表顏色：藍色和紅色。
This year 2015 marks South Korea's 70th anniversary of Liberation Day. I celebrated and commemorated our Liberation Day as a Korean designer by stamp work which could be represented as a memorial form. Graphic elements in this work were drawn from Korean flag figure that has features like curved lines, and representative colors.

Last Handshake Poster　2015　P.70
我把洪蘭坡的小說《最後 - 握手》改編成了《最後 - 握手》的話劇宣傳畫、小冊子。作者洪蘭坡把這個小說起名《最後 - 握手》。他起名的意圖是《握手》或者《惡手》(在韓國語：握手，惡手) 每個手的動作含有別的意義，而且我沒有對圖片進行加工。
This is an advertising poster and brochure work after reading a play written by Hong Nan Pa in 1921 who composure and writer as well. Handshake in Korean is a homonym with awful skill as well. Spelling in Korean is same each other but in Chinese different. I used photograph of hands as a main object which might be figured out differently by each gesture with graphic line elements.

Always New Dubai　2014　P.70
用杜拜優美的網緻表達他的多彩多姿，讓觀眾產生對杜拜好奇。總體上構成是既簡單又反復的、在色彩斑斕的網緻上充滿活力的跳舞，表達了各種各樣款式的積極性、迷人性。
The aim of this project is to show you the fresh and diverse image of Dubai with Arabic cloth and pattern representing Arabic beauty, also make viewers cause curiosity about Dubai. The composition is simple and repeat. With adding patterns on clothes recurring movement.

The dots collaboration work　2015　P.102
Joining the dot 是英國《DixonBaxi studio》主辦、2016 年開始展示的合作項目。在全世界各地活動的設計師用點

(dot) 創造了一個作品。作品上的每一個點都是我努力的痕跡。我把「點的數量越多就代表自己越強大」作為標題。
This is a collaboration work titled "Joining the dot" which will be curated by UK studio, DixonBaxi in 2016. About 100 designers based in lots of country worked about "dot" in their way. I set up the dot to "trace of effort". The more dots, the stronger I am - words are put aside.

Typography Design Award　2015　P.165
這個宣傳畫的形像是不完整的橢圓。很多個橢圓交織在一起變成了一個字「融」：設計者的融合、舊和新的融合。
The identity of this poster is an imperfect circle, ellipse. A whole lot of ellipses finally are composed of one letter " 融 " which means confusion between designer and designer, old and new, left and right, nation and nation.

Korean Thanksgiving Day Illustration　2015　P.246
這個設計就是以韓國的中秋節的影像做的卡片。我把秋節代表的菜：棗核祭祀器皿 (酒杯、香爐) 通過圖片完成了。
This is a simple card work about Korean representative holiday, Thanksgiving Day. I used objects for jujube of Thanksgiving Day food and woodenware like incense burner, wooden cup, ancestral tablet we usually use on Thanksgiving Day.

Move like this　2015　P.247
這是我一個人做的舞蹈節慶的宣傳系列。我想把這個作品表達的充滿活力，我用了很多人可以有同感的提案 (Move like this)，三個作品都有不一樣的意義。
This is a series of dance festival posters, personal project. I intended that posters could give viewers dynamic impression after seeing those right away, I figured out a method wining the sympathy with suggestion - Move like this. Three posters have each idea.

台灣 Taiwan

1995 年生於嘉義。現居台北。復興商工廣告設計科畢業，現就讀實踐大學媒體傳達設計學系。

Born in 1995 in Chiayi, Taiwan. Graduated from Fu-Hsin Trade & Arts School, Currently studying Communication Design in Shih Chien University.

李威　Lee Wei

www.behance.net/leeweidesign

Q. 請問您認為該國最棒的是什麼？(如國家的特色或文化等) 您的創作是否受其影響？

A. 可能因為政治現實或是歷史因素，我在成長的過程中一直感覺，我們的社會對在地文化很沒有自信，認為那是庸俗、上不了檯面的，然後就會去模仿或複製別人的文化、覺得別人的文化比較酷。但我覺得應該要深入認識它們、挖掘它們，從中找到屬於我們自己的特色、美學、創意；所以我也常常在思考在地文化的更多可能性。

Q. 請問您如何獲得靈感？

A. 我喜歡逛書店，也喜歡書店的氛圍。翻翻不同領域的書，可以刺激產生想法。另外就是看樂團表演，去感受、享受；對我來說那是一種非常真實的創作。

Q. 請和我們分享您喜歡的書籍、音樂、電影或場所。

A. 我很喜歡關於藝術家的紀錄片，像是《凝視瑪莉娜》、《跟著奈良美智去旅行》、艾未未的《草泥馬》等等；藝術家堅韌的創作意圖總是讓我感動，也給了我很好的提醒與學習。

Q. 除了當設計師 / 插畫家，你是否已經開始規劃下一階段的目標？例如策展、學習煮菜、登山......

A. 想玩樂團，很漂泊很台的那種。

Q.What do you like best in your country? (such as country feature or culture)Has it made a difference on your creation?

A. Probably due to the political reality or historical factors, I have been feeling that our society is unconfident with local culture, thought it was vulgar and could not been showed off, then we started to envy and copy other countries' cultures. But, I think we should more understand and explore our cultures, to find our own characteristics, aesthetics and creativity, so I often think about the possibility of local culture.

Q.How do you draw inspiration?

A. I love the bookstore and the atmosphere of there. Looking around the books in different fields can stimulate the production of ideas. Besides, I like to watch the band perform, to feel and enjoy it. For me, that is a very real creations.

Q.Share good books, music, movies or places with us.

A. I like the documentaries about artists, such as "Marina Abramovic: The Artist Is Present", " Traveling with Yoshitomo Nara ", and "Ai weiwei: Never Sorry"; The strong creating intentions of artists always touch me a lot, and give me a good lesson of reminder.

Q.Have you started to set up new goals for next period except being a designer or illustrator ? like curating, learning cooking , climbing......

A. Want to play a band, a very Taiwanese band.

Live Bomb, Already explored *2014 P.95*
將視覺凝結在即將引爆的時間點，以爆炸球體佔滿視覺版面製造張力與緊張感，非常直接明瞭的呼應展演主題。
The time is frozen at the moment of exploding. Using the explosion sphere to occupy the visual space, presenting a sense of nervous and tension that straightforward echo the theme of exhibition.

幻想維度 Tesseract *2014 P.95*
「有一些當下總想要逃避、有一些未來等不及實現、有一些回憶還捨不得忘記。幻想中的現實，在音樂裡實現。」將「幻想」的概念延伸到人類對穿越時空維度的想像與憧憬，視覺以幾何學上的四維超正方體（tesseract）做為主題，寓意演奏者的音樂帶領人們脫離現實的枷鎖與限制，創造幻想中的種種美好。
"Want to escape something at that time, want to realize something in the future, want to remember some memories. The music could realize the fantasy in the reality. " I extend the concept of "fantasy" into the imagination and longing for traveling through space-time by human. Using tesseract on geometric as the main visual, which means the music lead people go out of the shackles of reality and limitation, creating the beautiful imagines of fantasy.

為夢想設計 Design Your Dream *2014 P.95*
以設計領域中最基本的符號：基本幾何、黃金比例、尺標等元素，排列構成了漢字的「夢」。設計與夢想總是相輔相成，勉勵設計人在追尋夢想的路上，不要忘記初衷：我們為設計夢想，為夢想設計。
Using the most basic symbols: basic geometry, golden ratio, rulers and other elements to arrange and construct the Chinese character "dream." Design and dream supplement and complement each other, this work encourage designers who pursuing their dream, do not forget our original intention: We design for dream, dream for design.

金光之光魚刺客聯盟發光展 kim-kngekng *2014 P.95*
解構漢字「光」的型態、加以抽象化表現，呼應展覽主題，散發出七彩各色眩目的金光之光。
Deconstruction and abstraction of Chinese Character "light" in order to reflect the theme of the exhibition and sparkle with a dazzling golden light.

新加坡 Singapore

Lemongraphic

www.lemongraphic.sg

Rayz Ong 是新加坡人。多媒體設計師專注於向量設計、互動及資訊設計。角色設計則是他的最愛。畢業於拉薩爾學院傳播設計藝術學士榮譽學位。擁有對多媒體設計強大的熱情，從一開始就喜歡設計美麗並引人注目的平面設計，擁有一眼能快速為了各種設計元素給出建議，更重要的是，它具備了創造性的思維並每天一直在尋找新的可能性。

Rayz Ong is a Singaporean multimedia designer who specializes in vector illustration, interactive and information design. Character design is his true love. He was graduated from Lasalle College of the Arts Bachelor of Arts (Hons) Degree in Design communication.

He has a strong passion for multimedia design and loves to create beautiful and eye-catching graphic designs from scratch. He has an eye for all sorts of design elements and is quick to advice on any design related issue. On top of that, Rayz is equipped with a creative mindset and is always looking at new possibilities everyday.

Q. 請問您認為該國最棒的是什麼？(如國家的特色或文化等) 您的創作是否受其影響？

A. 新加坡是個多元種族的國家，你可以品嚐到來自不同文化的食物，這是我最喜歡的一點，就像是個食物天堂。我們的創作風格通常是基於新加坡對我的啟發跟我看見的融合。

Q. 請問您如何獲得靈感？

A. 旅行會讓你看到不同的文化，幫助培養欣賞和關心，有更多的渴望去探索世界各地。過程中會嘗試更多不同的設計風格，讓你了解，世界有豐富的設計和藝術多樣性。

Q. 請和我們分享您喜歡的書籍、音樂、電影或場所。

A. 日本是我得到最多靈感的地方。日本的文化令我驚訝，尤其是當我去年去到東京秋葉原時。這是考慮到銷售動畫、電視遊戲、漫畫的宅男文化中心，人物設計和收藏品都無處不在。

Q. 現在，回頭來看這些帶著遺珠之憾的作品，您有什麼新的感觸？

A. 我不會感到後悔，至少當有機會時我試過(笑)。

Q. 你對生活的細節上有什麼堅持嗎？(像是上廁所時一定要看詩集之類的)

A. 擁有判斷力是身為企業家最重要的事情。決心讓你的實力得到成功的展現。別對客戶的拒絕或反應害怕，就當它是個對自己的挑戰。一旦度過了，你會變得比以往更強大並成功，如果沒有半途而廢。

Q.What do you like best in your country? (such as country feature or culture)Has it made a difference on your creation?

A. Singapore is a multi-racial country where you are able to taste different type of foods from different culture which I love most here. It likes a food paradise.
Our creation style is usually based on the fusion of what we inspire and see here in Singapore.

Q.How do you draw inspiration?

A. Traveling exposed you to different cultures which help foster appreciation and compassion as a desire to explore more around the world. During travelling you will get to explore different design style that will make you understand that the world is a big place with full of diversity in art and design.

Q.Share good books, music, movies or places with us.

A. Japan will be the place where i get the most inspiration, the culture of Japan amazed me while i visit Akihabara a district in Tokyo during my trip last year. It is consider an otaku cultural center where tall shopping mall that sell video games, anime and manga comics. Character design and collectibles are prominently display everywhere throughout the district.

Q.Now, look back to these works of regret for not been selected, how do you feel that?

A. I wont feel regret. At least I did try when there is a chance. :)

Q.What is your insist on your life's details ? like toilet with your favorite poem?

A.Determination is the more important thing that you need to be for an entrepreneur. It's determination that gives you the strength to take those extra measures that lead to success. Do not afraid of client rejection or feedback just take it as a challenge for yourself as this create the learning curve initially. Once you get over it, you will be stronger than before and will eventually be succeed at the end if you didn't give up halfway.

Website Simplified infographic design *2012 P.82*
網頁資訊簡化設計是使用三階段有效計畫，實施更簡單的網站設計。單件 A4 尺寸海報資訊圖表讓你了解並簡化你的網站設計流程。
Website simplified infographic design is a process of website design in a more simplified way using 3 effective stages from planning, design layout to strategic implementation.
A one piece A1 size infographic poster for you to understand and simplified your process in developing your website.

Singapore Icecream Sandwiches infographic design *2014 P.82*
新加坡冰淇淋三明治資訊設計。新加坡氣溫升高？為何不看看新加坡冰淇淋三明治，美味和不同品嚐的方式。
Singapore icecream sandwiches infographic design. Weather is heating up in Singapore? Why not check out what the Singapore ice cream sandwich is about, the delicious flavours and different ways of savouring them.

The Art of movtivation infographic design *2014 P.83*
此設計的動機是跟大家介紹一下每天的工作經驗中生產效率和積極性。圖表顯示針對你的員工什麼樣的個性得用什麼技巧來激勵他們，將其劃分成四種，社交型、工作狂型、不安全感型、玩咖型。
The Art of Motivation infographic design tell you about the productivty and motivation during daily working experience. A flowchart gives an idea of what personality your employees may have and tips to motivate them which we had classified them into four different category Social, Workaholic, insecure, power player.

Saving Water infographic design *2013 P.83*
你真正地使用了多少水？很多人都用低流量的蓮蓬頭或馬桶，但我們每天使用的東西消耗了多少水資源該如何比較了這圖表，以幫助瞭解我們的日常生活的影響。有些資訊可能讓你大吃一驚……。
How much water are you really using? Many of us have low flow shower heads and our toilets are using less water, but how does that compare to the water that goes into the things we use and consume every day? We created this infographic to help better understand what our daily impact really is. Some of the information might surprise you...

Bad Hire Survey *2013 P.84*
新加坡 RecruitPlus 不良雇用調查設計。人資的重要性總是被忽略，就像是有世界第一的烹飪培訓和廚具設備，但使用的人卻連刀怎麼拿都不會。這就是為什麼 RecruitPlus 決定委託我們對公司員工進行第一次調查。
Bad Hire Survey information design for RecruitPlus (Singapore). The selection of the human resource is always neglected. That is akin to having world class culinary training and kitchen equipment but using someone who don't even know how to handle a knife to begin with. That is why RecruitPlus Consulting decided to commission our first survey targeting exclusively on companies' hires that just couldn't deliver.

37min Busride *2009 P.84*
37 min Busride 是新加坡的資訊設計。我搭公車 174 號，從武吉巴督烏節路，總共有 33 個公車點。在整趟路途中，我記錄乘客上下車的數量、種族、性別、年齡等等。我將這些數據運用到設計中。
37 min Busride is an information design project in Singapore. I simply took a bus number 174 in Singapore, From Bukit batok to Orchard Road. A total of 33 bustop throughout the journey. During the journey, I record down the number of passenger board, alight, and on-board data statistics which include, the races, gender, age group and many more. While this raw data had been collected I use graphic design (information graphic) in convert this into a design where people can understand the complex information.

Global Trend Branding *2014 P.196*
為 Global Trend 品牌設計。是間線上科技商品購物，有最好最新的商品。
A branding project for Global Trend marketing. Global Trend is an online technology shopping store that brings in the best and latest tech stuffs in town.

OLEX Personal Identity Branding *2014 P.197*
OLEX 個人識別是為 OLEX 的 CEO 所做的品牌設計。將 O 像素化代表整個品牌，用橙色、粉色、綠色和藍色。
OLEX personal identity is a branding project for the CEO of OLEX. Pixilation of "O" in creating the entire branding stationary for OLEX. Dissecting of pixels into four different corporate colors as follow Orange, Pink, Green and Blue.

台灣 Taiwan

平面設計、書籍裝幀、唱片電影包裝、手繪插畫、室內裝置、藝術視覺指導。
近期作品犬貓人劉以豪晃京都寫真書（Ryu Traveler In Kyoto）、寂寞拍賣師（The Best Offer）、嗜血戀人（Only Lovers Left Alive）、戀夏小情歌（God Help the Girl）等…電影視覺包裝設計。

Graphic design, artwork design for books, CDs and DVDs. Illustration. Visual arts director. Recent works are Ryu Traveler in Kyoto photo book, and DVD packaging design for films including The Best Offer, Only Lover Left Alive and God Help the Girl.

李惠康　Li Hui-Kang

www.cargocollective.com/huikangli

Q. 請問您認為該國最棒的是什麼?(如國家的特色或文化等) 您的創作是否受其影響?
A. 市場、夜市 兩者皆為庶民文化，也是台灣生活中最融洽的元素，喜歡逛市場與夜市交談詢問當下氣氛，因為不了解食材好奇心誘發讓人想嘗試衝動。
小時候長輩們賣冬瓜茶、冰品與饅頭，都在氣味與食材的環境下成長，多少會被影響，在設計上會先看媒材本質，但並不想直接表現，就像做菜般可以單吃食材也可以混著吃出新的滋味。

Q. 請問您如何獲得靈感?
A. 生活、好奇心。

Q. 請和我們分享您喜歡的書籍、音樂、電影或場所。
A. 裝苑(SO-EN)或伊藤潤二(Junji Ito)漫畫、古本，音樂與電影無特定，推薦看捷克導演 Věra Chytilová 的雛菊(Sedmikrásky)，說故事方式與剪接、美術現在看來還是非常厲害，常去夜市與淳久堂(Junkudo)、田園城市書店(Garden City Publishers)。

Q. 現在，回頭來看這些帶著遺珠之憾的作品，您有什麼新的感觸?
A. 並沒有太多感受，那些都是過去的事物。

Q.What do you like best in your country? (such as country feature or culture)Has it made a difference on your creation?
A. I think it would be night markets. You'll see how friendly Taiwanese are. I enjoy walking around night markets and chatting with vendors. I'm always passionate about foods. The elders in my family used to selling hand-made local snacks, so I kind of grew up as a foodie. Art creation is like cooking in some way. You can transfer the material to a different feature, a new flavor.

Q.How do you draw inspiration?
A. Be curious about all aspects of my life.

Q.Share good books, music, movies or places with us.
A. I love SO-EN magazine and Junji Ito's comic books. I recommend you the film "Sedmikrásky" from a Czech director, Vera Chytilová. The way he tells the story and the edit skills are amazing! Night markets, Junkudo and Garden City Publishers are my fav places.

Q.Now, look back to these works of regret for not been selected, how do you feel that?
A. These works complete me. They passed and then I move on.

White Bird in a Blizzard　2015　P.129
電影中緊張神經質在平面上是比較難去闡述，所以在編排上做了滿大實驗，我知道在繁體字閱讀上是有難度接受度也是，但整體視覺上完全達到我要緩慢流動不安氣息。
The plot is tense. So I made the text flow uneasy. I know it's difficult to read, but why not!?

PANTONE 4675 C　2013　P.129
首次個人展覽設計許多版本，用不同觀點看待性愛這件事，總是希望是有點溫柔但也請用力一點的狀態，PANTONE 805 C + PANTONE Cool Gray 1 C + PANTONE 7543 C，三個特色搭配愛慾痕流滿分。
It was one of the posters from my first exhibition. Trying to see sex in different aspects. I'd like to show it in a way which is only gentle but hard. I think the three pantone colors make lust outstanding.

華麗上班族 Office　2015　P.129
在有限的設計素材之內，適切地讓看慣的視覺上有新感受，包括顏色修飾、編排與字體上重置，不重蹈原來花樣繁複俗套文字編排，剛好的空間恰好的華麗。
We tried to make viewer have a brand new visual experience within the limited design materials, including the color modifying and the re-set of layout and type font, we don't want to repeat the original and complex pattern to arrange the text, we want a suitable space and suitable gorgeousness.

TRASH Live in Live Rock Tour　P.217
空間場域看待 Live 這樣的演出形式，不外乎音樂給予的搖滾節奏，演出者與環境之間產生出的立體元素，拍子、樂器、汗水、尖叫聲、完美結束。
Live shows combine elements like rhythm, instruments, sweating, screaming and the satisfactory ending. I threw them into the font.

台灣 Taiwan

李宜軒　Li Yi-Hsuan

www.yihsuanli.com

李宜軒，台灣視覺設計師，擅長平面設計、識別設計，熱愛嘗試各種實驗性的創作及材質的運用，希望發展出更多可能性，對於設計也擁有高度熱情及堅持。作品曾獲台灣遊戲新人獎、新一代設計的廠商特別獎及 ADAA 決選、韓國 k-design award 及澳門設計雙年展入圍等，收錄於 computer arts magazine、Inspire magazine 及亞洲設計年鑑、法國 Etapes 線上精選作品，於松菸及台灣傳藝中心等展出，目前就讀於交通大學應用藝術所，研究視覺設計及介面相關設計。

Hsuan(1992) is enthusiastic about experimenting new material and idea combination to create more possibilities; Hsuan is passionate you might say, stubborn about designing the highest quality works. Her designs has won Best original game Award of Taiwan Mobile Elite Award, Sponsors Award by 2015 YODA, also was admitted to compete for ADAA and presented in Computer Arts magazine, Inspire magazine, APD no.11, Etapes online(France). Her works was later on demonstrated in National Center of Traditional Arts and Songshan Cultural and Creative Park. She is now studying Interface design and Visual design at National Chiao Tung University Institute of Applied Arts.

Q. 請問您認為該國最棒的是什麼 ?(如國家的特色或文化等) 您的創作是否受其影響？

A. 我想台灣文化的多元和無限的包容力是影響我創作非常重要的因素，台灣因為過去歷史緣故，收納了許多不同想法和意見，這些都是創作很重要的養分。

Q. 請問您如何獲得靈感？

A. 我的靈感來自身邊的一切事物，每件物品、每個人、每個角度，都可以是創作時的靈感。

Q. 請和我們分享您喜歡的書籍、音樂、電影或場所。

A. 我非常喜愛鄉土文學，尤其是八十九十年代的散文選，電影也偏好關於真實人生題材的類型，之前超愛看公視的人生劇展，每看完一部就體會了一次不同的人生。

Q. 現在, 回頭來看這些帶著遺珠之憾的作品, 您有什麼新的感觸？

A. 至少每個作品我都非常努力的執行過, 而且我也完成了！

Q. 除了當設計師 / 插畫家, 你是否已經開始規劃下一階段的目標？例如策展、學習煮菜、登山 ……

A. 希望可以出國一段時間, 回歸初心創作, 將接案的數量降低, 然後 …. 把論文完成！

Q. 你對生活的細節上有什麼堅持嗎？(像是上廁所時一定要看詩集之類的)

A. 1. 一定要吃早餐, 才能開始一天的工作。

2. 桌子一定要整齊, 盡量不要有雜物！

Q.What do you like best in your country? (such as country feature or culture)Has it made a difference on your creation?

A. I think the multivariate of Taiwanese culture and unlimited tolerant both are very important factors that affect my work, because Taiwan's history in the past, incorporating many different ideas and opinions, these are important nutrients of creations.

Q.How do you draw inspiration?

A. I was inspired by everything around me, each thing, every person and every angle, it can be inspiration when I create.

Q.Share good books, music, movies or places with us.

A. I love local literature especially selected of eighties and nineties. And movies prefer to kinds about real life, I used to love watching Taiwan Public Television Service Online " Life story", every time I watch just like have another life experience.

Q.Now, look back to these works of regret for not been selected, how do you feel that?

A. At least I have try hard every works and I also completed!

Q.Have you started to set up new goals for next period except being a designer or illustrator ? like curating, learning cooking , climbing......

A. I would like to go aboard for half or one year. In that period, I hope I can do some works not for the case, and most important thing is... I need to finish my paper!

Q.What is your insist on your life's details ? like toilet with your favorite poem?

A. 1. Must have breakfast before beginning a new day's work.

2. My desk must be very clean, I can't work in a mess!)

Well...... I just want to make a fancy book! 2015 P.27

"Well...... I just want to make a fancy book!" 是一本創作集, 此書跳脫了習慣的設計模式, 這次我不給自己任何侷限, 在創作的過程中也記錄了許多生活的細節, 當創作到了一個段落時才開始思考如何命名各書籍名稱, 而頁面上層層疊疊的貼紙代表了想法重建又打破的過程, 而某些頁面上還留下貼紙撕下後的痕跡, 內頁每頁幾乎都貼上了標籤, 除了標記頁數, 也為頁面留下註解。書籍包裝使用了鋁箔紙, 這頁粗糙的質感除了能夠詮釋出 "fancy" 意涵, 並且可以在每次讀過後又會留下一條一條的摺痕, 記錄下每一次的閱讀過程。

well...... I just want to make a fancy book" is a personal work for Le' exhibition. Comparing with other works, I started this project in a very different way which is no topic and any regular limitation. I collected images from my previous design works, my life and my surroundings. After I finished the collection, I started to think about the title of this book. When you are reading this book, you can find there are lots of labels which is a trace to make a title - "well...... I just want to make a fancy book!"(I changed lots of titles and finally I decided this.) Besides, there is a label in every two pages showing notes of the page number and concepts of the image. Furthermore, I chose aluminum foil as the texture of book cover to catch attention. I think aluminum foil can describe " fancy" very well and the texture also can record the folding line made by every reader.

REPORT OF A MONOMANIA DESIGNER 2015 P.28

一位設計偏執狂的解析為 2014~2015 期間所有作品的整理呈現, 設計概念從一本診斷書出發, 以旁觀者的角色說明設計師李宜軒這個角色, 作品集選用紅色為主色調, 搭配暗灰及白以簡潔明快的視覺風格呈現。

REPORT OF A MONOMANIA DESIGNER ,a portfolio of yihsuan li, concluds all of her works during the period of 2014~2015. This book is inspired by diagnosis and it analyzes YIHSUAN LI deeply on observer side. Furthermore, with using red as main color and gray and white as decorated color, this book lookes very simple but classy.

緩緩生活節 Slow Slow Festival 2015 P.65

緩緩生活節是一個在台三線上的活動, 希望讓都市裡步調急促的人們可以放慢腳步騎著單車享受大地的空氣和在地的味道, 活動中也記錄了許多生活的細節, 畫面裡有台三線沿途會看見的大片稻田、茶田及山景, 字體設計柔和圓滑, 搭上笑臉後彷彿可以感受到愉快的氣息。

"Slow Slow Festival" is an activity of Taiwan Main Road 3. We hope this activity can slow down fast life of people who live in the urban areas. Attendants can enjoy fresh air and nature scenery by riding bicycles. I design this visual in a brisk way with bright colors and interesting images such as wide rice field, tea field and mountain views. Besides, I use smooth typo with a smiling face to describe the happy atmosphere of this activity.

獻世報 The Revenge of Environment 2014 P.68

以往災害給人的感覺是嚴肅、沉重的, 主動關心的程度也不高, 因此我們轉換呈現方式, 利用畫報與故事包裝人為災害的新聞議題, 加上具象化的災獸來呈現每種災害對環境造成的影響, 藉此提高大眾對於台灣人為災害的關注。

People paid less attention on environmental issues in the past, because information related to environmental disaster was often transcribed orally. Therefore, We thought about how can convey the message we want to spread. Finally, we found that the answer is "Design". Hopefully through our creativity, people can think ruminate and pay more attention on this issue.

美濃油紙傘 MEI NONG OIL-PAPER UMBRELLA 2015 P.72

油紙傘的結構及型態極美, 優雅的傘面和質感都深深地吸引著我, 代表文化厚度的油紙傘, 一把傘就是一個故事, 因此我為紙傘實驗性的設計了一系列的視覺, 整體呈現以紙傘美麗的骨架結構為主, 加上簡單的橘紅色料, 畫面簡潔純粹。

The structure of Oil-paper umbrella is extremely beautiful and so as the hand-made tactile quality. I think Oil-paper umbrella can represent part of Chinese culture and every umbrella has one story of their own. With simply few colors and clean canvas, this experimental project shows everyone how beautiful of the Oil-paper umbrella is.

秋曉 Qiu Xiao 2015 P.100

爺爺是位老師, 所以為孩子取名字時非常講究, 秋曉是四阿姨的名字, 秋天是桂花盛開的季節, 因此我使用了桂花織出了秋曉二字, 搭配上朱熹描述秋天美景的《詠岩桂》, 詩中內容唯妙唯肖地刻劃出了岩桂純潔的天姿與醉人的清香, 與桂花織起的 " 秋曉 " 二字組成一幅畫。

Grandfather is great teacher. He gives a name to a newborn baby through his wisdom. For instance, "Qiu Xiao" is my aunt's name. "Qiu" means birth season which represent autumn. "Xiao" means successful life.

Last autumn, I found Osmanthus flower bloomed, and this flower was used to formulate two Chinese characters with a poem made from Zhu Xi (a renowned poet of china). This work shows a graceful atmosphere of autumn and kindness of my dear aunt "Qiu Xiao".

海戀 Sea Fever 2015 P.100

與海相比, 我們實在太過於渺小, 因此我用 " 孤寂感 " 來呈現整個畫面, 以 " 靜 " 去描寫整個氛圍, 一艘小船漂流於海之上, 陪伴它的是冰山、海鷗, 和一顆掛大月亮, 周圍包覆了整個空間, 以海戀這首詩佐味, 整幅畫面安穩寂靜, 這就是海和我之間的關係。

Comparing to the wild oceans, we are thought to be too tiny and powerless in this world. This truth makes us feel "loneliness" which drives me to design the poster. I describe atmosphere of silence. There is a ship on the sea beside the iceberg and the seagull is flying with a big moon on the sky, which makes us peaceful and comfortable.

小丑蔬食工作室 Crown has a vegetarian restaurant 2014 P.153

小丑蔬食工作室的設計元素融入了三大元素 新鮮食材、小丑、笑容, 以此強調餐廳的理念「新鮮的食材」、「親切的服務」, 整體設計以質感、簡約為主, 餐廳的整體設計也以此理念發展。

"Crown has a vegetarian restaurant" 's logo is based on three important elememts "fresh food", "Crown face" and "Smile" to emphasize main concept "using fresh food" and "good service".

馬來西亞 Malaysia

林旂鋒　Lim KF

www.behance.net/limkfung

土生土長於馬來西亞－沙巴州，2009 年為了追求夢想，遠赴台灣就讀商業設計科系。2014 年研究所畢業後，任職於臺北一間知名的創意策略、品牌定位與視覺設計公司。除了擅長於平面設計、字型設計以外，更喜愛嘗試將不同材質媒材與手作技法應用於設計創作上。

設計作品曾獲選刊登於歐洲著名設計網站 Fubiz. net、Designtaxi.com、香港 viction:ary 出版的《Hanzi • Kanji • Hanja》設計書籍、馬來西亞的《CUTOUT》設計雜誌

Originally from Sabah, Malaysia and spending the last 4 years in Taiwan, He loves to work with simplistic, minimal design styles, as well as dabbling in a bit of hand-rendered typography and prints. Being multidisciplinary enabled him to take on diverse range of projects including branding, typography, editorial design, and printmaking.

Q. 請問您如何獲得靈感？

A. 有時候從書籍，或聽別人的故事。但大部分都從網路作品集例如：Behance 或 Pinterest。

Q. 請和我們分享您喜歡的書籍、音樂、電影或場所。

A. 星際大戰系列作品。

Q. 現在，回頭來看這些帶著遺珠之憾的作品，您有什麼新的感觸？

A. 不曾覺得有什麼是遺珠之憾，它們只是還未得獎罷了。

Q. 除了當設計師 / 插畫家，你是否已經開始規劃下一階段的目標？例如策展、學習煮菜、登山

A. 投入手作與印刷技術、籌辦設計節／音樂節。

Q.How do you draw inspiration?

A. Sometimes from books, listen to other's story. but most of time from internet portfolio like Behance or Pinterest.

Q.Share good books, music, movies or places with us.

A. Recently did the coolest thing is driving small plane roaming in the sky, the feeling of freedom words can not express.

Q.Now, look back to these works of regret for not been selected, how do you feel that?

A. did not feel any regret, they just have not winning any awards yet.

Q.Have you started to set up new goals for next period except being a designer or illustrator ? like curating, learning cooking , climbing......

A. Involve in hand-made inputs and printing technology, organising Design Festival & Music Event

居鑾在動 音樂節門票 Kluang Rockin Music Festival Ticket Design　2015　P.66
《居鑾在動》音樂節的主辦單位與活動地點是一間提供樂器販售、音樂教學的複合式藝文咖啡廳。店裏主要販售的樂器有 ukelele，因此以 ukelele 的造型為設計概念，利用異材質（橡皮筋）去表現琴弦，增添互動性與趣味性。印刷技術部分找了馬來西亞有名的凸版印刷工作室 The Alphabet Press (TAP) 合作，選擇以強調質感與觸感的凸版印刷技術，提升門票的精緻度與收藏價值。
The Kluang Rockin' Music Festival was organised by a fusion of arts and culture café that sells music instruments and offers music lessons on a daily basis. It is also the location where the music festival was held. As ukeleles are the major music instruments sold at the café, the design concept of the tickets were inspired from it with an inclusion of the elastic bands. It is not only representing the string found in the ukulele, but also help to extend the interaction and engagement with the attendees. The Alphabet Press (TAP) — a dedicated bespoke letterpress stationery maker that is pioneering the letterpress print renaissance in Malaysia, was chosen to collaborate in making the idea a reality. Simply because, the texture and the tactile quality of a letterpress print help to elevate the collecting value of the tickets.

字 慧 手作字型設計 W I S D O M Handmade Typography Project 李小龍 / 愛因斯坦 / 卓別林 / 黛安娜王妃 / 萊特兄弟　2014　P.216
『字 慧』手作字型設計－藉由手作字型創作與名人金句做結合，為名人之金句增添藝文性質及傳達名人的正面思想與精神，同時提供創新且具有動感的圖像創作，並期許能設計與觀者產生共鳴的視覺表現。
A series of handmade typography entitled "WISDOM". The project features quotes by famous personalities and film actors of the past: Bruce Lee, Charlie Chaplin and Wright Brothers.The typography are created by using laser cutting, stitches and handsews the words, and spells them out using needles.

台灣 Taiwan

林賢榮　Lin Xian-Rong

www.behance.net/pandean

國立臺灣科技大學建築研究所畢業，曾在哈爾濱工業大學建築設計院和西安建築科技大學建築設計院實習，以及在張瑪龍建築事務所擔任助理設計師 。

2013 ｜臺北設計獎｜網路人氣獎｜佳作

2012 ｜鋼結構人行陸橋創意競賽｜佳作

2010 ｜新一代設計展｜優選獎

2009 ｜高雄市重點地區挽面創意構想｜優等獎

Graduated from National Taiwan University of Science and Technology Institute of Architecture, He has interned in Xi'an University of Architecture and Technology of Architectural Design Institute, and has serve as an assistant designer in Malone Chang Architect.

2013 Taipei International Design Award Most Popular Award Honorable Mention

2012 Steel pedestrian bridge ideas contest Honorable Mention

2010 Young Designers' Exhibition Judges' Award

2009 Key areas of Kaohsiung creative idea Merit Award

Q. 請問您認為該國最棒的是什麼 ?(如國家的特色或文化等) 您的創作是否受其影響 ?

A. 雖然我出國經驗並不多，但相較之下我還是喜歡台灣的生活。我認為台灣的特色是騎樓、鐵窗、違章建築等等，這些元素也常讓設計師有創作上不同的想法。生活環境中各處都有一些有趣的事物可以發現，並且思考這些東西為何存在，又有什麼作用，了解這些因素對於創作都是有幫助的。

Q. 請問您如何獲得靈感?

A. 創作靈感通常來自於生活上的體驗，也或許是一段音樂、一場夢境、一個畫面，只要有想法的事物都有可能是創作上的靈感。雖然我沒有特意了解靈感是從何而來，但生活上我熱愛攝影，觀察自然或人群或許都是有趣方式。而在創作時會聽一些沒有主唱的音樂，例如後搖。

Q. 請和我們分享您喜歡的書籍、音樂、電影或場所。

A. 我個人喜愛關於時空、時間、未來的科幻電影，裡面有很多議題可以思考，例如星際效應、蝴蝶效應。因為個人非常喜愛路易斯康 (Louis Kahn) 建築師，也推薦這部紀錄片「我的建築師：尋父之旅」(My architect: A Son's Journey, 2003)。另外我喜愛廢墟攝影，廢墟是人們拋棄後的建築空間，出環境接受後讓時間與氣候去創作的物件，觀察這些類型的事物議題，也是我所喜愛的。

Q. 現在，回頭來看這些帶著遺珠之憾的作品，您有什麼新的感觸?

A. 作品的存在是作者本身的心力及時間去完成，若作者是用心去完成並實踐作品，無論作品是否被看見或得獎，我認為對作者本身都會是好的，因為每個人價值觀及審美觀都不同，沒有任何一件作品可以讓所有人都喜歡並且接受的。而這些遺珠作品也是作者本身一部分的能量，這些過程都會幫助作者本身的成長。當然也要更充實自己，並且學習其他設計師的思考方式，而不是學習作品本身。設計並非求美 , 而是求正確。

Q.What do you like best in your country? (such as country feature or culture)Has it made a difference on your creation?

A. Although I don't have much experience of go aboard, but I still love live in Taiwan. I think characteristic of Taiwan are the overhangs of storefronts, window railing, illegal buildings, etc. These elements make designers have different ideas on create. There are many interesting thing around my life, and think why they exist? What they looking for? It's helpful to understanding this for create.

Q.How do you draw inspiration?

A. Actually the ideas came from the experience in my life, maybe a part of music, a dream, a image, everything it could be the idea of my creation. Although I did not know where it came from, but I love photography, observation of nature or people are interesting way probably. And I will listening music without singer like post-rock.

Q.Share good books, music, movies or places with us.

A. Personally like about space, time, future, something like sci-fi movies. There are many issues you can think, like Interstellar, The Butterfly Effect. Also recommend the documentary "My Architect My architect: A Son's Journey, 2003". And I love photograph of ruins, ruins are architecture abandoned by people, something created by time and climate then make environment to accept, it's my favorite to observing these.

Q.Now, look back to these works of regret for not been selected, how do you feel that?

A. Why works exist because the author's effort and time to complete, if it has been completed with true heart whether be seeing or winning or not, I think it is good for author. Because each person values and aesthetics are different, there is no one can make everyone to love and accept. And those work also can be a part of energy for designer. Process will help author to grow, should fulfilling yourself of course and learn how the other designer think not the works.Design is not for the beauty, but demand correct.

Anamorphosis 2010 P.75

實驗性的造形藝術，嘗試利用影像位移的方式創造時間與空間的關聯性，或許空間藝術與平面藝術有更多的可能性。

The artistic shape, try to create the relevance of time and space by using image displacement, perhaps space art and graphic art has more possibilities.

Hello 2015 P.183

本案店名用親和的招呼語來命名「哈囉」，主視覺 Logo 則用簡單的線條呈現飲品的形象。為了行銷策略，將 Logo 設定為黑白主色，每季不同的主打飲品作為副色，並將名片做雷射切割加工，讓名片與 DM 做一體式的宣傳，利用 Logo 圖形在 DM 呈現不同季節的主打飲品，將不同季節的行銷策略配合活動做些許的彈性變化，希望讓客人嘗試更為貼心的飲品。

Image name in this case with kiss of greeting to name 'hello', primary visual logo with simple lines show drinks. For marketing strategy, logo set for black and white and color, on a quarterly basis different main drinks as deputy color and business card in laser cutting, let business card and DM do one type of propaganda, presents a different season's flagship drinks in DM, using a graphic logo, marketing strategies for different seasons with activities to do some change in the elasticity of, want to let the guests try to sweet drinks.

台灣 Taiwan

林宇晟　Lin Yu-Cheng

www.examplewordpresscom73693.wordpress.com

1978 年生。專業領域：視覺設計、文案撰寫、專案企劃。
曾獲 2015 APD 亞太設計年鑑海報設計類入選。
2014 第一屆包裝達人創意競賽第二名、台灣視覺設計獎印刷設計類金獎 & 識別設計類金獎。
2013 APD 亞太設計年鑑標誌類入選、金點設計獎視覺傳達設計類 & 包裝設計類金點標章。

Born in 1978. Specialties: Visual design, copywriting, project planning
Awards:
1. 2015　Entry Award of the Poster Design category, Asia-Pacific Design (APD)
2. 2014　Second place of the 1st Creative Packaging Design Competition / Gold prizes of the Print Design and CIS Design categories, Taiwan Visual Design Awards
3. 2013　Entry Award of the Logo Design category, Asia-Pacific Design (APD) Golden Pin Design Mark in the Visual Communication and Packaging Design categories, Golden Pin Design Award

Q. 請問您如何獲得靈感？
A. 保持對生活中環境及人事物的敏銳觀察及好奇心，以此內化為創作的基底元素。書籍、音樂、旅行中的種種見聞及思索，都是觸發靈感的來源。

Q. 請和我們分享您喜歡的書籍、音樂、電影或場所。
A. 電影：卓別林、希區考克、黑澤明、金基德、蔡明亮、侯孝賢、王家衛、李安 ⋯⋯。
書籍：米蘭昆德拉、費茲傑羅、馬奎斯、杜思妥也夫斯基、宗薩欽哲、南懷瑾、楊照、黃春明、白先勇、村上春樹、卡繆、卡爾維諾 ⋯⋯。
音樂：Bob Dylan、The Beatles、John Lennon、陳昇、李宗盛、羅大佑 ⋯⋯。
場所：好山好水的地方。

Q. 現在，回頭來看這些帶著遺珠之憾的作品，您有什麼新的感觸？
A. 這些作品，多半是純粹個人設計創作，以維持創作動力及實驗性為出發點，姑且不論好壞，我認為這對設計師來說，是不可或缺的自我鍛鍊。

Q. 除了當設計師 / 插畫家，你是否已經開始規劃下一階段的目標？例如策展、學習煮菜、登山 ⋯⋯
A. 徒步環島。寫小說、散文。策展。

Q.How do you draw inspiration?
A. I enjoy observing the world around me with curiosity and a sharp mind, and take my observations as the basis of my creation. Books, music and travel, as well as thinking sprouting from these activities, are all the sources of inspiration.

Q.Share good books, music, movies or places with us.
A. Movie: Chaplin, Hitchcock, Akira Kurosawa, Ki-duk Kim, Tsai Ming-liang, Hou Hsiao-hsien, Wong Kar-wai, Ang Lee, etc.
Books: Milan Kundera, Fitzgerald, Márquez, Dostoyevsky, Dzongsar Khyentse Rinpoche, Nan Huai-chin, Yang Zhao, Huang Chun-ming, Kenneth Hsien-yung Pai, Haruki Murakami, Camus, Italo Calvino, etc.
Music: Bob Dylan, The Beatles, John Lennon, Bobby Chen, Jonathan Lee, Lo Ta-yu, etc.
Place: Good place good to go.

Q.Now, look back to these works of regret for not been selected, how do you feel that?
A. These are mostly my design works, created to maintain my creativity and find a way for experimental works. Whether good or bad in artistic value, they are opportunities for a designer to master the art.

Q.Have you started to set up new goals for next period except being a designer or illustrator ? like curating, learning cooking , climbing......
A. Travel around the island of Taiwan on foot; writing fiction and prose; exhibition curating.

木木川空間設計 2015 筆記書　2014　P.13
筆記書以木木川的筆劃構成主視覺元素，畫面分割的結構中表現出空間建築的意象，在具體與抽象之間延伸出想像，經由書籍骨架前後對照的關係脈絡，建構出空間無限展延的書籍氛圍。
The notebook features the characters " 木 木 川 (mumuchuan, 'wood-wood-river')" as the key visual element. The composition divided into several parts represents an image of space and architecture. Imaginations come up between the concrete and the abstract; through the relationships of the front and back frames of the composition, a reading ambience that extends to every nook and cranny of a space seems to be created.

歸鄉無路 -1-4　2014　P.90
「歸鄉無路」系列海報，透過書法字 & 幾何 & 線性文字 & 剪影圖騰的運用，視覺上呈現東西文化元素交融的和諧感，意念上傳遞異鄉人心境內外的歧異變化，並引申出過度文明中人類對生存價值及初衷的遺棄與失落。
In the series of posters for "No Direction Home," a visual harmony of Eastern and Western cultures is presented through the application of calligraphic writings, geometric shapes, linear characters, and silhouette. The concept reveals different psychological changes of outlanders; it also implies human beings' abandonment and loss of the value and original intention of living, in an excessive civilization.

創生造活 INFINITE CIRCULATION　2008　P.93
創意來自生活的體驗、生命的探索，藉由作品設計人又直接或間接的改變了生活的風貌。「創生造活」主旨在論述這樣一個不停循環的過程，讓我們在探究創意生成的同時，也體會到設計之於生活的價值與責任。
The idea from the experience of life The explore of life.Used the work design people and direct or indirect to change the style and features of life The purpose of INFINITE CIRCULATION is discuss about the process of this continually circulate in. The same time when we are looking the meaning of create. We also knew.the responsibility and values of design.

迴集行路　2009　P.93
「迴集行路」的精神在闡述生命的過程，是在不斷迴轉、集聚的行進間尋找出路。當我們都感受到生活顯現出的疲乏與空虛，是否我們都忘了迴歸到生命的本來面目？而整個世界的紛擾、情感的糾纏、關係的聚散，原因也許就在我們自己本身。藉由設計的表現形式，轉化與匯聚人這個複雜生命體的精神價值，回歸原點重新找到生命與設計的連結脈絡。
"Returns to the collection travels" the spirit in the elaboration life process, is unceasingly is rotating, gathers on the move seeks the outlet. When we all feel tiredness and the void which the life appears, whether we all did forget to return to the life original appearance? But the entire world is troubled, the emotion pesters, relational assembling and parting, the reason perhaps in we itself.The creation method affiliation by the design manifestation, transformed and the gathering person this complex life body spiritual value, returns the zero point reto find the life and the design linked vein.

顯內隱外　2010　P.93
由線構成的三角形，象徵生命形而下的存有，以矛盾圖形呈現出表相的曲折、進退失序；內裡的實體三角形象徵生命 (設計) 形而上的狀態。當外在彷彿完整卻扭曲變形的時候，那緩慢從黑暗中、被忽視中所顯露出的本質內涵，才能讓生命找尋到下一個出路。
Triangle formed by line symbolized that exist of the life shape , demonstrates the twists of the looks of forms, advances and retreat out-of-sequence with the contradiction figure; The triangular image of entity inside seeks the life (design) State that in shapes.
It could let the life look for to the next outlet when external is intact but twists the time out of shape as walking back and forth externally, essential intension manifested in that is slow from the darkness and ignored.

中國 China

1987 年生於山東，現工作生活於北京。

2010 年畢業於中央美術學院，獲學士學位，現就讀於中央美術學院，碩士。

Born in Shandong, China in 1987, now working and living in Beijing.

Graduated form China Central Academy of Fine Arts and got the bachelor degree, now studying as a master in China Central Academy of Fine Arts.

劉寶　Liou Bao

www.weibo.com/liubaodesign

Q. 請問您認為該國最棒的是什麼？(如國家的特色或文化等) 您的創作是否受其影響？

A. 包容吧。肯定會受影響啊，從小就在這樣的環境下長大，無形中肯定會影響很多的。這種東西已經根深蒂固的在我自己的身體裡了。

Q. 請問您如何獲得靈感？

A. 上網啊、看書啊、聽音樂啊、出去玩啊……都會有啊，看面對什麼問題吧，不過靈感靠不住，這東西太嬌嗔。還是不斷去嘗試吧，平時把基本功做好。

Q. 請和我們分享您喜歡的書籍、音樂、電影或場所。

A. 說一下音樂吧，還是蠻喜歡萬能青年旅店樂隊的音樂。一幫人在自己的業餘時間湊在一塊玩音樂，還玩的不錯。

Q. 現在，回頭來看這些帶著遺珠之憾的作品，您有什麼新的感觸？

A. 沒有太認真想過甚麼階段性目標，但現階段還處於每天都有所獲有所想，鬥志滿滿的狀態。

Q. 除了當設計師 / 插畫家，你是否已經開始規劃下一階段的目標？例如策展、學習煮菜、登山

A. 下一階段可能準備做個業餘藝術家，在設計之餘去搞搞藝術。

Q. 你對生活的細節上有什麼堅持嗎？(像是上廁所時一定要看詩集之類的)

A. 一定得有茶喝。

Q.What do you like best in your country? (such as country feature or culture)Has it made a difference on your creation?

A.Inclusiveness I think. Certainly I will be influenced by it, we growing up in such an environment where influenced us in many things, and it have been ingrained in my own body.

Q.How do you draw inspiration?

A. Browsing internet, reading book, listen to music, hang out......but inspiration is unreliable, it is too unpredictable, so just keep trying and do the basic skills well.

Q.Share good books, music, movies or places with us.

A. Let's talk about the music, still love Omnipotent Youth Society, a bunch of people stick together and play the music at leisure time, but they still playing well.

Q.Now, look back to these works of regret for not been selected, how do you feel that?

A. The moment of that time make me feel the most, it was quite recalling.

Q.Have you started to set up new goals for next period except being a designer or illustrator ? like curating, learning cooking , climbing......

A. Maybe being a amateur artist, do some arts besides design.

Q.What is your insist on your life's details ? like toilet with your favorite poem?

A. Most have tea.

托普歐樂居 - 梁碩個展 Pology Liang Shuo's solo exhibition　2015　P.101

展覽藝術家的作品是在搭建一個拓撲空間作品，作品有內外兩個空間，人是可以穿梭於作品內部的（是一個比較 " 渣 " 的工程），外部是只能遠觀的（採用大理石壁紙貼的光鮮亮麗）。基於藝術家的理念我把展覽信息排了一個類似於貼紙的滿屏效果，跟藝術家創作過程中裁掉的渣料的形狀進行結合，共同構成畫面。

The characteristic of artist's works in the exhibition is to build a topological space works with both internal and external space, people can shuttle in the internal space (it is a relatively " terrible " project), the outside space is just for sightseeing (pasted with glamorous marble wallpaper). Based on the concept of the artist's exhibition, I created the exhibition information with the effect which is similar to full screen, combined with the shape of slag produced during the artist's creating process, then constitute the visual.

微咖啡 We Coffee　2013　P.164

最初接觸到這個項目是從品牌命名開始的， " 快節奏，微生活 " 是我們的態度。我們的想要的是建立我們與咖啡之間的聯繫，讓我們與咖啡之間發生一個故事，單獨的我們跟單獨的咖啡作為本體是孤立的，然而當我們遇到咖啡，這之間就變得不一樣了，有了關係才是生活。

The initial contact with this project is form the beginning of the brand' name, " fast-paced, micro-life " is our attitude. We tries to build the connection between the coffee and us, making it happen a story between us, a single-individual-we and a single-individual-coffee is isolated, however, everything started to change when we met coffee, it is true life when build a relationship with coffee.

嘀嘀打車　2013　P.165

嘀嘀打車現在叫滴滴出行，創意出發點還是從產品本身定位預約出行的點出發，以字母 "D" 與定位圖形的結合，簡約清晰，使信息能夠更有效的傳達。

The creativity of DiDi is start form the characteristic of produce which could make reservation for positioning, we combined the letter "D" with positioning graphics, it is clear and simple for conveying information more effectively.

台灣 Taiwan

劉律宏，平面設計師，在工作之餘創作。擅長影像
合成與細膩的點陣圖創作，企圖在二維的平面紙張
上，建築一個立體的異次元空間。獨立出版資歷約
三年：2012 年 11 月成立大礦試料工作室，出版
PGO、Worm、文明人的病 - 晚餐等 zine 的創作。

Liou Lyuhong, a graphic designer, creating after working. I'm
expert in photomontage and elaborate raster graphic creation,
trying to build an extra space dimension on papers. I'm also
being an independent publisher for three years. 大 礦 試 料,
my own working studio, was established in 2012:PGO, worm,
sickness in modern people(dinner), was published in these years.

劉律宏　Liou Lyu-Hong

www.riserrr.com

Q. 請問您如何獲得靈感？
A. Music Videos, 時常花一整個下午看 MV, 其他什麼都不做。

Q. 請和我們分享您喜歡的書籍、音樂、電影或場所。
A. 很喜歡萬金油的小說,前陣子住院的時候,看了好多遍《我們從未不認識》。
喜歡小說裏描述的故事,就像是不斷在日常身邊發生的故事,平凡卻深刻。
最近在聽 Grimes 的新專輯 Art Angels：戴上耳機,將音量開到最大,閉上
眼睛,爽到上天堂。

Q. 除了當設計師 / 插畫家,你是否已經開始規劃下一階段的目標？例如策展、
學習煮菜、登山
A. 下一階段只希望將生活好好安妥,開始把當兵前所累積的作品以及出版
計畫,一一執行出來。

Q. 你對生活的細節上有什麼堅持嗎？(像是上廁所時一定要看詩集之類的)
A. 堅持一個禮拜洗一次衣服。(懶

Q.How do you draw inspiration?
A. Music Videos. I usually do nothing but spend a whole afternoon
watching music videos.

Q.Share good books, music, movies or places with us.
A. I love wan-jin-you, a Taiwanese novel writer. I've read his latest
novel "We've never met before. "many times when I stayed in
the hospital not long ago. The plot in the fiction is from daily issues,
common but impressed.

I'm in love listening the latest album "Art Angels" from Grimes
recently. I fly to the heaven by wearing the headphone, turning the
volume to the maximum level and closing my eyes.

**Q.Have you started to set up new goals for next period except
being a designer or illustrator ? like curating, learning cooking ,
climbing......**
A. I just want a peace life during my next stage. Also, I want to
arrange my works when in the army and start to carry out my
publishing plans step by step.

**Q.What is your insist on your life's details ? like toilet with your
favorite poem?**
A. I insist that doing laundry once a week is my prime directive of life.
(Am I lazy?)

Worm 2012 P.25
我將這些記憶剪貼,記錄我從新竹離開,到台北讀書這幾年間所發生的事情。「記憶如蛆遲緩繁殖,總有一
天這些記憶將充滿我整個人、整個意志,我因這些宿命、而生而滅。」
A book telling stories about me leaving my hometown to Taipei. I clipped these memory and
kept it in this zine. Memory is like the worm, it breeds slowly, and someday, the memory will fulfill
my body, my will, and my destiny. I live and die for it.

小島 Island 2015 P.69
小島是一處位於高雄的多元藝術空間,整棟建築分成三塊：藝廊、室內設計工作室、旅店。這三塊區域也如
同標誌上的三層線圈,聯想地圖繪製的方法,應用在這次的設計上。
"Island" is a diversifying art space located in Kaohsiung City. There are three parts:the gallery,
interior design studio and the hotel. These three parts also represent the three circles in the visual
design. I use the main concept of drawing the map and appling it to this work.

你從哪裡來？你往哪裡去？ Where are you from? Where is your destination? 2013 P.100
如果我們將生活反覆地摧毀與建造,如同海報上的元素一樣,其實我們正在做的就是重新檢視生命的意義。
The process we built and destroy life back and forth is a reviewing the meaning of life, just like
the elements on the poster.

水晶象牙 Crystal Ivory 2013 P.292
小學開始沈迷於 BBS 網路世界,那時正流行 88x31pixel 的 GIF 動態圖片。幻想網路世界是由細小的水晶碎
片組成,而這些碎片建構出一座又一座的象牙塔,我用滑鼠偏執地畫出住在水晶象牙塔裡的內心怪物。
When in elementary school, I was obsessed in BBS world. It was a time when 88X31 pixels
dynamic gif graphics became popular. The screen, the pictures, and all the tiny stuff on the
Internet are built by crystal ivory. I draw the little monsters living in the crystal ivory tower.

台灣 Taiwan

劉懿德　Liu Yi-De

www.liu19920609.wix.com/edengraphicdesign

一個才廿出頭歲卻老是被小朋友誤會稱呼叔叔的哥哥；一個打小喜歡畫圖的傢伙；一個從小可以拿著一本自己看不懂的書翻一整天的怪小孩……

從唐詩三百首看到詩經楚辭、從古典文學看到翻譯小說，書在沒有電腦的孩提時期是最實在的消遣娛樂，但也是因為這樣幾乎跟電動絕緣，導致現在不會打電動，還在努力學習中！

A twenty-year-old young man who is always been called uncle by children, a guy who likes to draw since he was little, a weird kid can read the book which he wasn't understand all day.

Read from Three Hundred Tang Poems to Classic of Poetry and Ci, from Classics to translation fictions. Books are the most entertaining stuff in his childhood, not computers. According to this reason, he almost insulated with video games.

Although he cannot play any of it, he is trying hard now.

Q. 請問您認為該國最棒的是什麼?(如國家的特色或文化等) 您的創作是否受其影響？

A. 其實我覺得台灣最棒的事情莫過於「擁抱新舊文化的機會」！

舉例來說好了：我們的教育制度告訴我們要要「修身齊家」，所以我們從小免不了論語孟子、詩經宋詞等文化內涵的認識與學習；放下課本走出教室，常看到長輩會提攜著小朋友到廟宇祈福，或求平安健康、或求事業功績，當下所處的環境老實說是一個文物美術館－在裡面可以看到工筆山水繪畫、書法創作佈局、工藝雕刻藝術等。

所以我們可以使用的「素材」太多了，且看你怎麼樣去使用它跟安排它！

有許多的設計師或藝術家，喜歡在舊有文化裡面淬煉嶄新的表現方式，尋找一種可能性與實驗性的化學作用，以及一種「自我認同」！

在創新表現中恪守歷久彌新的文化價值；在舊有文化藝術中發掘與現代思想環境接軌的契機；以東方元素揉合西方表現技法、用西方素材概念表達東方禪意哲學！

也是因為這種「齊人之福」讓我覺得非常有趣、好玩！(笑)

Q. 請問您如何獲得靈感？

A. 我本身比較偏向「挑戰制度」及「碎片閱讀」的方式取得靈感！所謂的「挑戰制度」便是對於「不滿的事情提出抗議，希望這個世界能不能再好一點！」為出發點；至於「碎片閱讀」則是不一樣的概念，現在人生活步速緊湊，要抽出時間專心的閱讀實在有一點困難，所以越來越多人會利用空檔的時間來汲取零碎的知識，誠如網路上分享的短篇文章、新聞報導、Youtube 上的片段影片等，都是我挖掘靈感、概念的管道。

Q. 現在，回頭來看這些帶著遺珠之憾的作品，您有什麼新的感觸？

A. 台灣人有一句話叫做：「孩子再不好終究是自己的孩子！」我想我的感覺跟為人父母一樣吧(笑)

在藝術領域翻滾的人都有一種「餓鬼」的偏執，永遠都覺得「不夠、不夠、還不夠！」創作這種東西很多時候比較像一種「照片留影」或是「錄音留聲」的概念，回頭看看小時候可能滿臉雀斑、其貌不揚；五音不全、荒腔走版，但是雖然嘴裡不饒人，不過還是會愛著他！因為終究還是自己呀！對吧？

Q.**What do you like best in your country? (such as country feature or culture)Has it made a difference on your creation?**

A. I think the best thing in Taiwan is that "The chance to embrace the old and new culture."

Take our education as an example. The education system taught us to cultivation ourselves and take care our family. So we have learned Analects, Mencius, Classic of Poetry and Ci since we were in childhood. As you put down the book and walk out the classroom, you can see elders and kids going to the temple to pray. Pray for health, safe good grades and good enterprise. The current environment in which to be honest is a heritage art gallery. Inside you can see the meticulous landscape painting, calligraphy layout, carving arts.

We can use a lot of "materials", and it depends on how you use it and plan it.

There are many designers or artists, like to figure out the new expression in the old culture, looking for a possibility of experimental chemistry, as well as a kind of "self-identity".

Abide in innovation performance in timeless cultural values; find the opportunities to combine old cultural art and modern thought; mix up the oriental element with Western performance techniques, express Eastern Zen philosophy with Western material concept!

Q.**How do you draw inspiration?**

A. I prefer "challenge the system" and "trivial reading". The so call " challenge the system" is to fight for the dissatisfaction and wish the world be better. "Trivial reading" is a different concept. It's hard to spend extra time on reading, due to the modern life style. So more and more people will make use of neutral time to learn fragmentary knowledge. For example, the short article which shared on the Internet, news, videos from Youtube, etc. All these are the way that I get my inspiration.

Q.**Now, look back to these works of regret for not been selected, how do you feel that?**

A. We have a saying in Taiwan, it's called "kids are not good enough, but they are my kids anyway." I think my feeling is quite alike with the parents. (laugh). Artists have a kind of "hungry" paranoia. We always think it's not enough at all. Creation sometimes is a concept like "photo taken" or "sound recordings". Looking back the childhood. Although freckled, homely; tone deaf, adorned, we can't find any good of him, however, we still love him. After all, it's still me. Right?

海洋強國夢 Ocean with country　2014　*P.121*
用魚拓的概念將國家色彩與國徽的意象結合，簡單直接的表達出海洋與國家的關係。
Rubbing of the fish with the concept of the national colors and national emblem imagery shows the combination of simple and direct expression of the relationship between the ocean and the country.

家園系列 Homeland Series　2013　*P.121*
使用簡約的色塊組合，表現稻田灌溉後反射陽光的耀眼色彩，再一次找回屬於台灣人的台灣印象。
Use simple color combinations. After the rice fields are irrigated, it will reflect the dazzling sunlight. Find the way back to the impression that belongs to Taiwanese.

大地之聲 Sounds　2014　*P.122*
到底有多久，我們沒有注意去聽大自然的聲音？好久好久，我們是不是已經聽不懂大地要對我們說些什麼了。
How long have we not paid attention to listen to the sound of nature? Too long... We probably don't understand what the nature is trying to tell us anymore.

自由 Freedom　2015　*P.122*
使用漢字「自由」的筆畫轉化成囚禁的牢籠，利用反諷的手法表達出我們都是在侷限的潛規則牢籠裡面追求若有似無的自由。
The idea of this design is to use the strokes "freedom" of Chinese characters to convert into captivity cage, the use of irony technique expresses that we are all living in the cage of unspoken rules, at the same time pursuing the hard freedom.

性騷擾 Sexual harassment　2015　*P.122*
使用大膽、鮮明的對比色彩營造一種視覺衝擊的不安定及危險感；露骨的圖像表達出言語性騷擾帶給受害者強烈的傷害以及遭受侵犯的感覺。
Use bold, bright contrasting colors to create a visual impact of insecurity and sense of danger; explicit images express verbal sexual harassment hurts victims deeply and a strong sense of violation.

指揮家 系列 - 火、風、心　Conductor Series - Fire, Wind, Heart　2015　*P.123*
將漢字筆畫轉化成指揮家的音樂律動，試圖將傳統的漢字書法之美與音樂律動感結合，營造一種印象性的舞台效果。
Convert Chinese character strokes into the rhythm of music conductor. Try to combine the beauty of traditional Chinese calligraphy and the music rhythm, to make an impressive stage effects.

反撲系列 Counterattack Series　2013　*P.123*
人類開發環境，以為大地無聲便肆無忌憚開採與掠奪，悲哀的是報應與破壞的副作用總有一天終究得由人類自己承擔。
People exploits environment. They think the nature doesn't resist, so keep expanding and plundering without hesitation. The sad thing is the consequences of retribution and destruction. One day people will suffer from it.

幸福系列 Happiness Series　2013　*P.123*
我們一直在追求幸福，但是真的的幸福到底是什麼？應該是要像嬰兒一樣有母親在身邊；有呵護重要事物的能力，這才是最簡單真實的幸福。
We humans but reaching for happiness, but what is a real happiness? It should be like a mother being close to the infant, the ability to care for the important thing. This is the simplest way of true happiness.

香港 Hong Kong

陸貽敏　Luk Jerry

www.innoise.org

Jerry Luk / 陸貽敏 - 香港年輕設計師，於 2011 年成立個人設計工作室 innoise，善於融合現代與細緻的風格，創造風格強烈的創意作品，主力從事項目涵蓋：品牌設計，美術指導，平面和動畫設計等等。追求適切而簡約的設計，運用圖像準確傳達項目重點及訊息。相信好的設計並不僅僅意味著給予一個項目美觀的外表，而是利用它們自身的功能和特點，透過設計語言重新呈現及提升其本質。

Jerry Luk, who founded his own multi-media creative house "innoise" in 2010, specializes in creative projects including branding, art direction, graphic and motion design. He also enjoy following his inspiration to do all kinds of self-developed artworks, projects and unique products.He believes that a good design does not only means to give a brilliant image to a product or a brand, instead it's used for utilize a product's function and building a distinctive image towards a brand. Based on this principle, he aims to tailor innovative ideas combined with his solid experience and technical know-how.

Q. 請問您如何獲得靈感？

A. 盡量看一些平面設計範疇以外而美麗的事物。

Q. 請和我們分享您喜歡的書籍、音樂、電影或場所。

A. 書：人造衛星情人，臺北人及一些日本時裝或生活雜誌。

音樂：EGO-WRAPPIN-Neon Sign Stomp，Sukiyaki Kyu-Sakamoto，Gust De Meyer-Casioworks 1.2.2。

電影：Stoker, Shinning, 花樣年華。

場所：我的辦公室或河邊。

Q. 現在，回頭來看這些帶著遺珠之憾的作品，您有什麼新的感觸？

A. 過往的每一個項目總會因為時間、預算、場地等各種因素而沒能把心裡認為最完美的想法呈現出來，但每一個項目所帶來的經驗總是可以完善未來的挑戰，故此，即使有時不能完全呈現初始的念頭，但我想透過累積經驗，還是可以一點一點地慢慢步向完美的方向。

Q. 你對生活的細節上有什麼堅持嗎？(像是上廁所時一定要看詩集之類的)

A. 我的辦公桌必須非常整潔及零雜物。

Q.How do you draw inspiration?

A. I would see some beautiful things out of graphic design

Q.Share good books, music, movies or places with us.

A. Books: Sputnik Sweetheart by Haruki Murakami, Taipei People by Pai Hsien-yung Some Japanese fashion and lifestyle magazines

Music: EGO-WRAPPIN - Neon Sign Stomp, Sukiyaki - Kyu Sakamoto, Gust De Meyer - Casioworks 1.2.2

Movies: Stoker, Shinning, the Mood for Love.

Place: My office or river side.

Q.Now, look back to these works of regret for not been selected, how do you feel that?

A.Works are difficult to end up with the best idea i had at the beginning because of limitations of time, budget, venue and so on. However the experience accumulated from each of them can always equip me for the next challenge and bring me few steps closer to perfection. So I will keep learning from those experiences by working it out bit by bit, then move step by step towards perfection.

Q.What is your insist on your life's details ? like toilet with your favorite poem?

A. My desk has to be very clean without any unwanted stuff.

藝術製造所 Art Fab Lab　2015　P.65

《ART.FAB.LAB 藝術。製造所》以製造所作為展覽。這不只是開放讓人參觀數位製造的實驗室。從數位製造的硬件、空間，如何建構成藝術家們的創作場所、駐場藝術家的創作過程，以至作品完成展出、遇上不同的人，所有這些都是展覽的展品。創作上採用了近似街頭廣告和視覺麻木的風格設計主視覺，視覺麻木為展覽創造了一個強烈的視覺形象，擺脫藝術展覽一向予人孤芳自賞的印象。設計最後修改成較簡潔的感覺，讓海報上的展覽資訊更清晰。

"ART.FAB.LAB" is a project combining fabrication laboratory with art exhibition, promoting maker culture and presenting how digital fabrication intervene art and design creation through the artworks of various artists from the world over, Fab Lab and Artist-in-LAB. With workshops and seminars, the viewers can have a taste of digital fabrication applying to art and design. We are honored to be invited as the art director creating the visual identity for the event. To make the exhibition more noticeable to the general public, we adopted a propaganda-like design as the key visual to promote a vigorous and welcoming image, altering the proud and aloof impression of art exhibitions. The design was finally modified to be more neat to make the information more reader-friendly.

聲的形態 Wave Form　2014　P.65

【Wave Form 聲的形態 】跨媒界創作展，邀請了 16 位不同界別的創作人以黑膠唱機為出發，創作代表他們對聲音形態想像的作品。故此聲音的形態就成為了海報創作的主旨。我將 " 聲的形態 " 四字的讀音，利用特別編寫的程式分別轉化成四塊聲浪圖作為海報的主視覺。我亦運用同一程式把所有參展藝術家名稱的讀音，轉化成縱向的音浪線條，以透明油墨印於海報上。配上由唱機外觀所設計的標誌，使所有元素得以統一及呼應展覽主題。這個草案原來想傳達一種陰沉及寂靜的感覺，但客戶還是希望展覽顯得比較富生氣，故此最後還是選擇了另一個顏色的方案。

Wave Form" exhibitions contains 16 artists from different disciplines – music, graphic design, installation art, photography, fashion, etc, interpreting the form of sound from their perspective, revisiting and rethinking about the form of sound, and sculpting it into a real representation with turntables as a media.Soundwave, therefore, became the keynote of the poster design. I rendered the pronunciation of the title (聲 的 形 態) into four lumps of waveform, through a computer program created by Keith Lam, as the key visual of the design. The artists' names were also rendered into sets of vertical lines which are printed with a translucent ink and orderly lied on the poster. I transited the image of a turntable as the logo, in order to make all the elements more united and relevant to the theme. The original design was appeared to be more gloomy and still, but the color tone was end up modified due to customer's opinion.

野設計 製造所 Design Fab Lab　2015　P.65

為高雄市設計節的其中一個展覽項目，以衣、食、住、行等為主題，邀請了世界各地的設計師及藝術家們，以數位打印及切割等製造技術創作不同範疇的作品，藉此探討當下科技與生活之間的互動關係。同時亦展現了不同創作者對數位製作的獨特詮釋。原案是比最終的定案在色彩上要來得比較柔和及親切，以及想要突出展場中屋形的主視覺，而海報中大量的空白也是大形展覽海報中比較少用的。然而經過與客戶反覆商討，最後的定案更改了少量元素的安排及更換了一種比較醒目的藍色而放棄了這個草案。

"Design Fab Lab"is one of the exhibition in 2015 Kaohsiung Design Festival, promoting makers movement by showcasing the works created with Digital Fabrication and traditional craftsmanship based on four elements, Clothing, Food, Shelter, Transportation, of our daily life. The design originally adopted a rather soft and harmonious color tone to highlight the house-shaped key visual, and used a lot of white space which is uncommon in poster design for such large scale exhibitions. After discussing with the customer, we agree that we can fine-tune some elements and change the color to a eye-catching blue instead of using the original design.

Experimentalism　2013　P.121

XXXXXXXXXXXXXXXXXXXXXXXXXXXXXXXXXXXX

台灣 Taiwan

1976 年生，台灣人。經典奇幻醬，辣，經驗豐富的 CG，童書，新鮮的機械零件，新鮮的人物設計和新鮮的紅眼睛，70 吋。

之所以作畫無關乎愛、信念和熱情。

Born in 1976, Taiwan. Classic fantasy sauce, spicy, seasoned CG, children's book, fresh mechanical parts, fresh character design and fresh red eyes, 70".

I draw nothing but love ,faith and passion.

披薩先生　Mr.PIZZA!

www.behance.net/pizzart

Q. 請問您如何獲得靈感？

A. 整理工作室。公路車。慢跑。上大號。逛家樂福。街頭速寫。

Q. 請和我們分享您喜歡的書籍、音樂、電影或場所。

A. 鋼彈模型書、IKEA 型錄、藝術家畫冊。

爵士樂、搖滾樂、聖誕歌曲、麥可傑克遜。

我愛台灣。

Q. 現在，回頭來看這些帶著遺珠之憾的作品，您有什麼新的感觸？

A. 我會持續這種風格一段時間來試探市場。

不管好與不好，我都會畫得很開心，因為我真心喜歡畫這樣的東西。

Q. 除了當設計師／插畫家，你是否已經開始規劃下一階段的目標？例如策展、學習煮菜、登山……

A. 我想當街頭藝人，抱著吉他自彈自唱。

Q. 你對生活的細節上有什麼堅持嗎？(像是上廁所時一定要看詩集之類的)

A. 我總是會帶著速寫本和相機。

我討厭鍵盤聲音。

我拒絕使用智慧型手機。

我總是穿著陸軍內衣。

Q.How do you draw inspiration?

A. Clen up my studio. Road bike. Jogging. Take a dump. Carrefour shopping. Street sketches.

Q.Share good books, music, movies or places with us.

A. Gundam weapons, IKEA catalog, artist book.

Jazz, rock, Christmas songs, Michael Jackson.

I love Taiwan.

Q.Now, look back to these works of regret for not been selected, how do you feel that?

A. I will keep this style for a while to test the market.

Whether good or not, I will draw very happy, because I really like to draw such stuff.

Q.Have you started to set up new goals for next period except being a designer or illustrator ? like curating, learning cooking , climbing......

A. I want to be a busker, a guitar singer.

Q.What is your insist on your life's details ? like toilet with your favorite poem?

A. I always carry a sketchbook and camera.

I hate the keyboard sound.

I don't use smart phones.

I always wear a military T-shirts.

成真吧！Make it real!　2015　P.268
機械女孩在平板上畫的狗活了過來，強調產品的方便與一筆在手創意無限的概念。
The dog which the mechanical girl draw on tablet jump out and become alive ,emphasizing convenience and unlimited creative.

對峙 Confrontation　2015　P.268
海底世界充滿未知，隨時都有可能出現敵人。
Underwater world full of unknown ,enemies may show up at any time.

雙子座 Gemini　2015　P.269
我試圖以我獨特的機械美感重新詮釋星座。
I try to reinterpret Zodiac with my unique mechanical aesthetic.

武器毛筆 Weapon Chinese brush　2015　P.269
不一樣的職業使用不一樣的武器，成就不一樣的夢想。

武器沾水筆 Weapon Dip pen　2015　P.269
不一樣的職業使用不一樣的武器，成就不一樣的夢想。
Different profession use different weapons, make different dreams come ture.

武器澆花壺 Weapon Watering Pot　2015　P.269
不一樣的職業使用不一樣的武器，成就不一樣的夢想。
Different profession use different weapons, make different dreams come ture.

中國 China

趙猛　Mung

www.behance.net/Mung411

趙猛，新銳平面設計師。1990 年生，本科 / 碩士均畢業於河北大學。作品榮獲：2015 金點設計獎 - 年度最佳設計、2015 第十屆澳門設計雙年展（學生組 - 視覺形象類）金獎、銅獎各壹枚、2015 靳埭強設計獎（學生組）銀獎；入選出版物：第 9/10/11 屆《APD 亞太設計年鑑》、《GDC-15 作品集》、《Brand 創意呈現 2》、《字賦不凡》；入選展覽：第 2/3 屆上海 & 亞洲設計雙年展、第 9/10 屆澳門設計雙年展、2015 漢字意象海報展。

Zhao Meng, graphic designer. Born in 1990, graduated from Hebei University. Awards: 2015 Golden Pin Design Award - The Best Design, 2015 The 10th Macau Design Biennial - Golden & Bronze, 2015 Kan Tai-Keung Design Award - Silver.

Selected works: The 9 / 10 / 11 Session of APD Asia Pacific Design Yearbook, GDC-15, Brand No.2, 字 賦 不 凡 . Exhibitions: The 2/3 session of SAGD, The 9 / 10 session of the Macau design Biennale, Ideology of Chinese Characters - 2015.

Q. 請問您認為該國最棒的是什麼 ?(如國家的特色或文化等) 您的創作是否受其影響 ?

A. 我個人覺得是書法，因為它擁有悠久的歷史淵源，一種全然不同於西方書寫的表現形式，或粗曠或內斂。我的一些字體試驗作品會受到書法影響，包括漢字本身固有的一些間架結構對我的影響。

Q. 請問您如何獲得靈感 ?

A. 我獲得靈感主要通過網絡(Behance、Brand new、cargocollective)，另外會購買大量的畫冊和書籍。

Q. 請和我們分享您喜歡的書籍、音樂、電影或場所。

A. 我喜歡的書籍:《真實的設計 - 荷蘭現代主義與視覺識別》。

音樂:蕾哈娜。

電影:獨自等待、重慶森林。

場所:安靜的書店。

Q. 現在，回頭來看這些帶著遺珠之憾的作品，您有什麼新的感觸 ?

A. 遺珠之憾的作品不能說明本身不好或者怎麼樣，設計的過程是雙向選擇的過程，我的作品猶如我的孩子，我會平等對待每一件作品。

Q. 除了當設計師 / 插畫家，你是否已經開始規劃下一階段的目標 ? 例如策展、學習煮菜、登山

A. 下一階段的的規劃應該還是停留在設計上吧，慢慢積累作品走好每一步。

Q. 你對生活的細節上有什麼堅持嗎 ?(像是上廁所時一定要看詩集之類的)

A. 其實也沒什麼堅持的啦，可能上廁所的時候大部分是在玩手機或者聽歌吧。

Q.What do you like best in your country? (such as country feature or culture)Has it made a difference on your creation?

A. I personally think is the calligraphy, because it has a long history and a completely different in the form of Western writing, either rough or restrained. Some of my Chinese character test works by calligraphy effects, including effects of character itself inherent some schematic structure of my.

Q.How do you draw inspiration?

A. I get the inspiration for the main Behance (Brand, new, cargocollective), and will buy a lot of books and books.

Q.Share good books, music, movies or places with us.

A. I like the books: "the real design - Holland modern and visual recognition".

Music: Rihanna.

Movie: alone, Chongqing forest.

Place: quiet Bookstore.

Q.Now, look back to these works of regret for not been selected, how do you feel that?

A. Pearl of regret cannot show itself is not good or how, the design process is the process of two-way choice, my work is like my children, I will treat every piece of works equally.

Q.Have you started to set up new goals for next period except being a designer or illustrator ? like curating, learning cooking , climbing......

A. Planning the next stage should remain in the design of it, slowly accumulating works every step of the way.

Q.What is your insist on your life's details ? like toilet with your favorite poem?

A. In fact nothing to you, may be on the toilet when most are playing phone or listening to music.

河北省高校藝術學學科建設研討會 - 會議畫冊設計 Hebei Province College of art subject construction seminar - conference book design　2015　P.14
畫冊的主體視覺符號為一個破碎的畫框，意味打破大眾對傳統繪畫的認知，加入大量的線條在裡面增強一定的形式感。
Pictures of the main visual symbols for the a broken frame, means to break the public's perception of the traditional painting, add a large number of lines inside enhanced certain forms.

童趣 Playful　2015　P.147
童趣為一家兒童美術培訓機構，設計的最初確定為以字體設計為品牌 Logo，結合笑臉圖形彰顯行業特徵，整體品牌視覺印象的調性為活潑歡快。
Playful as a children's art training institutions, the design originally identified as font design for the brand logo, combined with smiling face graph reveals the features of the industry, overall brand visual impression of tonality is cheerful and lively.

武茶人 Wu Charen　2015　P.147
武茶人是一款原創茶服的品牌 Logo，隸屬於模糊服裝子品牌；不想用任何裝飾的元素加入畫面，品牌 Logo 就是三個漢字，英文都未做保留，盡量保持它的單純和質樸。
Wu Charen is an original tea service brand LOGO, part of the fuzzy clothing brand; do not want to use any decorative elements to join the picture, brand LOGO is the three Chinese characters, English are not retained, try to keep it simple and plain.

小雞和豆芽的故事 Chicken and bean sprouts　2015　P.148
這是為一家餐飲行業做的品牌形象設計，消費群體多為青年人，所以設計的調性偏向西方現代，設計內容包括標誌和一些 VI 基礎元素；在整體中貫穿插入線條的使用使之作為輔助圖形。
This is a food and beverage industry to do the brand image design, consumer groups for young people, so the design of the tonal bias in the west, the design content including signs and some VI busic elements; in the overall use of the Insertion lines as a supplementary graphics.

Yaker Coffee　2015　P.149
為一家咖啡店做的品牌形象提升，設計調性以西方簡潔現代感為主，色彩表現上保持整體清新的調性，以整體的視覺體驗為主。

For a coffee shop to do the brand image enhancement, the design of the West simple modern sense of tone, color performance to maintain the overall fresh tone, the overall visual experience based.

河北大學工商學院 2015 年畢業設計展覽 College of business, Hebei University graduate design exhibition　2015　P.149
此次展覽的主題為 " 覺悟 "，意味一種視覺上的領悟、對話，加入一定的漸變在裡面意味對學生時代 1-4 年級的一種回顧。
The theme of this exhibition is "consciousness", which means a kind of visual understanding and dialogue, which is a kind of a review of the 1-4 grade of the students.

心經全文字體設計 The Heart Sutra font design　2015　P.211
心經全文設計是在對傳統宋體字的一種探索，該作品入圍了 2015 年金點設計獎頒獎典禮名單（共 2360 件投稿，57 件入圍）；我對於傳統的字型框架做了打破，筆劃之間的組合方式更加自由隨意，充滿了隨機性。
The full text of heart meridian design is in a kind of exploration of Traditional Song typeface, the works a finalist in the 2015 Jindian design award awards list (a total of 236 submission, 57 finalists); I for the traditional framework of font do break, combination between strokes more free, full of randomness.

將進酒試驗字體設計 QiangJinjiu font design　2013　P.212
將進酒這套字體設計是我 2013 年的作品，當時參加 2013 的 Hiii Typography 大賽榮獲優異獎。將進酒屬於視覺暗示的字型試驗，對於此項字體做了一些扭曲之感，來彰顯它本身的不可預測性。
For this set of font design is my work in 2013, participated in the 2013 Hiii Typography contest won the excellent award. Will belong to the visual cues font test, for the font do some distorted sense of, to highlight the unpredictability of itself.

泰國 Thailand

我是位視覺傳達設計師，專注於品牌設計、包裝設計、海報設計。同時，我也全心投入到排版和插畫。在曼谷，是 The head and the heart design studio 的創立者。我有廣大的興趣，這是為什麼喜歡嘗試新媒體及跨領域工作。

I am a Visual Designer, focusing on Branding, Packaging, and Printed works. Meanwhile I dedicate myself into typography and illustration works as well. I am a founder of The head and the heart design studio in Bangkok. I have a wide range of interest that's the reason why I love experimenting on new media and work across disciplinary.

Nan Napas

www.nan-napas.com a

Q. 請問您認為該國最棒的是什麼？(如國家的特色或文化等) 您的創作是否受其影響？

A. 我喜歡泰國傳統的枝編工藝還有寺廟上的壁畫，泰國寺廟和古老建築、中國城、還有 Bkk 沿著河流的社區、泰國的食物。我會思考自己作品與生長環境的關連性，尤其是枝編工藝和寺廟豪華的裝飾，它們都反映在我的作品 Bellis、Selfpromotion，還有其它插畫作品上。而且我認為這些文化都會自然地表現在許多泰國學生的的藝術設計上，在我看來，手工藝和精緻的藝術作品給予我們這些泰國的設計師力量，但同時我們的思考方式也限制了對美學的理念，我們必須擴展美的定義範圍，將思維提升到另一個層次。

Q. 請問您如何獲得靈感？

A. 我都是先從一個簡單、老掉牙的理念開頭，然後去深入探討、研究它，這樣做總是會讓我找到好的方向。有時候我會走到外頭摸索這個城市，調查不同的設計領域，像是室內設計、建築設計，我的靈感大部分都來自那時身邊的事物，可能是音樂、藝術家、藝術作品、對話，或是隨機的場所。

Q. 請和我們分享您喜歡的書籍、音樂、電影或場所。

A. 音樂：我喜歡 Lord、酷玩、詹姆仕·布朗特、爵士，她與他。

圖書：我愛國家地理雜誌，我在伊朗長大、攝影書未來小妹、TED talk。(這是一個演講，但我認為內容跟讀一些好書同樣值得)。

電影：大吉嶺有限公司、宇宙的最後生命、大狗民、曾經、愛是唯一、曼哈頓戀習曲、愛在日落巴黎時和愛在黎明破曉時、飢餓遊戲、岩井俊二的所有電影、神隱少女等等。

地點：泰國的 TA Prachan、老城曼谷、清邁、中國城、夜晚的 Ratchadamnern road。紐約布萊恩公園、雀兒喜、下東城、西村和紐約鄉村。

Q.What do you like best in your country? (such as country feature or culture)Has it made a difference on your creation?

A. I like Thai traditional wickerwork, mural on temple's wall, interior of Thai temple, old building, China town, community and place along the river in bkk and Thai food. When I was thinking about it I started to see a connection between my works and the thing I grew up with especially the wickerwork and the lavish ornament in temple reflect on such as Bellis, Selfpromotion (my works) and my illustration work. Moreover I believed that this culture innate in many of Thai art and design students. In my opinion the hand craft and very fine artwork is a strength for some of Thai designers but at the same time the way we were taught was limited our concept of beauty, the definition of beauty must have wider range and it had to be pushed into another level with thinking process.

Q.How do you draw inspiration?

A. I always start with a simple thought and cliche idea then I explore, research, dig in and it always lead me to good place. Sometime I went outside and explore the city, I searched on a different design field such as interior or architecture. Most of the time inspiration came from what inspired me or what surrounded me at that time, it could be music, people, artists, artworks, conversations, or random places I went.

Q.Share good books, music, movies or places with us.

A. Music : I like Lord, Coldplay, Jame Blunt, Jazz, She and Him.
Book : I love Nat Geo, Persepolis, Mirai Chan photo book, Ted talk(it's a talk but I think the content worth for me to assume I read some good book)
Movie : Darjeeling Limited, Last life in the universe, Citizen Dog, Once, Begin Again, Before Sunset and Sunrise, Hunger Game, Movies from Shunji Iwai, Spirited Away and many more.
Place : In Thailand : Ta Prachan, Old town Bangkok, Chaing Mai, China town, Ratchadamnern road at night. In New York : Bryan Par, Chealsea, Lower east side, west village and New York countryside.

Milk 2014 P.39
我不喜歡喝牛奶，每次喝牛奶就覺得難受，但是小時候父母會強迫我每天喝。因為他們相信牛奶有很好的蛋白質與鈣質來源，在看過這本書的內容之後，我才發覺自己有乳醣不耐症。這本書會告訴你在喝牛奶時，許多你可能不知道的事實。
I don't like drinking milk and I always feel sick when I drink it but when I was young my parents forced me to drink it everyday because they believed milk were really good source of protein and calcium. After I researched for the content in this book, I realized that I was Lactose intolerance. The book will show you many facts that you may not know of what containing in milk you drink.

Bellis 2014 P.54
Bellis 是紐約當地的有機農場。在包裝面上以手繪插圖還有編織技法詮釋他們的理念與品牌精髓，創造出有機、手工、在地和未加工的感覺。
Bellis is an organic local farm in NY. I express their philosophy and brand essence by using the hand-drawn illustration and woven technique in one of the packaging panel in order to create the feeling of organic, hand-made feel, local and unprocessed.

Jida Watt 2015 P.54
Jida Watt 的核心概念是手工、動人、陰柔、古典，我用了襯線字體與木箱包裝呈現古典手工的感覺，包裝上設計的造型也會讓你想到眼鏡的造型。
The key concept of Jida Watt is hand craft / glamorous / feminine / vintage. I decide to made the logo type with serif font and the packaging wood box graphic illustrates vintage feeling and hand craft moreover the shape of the design on the packaging will remain you of glasses shape .

Self promotion 2013 P.114
這是我在學校的 type2 課時做的自我宣傳。自我宣傳的內容是關於我的背景、喜歡的事物、我不被人知曉的故事。這是非常私人的作品，所以我使用非常複雜的摺法給觀眾打開，我最親密的朋友總是跟我說我的想法太過複雜曲折，但令人驚訝的是，過去我從沒想過這個性格可以應用到折疊的系統上。
This was my self promotion that I was made in School "Type2 class." The content in this self promotion was about my background, things I liked, my story that no one had ever known before. This work was quite personal so I chose very complex folding for the readers to open it. My closest friend always tell me that my thought was very complex and complicated, surprisingly this personality reflected into the folding system which I never ever thought about it before.

21 2014 P.191
2014 年 Pratt institute 香水的品牌與包裝設計，品牌名稱的來源是因為人在死亡的時候，身上會減少 21 克，

據說這是靈魂的重量。我決定使用三角形，因為這樣的幾何形狀可以表現出神秘感，如果形狀有性別的話，我相信三角形是女性，這類型的女性既輕柔又固執、自信、積極。
This is a perfume branding and packaging design class in 2014 at Pratt institute. The brand's name derived from the believe that when you died your body would loss 21 grams and that weight contained your soul. I decided to use the triangle shape because this geometric shape could reflect mystery feeling and if the shape has sex I think triangle means woman, the character of this type of woman is not soft and gentle but she is very headstrong, confident and progressive.

Hands and Heart 2015 P.191
客戶給我三個他們咖啡店的概念關鍵字，分別是極簡、禪風、上下對比。從這三個關鍵字開始，試圖將它們轉換成視覺，一開始我發展 Logo 有兩個矩形，暗示咖啡店的店名，上方的矩形是「手」，下方的矩形是「心」。然後我將禪的哲學「凡所有象皆是虛妄」利用在 Logo 的負空間，當我們看負空間時，H 就會表露出來。
When I got this job the client gave me 3 keywords of their coffee shop concept, they were minimalist / zen / contrast of context. Then I started working from these words and tried to illustrated them into a visual. At the beginning I developed the logo as you could see they were two rectangles which implied to the name of the coffee shop the top rectangle was for "hands" and the bottom one was for "heart." Moreover I used zen philosophy about "things that you can see and things that you can't," into the negative space of the logo symbol that would reveal H out when we pointed it out.

Typography project 2014-2015 P.225
這是一套我個人的字體設計創作，沒有任何委託，我只想讓這些作品捕捉自己那個瞬間的思想與情感。
This is a set of my personal typography works. They are done without any commission and many of them I only want to capture my thought and feeling at that moment.

Be the change you want to see in the world 2015 P.229
我被委託設計 Icare 海報背面的文字排版。那時他們給我一個摘要，希望我詮釋「要改變世界先由自己做起」，用手寫體的風格詮釋它。我決定將美麗的手寫字和插畫結合在一起，在左側描繪戰爭故事，右側描繪的是和平的符號。
I was commissioned to do typography on the back of Icare poster. At that time they gave me a brief that they want me to express the quote "Be the change you want to see in the world" and illustrated it in hand lettering style. I decided to illustrated the beautiful hand lettering and combined it with the illustration; on the left side portrayed war story and on the right side portrayed peace symbolic.

馬來西亞 Malaysia

魏淑樺是一位馬來西亞平面設計師和插畫家。她畢業於平面設計學位，專攻出版印刷設計，插畫和品牌設計。透過各種設計媒介，她帶出了細心周到的設計解決方案。她在每個作品的小細節上都非常精準和耐心地仔細端詳。她希望能培養人們對設計的觀念，像是設計能對人類生活有著極大的作用。

Ngooi Su hwa is a graphic designer and illustrator based in Malaysia. She graduated with a Bachelor's degree in graphic design with a specialism in publishing design, illustration and branding. She develops design solutions with the ideas that are beautifully thoughtful in various medium. She scrutinised every single detail of her work with precision and patience. She hopes to nurture people's mindset towards design as design has an impact on human living.

魏淑樺 Ngooi Su-Hwa

www.behance.net/suhwa

Q.請問您認為該國最棒的是什麼？(如國家的特色或文化等) 您的創作是否受其影響？

A.我成長於馬來西亞。讓我最愛的是當地的美食和文化遺產。除了豐富多樣化的美食選擇，它擁有了豐富的文化遺產，例如歷史景點，手工藝品和多姿多彩的佳節。我將我國的文化精華元素放進設計流程，因為生機勃勃的文化一直都賦予我設計靈感。

Q.請問您如何獲得靈感？

A.為了找尋更多的設計靈感，我經常會去參觀設計展覽。欣賞設計師們的作品，瀏覽設計網站和翻閱設計書刊都是我豐富靈感的來源。透過文字和視覺上的閱覽帶給了我天馬行空的想像。此外，與志同道合的設計師交流也能激發我產生獨特的想法。

Q.請和我們分享您喜歡的書籍、音樂、電影或場所。

A.我想要分享馬來西亞的歷史文化遺產街，例如馬六甲的雞場街，檳城的喬治敦和柔佛的陳旭年街。雖然這些老地方已被擴張，結合了舊與新的元素，卻還保留了古色古香的魅力和傳統氣氛。我喜歡徘徊在這些老店外，不僅是因為它緩慢的生活節奏也是因為這裡的的小事物使這成為了懷念舊時光的好去處。

Q.你對生活的細節上有什麼堅持嗎？(像是上廁所時一定要看詩集之類的)

A.每天早上，在我閉著眼處於清醒或半醒的狀態下，我腦子喜歡計劃著當天所需要完成的活動與事項。在我清楚地規劃好當天的事後，我才會離開我溫暖的被窩。特別是在我有繁忙課業或工作的時候，這是我常會做的事。過程中能幫助我有條理地整理思緒和準備好應付當天的規劃。

Q.What do you like best in your country? (such as country feature or culture)Has it made a difference on your creation?

A. I grew up in Malaysia. The most I like about Malaysia is the local culinary and local cultural heritage. Apart from the plentiful culinary with scrumptious varieties to choose from, Malaysia boasts a rich cultural heritage, from a huge variety of beautiful historic venue, art and crafts to the colourful festivals. Its vibrant culture has always inspired me to take the essence into my design process.

Q.How do you draw inspiration?

A. To get myself more ideas flowing, I am always looking for inspiration by paying a visit to design events. See great work which had done by designers, browse through the design websites and flipping through design publications are the source of great inspiration. It leads me to the unconstrained imagination through reading the words and visual. Besides, talking to likeminded designer would also inspired me a lot and come out with untapped idea.

Q.Share good books, music, movies or places with us.

A. I would like to share the Malaysia's historical heritage streets like Jonker Street, Georgetown and Tan Hiok Nee Street which are respectively located in Malacca, Penang and Johor. Although the old places has been expanded into the bustling of old and new mix, it is still retaining an old-world charm and much of its traditional atmosphere.
I like to wander through these old shophouses to whittle away the hours not merely because of its slower pace of life but the little things you found here made a good place for me to remember the good old days.

Q.What is your insist on your life's details ? like toilet with your favorite poem?

A. Early in the morning, I always like to plan activities and things that need to be done when I'm consciously or half consciously awaked with the eyes closing. This happened most of the times especially when I am overloaded with my assignments and works. I will only leave my bed after I clearly organised my to do list. This process actually helps me in the way that I feel like my thought is organised enough and more prepared to cope well for the day.

個人品牌 & 代表作書刊 Self Branding & Portfolio 2015 P.17
固定的日常生活非常乏味。我是一個有著好奇心的設計師。求知慾的態度是讓我遠離安全無變化區域的動力。我的個人品牌標誌顯示了這名橫跨格子邊緣，意味著不讓自己停留在無變化的範圍。秉持著好奇心，我能一直向外移動，能體驗更多事物，使我成為更好的設計師。接著，應用個人品牌的概念來包裝我所收藏的代表作書刊。
Routine is boring and tedious. I am a designer with curiosity nature. Curiosity is the driving force capable of moving me from a safe and rigid region. My constructed logo with my name crossing the border meaning not to let myself stay in a regular region. Being curious, the more I moving out the space, the more I could see and experience to make myself a better designer. The concept of my self branding is applied to package my portfolio which packed with the artworks I have done.

醞釀中的快樂 The Brewing Happiness 2015 P.17
「醞釀中的快樂」是一本活動書籍提供給想要快樂的人。此書不僅能提供個人使用也能與你的朋友，家人和另一伴一起分享共用。除此之外，書本所提供的空間能讓讀者用文字和畫畫記錄珍貴的時刻及進行有趣的活動。在市面上能找尋到很多激勵人們如何擁有快樂和幸福的書刊，但此書的特別之處是與其閱讀你需要用行動去完成快樂的任務。
The Brewing Happiness is an activity book for people who wants to be happy. The book is created not only for personal used, it can be used with friends, family and loved one. Space is provided for audience to scribble thoughts, draw, capture the precious moment and carry out fun activities. It is a to do approach book instead of a book to read how to be happy.

法國長條麵包 Baguette 2013 P.18
以法國長條麵包命名的這本雜誌是提供麵包師傅和愛吃麵包的讀者閱讀。此雜誌除了包含著多樣化的麵包食譜之外，還提供了有用的麵包知識，例如麵包的科學常識，麵包的健康益處和麵包與酒的搭配。
Baguette is a magazine for both bread bakers and bread eaters. It is packed with a variety of bread recipes, as well as providing useful bread knowledge, ranging from the art and science of bread, the health benefits and even how to pair bread with wine.

阿華田包裝改革 Ovaltine Packaging Revamp 2013 P.48
改革阿華田包裝的宗旨是要給予它一個嶄新的包裝設計以便能吸引人們更多的目光。嶄新的阿華田包裝在視覺上展示了產品的賣點為天然有益健康的精力飲料。引用登山者的角色為代表，飲用了阿華田後會精力充沛及身強體壯。
The objective of the project is to revamp Ovaltine packaging to put an update look that appeals to people. The refreshed look of Ovaltine has visually projecting its unique selling proposition as a naturally wholesome energy drink. Using mountain climber as a mascot, climbing up the Ovaltine drink to represent energy gained and body strengthen after consuming Ovaltine.

防止虐待動物協會品牌設計 SPCA Branding 2013 P.158
防止虐待動物協會是國際性的動物福利組織聯盟，目的是保護動物，減少所有動物所受的苦痛。改革防止虐待動物協會的宗旨是要給予它一個嶄新的品牌身份，讓它擁有強大及正面的價值和帶來極高的識別度。嶄新的品牌身份關注在對動物的關懷和保護。把字母 C 和 A 合併形成一個動物的形狀再嵌入兩個像盾似的弧形保護物。這混合加固了人類對動物保護的兩者關係。帶著友善的語調和氛圍的視覺設計使人們被吸引成為防止虐待動物協會的一份子。
SPCA is an animal welfare organisation protecting defenceless animals and to alleviate their suffering. The objective of the project is to rebrand SPCA to give a brand new identity that has a strong and positive value that makes SPCA highly recognisable. The new identity focused on caring and protection towards animals. Both of the letter C and A are combined to form a shape of animal and embedded in the two rounded shields. The blending reinforces the relationship between human protection towards the animals. The design carries a tone of friendly to make people feels inviting to join SPCA.

咖啡館指南 A Guide to Coffee Café 2014 P.270
這採用插畫形式呈現的咖啡館指南有助於人們發掘馬來西亞獨立咖啡館的美味佳餚、飲料、甜品和環境。
A Guide to Coffee Cafe is a pictorial guide that sources the interesting cafes, assisting in discovering the independent cafes in Malaysia to go for the great food, drink, dessert and ambience.

越南 Vietnam

Nhatminh Phan

www.behance.net/nhatminhphan

我是越南胡志明市的自由平面設計師，專業是品牌、編輯設計、排版和 UI/UX 設計。極簡主義和完美主義的狂熱信徒，喜歡乾淨、現代、簡單和具有創意的設計，同時也是傳統的愛好者。試圖讓自己的作品時常結合傳統元素，希望我的設計能帶給你一些啟發。

I'm a freelance graphic designer based in Saigon, Vietnam. I specialize in Branding, Editorial design, Typography and UI/UX design. I'm a crazy fan of minimalism and perfectionist, in love with clean, modern, simple and creative design. Be a real tradition lover as well, I try my artworks with traditional elements very often. Hope my works inspire you somehow.

Q. 請問您認為該國最棒的是什麼？(如國家的特色或文化等) 您的創作是否受其影響？

A. 我喜歡我們國家的風景、人和文化，也喜歡旅行，發現國家最細微的地方，我的國家形狀很長，分成三個區域，邊界的文化和視野都有許多好玩的差異，我是熱愛傳統的人，因此旅行經驗常常影響我的作品，有時候不只是設計的元素，在旅行時間的啟發也讓我更加努力去創作接下來的設計。

Q. 請問您如何獲得靈感？

A. 靈感無處不在。我會觀察、尋找習慣裡有沒有新的事物，在日常裡試著做一些蠢事，聽輕柔的音樂，或是和陌生人聊天。

Q. 請和我們分享您喜歡的書籍、音樂、電影或場所。

A. 書籍：字的設計有道理、Grid System Raster Systeme、the grid、Communication Arts Magazine、雜誌 PRINT、Logotype…。

音樂：愛黛兒。

電影：商標世界、荒野生存、白日夢冒險王、魔髮奇緣。

場所：北越、越南小島 …。

Q. 除了當設計師 / 插畫家，你是否已經開始規劃下一階段的目標？例如策展、學習煮菜、登山 ……

A. 如果我不再是設計師的話，我會是個旅行家，旅行讓我的生活變得美好，但我還是喜歡當一個設計師，旅遊是我最主要的休閒以及靈感來原。策展也很有趣，可以讓我提出想法，管理其他設計，在設計可以得到更多的成就。

Q. What do you like best in your country? (such as country feature or culture) Has it made a difference on your creation?

A. I love my country with landscape, people and culture, I love traveling to discover the smallest piece of the country. My country shaped long, divided into 3 regions with many interesting differences among the border about the culture and views. I'm a tradition lover as mentioned above, that's why my works are usually inspired from the trips I have, sometimes it's not about the element in design taken from the journey around the country, it's about an indirect inspiration make me work harder to create the next good designs.

Q. How do you draw inspiration?

A. Inspiration is everywhere. I collect them by observing, looking for new things on the old ways, try doing something that is stupid in normal day, listening to soft music or just hang out to meet strangers and chat with them.

Q. Share good books, music, movies or places with us.

A. Books: Thinking with type, Grid System Raster Systeme, the grid, Communication Arts Magazine, PRINT magazine, Logotype,...

Music: Adele.

Movies: Logorama, In to the wild, Walter Mitty, Tangled, ...

Places: North of Vietnam, Vietnam's island,...

Q. Have you started to set up new goals for next period except being a designer or illustrator? like curating, learning cooking, climbing......

A. In case I am no longer a designer, I will be a very hardcore traveler. That makes my life beautiful, but actually, I still love to be a designer and travelling is my main relaxion as well as inspiration. Curating is interesting too, that way I can propose ideas, manage the design from other, so that I could achieve much more for design.

Death Money 2015 P.33

「燒紙錢」是越南的傳統，在文化和精神上代表著特殊的意義。紙錢的材質、形狀還有顏色也是很特別的平面作品，雖然越南人生活中使用的紙錢是源自中國，我還是把它「越南化」，給予它新的平面設計，嘗試新的色彩，遵守「重新設計」的目標，我仍然保留紙錢原本的外觀，我不想改變它的精神。

"Burning Death Money" is an ancient tradition of Vietnamese that contains special meanings of culture and spiritual life. Death Money is also special graphic works with materials, shapes and colors. However, Death Money that Vietnamese daily use comes from China. I "vietnameselized" it, give it a new graphic system, some new color experiments. Following the aim of "Redesign", I still keep the original appearance of Death Money, which is the soul I do not want to change.

Nutie Packaging 2015 P.51

我最近為某品牌銷售各類堅果，包括 Logo 和包裝工作。我為包裝盒設計了很多選擇，滿足自己的創作慾。我不僅設計包裝也設計了標籤和說明書。所有的作品和攝影都自己親手來做。

My latest work for a brand selling kinds of nuts, including logo and packaging. I created many options of boxes to please myself of crafting. I didn't only make packages but also created print tags and manuals. All my works were set up and photographed by myself.

Random Layouts 2015 P.252

這些是我隨機替雜誌做的排版，我喜歡用漂亮的圖像和字體排版，我在生活中和平面設計也很在意這個，我真的很喜歡編輯設計，可以透過許多有趣的實驗體會自己的感覺，排版是我設計的力量。

Here are some of my random magazine layouts. I love making layout with stunning images and typography, they're usually about what I care in my life and graphic design. I really love editorial design which I can experience my feelings with many interesting experiments of layout - my strength in design.

台灣 Taiwan

筆名 Puckish Boy，非專科生因興趣開始了創作
之路，圖像理念時而探索人生觀時而為了惡趣而
畫，風格偏美式．曾因慈善活動與香港 26 個服
飾品牌聯名，也幫 BRS Nike office 提案設計，
個人作品也被收錄在 2016 亞洲插畫年鑑。

pseudonym: Puckish Boy

Creation is begin with interest not specialism.

Explore the philosophy and play the mischief with something is my picture in mind.

—Due to charitable activities, "P.BOY" had been co-brand with 26 clothing brand of HongKong.

—Design proposal for BRS Nike Office.

—include in 2016 Asia illustration collections.

倪旗璜　Ni Ci-Huang

www.puckishboy.tumblr.com

Q. 請問您如何獲得靈感？

A. 電影或是生活周遭的小細節。

Q. 請和我們分享您喜歡的書籍、音樂、電影或場所。

A. 音樂喜歡聽輕快節奏的混音，如 Seve、The Woods (Ghosts Remix)... 邊聽邊畫特別帶感。

Q. 除了當設計師 / 插畫家，你是否已經開始規劃下一階段的目標？例如策展、學習煮菜、登山

A. 身為插畫家目標當然還是希望能夠辦展，讓更多人看到我的作品，但目前作品太少，還有一段路需要努力。

Q. 你對生活的細節上有什麼堅持嗎？(像是上廁所時一定要看詩集之類的)

A. 我想應該是假日都一定要運動，這很重要，打籃球是我抒發壓力的管道之一。

Q. How do you draw inspiration?

A. Movie or details of life.

Q. Share good books, music, movies or places with us.

A. Reggae Is my favorite music type. Love to listening reggae when I painting...

Q. Have you started to set up new goals for next period except being a designer or illustrator ? like curating, learning cooking , climbing......

A. As a illustrator, I wish I can hold my personal exhibition in one day. Let more people to see my works. I know I need to work hard to make it come true.

Q. What is your insist on your life's details ? like toilet with your favorite poem?

A. Exercise is the most important thing. Play basketball can relieve stress of my life.

致命頭顱 Fatal Skull　2015　*P.271*
以各種元素所結合的印第安頭像創作。
Indian avatar is created with various of elements.

極無常 T.C.H.W　2015　*P.271*
以中國文化中的神祇 " 黑白無常 " 與太極標誌做結合。
Combine Chinese culture(traditional) "Heibai Wuchang" with "Tai Chi".

癮 Addiction　2015　*P.271*
癮是一個黑洞，一旦進入此空間將會迷失自我。
Addiction like a black hole.
Once you fall into the space, you will lose yourself.

臉 Face　2015　*P.272*
以個人的代表圖像為主軸，以撕紙創作傳達出每個時期不同面像，紅色為熱情、黃色為迷網、藍色為憂鬱。
Addiction like a black hole.
Use personal representative to be a center. Tearaway convey different aspects of each period.
Red is passionate. Yellow is confused. Blue is depressed.

新加坡 Singapore

2013 年由 Reinold Lim（檳城）和 Sarah Tan（新加坡）創立 Oddds。主要專注於品牌設計、美術指導、平面設計、圖標設計等。他們的信仰圍繞新人類學以及他們的作品概念反映出行為及未來主義。

Oddds was established in 2013 by Reinold Lim (Penang) and Sarah Tan (Singapore). Oddds' main focuses are Branding, Art Direction, Graphic Design, Icon Design etc. Their beliefs revolve around the notion of The New Anthropology and their works reflects significantly on behaviours and futurism.

ODDDS

www.oddds.com

Q. 請問您認為該國最棒的是什麼？（如國家的特色或文化等）您的創作是否受其影響？

A. 便利、基礎設施、有效性服務、交通運輸、輔助功能等。

Q. 請問您如何獲得靈感？

A. 往往會被周圍的環境、網路資源和平台得到啟發。

Q. 請和我們分享您喜歡的書籍、音樂、電影或場所。

A. Reinold: Takk Cafe（英國曼徹斯特）、顛倒思考題（保羅. 亞頓）。

Sarah: 芳鄰樂團和 Jaymes Young（音樂）、波多貝羅市集（英國倫敦）。

Q. 現在, 回頭來看這些帶著遺珠之憾的作品, 您有什麼新的感觸？

A. 仍然對我們所做的感到激動、激發和感謝。藉由時間的記錄, 這是我們的成長經驗。

Q. 除了當設計師 / 插畫家, 你是否已經開始規劃下一階段的目標？例如策展、學習煮菜、登山......

A. 最近從 youtube 和 Food Channels 上學習做飯和煮咖啡的藝術。或許未來會擁有一間咖啡館。

Q. 你對生活的細節上有什麼堅持嗎？（像是上廁所時一定要看詩集之類的）

A. 一杯好咖啡激勵和照亮我的每一天。

Q. **What do you like best in your country? (such as country feature or culture) Has it made a difference on your creation?**

A. Convenience, Infrastructure & Effectiveness in terms of Service, Transportation, Accessibility ,etc.

Q. **How do you draw inspiration?**

A. We tend to be inspired by the environments that surround us, via online resources and platforms.

Q. **Share good books, music, movies or places with us.**

A. Reinold: Takk Cafe (UK, Manchester), Whatever You Think Think the Opposite (Paul Arden)

Sarah: The Neighbourhood & Jaymes Young (music), Portobello Market (UK, London)

Q. **Now, look back to these works of regret for not been selected, how do you feel that?**

A. We are still excited, stoked and grateful with what we have done. It is a record of our growth and experience through times.

Q. **Have you started to set up new goals for next period except being a designer or illustrator ? like curating, learning cooking , climbing......**

A. We are currently learning to cook and the art of coffee brewing from Youtube and Food Channels. We are thinking maybe, perhaps to set up a cafe in the near future.

Q. **What is your insist on your life's details ? like toilet with your favorite poem?**

A. A cup of good coffee every day motivates and brightens our days.

Mild Whistle 2014 P.184

Mild Whistle 的新識別是由超越形式的組合環繞放克壓條所造成的。像一陣溫柔的風, 兩個對立或複雜性為設計師帶來靈感。設計師想要它誇大, 使用魅力又現代的加寬凸版。用青銅和綠松石的柔和色調, 金屬色調和棉花表現了藝術指導和設計師的思想。

Mild Whistle's new identity stems from a paradox effect surrounded by a combination of funk layering beyond formality. Like a gentle thunder - where two opposites or complexities bring about the designer's works as it; being louder than what the designer intends. The identity broadens with usage of letterpress accompanied by glamour with modernism. This is created with the intertwining between bronze and a soft tone of turquoise. The play of metal tones and pieces with cotton represents the designer's ideologies of art direction and design.

Floralpunk 2014 P.184

Floralpunk 是成立於德國的珠寶服飾品牌, 最近透過部落客 Julia Doan 在越南胡志明市駐點, 由她仔細管理產品。重塑後的品牌識別結合休閒與時尚, 經典而現代。Floralpunk 以花的器官為靈感來源, 為了設計品牌系統, 類型的選擇扮演著關鍵的角色, 名片以霧面燙印, 給予人沉靜完美的懷舊感, 在識別上是很顯著的風格。其他相關設計的顏色使用黑色與粉色調, 用層次的疊加做出柔和的花朵顏色。

Simply timeless. Floralpunk is a jewellery & apparel brand, originally founded in Germany. Currently based in Saigon, Vietnam by blogger, Julia Doan, who carefully curates the products. A rebranding identity envelopes a blend of casual effortless chic. Classically contemporary, Floralpunk was inspired by floral organs. In order to devise a brand system, the selection of type played a key role in Floralpunk. Matt foil-stamping of the Namecards gives quiet confidence flawlessly worn - a remarkable touch in the identity. A set of collaterals plays with a tone of black & pink, layers upon layers that softens punk in floral colours.

OTNA - Oddds The New Anthropology 2014 P.185

靈感來自創始人的魅力和行為, 認知的好奇心與研究人類設計、價值哲學的角度思考。形象識別圍繞在 Oddds 的信念。Deep Sea Complexity, 所有事情表面下都被想像和創造。Bravery in Hunting, 不知不覺透過藝術方向和實驗來實現。Glamour of Illusion, 神秘的洞察力。Science of Atmosphere 想像力帶來無限的視覺語言。

From inspiration from the founders' fascination of human behaviours & cognitive curiosities with perspectives of the study of humankind, design, philosophical values & new thinking. The visual identity ties in around Oddds' beliefs. Deep Sea Complexity; where all things imaginable can be created beneath surfaces. Bravery in Hunting; where what lies unknowingly can be brought about with intentions and experiments through art & design direction. Glamour of Illusion; where mystique is brought together by clairvoyance. Science of Atmosphere; where imagination of methods brings about unlimited visible language.

B&B 2015 P.185

Bread&Biscuit 一實驗性品牌, 透過 Oddds 將其概念化。複雜性因使用解構的插圖和自由格式的排版發揮。執行並導致混合的產品走進異國（比喻）, 不確定周圍環境才得以讓觀看者自由地解釋, 因此, 轉變成將四種語言用在品牌上, 探索語言的想像力。現實與想像的融合, 其中意會變成部分實際與部分有形。與此相反, 插圖的複雜性創造了好奇心的空間。

Bread&Biscuit, an experimental brand conceptualised by Oddds. The intricacy of Bread&Biscuit emerges with the usage of de-constructed illustrations and play of free-form typography. Executed and resulting in hybrid creatures walking into foreign lands (metaphorically), unsure of their surroundings only to be freely interpreted kind or wicked and translated by its viewer. Thus, transforming into linguistic imagination with the exploration of four different languages seen in the branding. A fusion of reality versus imagination where the knowing becomes part actual and part tangible. On the contrary, the complexity of these illustrations creates much room for inquisitiveness.

台灣 Taiwan

1993 生於新竹，2015 南臺科技大學視覺傳達設計系畢。一場陳進東老師的演講，從此愛上包裝設計，隔年與好友組成團隊，以兩件作品入圍新一代，大三開始摸索品牌與設計管理，畢業那年拿下金點新秀包裝設計年度最佳設計獎。

Born in Hsinchu, 1993, graduated from Southern Taiwan University of Science & Technology. At fresh man year, I participated Magic Creative Creation Supervisor, Chen Jin Dong's lecture, that made me obsessed with packing design. A year later, I recruited a team with friends to research deeply about packing design. At the meantime, we created two works which nominated YODEX, unfortunately we did not won. However, at junior we worked harder on brand and design management. With two more year efforts, we used My Master's off gathering Herbs won the Young Pin Design's packing design award finally.

ONE POINT ONE 設計團隊

www.behance.net/4a0j2049490a

Q. 請問您認為該國最棒的是什麼？(如國家的特色或文化等) 您的創作是否受其影響？

A. 文化的底蘊。中國夢之聲歌唱節目中，有一位來自西藏門巴族的女孩，她是央吉瑪，在總決賽前他說過一段話：「人生太短，來不及模仿別人，所以永遠不要放棄做自己。」而後他唱了一首自創曲《醒來吧》，將流行音樂結合世界音樂、少數民族音樂，運用了蒙古族的呼麥、朝耳唱法，歌曲的特色以及詮釋都跳脫了我對音樂既有的印象，或許這些西藏文化就是他最與眾不同、最珍貴的底蘊。我一直深深的記得這句話，就好像時時刻刻提醒著我，不要忘本，不要忘記自己原來擁有的東西。

Q. 請問您如何獲得靈感？

A. 對我來說靈感就藏在生活之中，我喜歡隨時隨地注意各種細節，然後不知不覺的記下來，將他放在大腦的某個角落，等到談論、思考、創作中有相關或看似不相關的東西一出現時，他就會帶我打開那扇門，阿！的一聲。有了！我想到了。

Q. 請和我們分享您喜歡的書籍、音樂、電影或場所。

A. 提姆. 布朗《設計思考改造世界》、喬. 麥柯馬克《簡潔的威力》、卡曼. 蓋洛《跟 TED 學表達，讓世界記住你》仔細看會發現，這裡面沒有一本設計的書，但卻跟設計有著莫大的關係，裡面的關鍵詞是思考、簡潔、表達，這三樣在設計裡環環相扣，我希望分享給他人的不僅僅只有好的設計作品，更希望把一些能夠影響設計、甚至設計之外的觀點帶給大家。

Q. 你對生活的細節上有什麼堅持嗎？(像是上廁所時一定要看詩集之類的)

A. 一個人在一段日裡，一定要有一些孤獨的時間，遠離所有喧囂，在那段時間裡享受片刻的安靜，好好地剖析自我、反思、規畫新的目標，讓自己進步，懂得享受孤獨，也是一種樂趣。

Q. What do you like best in your country? (such as country feature or culture)Has it made a difference on your creation?

A. Heritage of culture. A girl who name Yang Ji Ma, also a Tibetan. Once she said in the China TV show <Chinese Idol> final, "Life's so short, we don't have time to imitate others, so just not give up to be yourself." After she spoke, she sang her original song that named <Wake up> that mixed up pop music, world music and folk music, used Mongolian's singing techniques. It changed my music knowledge during the features and expression she performed with. Perhaps this is the reason that Tibet culture is different from others. I deeply memorized her word as well as reminded myself. Do not forfeit. Do not left behind the things we already hold.

Q. How do you draw inspiration?

A. For me, inspiration hide everywhere in our life. I like to notice every detail with it and keep in my head. Until discussing, thinking, or created some relevant or irrelevant subjects shown up, inspiration would help me to open a door. And I would be like saying, "Yes, GOT IT."

Q. Share good books, music, movies or places with us.

A. Change by Design: How Design Thinking Transforms Organizations and Inspires Innovation / Tim Brown / Brief: Make a Bigger Impact by Saying Less / Joseph McCormack / Talk Like TED:The 9 Public-Speaking Secrets of the World's Top Minds / Carmine Gallo

Above those three books, when you focus on. You would know they aren't talk about design, but built a great relation with design. Think, simplified, and express are key words and gears in design. I hope I can share with not only great works but also something effect design or non-relate design points to people.

Q. What is your insist on your life's details ? like toilet with your favorite poem?

A. When People live in their life, must have some lonely moment. Leave away from every noise nearby, enjoy the silent that reflect ourselves and planning a new goal to improve ourselves. To realize lonely, also is a joy.

源本質 Essence 2015 P.20

源，自於本質。「本質」隱喻了我們學習設計的初衷，由最原始的起點出發。即使再多的世俗紛擾驚嚇動了我們來時的腳步。終，望能「莫忘初衷」、認識自己、接受自己、面對當下、回到源頭找回曾經的熱與誠。

Essence is derived from the beginning desire of design. It means no matter how difficulties and challenges shaken our rest of life, we cannot forfeit the dream we dream, and keep the enthusiastic go on and on.

璞 JADE FACE 2015 P.21

璞，玉也，指未經雕琢，包藏著玉的石頭。設計的路程如同一顆璞玉，從普通的石頭，經歷千萬年的河川沖刷，這些琢與磨，終形成璞玉。璞玉是內顯的，由表層包覆內在，蘊藏一股巨大潛力，唯有挖掘才能看到事物的本質。

Pu means a diamond in the rough. Just like the way of design. Starts from the stone, been thousand times of beats and turn into beautiful jade in the end. None of jewelry are splendid at first. It have great uncharted potential and we must break its to discover the luster.

留一份情 Leave a Memory 2014 P.46

紅包為傳統華人文化中承載著情感的媒介，有感於現代生活節奏已不同於以往，使用完後好像沒了存在意義。本專案運用隨身攜帶的錢包與之結合，每當拿起錢包購物時，人與人之間的交流浮現於腦海，達到回憶留存的共鳴。

Traditional red envelope bag one-time use, lead to interpersonal emotional desalt, this project use wallet as a combination, a blend of the tainan traditional grilles, retain memories, every time I picked up a wallet shopping, remember in your mind, thus achieve deeper feelings.

鄭鮮虱 - 虱彼鬆魚鬆系列 ZHENG SIM SAY - SHI BI SHOU 2014 P.46

此款虱目魚鬆包裝最大特色，內盒拉開時，內包與外包裝鏤空的魚鱗呼應，形成魚鱗閃動的效果。內包魚鬆以各色鱗片區分口味。在開盒時，才顯露的魚頭和魚尾，在發現之際那種即時與人分享的感受。

The outer packing special structure in open box will show the fish head and tail, the feeling of being found that in time to share with people. Inside the box when smoked pull, the inner packaging graphic design with the outer packing is hollow-out the scales, form scales flashing effect.

鄭鮮虱 - 老虱說生鮮系列 ZHENG SIM SAY - Simon Say 2014 P.46

生鮮包裝以教育為核心，將虱目魚擬人化成老師，結合縷空對話框，清楚告知「虱目魚」的營養價值，分別對應一般家庭：小孩、壯年、老年人進行營養價值的連結，針對為健康著想之家庭主婦進行溝通，與消費者達到互動。

In order to achieve clear told "milkfish" the purpose of the nutritional value, Fresh packing with education as the core, Corresponding average household : Links to child, prime of life, the old man's health. In view of the for the health of the housewife to communicate. Will milkfish personified as a teacher, Add element of a school in ancient China, bamboo slip ,Chinese Ink combining modern hollow out dialog box , Interaction with consumers.

言師採藥 CAI YAO P.172

為台南市古井藥房打造全新品牌，以「言師採藥」為品牌命名，希冀藉由古井藥房之師，為年輕大眾採取良方。目標族群定位為上班族，因熬夜加班所帶來許多文明病，取出六大病因，並將包裝以趣味及詩之意境呈現。

To create a new brands for Tainan Gujing pharmacy that named "My master's off gathering herbs", which hope the pharmacist allocating good prescription for young generation. We set business men are our main customer, because most of them usually work overtime may diagnosed modern plague. Therefore we focus on six common plagues and combine with interesting poetry artistic conception for packaging.

南韓 Republic of Korea

朴金準　Park Kum-Jun

www.601bisang.com

畢業於弘益大學平面設計系，並在 Cheil Worldwide 擔任藝術總監直到自身在 1998 年創立 601bisang。「601 Artbook Project」自 2003 年開始經歷了八年，先後得獎，2012 年紅點設計、第 11 屆金蜂獎、2014 墨西哥國際平面設計雙年展大獎賽、紐約 ADC 獎金獎、ONE SHOW 國際創意節金色鉛筆、2009 I.D. 年度設計回顧最佳分類、中國國際海報雙年展最大獎。參加過許多國際展覽，作品在世界各地博物館展出。

He studied graphic design at Hong-ik University and worked as an art director at Cheil Worldwide before he founded 601bisang in 1998. From 2003 he managed "601 Artbook Project" for 8 years. He has won red dot: Agency of the Year 2012, Red Dot Award (Grand prix), Golden Bee 11, Moscow International Biennale of Graphic Design 2014 (Grand Prix), the New York ADC (Gold Medal), The One Show (Gold Pencil), I.D. Annual Design Review 2009 (Best of Category) and China International Poster Biennale (Grand Award). He participates in various international exhibitions and his works are housed in museums all around the world.

Q. 請問您認為該國最棒的是什麼？(如國家的特色或文化等) 您的創作是否受其影響？

A. 韓國擁有自己的語言稱為 Hangeul。韓文是散播科學、理性的頭腦和造福人民的決心。過去幾年中，我試圖以韓文和圖案特徵創作，凸顯韓文為設計元素的無限可能性，作為一名韓國設計師，我會繼續將韓文納入我的設計作品，並驕傲地展示它的美學價值。

Q. 請問您如何獲得靈感？

A. 我都在身邊尋找靈感。可以來自歷史、別人留下的痕跡、自然、每天的生活。我發現在傳統與現代、數位和模擬、物質和精神之間的關係、衝突和和諧。有時來自狂野的想像力和實驗。我總是潦草地記下工作時或在床上的想法，這些備忘錄會成為有用的指導。浴室也是靈感出現的重要場所。

Q. 現在，回頭來看這些帶著遺珠之憾的作品，您有什麼新的感觸？

A. 開始新的項目是令人振奮的，雖然結果總不如預期。其中的不足總在結束後顯得更漫長，也是因為這些不足使我了解自己並沒有看到整體，而且太容易跟自己妥協。甚至有時後悔成為一名設計師。只有一個解決辦法：重頭開始。

Q. 你對生活的細節上有什麼堅持嗎？(像是上廁所時一定要看詩集之類的)

A. 我很珍惜溫暖的陽光和微風，溫柔地撫摸我的臉頰，我的花園裡有張小椅子，我的挑高工作室裡有不同的工具和舊書還有印第安墨水的香氣，還有我實驗出來的屬於我的顏色。我喜歡撫摸我的狗，當牠在我腳邊伸懶腰時。一週一次跟我妻子一起看電影，和親人小酌，並感恩這一切。

Q.What do you like best in your country? (such as country feature or culture)Has it made a difference on your creation?

A. Korea has its own alphabet called Hangeul. Hangeul was borne of a scientific, rational mind and the determination to benefit the people. Over the past several years, I have attempted to create pieces that draw on the figurative and pictorial characteristics of Hangeul. These pieces highlight the infinite possibilities of Hangeul typography as design elements. As a Korean designer, I will continue to incorporate Hangeul into my design projects and proudly showcase its aesthetic value.

Q.How do you draw inspiration?

A. I find inspiration all around me. It can come from history, the traces left behind by others, nature, and everyday objects. I discover harmony in the relationships and conflicts between tradition and modernity, digital and analog, and the material and the spiritual. Sometimes, my inspiration springs from wild imagination and experiments. I always scribble down ideas that come to me while at work or in bed, and these memos add up to a useful guide. A bathroom is also an important place for inspiration.

Q.Now, look back to these works of regret for not been selected, how do you feel that?

A. It is exhilarating to begin a new project, but it does not always end up as I expected. Some flaws become apparent long after the project has come to an end. It is these flaws that make me realize that I failed to take a holistic perspective and that I compromised with myself too easily. Sometimes, I even regret that I became a designer. There is only one solution: to start again from the beginning.

Q.What is your insist on your life's details ? like toilet with your favorite poem?

A. I cherish warm sunlight and gentle breezes that tenderly touch my cheeks, my garden with its tiny chairs, the fragrance of Indian ink in my high-ceilinged workroom equipped with diverse tools and the scent of old books in my library, and my experiments to create my own colors. I love stroking my dog who always stretches out at my feet, going to the movies with my wife once a week, having a drink with my loved ones, and being thankful for everything.

EOUREUM - The Uniting of Two 2006 *P.23*
Eoureum，兩個人的生活故事的共同點，這個世界賦予的溫暖目光。以「Eongcha、Eoadyeocha、Heicha」包裝了這本書的主題。透過題目 "the uniting of two" 試圖找到這個世代被遺忘的整體。
Eoureum — the uniting of two is the story of people's lives, and the warm gaze bestowed upon this world. This book opens with 'Eongcha', 'Eoadyeocha', 'Heicha' the Korean sound of cooperation that encapsulates the theme of this book, and tries to find the meaning of a united whole — something we have forgotten in this age —through the topic "the uniting of two".

ARTBOOK PROJECT 2008 Catalogue 2008 *P.24*
用 29 個 A 和 B 來代表 29 個得獎作品。分別代表「藝術」、「書」。這些字母編排在書前後中的森林兩邊。
The book begins with 29 "A"s and "B"s heading each of 29 award winning works. Standing for "Art" and "Book" respectively, these letters are arranged in both the beginning and the end of the book alongside the image of a forest.

Hangeul. Dream. Path 2011 *P.25*
一個破舊、過時的打字機、牆上的鐘的指針，默默的環繞在我的童年，這給生活帶來了世界的節奏，水稻表現生命週在這之中最純粹的時候…。我收集這些在時間中的痕跡，以韓文有質感地讓這故事被顯見。
A worn out, dated typewriter, the hands of a wall clock that crept around slowly to form the circumference of my childhood, musical instruments that brought rhythms of the world to life, and rice stalks that show the cycle of life in its purest for...I gathered these traces of time engraved in everyday objects and nature.

Who is it 2016 *P.26*
Who is it? 是生活的軌跡、書裡的日曆。也是 601Bisang 今年第一個項目。它是書和日曆的組合，可以獨立使用。日曆中的每一頁設計成可用的明信片。標題用韓文跟英文寫在正反面，標記著故事的開始。
Traces of Everyday Life, a Calendar in a Book - Who is it? is 601bisang's first project of the year. It is a combination of a book and a calendar and can function independently as either one. Each leaf of the calendar is designed to be utilized as a postcard. The title, written in Korean and English on the front and back, marks the beginning of the story.

601 ARTBOOK PROJECT 2008 *P.98*
此比賽海報圍繞的主題為「自然和人」。三部分組成的系列「想像？」、「呼吸…」、「飛！」。表現自然和人之間的和諧互動。此外，該系列海報相互超越代表的生活方式。
The "601 Artbook Project 2008" competition posters revolve around the theme "Nature and Humanity". The 3-part series consisting of "Imagine?", "Breathe...", and "Fly!" embodies the interaction between and the harmony of nature and humanity. In addition, the poster series

transcend from one another as though to represent the circle of life.

4EMOTIONS' EYE 2013 *P.98*
關於人類情感的系列海報，喜、怒、哀、樂。概念「眼睛是宇宙」講述的是在宇宙中，人類微妙又脆弱又小的感情。四種混亂的情緒是我內心的一種表現。為了擴增感覺，磷光顏料的背景下，在黑暗的環境中散發柔和的餘暉。
This is an exhibition poster series about four emotions that humans feel: Joy, Anger, Sorrow and Pleasure. Its concept, "Eyes are the universe" is expressed by the waves of the universe, which narrates that feelings are delicate beings and humans are fragile and small inside these feelings. The chaos of the four emotions is an expression of my inner self. In order to expand the feelings, phosphorescent pigments are used in the background, which emit a soft afterglow in a dark environment.

Digilog 601-Harmony through Design 2012 *P.99*
紀念 2012 年在紅點設計大獎得主，含有符號意象及賦予 digilog 概念。XX 和 XY 表達了探索宇宙的時間和空間、西方和東方的搭配、創意性對話的來往，結合符號融入其中，賦予 digilog 具體的意義。將 digilog 的概念作為一個活體動物，使用青蛙腳重疊，XY、TS、EW、FT 的開頭字母和符號完成。
Commemorating the winner of Agency of the Year 2012 in Red Dot awards the posters contain symbolic imagery that gives the digilog concept tangible from: xx & xy expresses the existence itself; time & space, the exploration of the universe; east & west, the pairing of East and West; from & to, creative conversation; and the ampersand binds each of these opposite elements into one, giving concrete meaning to digilog. This poster series, which expresses the concept of digilog as a living thing, uses overlapping Frog Script to create shapes of biological creatures. The initial letters of the motifs (XY, TS, EW, FT) from the skeletons, and symbols that fit the motifs complete the shapes of the bodies.

The 3rd? Korea International Poster Biennale! 2013 *P.99*
在 2002 韓國國際海報雙年展開始舉辦的兩年後，設計和文化部門透過人形泡泡傳達如果繼續舉辦展覽這種不幸的狀況的訊息。呼籲所有相關機構以防止韓國雙年展從有到無。即使泡泡消失，仍有油墨破裂的痕跡。此外，KIPB 特別突出，這是一種抗議雙年展繼續在未來舉辦。
Began in 2002 Korea International Poster Biennale came to a halt after its 2nd biennale in 2004. Design and cultural sectors deliver messages to continue the poster biennale by creating bubbles of a human shape, which portrays this unfortunate situation. It appeals to the related organizations and institutions to prevent the only poster biennale in Korea from coming to nothing. Even though bubbles vanish, the traces of burst remain as the bubbles are created by grinded ink. Also, the word KIPB(Korea International Poster Biennale) is made to stand out. This is a kind of protest poster to continue the biennale in the future.

印度尼西亞 Indonesia

POT Branding House

www.potbrandinghouse.com

我們是住在萬隆、深思熟慮、特立獨行並且熱情洋溢的千禧世代，與名為醜陋的怪物、機能障礙大陸、淘汰品女巫搏鬥著。我們致力於發現價值、創造經驗，帶來視覺的魔法火花，無論是無形的和有形的，透過品牌理念、品牌企業、品牌經驗與品牌傳播。我們服務的對象：廣告(各種行業)、教育、政府、媒體與傑出的團體。

We are Bandung Based thoughtful, maverick and passionate millennials with vision to fight the monsters of ugliness, the land of disfunction and the witches of rejectors. We always dedicate ourselves to discover the value, craft the experience and deliver with sparks of visual spells, be it intangible and tangible. Through Brand Idea, Brand Venture, Brand Xperience and Brand Communication. Parts that we serve: Commercials (in variety of industry), Education, Government, Medias and Prominent Communities.

Q. 請問您認為該國最棒的是什麼?(如國家的特色或文化等)您的創作是否受其影響?

A. 印尼同時被稱為 Nusantara，是個非常有活力的熱帶象徵，體現在許多事物上，影響了我們的創作習慣。擁有熱度、傳統(舞蹈、視覺圖像等)、殖民主義的痕跡，以及其他經歷，我們非常著迷於如此多元的氣息，與自然物質共處，像是沙灘、樹林和其他豐富的自然資源。然而我們居住在市區，受到西方影響，也透過網路世界產生連結。

Q. 請問您如何獲得靈感?

A. 我們和將亞洲的價值與印尼的美緊密結合，體現在我們的作品上。像是部落圖騰、傳統舞蹈、傳統料理以及其他，還有，書籍與文學在思想行動扮演很重要的部分，使我們與傳統習俗均衡，另外我們也集思廣益，頻繁地執行集會，以達成最大化的過程與結果，像是探索、工藝、運輸。

Q. 請和我們分享您喜歡的書籍、音樂、電影或場所。

A. 書：Designing Brand Identity by Alina Wheeler, Infographics by Jason Lankow, TinjauanDesainGrafis by AriefAdityawan
音樂：Yelle, Tame Impala, Bali Lounge, Fakear, Coldplay, Toe, Sigmun,
電影：The Intern, Pulp Fiction, The Fall, Star Wars, 還有許多。
地方：任何地方都是。

Q. 現在，回頭來看這些帶著遺珠之憾的作品，您有什麼新的感觸?

A. 如果作品沒有被採用，我們會當作是一個必然的過程，讓我們學習保持更高的質感，還有，我們身為設計師，必須同時和使用者、品牌溝通，如果客戶或合作夥伴能記住這點，我們會很開心。

Q. What do you like best in your country? (such as country feature or culture)Has it made a difference on your creation?

A. In Indonesia which also called Nusantara it is the very dynamic tropical nuance that embody in every matters that influence our creations habit. The heat, the sense of heritage (Dance, visual patterns, etc), colonialism residue and other experiences. We are very intrigued by the diversity of flavors that reside in every natural entities in Indonesia such as the beach, the woods and other rich natural resources. However since we lived in the urban area, western influence also takes part, and not mentioning those connection through online world.

Q. How do you draw inspiration?

A. We are work closely with Asian value and wonder of Indonesia then embody them into our works, like a tribal visual patterns, traditional dances, heritage foods and so much more. Also the books and literature take serious part for every execution consideration which keep us balanced the conventional methods. We also brainstorm and conduct kick-off meeting quite frequent to have the maximum process and result, which is Discover, Craft, Deliver.

Q. Share good books, music, movies or places with us.

A. Books we read: Designing Brand Identity by Alina Wheeler, Infographics by Jason Lankow, TinjauanDesainGrafis by AriefAdityawan Music we listen: Yelle, Tame Impala, Bali Lounge, Fakear, Coldplay, Toe, Sigmun.Movies we watch: The Intern, Pulp Fiction, The Fall, Star Wars, so much moreeee. Places we went: It could be anywhere :)

Q. Now, look back to these works of regret for not been selected, how do you feel that?

A. If there's any works that not being selected, we are take it as the progress of learning to keep more the quality bar still high. And also, we are very happy if the clients or partner could remind us that, we as the designer should talks both ways with user, the brand and the other impact itself.

Teras Concept 2014 P.85
關於 Teras：Teras 是位於印尼婆羅洲島三馬林達的室內設計與建築顧問，將概念性的想法構築為實體。Teras 來自「terrace(陽台)」這個單字，它是室外與室內的連結。說到連結，這個案例主要是創造總體規劃、室內概念、景觀和建築到展覽設計。
案例重點：我們的任務是固定 Teras 的根本，透過建立它們的品牌故事、品牌標識、平面文宣和市場傳播，砥礪品牌的價值與特色。
About Teras : Teras is an interior & construction consultant based in Samarinda, Borneo Island Indonesia which brings conceptual thought process into Physical Existence. Teras derived from terrace word which is a connection between Exterior & Interior. So to speak of connections, the projects are mainly create master plan, interior concept, landscape & architecture to exhibition design.
Project Focus : Our task is to solidify roots of Teras, and sharpen the brand value and characteristic through Craft their Brand Story, Brand Identity, Graphic Collaterals and Marketing Communication.

Oaksva 珠寶 OaksvaJewellery 2015 P.143
萬龍的精緻珠寶行，使用保存的種子是它們的主要特色。精心手工製作出來的物件，保證讓你有彷彿將藝術品穿在身上的感覺。
案例重點：重新評估如何加強 Oaksva 的價值傳達(視覺上與口語上)，創造更多可以應用到許多接觸點的視覺語言。
焦點項目：reasses 如何 oaksva 加強其價值為通訊(視覺上和口頭上)創造可應用於許多接觸點更通用的視覺語言。
About Oaksva :An exquisite jewellery line from Bandung that uses preserved seeds as their main feature. Handcrafted meticulously, you are guaranteed a statement making piece that feels like you are wearing art on your body.
Project Focus :Reassess how Oaksva reinforce their value into communication (visualy and verbally) create more versatile visual language that can be applied to many touchpoints.

Kamara Spa Indulgence 2015 P.199
關於 Kamara： Kamara Spa 是位在 timikapapua 森林中，讓心靈、身體與靈魂放縱的療癒聖地，Kamara Spa 是首先在巴布亞建立綜合水療服務的溫泉按摩中心。
案例重點：我們負責全部的品牌計畫，從品牌名稱、識別，到室內設計的建構與開發，為了確保品牌傳遞的接觸點，並且可以增進整體的溫泉服務。
About Kamara :Kamara Spa, is an intimate rejuvenating sanctuary in the middle of timikapapua vest forest to indulge mind, body and soul. Kamara spa Indulgence is the pioneer to be established in papua as they have an integrated spa treatment
Project Focus :We Responsible fully in their branding project from Branding Name, Identity, to construction of interior design and development. It is all to ensure all touchpoint of branding delivered and can enhance the full indulgence of the spa service itself.

印度尼西亞 Indonesia

Putri Febriana

www.behance.net/PutriFebriana

我是 Putri Febriana，印尼雅加達的平面設計師、插畫家。畢業後成為全職平面設計師，在許多雅加達的平面設計機構工作，像是 FullFillArtplication、DesignLab 和 Kineto Strategic Visual Communication。在 2014 年八月的時候，決定成為個體經營者，我的專業是排版設計、簡單的平面插畫、地圖插畫和資訊圖表設計。

My name is PutriFebriana. I am a Graphic Designer & Illustrator based in Jakarta, Indonesia. After I graduated, I worked as a full time Graphic Designer for several Graphic Design Agency in Jakarta, which are FullFillArtplication, DesignLab and Kineto Strategic Visual Communication. On August 2014, I decided to be self-employed. I'm focusing on layout design, simple flat Illustration, maps illustration and infographic.

Q. 請問您認為該國最棒的是什麼？(如國家的特色或文化等) 您的創作是否受其影響？

A. 我最喜歡印尼的地方是，它是個環海國家，當地的食物有豐富的辛香料，還有許多手工製品，印尼還有不同的部落和文化，帶給這個國家不同的顏色。

Q. 請問您如何獲得靈感？

A. 在國內旅遊活到國外旅遊、和自己同業的夥伴來場創意的對談，還有日常生活都給我許多靈感。

Q. 請和我們分享您喜歡的書籍、音樂、電影或場所。

A. 書：茉莉人生。
音樂：Phoenix、Feist、Daft Punk、白鞋情侶會社。
電影：伍迪艾倫、魏斯安德森、絕地救援、戀夏五百日。
場所：峇里島、巴賽隆納、巴黎。

Q. 除了當設計師 / 插畫家，你是否已經開始規劃下一階段的目標？例如策展、學習煮菜、登山

A. 是的，我想成為有創意的創業家，販賣自己插圖的日常用品，像是時尚配件或是藝術印刷品。

Q.*What do you like best in your country? (such as country feature or culture)Has it made a difference on your creation?*

A. What I like the best from my country is that Indonesia is a coastal state, the local foods which rich in spicy seasoning, and many local handmade products. Indonesia also has different tribes and cultures, which also gives colors to this country.

Q.*How do you draw inspiration?*

A. I get my inspirations from travelling both from within this country or abroad outside, building up a creative talk with my associates that works in the same industry, and also from my daily life.

Q.*Share good books, music, movies or places with us.*

A. Books : Persepolis by MarjaneSatrapi.
Music : Phoenix, Feist, Daft Punk, Disclosure, White shoes & the couples company.
Movies : Woody Allen's movies, Wes Anderson's movies, The Martian, 500 days of summer.
Places : Bali, Barcelona, Paris.

Q.*Have you started to set up new goals for next period except being a designer or illustrator ? like curating, learning cooking , climbing......*

A. Yes, I want to be a creative preneur who sold daily use products with my own signature illustration. Such as in fashion accessories, art print, etc.

Crossing the Street on a Rainy Day 2015 *P.266*
人們在下雨天跨越大型路口的時候遇見彼此，受到這樣的場景啟發的作品。從上往下看，他們看起來就像是美麗的圖形，許多顏色碰撞在一起，產生了這個瞬間。
I made this artwork inspired by the people who meets together at the same time when crossing a big intersection in a rainy day. They all look like a beautiful pattern when seen from far above, many colors colliding into one big moment.

Summertime 2015 *P.266*
描繪海邊快樂的夏日情境，人們穿著漂亮鮮豔的比基尼享受著熱情的夏天，在這張圖裡，我試著捕捉人們在假期享受休閒時刻的歡愉，讓海浪觸碰你的指尖，讓沙灘成為你的坐席。
Describing an ambience of a happy summer season in the beach. People are wearing beautiful and colorful bikinis while enjoying summer heat. In this image, I tried to capture the essence of people happiness who spend their leisure time during holidays. Let the waves hit your feet and the sand be your seat.

Patisserie 2015 *P.266*
杜拉麗是製作法式麵包和甜點的品牌，我深深著迷於他們櫥窗展示櫃的糕點，我去過杜拉麗的總店和香榭麗舍大道的分店，在那裡品嚐它們著名的糕點，馬卡龍和玫瑰聖歐諾斯。
I was mesmerized by the window display of Ladurée Patisserie, a french bakery and sweet maker, on my second trip to Paris. I went twice to their stores at Avenue des Champs-Élysées and Rue Royale, and tried their famous pastries, macarons and Saint-Honoré a la rose.

Japan Icons Illustration Past 2014 *P.267*
同一個國家在不同時間點產生的文化。在這個插圖系列裡，我想呈現過去與現在的日本文化，雖然我並非出生在那裡，當地的文化仍舊影響了我的國家還有我的日常生活，舉例來說，我喜歡童年的電影跟食物，我發現看著這兩種不同時空的差異，還有人們如何發展自己的文化都很吸引人，我認為文化與生活的脈絡相同，無法被分開。
A culture of 1 country in 2 different time. In this illustration series, I tried to bring the Japanese culture from the past and present. Although I'm not experiencing directly from where it is originated, these cultures also effecting in my daily life in my country, for example like my childhood movies and food. I found it attractive to see the differences between these 2 times, how people always develop their cultures. I think cultural and life is a one pulse that can't be separated.

Japan Icons Illustration Present 2014 *P.267*
同一個國家在不同時間點產生的文化。在這個插圖系列裡，我想呈現過去與現在的日本文化，雖然我並非出生在那裡，當地的文化仍舊影響了我的國家還有我的日常生活，舉例來說，我喜歡童年的電影跟食物，我發現看著這兩種不同時空的差異，還有人們如何發展自己的文化都很吸引人，我認為文化與生活的脈絡相同，無法被分開。
A culture of 1 country in 2 different time. In this illustration series, I tried to bring the Japanese culture from the past and present. Although I'm not experiencing directly from where it is originated, these cultures also effecting in my daily life in my country, for example like my childhood movies and food. I found it attractive to see the differences between these 2 times, how people always develop their cultures. I think cultural and life is a one pulse that can't be separated.

新加坡 Singapore

Quirk

www.quirk.sg

Quirk 是一個整合營銷傳播公司。我們相信好的設計是可以轉化為有利的經營成果，進而得到可觀的投資報酬率。

我們自 2009 年成立公司以來已參與超過 700 個項目，期間包括和 200 多間中小型企業，跨國公司和政府部門合作。這些經驗都讓我們進步成長。

Quirk is an integrated marketing communications agency. We believe that good design should convert into quantifiable business results resulting in a positive ROI.

With more than 12 years of experience, we have experienced an exponential growth since the company's incorporation in 2009 having worked on more than 700 projects with more 200 companies ranging from SMEs, MNCs and Government sectors.

Q.請問您認為該國最棒的是什麼？(如國家的特色或文化等) 您的創作是否受其影響？

A. SG50 (2015 是新加坡的 50 週年)！看著大家一起慶祝我國 50 年來大大小小的成就，這讓我們更了解新加坡 — 我們的遺產，我們的歷史，我們的文化，以及我們的設計。我們也看到了不同領域的設計師之間的合作，為創造描繪新加坡的獨特優點而一起努力。這帶給我們非常大的啟發。當然，許多客戶在 2015 都希望我們設計出關於 SG50 的東西。# walao # simialsoSG50

Q.請問您如何獲得靈感？

A. 我們都從團隊裡互相攝取靈感。每個人來自不同的背景，我們可以一起討論商量，以構思更好的概念。每週都會有一個分享會，讓我們分享一周所發現的有趣事物，或者是遇到的設計瓶頸。

Q.請和我們分享您喜歡的書籍、音樂、電影或場所。

A.我們幾乎每天都會分享前一晚看的電影，去過超酷的餐廳，閱讀的好書等。如果你好奇我們喜歡什麼？驚悚的，刺激的，恐怖的，科幻的（火星救援！），甚至是超級英雄。只要你說得出來，我們都愛！

Q.你對生活的細節上有什麼堅持嗎？(像是上廁所時一定要看詩集之類的)

A.1. 對工作保有熱忱，對社會保有關愛。

2. 團隊精神 - 每個月都會舉辦有趣的活動，讓我們在工作以外一起放鬆，同時也建立更良好的默契。

3. 噢！我們還堅持在茶水間裡一定要有這無敵好吃的芥末海帶混合堅果。

Q.What do you like best in your country? (such as country feature or culture)Has it made a difference on your creation?

A. SG50 (2015 was Singapore's 50th birthday)!! Especially how the entire nation came together to celebrate both the small and big achievements in our lives and as a country. It gave us the opportunity to learn more about Singapore - our heritage, our history, our culture and our local designs. There were also many collaborations between designers (from different disciplines) to create designs that portray Singapore's unique identity which inspired us a lot. Of course, almost all our clients wanted us to design something related to SG50 that year. Oh well, #walao #simialsoSG50

Q.How do you draw inspiration?

A. We draw inspiration from our team. Having people from different backgrounds and hence perspectives, we bounce off ideas with each other. Our weekly sharing session provides the right platform for us to do so. We share about interesting ideas we came across the past week, things we did over the weekend and even roadblocks should we face any.

Q.Share good books, music, movies or places with us.

A. Almost everyday, we will share about a movie we watched last night, a cool restaurant we visited, a good book we read. If you ask us what we like? Thriller. Romance. Sci-fi (The Martian!!). Action. Horror. Indie. Ok even superheroes. You name it, we love it.

Q.What is your insist on your life's details ? like toilet with your favorite poem?

A. 1. Passion in our work and compassion for society.

2. Bonding within the team is also very important to us; we have a monthly outing as an agency where we have fun together outside of work.

3. Oh and we always insist on having this super yummy wasabi and seaweed mixed nuts in our pantry.

Singapore Institute of Architects I AM ARCHITECT Council Booklet 2015 P.31

如何成為一名建築師？建築師代表的是什麼？我們應該如何慶祝偉大的建築作品？新加坡的建築師有許多傑出的作品，但因為少了推廣的機會，這些作品未能讓大家了解欣賞。因此，新加坡建築師學會創建了《我是建築師》運動，想藉由它推出一系列的宣傳活動讓更多人接觸建築學。這非常需要會員們的支持。於是，我們設計了這本《我是建築師》。我們把代表堅固，力量和穩定的三角形作為主要的設計元素。它也代表了新加坡建築師學會想要成為一個不斷創新，堅韌的機構的堅定宣言。每個冊子都個別印上會員的名字，以增加他們對這個運動的參與感，讓他們也想自發地推廣他們的職業，為他們的專業感到驕傲。

Who is an architect? What does it mean to be an architect? How should we celebrate great architectural works? Singapore architects do amazing work but there has not been much effort to promote it to non-architects. Singapore Institute of Architect's I AM ARCHITECT campaign aims to fill this gap with a series of publicity initiatives, which will require buy-in and contribution from the members, hence the inception of the I AM ARCHITECT council booklet. Triangles, a shape that provides strength and stability, were used as a main design element for its fundamental relevance to architecture. It also represents the council's firm manifesto to be an institute with relevance. Each booklet is also personalized with the member's name to make them feel part of this movement to promote and better the profession.

The Pod 2013 P.170

啟發於日本的膠囊旅館，The POD 提供想要輕鬆方便的旅客一個既簡約又舒適，猶如「豆莢」的住宿設施。從這室內設計理念中汲取靈感，我們利用簡單的正方形（類似豆莢）和簡潔的線條來設計 The POD 一系列的品牌視覺產品，包括徽標，指示牌，營銷手冊等，還為 The POD 設計了專屬的數字字體，作為它們的房號和床號。

Inspired by the capsule hotels in Japan, The POD offers cozy and minimalistic "pods" for discerning travellers who desire fuss-free and convenient living. Drawing inspiration from this interior design concept, Quirk created an identity, from the logo and signages to other hotel collaterals, based on simple squares (to resemble the pods) and clean lines. A custom numerical typeface was also designed for the room and bed numbers.

Zaffron Kitchen 2011 P.171

Zaffron Kitchen 是一間有現代風格的印度餐廳。我們想要打破大家對於印度餐廳的傳統既定印象。印度餐廳的品牌設計不一定要複雜誇張。它也可以很有時尚與現代感。我們利用簡約的線條、和諧的顏色，大膽調皮的文字來體現新一代的印度文化。餐廳一開張就得到很好的口碑，許多客戶詢問是否能購買我們設計的服務生圍裙，也有很多人把照片上傳到個人博客。這些都幫餐廳打響了名聲，也達到非常好的宣傳效果。

Zaffron Kitchen, a brand new contemporary Indian restaurant, required a full set of corporate identity collateral and website for its restaurant opening. We had to come up with ideas and colors that were chic and reflected the modern Indian ethnicity, yet steering clear of the usual suspects portraying Indian culture. The response from the rebranding were overwhelmingly favorable - many customers enquired about the sale of the aprons, took pictures and placed on their personal blogs/ websites which in turn encouraged word-of-mouth advertising for the client as well as offering an interesting additional revenue-making sideline.

Craft Bistro 2015 P.171

儘管菜單豐富多樣化，Craft 一直被視為只是間提供飲品與甜點的咖啡廳。午餐和晚餐時的人流稀少。求根究底，我們發現問題出在 Craft 從取名到視覺與室內設計都沒有一個連貫統一的主題和概念。於是，我們決定把 Craft Bakery & Cafe 改名為 Craft Bistro，並且重新改造其品牌的徽標，室內裝潢，視覺設計等。最後得到的是一個專注於提供優質手工餐點和簡約舒適環境的小餐廳。

Branded as a bakery and café initially, Craft found it difficult to attract the lunch and dinner crowd despite its extensive menu. The main issue identified was a weak and incoherent branding, stemming from its name to its interior and collateral design. Following a name change to Craft Bistro to better reflect its offerings, we looked into redesigning the logo, brand and space. The result was a simple and honest brand, focused on providing wholesome and artisanal foods in a relaxed and cozy environment.

馬來西亞 Malaysia

張志偉　Raymond Teo

www.athome.my

張志偉

1982 年出生於馬來西亞柔佛州麻坡縣。

2003 年畢業於馬來西亞 MSC International College 多媒體設計系。

2004 年就職於雙福殘障自強發展協會。

2007 年 11 月與同伴開創品牌團隊 AT HOME CREATIVE。

2012 年創立服飾品牌 ARJD Bro. Bears。

2014 年成立個人使命品牌 RUN, RAY RUN。

Raymond Teo

1982 - Born in Muar, Johor Malaysia. 2003 - Graduated with MSC International College in Multimedia Design.

2004 - Joined Double Blessing.

(Association for The Disabled Person)

2007 - Established branding agency AT HOME CREATIVE.

2012 - Founded clothing brand ARJD Bro Bears.

2014 - Launched personal mission brand RUN, RAY RUN.

Q. 請問您如何獲得靈感?

A. " 未雨綢繆 " 是我獲得靈感的關鍵。從生活中無拘束的對各方面事物的觀察, 收集與分享, 信息就被文件夾式的儲存在腦海裡; 該信息就會與我們的成長環境, 認知, 或是情感結合; 當被指派任務時, 大腦會自動反射, 將被身體消化分解後的資訊, 組合並呈現具個人特色的看法及作品。這與通過一般熟悉的 " 研究 Research" 而得來的靈感, 不同的是, 前者為主動性, 且在愉悅放鬆的狀態下更好的吸收; 後者為被動性, 在有限時間內, 吸收與消化不良, 而生成了淺薄的表面功夫之做。這就說明了, 為何設計師不屬一種單純職業, 而是一種全人的生活態度。

Q. 請和我們分享您喜歡的書籍、音樂、電影或場所。

A. 值得推薦的是這部泰國導演韋西·沙贊那庭於 2004 年的作品 " 大狗民 "。故事描述男主角從鄉下到城市發展, 在基層謀生數次更換工作崗位之間發生的趣事。其中有一段是說男主角在罐頭魚工廠切割魚時, 不小心把自己的手指切了下來, 並隨著輸送帶入罐出貨了, 之後就是一連串尋找手指的情節 …… 聽起來就很詭異好玩了吧! 這部電影被歸類於 Cult 電影, 拍攝與剪接手法大膽創新, 再加上無伴奏合唱配樂, 絕對不會打瞌睡, 歷經十年的時間還是記憶猶新。

Q. 現在, 回頭來看這些帶著遺珠之憾的作品, 您有什麼新的感觸?

A. 一定程度的自戀對設計師來說蠻重要的, 部分客戶尋找的就是具備這種獨道自信表現的設計師, 例如做好了一個 Logo 會一直看回去, 即使時間久了, 都還是會滿意自己的作品, 其中一筆一劃都留下了思緒的痕跡, 同時也能看見自己的成長。好一些自己中意的作品都是與個人, 家人, 信仰有關, 所以感覺格外親切。作品除了能說服自己, 能被欣賞也是件得意的事, 這也是工作中重要的推動力!

Q. How do you draw inspiration?

A. I draw inspiration from planning thoroughly in my work. Having to see the world at a lower height trained my observation skills, allowing me to collect, express and keep ideas I saw and store them in my mind in categories. The ideas gathered in my mind grows alongside with my surroundings, through learning, and experiencing life. And when given a task, our brain breaks down the information, process them with our ideas and expressing them with our daily work. This is why a designer's life is not just merely a job, but a holistic way of life.

Q. Share good books, music, movies or places with us.

A. The movie that i'd to recommend is the one directed by Thailand director Wisit Sasanatieng, which was screening back in year 2004, titled 'Citizen Dog'. The story starts with a country boy lives a grassroots life in the Bangkok city and the fun stories that happen among the jobs switching by the role. One of the memorable scenes is where "Tob" he was working in a canned fish factory, his finger is accidentally cut by himself, and it flows with the production line, end up be filled in one of the cans. The story flows with the journey how that finger is found. It sounds ridiculous and fun, right? This movie title is classified as a 'Cult' film, which the way they present the movie in different approach, addition with a-cappella soundtrack, the movie still fresh in mind after a decade.

Q. Now, look back to these works of regret for not been selected, how do you feel that?

A. A part of our client is looking for designers with, a representation of their self-confidence. Let's say right after a logo's development, I would look back from time to time and yet still feel satisfied with the works. It's like every stroke we crafted leave traces of thought. Seeing it growing overtime and being recognized by others. Some of the works that are my favourite which relates to me mtself family & faith. My works is a drive that continuously motivate me to create more for others to appreciate. And that is the integral part of work.

Katherine Yu 2013 P.154
這是一個為家母 60 歲大壽準備的禮物。構圖上表達的是母親 (名: 梅花) 生命中鑽石般堅定的基督信仰。每年母親生日, 都會依據一貫的設計概念, 發展成不同的紀念禮品贈送親友, 以達成母親分享福音的心願。
This is a gift made for my mother's 60th birthday. The entire composition shows a motherly motif as my mother's Chinese name blossoms. In the centre of it is the faith she believes in. During her every birthday, commemorative gifts are made for friends and relatives using this logo. In order to which reach my mother's wish to share the Gospel.

活水堂 Living Waters Presbyterian Church 2015 P.154
活水堂靠河的地理位置啟發了我以 " 水 " 為設計的基礎元素, 加上聖經中出現 " 水 " 比喻如: 福如春雨, 福杯滿溢, 飢渴慕義等呈現了這個作品。文字方面, " 活 " 字下型似 " 口 ", 象徵 " 開口讚美 ", " 堂 " 字中間型似 " 眼 ", 象徵 " 舉目仰望 ", 為敬拜時虔誠的表現。
The church is landed at the bank of Maharani River back to the town in Muar. This lead me to have water as the basic elements for the entire visual design. In the Bible, water is a metaphorical representation related to welfare, records can be found such as 'Showers of Blessing', 'Cup Runneth Over' & 'Blessed are those who hunger and thirst for uprightness' etc. The parts of Chinese characters of the church name are replaced with the flow of water element, the 'Mouth' and 'Eyes' represent the sincere worshiping.

H.O.P.E. Foundation 2015 P.154
H.O.P.E. 文化遺產保留宣導基金會 Logo 以地理等高線圖為起點, 文化遺產的地域性則以平面地圖形式表現。" E " 曲線象徵本地在保存工作上面臨的挑戰, 基金會以 " 教育 " 為橋樑, 跨越障礙。" O " 中為運籍信託人簽名, 雙手合實, 對這片土地美好未來的期望。
H.O.P.E. speaks for the act of respecting the HERITAGE, conserving the ORIGIN, implementing the PRESERVATION & continuation of EDUCATION. The creation of the logo identity was inspired by the autograph of one of the trustees of the foundation. The man who is fighting for the residency rights for siam people who been here since they came and now living as a part of our Malaysian society. The concept is formed by the uniqueness of the autograph. The autograph resembles a praying hand that symbolises hope from a person. The dots and lines represents ground surface height points and surface unique shapes, commonly used in topography. In the other hand, the concentrated line is related to the pathways of life and the dots all around it are the events happening throughout the way. A topography is used to define a location's natural

geographical condition, in which reflectsa location's heritage. This location's heritage can be the population that existed, architectural developments, or even traditional practices that survived until the current times, in right to be reserved and protected for them. H.O.P.E. plays the biggest role in this. By using the rationale of a bridge for crossing-over waters in the alphabet E, this strongly fulfils the main objective of the stance towards Education that can bring people forward through challenges of the times.

創意數學 Creative Math 2010 P.154
創意數學為一項透過創意方式教導數學的理解與運用方式。從另一個角度與學生分享學習數學的樂趣, 並引發他們對數學的熱愛。在 Logo 的構想上很直接, 結合文字與數字 0-9, 讓學生在細細研究該 Logo 時, 也能明白所謂的創意。
Creative Math, a brand creative method teaching and learning mathematics. Sharing student the fun and interesting perspective of learning mathematics throughout the connections with our daily life, inspire their curiosity in digging deeper in the subject. By replacing the parts of Chinese characters with 9-0 digits, it presents the logo with the native idea of creativity, audiences is able to capture the philosophy by overviewing the logo itself.

缺陷美 Beauty Of Defect 2014 P.154
" 缺陷美 " 是一個專為殘障兒童而設的美術室。殘障同胞身體不完美的美感, 四肢雖然並不能被大腦支配, 但他們能透過美術與創作表達他們的內心世界。BOD 的設計就是三個標準大笑嘴, 充分表現他們積極樂觀不放棄的天性。
BEAUTY OF DEFECT, an art space developed for children with disabilities. The beauty of imperfection of the disabled bodies, their limbs might not be able to control by brain, but yet they are capable to voice out loud through art. There are 3 big smiling mouths can be found from the logo, nothing much but to reflect the positive way of their life in opposing the imperfection.

Run Ray Run 2014 P.155
這是屬於自己的個人使命計劃。" Run " 與我的身體是相衝的, 因為我跑不了, 選用兩個 "Run", 除了想凸顯 " 跨越現實中的跑道 " 精神外, 更要帶出 " 人生就是要定睛向前 " 的概念。三個 "R" 組合成一個完整的 "R", 簡潔且清楚傳達 " 不停滯 " 的生活精神。
A personal missionary project that motivate a better life to be. 'Run' is contradicting the physical condition of my body, as i can't literally 'run'. To raise up the concept of breakthrough physical barriers, by using two 'run' helps delivering the positive momentum of overcoming challenges of life. Three 'R' parts joining together as a complete 'R', generate non-stop energy that empower our living.

俄羅斯 Russian

自 2010 年開始於公司工作。專注於 Logo 及品牌。有效的視覺傳達開發、維護、諮詢、數個莫斯科政府部門的圖像發展。我的工作包括技術性的設計過程，那就是：作業合法化、比重及簡潔的設計，開發適應各種使用條件及生產技術方面的知識。

Works in industry since 2010.

Specialization- logo / branding.

Effective visual communications development and maintenance. Consultations. Presentations development for several Moscow government departments.

My work specification consists of technical approach to design process. That is: validity of operations, proportions and "design cleanness", development adaptation for various usage conditions, knowledge of production technological aspects.

Roman Namek

www.behance.net/namekone

Q. 請問您認為該國最棒的是什麼？(如國家的特色或文化等) 您的創作是否受其影響？

A. 我不是一個愛國者，但我愛我的國家。在這裡出生、長大，生活都在這。最近我的國家做了很多讓設計業更好的事，這讓我很高興。

我相信現在設計跟和平會共處。

Q. 請問您如何獲得靈感？

A. 看看四周，注意所有圍繞在我跟世界中的細節。關注我的 VSCO http://namekone.vsco.co，這有我所有的靈感。

Q. 請和我們分享您喜歡的書籍、音樂、電影或場所。

A.Bill Gardner&Anne Hellman 的 LogoLounge 9 是現在我隨身攜帶的書，Hed Kandi 音樂公司我愛了六年。

Q. 現在，回頭來看這些帶著遺珠之憾的作品，您有什麼新的感觸？

A. 雖然現在註定不會被選上，但我會一試再試直到達成目標。

Q.What do you like best in your country? (such as country feature or culture)Has it made a difference on your creation?

A. I can't say that I'm a patriot, but I love my country. I was born here, grew here, and living here. Recently, my country is doing a lot to make the design industry better, it makes me glad.

I believe in contemporary design and peaceful coexistence.

Q.How do you draw inspiration?

A. Looking around, attention to all of details around me and the world.

Look in to my vsco: http://namekone.vsco.co - here is my inspiration.

Q.Share good books, music, movies or places with us.

A. For now the LogoLounge 9 by Bill Gardner & Anne Hellman is my handbook, Also Hed Kandi music is my favorite UK-based music label for 6 years.

Q.Now, look back to these works of regret for not been selected, how do you feel that?

A. Well, I'm not fated to be selected for now. I'll try again and again up to the goals achievement.

Lina Goldie *2015* *P.186*

Lina Goldie 目的為別緻、當代時尚。該品牌喚起了人的心「一種無關乎年齡，是態度」。一個真實的原創，總是定義時尚的下一步該往哪走。Goldie 為客戶提供客戶獨特訂製服裝和配件，體現了感性和精緻的生活風格和更多。

Lina Goldie is the go-to destination for chic, contemporary fashion. The brand evokes a mindset - an attitude, not an age. It's a true original, always defining fashion's next stride forward. Goldie offers a unique apparel and accessories for customers who embodies a sensual, sophisticated lifestyle and something more...

Telecom SB *2015* *P.186*

為一家提供針對不同複雜程度所安裝錄影監控、門禁系統、防盜報警、門外對講機和其他工程系統開發公司所設計的企業識別。隨著從事的國外及俄羅斯供應商的維護安全及高品質設備運送，公司注重在安裝及建築工程生命保障服務，監測自動化系統及電力和水的運算。

This visual identity was developed for a company, which carries out installation of video surveillance systems, access systems, intruder alarm systems, on-door speakerphones and other engineering systems on objects of different complexity. Along with mounting they are engaged in maintenance of security arrangements and deliveries of the high-quality equipment from foreign and Russian vendors. Important area of activity of the company is installation and service of engineering life support systems of buildings - systems of automation of monitoring and the accounting of electricity and water.

AmentoNeva *2015* *P.187*

AMENTO NEVA 俄羅斯金屬設備加工公司。提供複雜的運送、金屬切削、研磨、金屬製品裝配及測量工具。

AMENTO NEVA is the Russia- based company focused on the metalworking equipment. The company provides complex delivery of metal-cutting, abrasive, metalwork assembly and measuring tools for the industrial enterprises.

Logos of 2015 *2015* *P.201*

我在 2015 最自豪的 Logo 和商標。

The selection of logos and marks I've proudly made in 2015.

日本 Japan

日本平面設計師。東京出身，畢業於東京武藏野美術大學空間演出設計學科。曾獲 2013 年第一屆東京裝画賞金賞。是 YAEI 團隊的劇作家與設計師。

Graphic Designer in Japan.

Born in Tokyo. Graduated from the Department of Scenography, Display and Fashion Design, Musashino Art University,Tokyo.

Won the Golden prize of the 1st Tokyo Book Jacket Illustration Competition 2013. And belonging to the team YAEI as a dramatist and designer.

大竹竜平 Ryuhei Otake

www. ryuhei-otake.com

Q. 請問您認為該國最棒的是什麼？(如國家的特色或文化等) 您的創作是否受其影響？

A. 我是日本人，我喜歡日本的語言，日語是很複雜的語言，使用漢字、平假名和英文，複雜的日本文字讓我感受到設計與字體設計的深奧。

Q. 請問您如何獲得靈感？

A. 從看小說得到靈感。

Q. 請和我們分享您喜歡的書籍、音樂、電影或場所。

A. 我最喜歡的小說是姜峯楠的《你一生的故事》，它是完美的科幻小說。

Q.除了當設計師 / 插畫家，你是否已經開始規劃下一階段的目標？例如策展、學習煮菜、登山

A. 我在大學讀書的時候就開始寫劇本了，每年在我的劇團都會有演出。這是跟設計一樣重要的事情。

Q.What do you like best in your country? (such as country feature or culture)Has it made a difference on your creation?

A. I am Japanese. I like most things in my country is Japanese. Japanese is a complex language to use kanji and hiragana, English. I feel the depth of design and typography in the complexity of the Japanese.

Q.How do you draw inspiration?

A. What I get the most inspiration, it is to read the story of novel.

Q.Share good books, music, movies or places with us.

A. My favorite novel is "Stories of Your Life and Others" by Ted Chiang. II is the perfect work in SF novels.

Q.Have you started to set up new goals for next period except being a designer or illustrator ? like curating, learning cooking , climbing......

A. I'm writing a playbook of the theater from the time of college students. I'm going performances every year in my theatrical company. It is important work as design work.

武藏野美術大學畢業典禮 Musashino Art University Graduation Ceremony 2015 P.27
這是替武藏野美術大學畢業典禮設計的小冊子，使用在日本代表喜慶的顏色去做設計。
This is a pamphlet designed for Musashino Art University graduation ceremony of Japan. I expressed it by a Japanese-style happy color and design.

請自行命名 Please title it freely 2015 P.128
替我的劇團設計的海報，我想表現出寂靜與科幻的感覺，首演與第二輪演出的海報，稍微更動了顏色與插畫，這精美的插畫是由寺本愛繪製的。
These works are poster design for my theatrical company. I expressed Science Fiction story and stillness. I changed image color and illustration by the premiere and a repeat performance. The wonderful illustration is illustrated by Ai Teramoto.

英雄夢幻譚 EIYU MUGENTAN KOJIKI 2013 P.128
北辰舞踏的公演海報。這件作品在詮釋一個古老的日本神話，我在海報表現出北辰的節奏與律動。
This is a poster work for Butohperformances. It is the work which expressed a old myth of Japan. I expressed rhythm and a fluctuation of Butoh.

觀光 Sightseeing 2014 P.128
個人創作，使用觀光地圖的素材完成的拼貼作品。
This is my personal work. It is the collage work using the scrap of the sightseeing map.

y 與 x 的事情 The situation of y and x 2014 P.128
替我的劇團設計的海報。主題是數學，用銀色墨印刷，精美的插畫是由寺本愛繪製的。
This works is a poster design for my theatrical company. This is a work with mathematics as a motif. This is printed with silver ink. The wonderful illustration is illustrated by Ai Teramoto.

忍者 NINJYA 2014 P.281
個人創作，用拼貼畫的形式表現出日本忍者與妖怪。
This is my personal work. This is an illustration representing the Japanese ninja and the apparition. This is made of old print of collage.

鍋坊主 NABEBOUZU 2014 P.281
個人創作，表現出日本忍者與妖怪的拼貼畫。
This is my personal work. This is an illustration representing the Japanese ninja and the apparition. This is made of old print of collage.

斯里蘭卡 Sri Lanka

Samadara Ginige

www.samadaraginige.com

Samadara Ginige 是一個屢獲殊榮的 Logo 設計師，擁有超過 10 年的國際經驗。她一直與來自世界各地的客戶合作各種項目，包括品牌識別、平面和 UI/ UX 設計。她以個人最著名的特色贏得了 2014 年和 2015 年 A' 國際設計大獎。Samadara 具有設計簡單圖像的特殊能力。她的作品被刊登在許多設計相關的博客，文章，畫廊，書籍和雜誌。她喜歡在她工作之餘學習新的技術，素描，排版和手工刻字。

Samadara Ginige is an award winning Logo Designer with over 10 years of international experience. She has been working with clients from around the world on a range of projects including brand identity, graphics and UI/UX design. She won the A'Design Award in 2014 and Design Award in 2015 for her famous personal identity. Samadara has a special ability to design simple monograms. Her work has been featured in many design related blogs, articles, galleries, books and magazines. She loves learning new techniques, sketching, typography and hand-lettering in between her work.

Q. 請問您如何獲得靈感？

A. 我會從大自然間獲得靈感，這是最棒的來源。從紡織到音樂，都被大自然所啟發。我習慣聽著音樂工作。

Q. 請和我們分享您喜歡的書籍、音樂、電影或場所。

A. 幾何設計基礎（S. Pentak 和 A. 勞爾）、設計幾何學（金佰利 · 伊蘭姆），新 · 設計基礎（埃倫 · 勒普頓和詹妮弗 · 科爾菲利普斯），神聖的幾何 - 創建設計（羅素西蒙茲）
音樂：我喜歡獨立，鄉村和搖滾。例如，Song for Zula by Phosphorescent。

Q. 現在，回頭來看這些帶著遺珠之憾的作品，您有什麼新的感觸？

A. 有些設計沒被選上而有些是我個人的創作，我相信每件設計一定都會有它的容身之處，我相信它們遲早都會被找到，我全部的作品都是努力完成的，它們未來將會啟發我的創作。

Q. 除了當設計師 / 插畫家，你是否已經開始規劃下一階段的目標？例如策展、學習煮菜、登山......

A. 我的下一個目標是計劃在 2016 年 6 月舉行個展，我打算展示 70~80 件自己的設計作品，有 Logo，設計排版，平面等。

Q. How do you draw inspiration?

A. I get inspiration from the nature. It's the best source of inspiration. From the textile patterns to the music we've created, we've been inspired by the nature. I usually work with music on.

Q. Share good books, music, movies or places with us.

A. Basics (S. Pentak and A. Lauer), Geometry of Design: Studies in Proportion and Composition (Kimberly Elam), The New Basics (Ellen Lupton and Jennifer Cole Phillips), Sacred Geometry - Designs of Creation (Russell Symonds)

Music: I enjoy Indie, Country and Rock genres the most. Eg. Song for Zula by Phosphorescent

Q. Now, look back to these works of regret for not been selected, how do you feel that?

A. Some of these designs didn't get selected and some of them are my own personal projects. I believe that every design has a place in the design universe. I'm sure these designs will find their owners sooner or later. All my designs are achieved by hard work. They'll inspire my future work.

Q. Have you started to set up new goals for next period except being a designer or illustrator ? like curating, learning cooking , climbing......

A. My next goal is my debut solo exhibition which is planned to be held in June 2016. I intend to exhibit 70-80 of my design work from the logo, typography, graphics and quotes categories.

Handmade Ideas 2014 P.152

這件作品的概念，我想要描繪燈泡通過手去接收電力並發光，以玻璃燈泡透過手供電的理念，表示創意藝術是透過手創造的。

In this concept I wanted to depict the light bulb which takes in electricity and generate light in the form of a hand. The glass bulb depicts ideas which are powered by the hand, suggesting creative art is made from hands.

Doctor Bird 2014 P.152

醫生鳥會以一種角度快速地振翅翱向上，醫生鳥（紅嘴長尾蜂鳥）是燕尾刀翅蜂鳥的通用名稱，它是牙買加的國鳥。我利用其常常的尾巴作為曲線，表現出鳥類快速震動翅膀的動作。

A Doctor bird which is moving rapidly upwards at an angle. The Doctor Bird (Trochilus polytmus) is the common name for the Swallow-Tail Hummingbird, the national bird of Jamaica. It shows the bird's rapid movement using its long tail as a curve.

Quote Garden 2013 P.152

此件作品的理念是想要給觀眾有花的感覺，我使用引號的符號做成花瓣，象徵好的引號像是美麗的花朵，這個 Logo 可延伸至網頁或是部落格。

The idea was to give the feeling of a flower to the viewer. I used quotation marks as the petals, symbolizing 'good quotes are like beautiful flowers'. This logo can relate to a website or a blog that publishes quotes.

Eagle 2015 P.152

老鷹是巨大而強悍的鳥類，擁以比其他鳥類還要寬大的翅膀，在這個 Logo 裡，我誇大了它的翅膀，想要凸顯它的寬大，並展現它獨特的形狀。他的頭、嘴和眼睛則在負空間裡表現出來。

Eagle is a large and powerful bird with relatively longer and broader wings. In this logo-mark my intention was to highlight its broad wings by exaggerating them, showing the unique shape of the wings. Its head, beak and eyes are carved out in the negative space.

C Letter-mark X 2015 P.152

我在替某個音樂製作人雙人組製作接案時，發展出這個理念。他們兩人的專長是製作高能量的樂曲，他們的舞台名字開頭字母是 C，我結合了字母 C 與能量的符號。

I developed this idea while I was working on a project for a music producer duo that specializes in composing high energy music. Their stage name starts with the letter "C". I combined the letter C with the energy symbol.

Stand 2013 P.152

這是在執行另一件案子時，突然腦海中閃過的靈感，我想設計一個人站在字母 A 裡，但不想改變字體的一致性，所以我讓字母 A 看起來像是一個人的下半身，穿著褲子和鞋子。

This was an idea which ran across my mind while working on a different project. I wanted

to design a person standing in the letter "A". I didn't want to change the consistency of the letters of the typeface. So I made the letter "A" look like the bottom part of a person standing wearing a trouser and shoes.

I developed this idea while I was working on a project for a music producer duo that specializes in composing high energy music. Their stage name starts with the letter "C". I combined the letter C with the energy symbol.

Let design inspire your soul P.215

這也是引用我的另一句話，並且是我自己的手寫字體。我們都在尋找靈感，我想讓觀眾在欣賞引用句子的意涵時，也因為看到美觀的設計而受到啟發。

This is also another one of my own quotes which was hand-lettered by me. All of us seek inspiration. I wanted the viewer to get inspired by the aesthetic look of the design while comprehending the meaning of the quote.

Be brave blame none 2015 P.215

我愛排版還有手寫字體，我想出了一些自己對於設計和人生的佳句，一有機會我就會設計字體名言海報，這是其中一幅，這些海報正持續地在畫廊展示。

I love typography and hand-lettering. I have come up with a few of my own quotes about design as well as life. Whenever I get a chance I design typographic quote posters. This is one of them which is being continuously featured on galleries.

馬來西亞 Malaysia

設計是從生活中的內容產生共同的語言，對於透過設計去溝通和臆測感興趣，在開放的視覺敘述下，事物會稍微扭曲、干擾，也不會失去真實，最後的設計可能變成對於日常的矛盾誇張、「好品味」的顛覆，或者對於美感的開放，我總是牢記著設計不只是表達自己的喜好，還要有清晰的理解與關連性，加上良好的幽默感與誠實。

I am interested in communicating and speculating through design using a common language within the context of everyday life. In an open visual narrative that is by slightly distorting, disrupting the matter but not losing its truth. The final design could be a paradoxical exaggeration of conventions, a subversion of 'good taste', or an openness toward an aesthetic fiction. I always keep in mind to design something that is not just an expression of my own interests, but is also understandable with clarity and relevance. And yes good humour and honesty.

謝依津　Sha Yee-Jin

www.cargocollective.com/ejinsha

Q. 請問您認為該國最棒的是什麼 ?(如國家的特色或文化等) 您的創作是否受其影響 ？

A. 最棒的是食物, 充滿活力且跨文化的口味。馬來西亞的菜餚調和了甜、酸和辣, 加上羅勒拌炒。適應各種變化, 開放並擁抱新的影響, 我們習慣了在碗裡混合兩種或更多元素, 這讓我們在創作時渴求 80% 的和諧與 20% 的衝動。

Q. 請問您如何獲得靈感？

A. 巧合、話語、事實、身份、科學幻想、流行和執著。還有一些被遺忘或忽略的日常細節與事物。

Q. 請和我們分享您喜歡的書籍、音樂、電影或場所。

A. 書籍：目前是黑特・史德耶爾的《The Wretched of the Screen》。

音樂：目前是 James Ferraro-Sushi。

電影：目前是維多莉亞（2015）。

場所：目前是家裡還有荷蘭。

Q. 現在, 回頭來看這些帶著遺珠之憾的作品, 您有什麼新的感觸？

A. 嗯, 就下次再接再厲吧, 如果你創作那些作品時覺得很快樂, 就沒什麼好後悔的。

Q. 除了當設計師 / 插畫家, 你是否已經開始規劃下一階段的目標？例如策展、學習煮菜、登山

A. 多多做事, 少說廢話, 活在當下。

Q. 你對生活的細節上有什麼堅持嗎?(像是上廁所時一定要看詩集之類的)

A. 努力喝咖啡, 努力做自己所愛的事, 追求自己所要的生活。

Q.What do you like best in your country? (such as country feature or culture)Has it made a difference on your creation?

A. The food. It is a vibrant mix of cross culture flavours. The malaysian taste palette of sweet, sour and spicy has stir fried the rojak(mixing) nature in us. Being adaptive to changes and are open to embrace new influences, We are used to blend 2 or more different elements into one bowl. This has made me hungry for 80% harmony and 20% irrationality in my works.

Q.How do you draw inspiration?

A. Coincidence. Words. Truth. Identity, Pop and obsessions. Everyday things are forgotten or taken for granted.

Q.Share good books, music, movies or places with us.

A. Book: Currently: Hito Steyerl's The Wretched of the Screen.

Music: Currently: James Ferraro-Sushi.

Movie: Curently: Victoria, 2015.

Places: Curently: Home and Holland.

Q.Now, look back to these works of regret for not been selected, how do you feel that?

A. Ah, just try again next time. If you were happy making those works, there is nothing to regret about.

Q.Have you started to set up new goals for next period except being a designer or illustrator ? like curating, learning cooking , climbing......

A. Do more, say less, live in the present.

Q.What is your insist on your life's details ? like toilet with your favorite poem?

A. Have coffee everyday, work hard in what you love and pursue your passion.

Metaphors into the 4th Dimension 2015 P.30

書籍設計，Anne Kranenborg 與 Dayna Casey 的合作。為了反映標題，這本書的形式被排版成可以從四種不同的方向 (北、南、東、西邊) 閱讀，過場時需要讀者轉變自己的視角，就像是作者說的，「這樣的設計過成表現必須在變得直覺之前重複合理化」，這本書永遠是流動的狀態，等待著人們提供它場景的時刻。

Book Design for Anne Kranenborg in collaboration with Dayna Casey. As a reflection to the title, this book is typeset so it could be read while physically turned in four different directions (north, south, east, west) . This transition demands a change of the reader's perspective. Just as described by the author, 'The design process presented must be repeatedly rationalised before it becomes intuition.' The book is also in a constant state of fluidity, awaiting the moment in which a person provide its context.

Medi(s)tation 2015 P.71

與 PimPiët 合作的項目，這個裝置是關於數位文化在我們的日常生活裡扮演著核心角色，我們被多媒體機器和科技給豢養、主導。描寫從現實與人際關係逃離到幻想與妄想裡、產生精神分裂、科技侵蝕到工作與休閒、公眾與私人，如此倒錯的觀念，在這個項目裡，我們將連結從它身上移開，讓現在成為一個實體、一個影像，它仍然可以給予我們寧靜，安全和歸屬感，這個瞬間我們要談談一關於文字，資訊以及連結的離去。

Project in collaboration with PimPiët. This installation is about digital cultures playing a central role in our daily lives. We are territorialized by multimedia machines, guided by technologies. This is a depiction about faulty perceptions, a withdrawal from reality and personal relationships into fantasy and delusion, and a sense of mental fragmentation. Technology has erode the former distinctions between work and leisure, public and private. In this project we took connectivity away from them, what becomes now is an object, an image that could still provide us a sense of tranquility, security and belonging. To say something about nothing — about words, and information, and connectivity going away.

Slightly Strange Matters 2014 P.253

這個作品是荷蘭皇家科學院的畢業項目。如果這些書籍還有海報過於標準, 那麼我們可能瞥過一次就走了, 如果太過瘋狂, 我們又可能忽略它。熟悉感常常阻止我們看得更深入, 我們需要陌生感讓我們從麻木的感性, 還有停滯的思考中逃離出來。陌生感並不是要欺騙觀眾或誤導觀眾, 而是具有建設性地讓我們探討周圍的事物。

Graduation Project in Royal Academy of Art, NL. If these books and posters were too correct and expected, we would glance once and move on. If it is too crazy we might ignore it too. As familiarity often prevents us from looking deeper, we need strangeness to get us out from a

kind of perceptual numbness, out of unthinking consumption. To introduce strangeness is not about tricking the viewer into misperceptions. Strangeness can be good and constructive, it is not merely for attention as we presumed.

Where is Karen 2015 P.253

與 Karen Huang 的合作，攝影是 Iris van der Zee。「Oh boy, please cry」，Karen 的時裝系列是在描寫她在瑞典經歷的性別平等議題，我們想訴說一個關於性別模糊，一個關於布料和文字混合的故事。

In collaboration with Karen Huang, photography by Iris van der Zee.'Oh boy, please cry.' Karen's fashion collection was a depiction of the gender equality she experienced in Sweden. We want to tell a story about women and men in a garment, about textile and text in a piece.

馬來西亞 Malaysia

我是一位來自馬來西亞怡保的平面設計師，從出生就有一個不平凡的人生經驗，令人難以置信及難以想像的機會發生在我身上。

I am a graphic designer from Ipoh, Malaysia. I was born to have an extraordinary life experiencing the incredible and unimaginable chances happen to me.

Shelly Liew

www.behance.net/salipuma

Q. 請問您認為該國最棒的是什麼？(如國家的特色或文化等) 您的創作是否受其影響？

A. 荷蘭，開放的設計態度，都讓設計師去探索任何自己想做的事。保持探索想像力和勇於發展的經驗，在進步中學習。所以你可以看到他們的設計鼓舞、大膽，使設計更加好玩。讓設計成為生活中的一部份。

Q. 請問您如何獲得靈感？

A. 我用自己的雙手創造每次令人印象深刻的結果。我喜歡用十根手指探索新事物，觸摸的感覺讓我感受到事物中的獨特性。我的靈感通常來自於感覺，無論我想像到什麼都可以用雙手創造。儘管沿途都有挑戰，但我會用這種精神來尋找不可思議的想法，得到非凡的結果。這是我的一種幸福，感受任何事情並用雙手創造。

Q. 現在，回頭來看這些帶著遺珠之憾的作品，您有什麼新的感觸？

A. 我覺得，雖然這些作品沒有被選中，但它已是一個很好的嘗試。因為你可以在過程中學習，而且只有自己瞭解。一切都是關於你如何嘗試把事情做得更好，就像是學習的過程，學習更多，得到更多。

Q. 你對生活的細節上有什麼堅持嗎？(像是上廁所時一定要看詩集之類的)

A. 用我的想像感受所有事情，並用我的手完成。創造自己的個性並應用在自己的設計。

Q. What do you like best in your country? (such as country feature or culture)Has it made a difference on your creation?

A. Netherlands, the way of the design quite open mind for me, they are allow designer to explore whatever they want to do. Keep explore the imagination and dare to experience the development, and learn something between the progresses. So you can see their design is inspiration, daring and also make the design more playful. To make design be a part of life.

Q. How do you draw inspiration?

A. I design the extraordinary chances that create an impressive result with my hands. I like to explore new things with my ten fingers, this sense of touch give me the awareness sensation about the distinctiveness between things.My inspiration usually comes from the sensations, and whatever I can imagine I can create with my hands. Even though there are challenges along the creative thinking process, I will use this awareness to search for variable incredible ideas to get the extraordinary result. And this is my happiness, felt for things with my imagination and making it happens with my hands.

Q. Now, look back to these works of regret for not been selected, how do you feel that?

A. For my opinion, although those works not been selected, but it is a good try to do the project out. Because you can learn something between the progress and no one will know what is it. Is all about what you get and try to do things better. Is just like a learning process, to learn more and explore more.

Q. What is your insist on your life's details ? like toilet with your favorite poem?

A. Felt for things with my imagination and making it happens with my hands. Create your own personality and apply on your design.

Game Box Design Arbeidsmarkt 2015 *P.51*
這是我在 Studio Dumbar 實習時做的勞動市場遊戲設計，不幸的是，因為目標是藝術總監，他們喜歡更嚴肅、簡潔，而不是好玩而已。
A Game box design Arbeidsmarkt when I doing my internship at Studio Dumbar. Unfortunately, because the target is Art director, they prefer make it more serious and clean instead of make it so playful.

STAEDTLER Limited Edition Packaging 2013 *P.52*
現在 Staedtler 素描筆沒有比以往有名，這個項目是創造限量版的包裝提升素描筆的質感。用鉛筆描繪三種復古鉛筆素描 (交通工具、房屋、配件)，讓藝術家或學生回憶鉛筆素描的時期。
Nowadays, Staedtler Graphite Pencil has not so famous as before, so this project is to create the limited edition packaging to promote the nature of graphite pencil. Use the graphite pencil to sketch the three categories of vintage pencil sketch (transportation, house-hold and accessories), let artist / art student memory the period of graphite pencil.

CAFEOLOGY Packaging Design 2013 *P.55*
CAFEOLOGY，獨立飲品供應商、餐廳、咖啡廳。背負著新的精神以促進只有提供公平貿易商品的價值。反映此一核心價值，品牌傳達「我們所做的一切百分之百公平」。CAFEOLOGY 提供最好最全面的公平貿易飲品。這種包裝目的是促進公平貿易的重要和提供咖啡愛好者更多選擇。
CAFEOLOGY, an independent supplier of beverages to restaurants and cafes, is undertaking the new drive to promote its cover value of only supplying Fair-trade products. Reflecting this core value, brand communications will center on the theme "100% Fair-trade in Everything We Do". CAFEOLOGY provides the finest and most comprehensive range of Fair-trade beverages. This packaging aims to promote CAFEOLOGY ranges of products to coffee lovers as well as promoting the important of Fair-trade.

SoundEnergy 2015 *P.173*
這是我在 Studio Dumbar 實習時為 SoundEnergy 做的新形象識別。透過大量的試驗和發展，使其維持原有特性，將熱情降溫。從頭到尾都是一個很好的學習過程。不幸的是，由於生產因素，最後並不是最終定案。
A New Identity for SoundEnergy when i doing my internship at Studio Dumbar. This project through a lots of experiment and development to make the sustainable identity, spread the feeling of warm to cool, is a good learning process from start until the end. Unfortunately due to some production effect, it cannot be the final identity.

台灣 Taiwan

平面設計師，1992 年生於新北市板橋。擅長標
準字設計、識別系統設計與包裝設計。

曾獲 2014 台灣新一代設計獎包裝類銀獎、作品
入選第十一屆 APD 亞太設計年鑑。

Taiwanese graphic designer, born in New Taipei City in 1992,
is expert in Logotype, Visual Identity and Package Design.
Awards
2014 The Taiwan Young Designer's Award,
2015 Works were selected into the Asia-Pacific Design No.11

施博瀚　Shih Bo-Han

www.behance.net/bohanshih

Q. 請問您認為該國最棒的是什麼？(如國家的特色或文化等) 您的創作是否受其影響？

A. 台灣為世界上少數使用繁體漢字的國家，繁體漢字結構多變、樣態優美、寓意於形、韻味十足，是我們引以為傲的文化。我擅長將自己的創意融於漢字，或將漢字與圖像、歐文做結合，並應用於海報、包裝或版面設計之中。

Q. 請問您如何獲得靈感？

A. 我喜歡逛超市，尤其是國際超市，很特別吧。我認為設計是貼近生活的，而食衣住行中，食為首要、是人類基本需求，與食有關的設計便是最貼近我們的設計。我常會觀察食品包裝的用色、字型設計、包裝形式與材質應用等等，也喜歡收集其包裝紙、提袋、DM 等印刷物，當我靈感缺乏時便取出來翻看，有助於創意發想。

Q. 除了當設計師 / 插畫家，你是否已經開始規劃下一階段的目標？例如策展、學習煮菜、登山

A. 除了做設計，我期許自己能成為一位演說家。設計的理解、美醜評判很多時候是很直覺的，但設計的邏輯卻是十分多元且可以加以歸納與整理的。我喜歡與人交流彼此對設計的認知面向與看法、喜歡溝通答辯中互相激盪的過程、喜歡將自己的經驗分享給大眾，所以我想成為一位好的演說家。

Q. 你對生活的細節上有什麼堅持嗎？(像是上廁所時一定要看詩集之類的)

A. 這題讓我想到一件事 (笑)。我的個性條理分明，不喜歡模糊不清的事物，舉個很微小的生活例子來說：在連鎖餐飲店點餐時，只要有附餐飲料，我很不喜歡店員把檸檬紅茶說成紅茶 (在台灣，很多店員真的會這麼介紹)，每當我做好喝到紅茶的心理準備但喝到的卻是檸檬紅茶時，總會感到些許的落寞。

Q.What do you like best in your country? (such as country feature or culture)Has it made a difference on your creation?

A. Taiwan is one of the few countries of the world that uses traditional Chinese characters. It's the culture that we are intensely proud for their multiple structures, their elegant shapes, implications in their forms and their incredible charm. I'm proficient at combining my ideas with Chinese characters or combining Chinese characters with pictures or the Latin alphabet, and apply them to posters, packaging and layouts.

Q.How do you draw inspiration?

A. I love taking a stroll in the supermarket, especially in the international supermarket, because I think the design is very close to the life, among others, the food is the most important and is also the basic necessities of human beings. As a result, the food-related design is the most close to our design. I frequently observe the colors, font design, forms and materials of the food packaging. Also, I am fond of collecting the wrapping paper, bags, and some printed products. I find inspiration in them for the purpose of creative thinking.

Q.Have you started to set up new goals for next period except being a designer or illustrator ? like curating, learning cooking , climbing......

A. Apart from the design, I hope I can become an orator. Very often understandings of the design and judgments of beauty and ugliness are intuitive, but the logic of the design is very diverse, which can be inducted and arranged. I love communicating cognitions and thoughts of the design with others, I love each stirring process during communications and defenses, and I love sharing my experiences with the public, therefore I want to become a good orator.

Q.What is your insist on your life's details ? like toilet with your favorite poem?

A. This question reminds me of one thing (laugh). I am an organized person, so I hate the vague things. For instance, when I order in chain restaurants, I don't like that clerks mistake black tea as lemon tea as long as the main dish comes with a free drink (many clerks do so in Taiwan), because I always feel a little disappointed when I prepare to taste a black tea, but actually, it's a lemon tea.

瀚字選 Bohan's Logotype Collection Exhibition 2015 P.79

瀚字選是我個人的漢字標準字作品展。漢字是我們的文化，結構多變、樣態優美，設計上卻有更多挑戰。本次選擇了 10 組作品介紹其背後的故事與設計方法；此外也為這個展覽設計一套標題專用字型：筆劃起頭圓潤、末端如凝霜、方正雅緻，命名為「凝明體」。

For My Chinese Characters Logotypes Exhibition. Chinese characters represent our culture. There are more challenges for the design because of multiple structures and elegant shapes. This time I choose 10 pieces of work for introducing the stories behind them and the method of design. Besides, I also design a set of title font, especially for this exhibition: beginning with the mellow stroke, trail as cream, and "Ning Ming Font" is the name I give to it.

先發誌人 Layout-Man 2015 P.104

此為「雜誌編排設計展」海報。這張海報，文案全由中文構成，注重中文的編排設計與圖形間比例關係的平衡，達成視覺的和諧。

It's the poster for "The Layout Design for the Magazine". This Chinese-copywriting puts emphasis on the design of Chinese arrangement and the balance among the figures, achieving the visual harmony.

字生字面 Let characters run the cover 2014 P.104

此為「書籍封面標準字設計展」海報提案稿。將「紙張被掀起」的圖像融入於這張海報的標準字設計之中，明確傳達「書籍封面設計」與「標準字設計」此展覽的兩大主題。

It's the poster proposal for "The Typography Design for Book Cover". I combine the image "turning over a piece of paper" with the poster's logotype design. I clearly express my ideas to the main themes of this exhibition "The Design for Book Cover" and "The Design of Logotype".

喜羊迎春 Spring Goat 2015 P.250

2015 羊年新年賀卡設計。跳脫以往使用東方書法字作為卡片主題，這張新年卡用單純的線條結合數字排列，

一共融和了「西曆 2015 年、中國羊年、春節」三種意象。

It's a Chinese New Year Card design for 2015. It's different from the past that I used the calligraphy as the theme of the card. The idea of this New Year Card is to integrate the simple lines with the digital arrangement, combined with "the Western calendar 2015", "the Year of the Goat" and "the Lunar New Year

馴鹿聖誕 Christmas Reindeer 2014 P.250

聖誕賀卡設計。將「Merry Xmas」排成馴鹿的造型作為畫面主角，顏色上不使用一般象徵聖誕節的紅與綠，而是使用螢光黃色，如此可以讓觀眾的目光專注在這個文字排列的巧思上。

It's a design for Christmas card. I design a shape of the reindeer with the words "Merry Xmas". As for the colors, I use the "Glow yellow" instead of the traditional colors of Christmas "Red" and "Green". In this way, people can be attracted to focus on the ingenuity of the words' arrangement.

聚樂 The Gather of Joys 2015 P.251

聖誕賀卡設計。將「Merry Xmas」各字母分別拆解，重新組合為漢字「聚」與「樂」兩個漢字。希望大家在聖誕佳節時，都能齊聚一堂、分享歡樂。

It's a design for Christmas card. I disassemble the words "Merry Xmas" and then I assemble them again into two traditional characters " 聚 (Ju) (gather) and " 樂 (Le)"(joys). I hope everyone can gather together to share joys at Christmas.

南韓 Republic of Korea

我是位平面設計師，工作範圍很廣，從為韓國國內小咖啡廳設計品牌形象。現在主要設計品牌視覺。

I'm a graphic designer, work on a wide range of design tasks from brandings of small cafes to those of national events in South Korea, mainly working on brand identity designs.

申載昊　Shin Jae- Ho

be .net/jaemon

Q. 請問您認為該國最棒的是什麼？(如國家的特色或文化等) 您的創作是否受其影響？

A. 韓國人大多都有時尚意識, 他們喜歡享受新的有趣事物, 也很快的適應環境。這種性格激勵我更多創意跟全新的設計。

Q. 請問您如何獲得靈感？

A. 我一直都有在思考創新的設計和鼓舞人心的因素。可以是某人走在我人生中的那第一條路。你知道, 設計領域包含一個人的生活、文化、個性, 然而, 任何圍繞在我們身邊都可以是很好的素材, 來自不同國家藝術背景的人談話, 和我朋友講笑話。

Q. 請和我們分享您喜歡的書籍、音樂、電影或場所。

A. 我推薦弘大和延南洞的街道。弘大有很多年輕的藝術家, 會使你感到新鮮和活力。延南洞的街道是平靜的地方不同於弘大, 有很多漂亮的咖啡廳, 激發我許多感覺和創意。如果你需要休息或思考一些重要的事情, 這會是完美的選擇。

Q. 現在, 回頭來看這些帶著遺珠之憾的作品, 您有什麼新的感觸？

A. 如果最後客戶不接受你的作品, 不需要感到失望。經驗本身就是你珍貴的財產, 如果你是位設計師, 讓客戶對你的作品滿意是很重要的工作。只要有客戶, 我們更像是位設計師而不是藝術家。當我們為客戶工作時, 客戶就是總監, 我們需要尊重客戶的想法, 工作時試圖參考他或她的意見。

Q. 除了當設計師 / 插畫家,你是否已經開始規劃下一階段的目標？例如策展、學習煮菜、登山

A. 我的父母都是音樂家, 我的父親是位歌手、作詞家, 我的母親是聲樂家。所以我是聽音樂長大的, 當我八歲時, 我父親給我一把古典吉他, 從那以後, 我就很愛彈吉他。在那段日子裡我已學會創作。

Q. 你對生活的細節上有什麼堅持嗎？(像是上廁所時一定要看詩集之類的)

A. 尊重和關懷, 顯然地是以我的標準！

Q.What do you like best in your country? (such as country feature or culture)Has it made a difference on your creation?

A. People in South Korea are mostly fashion-conscious.
They love to enjoy new and interesting things and they are also quickly adjust to their surroundings. This character of Korean people inspire me to more creative and fresh designs.

Q.How do you draw inspiration?

A. I always think of creative design and inspirational materials. They can be people walking along the street, the road for the first time in my life. As you know, the field of design contains one's life, culture, and character, therefore, everything around us can be good materials which provide us the best artistic perspective. conversations with many people from various countries, and jokes with my friends.

Q.Share good books, music, movies or places with us.

A. I recommend the streets of Hongik University(Hong-Dae) and the streets of Yoennam-dong. There are a lot of young artists in Hong-Dae so it will make you feel fresh and energetic. The streets of Yoennam-dong is calm and silent place different form Hong-Dae. There are lots of beautiful cafes which inspire my feelings and creativeness. It will be a perfect place if you need some rest or think to yourself about something important.

Q.Now, look back to these works of regret for not been selected, how do you feel that?

A. If the client doesn't accept your work finally, you don't have to be disappointed. Experience itself is your valuable property. If you are a designer, it is as important as your great work to make your clients satisfied with your work. As long as we have clients, we are more of designers than fine artists. When we work on "the client's job", the director is the client. In this respect, we need to respect the client's idea and try to reflect his or her opinion during the work.

Q.Have you started to set up new goals for next period except being a designer or illustrator ? like curating, learning cooking , climbing......

A. My parents are musicians. My father is a singer song-writer and my mother majored in vocal music. So I grew up hearing music. When I became 8 years old, my father gave me a classic guitar. From then, I have enjoyed playing the guitar. In these days, I have learned composition.

Q.What is your insist on your life's details ? like toilet with your favorite poem?

A. Respect and caring. But clearly my own standards!

Busan Indie Connect Festival 2015 *2015 P.200*
BIC FEST 意思是多元而統一。我曾用方形為基底來變化十種圖形, 像素是電子設備的最基礎、簡單的表達方式, 是作為模板的主要形式。展現了多種意義。Logo 是將 " 搖桿 " 符號化。
BIC FEST meaning is " Diversity and Unity " I used to rule the 10 kinds graphic modules the motif of the basic form is Square. "Pixel" and the most basic "electronics device" simply to express the square, was show as the primary form of modules. The module shows various something meaning. The Logotype is the symbolising 'Joystick'.
Gapyeong Pine Nuts Rebranding Project *2015 P.203*
山、微風、山谷, 帶著韓國傳統民間繪畫技術。
Of the mountain, the breeze brought the graphic motif of Korean traditional folk painting techniques to draw you left Vallev.

澳門 Macau

施雅欣　Si Cathy

imtaimei@gmail.com

施雅欣，2013 年畢業於澳門理工學院。是位視設計為生活的一部份、熱愛並堅持創作的設計師。擅長運用直覺與美感把項目主題表達得淺顯易懂，讓一般大眾也能夠享受設計的美好。
作品曾獲澳門設計雙年展、iF design Award、墨西哥海報雙年展、GDC、貳零壹肆 - 傑出華文漢字設計作品展等肯定。

Cathy Si, graduated from the Macao Polytechnic Institute in 2013. A designer who seeing the design as one part of her life, with patient and insist on creating. She is good at using intuition and aesthetic to express the theme of project clearly, so the general public can enjoy the beautiful of design.
Her works gain recognition from the Macau Design Biennial, iF design Award, Mexico Poster Biennale, GDC, Outstanding Chinese Character Design Works Invitation Exhibition 2014, etc.

Q. 請問您認為該國最棒的是什麼？(如國家的特色或文化等) 您的創作是否受其影響？
A. 澳門是個很棒的地方，現代傳統、前衛保守都共濟一堂。在創作來說，可以培養多元思考是一件很好的事。

Q. 請問您如何獲得靈感？
A. 有時想很久，有時想一下。對我而言，通常在兩個極端的地方就有靈感。所以要麼直接、要麼是深思熟慮後的結論。

Q. 請和我們分享您喜歡的書籍、音樂、電影或場所。
A. 可以引人思考的書籍、地方都喜歡。像是哲學入門那些。

Q. 現在，回頭來看這些帶著遺珠之憾的作品，您有什麼新的感觸？
A. 如果可以像畫作一樣，我也想刪了它們。

Q.What do you like best in your country? (such as country feature or culture)Has it made a difference on your creation?
A. Macau is a great place, modern and traditional, avant-garde and conservative, all the styles come together in there. It is a good thing for creators to develop pluralistic thinking.

Q.How do you draw inspiration?
A. Sometimes I have to think for a long time but sometimes not. For me, I usually get the inspiration from these two extreme situations. So either directly thinking or a conclusion after careful consideration.

Q.Share good books, music, movies or places with us.
A. I like the thought-provoking books or places, such as philosophy introduction.

Q.Now, look back to these works of regret for not been selected, how do you feel that?
A. I would like to delete them just like the painting.

圖書館週 SEMANA DA BIBLIOTECA DE MACAU　2014　P.59
澳門圖書館週為每年春天由澳門文化局中央圖書館舉辦，推廣閱讀。圖書館週由一系列活動組成，如好書交換、系列講座、工作坊等。設計主要由書卷及文具組成生動的字體，希望以東方文字吸引更多本地不同年齡層讀者。並以不同色相區別與串連一系列活動。
"Macau Library Week" takes place during springtime every year. This event is organized by Macau Central Library aims to promote reading to the public."Macau Library Week" features a series of activities includes book exchange, talks, workshops, documentary etc. On the main image we create stylized Chinese characters with the design of scrolls and stationary. With the use of Chinese language, we hope to reach more local Chinese from all age group. And using different color to link a series of activities.

幸福感 Happiness　2015　P.59
幸福感是 2015 年全藝社舉辦的蘇侃哲與蔡國傑雙人繪畫作品展。蘇侃哲和蔡國傑，是兩位幸福的男人，對藝術充滿熱忱的追求及執著。此次設計旨在傳達展覽主題－幸福，又因為是雙人作品展，於是使用有對比度但又溫和的綠色及粉紅色，融合畫作元素。觀賞的同時，獲取資訊也能夠感受到幸福的感覺。
"Happiness" is an exhibition of works by José Lázaro das Dores and CaiGuoJie, who are two happy men who have been falling passionately in love with art. Both like to create their paintings with a lively and clear style.The design is intended to convey the theme of the exhibition-happiness, so two soft and gentle color-green and pink were being used, meanwhile the high color contrast also tell people it is a Duo exhibition. With elements from their paintings, let people can feel the happiness while they watch the poster.

氹仔圖書館標識系統 Taipa Library Signage System　2015　P.60
氹仔圖書館為澳門氹仔區域一大型圖書館，致力於為市民尤其是青少年及家庭讀者提供服務。館內設計及佈置以鮮亮色調為主，歡快的基調為讀者提供輕鬆舒適的閱讀環境。
此次設計，配合空間的結構，創造出圓滑的弧度及新鮮的字體及圖標。使得設計俱有識別度，便於讀者快速地辨認亦為新圖書館建立識別形象。一切為了更好的使用館中設施服務。
Taipa Library is a large library in Macau's Taipa district which dedicated to providing reading services. The design and decoration inside the library mainly use bright color so the cheerful background provides relaxing reading environment to the readers.
For the design, in conjunction with the space structure, we use sleek arcs and a brand-new typeface to make the design highly recognisable and give the library a new image. Meanwhile, signs with clean lines also provide clear direction information to the readers. All is for provide better service.

抗戰時期的澳門社會民生攝影展 Exposicao de Fotografias-A Sociedade de Macau Durante a Guerra Sino-Japonesa　2015　P.60
為紀念中國人民抗日戰爭勝利暨世界反法西斯戰爭勝利七十週年，文化局澳門中央圖書館於 2015 年九月主辦 " 抗戰時期的澳門社會民生 " 攝影展及講座，從中反映當年澳門社會民生的情況。雖然抗戰是悲慘的歷史，但展覽更多的是體現澳門居民對難民的幫助、同為中國人共度時艱。所以特別以不同的角度出發，使用寶藍和金色、那個時代的美術標題字，詮釋這段金色歲月。排版上如同報紙，體現展覽反映史實，觀看時猶如翻閱一份陳年報紙一般。
To commemorate the 70th Anniversary of the Victory of Anti-Japanese War, Macau Central Library held the photo exhibition and seminar of life of Macau society during the Anti-Japanese War in September of 2015, to mirrors the life of Macau local community at that time. Although it was a miserable time, the exhibition mainly focus on how Macau people helped refugees to go through the hardest time. So we using a different way to do it. Using color of sapphire blue and gold, typical artistical typeface of that time to illustrate the Golden time . Combining the information of the exhibition, the poster's layout looks like a newspaper, shows the essence of the exhibition is to reflect the history, looking over the poster is like go through a old newspaper.

馬來西亞 Malaysia

Somethingwong

www.behance.net/karming

Something Wrong，生於 1993 年吉隆坡的平面設計師。 2014 年畢業於馬來西亞藝術學院。畢業後，他從事視覺設計、編輯出版、品牌形象、印刷品與紙張的研究。他喜歡與各個不同領域的專業人士工作，因從中能夠獲取不為人知的啟發。除此之外，他的一些早期作品都為他贏得了讚譽，如 Adobe Design Achievement Awards 2013 & 2014 和 Antalis Conqueror Happy Contest 2014 的金獎。

Somethingwong, a developing graphic designer born in 1993 Kuala Lumpur. Graduated from Malaysian Institute of Art in the year 2014. Upon graduation, he's been working on visual design, editorial, brand identity, printed matter and understanding papers. He enjoys working with different individual regardless of professions and often be inspired by untold stories. Some of his early works have won him recognition such as the Adobe Design Achievement Awards 2013 & 2014 and Gold Award in Antalis Conqueror Happy Contest.

Q. 請問您認為該國最棒的是什麼？(如國家的特色或文化等) 您的創作是否受其影響？

A. 馬來西亞最特別莫過於是多元種族和每個人都至少都懂兩個語言以上外，就是我們的設計也是蠻多元的：有的很荷蘭、有的很日本、有的也很西方等。這裏的生活方式沒有很直接的對我做事（設計）的方式有很大的影響。覺得做自己覺得對的，開心的事就對了。

Q. 請問您如何獲得靈感？

A. 通過與不一樣領域的人溝通和交流能夠領悟到極為獨特的構思和意見。畢竟每一個議題都有不一樣的言論和見解。那是我覺得最有趣的地方所在。

Q. 現在，回頭來看這些帶著遺珠之憾的作品, 您有什麼新的感觸？

A. 也不會覺得難過或者沮喪的。每一個沒被選中的個案都是給予我們一個機會做出更好的提案。

Q. 除了當設計師 / 插畫家，你是否已經開始規劃下一階段的目標？例如策展、學習煮菜、登山

A. 現在比較想要多接觸設計管理和印刷方面的知識，做純設計以外的東西。旅行也是在我的計畫之中。

Q. 你對生活的細節上有什麼堅持嗎？(像是上廁所時一定要看詩集之類的)

A. 好像佐藤可士和一樣，都是強迫症一族。桌上的東西都是排得整整齊齊的，自己的作品也不例外。

Q. What do you like best in your country? (such as country feature or culture)Has it made a difference on your creation?

A. I would definitely say it's the cuisines here and the multicultural with a variety of languages - Chinese, Malays, Tamil and other native languages. Thats what make this country special in its own way. Other than that, the design scene here might not seem to be outstanding but our design culture do have our very own influences. The overall culture don't really directly change the way I approach my profession, doing the right thing for the client is always my way I guess.

Q. How do you draw inspiration?

A. I often inspired by talking to different individuals despite of their professions. They can be musician, marketer, interior designer, businessman, educator or whoever your life comes across with. There are so many experiences and stories you do not know about, that's fascinating to me.

Q. Now, look back to these works of regret for not been selected, how do you feel that?

A. When my works are not selected, most of the time I don't really feel bad as I know there must be a reason. They might have something better or more suitable for their needs. If I get rejected, I'll take it as another opportunity to approach the project in a different direction. There are more possibilities and you can push yourself better.

Q. Have you started to set up new goals for next period except being a designer or illustrator ? like curating, learning cooking , climbing......

A. For now, I wish to extend my ability to achieve greater tasks instead of just being a regular graphic designer who only lingers around AI, PS or ID. Maybe client servicing, management and involve more in the production process. This is the reason why I started working as a freelancer than being employed. To start travelling is on the list too!

Q. What is your insist on your life's details ? like toilet with your favorite poem?

A. I am a OCD Like Kashiwa Sato. There are always clean and tidy on my desk,and so were my works.

Self Initiative, "Hi, Me and My Family" 2015 P.102
早期成長的系列海報，我時常思考擁有家庭的意義，在一起和分開、作為中國人、做為多元文化背景下的個體 這是我的故事的一部份。
A series of early developed posters. I often questioned about the meaning of having a family, being together and separated, being a Chinese, being an individual in a multicultural context... This is a part of my story.

Red Packet Design Proposal 2015 P.236
2016 年猴年紅包設計的提案，紙張經銷公司的年末附屬設計。
A red packet design proposal for the year of monkey, 2016. A year end collateral design for a paper distributor company.

Kyoorius Launch Book Cover Design Proposal 2014 P.237
書封設計，Kyoorius 2015 年推出的書，印度。
A book cover design for the editorial—Kyoorius 2015 Launch Book, India.

Kyoorius Subscription Card Design Proposal 2014 P.237
視覺設計，Kyoorius 的訂閱卡。
A series of visual designs for Kyoorius's subscription card.

日本 Japan

2012 年畢業於武藏野美術大學視覺傳達設計學科，開始成為自由設計師，活躍在平面設計、品牌設計、展覽設計、畫冊設計等。

Graduated from Dept. Visual Communication Design Musashino Art University in 2012, and started working as a freelance designer. Being active in graphic design, branding, exhibition design, book design, etc.

大崎奏矢　Soya Ohsaki

www.soyaosaki.com

Q. 請問您認為該國最棒的是什麼 ?(如國家的特色或文化等) 您的創作是否受其影響？

A. 我最喜歡自己國家的部分是, 抱持著關懷彼此的精神, 我們只向自然與食物表示敬意, 而不是人。這樣的精神對我的設計來說也十分重要, 如果你不能尊敬客戶還有主題, 那麼好的設計就不會誕生。

Q. 請問您如何獲得靈感？

A. 在我感到放鬆的時候, 像是散步欣賞風景、與友人父談。

Q. 請和我們分享您喜歡的書籍、音樂、電影或場所。

A. 我喜歡日式庭院, 其中足立美術館、兼六園、殿谷戶庭園都令人印象深刻。

Q. 你對生活的細節上有什麼堅持嗎 ?(像是上廁所時一定要看詩集之類的)

A. 走在路上的時候, 如果發現一些有趣的排版設計我就會立刻拍下來, 對我幫助很大。好玩的排版設計總讓我會心一笑。

Q. What do you like best in your country? (such as country feature or culture)Has it made a difference on your creation?

A. I like the most in my home country is the spirit of caring for each other. Only we are living pay homage to nature and food, rather than people. Its spirit is also important in my design work. If you cannot pay respect for the client and subject matter, good design will not born.

Q. How do you draw inspiration?

A. I have received a lot of inspiration when you are usually relaxed. For example, of the way to work landscape, a conversation with friends.

Q. Share good books, music, movies or places with us.

A. I like the Japanese garden. Among them Adachi Museum of Art, Kenrokuen, such as Tonogayato garden are impressive.

Q. What is your insist on your life's details ? like toilet with your favorite poem?

A. I will take a picture if I find some interesting typography designs when walking down the street. They would be helpful. Amusing typography makes me smile.

闇の器 Yami no Utuwa　2014　P.41
裝幀設計, 對象是川崎雄司的書《闇の器》。
This work is a book design of "darkness of the vessel", written by Yuji Kawasaki.

渦 Uzu　2014　P.42
由川崎雄司撰寫的小說, 由三個章節組成：蜥蜴、鳥、青年。
This work, Yuji Kawasaki wrote, is a novel that consists of three chapters, "lizard", "bird", "youth".

立體主義的排版 Typographic of Cubism　2012　P.103
以立體主義為創作概念的海報。
This work is a poster that was made by the modeling philosophy of cubism to the concept.

仮面の子 Children of Mask　2014　P.103
在坂爪康太郎舉辦以面具為主題的展覽中展出的海報。
This work is a poster for the exhibition of Kotaro Sakazume in which the mask theme.

STUDIO FORMGIVING poster　2014　P.103
替 STUDIO FORMGIVING 製作的公關海報。
This work is a poster made for public relations of STUDIO FORMGIVING.

ALBAn　2014　P.146
餐廳品牌設計, 我們設計了企業識別、傳單和網站。
This work is branding work for the project to the catering service. We made the CI and leaflet and web.

PARADI　2013　P.146
時尚品牌 PARADI 的品牌設計工作, 我們做了企業識別、包裝還有吊牌。
This work is branding works of fashion brand PARADI. We made the CI and packaging and tags.

Spiral Scole　2015　P.255
在多元的文化設施「Spiral Scole」舉辦活動時的海報文宣設計。
This work is flyer design of the event, which was held in the complex cultural facilities spiral.

台灣 Taiwan

我們是一間小獨立設計工作室。主要是為國際或本地客戶做品牌形象設計及數位解決方法。

We are a small independent design studio, focusing on brand identities, digital solutions and objects for international & local clients.

Studio Weidemüller

www.weidemuller.com

Q. 請問您認為該國最棒的是什麼?(如國家的特色或文化等)您的創作是否受其影響?

A. Jan: 身為一個外國人居住與工作在台灣,來自多方面的衝擊,文化、食物、環境、建築和語言上多方面的不同皆深深影響了我的創作,對我來說這裡猶如另一個星球,跟我出生的地方徹底的不同!同時我也發現我自身文化的差異與學習珍惜它,這幫助我打開視野更且更樂意嘗試新事物!

Juimei: 最棒的是自由,每個人都可以做他們自己,創造出自我特色!

Q. 請問您如何獲得靈感?

A. Jan: 出外走走,旅行和持續對事物有興趣,這些平常可做的生活小細節都是我的靈感來源,當然還有多閱讀書籍,雜誌,極簡風格,日本文化和網站瀏覽,習慣性地收集世界各地有趣得設計!對我來說,最能激發出靈感的方式是變換環境,轉換工作地點與不同的人合作和瀏覽不同的事物.最重要的是不要等或找尋靈感,動手做就是了!

Juimei: 四處旅遊,多逛博物館,美術館吸收新知,網路也是一個很棒的資源。

Q. 請和我們分享您喜歡的書籍、音樂、電影或場所。

A. Jan: 書籍:The art of looking sideways. Movies: 動畫 Places: 永遠都喜愛倫敦,但是最好問 Jumei,他比我熟!

Juimei: 我個人很喜歡獨立音樂,音樂總是可以帶領我穿越不同的感官.倫敦是個很讚的城市,它擁有自己多面的文化和一直不斷的改變一直向前邁進。

Q. 現在,回頭來看這些帶著遺珠之憾的作品,您有什麼新的感觸?

A. 如果你無法順利賣出你的作品給客戶,那你就失敗了!

Q. 你對生活的細節上有什麼堅持嗎?(像是上廁所時一定要看詩集之類的)

A. Jan: 我的另一半,如果沒有他就不會有現在的工作室。

Juimei: 每日一杯咖啡,保持生活的活躍率與創造力!當然不斷的旅行是必要的!

Q.What do you like best in your country? (such as country feature or culture)Has it made a difference on your creation?

A. Jan: As I'm a foreigner living and working in Taiwan it has a huge impact on my output. Here are so much new things to discover. The cultural differences, the food, the environment, the architecture and the language. It's somehow like living in another world. I also discovered my own cultural difference and learned to appreciate them. It helped me to be more open minded and try new things.

Juimei: The best part in Taiwan which is "freedom", Everyone can be themselves and create with own personality.

Q.How do you draw inspiration?

A. Jan: There is no secret inspiration, go out, travel and keep your eyes open. Also books, magazines, minimalism, music, Japan, any kind of system and the internet. I collect all over the world interesting designs and put them in our archive. But one thing what works well for me is to change my environment. Work in different places, with different peoples and see different things. The most important is not necessary waiting or looking for inspiration. More important is to start working.

Juimei: Travelling, museums and webs surfing.

Q.Share good books, music, movies or places with us.

A. Jan: The art of looking sideways. Movies: I pretty much love animation Places: Always loved London, but better ask Juimei.

Juimei: me personally pretty enjoy some indie musics, it could bring you to different sense and feeling. London is an amazing city, it has own so many different sides with cultures and it always changing, moving forward!

Q.Now, look back to these works of regret for not been selected, how do you feel that?

A. If you can't sell your work you did fail.

Q.What is your insist on your life's details ? like toilet with your favorite poem?

A. Jan: My partner, without her this studio wouldn't be so successful in Taiwan.

Juimei: A coffee a day keep the life awake! Travelling! travelling! travelling!

Piano Piano Logo Design 2015 P.197

此設計概念是一個在於台北充滿獨立時尚生活風格女性的品牌,我們設計了一個新古典襯線字體,風格現代但永恆耐看與質感優雅。

Unused logo concept for a Taipei located lifestyle fashion brand for independent woman. We designed a neo-classic serif typeface, modern but timeless with elegant characteristics.

Blak typeface 2015 P.229

Blak 是當代對於黑體字簡化的詮釋,特殊設計可供展示用途與大膽的應用上。

Blak is a simplified contemporary reinterpretation of Blackletter. It's special designed for display purpose and bold application.

X-mas 2014 P.259

我們寄送給與客戶與好朋友們的一個 gif 動畫。

A gif animation we did send out to clients and good friends.

南韓 Republic of Korea

出生於韓國 1958 年，平面設計師。1995 年任職於 Namseoul University 當視覺傳傳教授。在韓國弘益大學獲得視覺傳達設計博士學位。2005 年曾擔任韓國包裝設計協會的主席，2011 年擔任弘益通信設計座談主席。2015 COW 國際設計展的陪審。亞洲海報前衛實驗設計展等，並在首爾、平澤、倫敦、日本大阪、名古屋、秋田、澳洲坎培拉舉辦個展。

Byoung-il Sun was born in Korea in 1958. Graphic designer based in Seoul. Professor of Visual Information Design at Namseoul University since 1995. Received a doctoral degree in Visual Communication Design at Hongik University in Korea. In 2005, he served as a chairman of the Korea Institute of Packaging Culture Design. In 2011, he also served as a chairman of Hongik Communication Design Forum. Jury at France Poster for tomorrow, COW International Design Festival. 2015. Asia Next Poster Experimental Design Exhibition, etc. His solo exhibitions have been held at Seoul, Pyeongtaek, London, Japan Osaka, Nagoya, Akita, Australia Canberra.

宣炳一　Sun Byoung-Il

www.sunbi.kr

Q. 請問您認為該國最棒的是什麼?(如國家的特色或文化等) 您的創作是否受其影響？

A. 超過五千年的文化底蘊。我愛我的國家受宗教、科學、藝術和文化，完美和諧的創造多樣化的文化遺產。藝術精神包含神秘和奇妙成為一個巨大的背景，在這個悠久燦爛的文化中往往會影響我的創作。

Q. 請問您如何獲得靈感？

A. 我的靈感來自於世上萬物。此外，每個象徵都來自於一件事物，而每張圖的基礎都是個象徵。針對這點，我總是記下我的靈感，而圖全都來自於這裡。

Q. 除了當設計師 / 插畫家，你是否已經開始規劃下一階段的目標？例如策展、學習煮菜、登山……

A. 現在，我的最終目標是經營一間社會企業型的學院或另類的學校，像是一個創意小學校、海報學校、有想像力的學校。我想給年輕人思考自己的職業生涯，或者因為經濟困難但未來有巨大潛力成為偉大藝術家有一個地方可以去。

Q. 你對生活的細節上有什麼堅持嗎?(像是上廁所時一定要看詩集之類的)

A. 我的設計從「尋找」開始。幫助我有不同的觀點看世界，以實驗的形式完成，然後將共存的意義實現。設計是「停」，但我一直持續思考，不斷前進吧，美學的完整成為繼續創作的動力。

Q. **What do you like best in your country? (such as country feature or culture)Has it made a difference on your creation?**

A. About 5,000-year-long cultural heritage.
I like my country's diverse heritages created by a perfect harmony among religion, science, art and culture. The art spirits containing mystery and wonder become the huge spiritual background of a formative form. Our glorious culture in this long history often affects my creation.

Q. **How do you draw inspiration?**

A. All my inspirations begin with things, and I get ideas from them. In addition, a symbol is found through things, and an image is configured based on this symbol. For this, I always use my inspiration note. All my works originate from the images in this note.

Q. **Have you started to set up new goals for next period except being a designer or illustrator ? like curating, learning cooking , climbing......**

A. Right now, my ultimate goal is to establish and operate a social enterprise-type academy or an alternative school such as a small creative school, poster school and imagination school. I want to give young people who have no room to think of their career or future because of economic difficulties despite a great potential an opportunity to grow into great artists with a decent program.

Q. **What is your insist on your life's details ? like toilet with your favorite poem?**

A. My design starts with 'searching.' Here, 'searching' helps me have a vision to see the world with a different perspective. It is completed with an experimental form, and then a true meaning of coexistence is realized. Design is 'stopping.' However, my thinking continues all the time. Keeps moving forward! The aesthetics of completion becomes a driving force for creation.

Forest to precede civilization, desert to follow　*2014　P.130*

法國作家－夏多布里昂曾說過：「在森林和文明之前，在沙漠和文明之後（森林前導文明，而沙漠緊跟在後）。」人類文明可能在樹林中開始，幼發拉底河、底格里斯河兩河流域發展的尼羅河文明和印度河文明、黃河文明也是。雨林明顯是最大的資源支持這些早期文明成長。然而，讓早期文明發源的這些雨林，如今只剩於沙漠。人類生活就是你與自然生態和它的壽命，而正確的答案就是共存的智慧。

French writer Chateaubriand (F. Chateaubriand) is "in front of the forest and civilization after civilization remains in the desert" (Forest to precede civilization, desert to follow) left a word. Human civilization may have begun in the woods. Euphrates Mesopotamia civilization occurred, the Tigris River by the way were able to thrive in a Nile civilization and the Indus civilization, the Yellow River civilization womb and also forest. The forest was a source of significant resources to support the population increase in these early civilizations. However, the forests that can happen in many of these early civilizations originated based on today we found only desert. Humans live, is that even you can be with natural ecosystems can be the life of a true ecosystem. The right answer is the wisdom of co-existence.

Puchon International Fantastic Film Festival Official Poster　*2014　P.130*

於 2008 年 7 月 18 至 27 號的第 12 屆富川國際幻想電影節官方海報。由圖像、幻想、高漲的自由所設計，自由地在天空中飛翔，多彩的翅膀像是希臘神話中的伊卡洛斯。翅膀代表自由、想像、幻想，通過富川國際幻想電影節傳達高漲的信息。雙翼在人類的內外意味著推測的變化。

An official poster of the 12th Puchon International Fantastic Film Festival which was held from July 18 to July 27, 2008. This poster designed under the theme of 'imagination, fantasy and soaring for freedom' illustrated a person freely flying in the sky with colorful wings just like 'Icarus' in Greek mythology. The wings represent 'freedom, imagination and fantasy,' sending a message of 'soaring' through Puchon International Fantastic Film Festival. These wings painted on both inner and outer sides of a human mean changes in speculation.

Education　*2011　P.132*

人們已經有教育的觀念。通過各式書籍，教育環境、人性化、智慧和學習已經逐漸成熟。海報表現出教育對於人的多重要。

Through education, the concepts that people are finished. Knowledge through a variety of books that are educational environment and humanity, wisdom and learning mature gradually. The poster for growth as a human right stressed the importance of education.

How long will it last?　*2014　P.132*

嚴重的警告因為人類造成的環境破壞，在人臉上有許多動物的剪影，反射出現今的環境，其價值還會持續多久。

It warns serious environmental destructions caused by men through an illusion comprising diverse animal images in a human, reviews current environment and asks how long its value would last.

Oil Spills affect human life　*2007　P.132*

一艘油輪在朝鮮半島西部的海上漏了 12,547 公斤的石油。這使六個城市在這次遭了大災難，46 種魚類因此消失。現在看來，這將需要幾十年來回復。這張海報強調了環境的重要性，注重漏油的可能。強調因為人類的消極和漂浮的油桶，視覺化他們的暴行。傳達了一個信息、人為災難，最終影響人類。

An oil tanker spilled 12,547 kg of crude oil into the sea west of the Korean Peninsula.
It was a catastrophic accident in which six cities suffered from this disaster, and 46 fish species disappeared. It appeared that it would take tens of years to restore the ecosystem. This poster emphasizes the importance of environment, focusing on oil spills. It attempted to emphasize the pain of oil spills through people's negative forms and floating oil barrels and visualize their brutality. It delivers a message that a manmade calamity eventually affects men.

Our wish is barrier-free sky　*2013　P.132*

住在加沙的巴勒斯坦人被以色列圍困的悲慘人權狀況，同時傳達給他們希望。「我們的願望是沒有阻礙的天空」，天空、雲、文字。

It attempted to warn the miserable conditions of human rights of Palestinians who live in Gaza under Israeli siege and, at the same time, deliver their hope. This image emphasizes 'Our wish is barrier-free sky' with the sky, cloud and text painted on a block.

I wish to fly　*2003　P.132*

以生活和生態的重要價值為主題，描述實現必須通過密閉的框架的蝴蝶，並希望變得更加貼切。

The value of a life and the importance of ecological environment are themed. It described the realization of reality through a motive of diverse butterflies confined in a frame and hope which becomes more ardent.

Save our food-No more GMO　*2014　P.132*

一顆馬鈴薯，因為基因改造變成有尖銳的刺的基因品，強調基因改造 (GMOs) 的破壞性。警告 GMO 已成為更加嚴重的危害。

This poster emphasizes the devastating aspects of Genetically Modified Organisms (GMOs) by describing sharp thorns on a potato, one of the GMO crops. It tried to warn the hazard of GMO environment that has become more serious.

日本 Japan

上杉 滝 Taki Uesugi

www.knotfor.co.jp

1977 年出生於日本大阪，2003 年畢業於東京造形大學美術學科後，在 "gift unfolding casually" 工作，2013 年設立公司 " Knot for "

得獎：

2016 東京字體大獎 / 入選
2015 臺北設計獎 / 銅獎、評審團推薦獎
第 11 屆日本富山國際海報三年展 / 入選

Born in Osaka Japan, 1977. After majoring in painting, he graduated from Tokyo Zokei University in 2003. Working as freelance as well as at "gift unfolding casually", he established Knot for Inc. In 2013.

Award:

Tokyo TDC Award 2016 / Selected
Taipei International Design Award 2015 / Bronze Award, Judge's Special Award
The 11th International Poster Triennial in Toyama 2015 / Selected

Q. 請問您認為該國最棒的是什麼？(如國家的特色或文化等) 您的創作是否受其影響？

A. 提到日本文化，枯山水、能樂、琳派的作品都是非常美麗的，身為日本人，我也對此感到驕傲。使用具有不同含義的抽象事物，我認為是有吸引力的，透過廣泛的方式傳達視覺訊息，是視覺傳達設計非常基礎的方法，同時，我也相信好的設計不只包含這些而已，以電影為例，不只有簡單清楚的故事才能做出好的電影，當我們看到困難或深奧的故事，我們可以從表演者的動作、姿勢、臉部表情或風景感受到隱喻，我認為這也是構成電影有趣的要素。

日本文化喜歡注重這些隱喻，我也是。另一方面，現代文化像是漫畫與御宅文化也十分有吸引力。我的居住地東京是個充滿刺激的地方，我可以體驗世界上最先進的事物，新舊混合的日本文化與海外的文化、混亂與新奇是現在日本的魅力點，在創意方面，日本也許是個自由、充滿多樣性的國家。

Q. 請問您如何獲得靈感？

A. 有時候很難單從言語中去理解人們想要的是什麼，舉例來說，有時候從客戶的臉部表情、手勢或是說話方式的差異，可以獲得他們深層的需求。我相信在意到這種細微的感受與否，對於設計會產生極大的影響，我認為靈感就隱藏在深刻的洞察力之中。

Q. 請和我們分享您喜歡的書籍、音樂、電影或場所。

A. 我喜歡出現在我生活中的所有的音樂，我曾經非常著迷於音響設備，但非常燒錢，意識到不管擁有再多設備都沒有滿足之日的時候，我就放棄了。因為我在大學主修油畫，我喜歡去藝術博物館或是畫廊，和我的朋友們談談彼此的想法。

Q. 現在，回頭來看這些帶著遺珠之憾的作品，您有什麼新的感觸？

A. 因為這種事在我們的職業時常發生，我不怎麼在意。我寧願專注在如何在下一次的提案中想點子。

Q.除了當設計師 / 插畫家，你是否已經開始規劃下一階段的目標？例如策展、學習煮菜、登山 ⋯⋯

A. 工作空檔時我會去衝浪和做瑜珈。維持身心健康讓我變得積極且充滿創意，和只是在電腦前工作相比，衝浪和做瑜珈帶給我工作上良好的影響，此外，除了客戶的工作，我也會自行創作提升自我。

Q.What do you like best in your country? (such as country feature or culture)Has it made a difference on your creation?

A. In terms of Japanese culture, these works of, Dry Landscape Gardens (枯山水), Noh (能樂) or work of "Rimpa"(琳派の作品群), are very beautiful and as Japanese, I am very proud of them. By abstracting objects, they include various meanings, which I believe is appealing. Conveying information visually in a comprehensive way is fundamental for visual communication design, yet at the same time, I believe only these does not create good design. For example, thinking of movies, only clear or easy story does not make the movies interesting. When the story was difficult or abstruse, we could feel metaphor from actors' lines, pause, face expression or scenery, which I believe make the movie interesting.

Japanese culture tends to value these metaphors, and this is the one of the things I like about. On the other hand, modern culture such as Manga (漫画) and Otaku culture (オタク文化) are also attractive besides old traditional ones. Tokyo where I live is very exciting and I can feel the most modern things from all over the world. Mixture of new and old, Japanese culture and cultures from all over the world, chaos and novelty are the attractive parts of current Japan. In terms of creativity, perhaps, Japan is a country of freedom with diversity.

Q.How do you draw inspiration?

A. Sometimes, it is difficult to understand what people want from only their words. For example, sometimes it is very important to gain a deep insight into clients' facial expression, gestures or how they use words differently.
I believe that design is greatly influenced whether you notice a slight feeling nor not. And I believe inspiration is hidden behind such deep insight.

Q.Share good books, music, movies or places with us.

A. I love all kinds of music, which are always in part of my life. Once I was really into the Audio devices, however money went quickly. Since I realized that how much you have it would not be enough, I gave up. Since my major in university was Oil Painting, I love to go to the art museum or gallery just chatting our thoughts with my friends.

Q.Now, look back to these works of regret for not been selected, how do you feel that?

A. Since this always happens in our job, I would not mind. I would rather focus on how to propose the ideas for next projects.

Q.Have you started to set up new goals for next period except being a designer or illustrator ? like curating, learning cooking , climbing......

A. I surf and do yoga if I have free time during work.
By sustaining health physically and mentally, I can be positive and creative. Compared with having used to work just on my computer, surfing and doing yoga give very good influence on my work. Plus, in parallel to the clients' work, I also create my work in order to meet my aesthetic.

致敬喬治·莫蘭迪 Hommage a Giorgio Morandi　2015　P.110
向喬治·莫蘭迪致敬。使用攝影棚零碎的照片創造出來的視覺空間。
An homage to the painter Giorgio Morandi.
A visual space created by using fragmented photographs of a photography studio.
Knot for, Inc.　2015　P.110
設計工作室 Knot for, Inc. 宣傳設計。「一個結連接兩條繩子」的設計主題，傳達了公司的哲思。
An advertising design for the design office "Knot for, Inc."
The design of "a knot connecting two strings" is a motif to convey the philosophy of the company.
靜物畫 (致敬喬治·莫蘭迪)NaturaMorta (Hommage a Giorgio Morandi)　2015　P.111
向喬治·莫蘭迪致敬。用物件構成字母，遵照靜物的佈置排版，再用炭筆畫出來。
An homage to the painter Giorgio Morandi. Letters were physically built, laid out and positioned as a still life, then drawn with charcoal.
SPACE SHOWER RETSUDEN　2013-2015　P.112
日本音樂頻道 "Space Shower TV" 舉辦活動時的視覺，被使用在海報、傳單、官方網站和實際的活動空間裡。
A visual created for an event held by the Japanese music channel "Space Shower TV". It was used in posters and flyers, as well as on the official website, CM, and shown in the actual event space.

台灣 Taiwan

蔡佳豪 Tsai Chia-Hao

www.behance.net/tsaichiahao

蔡佳豪，1986 年生於台灣台北，
2010 年畢業自景文科技大學視覺傳達設計系，
現從事書籍裝幀設計、展演活動視覺設計、視覺
識別設計 … 等平面設計事務，
2013 年三件作品入圍 GDC13 平面設計在中國，
2014、2015 年數件作品入選《亞太設計年鑑
Asia-Pacific Design》。

Tsai Chia-Hao, born in 1986 in Taipei.graphic designer.
Especially keen on book design、Packaging、typography、
Visual Identity、performing arts、exhibition.
3 GDC13 nominations.（Graphic Design in China 2013）、
included in Asia Pacific Design no.10/no.11.

Q. 請問您認為該國最棒的是什麼 ?(如國家的特色或文化等) 您的創作是否受其影響 ?

A. 食物。

Q. 請問您如何獲得靈感 ?

A. 上網、看電影、看書、看雜誌、玩樂、與人聊天、放空、看 NBA、吃飯。

Q. 請和我們分享您喜歡的書籍、音樂、電影或場所。

A. 最近多了一個深愛的樂團：King of Leon，主唱歌聲很有特色，非常推薦。

Q. 現在，回頭來看這些帶著遺珠之憾的作品，您有什麼新的感觸 ?

A. 說明作品和說服客戶的能力永遠都可以再進步。

Q.What do you like best in your country? (such as country feature or culture)Has it made a difference on your creation?

A. Food.

Q.How do you draw inspiration?

A. Surfing, see the movies, read the books or magazine, chat with people, space out, watch NBA, eat.

Q.Share good books, music, movies or places with us.

A. Recently I am in love with a band: King of Leon. The vocal has distinctive voice so I strongly recommend them.

Q.Now, look back to these works of regret for not been selected, how do you feel that?

A. It tell us that you can always improve your ability to convince the clients.

北埔民•居 2015 P.15
理所當然地以黑白照片呈現老街的歷史感。而老房子的手繪稿則提升其中的溫度，自行設計的書名字體帶點古樸又兼具現代感，讓整體風格不會往陳舊的方向偏去。
Naturally use black and white photographs to show a sense of history of the old streets. The hand-painted pieces of old house raised the temperature on it. The self-designed title font makes people feel a little of both ancient and modern, so that the overall style does not trend to the old way.

有一種謠傳 There is a rumer 2015 P.15
利用漫畫對話框的變形，表現「謠傳」的傳播感、以及它帶有曲解成分的不確定感。
Using the deformation of comic dialog to present the sense of spreading "rumors" and the uncertain of its composition of twist.

佛陀標準時間 - 1&2 Buddha Standard Time - 1&2 2015 P.15
為了呼應佛陀標準時間是「每個人在每個刹那皆可取得」，左邊這款在畫面上作出時間的進行感。副標每個字中間都加了一橫劃，依附在像是翻頁鐘也像是老式手動日曆的數字旁，除了呼應書裡重點的每個刹那間，橫畫的漸淡，也加強了時間的流動感。右邊這款在十二個圓圈（時鐘意象）邊緣各放了一個隨機的點，象徵時間裡的任何一刻、一刹那，時鐘後方隱約可見佛臉的線條，則呼應了本書的佛教內涵。
To work in concert with 'Everyone can be received in every moment' from "Buddha Standard Time," I present the sense of processing time on the picture, as to the subtitle, each word is inserted with horizontal stroke, and next to the numbers which like flip clock or old-fashioned calendar. Except that, the horizontal line gradually grow faint in order to strengthened a sense of the flow of time.In concert with 'Everyone can be received in every moment' from "Buddha Standard Time," The left work I present the sense of processing time on the picture, as to the subtitle, each word is inserted with horizontal stroke, and next to the numbers which like flip clock or old-fashioned calendar Except that, the horizontal line gradually grow faint in order to strengthened a sense of the flow of time. The right work I put a random point in each edge on the twelve circles (with the image of clock), as a symbol of the moment of time, behind the clock you can see the line of face vaguely, it echoes the intension of Buddhist from this book.

The more I see, the less I know for sure. 2014 P.220
在畫面裡將「MORE」和「LESS」的意象表現出。
Present the image of "more" and "less" on the picture.

台灣 Taiwan

蔡慕吟，台南應用科技大學視覺傳達設計系畢業，台灣雲林縣人，現居於台南市，專長範疇涵蓋字體設計、品牌設計等平面設計。

Mu-yin Tsai, graduated from the Department of Visual Communication, Tainan University of Technology. Born in Yunlin, Taiwan and now living in Tainan City. Specialize in typography design, brand design and graphic design.

蔡慕吟　Tsai Mu-Yin

www.behance.net/mu-yin

Q. 請問您認為該國最棒的是什麼？(如國家的特色或文化等) 您的創作是否受其影響？

A. 我認為最棒的是傳統的文化色彩及鄉土民情。自小生長於雲林的小農村，眼前看到的都是田野風光，水牛農耕、採收、煙窯。我擁有了許多有趣的生活體驗，而這些自小我都能見到的景象，在我創作二十四節氣字體時，有著相當的幫助，因為那是再平凡不過的大自然了。雖然目前尚未完整的將二十四個節氣創作完成，但我會持續努力。

Q. 請問您如何獲得靈感？

A. 如果將字體設計分為理性與感性，那麼理性，所指的就是有好的基礎、美感的培養。感性，則是對生活周遭的體悟。我想大概也是因為自己滿喜歡看書的原因，所以當看完一篇文章或聽到一首歌，喜歡用文字設計傳達它深厚的含義。

Q. 除了當設計師 / 插畫家，你是否已經開始規劃下一階段的目標？例如策展、學習煮菜、登山

A. 除了設計師的職位以外，下一階段的目標希望自己能經營一間設計結合飲食的小店。以台灣小農辛苦栽種的蔬果為食材，並加入美學 (擺盤、室內空間設計等)，營造味覺與視覺獨特的饗宴。

Q. 你對生活的細節上有什麼堅持嗎？(像是上廁所時一定要看詩集之類的)

A. 喜歡把字寫的很工整，例如填一份資料或寫一篇文章，希望可以把字寫的工整到不需使用修正液 (帶)。

Q. What do you like best in your country? (such as country feature or culture)Has it made a difference on your creation?

A. I think the best part of my country is the traditional color and local culture. Growing up in the small rural of Yunlin, I could see all the fields scenery, the buffalo farming, harvesting, Kang Yao...... I have so many interesting life experiences, and these scenery I saw from my childhood help me a lot when I was design the typography of the 24 solar term. Because it is the nature which can't be more common. Although I have not complete this creation, I will continue to try hard.

Q. How do you draw inspiration?

A. If you divide the typography design into sense and sensibility, then the sense would refer to all the good foundation, cultivating of beauty. Sensibility, it is the realized that you learn from life. Probably because I like reading, so I am used to communicate the profound meaning by typography design after reading an article or listen a song.

Q. Have you started to set up new goals for next period except being a designer or illustrator ? like curating, learning cooking , climbing......

A. In addition to being a designer, for the next step, I set a goal that manage a shop combine design and food. Using fruits and vegetables from Taiwan's farmers, and mixed with aesthetic(the art of plating food, interior design, etc.), to create a unique feast of taste and visual.

Q. What is your insist on your life's details ? like toilet with your favorite poem?

A. I like to write words neatly, for example, I hope to fill in an information or write an article without using correction fluid (tape).

MEI YUN WU 珠寶工作室 L'ATELIER de MEI YUN WU　2015　P.202
MEI YUN WU 為珠寶設計師名字，LOGO 以 M、Y、W 及珠寶閃亮的意象為架構，L'ATELIER 則為法文中工作室之意。L'ATELIER 使用 Futura 字型，呈現沈穩、尊貴的感覺。黑色搭配金色更顯出出珠寶設計師給人的氣質。
MEI YUN WU is the jewelry designer's name. The Logo use M, Y, W and the shinny image of jewelry as the structure. L'ATELIER means 'studio' in French, I choose Futura font to present the calm, noble feeling. Black with gold color gives the temperament of jewelry designer.

二十四節氣 The 24 Solar Terms　2014　P.226
字體的架構、元素及配色詮釋節氣的意境，並表現節氣在自然界中產生的現象。
The structure, elements and color of typography, interpret the conception of the seasons, and present the phenomenon in nature.

作伴 Keep you company　2015　P.227
七夕是一年當中，牛郎和織女相見的日子，以「作伴」兩字為主軸，牽引出兩人在七夕相會刻骨銘心的故事。
Chinese Valentine's Day is the day the cowherd and the Weaving Maid could meet each other on the magpie bridge. Using two words " 作　伴 "(means keep company) as the main idea to present their unforgettable story.

Christmas Cards　2013　P.227
字體以禮物緞帶的形態做文字架構，印刷後加工則使用留白打凹的方式，如冬季的雪景，在寒冬傳達給對方溫暖的祝福。
With the form of gift ribbons to create the architecture of typography, using white space an dented after printing, looks like a snow sense in the winter, convey a warm blessing to you.

元宵卡 Lantern Festival Cards　2015　P.227
以燈籠的形體發想「元宵」兩字，台語諺語「十五上元暝」，元宵節是新年最後的壓軸節慶，又元宵節因以燃燈為主，故也叫做「燈節」。
Using the shape of lantern to express two words: "Yuan" and "xiao." In Taiwan, there is the old saying goes: " On the 15th, the night of January 15," The Lantern Festival is the last festival before the New Year, and due to the lantern-lighting based festival, it is also call the "Festival of Lights."

台灣 Taiwan

曾國展，臺灣平面設計師。畢業於雲林科大，視覺傳達設計系。目前專職於平面設計領域，包含字體造型、企業識別系統、品牌、展演活動、書籍封面、雜誌排版、藝文表演等平面設計。作品曾收錄於 Victionary、Design360° 雜誌、APD-亞太設計年鑑。

Green Tseng, Taiwanese Graphic Designer. Graduated from the National Yunlin University of Science and Technology with a Bachelor Degree of Visual Communication Design. Currently working as a freelancer, specializing in Graphic Design include CIS, VI, Branding, Book Cover, Magazine Layout, Commercial Photography, and Filmmaking. His works were printed by Victionary, Design360° and Asia-Pacific Design.

曾國展　Tseng Green

www.behance.net/tsengreen

Q. 請問您認為該國最棒的是什麼?(如國家的特色或文化等) 您的創作是否受其影響？

A. 臺灣的文化承襲過往卻對未來產生迷惘，並不是說臺灣沒有文化，它其實是歷史淵源很深的國家，經歷殖民與現代的洗禮為這片島嶼醞釀出豐厚的人文價值，但對於其推廣層面與傳承明顯不夠深入，我們總是看不見自己，卻往往推崇國外的流行事物，這當然也是個有趣的現象，同時這也一直影響著我們，因為我們都正在試圖探索自己的文化與風格，而設計師如是。

身為使用漢字的華人，文字是我們最常接觸的媒體，它承載著溝通與文化演進的使命，可說是相當具有指標性。但在我的觀察裡，臺灣目前仍是個講求功能性大於美感的國家，我們的招牌與資訊媒介往往傳達了資訊卻忽略美感，各種不拘小節與不講究字體設計的公共指標讓大眾下意識默認這樣的現況，或許帶著這一份倔強，讓我對於字體設計有種堅持，希望能夠透過文字傳達文化內涵，透過文字傳達漢字的美與其不同的可能性。

Q. 請問您如何獲得靈感？

A. 靈感來自於生活經驗的累積。我喜歡動手做設計，在不斷練習中累積對於設計風格的經驗，不管是不是商業案，只要有好的題材就動手嘗試，我認為技術經驗的累積如同寫書法一樣，熟能生巧後便能掌握字體的精髓，當然靈感一來做什麼都快，但透過經驗，我們可以更快速的讀取記憶中的感覺，甚至是從過往的經驗中去創造出不同的可能。當然，如果真的沒有靈感時，我認為討論是一個很棒的方式，我們可以找朋友討論，不要以發想的方式去做思考，而是以對話的方式去發現問題尋找答案，透過溝通我們可以激盪出不同的答案，因為每個人思考的方式不同，丟出來的答案也不會一樣。

Q. 現在，回頭來看這些帶著遺珠之憾的作品，您有什麼新的感觸？

A. 槍稿或練習的作品其實就像素材，當你有需要的時候，回顧過往的作品也許能帶給你答案。也許這次沒有嘗試的風格留到下次會有更好的表現，這都不是不可能；練習的作品也是，練習是為了更熟能生巧，好幫助下一次面對不同狀況，因此如果調整心態，會發現這些作品其實都是幫助自己變得更穩重、更有效率。另外，更重要的是「檢討」的過程，每一件作品我們都希望可以被客戶採納，但當它沒被客戶選用時，透過檢討與反省的過程，能夠幫助我們釐清問題，為什麼沒被選上？是否與客戶地溝通上產生問題？如何在下一次提案時更有效地掌握客戶的需求？這些甚至是幫助自己成長更快的方式。

Q.What do you like best in your country? (such as country feature or culture)Has it made a difference on your creation?

A. Taiwan's cultural inherited the past but then being lost to the future, doesn't mean there is no culture of Taiwan it is actually a historical origin country, experiencing the colonialism and modernization made this island brew rich cultural value, but obviously the promotion and inheritance are not deep enough. We always admire popular things from abroad but ourselves, which is a interesting tread. Meanwhile, this also affect us, because we are trying to explore our own culture and style, so do the designers.

As the user of Chinese characters, the text is the media we most contact with. It carries the mission of communication and cultural evolution, it can be said to have quite indicative. But in my observation, Taiwan is still a country emphasis on function than aesthetics. Our signboard and information media often convey information but ignore the aesthetics, the variety of public indicators do not pay attention to typography design makes people acquiesce this situation. Perhaps is the stubborn and insist for typography, I hope to convey the culture connotations through the characters, to convey the beauty and possibilities of Chinese characters.

Q.How do you draw inspiration?

A. From the accumulation of life experience. I do love DIY and accumulate the experience of design style by constantly practice. whether it is a commercial project or not, I would try anything as long as there is a good subject. I think the accumulation of technical experience is the same as calligraphy, you can grasp the spirit after doing a lot of practice. Without a doubt that inspiration can help creating things faster, but with experience, we can read the feeling of memory more quickly, even create different possibilities from past experience. Of course, if you really do not have inspiration, I think the discussion is a great way, we can find a friend to discuss, try not to develop conception, instead, try to find the questions and search the answer in the way of dialogue. Through the communication, we can bring out different answers, because each person has his way of thinking, and the answer they throw out will not be the same.

Q.Now, look back to these works of regret for not been selected, how do you feel that?

A. Draft or practice piece is like a material. When you have and hold a need, reviewing past works may be able to give you the answer. Perhaps that the style you did not try this time will have better performance next time, it is not impossible. So as the practice works, they are made to be perfect in order to help facing different situation next time. If you adjust your attitude, you will find these works are actually helping yourself to become more stable and more efficient. In addition, the process of "examination" is more important for us, we hope each works can be adopted by clients, but when it is not selected by clients, we should review and reflection then clarify the problem. Why they have not been selected? Does it cause problem with communication? How to grasp client's need more effectively next time? These are the faster way for us to grow up.

獨立急行インディーエクスプレス INDIE EXPRESS　2015　P.91
標準字設計上，在文字設計上加上指引與匯集的意向。字體選擇粗獷有氣勢的特粗黑體為設計骨架，結合列車車廂緊密連結的特性，將字體的負空間緊密地扣在一起。
The design imagery of typeface is to lead and to integrate. The powerful and masculine font is the design structure, combined with the characteristics—closely attaching—of passenger cars, links the negative space in the font.

東京都 Tokyo Info.　2012　P.220
以東京旅遊導覽海報為創作概念，字體設計以日本國旗代表顏色紅白兩色直接體現於作品本身，造型結構以日本繁複的交通網絡為基礎。
The creative concept of the poster is based on Tokyo travel guide. The font design integrates with the colors of red and white, which represent Japanese flag. The structure type reflects complex transportation network in Japan.

公轉自轉 Rotation & Revolution　2014　P.220
字體練習，假想空間的軸心，依照字義做出轉動的特性，利用錯視製造出空間感。
Typography practice. Imaging the axis of the space, in accordance with the word meaning to make the rotation characteristics, and use illusion to create a sense of space.

倍潔雅 BEI-JIE-YA　2015　P.221
為倍潔雅產品重新塑造品牌標準字，此設計為提案階段的字體設計過程。
For rebranding the production of BEI-JIE-YA, I design the new Typeface and show a presentation

to client. This is the process of creating the typeface.

來日方長 Long day　2012　P.221
字體練習，透過重疊性的設計手法詮釋字意。
Explaining the meaning of the words by the design skill of overlapping.

花草與潮汐 Flowers And Tidal　2014　P.221
字體練習，嘗試將日文字結合中文字產生字體視覺上的新穎感。
Typography practice. I tried to combine Japanese characters and Chinese characters, creating new vision of typography.

方正之士 The Righteous　2012　P.221
君子守節如竹，方正之士意即品性端正者，以竹節之形築構文字之內涵。
Junzi should live up to his principles just like bamboo, the righteous means a person of good character, so I build the connotation in the shape of Bamboo.

書法 Calligraphy　2014　P.221
字體練習，中文與日文的淵源之深希望透過字體的表現結合，以中文漢字的架構搭配日文的平假名與片假名的筆畫，創造出有兩國文化下的字體結合。
Typography practice. I tried to present the combination of the deep origin between Chinese and Japanese through the fonts, using the structure of Chinese characters to pair with the strokes form Hiragana and Katakana, to create the fonts that have two cultures form Taiwan and Japan.

CTA

台灣 Taiwan

王俐婷，台灣設計師，接受了幾年視覺傳達設計的專業訓練。專注於實驗紙張材質與後加工技術，進而運用在書籍上以表現文本內容與增加讀者閱讀經驗。此外也規劃品牌形象，設計書籍以及活動視覺。現與伙伴成立目目和設計工作室，希望未來被商業案追著跑以外也能持續創作。

Taiwanese designer, LiTing Wang originally trained in communication design. She is interested in paper texture, printing technique and finishing. Her areas of work cover branding, book design and events visual design as well. Currently, she is working in Muho design studio that she found with her partner, hope can continue to doing design when chasing by case in the future.

王俐婷　Wang Li-Ting

www.cargocollective.com/litingwang

Q. 請問您認為該國最棒的是什麼？(如國家的特色或文化等) 您的創作是否受其影響？
A. 很多人都說台灣最美的風景是人，雖然感覺有點抽象但我也這麼認為。所以我喜歡創造跟人的互動有關的設計，喜歡觀者透過觸覺或透過親自體驗去感受我的作品。

Q. 請問您如何獲得靈感？
A. 逛超市，逛食譜網站。

Q. 除了當設計師 / 插畫家,你是否已經開始規劃下一階段的目標?例如策展、學習煮菜、登山
A. 開發健康的零食點心(認真的)，最近在研究無澱粉蛋糕，無糖零食，剛好搭配我需要靈感就想吃東西的壞習慣，希望很快有需要的少女們可以在我工作室的網站上買到!

Q. 你對生活的細節上有什麼堅持嗎？(像是上廁所時一定要看詩集之類的)
A. 當我感到焦慮或靈感枯竭時我喜歡不斷的吃東西，所以做設計時我喜歡隨手有綺果彩虹糖，她是我的工作良伴小小一包有好多顆可以一個接一個!

Q. What do you like best in your country? (such as country feature or culture)Has it made a difference on your creation?
A. The most beautiful scenery in Taiwan is the people. This is what this place is known for. A little be abstract, but I do think so. I think that is why I more like to focus on the interaction between my works and the people than just on sight or auditory sensation. I would like to know more about the inner needs of human beings.

Q. How do you draw inspiration?
A. Taking a trip to the supermarket. Surfing the recipes website.

Q. Have you started to set up new goals for next period except being a designer or illustrator ? like curating, learning cooking , climbing......
A. Working on studying the healthy dessert recipes (seriously)! Recently, I have a great interest in making gluten-free dessert and starch-free cakes. Hopefully, you can buy the products on my studio website soon!!!

Q. What is your insist on your life's details ? like toilet with your favorite poem?
A. When I feel anxious or inspiration dry up, I tend to keep eating. The Skittles has become my best companion when I do the design thing. A lot of small rainbow balls in one package. I can't stop it!

過於喧囂的孤獨 Too Loud A Solitude　2015　P.40
藉由更多的感官體驗帶領讀者感受故事，這是一本關於知識與思想不滅的故事，關於知識所帶來的毀滅以及新舊時代衝突的故事。我的目的是希望透過對於構成一本實體書的元素的安排，例如紙張的選擇，印刷或後加工等…去表達故事內容。因此內頁設計將隨著故事內容而有所改變。
Leading readers to understand stories by interacting with the book. It is a book about the indestructibility of knowledge and thoughts, about the destruction caused by knowledge, and the conflict between the old and new eras.My purpose is the use of the format of a novel in relation to the content, so that the formats would change to follow the story.

The Sunshine at Night　2015　P.53
重新詮釋 Sparklehorse -"Dreamt for Light Years in the Belly of a Mountain" 的專輯封面。靈感來自於第一首歌 "Don't Take My Sunshine Away"。這首歌創作期間正好是主唱人生中的轉折點；從悲傷至充滿希望。所以我以很多對比手法表現。並以時間河流的意向表達所有一切終將被分割切碎並緩緩被帶走。
The river of time will carry everything away and flow everything apart. My inspiration came from the first song of the album "Dreamt for Light Years in the Belly of a Mountain"- "Don't Take My Sunshine Away." For me this is a turn from sad to hopeful, downcast to upbeat process. The rhythm has a strong contrast. the logotype look like floating in the water and be washed away by the river.

ATELIER de C and J　2015　P.190
Atelier Chaio and Johnson 是由兩位留法的伙伴共同組成，因此標誌設計以兩人名字交疊組成品牌名稱為重點，此外全名以大寫排列時字母中藏有許多圓形造型，象徵甜點中常出現的馬卡龍、餅乾等產品。
Atelier Chaio and Johnson was found by two people that studying in France. The identity was the combination of their name.

IDEAOLOGY　2015　P.190
Ideaology = Idea+ Ideology,
創意與思想結合的新創字。此咖啡店注重創意，以咖啡入菜並研究食物與咖啡的搭配，所以在 logo 設計上我融入括號的意向，括號內可替換各種物品或經典名言，借以表現品牌創意與經典的形象。
The café shop's name is the combination of two vocabularies-idea and ideology. It focuses on making good coffee and food pairing for café lovers. The logo combines an image of curly bracket. Inside the bracket, it can be placed on any thing or quotes.

台灣 Taiwan

我來自台灣高雄，沒什麼不同，就跟你一樣！

I from Kaohsiung, Taiwan
I'm no different, just like you.

王騏肇 Wang Qi-Zhao

www.cargocollective.com/QiZhaoW

Q. 請問您認為該國最棒的是什麼 ?(如國家的特色或文化等) 您的創作是否受其影響 ?

A. 台灣最獨特的我想，應該就是 " 溫度 " 吧！

總有著滿滿的熱情，甚至瘋狂的熱血。

Q. 請問您如何獲得靈感？

A. 我喜歡來自不同文化的相關知識，差異、總能帶給我全新的角度。

Q. 除了當設計師 / 插畫家，你是否已經開始規劃下一階段的目標？例如策展、學習煮菜、登山

A. 其實，我很想當個幕後配音員，聲音是一雙無形的手，在不知不覺中騷動著我們的每個細胞。如果我也能用聲音做創造出些什麼，那應該很有趣吧～嘿嘿！

Q. 你對生活的細節上有什麼堅持嗎 ?(像是上廁所時一定要看詩集之類的)

A. 床鋪棉被必須保持平整！

Q.What do you like best in your country? (such as country feature or culture)Has it made a difference on your creation?

A. Taiwan's most unique I think, should be the "warm" !
Always have full of enthusiasm, even crazy .

Q.How do you draw inspiration?

A. I love every knowledge from different cultures, different, always gives me a new perspective.

Q.Have you started to set up new goals for next period except being a designer or illustrator ? like curating, learning cooking , climbing......

A. In fact, I would like to be a dubbing, sound ,it is a pair of invisible hand, commotion every cell of our body unknowingly. If I can use my voice to create something new , its ganna be really fun, haha!

Q.What is your insist on your life's details ? like toilet with your favorite poem?

A. Bed quilts must remain flat!

蠅頭細書 - 概念書籍設計 Flies head tiny book-Concept of Book Design 2012 P.9

書，在這影像爆炸的時代中已漸漸失去歷史流傳者的角色，但它卻是唯一還保有溫度、感情、用文字述說、以白紙黑字呈現，紙的紋理烙印於手心後深刻體會每則故事背後的那一滴淚最原始的感動。本創作想藉以 " 蠅頭細書 " 傳達現在的 " 書 " 已讓人漸漸遺忘，必須藉由一些特殊的方式才能激發讀者伸手並拿起書的慾望，早已失去 " 書 " 傳達知識文明崇高的地位。將 " 蒼蠅 " 轉意猶如現今媒體氾濫的時代，唯有如屎般爛臭的訊息才得以獲得讀者的注意，也藉此幽讀者一默，讓人第一時間因蒼蠅注意到此書，藉而反思是書的本質而不是蒼蠅。本書內頁使用日常生活中的報紙反應現在媒體社會中的收視率文化，對應封面的蒼蠅，呈現讀者失交的感官，曾幾何時文字以成了焦點的陪襯品，價值與收視率呈正比，紙的紋理烙印於掌心後剩一頁頁故事背後那最純真的感動早已被讀者忽略。

Book, in this era of image explosion has gradually lost the role of the historical spread, but it is only to maintain temperature, feelings, words describing black and white rendering, texture of paper imprinted deeply understand the story in the palm of the hand moved behind the tear is the most primitive. The present invention teeny fine book and would like to convey the "book" people have gradually forgotten, must be by some special way in order to stimulate the desire of readers to reach out and pick up the book, have long lost the "book" to convey the lofty status of the knowledge civilization. "Flies" to turn back as if today's era of media proliferation of only such a rotten stinking feces message was able to get the reader's attention, but also to quiet the reader a silent, people first noticed this book flies by while Reflection is the essence.

根 Life Eternal 2012 P.91

葉歸根，根如命，命永恆。宇宙萬物的根源就像一個循環，根生莖，莖生葉，葉歸根。生命遵循著自然法則永恆的延續著。以精子與卵子象徵生命，再將精子圖象轉義為植物的根，卵子外型為蛋形，意旨吸取養分，生命綿延不絕。

Leaves return to their roots, root resemble life, life is eternal. The source of all things in the universe is like a circle, root grows stem, stem grows leaves and leaves return to their roots. Life persists eternally with the laws of nature. Sperm and egg to symbolize life and then Sperm escaped to the roots of plants Image, the egg shape for the egg, intention of absorbing nutrients, Endless life

自由滅頂 God Bless 2013 P.91

如果有一天，連神都幫不了我們，那只能自求多福了！
If one day, even God can't help us, we can only rely on themselves!

Day After Day 2013 P.91

地球，一個不只孕育了我們的地方，一個曾經美如天堂的星球。物極必反，越是進步人類卻越是殘暴與盲目，一步一步、一日一日的自掘墳墓，而逼迫人類一步步邁向死亡的兇手正就是我們自己。

Earth, a place, not only gave birth to us, a once beautiful as paradise planet. When things reached the extreme, they can only move in the opposite direction, but more civilized, more greedy, but more brutal and blind, but the murderer who forced us to step into death were ourselves.







日本 Japan

古屋貴広

藝術指導 / Werkbund Inc. 執行長

1981 年生於日本，2004 年畢業於多摩美術大學情報設計學科，進入設計公司工作多年，2009 年離開公司並創立了 "Werkbund Inc."

Takahiro Furuya

Art Director / Werkbund Inc. CEO

He was born in Japan in1981. 2004 graduated in Tama Art University(Information Design Department). He joined good design company after graduating from college , after being as a freelance designer several years he leaved the company and established "Werkbund Inc." in 2009. Werkbund Inc.

Werkbund Inc.

www.werkbund.jp

Q. 請問您認為該國最棒的是什麼 ?(如國家的特色或文化等) 您的創作是否受其影響 ?

A. 我愛日本,因為日本人擁有豐沛的同理心,以及獨一無二,細膩的情感表達技巧。

Q. 請問您如何獲得靈感?

A. 從看的書和往常的城市風貌。

Q. 請和我們分享您喜歡的書籍、音樂、電影或場所。

A. 音樂很棒,從聽覺接收到的資訊,比起從視覺得到的資訊,更加能刺激想像力,最近我也會聽古典樂。

Q. 除了當設計師/插畫家,你是否已經開始規劃下一階段的目標?例如策展、學習煮菜、登山

A. 我喜歡釣魚,所以我覺得自己會到海邊當漁夫。

Q. 你對生活的細節上有什麼堅持嗎?(像是上廁所時一定要看詩集之類的)

A.「理所當然地做理所當然要做的事。」

Q.What do you like best in your country? (such as country feature or culture)Has it made a difference on your creation?

A. I love Japan. Because Japanese have the richness of compassion and emotional expression to delicate skill and others because it's unique.

Q.How do you draw inspiration?

A. I am inspired from such as a book you are reading and townscapes come routinely to eyes.

Q.Share good books, music, movies or places with us.

A. Music is very good. Information from the hearing is strongly stimulate the imagination rather than vision. Recently, I listen classical music too.

Q.Have you started to set up new goals for next period except being a designer or illustrator ? like curating, learning cooking , climbing......

A. I like fishing . So I think that it will go to sea as a fisherman .

Q.What is your insist on your life's details ? like toilet with your favorite poem?

A. "Do what's expected as expected."

善光寺賓頭盧市 Zenko-jibinzuru-ichi 2015 P.79

善光寺是日本長野縣著名的寺廟，廟裡供奉著賓頭盧尊者，在寺廟舉行的市集名稱就是「善光寺びんずる市」。

" Zenkoji Temple " is a famous temple in Nagano Prefecture of Japan .It is the " Binzuru " that is being enshrined in the temple .The name of the free market to be held in the temple is the " zenko-jibinzuru-ichi ." Participants will sell handmade goods .

明日的 JOE 時代展 "ASHITA NO joe and That era " Exhibition 2014 P.116

我想做出象徵亂世的海報，留下強烈的視覺印象。

I wanted to make a poster that symbolizes the troubled times. And we aim to strongly remain in visual impression .

岡崎藝術座 ISLA! ISLA! ISLA! OKAZAKI ART THEATRE "ISLA! ISLA! ISLA!" 2015 P.116

ISLA 意旨 island(島)，這個劇投入了導演自身對於尋根的想法。

The "ISLA", means " island ." This theater has been put is director of thought to explore their own roots .

Chelfitsch "Super Premium Soft W Vanilla Rich" 2015 P.116

Chelfitsch 是岡田利規在 1997 年創辦的劇團，他負責撰寫劇本並執導演出，chelfitsch 名字的由來是小孩子對於英文 "selfish" 的錯誤發音。

Chelfitsch Theater Company was founded in 1997 by Toshiki Okada, who writes and directs all of the company's productions. The name "chelfitsch" comes from a baby's mispronunciation of the English word "selfish."

翻騰的光：石田尚志 Billowing Light：ISHIDA Takashi 2015 P.117

在現代藝術與影像的領域受到極大注目的石田尚志，第一次舉行的大型個展，在橫濱美術館舉行，這是我替此次展覽設計的海報。

This poster is for the first time and large -scale solo exhibition for Ishida Takashi who get a great deal of attention in the area of contemporary art and video. This exhibition was held at the Yokohama Museum of Art .

RISM by RISINGWAVE 2015 P.150

這項產品並不是香水噴霧，而有別於傳統消費市場的是凝膠型的芳香劑，酷炫的瓶身讓年輕人願意隨身使用，而且攜帶方便。

This product is not a spray in perfume , is the fragrance of " gel " type was not the conventional market .So that it can be used casually in young men is any place , was willing to be a cool bottle and easy to carry.

MARUSHI MEAT 2014 P.151

我們的工作項目有公關策略 / 命名 / 室內 / 菜單設計 / 服務 / 制服設計 / 平面設計，而這間商店導入我們全部的工作項目。

We were responsible for the field of PR strategy / naming / interior / menu development / services / Uniform design / graphic design.

And this store was able to be involved in comprehensive.

Hair salon STOVE 2015 P.151

STOVE 是山形縣的美容院名稱，我們替這間店做了室內設計、符號系統、平面設計。

The stove is the name of a beauty salon in Yamagata. We designed the interior and the sign system and graphics of this shop.

印度尼西亞 Indonesia

Wildan ilham mahibuddin 是印尼雅加達講求務實精確的設計師。他的設計呼應在文化、地點和商業的實用需求，每個案件都在社會調查的基礎下完成。他喜歡在所有可能的媒體和領域工作，無論這領域對他的專業來說多遙遠，他就是那種熱愛提出想法的人。

Wildan ilham mahibuddin is a pragmatic precisionist designer based on Jakarta, Indonesia. He creates design that answers practical needs to use in between a culture, place, and a business. Every project that he made based on observations of society. He loves to work in all possible media and fields, no matter how far it is from his own disciplines. He is the kind of person who love to push the ideas.

Wildan Ilham Mahibuddin

www.behance.net/wildan

Q. 請問您認為該國最棒的是什麼？(如國家的特色或文化等) 您的創作是否受其影響？

A. 我喜歡我國的每個地方。總有一天我想到國內各個地方旅行，學習他們的傳統和社會，當然，我的所有設計也代表著自己的國家，我試著放入一些細節，讓設計看起來更有個性，至少我會覺得更有意義。

Q. 請問您如何獲得靈感？

A. 不要忘記四處瞧瞧，還有在你有空的時候多加思考。我總是在工作，所以當點子來的時候，我會在筆記本寫下來，用我的設計思考去發展它們，這種方式會帶給我靈感的答案。

Q. 請和我們分享您喜歡的書籍、音樂、電影或場所。

A. 我一直很喜歡閱讀自己專業的書籍，像是原研哉的《Designing Design》，或是 Dunne & Raby 的《Speculative Everything》。這些書總會提升我的點子，我喜歡接受任何事物，只要它是好的，無論別人怎麼想。

Q. 現在，回頭來看這些帶著遺珠之憾的作品，您有什麼新的感觸？

A. 如果我對此結果感到沮喪，這很正常，但不會想太多，就是繼續在下一次做到最好，你必須學習自己的錯誤，然後改善它。

Q. 除了當設計師/插畫家，你是否已經開始規劃下一階段的目標？例如策展、學習煮菜、登山……

A. 如果你將設計的思維帶入日常生活，那你就能辦到任何事。我是那種喜歡思考點子，勇於冒險的人，無論是多麼討厭的事，我喜歡接受它，不然就挑戰它，這是我的目標。

Q.What do you like best in your country? (such as country feature or culture)Has it made a difference on your creation?

A. I love every part of my country. Someday I want take my time to travel to each side of it and learn about their tradition and society of course it is, every project that I made always representing about my own country, I try to put some detail and making it more characteristic or at least it will look meaningful.

Q.How do you draw inspiration?

A. Always look around and think more about when you have a free time. For me, it's always working. Then after the ideas comes, I write it into my notebook and develop them using my general design thinking. it will lead me to the answer of my inspiration.

Q.Share good books, music, movies or places with us.

A. I always love to read a book that related with my disciplines, such as designing design by kenya hara or speculative everything by Dunne & Raby. These books always keep myself to push the ideas. I love to take everything. if it's good., surely I will take it. no matter how people think about it.

Q.Now, look back to these works of regret for not been selected, how do you feel that?

A. It's normal if I feel disappointed with the result, but don't think about it too much, just keep doing your best on next project, you should learn your own mistake and improvise it.

Q.Have you started to set up new goals for next period except being a designer or illustrator ? like curating, learning cooking , climbing......

A. If you apply design thinking to your daily life, surely you can do anything. I'm type of someone who love to push the idea and take a risk for everything. It doesn't matter how bad or it was the most hated thing in my life, I love to take it or challenge myself, that's my goal.

The Sign 2013 *P.42*
排版課的作業，內容是要重新設計既有的設計運動。
School project in typography class, the brief is to redesign the existing version about design movement.

Belajar 2014 *P.43*
在 Thinking Room 跨領域設計工作室的實習報告，這間工作室著重於許多設計範疇，Belajar 是學習的意思，有代表我所有經驗的意味。
Internship report as designer in Thinking Room multi-discplinary design studio that focused on many design fields, Belajar means study, it means to represent about all of my experiences.

Ethnic 2013 *P.80*
介於民族婦女肖像畫和排版的設計，以代表我的國家。
The mix between potrait of ethnic woman and typography to represent my country.

Playhard 2013 *P.80*
提交給設計學校Binus 大學的海報，結合各種形式的排版、形狀和線條創造一系列的海報，表達嬉戲的喜悅感。
Poster submission for School of Design Binus University. Combining all forms such as typography, shape, and lines to create series poster that represent about an the joyful of playing.

Philosophia 2015 *P.80*
philosophia 是本土時裝商店，注重現代、功能化的極簡設計，並受到印尼美感圖樣的影響。philosophia 販賣具有傳統與現代感的時尚配件，讓當代表印尼地方的圖形設計具有歷史與意義價值。
Philosophia is a local fashion store with focus on modern, functional and minimalistic design inspired by the Indonesian aesthetic pattern. Philosophia provides and distributes fashion pieces that look and feel at once traditional and modern. The brief was to make pattern design that represent some place in Indonesia with all of history and meaning behind it.

Alliance 2015 *P.81*
受到楠榜文化啟發的圖案設計，用現代的方法設計，表現出在傳統與現代之間的永續。
Pattern design inspired by culture of lampung, it was designed by modern approach to represent a renewal between form of traditional and present-day.

3 Things 2014 *P.213*
Thinking Room 系列的練習，用歌德字體做實驗海報。
An Exercise from Thinking*Room series of poster experimenting with Century Gothic.

Honest 2013 *P.223*
使用很多顏色和字體，傳達一個訊息：誠實是介於形式與情感的表達。
Using many colors and typography to deliver the message, honest is expression between form and emotion.

新加坡 Singapore

王愉雯　Wong Christina

www.behance.net/christinawong

王愉雯是來自新加坡的設計師。她的主要興趣和強項是在品牌設計，插圖和字體設計。她擁有南洋理工大學屬下藝術、設計與媒體學院的美術學、視覺傳播學士學位。她相信思維過程和概念是一個設計的基本基礎，而且她也非常欣賞美麗的顏色使用和字體。她堅信在設計上必須注入自己的思想和風格與項目的精髓和重點融合在一起。

Christina Wong is a designer from Singapore whose main passion and expertise lies in branding, illustration and typography. She holds a Bachelor of Fine Arts degree in Visual Communication from Nanyang Technological University's School of Art, Design and Media. She believes that the thought process and concept is the foundation a design stands on, and is captivated by beautiful use of colours and typography. She believes in injecting her own thinking and style into all of her creative projects while continuing to stay true to the essence of each project.

Q. 請問您如何獲得靈感？

A. 我的靈感大多數來自於網路、書刊、社交網站以及大家的日常生活中。我特別注意的是東亞以及北歐的設計，總覺得它們不僅美麗而且是具有地區代表性的象徵。

Q. 請和我們分享您喜歡的書籍、音樂、電影或場所。

A. 我在每個不同的時間點都有屬於自己的音樂。在思考的時候比較愛聽 Ed Sheeran, James Bay 之類的音樂。由於本身是基督徒，在遇到瓶頸需要一個人靜一靜的時候會聽聖樂。最近在趕工的時候最愛聽王若琳的 Bob Music 專輯，覺得特別 kuso 而且具有提神的功力。

Q. 除了當設計師／插畫家，你是否已經開始規劃下一階段的目標？例如策展、學習煮菜、登山

A. 因為即將要畢業了，所以預計會有一點時間空著找工作。在畢業後，我的夢想是帶著媽媽出外旅行。因為媽媽從來都沒有旅遊過，所以很想要在我們忙倒和變老前帶她看看世界。還有最近也買了一個膠片相機，可能可以在旅遊中學習怎麼用，一舉兩得。

Q. 你對生活的細節上有什麼堅持嗎？(像是上廁所時一定要看詩集之類的)

A. 我只能用木瓜肥皂。如果有一天世界上沒有木瓜肥皂了，我應該生存不下去。

Q. How do you draw inspiration?

A. I draw inspiration mainly from a lot of 'digging'. I dig around on the Internet, through books and magazines, social media and even snippets from everyone's daily life. I especially love East Asian and Scandinavian design, as they are not only beautiful but also effective in communicating the identity of their regions.

Q. Share good books, music, movies or places with us.

A. I have specific musical tastes for specific occasions. I enjoy listening to acoustic folk, alternative rock, indie (e.g. Ed Sheeran, Coldplay, John Mayer, James Bay) when I'm thinking and coming up with ideas. As I'm a Christian, when I need a breather and some quiet time in my own world I will usually turn to worship songs to realign and refocus myself. However when it's crunch time sometimes I can be a little weird. For example, I find that Joanna Wang's album Bob Music really has the power to energise and perk me up. It's like running on a sugar or caffeine high.

Q. Have you started to set up new goals for next period except being a designer or illustrator ? like curating, learning cooking , climbing......

A. As I'm graduating really soon, I figured there might be some time before I manage to find a job (although I hope it wouldn't be a long time). But during that time, I really want to travel with my mom without an itinerary. My mom's never been anywhere out of Southeast Asia so I really want to bring her to see the world before we get too busy and too old for it. Also, I'm planning to pick up film photography; I bought a film camera recently but haven't got around to using it yet.

Q. What is your insist on your life's details ? like toilet with your favorite poem?

A. I only use papaya soap. If the world runs out of papaya soap one day, I might cease to exist too.

Kid-O Repacking 2015 P.49

重新設計一個超市產品的包裝分為兩個不同的方向；一個作為適宜6-14歲的孩童，另外一個作為昂貴高檔品。紫色和橘色的手繪插圖為小孩帶來活力。

The brief was to redesign the packaging of a supermarket product into two varying directions; one as a product for children aged 6-14, the other as a luxury product. Purple and orange came together to create vibrance together with the whimsical handrawn illustrations for kids.

Harmony in Dissonance 2015 P.67

從2014年的「美麗的人 (不稱職)」續考，「和諧不和諧」主要是展示社會格格不入小人物的故事。在搜索「不和諧的和諧」中，探討人與空間，人與人，以及空間與空間之間的關係，以及如何透過顏色來代表故事。

A continued study from 2014's Beautiful People (The Misfits), Harmony in Dissonance aims to present the stories of the misfits of society. In search for the harmony in dissonance, this project explores the relationships between people and space, people and people, as well as space and space. This project also looks at how the colour grey can describe this sense of ambiguity.

Five Minutes Only 2014 P.168

FIVE MINUTES ONLY 是一個假設在2050年嘗試恢復新加坡被遺忘和衰退的傳統，並在一系列的調查後將它重新引入到2050年的觀眾群。因為普遍年輕人都大致上認為傳統中草藥是一個很麻煩不方便而且耗費時間的求醫方法，所選擇作為針對的傳統。該項目的目標是看到中藥被重新引入成為一種生活方式，也是一應俱全全島為2050年忙完成人便捷的醫療解決方案。

This project is a hypothetical attempt at reviving a fading tradition in Singapore, and reintroduces it to the audience of year 2050 targeted after a series of research and studies conducted. The chosen tradition is Traditional Chinese Medicine as many young people nowadays have the general idea that it is a hassle and also old-fashioned to consume Traditional Chinese Medicine, as opposed to off the shelves medications from the pharmacies. The vision of this project is to see Traditional Chinese Medicine being reintroduced and rebranded as a lifestyle and also as a convenient medical solution readily available islandwide for the busy working adults of 2050.

Tripod Dental Clinic 2015 P.169

TRIPOD 牙科診所被命名是因為牙科內側術語 "tripodization" 以及創辦診所的三人。設計的格調主要是想脫離以往慣例診所冷冰嚴肅的感覺。標籤裡也用 P 字母形成牙刷以及牙刷上牙膏的畫面。

Tripod Dental Clinic was named after the medial term 'tripodization', and also because of the trio that founded the clinic. While crafting out the identity for the clinic, we were careful in not misleading our audience to confuse the clinic with a camera equipment shop due to the name 'tripod'. Rounded letterforms were used as the main visual language for the brand, with the letter P stylised to form a toothbrush with toothpaste on it. The letter P is then used as an alternate independent logomark on other collaterals.

DAKOTA: The Typeface 2014 P.224

DAKOTA 是一個新新加坡最古老之一的公共住宅區，也即將被拆除走進歷史的達科達樽致敬的顯示類的字體。為了紀念新加坡建國 50 週年，這個項目試圖利用視覺設計來表達新加坡的歷史和故事。DAKOTA 採用了該住宅區裡的許多視覺上的細節和它所含有的獨特鋒利形狀。該字體所持有的雙透透視網格的靈感是來自達科達樽裡的許多的門面。

DAKOTA is a display typeface created as a tribute to Dakota Crescent, one of Singapore's oldest public housing estates that will soon be vacated to make way for new developments. As 2015 is the year of jubilee marking 50 years of independence for Singapore, this project attempts to communicate Singapore's history through design. DAKOTA takes inspiration from the estate's many intricate and fine details as well as its edgy geometric forms. The typeface is crafted within a hidden double perspective grid that was inspired by the Dakota Crescent's many facades.

Beautiful People The Misfits 2014 P.292

我們經常會動不動就打標籤貼在根據自己的外表的人。「美麗的人 (不稱職)」是一個評論著平等，美麗，奇妙可畏的世界。

We are often quick to slap labels on people based on their appearance. Beautiful People (The Misfits) is a commentary on how we are all created equal, how we are all created to be beautiful, how we are all fearfully and wonderfully made. Who has the right to judge who is beautiful, and who has the right to judge who gets accepted and who gets left on the sidelines?

台灣 Taiwan

顏睿，生於臺灣台北，現與夥伴一同成立目目和
設計有限公司，擅長透過文化與創意加值產品形
象，提供獨特的觀點與視覺呈現，期待各式合作
機會與平面設計案件。

Ray Yen was born in Taipei, Taiwan. He is currently being a co-founder of Muho design studio, specializing in Brand, Corporate identity, Typography, and Packaging design.

顏睿　Yen Ray

www.rayyendesign.com

Q. 請問您如何獲得靈感？

A. 散步或喝酒。

Q. 請和我們分享您喜歡的書籍、音樂、電影或場所。

A. 住家樓下的民權公園，只要靈感枯竭都會來冷靜一下?。

Q. 現在，回頭來看這些帶著遺珠之憾的作品，您有什麼新的感觸？

A. 希望有機會能讓它們重見天日。

Q. 除了當設計師 / 插畫家，你是否已經開始規劃下一階段的目標？例如策展、學習煮菜、登山

A. 自釀啤酒。

Q.How do you draw inspiration?

A. Take a walk or drinking.

Q.Share good books, music, movies or places with us.

A. Mingquan Park in front of my house. I like to take a rest there when my inspiration dry up.

Q.Now, look back to these works of regret for not been selected, how do you feel that?

A. Wish they can be seen one day.

Q.Have you started to set up new goals for next period except being a designer or illustrator ? like curating, learning cooking , climbing......

A. How to brew my own beer.

Hotel FOMF *2013 P.192*

以友誼的傳遞作為識別的概念，朋友連著朋友最終連至位於米蘭的飯店，形成了一個畫框，象徵著飯店本身與藝術與設計緊密相連。標誌僅使用文字與線條，置放在當地建築物時能不突兀的呈現，也能呈現簡約與現代的風格。

The logo was designed mainly based on the friendship relation diagram. Friends are connected to friends, and eventually to the hotel in Milan, forming a picture frame, symbolizing the design of the hotel closely related to taste and art. The decision of removing images and using only text and lines to create this logo was made based on the purpose of not being too strangely significant when the logos placed on the outside of local buildings. And a simple style may deliver the message of modernity and youth.

Interni 60th Anniversary *2014 P.193*

手勢是全球皆有的文化，尤其在義大利文化更為不可或缺，以手勢比出六十作為義大利雜誌 interni 的六十週年識別，並延伸出獨特的眼鏡搭配展場地圖，以及能讓觀眾與之互動的眼鏡，吸引更多人參與六十週年的盛會。

The main elements that we will use are hand which is universal language and also have the sense of Italian culture mix with the basic geometric shapes.
Logo : We used the simple shape of two hands doing 60 to tell about the celebration on this special event in Fuori Salone.
Typeface : Special typeface for this event which create from the geometric shape, one of our main elements.
Map : The map map booklet with special glasses, it says directly about Interni's 60th anniversary and special 60th glasses to use along with the map.

Divano *2013 P.193*

以復古裝飾性的標誌結合 1950 年代的插畫與廣告元素，將其風格應用在標誌設計、菜單、杯墊與店卡上。在菜單設計上以三種不同元素構成的圖騰來作為早餐、晚餐和飲品菜單的設計。

The Divano logo was designed with vintage decoration. We collected around 1950s image style as our visual elements like the pattern used in the covers of menus, coasters, and business cards. And used 1950s advertisement style in our coasters. About the menus, We have three different versions for breakfast, dinner, and drinks. Different menus used different material, and different kinds of visual elements.

Logo collection *2010-2015 P.194*

2010-2015 年間沒被選中但自己喜歡的標誌。
Logo collection from 2010 to present.

印度尼西亞 Indonesia

游可接

Yohanes Raymond (Nero | Graphic Design Boutique)

www.yohanesraymond.com

Yohanes Raymond 是印尼專業的平面設計師,對設計、時尚、排版和字體設計充滿熱情。從 2012 年開始接下許多品牌和平面設計的工作,主要有品牌標識、視覺設計、平面廣告設計、產品目錄、編輯設計、網頁設計,從海外到國內都有客戶,無論是企業或是個人。得過許多獎項,也在國際展覽展出、演講,在國際的品牌設計與平面設計刊物也有受邀刊登。

Yohanes Raymond is professional graphic designer based in Indonesia, have passionate about design, fashion, layout & typography. Since 2012, he have been working to some various project branding & graphic design. His Projects main focus is to make and build brand logo, visual identities, print design, catalog + editorial design, and website from overseas & local clients. He have worked some clients from corporate & personal business. And he got some award, international & local exhibition, speaker & his works given opportunity to enter at international publication about branding & graphic design.

Q. 請問您認為該國最棒的是什麼 ?(如國家的特色或文化等) 您的創作是否受其影響 ?

A. 印尼有許多豐富的文化,每個地區都擁有自己的特色,而且非常能啟發我的設計,像是品牌的圖形或顏色。

Q. 請問您如何獲得靈感 ?

A. 我們通常透過瀏覽網站參考設計,另外在公司喝一杯咖啡有助於鎮靜神經,然後我們會在用數位軟體設計之前會先塗鴉或設計草圖。

Q. 請和我們分享您喜歡的書籍、音樂、電影或場所。

A. 我們喜歡關於設計的書,像是 :

Do good design - David B Berman

Show Your Work - Austin Kleon

我們喜歡的地方是湖邊,因為會感到很平靜,喜歡的電影像是飢餓遊戲、移動迷宮 (冒險電影),還有豆豆先生。

Q. 除了當設計師 / 插畫家,你是否已經開始規劃下一階段的目標?例如策展、學習煮菜、登山

A. 是的!我想更精進自己的廚藝,今年我的廚藝往上昇了一個階段。

Q. 你對生活的細節上有什麼堅持嗎?(像是上廁所時一定要看詩集之類的)

A. 我們通常會在開始工作前來杯咖啡,播放我們喜歡的新 alunan 爵士,這樣做真的對我們的設計過程很有幫助。

Q.What do you like best in your country? (such as country feature or culture)Has it made a difference on your creation?

A. Indonesia is a country the rich culture. And of course each region in Indonesia has own culture for us very inspiring in our work for example : make pattern or colour for brand.

Q.How do you draw inspiration?

A. We usually are looking for inspiration through browsing in the wrong a web of one reference design, besides it also with tranquilize the mind in the company of a cup of coffee. After that we make doodle or sketch design before I get process design in digital.

Q.Share good books, music, movies or places with us.

A. We love book about design like :

Do good design - David B Berman

Show Your Work - Austin Kleon

We love place like lake because when we at lake we feel peaceful and we love movies like Hunger Games, Maze Runner (Adventure Movies), and also Mr Bean.

Q.Have you started to set up new goals for next period except being a designer or illustrator ? like curating, learning cooking , climbing......

A. Yes I want more expert for cooking, this year I get new level up for cooking skill.

Q.What is your insist on your life's details ? like toilet with your favorite poem?

A. We are usually started the day we work by making a cup of coffee , by making the news alunan of jazz that we love, and it really helps us to process a design.

UPPERHILLS - Convention Hall 2015 P.138

Upperhills convention hall 是國際餐旅業,提供奢華的套裝服務,概念上結合藍色與紫色,代表男性與女性,並使用大理石材質增添奢華感。我們做了概念式的商標和識別。

Upperhills convention hall is an international standard that has the luxury concept of packaged good . With the concept of a combined color blue and purple , which symbolizes as men and women , and the use of marble stone texture that adds to the luxury of a convention separate from it . And we help make it happen by doing the logo and identity conceptual and clearly.

SUMBER WARAS - TRADITIONAL CHINESE MEDICINE 2012 P.140

Sumber Waras 是位在印尼的傳統中藥鋪,藥療系統使用從中國傳來的傳統材料和藥草配方,Sumber Waras 在 19 世紀創立。品牌概念和視覺識別的根源是受到中國明朝的印章啟發,使用人參做為健康的象徵,我們想在品牌呈現的是,傳統中藥已朝向融合傳統概念和現代化,中國風的裝飾同樣也在品牌概念裡呈現。

Sumber Waras is traditional Chinese medicine shop in Indonesia. Drug treatment system using traditional ingredients and formulated from herbs that are taken directly from China. Sumber Waras build from the time of the 19th century. Concept Branding & Visual Identity in brand sources Sane is inspired by the time stamp china dynasty Ming, and using ginseng as a symbol of health, strength. And ginseng also known as plant capable of generating stamina. The impression we want presented in branding Traditional Chinese Medicine is more toward the modern with the classic concept of merging china. The use of ornamental china Asia adds branding concept in the presentation Sumber Waras.

STEPHANIE DJAYA - FOOD STYLIST 2015 P.141

世界上沒有多少人可以結合興趣與職業,但 Stephanie Djaya 可以做到。Stephanie Djaya 是印尼雅加達才華洋溢的料理家,和主廚 ItophToar 在美食電視節目 Itoph's Secret Recipe 擔任料理師,同時她也在巴厘島參與 Jamie Oliver 的飲食革命日。我們替 Stephanie 這位有才能的印尼料理家打造出良好、有創意的形象。

Not many people can combine two great passion & carrier, but Stephanie Djaya can combined it. Stephanie Djaya is talented food stylist from Jakarta - Indonesia. Her Experienced as a food stylist of cooking TV show 'Itoph's Secret Recipe' on foodie channel at Three Wise Monkey with Chef ItophToar. And she also participated as part of Jamie Oliver's Food Revolution Day project at Bali. And we help Stephanie to have good & creative images as talented Food Stylist from Indonesia.

RAYCHART - AUTHENTIC LEATHER GOODS 2015 P.142

Raychart 是印尼雅加達的本土品牌,推動材料和手工的質量,製做質感好的手工製皮革服件,手工製作出的細部觸感讓商品與眾不同,我們替 Raychart 創造明確的品牌識別,概念就是簡單、優雅。

Raychart is a local brand based in Jakarta-Indonesia, that promotes quality in materials , workmanship making a quality handmade product leather clothing . With the touch of detail in the workmanship makes this product be different from the others . And we help Raychart in creating branding identity clearly , the concept is simple, classy.

日本 Japan

以日本為中心活動的藝術指導兼設計師，專長是品牌設計、平面設計、包裝設計、編輯設計、網頁設計等。設計的特色是極簡化，把握素材的本質，移除不需要的元素。

Art director and designer based in Japan. I'm working on branding, graphic design, packaging design, editorial design, web design and so on. The features of my work are minimal designs which grasp the essence of materials and remove unnecessary elements.

高橋祐太　Yuta Takahashi

www.yutatakahashi.jp

Q. 請問您認為該國最棒的是什麼？(如國家的特色或文化等) 您的創作是否受其影響？

A. 日本是個「情感文化」社會，在日本，會偏向於打動人心的情感設計，例如，人們對於日本的包裝設計總有個印象：產品名稱與插圖擠在一起 (當然也有些例外)，雖然視覺感官可以辨識擁擠的資訊，在這種情況下人們在看到包裝設計的時候就不會去做一件事：思考。對受眾來說，「這個包裝想讓我們思考什麼事？」這是很難以想像的話。因為街道上充斥著情感式的設計，人們反而傾向於衝動購物。然而，朝向品味的生活需要健全的思考與決策，即使是在超商裡的包裝，也多少會影響到受眾。歐洲是思考文化的社會 (因此他們的消費文化比較平衡)，身為日本人得我們還有很多地方向歐洲文化學習。

Q. 請問您如何獲得靈感？

A. 首先，根據客戶的需求，我會先做客戶指定的市場研究，要讓我的研究成功，取得和理解市場既有的產品，和發現可能改變市場的新價值是一樣必要的。第二，用語言解析從市場調查得來的成果，將必要的元素與不必要的元素分開。第三，當我從第一和第二步驟中想出點子之後，我會思考這些新的價值要如何讓受眾了解，還有是否能帶給市場影響 (我會根據客戶的創新或保守程度做調整)。第四，開始繪製草圖，我會繪製大量的草圖，達到無論技術和準確性都能最佳捕捉到自身的想法的程度。第五，我會稍微休息，這樣回來的時候就可以用客觀的角度看待作品，就像是日本的俗語說的「燭台底下最暗」，如果太專注於一件事，就無法看到整體，因為這個原因，我一定會休息。第六，回顧這五個步驟之後，才算完成工作。第七，從完成的案子不斷積累的成果，將成為未來工作的靈感來源，根據我的經驗和從以前作品中得到的反思，精進自己的思考。

Q. 現在，回頭來看這些帶著遺珠之憾的作品，您有什麼新的感觸？

A. 這是非常有趣的問題，我想這是許多設計師都曾經歷過的事。我也因為複雜的因素而落選過，因為關係到客戶的想法與預算問題，從這個案例，我也發現自己有需要提升的地方，並將這次的學習應用在之後的案子中，舉例來說，我們身為設計師，透過自己的表達方式，向社會分享想法，它們不只用於如何消費產品，也可以用在激勵社會進步，某種意義上我們也在這個社會上分享這些想法。

Q.What do you like best in your country? (such as country feature or culture)Has it made a difference on your creation?

A. As Japan is a "culture of emotion," designs in Japan tend to be created with emotional impact in mind. For example, viewers of Japanese package design will get the impression that the product name and illustrations are all crammed together (There are, of course, exceptions.). While visual perception makes out the parts that make up the cluster of information, in cases like this there is one thing the viewer does not do when they are looking at a design in Japan: think. For the viewer, it is difficult to contemplate the words "what kind of thoughts does the package elicit?" Instead, people are inclined to buy impulsively because the streets are flooded with emotional designs. Though leading a decent life requires sound thinking and decision making, packaging sitting in a supermarket, for example, will still influence the viewer on some level. Europe is a culture of thought (thus their consumption culture is more balanced), and we as Japanese have a lot to learn from European culture.

Q.How do you draw inspiration?

A. First of all, based on the client's wishes, I start my research on the market that the client has specified. For my research to be successful, it is necessary to gain an understanding of the existing products in the same market as well as to discover new values that would change the market. Second, I linguistically parse the results from the market research, and separate the necessary elements from the unnecessary ones. Third, when I turn the ideas that were derived from the first and second steps into the product, I give consideration to how those new values would be comprehended by the viewer, and whether if it would make an impact on the market (I make adjustments based on how revolutionary or conservative the aim of the client is.). Fourth, I begin drawing up prototypes. I make lots of prototypes with the aim of inching closer to the design that best captures the ideals on a technical and accurate level. Fifth, I take a break so that I could come back to it later with an objective viewpoint. Just as the Japanese proverb "The darkest place is under the candlestick" says, you cannot see the whole picture if you focus too much on one thing. I make sure that I always take a break for this purpose. Sixth, after reviewing the process from the beginning to the fifth step, I finally finish the project. Seventh, the results that have accumulated from the completed work becomes a source of inspiration for future works. I refine my ideas based on my experience and things that I have gathered from

Q.Now, look back to these works of regret for not been selected, how do you feel that?

A. This is a very interesting question. I think this is something that many designers have experienced. In my case, I have had projects that were not selected due to complicated issues such as those involving the client's intentions and budget. But from these instances, I have discovered things I needed to improve on, and have applied what I learned in my future works. For example, we designers, in our presentations, share ideas like how our designs are not only used for products that are to be consumed, but they can also be used to galvanize society into improving itself. We share these ideas through various means with society itself.

Elternarbeit-Lehrerarbeit 2014 P.39

這本書將學術、跨學科和現代設計的元素放在一起，以白色做為背景表現認知的態度，另外，在排版上將圖片與文字分開，表現出客觀的思維。再來，此書的特點是透過節奏解決衝突的概念「生與死」、「過去與未來」、「個人與社會」，為了直接表現概念，從左邊和右邊擺入圖形，並在中心點取得平衡。

For this book design, academic, interdisciplinary and modern designs were required to work together. White color was chosen for the background to represent an epistemic attitude. Additionally, objective conception was expressed in the layout by placing images and typographies separate. Moreover, the graphic represents the characteristics of this book with images as balanced on the center or inserted from both sides. This intends to address conflict of concepts as "Death and Live", "Past and Future" and "Individual and Society," through a rhythm, expressing shrewd straight forward discussions.

Trinitat Special Edition 2014(vol.1), 2015(vol.2) P.41

我們設計了特別版的《Trinitat》，由 Michael Debus 撰寫的書，使用抽象、單色的視覺語言，呈現此書的意象與主題。而上下冊的靈感也是設計的一部份，這兩本書的封面都被分為上半部與下半部，所以當兩本書放在一起的時候，會成為一個互補的整體。

We designed this special edition of the book "Trinitat" by Michael Debus using an abstract and monochromatic visual language that reflects the book's intention and main theme. The idea of upper and lower is also part of design, since the cover of each book is divided into an upper and lower half so when the two volumes are stacked they create one complementing unity.

POLKA 2014 P.136

在創造 Polka 的品牌形象時，我用熱情、拓展的精神，作為 Polka 的特徵，使用 Polka 這個名字本身的含義，波爾卡圓點，做出洋溢著現代性與歡樂的商標。將圓點這個特徵拉出來，做出四種大小的點並隨機排列，設計出原創的圖樣，表現出 Polka 拓展精神、熱情、好玩、個性化的需求。

When I created Polka's brand image, I expressed the passion, pioneering spirit, and many of interests as Polka's identity. By used of polka dot that is the origin of the name of Polka, I produced the logotype that is full of modernity and joy. Then, by extracting the dots, I designed

the pattern of random arrangement of large and small four dots. It expresses the interests, pioneering spirit , passions, funs, the claims of individuality of Polka.

FLAT ARK 2013 P.137

我們負責 BMX 越野車花式世錦賽決賽 "FLAT ARK" 的視覺設計，使用兩條線來表達他們平凡又非凡的經歷，線上方的聚光燈代表 FLAT ARK，兩條線的形成一艘船的形狀，暗示方舟 (ARK)，在方舟上的五個圓圈代表舞動的自行車，整體看來，像是皇冠的圖案。

We were responsible for VI design for the BMX Flatland world championship final "FLAT ARK". We used two lines to express both their ordinary and their extraordinary experiences, with the upper line representing the spotlight of FLAT ARK. Seen in overview, the lines form the shape of a ship—one that suggests an ark. On this ark are five circles that represent dancing bikes. Seen as part of the whole, they have a crown-like motif.

Traditional festival of Japan 2015 P.137

替我們本土的節慶設計主視覺，它是每年秋天在日本四國舉行的傳統活動。我們選擇神話中的一個場景，運用日本的技法，像是金箔繪和書法，以及現代的設計，向這些技藝高超的工匠們致意。

We did the visual design for our local festival, a traditional event held every fall in Shikoku, Japan. We selected one scene from a myth, and used Japanese methods like gold leaf covering and calligraphy, as well as modern design, to pay homage to these skilled craftsmen.

Mandarin natural Chocolate 2016 P.139

此品牌採用「bean to bar」的巧克力生產過程。透過醒目的白色，優雅的現代設計，給予品牌現代感，以天生出眾、不容妥協的識別形象，結合簡約優雅和現代的印象。

Mandarin natural chocolate makes "bean to bar" chocolates, employing chocolatiers consistently working on the entire manufacturing process from the roasting of cacao beans to the finished chocolate bar. This modernistic brand expresses itself through stunning white, an understated elegance and modernistic graphic design. Our distinct identity, borne of our obsessive refusal to compromise, integrates a minimalistic elegance with a contemporary impression.

中國 China

大連民族大學設計學院講師／SGDA會員／漢儀字庫簽約字體設計師。

Dalian Nationalities University School of design Lecturer / SGDA fellow / HANYI FONTS Contract font Designer.

戰國棟 Zhan Guo-Dong

foison@qq.com

Q. 請問您如何獲得靈感？

A. 我是一個感性的人, 對生活、對自己從事的工作的感悟是至關重要的, 所以關心生活, 關注生活, 體驗生活, 一直以來都是我獲得靈感的重要途徑。

Q. 現在, 回頭來看這些帶著遺珠之憾的作品, 您有什麼新的感觸？

A. 這些「遺珠」正是我學習成長的過程, 每次面對它們都會把我的思緒帶回到那些青澀的創作時光中, 那時候一個人在國外雖然辛苦, 但日子過的單純, 沒有瑣事煩心, 可以專注於字裡行間的修行, 雖然當時一些對於漢字字體設計的認識是有些 " 問題 " 的, 這些 " 遺珠 " 如若以現在對漢字的理解重新再做一遍, 一定會比那時好上很多。但那時工作的心境卻是現在需要重新找回並堅持的。

Q. 除了當設計師/插畫家, 你是否已經開始規劃下一階段的目標？例如策展、學習煮菜、登山……

A. 能做一名字體設計師, 並不斷看到有更多的人在不同環境下使用自己的作品, 是件相當幸福的事。能做更多的作品出來會是我一直的目標, 尤其是正文用基礎字體, 一直以來都是我的理想。除此之外, 那就是伴隨我家女兒的成長, 當個好爸爸。

Q. 你對生活的細節上有什麼堅持嗎？(像是上廁所時一定要看詩集之類的)

A. 我是一個隨遇而安的人, 貌似沒有什麼特別的癖好, 如果一定要說一個的話, 我在飲食方面尤其喜愛麵條, 一天吃三頓都沒有意見, 連續幾天沒有吃麵的話, 就會感覺生活裡缺少了點什麼, 就會有幾天來沒吃過飯的感覺, 所以一定要吃麵。

Q. *How do you draw inspiration?*

A. I am quite sensational, and I think the feelings from life and my workare most important, so the care and experience about life have always been my main sources of inspiration.

Q. *Now, look back to these works of regret for not been selected, how do you feel that?*

A. These "regrets" are witnessing my learning progress. Every time I see them, they can always bring me back to the good old days of creation. I endured a lot in Japan, but my days were simple without trifles, andI could focus on the characters. I had problems on the knowledge of Chinese font design, and now with my understanding updated, it wouldbe much better, but the mind I was working in is what I have to pickup again and insist now.

Q. *Have you started to set up new goals for next period except being a designer or illustrator ? like curating, learning cooking , climbing......*

A. It is more than blessed to be a font designer, especially when more and more people are using my own work in different scenarios. My goal is to continue in making more works, especially elementary fonts forbody text, which has always been my aspiration. Besides, I want to bea good dad and grow with my daughter.

Q. *What is your insist on your life's details ? like toilet with your favorite poem?*

A. I have not particular habits, but if I must mention one, it would be my love on noodles. I am okay to eat noodles for three meals a day. If I missed noodles in my life, it seems to have something missing, so Imust eat some noodles.

無心 山水 Uncontrived Mountains and rivers 2014 *P.133*

無心、山水, 是幾年來我實踐字體設計的一點心得, 「無心」, 戒去一切雜念去面對自己手頭的文字, 捨棄無謂的樣式, 直追文字記錄傳播信息的本質, 只有這樣的字體才能更好的服務於人, 才會在這世上留存的更加長久, 所謂音「山水」之間。這是最初的觸動, 希冀和作為一名做字者的最大追求, 將這做成海報懸於工作室, 以時時告誡自己勿忘初心。

In recent years, whenever I design typography and fonts, I always envision a view of mountains and rivers – the gifts given to us by nature. In this way I hope to purify my heart and remove each and every distractions and properly prepare myself to deal with the task at hand; which is to create. The goal is to discard any dependence on existing styles. Rather, it is to catch the essence of the characters' existence, which is simply to record and disseminate information. Only by taking this approach can design rise above mere commercial considerations and be of benefit to humanity now and in the future. In the same way that nature integrates diverse elements into a beautiful whole, so should words and design be integrated. I strive to clear away the interference of what has been done before, and return to a child-like state of seeing things anew. In this way I hope to touch something as if they are new for the very first time. This is my hope, and what I constantly pursue, in my life as a designer.

文黑體 WH 2012 *P.214*

文黑體是以書籍正文橫排同時適用豎排泛排為主要目的進行創作開發的, 相對於現行具有時代感的黑體, 文黑體更具人文氣質, 它筆畫柔軟彈性兼具楷書筆畫含筆氣韻, 中宮內斂、重心向上, 字形性格溫柔和、積極開朗。相對於假想字身90%的字面設定給行文帶來寬鬆的字間距, 配合內斂的中宮, 緊湊的字面使得組文時都字間互不干擾, 單字清晰可見; 標點符號相對假想字身寬70%的窄幅設定, 減少了行文時斷句間的空白, 更得使文章行氣貫通, 給讀者帶來流暢的閱讀體驗。

WH is designed for the horizontal body text typesetting and vertical general typesetting use. Compared to other existing Heiti, WH is more humanistic. Its strokes are gentle, flexible and incorporated with characteristics of Kaishu. The centre is more condensed, and the centre of gravity is slightly moved upward, forming a soft, gentle, active and optimistic typeset. Compared to 90% version, the 100% version has an appropriate character distance, and with a tight centre, readers will not feel interfered during reading. The optimized punctuation reduce the blank spaces and bring a smooth reading experience.

瑞意宋體 RuiYiSong 2012 *P.214*

瑞意宋體是一款帶著很強個性的大標題字體, 它充分的表達著現代都市氣息, 摩天大樓般的高聳感、硬朗直線帶來的速度感、線與線強對比帶來的凌厲感、微妙而有張力的曲線帶來的力量感、嚴謹的細節帶來的精緻感, 同時盡可能保留漢字書寫的人文情懷, 有性格但不張揚, 這些都在表達著這個時代的審美取向。

RuiYiSong is a characteristic font for headings. It shows the sense of metropolis, the height of skyscrapers, the speed brought by straight lines, the strong contrast between line and plains, the strength from well-curved lines, the delicate and precise details as well as the humanism in writing Chinese characters.

絳雲明朝 JiangYun Mincho 2010 *P.214*

絳雲明朝是一款帶有雕版氣息的標題宋體試做, 將帶有雕琢感的筆畫型態與當代人的視覺經驗結合, 將簡體字結構與舊筆畫書寫結合, 希望能在傳統與現代的交融上進行一些探索。

JiangYun Mincho is a trial heading songti with the sense of engraving woodblocks. I wish to integrate simplified characters and old strokes, and explore on the fusion style of ancient and modern era.

文本明朝 WenBen Mincho 2010 *P.214*

文本明朝字面寬大、中宮放鬆、布白均勻、行文平整, 是一款簡約現代、帶有工業味道的正文用字。

WenBen Mincho is wide with a relaxed centre, and its B distribution is balanced. It is a simplistic typeset of body text with a sense of industrialism.

鐵線黑體 TieXian H 2010 *P.214*

鐵線黑體是與文本明朝相配合使用的一款為正文橫排為設定的黑體, 它具備了文本明朝字面寬大、中宮放鬆、布白均勻、簡約現代等特徵。同時, 因其筆畫剛硬且勾提轉折處有明顯的頓筆特徵, 因此取名為鐵線黑體。

TieXian H is a Heiti used together with WenBen Mincho. TieXian H also shares the characteristics of being wide, relaxed centre, balanced B distribution and simplicity. Also, the strokes are strong, and there are obvious angle transition at the end of strokes, so it is called TieXian H (meaning iron wire).

Creative Talk in Asia 亞 洲 創 意 對 話

May 2016 VOL.3 創刊於 *104.04 since 2015.04*

總編輯 *Chief Editor*	陳育民 *Chen, Yu-Ming*
編輯團隊 *Editing Team*	張立妍 *Chang, Li-Yen*
	張唯琳 *Chang, Wei-Lin*
	張譽靜 *Chang, Yu-Ching*
	陳怡璇 *Chen, Yi-Xuan*
	程婉菁 *Cheng, Wan-Jing*
	林峻瑋 *Lin, Chun-Wei*
出版者 *Publisher*	陳育民 *Chen, Yu-Ming*
地址 *ADD*	台灣 *, 807-72* 高雄市三民區汾陽路 *20* 號一樓 *1F.*
	No.20, Fenyang Rd., Sanmin Dist.,
	Kaohsiung City 807, Taiwan (R.O.C.)
電話 *TEL*	*+886-926-600-147*
出版時間 *Publishing Time*	*105* 年 *05* 月 *May 2016*

國家圖書館出版品預行編目 (CIP) 資料

CTA 亞洲創意對話 . VOL.3 / 陳育民總編輯 . -- 高雄市：陳育民，
民 105.05
　面；　公分
中英對照
ISBN 978-957-43-3485-8(精裝)

1. 設計 2. 創意 3. 亞洲

960　　　　105006716